• • •

American Iconology

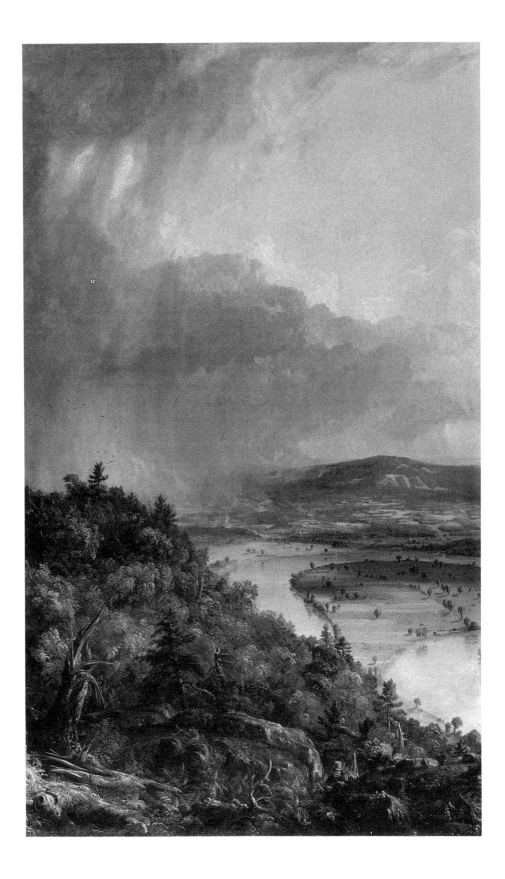

EDITED BY DAVID C. MILLER

· · ·

American Iconology

*New Approaches to Nineteenth-Century
Art and Literature*

YALE UNIVERSITY PRESS

NEW HAVEN AND LONDON

Frontispiece: Thomas Cole, *View from Mount Holyoke, Northampton, Massachusetts, after a Thunderstorm (The Oxbow)*, 1836 (detail).

Designed by Nancy Ovedovitz. Set in Joanna type by The Composing Room of Michigan, Inc. Printed in the United States of America by Thomson-Shore, Dexter, Michigan.

Library of Congress Cataloging-in-Publication Data

American iconology : new approaches to nineteenth-century art and literature / edited by David C. Miller.

p. cm.

Includes bibliographical references.

ISBN 0-300-05478-5 (cloth). — ISBN 0-300-06514-0 (paper)

1. Art and literature—United States. 2. Arts, American. 3. Arts, Modern—19th century—United States. 4. Ut pictura poesis (Aesthetics) I. Miller, David C., 1951– .

NX175.A47 1993

700'.973'09034—dc20 92-46082

CIP

A catalogue record for this book is available from the British Library.

The paper in this book meets the guidelines for permanence and durability of the Committee on Production Guidelines for Book Longevity of the Council on Library Resources.

3 5 7 9 10 8 6 4 2

• • •

Contents

CONTENTS

. . .

Acknowledgments

I am indebted to Angela Miller and to my wife, Charlotte Wellman, for their ongoing enthusiasm for this project as well as their considerable input at every stage of its development. Laura Quinn, David Lubin, Robert Ulin, and Sarah Burns were helpful at critical points. Albert Gelpi's encouragement proved invaluable early on, and a Mellon Postdoctoral Fellowship in the Humanities at Stanford enabled me to lay the groundwork for this book. Judy Metro and her colleagues at Yale University Press guided the project skillfully and graciously from start to finish.

• • •

Contributors

BRIGITTE BAILEY
Assistant Professor
Department of English
University of New Hampshire

DAVID BJELAJAC
Associate Professor
Department of Art History
The George Washington University

SARAH BURNS
Associate Professor
Department of Art History
Indiana University

ROBERT H. BYER
Assistant Professor
Department of English
Rhodes College, Memphis

HARRIET SCOTT
CHESSMAN
Independent Scholar

EMILY FOURMY CUTRER
Associate Professor
Department of American Studies
Arizona State University West

DAVID LUBIN
Associate Professor
Departments of Art History
and American Studies
Colby College

ANGELA MILLER
Assistant Professor
Department of Art History
Washington University, St. Louis

DAVID C. MILLER
Assistant Professor
Department of English
Allegheny College

KENNETH JOHN MYERS
Assistant Professor
Department of American Literature
and Civilization
Middlebury College

LAURA RIGAL
Assistant Professor
Department of English
University of Chicago

ALAN WALLACH
Professor
Departments of Art History
and American Studies
William and Mary College

D A V I D C. M I L L E R

. . .

Introduction

This book by scholars trained in art history, literature, and American studies places nineteenth-century American art within a variety of interdisciplinary contexts. Reflecting the growing theoretical and methodological sophistication that has transformed the humanities over the past two decades, the perspectives represented here bridge divisions between visual and verbal representation in order to relate literature, painting, sculpture, and monument art to the economic and social forces as well as the cultural needs and aspirations that gave them shape and meaning and that were influenced by them in turn.

Such a project adds to the growing field of iconological studies and both benefits from and contributes to the developing theory of iconology. In the 1930s Erwin Panofsky introduced the concept of iconology, which he opposed to iconography. Actually, he isolated three levels of meaning above the formal basis of any image. The first level consists of "primal" or "natural" meanings, including the recognition of facts and expressions (a level generally mistaken, Panofsky contended, for the formal level). We see something—a collection of sense data—as a manifold, a man or a tree, and we also respond empathetically to a complex of emotions evoked by this manifold. The second level is that of iconography or conventional meaning, involving the connection of motifs with themes and of concepts with images.

The third level of meaning, the iconological or intrinsic, offers "a unifying principle which underlies and explains both the visible event and its intelligible significance, and which determines even the form in which the visible event takes shape."[1] For Panofsky, iconology is to be "apprehended by ascertaining those underlying principles which reveal the basic attitude of a nation, a period, a class, a religious or philosophical persuasion—qualified by one personality and condensed into one work" (30).

Recently, W. J. T. Mitchell has refashioned the concept of iconology by centering

it in the relation between the visual and the verbal and by closely relating it to ideology. Iconology, for Mitchell, is the study of both "what images say" and "what to say about images"—the rhetoric of images, in other words.[2] So conceived, iconology offers a touchstone for the chapters in this book, providing a rationale for their focus on imagery as opposed to textuality, which for Mitchell serves primarily as a foil to imagery. Mitchell has led the way in arguing that the visual and the verbal are not in fact distinct ontological categories but distill themselves only in relation to each other. In *Iconology: Image, Text, Ideology* (1986), he argued that this ongoing process of mutual redefinition, subject as it is to changing social and cultural practices, is a sensitive index of ideology, broadly defined as "the structure of values and interests that informs any representation of reality" (4).

I do not claim that all the chapters in this book self-consciously share Mitchell's concerns and assumptions. The authors represented here take a variety of methodological and theoretical stances. Yet their very attempts to correlate the discourse of art with discourses as diverse as the religious, the political, and the commercial evolve from the premise that the visual and the verbal are deeply implicated in each other. Mitchell's work offers stimulation and guidance to anyone who would explore this fundamental relation. Moreover, just as he has shown how deeply interrelated they are, Mitchell has challenged the tendency in contemporary theory and practice to ignore or discount any distinction between the visual and the verbal. I shall explore some of the implications of this challenge in the Afterword.

The high degree of visual–verbal interaction throughout the American literary and artistic tradition makes the application of a theory of iconology to this body of material all the more imperative. It is especially timely in view of the considerable amount of work already being done in this direction on British and European culture. In a recent essay on the historiography of American art, Wanda Corn noted, "There are already signs that some scholars are trying to synthesize the close textual reading of pictures (events, spaces, buildings) with concerns for social and cultural analysis. By the same token, it may also be that the new interpreters are moving toward a more historically-based exegesis of art. Time will tell."[3] Corn cited Bryan Jay Wolf's article "All the World's a Code: Art and Ideology in Nineteenth-Century American Painting" (1984) as an example of work that probes this nexus.

Wolf's article focused on the issue of ideology as the link between a close formal and semiotic reading of American romantic paintings and the social and cultural context. Writing about key works by Asher B. Durand, Richard Caton Woodville, John Quidor, and David Gilmore Blythe, Wolf explored the ways in which these painters relocated their own artistic pursuits within an emerging market economy by participating in the restructuring of ways of seeing and in the recodifying of knowledge. He concluded that "acculturation for these artists had to do less with direct moral uplift than with the structuring of social perceptions. It was a question of representation—who controlled the ways of seeing. The result of this artistic strategy was twofold: it transformed representation into a cognitive structure fraught with enormous ideological weight and it produced a 'textualized' version of reality as a series of semiotic codes that we are still living with today."[4]

Wolf's speculations are readily compatible with a growing corpus of work by British and American scholars on the role of ideology in British neoclassical and romantic painting and literature.[5] In particular, concern with the sublime and the picturesque as they evolved in England has led these scholars to interrogate the ways in which such aesthetic categories functioned to naturalize conventions of seeing the landscape and the social life related to it. In assuming such perception to be intuitive and spontaneous, romantic modes of landscape depiction and description displaced matters of power and property from the actuality of class, gender, and race hegemony to aesthetic and symbolic realms, thus promoting them as transcendent and universal truths.

The chapters of this book follow the lead of such work on the British tradition by situating American art and literature within its various ideological matrices. To one degree or another, all of them consider the interplay of visual and verbal modes in what is best characterized as the development of an American national subjectivity. The social construction of this national subjectivity can be synchronized with the emergence of middle-class identity, which was propelled by the transformation of capitalism in the early nineteenth century. Artists and writers increasingly responded to and also helped to direct the opportunities opened up by expansion across the continent and into global financial markets. They interacted closely with such processes of the developing market economy as consumerism and commodification.

The complicated relations explored in this book among modes of expression, collective consciousness, and economic and social forces deepen and expand our understanding of nineteenth-century American cultural development on a number of fronts. Several chapters examine the role of gender differentiation in distilling new symbolic values. Others consider the instrumentality of landscape representation in the shift from a prophetic view of American destiny to one increasingly characterized by commercial values. The artist's relation to the national enterprise is a recurrent theme throughout this book. A number of the chapters theorize about the connection between visual and verbal modes. Certain discussions probe the changing role of the beholder as a critical aspect of the formal and even stylistic dimensions of works of art. Others foreground the conception of the visual that interacted with the role of the beholder at certain points in time. Taken together, these essays provide an overview of the changing relation between elite culture and popular or mass culture as the century progressed.

Perhaps the most important issue at stake in all this is the theoretical problem raised by these essays: just how are we to do justice to the intricate associations among art and literature, the changing nature of subjectivity, and the developing cultural context? While iconology provides an umbrella for the various concerns of this book, thinking about ideology over the past two decades has transformed the very concept of iconology. Indeed, if we accept Mitchell's definition of iconology as the imagistic counterpart of ideology, we do well to consider at greater length the role of ideology in contemporary cultural studies. The question of ideology, moreover, brings into play the issues of representation and motivation, hence providing a

fuller understanding of what the chapters in this book offer to the ongoing discussion of iconology and its place in cultural historiography.

The function of ideology, as it has come to be conceived more recently, is not to mask or mystify the exercise of power or the consolidation of property. Such words refer to a far less sophisticated notion of the Marxist relation between base (political economy) and superstructure (culture) than the one currently being refined under the influence of postmodernist theory. Far from suggesting that cultural products reflect the conditions of economic production and that ideology therefore operates as a kind of false consciousness, the emerging synthesis of Marxism, poststructuralism, semiotics, and feminism has issued in a conception of ideology that involves a much more dynamic interaction between the two. Departing from the earlier reification of the economic sector as a structure in some way mirrored by the superstructure of culture, one influential perspective on this relation reformulates both the economic realm and the expressive aspects of culture as processes of production continuously engaged in a dialectical exchange of values which often undercut each other. According to Raymond Williams, "We have to revalue 'the base' away from the notion of a fixed economic or technological abstraction, and towards the specific activities of men in real social and economic relationships, containing fundamental contradictions and varieties and therefore always in a state of dynamic process."[6] Simultaneously, the symbolic productivity that constitutes the superstructure achieves equivalence with the practical and material processes of production that generate the base by being removed from the transcendent realm of creativity and placed in the world of changing market forces and technological developments that always mediate creativity.

The equivalence of the symbolic with the material and practical informs Laura Rigal's analysis of Peale's Mammoth in the opening chapter. In considering representations of the mastodon in the rhetoric surrounding Charles Willson Peale's natural history museum as well as in two of the artist's most famous paintings—*Exhuming the Mastodon* (1806–08) and *The Artist in His Museum* (1822)—Rigal explores the ambivalence at stake in the Jeffersonian identification of private productivity with national good. Taking as her starting point the problem of labor at the heart of the Jeffersonian political economy (as opposed to the elite and commercial ideology of the Federalists), she traces the various conflicts evolving from the inevitable association of agricultural and artisanal labor with expansion across the continent. Peale's work of cultural production registered profound anxiety about "labor's potential for revolutionary change," a power that threatened to undo the very possibility for self-making. Within this context, Peale's Museum and its mastodon emerge as symbolic expressions of the "ethic of self-production" at the heart of the Jeffersonian-Republican political economy which helped to transform the profound contradictions inherent in it.

In order to avoid the hierarchical implications of the base–superstructure model that underlie the tendency to turn economics and culture into separate entities rather than interacting processes, it is perhaps more accurate to talk, as Williams does, of the "totality of social practices." But as he goes on to point out, while such a dynamic notion comports with the premise that social being determines conscious-

ness, it inevitably threatens to do away with the very basis for that determination. If we can speak meaningfully of the social construction of the subject or self along with its various forms of expression, we also risk losing sight of any priority in the connection of subjects to the system of social practices. With it disappears any notion of causality as well as of human freedom. Williams therefore prefers the concept of hegemony to that of the totality of social practices because it reinstates priority without bringing back the conceptual hierarchy that marred the older reflective model of culture. It does so by pointing to the exercise of power from above, of one class over another.[7] For Williams, hegemony nevertheless "supposes the existence of something which is truly total . . . which is lived at such a depth, which saturates the society to such an extent, and which, as Gramsci put it, even constitutes the substance and limit of common sense for most people under its sway, that it corresponds to the reality of social experience very much more clearly than any notions derived from the formula of base and superstructure" (37).

It is not difficult to see the relevance of this formulation of the diffusion of power for the role of art in an expanding nation in which authority was decentralized to an unprecedented degree yet where social and economic elites (Charles Willson Peale is a good example) still strove to maintain control. Within this context, works of art functioned to internalize power relations among members of their audience at a profoundly unconscious level. Rigal, accordingly, is interested in the way Peale's Museum as well as the bones of the mastodon housed within it frames the visitor as both subject and object of his own self-production, suggesting not only the project of self-making related to Republican virtue and middle-class aspiration but also self-mastery and self-containment. In her view, the Jeffersonian political economy advocated by Peale "aimed to produce a self-regulating social order by lifting all external, coercive force from the human body, while widening and deepening (or democratizing and elevating) the social field, wherein all persons were free not only to appear but to become the independent objects of their own production."

This concern with what Michel Foucault termed the "panoptic" displacement and diffusion of power is shared by Alan Wallach in "Making a Picture of the View from Mount Holyoke." In examining two preparatory drawings for Thomas Cole's The Oxbow, Wallach probes the historical processes leading up to the crystallization of the panoptic or panoramic mode that characterizes the painting. He considers these drawings "in terms of the dynamics of a complex set of interrelated, and mutually reinforcing, cultural practices," showing how the apparatus of the panorama, as a structure for representing the landscape, conditioned Cole's own composition: "The panorama might thus be thought of as a machine or engine of sight in which the visible world was reproduced in a way that hid or disguised the fact that vision required an apparatus of production." As with the experience of visiting Peale's Museum in Rigal's account, "what was being produced was not only a spectacle but a spectator with a particular relation to reality." The grafting of this convention onto the landscape issued in the "panoptic sublime," a moment in which vision and power converged in the "sovereign gaze" (the phrase is Foucault's). In appropriating and naturalizing this convention for seeing the landscape, Cole not only solved the problem of composition facing him in the view from Mount Holyoke but encoded

"new forms of middle-class hegemony." Wallach thus sees the ascent of Mount Holyoke as "a stunning metaphor for social aspiration and social dominance."

In "On the Cultural Construction of Landscape Experience: Contact to 1830," Kenneth John Myers takes a genealogical view in illuminating the emergence of aesthetic perception as a mode of internalizing authority. Myers argues that American romantic landscapes like those of Cole and Cooper set the stage for the popularization of the mental skills needed for appreciating landscape by representing them as if they were innate or natural. In considering The Pioneers (1823), Myers shows how Cooper contrasted Natty's natural ability to appreciate and interpret the landscape with the learning of Elizabeth Temple, which depends on the history of landscape appreciation. Cooper's portrait of Natty "obscures that history by promoting the culturally powerful fiction that landscape appreciation is a natural ability available to all uncorrupted men and women." Similarly, Cole's paintings of the Catskills in the 1820s superseded visual representations of that region that had treated it as a tourist resort, reflecting a self-consciousness about the cultivation necessary to respond to their beauty. In erasing the telltale traces of civilization, these images constructed the wilderness and the artist-prophet's relation to it in mythic terms.

Before the 1820s many well-to-do Americans knew "how to objectify natural environments as picturesque landscapes and to interpret them as illustrative of moral truths, but the cultural significance of the meanings they read into natural scenery was limited by the self-consciousness with which they approached the act of interpretation." Landscape could therefore "not be invoked as a higher kind of evidence as to the nature of the world or of God's purposes in it." Myers stresses the act of forgetting which characterized the new middle-class ethos. Aesthetic response was imagined to be spontaneous and intuitive: "Economically privileged Americans first learned to objectify natural environments as landscapes and then learned to forget the mental labor involved in this objectification." The "labour of admiring" referred to by the early nineteenth-century British traveler Basil Hall became so habitual as to seem instinctual. Much of Myers's argument is taken up with an effort to recover the long historical process behind this naturalization of the landscape which transformed both its representation and its meaning and which culminated in the invention of the picturesque, "a self-consciously disinterested mode of pictorial objectification."

For Angela Miller, the internalization of power relations extends to artistic composition and style. In "The Mechanisms of the Market and the Invention of Western Regionalism: The Example of George Caleb Bingham," Miller takes up Rigal's concern for the role of art in furthering nationalism and follows it into the 1850s with the emergence of the mass market. She shows how Bingham's paintings—especially his famous Fur Traders Descending the Missouri (1845)—implicitly advanced a political program closely linked to Henry Clay's "American System." Pictorially endowing the fluid society of the frontier with an illusory stability, these paintings reconciled regionalism and nationalism, western variety and social permanence. Miller attributes a similar function to the work of the Southwestern Humorists and to the promotion of the Daniel Boone legend. The assimilation of the West by the nation may have taken place primarily through trade and the emerging national

market, but it was also brought about "through cultural mechanisms, in this case the forms of high art, that normalized and situated the exotic, the marginal, and the unfamiliar" within a metaphoric temporal frame that cast this early period of growth as "the adolescent or primitive phase of national identity."

In Miller's view, "Bingham's classicizing style served as a semantic code through which to negotiate the competing claims of local and universal truth." But by the 1850s the artist's critical reputation was beginning to suffer from a confusion of codes that extended beyond his art to its critical reception. While for some "his efforts to translate a dialect into the lexical and semantic conventions of the King's English" made his vernacular subject matter palatable, others found it unsuitable. This disagreement reflected a basic ambiguity in current definitions of *character*, as either natural or conventional, which corresponded to divergent attitudes toward the national enterprise. Thus for Miller, a certain ironic complication of meaning evolved from the interaction between the artist and his increasingly pluralistic audience.

Fundamentally in question here are two interrelated issues: the problem of artistic intention and the problem of audience. Both impinge upon the scholarly interpretation of works of art in ways that transform our notion of the role of historical context. The older reflective theory of culture and ideology, whether basically positivist or Marxist, failed to see the intention of an artist or writer as sufficiently problematic. Whether a private act of transcendental intuition or a disguised motive grounded in a system of social and economic privilege, intention was conceived of as being unilateral, and history was thought to unfold along essentially conspiratorial lines. Panofsky's concept of iconology complicated this relation of artistic or authorial intention to historical context. In his formulation, the meaning of a work of art lies somewhere beyond the subject in the iconographic sense, while the source of artistic intentionality lies somewhere beyond the subject as creator. As he noted, the symbolic values of a work of art "are often unknown to the artist himself and may even emphatically differ from what he intended to express" (31).

Moreover, from our point of view, the meaning of a work of art changes from generation to generation and even from person to person. The word *subject* also conveniently points to the beholder or reader whose individual response takes place within a certain horizon of expectations and possibilities that constitutes an audience at any given time and place. Since Panofsky, the development of reader-response criticism and reception theory, along with the pervasive influence of phenomenology and hermeneutics, has helped both to locate the work of art or literature more precisely (yet necessarily more open-endedly) within this intersubjective realm and to lodge it more profoundly within the historical continuum that constitutes intersubjectivity. Current historicism has gone well beyond Panofsky in its ability, through the powerful tool of ideological analysis, to explore the realm of intrinsic meaning as it continually reconstitutes the different types of subject and their connections to each other.

The conflict between an artist's intention and his audience's response occupies David Bjelajac in "The Boston Elite's Resistance to Washington Allston's *Elijah in the*

Desert." Bjelajac is interested in showing how Allston's reputed genius was "socially constructed through the criticism and patronage of his Boston audience." Yet while Allston himself sought through the *Elijah's* dynamic and painterly surface to convey the Word of God, the "still small voice" of the Old Testament, "viewers were uneasy in their observation of [his] apparently random play of a heavily loaded brush . . . which seemed only to signify the dangerous, self-reflexive isolation of the romantic imagination." Allston's reliance on color and the evidence of swift execution (including the use of a medium mixed with skimmed milk) in the painting unnerved a Boston patriciate steeped in Common Sense notions of understanding and unable to grasp his effort to transfigure his material medium in a creative act of Coleridgean Imagination. But what viewers like the Unitarian minister William Ware (otherwise a champion of Allston) found most disconcerting was the artist's stark representation of the biblical wilderness—an evocation of the Burkean sublime—and of the massive tree in the foreground. If Allston's handling provoked "an almost Sartrean existential nausea over the cancerous, anarchic growth of this all-too-mortal, all-too-physical tree," it also invited horrifying projections.

For the Boston patriciate who sought to consolidate an intersubjective community of beholders during a time when New England was undergoing threatening social and economic transformation, such projections "could only fuel disordered thinking and morally rudderless behavior." *Elijah in the Desert* is thus the exception that proves the rule. For the most part, Allston's art fulfilled the desideratum of his upper-class patrons, who "preferred picturesque paintings of cultivation in which nature is represented under the control of man, socialized by agriculture and the progress of civilization."

Further reflecting the growing concern of contemporary scholarship with the question of subjectivity and the act of beholding, both Brigitte Bailey and Robert H. Byer focus attention on an aspect of the changing association between art and its implied audience. This changing association is not only symptomatic of but instrumental in the emergence of a national subjectivity, as Bailey demonstrates in "The Protected Witness: Cole, Cooper, and the Tourist's View of the Italian Landscape." In an account that in certain ways parallels Myers's view of their American work, Bailey places the representation of the Italian landscape in Cole's paintings and Cooper's travel writings against the backdrop of British and continental aesthetics and the tradition of viewing Italy as "other—apolitical, female, noncommercial, even paradoxically ahistorical." As a representation of the other for American tourists "intent on building a national identity based partially on the English model," Italy stood in contrast to England as heart to head, visual to verbal, female to male, aesthetic self to national self. Americans like Cooper and Cole followed British precedent in perceiving "the ritual of the Italian journey as an exposure to displaced or repressed categories of experience" that contrasted with the public values England directly inspired.

Bailey's focus thus overlaps with Bjelajac's, in whose account a natural typology (extended by Allston to the painting's color) shapes subjectivity. The Italianate landscapes of Cole and Cooper avoided, however, the unsettling implications of Allston's *Elijah*. For them as well as for other early nineteenth-century American

tourists, the trip to Italy "offered the chance to reconsider and visualize power relations between an elite self and the cluster of attributes assigned to the landscape of the feminine other." Italy was "easier to confront than gender and class differences at home." Aesthetics thus offered a way of "idealizing the other. . . . The tourist was able both to contemplate the antithetical and to keep it separate from the mundane." The transfiguration of sensual appeal through the aesthetics of the ideal—embodied in the veil of nostalgia and Claudian conventions for viewing the Italian landscape—offered a nonthreatening way for the rational mind to relax into reverie so that the artistic and the literary mediated each other's impact. Nevertheless, the dichotomy between England and Italy only reinforced the underlying polarity between literary and visual arts just as it ultimately undergirded the disjunction between public and private realms characteristic of middle-class life. Cultivation of the Italian landscape served the need for self-control; for "men of sentiment and intellect" it was the means "to manage the 'flow of action' at home." It bolstered class distinctions under assault by the same forces that frightened David Bjelajac's Boston elite.

Bailey's account of the ongoing social construction of the self in relation to nation making draws on Terry Eagleton's understanding of the role of the aesthetic in the reconfiguration of power. As she puts it, borrowing her terms from Eagleton, "As power moved from 'centralized institutions' to the newly defined 'independent subject,' this subject had to be reconstituted to internalize 'the law'—to act spontaneously in the interests of the political order. To the extent that the aesthetic served to build consensus, it worked as an 'effective mode of political hegemony.'"

The changing role of subjectivity in art's encounter with nature that in turn points to the genesis of middle-class identity in which private experience plays an increasingly prominent role is taken up by Robert H. Byer in "Words, Monuments, Beholders: The Visual Arts in Hawthorne's *The Marble Faun.*" Byer sees Hawthorne's romance as aspiring to the status of "monumental beholding" while at the same time presenting a critical view of it, "directed at its fictions of the visible and of personification." He places it in the context of two other roughly contemporaneous modes of beholding: the monumental oration and the stereoscope. Daniel Webster's Bunker Hill speech of 1843 stands paradigmatically for the former. Analyzing the orator's ekphrastic enunciation of the monument, Byer views the speech in terms of the contrast between the verbal and the visual: "This visual sign, which proclaimed and evoked an undoubted, universally accessible, transgenerational object of reverence—a sort of natural sign language of historical truth and national unity—was paradoxically valorized, in the rhetoric of the orator's performance, in contrast to words, whose written forms and malleable, unstable, merely rhetorical uses made them the medium of conflict and uncertainty between and within generations." Accordingly, the oration "sought to contain the anxiety that uncontrolled social change had opened up a fateful gap or abyss between the present and the past."

This unproblematic act of monumental beholding, in which the visual was cast as the natural, was the object of Hawthorne's skepticism: "In contrast to the orator's supreme fiction of the presence and recurrence of the heroic past, the numerous

scenes of beholding in Hawthorne's romance offer a different lesson or guide to beholding monuments." Scenes of beholding in *The Marble Faun* "acknowledge the elusive, uncertain play of distance and intimacy, of otherness and specularity between the monument and its beholder." Indeed, the very structure of the romance, in reflecting a "network of resemblances" between the various characters, produces "a sense of fluid, if partly unconscious, interchange of identity" that "calls into question the idea of individual autonomy at least insofar as this is conceived in terms of the metaphor of statuelike monumentality." The novel therefore suggests "a new sculptural aesthetic, one based on gesture, on the shifts and transitoriness of character." Critical here is the movement away from the natural pole of the visual and toward the "model of language's metamorphic flux or revisionary troping."

If Myers establishes the commercialization of the aesthetic and Bailey traces its feminization, Byer extends these modifications to the terror-inspiring Burkean sublime—so threatening to Bjelajac's social elite—as he documents its virtual disappearance in the 1850s as the result of a developing process of middle-class privatization. Another gauge of this transition in modes of expression and subjectivity (so responsive to economic and social change) is the shift from the close parallel between the visual and the verbal evident both in the appropriation of Italy that Bailey discusses and in Byer's monumental beholding, to the divergence between the two enacted by Hawthorne's romance.

Echoing this shift, for Byer, is the defamiliarization wrought by the stereoscope, which gained popularity in the 1850s. Contrary to the monumental beholding exploited by Webster, with its investments in corporate and even universal identity, both stereoscope and romance provoke the ambiguities of individual response, though in very different ways. If *The Marble Faun* suggests a dissolution of the sublime aspects of monumental vision, the stereoscope "reaffirms in the face of its uncanny views and passivities the honorific perspective of the sublime." Nonetheless, romance and stereoscope both participate in the unleashing of "erotic energies of vision [which] continually place the conventionally domestic in a perspective of instability, of skepticism about value." In both "the safe distances containing 'magical' images are time and again abrogated by the disjunctive shiftings of perceptual scale and focus." This is because the stereoscope, unlike the photograph, addresses (Byer quotes Jonathan Crary) "a fully embodied viewer" who is "binocular and situated in the space of pasteboard cards." Still, one is left to wonder to just what extent such examples of embodiment as stereoscope and romance acted as sources of resistance to the regime of middle-class socialization betokened by objective modes of representation like photography or the older monumental vision.

Byer's interest in the stereoscopic as "a mode of vision depending on the resolution of divergent optical perspectives" suggests an intriguing connection with my own observation about the defamiliarization that characterizes the most radical versions of so-called luminist painting as I see it in "The Iconology of Wrecked or Stranded Boats in Mid to Late Nineteenth-Century American Culture." Byer quotes Oliver Wendell Holmes, who imagined a new kind of experience made possible by the stereoscope: "There is . . . some half-magnetic effect in the fixing of the eyes on the

twin pictures,—something like . . . hypnotism. . . . The shutting out of surrounding objects, and the concentration of the whole attention, which is a consequence of this." This defamiliarization, which for Byer involves, in contrast to monumental beholding, a "miniaturizing reduction . . . constitutive of the medium of reverie and longing," comes close to what I see as the divergence of works by Martin Johnson Heade and Fitz Hugh Lane from earlier landscapes in the picturesque mode. Whereas such earlier works emphasized the presence of expression or character, the paintings of Heade and Lane disconcert the act of beholding, for "the eye lacks the conventional signals to guide it over the canvas; instead, it confronts nearly uniform contours and emphases which create an optical ambiguity, unsettling the mind." Both stereoscopic vision and luminist vision evidence the collapse of the old visual hierarchy that was the basis for monumental vision. Both in effect reencode the body of the viewer in presenting images of such unrelenting intensity as to seem hypnotic.

My intention is to tie this formal quality to the underlying cultural dynamics at stake in later nineteenth-century American art by way of a revealing iconographic element: the motif of the wrecked or stranded boat. The boat's more or less direct reference to the age-old trope of the ship of state suggests fears for and even a loss of faith in the American corporate enterprise during and following the Civil War—as exemplified by the title of Francis Augusta Silva's painting *The Schooner "Progress" Wrecked at Coney Island, July 4th, 1874*. Ultimately, I show how the proliferation of this motif, when seen against the background of the iconography of shipwreck, represents not only a dissent on the part of certain artists from the national enterprise but a breakdown of the Sister Arts idea. Moreover, such images heralded the shift from a world that was "God- and human-centered, historicist, and dramatically conceived to one that could be characterized as radically impersonal, primitivistic . . . and atmospherically conceived. The latter is a world in which God no longer clearly presides." I examine a passage from *Walden* that describes the rotting remains of a stranded boat in order to clarify some of the issues and dynamics at stake in the motif as it is employed by artists. These have much to do with the tension in American culture between the cyclical character of natural history and the linear and teleological character of human history as conceived under postmillennialism and its secular equivalent, the doctrine of Manifest Destiny. The optical ambiguity in the paintings reflects a conflict between the modalities of time and space. The work of a number of artists besides Heade and Lane involves, to one degree or another, a redefinition of temporal and spatial categories in relation to each other that looks forward to modernist modes of experience.

The dissolution of structures of experience organized around linear time (in religion and philosophy as well as in historical thinking) is not only reflected but shaped by the images I examine and has much to do with the impact of capitalist enterprise and the related developments of consumerism and commodification upon traditional ways of experiencing and understanding the world. The influence of commerce upon art becomes increasingly evident in the latter part of the century, and its effect is explored by Sarah Burns in "The Price of Beauty: Art, Commerce, and the Late Nineteenth-Century American Studio Interior." Burns departs

from earlier views of the artist's studio in this period in the degree to which she sees this opulently adorned space as in essence a salesroom as well as the symbol of a new breed of American painters. She establishes striking parallels between the display techniques of the studio and those of the department store, thus registering the extent to which art was being commodified. The "art atmosphere" created in the studio drew upon the psychology of display developed by L. Frank Baum and others for the department store. For their part, department stores "coopted the studio pattern, well knowing that artists' habitats signaled a seemingly Bohemian freedom from buttoned-up middle-class conventionality."

Focusing on the studio interior (both actual and depicted) of William Merritt Chase, Burns maps out "a vast area of ambivalence and anxiety that adjoined the escalating conflict between older discourses shoring up art's elevating moral and ideological cultural functions and the new, market-driven circumstances that forced confrontation with the commercial dimensions of artworks produced as luxury consumer goods promising individual self-gratification, both sensual and spiritual."

A central aspect of the commodification of art was the construction of the studio as feminized space. In examining this aspect of the association between the persona of the late nineteenth-century artist and the feminine, Burns relays the suggestions of Rigal, Bailey, and Byer concerning the appropriation by a patriarchal or masculinist culture earlier in the century of a gendered subjectivity linked to aesthetic experience and artistic pursuits. The underlying connection between feminization and cultural products resulting from the rise of mass culture like Peale's Museum, tourism, and the stereoscope illuminates a striking pattern among the sources of agency and motivation in nineteenth-century American culture. While ideology in the earlier part of the century tended to displace power relations by preserving a sacrosanct realm of art and aesthetic concerns, by the end of the century, according to Burns, power relations had come to permeate this realm in the form of the purely imaginary values of commercialism. The concept of art atmosphere implies the degree to which power had been dispersed and psychologized under the guise of feminine or subjective experience. It is especially revealing here to ponder the connotations of harmony in color as part of the reigning wisdom about art atmosphere in the late nineteenth-century studio—which according to Burns stimulated desire and bestowed an air of uncommon luxury and privilege—and the meaning of harmonious color in the aesthetics of Washington Allston set forth by David Bjelajac. What is more, although Burns does not address the issue of nationalism, it is worth thinking about the implications of commercialism for the role of a changing subjectivity in developing nationalism from one end of the century to the other.

Burns's study illuminates the all-pervasive hegemony determining the parameters of artistic experience at the turn of the century: "The gendering of consumption in the late nineteenth century wove itself into subtly or heavily eroticized suggestions embedded in the commercial displays and environments organized with the aim of weakening resistance while intensifying desire." The pressures of the market caught artists in a dilemma: how could an artist "create an aesthetic product destined for consumption in the marketplace without appearing to collude

too deeply with the process of its commodification?" Culture critics continued to look to artists as "leaders out of the materialism and luxury of the age." Yet the alternative offered by these critics, when considered from the vantage point of the various commentators in this book, itself appears to be no less a product, though dating from an earlier period, of the emergence of capitalism. As Burns puts it, any "hardheaded capitulation to business values and ethics seemed to threaten everything that cloaked art discursively with the mystery, purity, and transcendence of religion and empowered the rhetoric that still had a vested interest . . . in holding art aloft as a powerful instrument of cultural elevation and social control."

The question remains whether any real alternative, any viable source of resistance, to the continuing cooptation of culture by capitalism existed in nineteenth-century America. Was the ideology of capitalism all-pervasive? Did it constitute a self-enclosed system denying autonomy to individuals along with the ability to see beyond its boundaries, to act contrary to its (often unconscious) imperatives? Where do we locate the basis for freedom, the grounds for some degree of deliberate intervention, in order to avoid the implications of determinism? Did the system simply grind irresistibly on? I have noted how Raymond Williams's answer to this set of questions was to reinstate an element of priority within the system of social practices in the form of hegemony, or the power of one class over another. Whether this represents a satisfactory solution to the problem remains an issue for debate, and I shall address the question further in the Afterword.

The authors of the chapters presented here take no single position on this matter. In seeking to show how the Jeffersonian-Republican political economy "remains an endlessly transitional formation—or (still) moving picture—which both eases and masks the historical transformations it produces," Laura Rigal extends her concerns right up to the present, declaring that an "implicit subtext of [her] essay is . . . a reflection on the extent to which the discursive machinery of a poststructuralist, new historicism itself reproduces the structure of a production-based political economy it labors to revolutionize." Somewhat in contrast, Kenneth John Myers, reviewing the scholarship on landscape in America prior to 1800, seeks to outline a history of environmental experience which, while avoiding "lingering notions of the autonomy of individual consciousness," still acknowledges "the work of human freedom." Myers hopes to "uncover the inextricably doubled process by which historically constructed conventions determine individual experiences even as historically determined individuals refashion conventions so as to create new experiences and meanings."

In "Lilly Martin Spencer's Domestic Genre Painting in Antebellum America," David Lubin undertakes an approach which grapples with the problem by demonstrating that Spencer's work was "*both* ideological (encouraging accommodation to norms associated with a rising middle class) and utopian (resistant to class or gender domination), at once an instrument of social control *and* an instrument of social subversion." Lubin resists any impulse to pass judgment on Spencer's art and the sentimental discourse in which it is lodged, opting instead for an "implicit acknowledgment that art and the social configurations that produce it are inevitably multi-

valent, heterogeneous, and self-contradictory." He sees a painting like Spencer's *Domestic Happiness* (1848) both as a "defense of sentimental thinking against political and religious conservatives who fumed over the breakdown of patriarchal authority" and as a defense of the nuclear family from attack by feminists and social reformers on the left who would undermine it. If at one level the sentimental ethos of love "disguised and reinscribed rather than replaced authoritarian domination . . . in helping to bring about the internalization of bourgeois norms"—as Lubin summarizes Richard Brodhead's argument—at another level it enabled "an act of female instrumentality and agency, of antebellum women taking hold of the one and only weapon at their disposal, culture, and *using* it on their own behalf." Rather than escaping into ideal worlds, sentimental images like *Domestic Happiness* may have sought rhetorically to inspire male viewers to renew their commitment to their families at a time when family disharmony was becoming a norm. For Lubin, "To look at it this way, the painting was a politically active endeavor designed to improve a grievous, real-world situation by means of a seductive representation of an ideal world (as sentimentally conceived)."

Lubin's argument echoes other revisionist approaches to nineteenth-century sentimental culture which try to develop a perspective from within the culture rather than merely dismissing it for its bad faith, at least as this appears from a twentieth-century vantage point. While feminist efforts toward this kind of historical recovery acknowledge the limits to which one can go in reconstructing the cultural outlook of the past, they nevertheless involve a privileging of the historical subject whose inner world is in some way accessible and who exercises a relative autonomy. In response to those who would impose a kind of ideological straitjacket upon historical subjects, deriving from the Foucauldian position that subjects are the product of social discourse, Lubin presents the different perspective of Mikhail Bakhtin, for whom "meaning is invariably plural. Because of this, those who read or hear a discourse produce from it the meanings that they require." Whereas the former position "maintains that readers (or viewers) *are shaped* by language in ways that subject them to social discipline," the latter "argues that they *shape* the language in ways that enable them to resist such discipline." Such a view implies that popular culture provided the means by which "socially subservient classes, such as housewives, try to pry themselves loose from domination by their social superiors."

In "Mary Cassatt and the Maternal Body," Harriet Scott Chessman assesses this capacity of subjectivity to find a way around predominant discourses of seeing and being seen which constitute repressive ideological regimes through an examination of Cassatt's paintings of mothers and their children. Chessman extends Griselda Pollock's point that Cassatt rearticulated "traditional space so that it ceases to function primarily as the space of sight for a mastering gaze, but becomes the locus of relationships" by asking how Cassatt represents female sexuality and whether the ideal Pollock describes holds true for all Cassatt's work.

In considering the first question, Chessman finds that the discourse of sentimentalism, which by the late nineteenth century was increasingly in tension with women's actual social roles, afforded Cassatt "a rich language within which to encode women's sexuality indirectly, through the child's body, and that the ideal 'space

of the look' as a locus of relationships often becomes suggested through its disruption or absence rather than through its fully realized presence." Closely examining Cassatt's *Mother About to Wash Her Sleepy Child* (1880), Chessman finds that "one of the major keys to the representation of the mother's sexuality lies in the erotic presence of the child." The child, "as a small odalisque, enters in one sense into a position of vulnerability often assigned to female nudes."

In offering a possibility for both sexual identification and difference between mother and child, Cassatt consciously constructs sexuality as "unhierarchical and unthreatening," and she makes it difficult for the gaze of the viewer to become intrusive. If in doing so she utilizes the kind of felicitous, supportive space opened up in many sentimental novels, she also extends the discourse of the sentimental to encompass the role of the artist, suggesting both that the relationship between mother and child is not natural but constructed and furthermore that "the creation of art does not have to be grounded in a separation between artist and object, but can rise out of a more mutual relationship between the one seeing and the one being seen." Underscoring this view of motherhood as a construct, Cassatt's image is fraught with subtle tension, for she allows the viewer to sense that the child might not always escape objectification.

Chessman's answer to the second question—about whether the formulation of an ideal relationship between mother and child is true for all of Cassatt's later work—is a complex one. In exchanging Edgar Degas for Berthe Morisot as her primary mentor and friend around 1880, Cassatt turned from the representation of "a more conventional gaze to an attempt to refigure the gaze as mutual and undestructive." However, while her formulation of this sort of intimacy remained a recurrent possibility throughout her career, by the turn of the century she "began to counter her utopian images of the artist as a (largely) protective and pleasurably erotic mother with more disturbing images of mothers." Some of these images, like *Mother and Child* (1905), are subtly ironic, "exposing the workings of an intrusive gaze at the same time they appear to critique it." Here Cassatt seems to have shifted toward a more socially conscious awareness that "invites us to see and understand the inaccuracy of the cultural mirrorings charted with such soberness in this image." All the more in contrast to sentimentalist notions of women's spiritual and moral influence, Cassatt's images at times evoke the dawning fin de siècle awareness of the problems of gender and power explored by feminist writers like Charlotte Perkins Gilman.

If Chessman sees an opening in the predominant ideological regime of sentimentalism that enables an artist like Cassatt to step outside it in order to turn it to her own uses, this possibility is established as a somewhat broader cultural phenomenon by Emily Fourmy Cutrer in "A Pragmatic Mode of Seeing: James, Howells, and the Politics of Vision." Like Chessman, Cutrer pits the male gaze that she finds to be characteristic of popular culture in the late nineteenth century against the efforts of a few—in this case William James in *The Principles of Psychology* and William Dean Howells in *A Hazard of New Fortunes* (both published in 1890)—to conceptualize a mode of seeing that transcends the limitations of this predominant "scopic regime." Whereas for Chessman the foil to Cassatt's efforts to realign the act of seeing is a

sentimentalism which by the end of the century was increasingly at odds with women's actual social and economic opportunities, for Cutrer it is primarily the picturesque that is superseded by what she refers to as a "pragmatic mode of seeing." Cutrer's discussion thus illuminates from a later historical vantage point Byer's and my concerns with the defamiliarization of established modes of seeing beginning to take place around midcentury.

The new set of attitudes toward the visual delineated by Cutrer, involving the process of picturing and the metaphor of the picture as knowing, ensued from the challenge to the older scopic regime posed by the complex and contradictory environment of the city. Whereas James's *Principles* "provides a launching point for an exploration of pragmatic vision, Howells's novel charts that mode's progress across the ideological terrain of late nineteenth-century American culture." Cutrer calls this vision pragmatic because "it acknowledged, even embraced, the 'slipperiness' of vision, the possibility that sight was subjective and unstable, at the same time that it affirmed the significance of the visual sense in perceiving an external reality." It was accordingly "operational and contingent, finding its truth in action, consequences, and practice."

If James centered his theory of vision in a dialectic between preperception (or seeing what we know and have words for) and the relatively unmediated sensation which reinstates the vague penumbra around our concepts and thereby opens us up to new ways of apprehending the world, Howells puts Basil March, his protagonist and alter ego in *A Hazard*, through a process of what James characterized as "learning to see the presented signs as well as the represented things." Cutrer concludes, "In a curious and revealing reversal, then, March no longer possesses the male gaze but becomes himself the 'penetrated' object of desire."

This process parallels James's notion of the artist's training which follows from his at least implicit identification of the painter with the concept of genius. If March occasionally reverts to his habitual picturesque mode of seeing—involving framing and distancing, turning the urban environment into something one can remove one's self from in order the better to see it and morally judge it—he eventually comes not only to recognize "the disjunction between his expectations and what he quite literally sees" but to realize that he is complicitous with what he sees. This transition involves a privileging of heart over head, a substitution of the reciprocity of trust for one-way belief, as well as the giving way of a stable point of view. March thus winds up exemplifying an alternative to the artist Angus Beaton, who remains locked within his mental images or preperceptions, a devotee of both the visual and the verbal in a way that is reminiscent of the old Sister Arts idea from which the picturesque derived.

Especially telling, however, is Cutrer's finding that both James and Howells ultimately favored the verbal over the visual as a reaction to the naturalization of the new social environment of the city that was being codified by the mass-circulation magazines. If this attitude represented at one level an alternative to the prevailing scopic regime in which pictures increasingly played to a passive audience's desire for spectatorship, at a deeper level it betokened participation in an all-too-familiar politics of vision that was differentiated according to gender. Both men distrusted

the more radical implications of physical sensation. Here, Cutrer's findings concur with those of the other authors in this book who argue, following W. J. T. Mitchell, that the visual was allied to the feminine as against the masculine connotations of the verbal. Neither James nor Howells, for all their commitment to the innovations of pragmatism and realism, could escape the dominant bias of their century, which cast relatively unmediated visual experience as false and fickle.

If a number of the chapters in this book, mostly those about the first half of the nineteenth century, speak to the role of images in consolidating and reinforcing dominant ideologies, others, those which tend to locate their subjects primarily in the second half of the century, probe the capacity of imagery to undermine or transcend dominant ideologies. Does this pattern reflect an actual transformation in the role of the visual and of artistic and literary culture vis-à-vis the dominant masculinist and nationalist ideology? Or is it merely accidental or the result of differences in approach and methodology among those working in different time periods?

To answer this question, we need to do some groundwork on the way in which visual and verbal experience are defined, groundwork that takes us right to the heart of the theory of iconology and may have implications for the continuing efforts of cultural historians to interrelate images and texts. In the Afterword, I will have more to say about the issues that the authors of this book raise about subjectivity and language, along with the problems provoked by contemporary cultural studies and the capacity of a developing theory of iconology to respond to them.

1

LAURA RIGAL

. . .

Peale's Mammoth

In the summer of 1801, four months after Thomas Jefferson's inauguration, Charles Willson Peale (1741–1827) led a scientific expedition to the marshy farmland of southeastern New York. Some bones of the mammoth, or the "enormous nondescript of North America," had been unearthed by farmers digging marl, a claylike peat, for manure. Equipped and funded by President Jefferson and the American Philosophical Society, Peale traveled by carriage from Philadelphia and by boat from New York City to Shawangunk, a farming community near West Point. There he contrived a huge wooden pump to drain the excavation site and, hiring local men as wage laborers, exhumed the fragmentary remains of three mastodons. Enough bones were excavated to reconstruct two nearly complete skeletons. With the help of his son Rembrandt Peale and the Philadelphia wood sculptor William Rush, Peale manufactured the parts which were missing from one skeleton on the pattern of their counterparts in the others, carving them from wood or fashioning them from papiermâché. He commemorated his "immense labor" in a painting titled *Exhuming the First American Mastodon* (fig. 1.1), which he hung in the Mammoth Room of his natural history museum, next to one of the skeletons.[1] Unveiled in Philadelphia on Christmas Eve, Peale's mammoth brought him popular and scientific acclaim, doubling the museum's revenues and proving Jefferson's argument with Buffon that the "Great American Incognitum" was not simply a version of the African elephant or the Siberian mammoth, but a species "peculiar to America."[2]

American mammoth bones had circulated in Europe and North America since the days of Cotton Mather; a hundred years before Peale's expedition, Mather

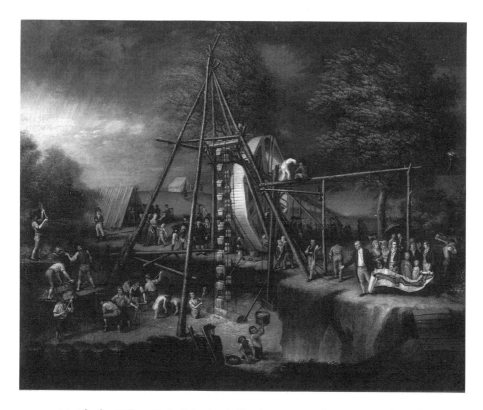

1.1. Charles Willson Peale, *Exhuming the First American Mastodon*, 1806–08. The Peale Museum, Baltimore City Life Museums.

identified huge leg bones and teeth unearthed near Albany, New York, as the remains of the Nephilim, the half-human/half-divine giants destroyed by God in the biblical flood.[3] Prior to the Peales' reconstruction of two skeletons in 1801, American anatomists named the American bones after those of the Siberian mammoth, a Russian derivation of the biblical Behemoth. The name *mastodon*, which Peale adopted, was coined by Georges Cuvier in reference to the breastlike bumps on the animal's teeth. As Jefferson recounts in a letter to Peale, the French naturalist had named the remains Mastodonte—or "bubby-toothed"—because of the "protuberances on the grinding surface of [its] teeth, somewhat in the shape of the mamma mastos, or breast of a woman."[4] Peale's expedition to Shawangunk proved the mammoth to be a mastodon, an enormous, extinct American quadruped. But the mythical "mammoth" also lived on in the bubby-toothed mastodon: the skeleton continued to be referred to as a mammoth, even by Peale, and, with the recreation of a whole mastodon from mammoth parts in the first year of Jefferson's presidency, the word *mammoth* entered the political lexicon of the time, in association with the social and economic policies of Jefferson and his supporters, the Jeffersonian-Republicans.

At the end of the American Revolution, Thomas Jefferson envisioned an ex-

tended republic of husbandmen that would reach one day to the Pacific Ocean. His model of an agrarian state, cultivating and consuming its collective independence while exporting its surplus, was designed to retard the "natural progress of the arts" toward commercial luxury on the one hand and the growth of an urban working class on the other. Jefferson's political economy was opposed to Britain's example of empire through commerce and manufacturing, yet it was nevertheless itself a vehicle of empire. In theory and in practice, an agrarian republic was necessarily expansionist. As its population grew, its agricultural character could be preserved only by continual access to land:

> In Europe the lands are either cultivated, or locked up against the cultivator. Manufacture must therefore be resorted to of necessity not of choice, to support the surplus of their people. But we have an immensity of land courting the industry of the husbandman. Is it best then that all our citizens should be employed in its improvement, or that one half should be called off from that to exercise manufactures and handicraft arts for the other? . . . Corruption of morals in the mass of cultivators is a phaenomenon of which no age nor nation has furnished an example. It is the mark set on those, who not looking up to heaven, to their own soil and industry . . . for their subsistence, depend for it on the casualties and caprice of customers. While we have land to labour then, let us never wish to see our citizens occupied at a workbench, or twirling a distaff. Carpenters, masons, smiths, are wanting in husbandry: but, for the general operations of manufacture, let our workshops remain in Europe.[5]

Despite its hostility to manufacturing, by century's end Jeffersonian political economy had come to embrace not only the farmer in the countryside, but urban artisans and self-supporting workers in general: in the course of the social and political conflict which accompanied the French Revolution, Republican artisans who supported Jefferson in urban seaports such as New York and Philadelphia expressed his production-based agrarianism as economic self-sufficiency generally.[6] Through the 1790s and the first decade of the nineteenth century, Jefferson's Republican supporters asserted his model of a virtuous workingman's republic against Federalists such as Alexander Hamilton, who wished to pattern the United States on Britain's example of commercial development through the creation of banks, stock exchanges, and a national debt. Fought in the press, in street parades, and at the political meetings of Democratic clubs, this first national party division was intensified by revolution in France and war in Europe. Most Republicans remained sympathetic to the liberal social goals of the French Revolution even through the Reign of Terror and after Napoleon's rise to power; they called their Federalist antagonists "paper noblemen" and identified them (erroneously) with Europe's ancien regime.[7] Federalists, by contrast, aligned themselves more closely with British reaction and sought in a variety of ways to pattern the United States on Britain's example of commercial development and cultural counterrevolution.[8]

The expression of an ethic of self-production by urban artisans in the course of this war of words and images implicates both Jefferson's agrarian political economy and the party division between Jeffersonian-Republicans and Federalists in the social and technological transformations of the protoindustrial period of manufactures in the United States. This period was characterized by the gradual, complex

shift from colonial forms of artisan production to wage labor, from household and workshop to factory production.[9] Jefferson's agrarian political economy is sometimes understood as the reflection of an underlying economic and social reality, a transcript of the fact that a majority of late eighteenth-century North Americans were, in fact, employed in agriculture. On the other hand, it is often viewed as ideology—a utopian and sentimental mask for class conflict, westward expansion, slaveholding, investment in manufacturing, and involvement in an international consumer market.[10] By focusing in this chapter on Peale's museum exhibit of the first American mastodon, I call attention, by contrast, to the longevity and resilience of Jeffersonian-Republican political economy as a discursive mechanism for the creation and preservation of a natural national culture.

As a mammoth frame, or superstructure, Peale's mammoth exhibit displays the fact that the discursive framework of Jeffersonian-Republican political economy was (and remains the remains of) the machinery of production which produces and naturalizes the United States as a collective historical entity. As a mechanism for producing properties, Jeffersonian-Republican political economy not only masked political, economic, and social conflicts but reproduced itself through them. As a site where a number of such conflicts intersect with the theory and practice of Jeffersonian-Republicanism, Peale's mammoth exhibit displays Jeffersonian-Republican political economy as a framework which not only proliferated properties in land, but which (always already, or from the beginning) reproduced and diversified itself through a variety of other discursive fields as well: as museum proprietor, Peale worked in the fields of anatomy, zoology, botany, ornithology, paleontology, ichthyology, mineralogy, paint making, printing, taxidermy, and mechanical invention, to name a few. As a reconstruction of Peale's reconstruction of the mammoth, this essay is part of a larger attempt to assess the continuing power of Jefferson's production-based political economy as a discursive mechanism for making history. Far from being extinct, Peale's mammoth reveals how embedded Jeffersonian-Republican political economy remains as an endlessly transitional formation—or (still) moving picture—which both eases and masks the historical transformations it produces. An implicit subtext of this essay is, then, a reflection on the extent to which the discursive machinery of a poststructuralist, new historicism itself reproduces the structure of a production-based political economy it labors to revolutionize.

In 1800, Jefferson himself had tried to extract a mammoth from Shawangunk through the offices of Robert Livingston and the Philadelphia physician Caspar Wistar.[11] As Livingston informed Jefferson from New York, "I made some attempts to possess myself of [the bones], but found they were a kind of common property, the whole town having joined in digging for them till they were stopped by the autumnal rains."[12] In Kentucky, seven years later, William Clark would be more successful: at Jefferson's request he employed local laborers to excavate more than three hundred mammoth bones from the Big Bone Lick. These bones were sent to the president in the White House, where he spread them out in the unfinished East Room and invited Caspar Wistar to come and study them.[13]

The Federalist press identified Jefferson's preoccupation with natural history

negatively with his religious Deism, his French sympathies, and his commitment to western exploration.[14] In 1808, for example, William Cullen Bryant was a fierce Federalist at the age of thirteen when he called upon Jefferson to resign and lampooned his fossilizing as impious and obscene:

Go wretch, resign the presidential chair,
Disclose thy secret measures foul or fair,
Go, search, with curious eye, for horned frogs,
Mongst the wastes of Louisianian bogs;
Or where Ohio rolls his turbid stream
Dig for huge bones, thy glory and thy theme. . . .[15]

On the Republican side, however, a sympathetic public hailed Jefferson in 1801 as the Mammoth President and celebrated his election as a second American Revolution after years of Federalist fiscal, social, and foreign policy.[16] Delighted with his victory, Republican dairy farmers in Cheshire Town, Massachusetts, presented Jefferson with a two-hundred-pound cheese, dubbed the mammoth cheese. The revolutionary motto stamped on its waxed surface read, "Rebellion against tyrants is obedience to God." With the mammoth cheese, the farmers of Cheshire Town opposed the virtue of agricultural productivity to the tyranny of Federalist fiscal and foreign policy and the party of Hamilton and Adams. The mammoth cheese, however, was preserved rather than consumed. For years it remained on display in the rotunda of the House of Representatives, until it rotted and was thrown out early in Jefferson's second term.[17] After the excavation of 1801, Peale's mammoth (or "Boney-parts") likewise became the object of Federalist satire and Republican celebration in Philadelphia's partisan press.[18]

Within the museum itself, three exhibition texts directly accompanied the skeleton: Peale's son Rembrandt's *Historical Disquisition on the Mammoth* (1804), Peale's painting *Exhuming the Mastodon*, and the museum *Guide* of 1803. These represented the assembled bones circularly, according to the logic of Jeffersonian-Republican political economy, as the source and summit, the means and end of Peale's own life of labor as artist and museum proprietor. By reconnecting the mastodon skeleton with the painting and pamphlet which framed it in the museum, this essay differs from art-historical discussions of Peale by displacing the painting from the center of focus and replacing it with the mammoth frame.[19] But, by reconnecting Peale's *Exhuming the Mastodon* with the other remains of the exhibit, including the *Disquisition* that was its print counterpart, the painting is, circularly, reframed by being restored to the framework of a museum which married image with word and "nature" with "culture" on the basis of production. In 1803, the museum *Guide's* description of the Mammoth Room represented the mastodon circularly as a skeleton within a skeleton: "Some bones of the Mammoth first gave rise to the Museum in 1785, which 16 years after possessed the first entire Skeleton."[20] Rembrandt's *Historical Disquisition* also identified the museum's origins with the mammoth's, from its founding at the end of the American Revolution until its fulfillment during Jefferson's presidency. At the end of the Revolution, a small number of mammoth bones were brought to Peale's painting room in Philadelphia, where they were displayed as curiosities:

"The bones of the MAMMOTH first produced the idea of a Museum, which, after eighteen years of rapid approach to maturity, under the unprecedented exertions of an individual, has in its turn enabled you to place among its treasures nearly a perfect skeleton of the MAMMOTH—the first of American animals, in the first of American Museums."[21]

Unlike such painters as John Trumbull or John Singleton Copley, Peale had seen battle during the Revolution and participated in revolutionary artisan politics. During his youth in Maryland, Peale worked as a saddlemaker's apprentice, an itinerant portrait painter, and a repairer of clocks, until, in 1763, a group of gentlemen-planters sent him to London to study painting with Benjamin West. By 1776, now a painter of portraits and miniatures in Philadelphia, he had allied himself with the city's revolutionary artisan community. During the war, he fought as a captain in the city militia on the battlefields of Pennsylvania and New Jersey and served on the Committee of Safety which confiscated the estates of Loyalists in the city.[22] After the war, Peale remained a loyal friend of Tom Paine and, during the 1780s, supported the radical Pennsylvania constitution, whose unicameral legislature, until it was overturned in 1790, presented such a threat to more conservative republicans.[23] However, he quickly reached the limit of his tolerance for social and political conflict. After the tumultuous city elections of October 1780, he retired from Philadelphia politics, which, by its disruption of long-standing social connections, had caused him deep personal distress and threatened to deprive him of painting commissions.[24] He moved his family into the house of a Loyalist that had been confiscated during the war and built a portrait gallery to one side.[25] Thereafter, in spite of his Jeffersonian allegiances, he claimed that his museum was above politics:

> I wish to be understood. This institution of a Museum can have no more to do with the politicks of a country, than with particular religious opinions.
> It has a much broader bottom. Facts and not theories, are the foundation on which the whole superstructure is built. Not on theoretical, speculative things, but on the objects of our sight and feelings—. . . the production, preservation, and destruction of all material things deduced from facts.[26]

Illustrating Jefferson's principle of an all-inclusive social field (in which "we are all republicans; we are all federalists"), Peale claimed that one day his museum would contain the world "in miniature." In 1802, Peale wrote to Jefferson that "my Museum, is [now] but part of an Establishment which in becoming national should embrace the exhibition of every article by which knowledge, in all its branches can possibly be communicated."[27] As a collection of every article by which knowledge might be communicated, the museum represented a virtually infinite number of fields, and a virtually endless amount of work. Yet, Peale insisted, "I possess thousands of specimens, yet thousands are still wanting—in fact it ought to be[,] as a Museum, a collection of everything useful or curious—A world in miniature!"[28]

By "world in miniature" Peale meant miniature in the textual sense of an epitome, compendium, or digest. As the entire world in digest form, his museum was a "Book" of nature which represented the possibility of actual, or literal, representation in the language of science, if not in the realm of politics or government. The

correlative of this was Peale's statement in 1800 that "the world itself is a Museum, in which all men are destined to be employed and amused."[29] Peale hoped that eventually his museum of the world would contain a specimen of every rock, insect, bird, fish, and quadruped produced by nature, brought together within a single "focus" and ordered according to the Linnaean system. As Peale never tired of repeating, Nature was a book whose structure was a display of both the original "Word" and the confining law of its Maker. As he inscribed it on a tablet at the museum's back door, facing out on the State House Garden:

> The book of Nature open
> ——explore the wondrous work
> ——an Institute
> of Laws eternal, whose unaltered page
> No time can change, no copier corrupt.[30]

Like Jefferson, Peale was a Deist: he regarded the world of nature as the work of a divine Maker, and his twenty-five-cent museum ticket bore the motto "Explore the Wondrous Work!"[31] The museum was an expression of natural theology: in Deist terms, the God of nature was not only the first cause, or unmoved mover, but an artisan extraordinaire, whose providential designs could be read in the leaves and stems or bones and muscle of his works. The museum represented nature as creation, "work," and "book," and the deity as its Maker, Artist, or Author. At the same time, museum texts traced the museum's origin to Peale's own gargantuan labor of production. As he expressed it in a letter to Jefferson, the museum's success was the result "of my unremitted labours for years with the view of establishing a PUBLIC MUSEUM."[32] Jefferson, in turn, identified the museum with Peale's labor when, referring to the finished mastodon, he wrote, "I shall certainly pay your labours a visit, but when, heaven knows." Although Peale's museum never became officially national and remained a private, or proprietary, form of public enterprise, it was housed after 1802 in the old Pennsylvania State House, the building known today as Independence Hall. Prior to the expansion into the State House on Independence Square, Peale's collection was displayed next door in the Hall of the American Philosophical Society, where Peale and his family also lived, in separate living quarters.

Peale's Museum never did contain the entire world in miniature. But it did display, among other things, "4000 insects in gilt frames, Minerals and Fossils in 4 large cases . . . a Marine Room of sundry Fishes, Lizards, Tortoises, Snakes, Shells, Corals, and sponges," 190 quadrupeds "mounted in their natural attitudes," and 760 birds, preserved by Peale's pioneering taxidermy techniques and posed in glass cases, the insides of which were painted by Peale and his sons "to represent appropriate scenery."[33] All these were catalogued according to Linnaeus, with their names written in Latin, English, and French, and displayed in gilt frames. After the move to the State House, the Peale family continued to live in Philosophical Hall, where the museum's "Arts and Antiquities" were also housed. This bric-a-brac assemblage included new inventions, American Indian artifacts, plaster casts of Roman statues, a saltshaker belonging to Oliver Cromwell, household gods from Pompeii, and wax

figures of a Chinese Labourer and Chinese Gentleman, an African, a Sandwich Islander, a South American, and "Blue-Jacket and Red-pole, celebrated Sachems of North America."[34] It was here that Peale's mastodon stood, on permanent display in a Mammoth Room of its own, mounted next to the skeleton of a mouse and accompanied by Rembrandt Peal's *Historical Disquisition* and Peale's *Exhuming the Mastodon*.

In a mammoth pun on the framing of the mammoth frame, each page of Rembrandt's ninety-two-page *Disquisition* was framed separately and strung, in ninety-two gilt frames, across the walls of the museum's Mammoth Room.[35] Peale's museum *Guide* of 1805 is not very specific about the exact relation between the mammoth and the *Disquisition*. Did the pages of the pamphlet lead the museum visitor up to the skeleton, which stood as ground and goal at *Disquisition*'s end? But it does record an original juxtapositioning of the pamphlet with the skeleton: "A particular account, by Rembrandt Peale of its discovery, with many interesting remarks on it, is in 92 gilt frames, hung up in a convenient gallery for viewing the Skeleton."[36]

In a manifestation of early national kitsch, scientific culture is here reproduced democratically or diffused to the public through the pamphlet's dismemberment and display. In the act of approaching and reading each page of the *Disquisition* sequentially, in its frames, the museum's visitors were themselves constituted, in the public gaze of others in the museum, as separate and separable subjects. At the same time, the democratic diffusion of the pamphlet was accomplished by its elevation as a collective object—in gilt frames that opened it to many eyes while preserving it from the wear and tear of human hands.

Like his son's pamphlet, Peale's painting was produced specifically for the mammoth exhibit, "to be placed," he wrote, "in the Museum near the Mammoth skeleton."[37] In addition, the composition of the painting can be traced to the pamphlet: in January of 1803 Peale sent an early version of the *Disquisition* to President Jefferson, with a letter in which he writes that the next edition of Rembrandt's pamphlet "probably will have plates; he was just beginning a view of our last days work at Masten[']s in which he introduces an American thunder-storm . . . it was in reality the most dreadful in appearance I had ever seen yet passed away with wind only."[38] Proposed by Rembrandt Peale for the *Historical Disquisition* but never executed, this scene is identical with the one pictured in *Exhuming the Mastodon*.

Both the painting and the pamphlet focus their narratives on a farm belonging to a German immigrant named John Masten. Peale made an initial expedition to Shawangunk in June of 1801, and there he visited the flooded pit and examined the bones spread out in Masten's barn. At first, he was permitted only to study and sketch them; but finally Masten agreed to sell his collection, along with rights to the bones remaining in the pit, for three hundred dollars plus new clothes for his wife and a gun for his son.[39] Returning briefly to Philadelphia for money and supplies, Peale was ready for a second expedition to Masten's farm in July.[40] Back in Shawangunk, he hired "upwards of 25" men at "high wages" ($1.12/hour) to assist with the digging[41] and, with the help of a local carpenter, designed and built the pump which would keep the site from flooding. This is the pyramidal structure, vaguely resembling the frame of a tepee, which dominates the work site in Peale's painting.

The mastodon is exactly what is missing from *Exhuming the Mastodon*; instead of the skeleton, a skeletal mechanism looms above the site. Supported by a complicated crisscross of boards and poles, Peale's pump reframes the scene within the scene, dividing and redividing the crowd of spectators who have come to witness the mammoth's second birth. Haphazardly (or, rather, in the style of documentary empiricism), Peale's mechanical contrivance cuts the scene into oddly fragmentary miniature scenes, or partial paintings within the painting. It is the working of the pump as a visual frame, as much as the crowd of spectators or the labor of digging, which makes *Exhuming the Mastodon* "a busy scene," as Peale described it in 1806.[42] Rembrandt Peale's pamphlet likewise frames a busy scene: both pamphlet and painting rhetorically raise the skeleton as a wondrous work of labor and looking, or recreational spectatorship and laborious production, on the basis of which painted image and printed pamphlet may be connected with one another:

> The attention of every traveller was arrested by the coaches, waggons, chaises, and horses, which animated the road, or were collected at the entrance of the field. Rich and poor, men, women, and children, all flocked to see the operation; and a swamp always noted as the solitary abode of snakes and frogs, became the active scene of curiosity and bustle: most of the spectators were astonished at the purpose which could prompt such vigorous and expensive exertions, in a manner so unprecedented, and so foreign to the pursuits for which they were noted. —But the amusement was not wholly on their side; and the variety of company not only amused us, but tended to encourage the workmen, each of whom, before so many spectators, was ambitious of signalizing himself by the number of his discoveries.[43]

Here, the object of wonder and amusement is as much the crowd of spectators as the machinery or the labor of production. The crowd attracts itself to the excavation: passersby are drawn by the coaches and horses on the road or already "collected" there. While the "foreignness" of "the operation" appeals to the crowd, the crowd's assembled "variety" amuses the Peales. The diverting diversity of the crowd stands in contrast to and is inversely reflected by the laborers below them: the men in the pit are not differentiated by sex, age, or class, but by the degree to which they can "signalize" themselves in the eyes of the crowd.

Exhuming the Mastodon likewise conjoins labor with looking. A random crowd of spectators, diversified by age, class, dress, and sex, is juxtaposed with a group of workmen in the pit, one of whom "signalizes" himself by raising a bone. In addition, however, the painting displays Peale's family, including eleven of his twelve children and two of his wives, Betsy DePeyster Peale, who died in 1804, and Hannah Moore Peale, whom he married in 1806. Grouped in a formal tableau in the right middle ground, the Peales of Philadelphia are set apart from both the laborers in the pit and the crowd around them. Except for Rembrandt, Peale's family was not present at the excavation: the visual field of the excavation site in the painting is complicated by the fact that both the crowd of spectators and the Peale family contain female as well as male subjects. The gendering of the scene intersects with the other divisions which structure both painting and pamphlet: the division between the farmers of Shawangunk and their urban employer; between the wage laborers in the pit and the Peale family above them; between the men who labor and

the spectators who view them; and, finally, between the spectators who view the painting itself, from outside, and the spectators and workers within it.

Exhuming the Mastodon illustrates that Peale's Museum was constellated, or structured, on many different, intersecting levels by a compulsion to rationalize labor's productive power. When Peale encountered actual farmers and farmhands at Shawangunk, his Jeffersonian-Republican model of independence came face to face with actual agricultural producers and, in the process, with its own self-divided relation toward labor. One of the ways this ambivalence is both manifested and contained is in the progressive frame which the painting imposes on the bodies of the laborers. In the painting, the men of Shawangunk stand on dry ground or on wooden steps, working knee-deep in water or resting momentarily, digging with shovels or with their bare hands. But their labor is rationalized into an obvious historical progression—from the nearly naked man at the bottom of the pit, through the half-dressed men digging with their hands, to fully clothed and hatted men working with tools. On the one hand, the workmen in the pit represent the collective labor of digging depicted within a single moment and, more subtly, through history. On the other hand, Peale's rationalization of the labor into developmental stages has the effect of framing it as the labor of a single man, represented through time (as if in a time-frame sequence) at different moments in the progression.

Just as the painting rationalizes labor as a human product, Rembrandt Peale's *Disquisition* rationalizes the labor of production by drawing a negative contrast between Peale's "liberal plan" and the "vulgar" curiosity, poor work habits, and unenlightened customs of the men of Shawangunk.[44] In 1798, Masten and his neighbors had spent several days drinking grog, dragging bones from the marl pit, and breaking many in the process, until the pit flooded and buried the rest. When Peale took over he carefully doled out the grog because, as he put it, "those who had drunk too much was not worth having."[45] While rationalized labor is the groundwork of the mammoth framed in Peale's Museum, unrationalized, disorderly labor is not part of the plan:

> Unfortunately, the habits of the men requiring the use of spirits, it was afforded them in too great profusion, and they quickly became so impatient and unruly, that they had nearly destroyed the skeleton; and, in one or two instances, using oxen and chains to drag them from the clay and marle, the head, hips, and tusks were much broken; some parts being drawn out, and others left behind. So great a quantity of water, from copious springs, bursting from the bottom, rose upon the men, that it required several score of hands to lade it out with all the milk-pails, buckets, and bowls, they could collect in the neighbourhood.[46]

In addition to employing themselves unproductively, the men were motivated by profit. For farmer Masten, Rembrandt's *Disquisition* recounts, the hope of gain "was everything" while, for his neighbors, "curiosity did much, but rum did more, and some little was owing to certain prospect which they had of sharing in the future possible profit."[47] They would be disappointed, however, because Masten ultimately refused to share with them "the price of any thing his land might happen to produce."[48] By contrast, Peale's reorganization and partial mechanization translates divisiveness and disorder into his own success. Contrasting the farmers' failure

with his father's liberal plan, the *Disquisition* is dedicated to Peale's "persevering zeal," which reconstructed a mammoth in Philadelphia,

> without any intermixture of foreign bones . . . where it will remain a monument, not only of stupendous creation, and some wonderful revolution in nature, but of the scientific zeal, and indefatigable perseverance, of a man from whose private exertions a museum has been founded, surpassed by few in Europe, and likely to become a national establishment, on the most liberal plan.[49]

Among the farmers and farmhands of Shawangunk, the German immigrant Masten is distinguished by the mammoth exhibit as a special object of redemption and preservation. In the painting, Masten is the dark figure near the bottom center of the painting, where he stands on a ladder. Halfway in and halfway out of the pit, he marks the limit and ground of the museum's field of visibility. Looking back from the extreme foreground, Masten most closely approximates the position of the viewer outside the painting's frame: alone and disconnected from the human groups in the painting, he seems in the process of leaving the site. Yet his gaze has been arrested by the figure of Peale, as it was not arrested by the bones in his marl pit. The *Disquisition* introduces its description of Masten as "an anecdote not uninteresting to the moralist," recounting that Masten "[spoke] the language of his fathers better than that of his country" and would have preferred to let the bones "rot as manure."[50] Unlike Peale, Masten regarded both farming and mammoth bones from an illiterate point of view, or so the Peales regarded him. But Masten was also a productive farmer. Born on his farm, he "was brought up" to farming "as a business,"

> and it continued to be his pleasure in old age; not because it was likely to free him from labour, but because profit, and the prospect of profit, cheered him in it until the ends were forgotten in the means.—Intent upon manuring his lands to increase its production (always laudable) he felt no interest in the fossil shells contained in his morass; and if it had not been for the men who dug with him, and those whose casual attention was arrested . . . for him the bones might have rotted in the hole which discovered them: this he confessed to me would have been his conduct, certain that after the surprise of the moment they were good for nothing but to rot as manure. But the learned physician, the reverend divine, to whom he had been accustomed to look upwards, gave importance to the objects which excited the vulgar stare of his more inquisitive neighbors: he therefore joined his exertions to theirs.[51]

What would Masten do if he were free from labor? The implication is that he would pursue natural history or at least visit Peale's Museum, where he would learn to regard his farm and himself as living artifacts of esthetic and scientific significance. At the same time, though, the *Disquisition* makes it clear that Masten belonged to a comparatively traditional community, one in which profit seeking was constrained and complicated by deferential social forms and cooperative labor. The farmer is moved less by his own "curiosity" than by the opinion of the "learned physician and the reverend divine." But being dependent upon learned authorities, to whom "he had been accustomed to look upwards," Masten has not learned to look for himself and has not, therefore, achieved the kind of independence the museum impressed upon its visitors. The "moral" of the story is that Masten's inability to see himself, his

property, and his mammoth bones as significant (or historically narratable) objects is a result of his failure to "employ himself" in recreational activities such as museum going, which could have opened him to the arts of spectatorship and self-regard.

The mammoth exhibit does not simply dismiss Masten as a figure external to the museum's visual field. This is partly because Masten's marginality epitomized the separate state of independence. But he was also impossible to dismiss because, as a property-owning farmer, he embodied Jeffersonian principles. While his disinterest or, rather, sheer interestedness in respect to the bones was disturbing to the Peales, Masten was a farmer concerned with increasing his farm's production, an ambition which was "always laudable."[52] As an agricultural producer upon whose labor Jefferson's political economy grounded itself, Masten was, theoretically, central to the picture. At the same time, though, both painting and pamphlet cast the non-English-speaking "foreigner" as a dark figure, against whom Peale's concern for public over private interest and scientific principle over local custom is foregrounded.

In the painting, Masten stands in an ambiguous, even faintly satanic position. Bryan J. Wolf has argued that the thunderstorm looming in the right background represents the threat of nature's retribution upon the technological domination of nature which is the painting's focus.[53] But the other dark place in the painting is the extreme foreground where Masten stands, half-integrated into the scene, with his eyes focused on Peale, the victor at the marl pit, which is Masten's property after all. In the mammoth exhibit, Charles Willson Peale, public ownership, and national good win out over Masten, localism, and private interest. However, while Peale was funded by President Jefferson and the American Philosophical Society, his museum and his expedition were also proprietary—or privately initiated and supported. The museum and the mastodon were assembled for the public good, but also in the private interest of Peale and his family. As the shadowy other at the mastodon site, Masten, therefore, represents Charles Willson Peale's own other self. Masten had been the first collector of the mastodon bones. More important, he represents Peale's uncultivated other self, insofar as Peale, like Masten, identified virtue with the means-end logic of production, public good with private happiness, or the national interest with his own family's welfare.

Production grounded and unified the diverse fields in which Peale labored as museum proprietor and, in *Exhuming the Mastodon*, he represents himself as an exemplary producer: as the object of his own making, the figure of the artist articulates the connection between individual and collective self-production. The role of artist and man of science was also, of course, inherently in conflict with that of the laborer, and the painting distinguishes Peale as cultivated artist and museum proprietor from the workmen in the pit. Peale stands at the edge of the pit, illuminated by sunlight. Gesturing to the laborers below with his right hand, he holds in his left hand an enormous scroll on which a life-size sketch of a mastodon leg is displayed. Unrolled horizontally, the scroll unites the members of Peale's family behind it in a tableau. This includes his three eldest sons, Raphaelle, Rembrandt, and Rubens Peale: Raphaelle Peale holds the opposite end of the scroll, while Rembrandt Peale stands at its center, pointing down to the drawing of the mammoth bones in

imitation of his father's role as public educator, artist, and restorer of the mastodon.[54] Rubens stands between them, with Peale's two youngest daughters in front of him.

Peale's gesture to the laborers digging in the pit below serves to identify them with himself and his own labors as founder and proprietor of the museum—labors which are the support of the family behind him. On the artist's scroll "the Word" is bone: in a graphic representation of the museum's equation of image with word and word with natural structure, nature is articulated as work (wherein the Maker's design is inscribed and legible). The drawing on the scroll also serves as a kind of heraldic device for the Peales themselves,[55] punningly representing foundation as the bones of a leg, or as the support of both the mastodon and the Peale family. As an emblem for the Philadelphia museum, which was also the Peale family home, the Word-as-bone reads, "Our support lies in the works of nature."

By introducing his family's portraits here, Peale celebrates the museum and its mammoth as the foundation and support of his family in Philadelphia. And, by opening this foundation of private support to the public gaze and identifying it with the men working in the pit, Peale connects the unity and support of the Peale family with the grounding of all society in productive labor. Of course, it was not only shared labor, but also the wage relation that restored the bones and connected the museum family from Philadelphia with the people of Shawangunk. In the painting, the half-naked laborer at the bottom of the pit stands in an Adamic pose, raising the bone he has discovered. Considerably smaller than the leg on Peale's scroll, this bone approximates Peale's arm in size and corresponds with the smallest bones in the diagram: it finds a place in the artist's sketch in a silent articulation of union, wherein the labor of the local farmers and the work of the urban artist are conjoined. But Peale's celebration of social harmony through an economic and cultural mechanism of production is also based on a productive disjunction between labor and its employment (and, correspondingly, between word and image, labor and work) whether that labor be Peale's own as museum proprietor or that of the workmen on whom the excavation also depended.

Standing between the men in the pit and the women and children grouped behind him, the figure of Peale not only mediates between the laborers and the members of his family, but separates them from each other: the Jeffersonian-Republican identification of private productivity with the national good is both the cause and the effect of a class distinction. While the painting celebrates the Jeffersonian-Republican revelation of labor as the nation's productive base and Peale's own labors as museum proprietor, it also records the artist's cultivated reluctance to identify himself and his family with the cultivators of Shawangunk.

Surrounded by their older brothers, two little girls stand at the center of the Peale family group. These are the youngest daughters of Peale and his second wife, Elizabeth DePeyster Peale, who died in 1804, two years before Peale began the painting. (Peale's first wife, Rachel Brewer Peale [d. 1789], was the mother of Rembrandt, Raphaelle, and Rubens. Peale married a third time in 1805: in *Exhuming the Mastodon* his new wife, Hannah Moore, stands immediately behind him.) However, Elizabeth DePeyster is also on the scene. Pictured at a distance from the family grouped

behind Peale, she stands at left, in a miniature landscape with a little boy (her son Titian Ramsay Peale II), pointing up toward the coming storm and directing him to the safety of the military tent in the background. Her gesture toward the storm in the far right corner is mirrored by Peale on the other side of the painting, who points down toward the laborers in the left foreground. The boy's body, in turn, mirrors in miniature the tripod arrangement of Peale's pump.

Pointing up to the clouds, Elizabeth DePeyster gives direct expression to anxiety at the work site. In a terrible irony, given the significance of metaphors of size and birth to the mammoth exhibit, Elizabeth, or Betsy, Peale died on February 19, 1804, unable to deliver an overly large baby boy after a pregnancy of twelve months. She died following an operation performed by a Philadelphia doctor to extract the baby.[56] Framed by Peale's pump, Elizabeth DePeyster Peale looks down at the laborers below while pointing to the storm coming from the right. With her gesture and her glance, she connects the laborers in the pit with the coming storm, while warning the child and directing him to the tent in the background.[57] The white tent beneath the blue sky is a place of comparative security in the scene: Peale had begun his Philadelphia career as a painter of revolutionary portraits, and the tent represents the revolutionary past within the Jeffersonian present of the painting. In good Republican fashion, however, its military presence is relegated to the distance, and the machinery and labor of production dominate the site instead. Linking the storm with the rebirth of the mastodon through labor, Elizabeth Peale expresses, even more clearly than the figure of her husband, the anxieties which structure and confront the mechanics of Republican political economy: that the laboring body not only produces but also threatens fixity and independence and that, within the framework of liberal-republicanism, progress is reproduction, or repetition.

In September of 1806, Peale was just beginning *Exhuming the Mastodon* when he wrote to his eldest daughter Angelica, juxtaposing the uncertain outcome of his "labour" on the painting with the imminent birth of a grandchild: Angelica's sister Sophonisba Peale Sellers was awaiting the birth of her first child. In the painting, Sophonisba stands behind the Peale family, beneath an umbrella, with her husband.[58] Juxtaposing the precarious labor of childbirth with both the looming storm in the background of the painting and his own labors with the paintbrush, Peale writes,

> I have on hand a picture which requires all my attention, and greater exertions than any undertaking I have ever done. How I shall acquit myself on the finishing is yet doubtful in a great number of figures in a busy scene of taking up the Mammoth Bones in a Deep Pit with numbers of spectators as was actually the case during that great labour. I hope to make it a very interesting picture, the subject being grand, nay awful, by the appearance of [a] tremendous gust coming on. Sophonisba will shortly be confined, she looms large.[59]

In the painting, Elizabeth DePeyster's youngest daughter, Elizabeth, points down to their father's sketch and looks up at her older sister Sybilla, who in turn points up to the storm and to the sky in general. Sybilla's gesture is the answer to a central query of American education during the antebellum period: Do you know who

made you? As her sister's teacher, Sybilla indicates that her Maker is in heaven. Since Elizabeth is pointing down to the sketch of the mastodon leg, the question is extended to the mastodon as well: its Maker is also above. Sybilla's gesture also connects the mastodon leg with the frame of the pump above her head. Since Sybilla and Elizabeth are the children of Elizabeth DePeyster, Sybilla's answer to Elizabeth's query can also be construed as a statement about their mother's whereabouts: "She is in heaven." On the other side of Peale's machinery, Sybilla's gesture is replicated, in a less harmonious context, by Elizabeth DePeyster Peale.

As the expression of the Jeffersonian-Republican reunion of means and ends, parts and wholes, the mammoth in the Peale Museum brings into focus a national interior in both the geographic sense of a continental interior and in the disciplinary sense which Michel Foucault defines as the framing of "visible subjects" as fields of knowledge whose interior, or subject, status circularly authorizes and unifies *as* fields the discursive frames which bring them into view.[60] As the expression of Jeffersonian-Republican political economy and its continental empire, Peale's mammoth makes visible the framed frame/work of a collective national subject as the dominated object of its own making and the dominating subject of its own gaze. Jeffersonian-Republican political economy was not, then, a mechanism simply for producing landed properties, but for deploying whole fields through the production and proliferation of visibly self-made subjects.

Within the framework of the Peale Museum, territorial expansion was inseparable from the celebration of the creator's wondrous "work." During Jefferson's presidency, the role which expansion as well as production played in Jefferson's political economy was evidenced most literally by Lewis and Clark's expedition of 1803–06, and the purchase of the Louisiana territory from Napoleon in 1804. On Jefferson's orders, most of the animal specimens collected by Lewis and Clark—prairie dogs, bighorn sheep, prong-horned antelope, and numerous weasels and squirrels—were sent to Peale's Museum in Philadelphia for preservation and display.[61] Peale's curatorial role in the Lewis and Clark expedition directly connected the exhibitionary framework of the Philadelphia museum with expansion into the continental interior: the scientific practices of collecting, classifying, and exhibiting the artifacts of the interior employed an urban artist such as Peale in the service of an economic expansion the engine of which was productive labor. In turn, Peale's Museum celebrated labor in general and Peale's own labor in particular as the productive source of collective independence.

Crucially, both expansion and production were suffused with a humanitarian ethic of tolerance within the museum's discursive and visual Jeffersonian frame. As humanitarianism, Jefferson's political economy prescribed a self-regulating social order which lifted all external, coercive force from the human body, while widening and deepening, or democratizing and elevating, the social field by framing it as a visual field wherein all persons were free not only to appear but to become the independent objects of their own production. Only in the open exhibitionary field of a society free from coercion could independence and stability appear. Only in such a field, further, would individuals be free to make, master, and contain themselves as living monuments to freedom. As articulated by Jefferson in his first inau-

gural address, the revolutionary freedom from coercion entailed a new disposition of power which was both the cause and the effect of an extended sphere of visibility. Both revolutionary and counterrevolutionary opponents of Jeffersonian-Republican self-production were to be regarded as monuments, untouched but safely contained in (the frame/work of) an open visual field. As Jefferson proclaimed at his first inauguration,

> We are all republicans; we are all federalists. . . . If there be any among us who wish to dissolve this union, or to change its republican form, let them stand undisturbed, as monuments of the safety with which error of opinion may be tolerated where reason is left free to combat it.[62]

Peale too had founded his museum in the act of distancing himself from political warfare. The museum was a monument to Peale's dislike of social conflict, which constituted another kind of social control through the arts of exhibition and display. The museum and the mastodon that epitomized its recreational suspension of productive labor did not mean simply the retreat of the artist from political conflict to the solitary status of the observer. Instead, they were the products of the displacement and diffusion of social struggle and social control to and through other sites of representation.

If, in Exhuming the Mastodon, the figure of Elizabeth DePeyster points to the structurally precarious nature of the social base, the contemplative man behind her embodies the successful reproduction of production in the figure of the self-made man. Framed by the wooden shack in the left middle ground, this is Alexander Wilson, Scots immigrant, dialect poet, and the father of American ornithology.[63] Arms crossed, hat on, Wilson stands at the summit of the chain of laborers digging below: the rise and progress of the labor in the pit is contained and recapitulated in this figure of the spectator. With his shovel, the uppermost workman tosses away a load of clay and with it, potentially, the yoke of labor. But the physical motion of his labor is translated into Wilson's independent pose: the contained self-regard of the scientific observer and self-made man. Arms folded, Wilson displays the cultivated autonomy which, according to the Jeffersonian logic of production, history itself labors to produce.

In 1808, the year the painting was completed, Wilson had just finished the first volume of his American Ornithology, which by 1814 would encompass more than five hundred bird species. A former handloom weaver and sometime pedlar, Wilson aspired to collect and classify every species of bird in the United States. While he worked on his collection, Wilson depended on Jefferson's patronage and on the bird collection in the Philadelphia museum, preserved by Peale's pioneering taxidermy techniques. Throughout the Ornithology Wilson repeatedly thanks Peale and refers to his museum. In turn, in Exhuming the Mastodon Peale placed Wilson in a position of honor, though, like Peale's family, Wilson was not present at the site. By including Wilson in the painting and placing him in a position of lonely eminence, Peale honors his example as self-made scientist, American author, and fellow laborer in the endless fields of natural history. Eventually filling nine volumes, Wilson's Ornithology brought familiar eastern species (robin, bluejay, etc.) together with

new species collected by Lewis and Clark and by Wilson himself on journeys through Tennessee, Mississippi, and Louisiana. Charting the migratory ranges of each species, while arguing for the inherently domestic character of American birds, Wilson's mammoth Ornithology implicitly identified the United States with the continent of North America. In this respect, it was, like Peale's museum, a Jeffersonian-Republican text and a monument to continental empire. Significantly, Wilson died in 1813 quite literally of overwork, of heart palpitations, chronic dysentery, and chronic poverty. As he wrote to his father in Scotland, a month before his death, "Intense application to study has hurt me much. My 8th volume is now in the press. . . . One volume more will complete the whole."[64] The final volumes of his collection would be completed by Charles Lucien Bonaparte, Napoleon Bonaparte's expatriate nephew.

Long before the success of his mammoth exhibit, Peale had employed the mammoth and its bones as metonyms of the "rise and progress"[65] of his museum as a whole. In a museum lecture of 1799, Peale traced the origins of his museum to three objects assembled in the early 1780s: his collection of portraits of revolutionary "worthies," a dried paddlefish, and the bones of the mammoth:

> Having made some progress in [a collection of the portraits of characters distinguished in the American Revolution]—my friend Col. Ramsey suggested the idea of amusing the public curiosity by putting into one corner of my picture-gallery some bones of the mammoth, the enormous non-descript of America. Mr. Patterson (Profesor of Mathematics in our University) encouraged the plan, and presented me with the first article, a curious fish of our western waters, with which to begin my Museum.
>
> From so small a beginning, arose a fabrick, which in some future day may be an honor to America.[66]

All three of these founding objects, paddlefish, portraits, and mammoth, are represented in Peale's famous self-portrait of 1822, The Artist in His Museum (fig. 1.2). But it is the mammoth leg beside the artist's leg which is the painting's punning frame and focus. Pictured between the mastodon skeleton, which is partly obscured against the window at right, and the hundreds of bird specimens that line the left wall, Peale has positioned himself as the point of integration between the mammoth One and the feathered Many, the gigantic and the miniature. As if he were one of the bird specimens in the cases at left, the artist in his museum is boxed in on three sides, with one end left open for viewing. The long upper room of the museum in Independence Hall serves as a single display case for the representative Man; expressing the art of self-production as self-containment, Peale is the biped on display. As the second creator of the world in miniature, Peale has encased himself as a specimen in a museum of his own making.

With his left hand, he indicates his own leg and, beside it, the leg of the mastodon. Through this gesture, Peale puns once again on leg as foundation: just as the counterpart of this mastodon bone supports the mastodon skeleton behind the curtain, so Peale's leg supports him. Far more than in Exhuming the Mastodon, punning humor works here to contain the grandiosity of the artist's act of self-production and self-display. However, the joke is not very funny because it is made at the

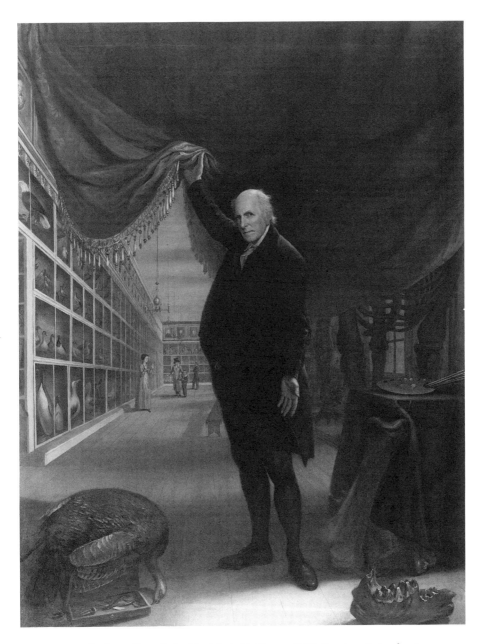

1.2. Charles Willson Peale, *The Artist in His Museum*, 1822. Courtesy Pennsylvania Academy of the Fine Arts, Philadelphia. Gift of Mrs. Sarah Harrison, The Joseph Harrison, Jr. Collection.

expense of the woman on the scene and masks domination as perfect openness, self-assertion as the withdrawal of self, and the presence of power as its absence, or extinction.

What Luce Irigaray has called the "re-mark" of gender is the primary source of amusement in *The Artist in His Museum*.[67] In Peale's painting, the two sides of the

museum correspond with two ways of looking which are represented, respectively, by the single woman who stands in the left middle ground gazing up at the mammoth with her hands raised and the single man in the far background, who looks down, in an attitude of distanced contemplation, at the birds on the left wall. This male figure exactly reproduces in profile the pose of the ornithologist Alexander Wilson in *Exhuming the Mastodon*. The woman, by contrast, stands with her back to the birds and looks up, in an attitude of wonder, at the mastodon on the other side of the room. Unlike the viewer outside the painting, the woman has a full view of the mammoth frame, which the curtain partly conceals. (The red drapery which cuts off the mastodon's head serves instead as a backdrop for Peale's head.) And since, with his left hand, Peale identifies the mastodon with his own body and its frame, the woman's wonder is also a joking mockery of the artist's grandiose self-display and of his identification of himself with the mammoth. Peale's pose is also mocked by the puffed-up penguin at lower left, in its museum case, next to a gull.

The woman's response to the gigantic skeleton finds its inverse in the self-containment of the independent young man at the rear of the museum, who studies the birds in their miniature worlds. Second only to the mammoth and perhaps to his collection of revolutionary portraits, Peale's remarkably large bird collection was the pride of his museum. As a laborious technique of restoration, or re-membering, taken to a graphic extreme, the museum practice of taxidermy epitomized a hyperreal fusion of Nature with Art accomplished by the reproductive machinery of a production-based political economy: the birds' feathers and skin were preserved with arsenic, and their bones and muscles replaced with statues carved from wood. The eyes, made of glass, were cast by Peale. In an unpublished museum guide titled "A Walk Through the Philadelphia Museum," Peale describes his method of refitting his specimens with monumental new frames: "In fact they are statues of animals with real skin to cover them—a stupendous labor!" So precisely were the "mussils of the quadrupeds" represented by their replacements within "that Painters might take them for models"[68]—which was exactly what Wilson did when he used Peale's birds as models for his illustrated *Ornithology*.

The bird-watcher, miniaturized by distance in the painting's background, mirrors the stance of the viewer outside the painting's frame: just as the autonomous man in the rear of the museum contemplates the birds within the Peale Museum, so the museum visitor, standing before *The Artist in His Museum*, considers Peale, foregrounded in the enormous display case he has built for himself. However, unlike the birds in their cases in respect to the man who views them, Peale's eight-by-six-foot self-portrait is not miniature in respect to its viewer. Hung on the museum wall, it looms over the spectator who stands below. The spectator's position must also be identified, then, with the position of the woman with her back to the birds, who stands in awe before the enormous frame across the room.

There are two other figures on the scene: a man and a boy divide the single man in the background from the woman in the middle ground. This couple walks together, the boy holding a book or, more likely, a copy of the museum *Guide* between them. Roger Stein has suggested that the four figures in the background of *The Artist in His Museum* represent a recapitulation of Lockean/Linnaean epistemol-

ogy, according to which they progressively emblematize, from background to foreground, sense perception, reason, and religious reverence or wonder: "The man sees, as the birds in the cases discover themselves to his sense; the father and son with a book reason justly upon the significance of the arrangement visually available in the cases and verbally ordered . . . in the catalogue in the child's hand, while the lady stands . . . with hands raised in wonder (her Quaker religion implies reverence)."[69] However, this reading reverses the more obvious developmental sequence of the figures, that is, from woman through dependent child to independent man. By missing the thematization of dependence versus independence in its connection with the interplay between the gigantic and miniature elements in the painting, Stein is unable to see in the distanced man and the awestruck woman the reversibility of the left and right sides of the painting and their thematic integration in the pivotal figure of the artist. He therefore misses the amusing side of the rational(-ized) amusement offered by the painting, amusement which follows from the association of the almighty mammoth with the foregrounded figure of Peale.

The woman, struck with wonder by the mastodon, and the young man, contemplating the bird families on display, recapitulate within the painting the two poles which structure the viewer's own experience before *The Artist in His Museum*. The containment of awestruck wonder as amused contemplation marks the containment of the viewer's awe before the huge painting within the more distanced and reflective gaze of the autonomous young man. Crucially, the ability to see the joke implies only amusement, not laughter. Peale is not holding the woman up to ridicule. In fact, Levity was a suspect category and one of the debilitating social vices his museum set out to cure.[70] Cultivated amusement was different.

The man and the boy with their printed *Guide* represent Peale's own mediating relation, as educator, to the museum visitor standing before the painting. As Stein argues, the four background figures emblematize the ordering power of textuality. But, as demonstrated by the moment of communion between father and son, this ordering power of the text is marked as male. The educational goal of the museum was the cultivated independence represented by the man in the rear of the museum: the logic of education leads developmentally *back* to the position of the independent young man in the distance, rather than forward to the woman's amusing awe. As Peale put it in his *Epistle on Health* (1803), "What charming conversations will a knowledge of this science (of nature) afford between the father and his sons at the age when they become agreeable and useful companions to each other. How often in their morning or evening walks might the Infirmities of age be beguiled, while recounting their observations and . . . the high-toned passions of the youthful nerve, might be restrained until it gains maturity."[71]

In a reflection of the museum's marriage of image and word, miniature and gigantic elements, the museum visitor who views the painting is positioned as simultaneously a male and female reader of Nature's Book. However, the egalitarianism implied by this reversibility of gender masks and reproduces a relation of subordination in which the female body, like the laboring bodies in *Exhuming the Mastodon*, is inscribed as both the prehistoric ground and the excluded part-object of Nature's Book.

In addition to the figure of the awestruck woman, Peale has included another humorous commentary on his mammoth act of self-display: the turkey specimen in the foreground. The head and neck of the turkey hang down because the bird is dead; but the body is positioned so that the turkey bows obsequiously toward the artist, epitomizing, as farmer Masten did, the attitude of the uncultivated subject, who refuses to willingly look and actively construct the museum of the world for himself. As unenlightened Nature without Art, the turkey embodies traditional or prehistoric customs, not simply of looking upwards to figures of authority but of bowing down to kings, priests, and tyrants. Of course, all of this is Peale's humorous self-commentary on the grandiose presumption of the artist who poses as the second Creator of the world in miniature. But the humor is also dark, even Gothic in tone. Although the turkey serves as a joke, it is perched on a box of tools that is open to view. Just as in *Exhuming the Mastodon*, the mechanics of the excavation are open to view in documentary detail, so here the drawer of the toolbox is open, and the viewer is invited to see the specimen of nature from the side of domination, clearly and graphically as it is originally: dead, formless, and empty. The open drawer, with its scalpels and pincers, invites the painting's viewers to see and use the visual technology of the museum themselves in order to reproduce the independent pose of the artist and recreate the world, through their own collective effort, as a monument to independent selfhood.

2

D A V I D B J E L A J A C

• • •

The Boston Elite's Resistance to Washington Allston's Elijah in the Desert

Standing in the midst of Washington Allston's retrospective at Harding's Gallery in Boston in 1839, visitors could turn their gaze from biblical paintings such as *The Prophet Jeremiah Dictating to the Scribe Baruch* (fig. 2.1) to pastoral scenes such as *Moonlit Landscape* (fig. 2.2) and to images of ideal women in reverie such as *Evening Hymn* (fig. 2.3).[1] Yet one of Allston's most experimental works, *Elijah in the Desert* (fig. 2.4), painted in just three weeks during the winter of 1817–18, was not included in the artist's retrospective. Members of the Boston elite had begun to collect Allston paintings in earnest after the artist had returned from London in 1818 with *Elijah* in hand. But not a single patron offered to buy the biblical landscape when Allston temporarily displayed it in the residence of Isaac P. Davis, one of Boston's leading merchant princes.[2] Unsold until 1827, *Elijah* was returned to England by a member of Parliament, who purchased it for one thousand dollars at a time when Boston patrons were underwriting *Belshazzar's Feast* to the tune of ten thousand dollars as well as acquiring other biblical and nonbiblical Allston paintings.

Elijah met neither the religious nor aesthetic expectations of its predominantly Unitarian Boston audience. Painted for a London audience that included artists, poets, and critics drawn to romantic ideas of the organic imagination, *Elijah* challenged the analytical understanding's demand for clear ideas and for images with firm contours and local colors. The fluid paint of Allston's *Elijah* did not empirically imitate nature's external appearances and differences but symbolically captured the

2.1. Washington Allston, *The Prophet Jeremiah Dictating to the Scribe Baruch*,
1820. Yale University Art Gallery. Gift of Samuel F. B. Morse.

invisible spirit or higher Reason animating it.[3] In the words of Allston's friend and
mentor Samuel Taylor Coleridge, the Reason or Logos connected all nature in a
"glad confusion and heedless intermixture" that defied the understanding's system
of classification.[4]

Praised by London admirers for its "wild grandeur," *Elijah* disappointed and
bewildered Boston patrons and critics, whose aesthetic principles were drawn from
Scottish Common Sense philosophy and the neoclassical theories of Sir Joshua
Reynolds rather than from Coleridge's anti-Lockean theory of the imagination.[5]
When the Unitarian clergyman William Ware wrote his biography of Allston (1852),
his memory of *Elijah*'s cool reception in Boston remained vivid. Try as he might to
overcome it, he continued to struggle with his recollection of the painting's ambig-
uous treatment of the biblical subject and with the apparently arbitrary forms of the
wilderness landscape.

By situating *Elijah* in relation to various aesthetic, religious, and cultural discourses
and to socioeconomic and political conditions in antebellum America, I hope to
suggest why Boston's patrons and critics were apparently uneasy and ambivalent

2.2. Washington Allston, *Moonlit Landscape*, 1819. Museum of Fine Arts, Boston. Gift of William Sturgis Bigelow.

toward the painting and why they failed to find reassuring meaning in Elijah's own discourse of forms. Allston's reputed genius as an "artist of the beautiful" was socially constructed through the criticism and patronage of his Boston audience.[6] In this chapter, I wish to explore why *Elijah in the Desert* failed to rest comfortably within that construction.

Allston's paintings challenged the interpretive capacities of Boston audiences. Beginning during his residence abroad, Allston increasingly subordinated subject matter to a Titianesque color technique.[7] Yet Boston critics mostly praised this ideal, abstract style. No matter what the specific forms or particular subject matter, critics saw above all else the harmonic colors that appeared to glow "from the canvas rather than to have been laid upon it."[8] Allston's atmospheric glazes of Venetian color transfigured the materials of art—subject matter as well as pigments—revealing the artist's moral and intellectual powers.

In semiotic terms, this Venetian glazing technique created a perfect signifier: while it made moral and intellectual signifieds or meanings materially visible, the translucent veils of color seemed to conceal the pigments or take "away the appearance of paint."[9] Allston's friend the Reverend James Marsh thus claimed that painting was defined by light and color, "an incorporeal, and in some measure spiritual material," which gives "a considerable preponderance to the soul."[10] As Allston's former brother-in-law, the Unitarian clergyman William Ellery Channing, told a

2.3. Washington Allston, *Evening Hymn*, 1835. The Montclair Art Museum,
Montclair, New Jersey. Gift of Mr. and Mrs. H. St. John Webb.

working-class audience, "Matter becomes beautiful to us, when it seems to lose its
material aspect . . . and by the ethereal lightness of its forms and motions seems to
approach spirit."[11]

Signifying the word or the voice of God, Allston's ethereal color begged the active
participation of the beholder, whose faith or aesthetic code of interpretation was
essential for sustaining the fiction of an immaterial, transparent language of paint.[12]
As an expression of communal faith in the unseen world of spirit, the harmonic
tones of Allston's color expressed an aesthetics or ideology of spiritual cohesion.[13]
During a time when democratic and liberal economic forces were rapidly trans-
forming traditional patterns of social behavior, Boston elite taste for Allston's imma-
terial art created an intersubjective community of beholders, who implicitly as-
serted that they were ontologically free of material needs and desires, that their lives
were not actually determined by the amoral values of the marketplace or by narrow
party interests. As a refined community of taste, Boston proved that commercial
and industrial wealth need not threaten the moral character of the republic.[14]
Wealth, like paint, was a means for spiritual transcendence, for cultivating through
the patronage of art, religion, and learning not only the individual soul but the

2.4. Washington Allston, *Elijah in the Desert*, 1817–18. Museum of Fine Arts, Boston. Gift of Mrs. Samuel Hooper and Miss Alice Hooper.

collective soul of the people, genteel and ungenteel alike. For this reason, said Reverend Channing, American workers could be grateful to the nation's philanthropic men of wealth as well as to her artists and intellectuals, who generously provided the means and exemplary models for universal self-cultivation.[15]

Boston patrons' cool response to *Elijah*, however, reveals how problematic was their faith in an immaterial language of art. When the paint surface became too material, the viewer's transformation of the medium into the immaterial Idea could be diverted by a fatally close inspection of the pigments *laid onto* the canvas. The materials would then compete against the proper poetic gaze that occurs at a distance, allowing the paint to dematerialize into an abstract, radiant light, the divine symbol of human consciousness.[16] For Boston's Unitarian critics, the imagination was a morally neutral faculty.[17] Unless the artist's imagination was spiritually elevated by a moral taste empirically attuned to the light of commonly shared religious truths, the work of art could become nothing more than an opaque solipsism, signifying man's imprisonment within an essentially meaningless universe of material languages.[18] This frightening, postmodern prospect was something that most antebellum Americans would not or could not contemplate. It is understandable, therefore, if many viewers were uneasy in their observation of Allston's apparently random play of a heavily loaded brush in *Elijah*, which seemed only to signify the dangerous, self-reflexive isolation of the romantic imagination. While Sir Joshua Reynolds had demonstrated that Venetian harmonic color could be reconciled with rational neoclassical principles of design, he also warned young art students that

Venetian technique could easily degenerate into confused sensuality or mere mechanical effect.[19]

Nevertheless, even from a proper, poetic distance, when the hand of the artist became virtually invisible and the landscape could be seen as a whole, Boston viewers remained disturbed by what they saw or thought they saw in *Elijah*. The terrifying, Burkean sublimity of the wilderness—often associated with banditry and anarchic violence—held little appeal for Boston's "cultivating gentlemen" as a place for meditative, hermitlike retreat.[20] American critics piously rejected Edmund Burke's association of the sublime with isolation, fear, and the amoral passions that insured preservation of the mere bodily self.[21] Sublime emotion was more properly generated from a cultivated moral taste that expressed its infinite desire for the perfection of Being. This "moral sublime" harmonized with beauty, for the rational harmony of the earth constituted a ladder leading upward toward the sublime, invisible truths that both vitalized and transcended nature's forms.

While *Elijah*, with its luminous, harmonic color, can be interpreted in terms of the moral sublime, for many of Allston's contemporaries the deathly wilderness forms seemed to suggest a frightening disjuncture between heaven and earth. This disjuncture apparently triggered unwanted associations not only with the Burkean sublime but with a Calvinist orthodoxy that had little optimism in the unbroken ladder of forms through which the soul could naturally ascend heavenward.[22] *Elijah*'s unsettling emblematic imagery, in fact, looked backward toward a pre-Lockean, allegorical style that may have suggested to antebellum Unitarians the enthusiasm of seventeenth-century Puritanism or the visions of mystics who spurned the empirical evidence of their senses and rejected traditional authorities for the immediate truths of an inner voice or light.

Allston certainly had no wish for *Elijah* to be interpreted as the vision of an antinomian mystic.[23] His employment of conventional allegorical and sacramental imagery suggests the desire to establish a psychic distance and space for traditional religious forms, thereby preventing absorption of the self in the light or voice of the Logos.[24] He surely assumed that his typological Old Testament imagery could be read as a moral exhortation and an endorsement of the mediating roles of Scripture and the church. Whatever Allston's intention, it was of secondary importance to members of his Boston audience, who were confronted by the enigmatic or apparently unacceptable intentions of the material object itself.

The composition of *Elijah in the Desert* demonstrates that Allston was not interested in the historical details of the Old Testament, but, like Coleridge, in its sublime poetic symbolism, which associates it with the book of nature—the hieroglyphic language of God's mind—and with the human imagination—the faculty that analogically participates in the divine act of creation. Allston minimized narrative detail, subordinating the figure of the prophet to a restlessly painted wilderness landscape seen through glazes of ambient color and light. The luminous, panoramic landscape arrests the eye before the beholder notices a tiny figure kneeling before a rock in the foreground. Critics and art historians have suggested that the ravens alone identify

this figure as the prophet Elijah.[25] Nevertheless, other motifs also refer emblematically to Elijah: the brook Cherith of 1 Kings 17 and a sheltering wilderness tree, a foreground mountain, and stormy wasteland that allude to Elijah's epiphany on Mount Horeb in 1 Kings 19. Elijah is part of an emblematic tradition of hermit prophets and saints that personify solitary meditation apart from the corruption of civilization.[26] Such a tradition had been popular in English landscape gardens, many of which were populated by hermits surrounded by suitable wilderness emblems. Allston especially drew upon the paintings of Salvator Rosa, who was famous in England and America for his wilderness scenes.[27]

Allston's Elijah, therefore, is not so much a biblical character situated within a historical narrative as he is the personification of solitary meditation or of a private communication with God. Elijah exists within a hieroglyphic landscape that serves to explicate the symbolic and typological meaning of Scripture as it relates to the prophet and to the entire providential plan for humankind. Thus, the dead, bifurcated tree that dominates the picture reaches beyond the horizon into the sky, its two trunks rhetorically gesturing or "speaking" to the beholder/auditor. Like a sermonizing clergyman, the tree mediates the moral or typological significance of the Word, directing the beholder/auditor on a spiritual journey that encompasses the sweep of history from its Adamic origins to its apocalyptic end. In harmony with the prophetic meaning of the Old Testament, *Elijah*'s forms shadow forth the antitypes of Christ's death and Resurrection and the advent of his heavenly kingdom. Thus, the leftward-leaning tree trunk points backward in space and time toward a desert plain sparsely dotted with palm trees, emblematic remnants of a "paradise lost."[28] Meanwhile, the rightward-leaning tree trunk possesses a rough cruciform shape in its lower half. The open, circular end of the crossbar has been hollowed out by decay, forming a small, cavelike entrance into the tree's interior. It glows invitingly with a golden brown light, exhorting the spectator inward even as the roots of the tree empathetically reach toward the kneeling Elijah to invite participation in the soteriological meaning of the cross. The tree's salvific content is clarified by the far end of the crossbar, which points like an index finger toward the distant horizon, and by the top half of the trunk, which reaches skyward into the liberating light of the sun (Son) and rightward toward a rocky mountain dotted by evergreen trees, emblems of eternal life. Reading from left to right, as if reading a book, the viewer progresses forward and upward from the desert plain of a paradise lost toward the heavenly promise of a paradise regained. Allston's imagery of spiritual ascent evokes not only the biblical text but also epic poems of pilgrimage, sermons, emblem books, and popular devotional literature such as the fifteenth-century classic *The Imitation of Christ* by Thomas à Kempis, who assured readers, "If your heart be right, then every created thing will become for you . . . a book of holy teaching."[29]

Central to this pilgrimage from fallen past to future bliss are Christ's sacrifice upon the cross and humanity's commemoration of that sacrifice. Allston's Elijah kneels before a natural rock-altar, receiving providential bread from ravens and water that miraculously flows in a stream from the cleft mountain above, like the blood that

flowed from Christ's side. Nature typologically signifies the central doctrine of Christian faith, Christ's atoning death, and the church sacrament of Holy Communion.

Elijah, who finally ascends alive into heaven in a fiery chariot, was a traditional type for Christ. The upward thrust of Allston's landscape underscores this theme, as does the three-pronged terminus of the tree pointing toward the open sky suggest Christ's Resurrection on the third day. Furthermore, Allston's mountain, which christologically bestows life-giving water, is the sacred Mount Horeb that Elijah was ordered to climb, whereupon he experienced an epiphany of the Word or Logos:

> And behold, the Lord passed by, and a great and strong wind rent the mountains, and brake in pieces the rocks before the Lord; but the Lord was not in the wind: and after the wind an earthquake; but the Lord was not in the earthquake:
> And after the earthquake a fire; but the Lord was not in the fire: and after the fire a still small voice. [1 Kings 19:11–12]

Traditionally, the still small voice prophesied the incarnation of Jesus Christ, the Word "made flesh" (St. John 1:14). Romantic artists and poets were drawn to Elijah's experience of the voice because it proved that God's presence was not ontologically bound to mere natural objects and laws. Jehovah shows that he is not a nature god: "His presence, when at last it is revealed, is experienced as something mysteriously apart from the world of natural phenomena."[30] As Allston's speaking cruciform tree suggests with its gesturing arms and pointing fingers, God's presence ultimately lies beyond the horizon, where the material world, as Allston later said in his Lectures on Art, "seems almost to vanish, and a new form rises before us, so mysterious, so undefined and elusive to the senses, that we turn, as if for its more distinct image, within ourselves, and there, with wonder, amazement, awe, we see it filling, distending, stretching every faculty, till . . . it seems almost to burst the imagination. . . . We call the awful form Sublimity. This was the still, small voice that shook the Prophet on Horeb."[31]

Unlike beauty, sublimity is not found in nature. Sublimity eludes the senses, signifying instead the presence of Reason, or the Logos, which dwells within the soul and which the soul dwells within. Nature's forms speak of God or point toward him only when the human mind analogically contemplates those forms in relation to eternity, projecting its imperfect intuitive knowledge of God's ideas outward, transforming inert physical objects into vital symbols.[32] While the beholder of Elijah in the Desert may be captivated by the sublimity of the wild, windswept landscape, the quietly kneeling prophet and the ministering ravens seem oblivious of the stormy environment. The prophet refuses to play the traditional pictorial role of an internal, awestruck viewer, cuing the painting's real-life viewers that the source of sublime feeling resides not in the objects of external nature but in a heightened internal consciousness. With eyes lowered to the ground, Elijah's self-imposed blindness opens his mind to the still small voice. This supranatural, suprahuman voice of Reason reveals that the soul's final destination lies beyond the horizon in the light of the heavens above. As the storm passes and the sky opens invitingly, a strange calm pervades the scene. Through carefully modulated oil glazes, Allston created an atmospheric harmony—imageless exhalations of ambient color—simulating the

gentle breath of the still small voice, the ordering, procreative Word or light of the Logos.

Such brilliant light signifies the divine mind of the Creator.[33] His providential eye is functionally opposite to the Lockean camera obscura: it is not passive but projective and dynamic, shooting forth luminous rays that indexically imprint themselves and shape their objects. This divine, energetic gaze cannot be returned: "The divine *esse* is to be perceived *directly* only by Itself."[34] This, too, explains Elijah's blindness. The humble Elijah dares not raise his eyes at the moment of revelation or of holy communion with the Logos. Any attempt to see God directly would be prideful and humanly impossible, inviting self-destruction. Thus, in his poem "Eccentricity," written several years prior to *Elijah in the Desert*, Allston condemned man's "vain, presumptuous sight" while invoking the sublime power of "that still voice that stole, / On Horeb's mount, o'er rapt Elijah's soul."[35] Unlike the godlike, projective power of vision, hearing is passive, a properly humble medium for God's creatures to receive divine revelation. Nevertheless, according to Allston, the still small voice "was more than [Elijah's] imagination could contain; he could not hear it again and live."[36]

Revelation must, therefore, be mediated through symbols or through forms adapted to human cognition. In the projective, imaginative act of perception and of artistic creation, the individual symbolically participates in the universal, procreative Word. Indeed, for Allston, the creative act became more important than what was created. The indexical traces or marks of the artist's mind seemed more symbolically revealing than the iconic representation of any particular subject.[37] *Elijah in the Desert* was, in fact, painted in the excited aftermath of Allston's second visit to the Louvre in 1817, when he experienced the painterly glory of Venetian Renaissance paintings. Titian's *Peter Martyr*, Tintoretto's *Miracle of the Slave*, and Veronese's *The Marriage of Cana* revealed to him that subject matter could become entirely irrelevant in biblical painting when compared with the overwhelming feeling of sublimity that he, as a spectator, experienced through the Venetians' "gorgeous concert of colors." As he recalled years later for the American Vasari, William Dunlap,

> It was the poetry of color which I felt; procreative in its nature, giving birth to a thousand things which the eye cannot see, and distinct from their cause. I did not, however, stop to analyze my feelings. . . . But now I understand it, and *think* I understand why so many great colorists, especially Tintoret and Paul Veronese, gave so little heed to the ostensible *stories* of their compositions. In some of them, *The Marriage of Cana* for instance, there is not the slightest clue given by which the spectator can guess at the subject. They addressed themselves, not to the senses merely, as some have supposed, but rather through them to that region (if I may so speak) of the imagination which is supposed to be under the exclusive domination of music, and which, by similar excitement, they caused to teem with visions that 'lap the soul in Elysium.' In other words they leave the subject to be made by the spectator, provided he possessed the imaginative faculty-otherwise they will have little more meaning to him than a calico counterpane.[38]

Allston thus suggests that the spectator's experience of religious feeling in these paintings owes everything to color and virtually nothing to the represented subject.

Yet the spectator must perceive this color in a properly imaginative, analogical manner, as an analogue for light, for the tones of music, and, ultimately, for the procreative Word of God. For a spectator who matter-of-factly confines himself to the inductive reasoning of the understanding, moving empirically from the particular to the general, the colors of such paintings will appear as nothing more than material pigments arranged in a certain arbitrary, decorative manner upon a flat surface—like a handcrafted counterpane. Thinking analogically in terms that began with the assumption of God's universal harmony and then descended "through the general to the particular," Allston displayed no interest in the physical presence of the Venetians' pigment, and he was not really concerned either with the power of their colors to define figures or objects as they existed in pictorial space.[39] The Venetians, instead, demonstrated that color could be liberated from material objects to form an ambient, translucent veil through which the imagination may perceive a host of "indefinite forms" underived from visual sensations. Venetian color poetically and prophetically appealed to the ear, not the eye, "giving birth to a thousand things which the eye cannot see," addressing that "region of the imagination which is supposed to be under the domination of music." Rebelling against painting's traditional enslavement to visible, external reality, its Lockean and Common Sense imprisonment within the palpable real or actual, Allston joined Coleridge and other romantics to argue that the imagination, guided by an inner "living voice," could emulate the divine act of creation.[40]

Allston had begun to develop the Venetian technique of oil glazing and the harmonic mingling of primary hues at a very early stage in his career, but as Elizabeth Johns has observed, his experience at the Louvre in 1817 "crystallized" his earlier discoveries so that his colors became less "discrete" or local and more prismatically diffused throughout the painting.[41] Color became liberated from specific, temporal objects to express the universal truths or logic of the human mind, analogously emulating the procreative power of the Logos. Quickly painting *Elijah* upon his return from Paris to London, Allston subordinated his Old Testament prophet not only to the sublime grandeur of a wilderness landscape, but, even more important, to an experimental painting technique almost guaranteed to astonish or startle a Boston audience. Virgil Barker, writing during the heyday of Abstract Expressionism, interpreted *Elijah* within the aesthetic terms of action painting, praising its "spontaneity in handling," its lack of finish, and Allston's "rapid follow-through upon the original impulse" so that "the brushwork approached the expressiveness of calligraphy."[42] Indeed, Allston's friend in London Charles R. Leslie observed that the *Elijah* "was painted with great rapidity," suggesting, perhaps, the inspiration of the still small voice.[43]

Allston painted *Elijah* with an unusual, experimental medium. As he later recalled for Henry Greenough, who recorded the comments,

> My colors were prepared in dry powders, and my vehicle was *skim-milk*; with this I moistened my powdered colors and mixed them of the same consistency as oil colors. My canvas had an absorbent ground, and my colors dried nearly as fast as I could paint. When I had completed my *impasto*, I gave it a coat of copal varnish, and while it was fresh touched into it with transparent oil colors, and afterward glazed it in my usual manner.

The picture was finished in an inconceivably short time (although I put into it as much study as in any other), owing to there being no delay from complicated processes. And it was the most brilliant for tone and color I ever painted. Although the experiment succeeded so well in London, where the milk is so bad that it goes by the name of "sky-blue," I have never felt at liberty to try it again, since my return to America. I am confident, however, that great results might be brought about by it.[44]

The complicated, quick-drying impasto technique thus necessitated a rapid execution. Why he "never felt at liberty to try it again" in America surely alludes, as we shall soon see, to the painting's negative reception in Boston. Overlaid with luminous oil glazes, the milky impasto colors are in restless motion, organically intermixing on the canvas, communicating and blending with one another in a manner opposed to the atomistic local color and firm contours of neoclassical paintings.[45] Liberated from the mere imitation of external objects, Allston's pigment is procreative, symbolic, energized by the Word. Indeed, in harmony with the theme of the still small voice and Elijah's eucharistic nourishment, Allston's milk-based medium typologically suggests St. Peter's admonition in the New Testament: "Wherefore laying aside all malice, and all guile, and hypocrisies, and envies, and all evil speakings, As newborn babes, desire the sincere milk of the word, that ye may grow thereby" (1 Peter 2:1–2). St. Peter's words of spiritual rebirth were important to those evangelical Protestants, like Allston, who believed in the necessity of a conversionary experience in order to be saved. During the nineteenth century, it surely was not uncommon to refer to the "milk of the word" or to God's Word as a spiritual food; for Jesus Christ was the Word made flesh, a reality typologically prophesied by Allston's Elijah in both its subject matter and its medium.[46]

Color was typologically and symbolically expressive because Allston defined it as light: "The only known instances of complete oneness in physical nature are the three primary colours, *Red, Blue, Yellow.* Unity (perfect) is the centre of Harmony: of which these *three components* of light, when joined may be considered the perfection in the physical world.[47] Allston thus employed a system of painting based upon the three primaries and the harmonious combination of all three into tertiary colors—olive, citrine, and russet—to suggest analogically the harmony of the universe and the existence of the Holy Trinity. Allston praised George Field's treatise on color harmony (1817), observing that the Englishman's ideas on color were close to his own.[48] According to Field, "Dull of consciousness therefore will be the mind that in contemplating a system so simple, various, and harmonious, as that of colours, should not discover therein a type of that TRIUNE ESSENCE WHO COULD NOT BUT CONSTRUCT ALL THINGS AFTER THE PATTERN OF HIS OWN PERFECTION."[49] The most ardent defender of Allston's Elijah and an opponent of Unitarian rationalism, Samuel F. B. Morse, was influenced by Field and by Allston's Trinitarian taste for harmonic Venetian color.[50] He thus told members of the New York Athenaeum in 1826, "This single fact, were there no others, of the existence of one entire perfect essence, *Light,* yet in mysterious union with *three* distinct essences, constantly separable in their nature from it into *three,* and three only, and resoluble again into perfect *oneness,* is such an example in nature of a mysterious union of *three* and *one,* as forever to forbid cavil at the Theological doctrine of the Trinity as unphilosophical and absurd."[51]

Certainly, Boston Unitarians did not feel compelled or inclined to interpret All-ston's system of color harmony in these contentious, theologically denotative terms. If anything, the musical harmony of Allston's color allowed Unitarians and other Protestants to escape the harshly discordant and divisive tones of doctrinal debate.[52] The imprecision or indefinite nature of Allston's color created a connota-tive atmosphere of spiritual meditation that refused to enforce any single meaning upon the beholder. Thus, while Allston's allegorical landscape suggests the media-tion of the Christian church with its traditional sacraments and creeds, Allston's symbolic medium addressed itself to a nondiscursive, aesthetic level of pure feel-ing.[53]

E. P. Richardson observed that Elijah's "landscape is seen as if through a veil of color. . . . The pigments are so fused in glazes that the color is dematerialized into air and light," an effect that is increased by the skimmed milk, which creates a chalky, "dry mat surface unlike that of ordinary oil paint."[54] Allston's fluid brushwork and ambient color dissolve the firm outlines or barriers between objects to create an overall pictorial harmony that relates foreground to background, sky to earth, part to part, and part to whole. The russet browns and olive greens of earth and vegeta-tion are reflected in the dark clouds above, along with passages of gray-blue and low-saturated violet or purple. As Jules Prown and others have pointed out, the blue-gray robe of the kneeling prophet visually associates him with the blue sky and the distant blue mountains, thereby suggesting the idea of heavenly transcendence.[55] Reinforcing the symbolic content of Allston's color, the milky impasto and golden yellow highlights in foreground and middle ground lead the eye in a diagonal zigzag toward the cream-yellow horizon, that margin of possibilities where the observable forms of nature meet the invisible "supernatural world of the sky."[56]

Though neoclassical critics and artists generally charged that Venetian color was merely sensual glitter, appealing only to the eye, its proponents seemed to insist that this quasi-scientific, quasi-mystical blending of colors was a kind of alchemy that signified analogically the harmony of the universe under the sovereign, procreative rule of the Logos.[57] As in the alchemical process that sought magically to transfigure base metal into gold, the painter's transfiguration of pigment into the prismatic light of the Logos depended primarily upon the moral virtue or mental powers of the practitioner himself. The successful blending of base pigments thus signified the spiritual purity of the painter who was clearly in harmony with the Word. Further-more, insofar as this chromatic harmony was interpreted as a religious communica-tion, the beholder's appreciation or taste for such tones signified that he or she, too, was a member of an elect group in tune with God's voice.

Venetian color attracted many members of the English school of painting, including Sir Joshua Reynolds and Benjamin West. West and others at one point even claimed possession of the "Venetian Secret" of color harmony.[58] Though Reynolds recog-nized that Venetian color could degenerate into mere sensuality and dazzling, deco-rative effect, he asserted in his annotations for the translation of Charles Alphonse du Fresnoy's De Arte Graphica (1783) his conviction that the ancient Greek painter Apelles employed a Titianesque glazing process: "Over his finished picture [Apelles]

spread a transparent liquid like ink, of which the effect was to give brilliancy, and at the same time to lower the too great glare of the colour."[59] As Reynolds knew from Renaissance color theory, the harmonic "true colours" of the Venetians were superior to unrefined, "raw" colors, for the glaring brightness of the latter appealed only to the vulgar, who seek, in Lodovico Dolce's words, to "gorge the eyes" and nothing more.[60]

As Allston told Henry Greenough, "The effect of glazing is to deepen the tone," to produce an infinite "variety of hues" while creating a "harmony and atmosphere" that "takes away the appearance of paint."[61] Painting with thin, oily glazes was "like painting with dark air," for in mixing the three primary colors with asphaltum and megilp, Allston created layers of diaphanous neutral tints—"Titian's dirt"—to "mitigate the fierceness" of the primary hues.[62] By decreasing their purity or distinctness, mingling or blending them, Allston made colors more sociable, genteel, and civilized. All colors existed in harmony, for the modified impasto or underpaint would continue to shine through the successive layers of glazing, and, as Allston assured Henry Greenough, "Wherever I find my picture wanting any color . . . I touch in that color" so that every area of the painting incorporates all three primary colors, whether blended in neutral tints or mingled in with sparkling touches of pure color.[63] To George Field, who admired Allston's technique, such complex color appealed to the "chaste," "cultivated or intellectual eye" that saw the color in symbolic or typological terms.[64]

Members of the Boston art audience, many of them familiar with Renaissance color theory and the Venetian glazing technique as interpreted through the English School, were certainly capable and inclined to interpret Allston's color in chaste, symbolic terms. Lawyers and clergymen interpreted Allston's harmonic technique in light of the aesthetics of oratory and rhetoric. As Allston's friend Judge Joseph Story observed, the "subtle elegance and grace of diction . . . color the thoughts with almost transparent hues."[65] Others, who admired and contributed to a growing taste for church hymns and musical concerts, compared Allston's diaphanous tones to sacred songs, ballads, or symphonies.[66] Nonetheless, *Elijah's* luminous glazes of harmonic color failed to attract a patron in Boston. As the painting was not publicly exhibited, it was not publicly reviewed, and few apparently saw the work when it was on loan to Isaac Davis in the 1820s. One who did see it at the time was the Unitarian clergyman and religious novelist William Ware, who recalled years later in his biography of Allston the distinctly mixed reaction that *Elijah* received:

> I turn . . . to another work of Mr. Allston, even though but comparatively few can ever have seen it, but which made upon my own mind, when I saw it immediately after it was completed, an impression of grandeur and beauty, never to be effaced and never recalled without new sentiments of enthusiastic admiration. I refer to his grand landscape of Elijah in the Desert. . . . It might have been more appropriately named, 'An Asian or Arabian Desert.' That is to say, it is a very unfortunate error, to give to either a picture, or a book, a name which raises false expectations. It matters not that you shall find something better than you expected; if it is not that which you expected, because it had been promised, you are at least, disappointed, and in some modes of mind, vexed. Especially in this the case when the name of a picture is a great and imposing

one . . . which greatly excites the imagination. What could be more so than this? 'Elijah in the Desert, fed by ravens' Yet extreme, and fatal to many, was the disappointment on entering the room, when, looking upon the picture, no Elijah was to be seen; at least, you had to search for him as among the subordinate objects.[67]

Claiming that Elijah was "hidden away among the grotesque roots of an enormous banyan tree," Ware concluded that "the Prophet, when found at last, was hardly worth the pains of the search" and that all those who came to view the painting with religious expectations, "who came to find . . . a most real and veritable Prophet, and who knew little and cared less, about art, all such probably, never did recover their equanimity, nor consider the loss less than total."[68] Yet Ware, who knew something about art and cared a great deal about it, did not consider Elijah a total loss, for "as soon as the intelligent visitor had recovered from this first disappointment, the objects which then immediately filled the eye, taught him that, though he had not found what he had been promised, a Prophet, he had found more than a Prophet,—a landscape, which, in its sublimity, excited the imagination as powerfully as any gigantic form of the Elijah could have done, even though Michael Angelo had drawn it."[69]

Nevertheless, a question or doubt remains implicit in Ware's provocative criticism of the Elijah. Could the imagination be excited in the same manner by a sublime, panoramic landscape as by the representation of a Michelangelesque prophet? As much as Ware professes to admire "the sublime masses of the distant mountains, and the indeterminate, misty outline of the horizon, where heaven and earth become one," he found his vision of the horizon blocked or inhibited by the grotesque forms of the so-called banyan tree:

> In this instance, which is rare, Mr. Allston neglected the general truth of nature, to single out and depict a subordinate particular, and that particular having no beauty or charm of its own—though certainly possessing a sort of savage grandeur—simply a piece of natural history and nothing more, which, however excellent in itself, is not the end or aim of this art. . . . There may be such a tree as this of Mr. Allston, with just such roots; but, if there is, none but the natives of the country know the fact, or naturalists, whose business it is to be acquainted with it through their science. And, to make it a principal object in a great work of art, is to degrade the art to the rank of a print in Goldsmith's Animated Nature. It was painting a mere whim; the whole tree, roots, branches and all, a mere whim, a *capriccio*.[70]

This tree, then, was both scientific, a piece of natural history, and at the same time a savage, fantastic caprice which assumed demonic proportions in Ware's febrile imagination: "The roots of this huge tree of the desert, in all directions from the main trunk, rise upwards, descend and root themselves again in the earth, then again rise, again descend into the ground and root themselves, and so on, growing smaller and smaller as the process is repeated, till they disappear in the general level of the plain, or lose themselves among the rocks, like the knots and convolutions of a whole family of huge boa constrictors."[71] Ware's experience of the painting and his account of that experience suggest an almost Sartrean existential nausea over the cancerous, anarchic growth of this all-too-mortal, all-too-physical tree. Try as he

might to say something positive about the painting, his visceral response is distinctly negative. Everything about the desolate, "illimitable," and "boundless" landscape suggests the "seeds of death," from the "tortuous and leafless branches" of the tree to the "range of dark mountains on the right" and the "heavy lowering clouds, which overspread and overshadow the whole scene" as if they constituted a funereal shroud.[72] Ware was so disturbed by what he saw that he almost refused to characterize the work as a biblical painting, insisting that the landscape was so overwhelming, "it would have been a great gain to the work if the Scripture passage could have been painted out, and the Desert only left."[73] Ware finally judges that Elijah is not one of Allston's best works because it is "a mere outward scene," an example of the natural sublime and, therefore, distinctly inferior to the artist's figure paintings, in which he "sought the sources of the sublime . . . in states of the human mind, rather than in any outward aspects of nature."[74]

Yet, for Ware, even Elijah's natural, Burkean sublimity is suspect, bordering upon the perverse. Allston's expression of nature is not the empirical product of the eye or of visual sensation. It is not a landscape of external nature. Despite his references to natural history, Ware seems to suggest that the bizarre, exotic landscape records the temporarily diseased or unrestrained conjurings of the artist's individual imagination. Without providing a clearly defined subject, Allston left the spectator with little or no direction and confronted him, instead, with a writhing morass of impasto pigment that failed to transfigure itself symbolically in the spectator's mind, except to suggest a twisted labyrinth of snakes.

Ware's references to banyan trees, boa constrictors, and junglelike specimens of nature's cancerous forms evoke the politicized rhetoric of scientific debate in Federalist Boston. As Linda Kerber has demonstrated, Anglophile Federalists long regarded natural history as the questionable outgrowth of the diseased French imagination that had infected Jeffersonian democrats.[75] Contrary to the neoclassical, providential order in the universe envisioned by Boston Federalists, French scientists such as Baron Cuvier postulated a capricious nature in which "immense collections of shells lie buried far from any sea, and at heights inaccessible to its waves: fishes are found in veins of slate, and vegetable impressions at heights and depths equally astonishing. . . . [Nature] seems pleased with exhibiting the monuments of her power in this disorder and apparent confusion."[76] Ware implicitly or unconsciously associated the apparent confusion of Allston's Coleridgean imagination with the confused nature espoused by French science and by political radicals suspected of atheism. To Ware and other Unitarians who continued until the time of Darwin to rely upon empirical evidence for proving God's existence, these anarchic visions could only fuel disordered thinking and morally rudderless behavior.[77]

In a manner related to Ware, though not referring specifically to the Elijah, the southern author William Gilmore Simms criticized Allston for advocating the subordination of recognizable subject matter to color or to the painting medium:

> Such a practice surrenders entirely every advantage that might be derived from the action of the subject, and must depend for its success with the spectator, upon some such influence, as that blaze of innumerable lights, suddenly cast upon the eye, emerging from a dark and prolonged passage . . . an effect which stuns and blinds, rather

than informs and enlightens, and which must, to our thinking, when the first impression is at an end, leave the spectator in a painful degree of uncertainty as to the character of that influence which has been at work upon him.[78]

Simms is here thinking of John Martin's fiery, apocalyptic version of *Belshazzar's Feast*, which so differed from Allston's more readable, neoclassical and didactic version of the subject.[79] But when joined with Ware's criticism of *Elijah*, Simms's criticism of Allston's radical art theory suggests that the artist's audience saw a political analogy between the anarchic freedom of the romantic imagination and the threat from below of popular disorder and vulgar taste. John Martin's violently sublime paintings of Burkean terror were anathema to members of Boston's elite. Despite Allston's admiration and defense of Martin's work, Oliver Wendell Holmes and others denounced Martin for pandering to the mob with a flashy, superficial technique that obscured or obliterated the potentially edifying biblical subject matter.[80]

Of course, the harmonious atmospheric colors that simulate the still small voice in Allston's *Elijah* bear little resemblance to the strong, abrupt contrasts of color and light in Martin's paintings. Rather than expressing the terror or fear of an external phenomenon, Allston's internally generated romantic sublime leads the eye toward the horizon and beyond. Yet the radically unfinished and calligraphic nature of Allston's impasto brushwork apparently prevented a clear view of the horizon. For members of the Boston audience, the artist's impulsive strokes seemed to describe nothing more than a terrifying, Burkean wilderness akin to a John Martin painting. As Edward J. Nygren has shown, while wilderness scenes or paintings inspired by the Burkean sublime were popular in England, they were certainly not so in America prior to 1830.[81] American art patrons favored picturesque paintings of cultivation in which nature is represented as being under the control of man, socialized by agriculture and the progress of civilization.

The merchant-industrialists and financiers who constituted the Boston elite prided themselves in being "cultivating gentlemen."[82] While accumulating wealth through entrepreneurial ventures such as textile manufacturing, they simultaneously purchased country or suburban estates outside Boston and played the role of the aristocratic gentleman farmer who sought to improve New England agriculture and the productivity of yeoman farmers. Boston capitalists thus held on firmly to the pastoral ideal of the independent yeoman farmer, even as the daughters of these farmers left the land to work in the textile factories of mill towns like Lowell and Waltham.[83] In fact, by scientifically developing more efficient methods of agricultural production and by offering economic opportunities in their textile factories, Boston industrialists sought to stem the demographic tide of westward migration beyond New England. The depopulation of Massachusetts was resulting in a loss of political and economic power relative to the rest of the nation. During the 1820s, while Allston's *Elijah in the Desert* remained unsold, members of the Boston elite attempted to persuade yeomen farmers of the benefits to be gained by remaining at home in New England rather than departing for the barbarous West. John Lowell, an Allston patron, thus urged New England citizens to consider that "by remaining at home much more and greater personal comfort will be secured to the

individual—much greater opportunities afforded for literary, moral and religious instruction."[84] While Allston's Elijah humbly blinded himself the better to turn inward toward the sacred space of the soul, the artist's wilderness landscape generated profane voices or noises in the minds of Boston patrons. It conveyed messages that subliminally contradicted or drowned out the harmonic tones of the "still small voice."[85]

The wilderness, in fact, signified a host of negative meanings for Boston patricians, who feared a mass population that eluded the control of established social and cultural institutions. They associated the wilderness with libertinism, banditry, and the democratic rejection of mediating authorities. Solitary meditation in desert landscapes surely evoked associations with revivalism and enthusiastic born-again experiences to Unitarian clergymen, who were attempting to stem the growth of popular denominations like the Methodists and Baptists and to cool the evangelical fervor of Calvinists like Lyman Beecher.[86] Jonathan Edwards, the leader of the Great Awakening in the eighteenth century, frequently had spoken in his "Personal Narrative" of retiring "into a solitary place . . . at some distance from the city, for contemplation on divine things and secret converse with God."[87] Edwards's Calvinism, his insistence upon the necessity of God's grace for a conversionary change of heart, had long been anathema to the enlightened Boston clergy.[88] Even when revivalists in the nineteenth century dropped the Edwardsean belief in the supernatural bestowal of grace, Boston liberals continued to insist upon a gradual, progressive change of heart in which individuals rationally chose to live according to the teachings and example of Jesus Christ. William Ellery Channing compared revivals to natural catastrophes like hurricanes, which overwhelmed audiences, depriving individuals of their free will, turning them into "machines" whose souls were inundated by a flood of emotion.[89]

Rather than a sudden, unpredictable change of heart, which seemed to occur outside of time and space in a kind of mystical, visionary realm, Unitarians like Channing and William Ware favored a deliberate process of moral improvement within the normal course of everyday life.[90] In their liberal, Arminian view, religion was not a separate sphere of experience outside of family, work, and leisure time but influenced or colored all aspects of human activity. Proper religious or moral behavior was, therefore, incompatible with solitary meditation. Such isolation could only lead to melancholy, brooding, and uncontrollable changes in mood. How was one to know that the voice one heard in lonely contemplation was really the still small voice of God? Had not Charles Brockden Brown, in his Gothic novel *Wieland*, posed the distinct possibility or probability that such voices were illusory, the deceptions of an artful ventriloquist?[91] Perhaps the seemingly arbitrary meanderings of Allston's loaded brush in *Elijah* too were the product of a kind of hallucinatory, satanic force? How many others besides Ware saw boa constrictors in Allston's pulsating labyrinth of paint?

Not everyone, of course. Samuel Lorenzo Knapp, like Ware a writer of religious fiction, defended Allston's *Elijah* against those who apparently preferred cheerful, pastoral landscapes: "The Judean mountains seemed fitted for the abode of prophecy. It is more natural and sublime to place the voice of inspiration among the deep

caverns and strong shades of the mountains, than by fountains or caves in the sunny fields of cultivation. Allston has caught the true philosophy to nurse his genius by the perpetual contemplation of these scenes and events, in the revelations of God to man, in which the power of God-head, transcending his natural laws, is visible and unquestionable."[92]

Knapp, who seems to have heard the still small voice of Elijah's epiphany as he gazed upon Allston's sublime landscape, implicitly associated the artist with the Old Testament prophet: "The fashionable world has no charm for him, and he is never found in its circles. . . . He flatters no one, abuses no one, nor is found in the train of anyone. He has truly an independent mind, without one particle of the moroseness which often accompanies that *godlike virtue*.[93] Allston's universally recognized high moral character may have guaranteed for Knapp and others the pure spiritual truth of the prophetic voice that emanated from *Elijah*. The artist's taste for meditation had not led to self-absorbed melancholy. Indeed, Knapp observed that "a little coterie of dear friends is his passion," and though "he seeks no idol of the day for patronage and praise," Allston does not lack for patrons.[94]

However, by the time that Knapp had published his favorable impression of *Elijah* in 1830, the painting had long since been exiled to England, for lack of a Boston patron. If *Elijah* is unique in Allston's oeuvre, as William Ware suggested, it is because the artist's Boston patrons could not reconcile the painting's harmonic color or voice with the all-too-material languages of the natural or Burkean sublime and the rapid gestural brushwork demanded by the quick-drying skim-milk medium. As Allston told Henry Greenough regarding the experimental technique that induced him to paint *Elijah* with such an inspired brush, "I have never felt at liberty to try it again, since my return to America. I am confident, however, that great results might be brought about by it."[95]

Boston patrons and critics preferred to see the artist's mind, not his hand, recorded upon the canvas. As Terry Eagleton argues, the bourgeois ideology or aesthetic of freedom was a two-edged sword. It affirmed "an idealized refuge" that soothingly masked society's "actual values of competitiveness, exploitation and material possessiveness," and yet aesthetic freedom from material conditions could also become a dangerous vision of "human energies as radical ends in themselves," signifying "a creative turn to the sensuous body" or a particularist resistance to universalizing, "instrumentalist thought."[96] Essentially sharing the ideological hopes and fears of his patrons, Allston increasingly effaced the sensuous, autographic traces of his hand, employing the glazing technique to dematerialize paint into the light of the Logos.[97] Populated by an ever-growing number of women, Allston's audience also wanted him to paint scenes that were not so much sublime as sublimely or divinely beautiful. Thanks in part to the influence of religious novelists like William Ware and Samuel Knapp, the heavenly "afterlife" seemed to collapse into the earthly present of bourgeois domestic gentility.[98] As members of the Boston elite increasingly retreated into rural retirement on their country and suburban estates during the 1830s, they created pastoral oases, their own Waldens, apart from "the mass of men" who "lead lives of quiet desperation."[99] Yet, unlike Elijah and other hermit-prophets and saints, they surrounded themselves with horticultural

gardens and placed themselves under the tender care of loving wives and daughters and occasionally dined or visited with other members of the affluent few. Furthermore, they purchased such paintings by Allston as *The Evening Hymn*, which suggested that angels had descended from heaven to guide them gently to their restful sleep in the invitingly rural, pastoral graves of Mount Auburn Cemetery, a mount in Cambridge that bore no resemblance to Elijah's Mount Horeb.

3

KENNETH JOHN MYERS

• • •

On the Cultural Construction
of Landscape Experience:
Contact to 1830

In James Fenimore Cooper's widely discussed novel *The Pioneers* (1823), the two char- acters who most value land- scape are the beautiful Eliz- abeth Templeton and the penniless frontiersman Nat- ty Bumppo. Miss Temple- ton is the only child of the wealthiest man in the town of Templeton and the most economically privi- leged character in the novel. When we first meet her, she is returning from boarding school, and her interest in landscape is presented as a function of both her education and her social standing. She has learned to appreciate natural environments as landscapes, she has the leisure to pursue this interest, and her continuing pursuit of it shows off her father's wealth and helps to legitimate it. At the opposite economic extreme, Natty is illiter- ate and uneducated, and his ability to appreciate the beauties of nature is presented as a function of his uncorrupted naturalness. Indeed, it is because Natty's ability to appreciate the local scenery is presented as an intuitive or natural response to the inherent beauties of the place that Cooper is able to privilege the ideological con- tents of those insights as expressions of objective truth. Because his insights are supposed to be unlearned and therefore unaffected by class or other interests, it is not Elizabeth but Natty who most directly and forcefully testifies to Cooper's belief that the "ordering of God's providence" is expressed by the material fecundity of the national landscape.[1]

Cooper's portrait of the learned Elizabeth is true to the actual history of land- scape appreciation in the United States, but his portrait of the uneducated Natty

obscures that history by promoting the culturally powerful fiction that landscape appreciation is a natural ability available to all uncorrupted men and women. This fiction is powerful because once individuals learn to forget the role of the self in the production of environmental meaning they experience those meanings as impersonal or disinterested truths. By midcentury, so many Americans had learned to (mis)take their interpretations of the environment for original revelations of impersonal meaning that landscape appreciation had emerged as a culturally central mechanism for confirming and—less often—challenging received cosmological, moral, and social truths. The national landscape became an ideological battleground as all manner of Americans used it to justify their most heartfelt beliefs.

Individuals can forget what the early nineteenth-century British traveler Basil Hall called the "labour of admiring" only after this labor has become so habitual among a given social group as to seem instinctual.[2] In this chapter I explore the historical process by which economically privileged Americans first learned to objectify natural environments as landscapes and then learned to forget the mental labor involved in this objectification. The first and longer part of the chapter is concerned with the invention of the picturesque, which I define as a self-consciously disinterested mode of pictorial objectification.[3] More specifically, I adopt the distinction among emergent, dominant, and residual cultural practices introduced by Raymond Williams and show how the mental techniques necessary to the apprehension of natural environments as picturesque landscapes were created out of earlier environmental experiences founded on the recognition of likeness.[4] In the final part of the chapter I turn my attention to the naturalization of the picturesque and show that it was only in the second quarter of the nineteenth century that the mental practices necessary to the objectification of particular environments as picturesque landscapes became so commonplace among leading elements of the northeastern elites that they were reconceptualized as natural rather than learned abilities. Throughout, I suggest that the establishment and expansion of the market economy encouraged individuals to develop a new interest in the uniqueness of things and that the invention of new styles of environmental experience was a consequence of this fundamental epistemological transformation.

On the Historiography of Landscape

Historians of landscape appreciation in British North America and the United States have usually been most concerned with nineteenth and, less often, the very late eighteenth centuries. When they discuss earlier environmental descriptions, they almost always interpret them as representing a status quo ante and use them to define a stable point of origin against which to plot subsequent developments. Almost all historians who have considered early descriptions have emphasized their dependence on classical, neoclassical, and biblical conventions for the description of the Golden Age, Elysium, Arcady, Eden, and Paradise. With few exceptions, they have based their analyses on examples drawn from a select group of texts including Columbus's announcement in 1498 that he had discovered the "earthly paradise," Michael Drayton's claim that in Virginia "the golden age still natures lawes doth give"

(c. 1605), John Smith's description of Massachusetts as "the paradice" of New England (1624), Thomas Morton's description of Massachusetts as "Natures Masterpeece" (1637), and George Alsop's evocation of the "Adamitical or Primitive . . . Innocency" of Maryland (1666).[5] Howard Mumford Jones expressed the dissatisfaction informing most of these studies when he complained that while the Renaissance "imagination sought for something fresh and fair [in the New World], some gleam of hope for humanity, some proof of Utopia or the Earthly Paradise or the Golden Age, the artistic idiom, whether words, pencil, or paint, became so worn, so conventional, that exact rendering of landscape was virtually unknown."[6] Like Jones, most of these historians have tacitly assumed that the early explorers apprehended the beauties of their world in much the same way we apprehend the beauties of ours and have tended to explain the absence of fully developed landscapes as evidence of expressive incompetence.

More recently, a new generation of historians including Wayne Franklin, Edward Nygren, and Robert Lawson-Peebles have emphasized the social determinants of individual perception and suggested that we shift our focus to the historical process by which culturally produced assumptions and expectations determine individual environmental experiences.[7] Such a shift is both welcome and long overdue. Although the revisionists have succeeded in fixing our attention on the social determinants of individual experience, however, they have continued to assume both the possibility of unmediated knowledge and the existence of a prelinguistic or precultural Self capable of attaining such knowledge. Because of these assumptions, they have tended to describe early authors as victims of history, passive subjects living in a "hallucinated" "dream-world," encumbered with "biased" "charts of expectation," unable to express their "actual experience" of the "simple reality" of North America.[8] In the pages that follow, my goal is to outline a history of environmental experience which avoids lingering notions of the autonomy of individual consciousness while still acknowledging the work of human freedom. I hope to do this by balancing the revisionary emphasis on the power of inherited structures of environmental meaning with a complementary emphasis on the power of individuals to refashion and redeploy those structures. By focusing on the dynamics of both cultural determination and individual autonomy, I hope to uncover the inextricably doubled process by which historically constructed conventions determine individual experiences even as historically determined individuals refashion conventions so as to create new experiences and meanings.

The Sovereignty of the Like

In the first part of *The Order of Things*, Michel Foucault defined the epistemological field, or *épistémê*, within which knowledge was constituted prior to the seventeenth-century.[9] Less concerned with the history of ideas than with the history of the epistemological assumptions which underlie and structure particular apprehensions and representations, Foucault assumed the arguments of Lovejoy and others for the cultural centrality of concepts such as the great chain of Being but argued that such ideas were "a mere surface effect" of a way of being in the world founded on

the recognition of "resemblance" (31). Within this epistemological field, "it was resemblance that largely guided exegesis and the interpretation of texts; it was resemblance that organized the play of symbols, made possible knowledge of things visible and invisible, and controlled the art of representing them" (17). For persons constituted under what Foucault called the "sovereignty of the Like" (43), consciousness was the consciousness of resemblance, and growth in knowledge was experienced as the recognition of hitherto unrecognized resemblances: "To search for a meaning is to bring to light a resemblance. To search for the law governing signs is to discover that things are alike."[10]

The European discovery of what was quickly conceptualized as the New World occurred at a time when the sovereignty of the Like was beginning to be challenged by the emergence of an analytical and referential discourse within which the perceiving subject was reconstituted as a self-governing center of knowing, things in the world were reconstituted as objective matter of fact, and language was reconstituted as a putatively transparent means of representation. Within this new epistemological field, the perceiving subject could still experience and represent relations between things in terms of resemblance, but resemblance was subordinated to and defined in terms of intrinsic identity and difference. Whereas persons constituted under the sovereignty of the Like had assumed that all things were fundamentally similar and had apprehended and represented them extrinsically in terms of their resemblance to other things, persons constituted within the later epistemological field assumed that all things were essentially unique, apprehended and represented them primarily in terms of their intrinsic characteristics, and defined those characteristics in terms of their likeness and unlikeness to the intrinsic characteristics of other things. Whereas differences between objects had once been apprehended as merely local variations from what was assumed to be the essential likeness of all things, resemblances between objects were now apprehended as surface phenomena veiling fundamental differences which could and should be analyzed and measured. Putatively independent both of the material things which were the objects of its apprehension and of the language with which it apprehended and represented those objects, the reconstituted I empowered itself by mentally withdrawing from the world so as to survey and master its divisions and differences.

The emergence of the new epistemological field depended on the development of new referential and analytical practices for the objectification of natural things as commercial goods and encouraged the development of new practices for the objectification of natural things as scientific facts and aestheticized landscapes. Although geography, geology, botany, landscape, and other historically innovative modes of environmental experience and representation did not become clearly defined practices until the seventeenth and eighteenth centuries, the emergence of new referential and analytical techniques began much earlier and was encouraged by and also encouraged the European exploration and colonization of Asia, Africa, and the Americas. Environmental descriptions in discovery, exploration, and settlement narratives evidence the conflict between the older epistemological field founded on likeness and emergent referential and analytical practices. By attending

to changes in the structure and content of these environmental representations, one can reveal something of the historical process by which Europeans gained increased power over the world by reworking older modes of knowing and expressing so as to create and express a new awareness of and interest in the integrity and uniqueness of things.

Columbus's Letter of 1493

One of the ironies in the history of European exploration and expansion is that although Columbus's first voyage is one of the events we use to date the beginning of the "modern" world, Columbus himself was one of the least modern of the explorers. Unlike later landscapists who mentally remove themselves from the objects of their interest in order to describe the differences which make them unique, Columbus is primarily concerned with the recognition of the essential, and all his descriptions therefore have the anti-Brechtian effect of making the foreign familiar. His long account of Hispaniola in his letter of 1493 announcing his discovery of the long-desired western route to the "Indies" is representative:

> In it there are many harbours on the coast of the sea, beyond comparison with others that I know in Christendom, and many rivers, good and large, which is marvellous. Its lands are high; there are in it many sierras and very lofty mountains, beyond comparison with that of Tenerife. All are most beautiful, of a thousand shapes; all are accessible and are filled with trees of a thousand kinds and tall, so that they seem to touch the sky. I am told that they never lose their foliage, and this I can believe, for I saw them as green and lovely as they are in Spain in May, and some of them were flowering, some bearing fruit, and some at another stage, according to their nature. The nightingale was singing and other birds of a thousand kinds, in the month of November, there where I went. There are six or eight kinds of palm, which are a wonder to behold on account of their beautiful variety, but so are the other trees and fruits and plants. In it are marvellous pine groves; there are very wide and fertile plains, and there is honey; and there are birds of many kinds and fruits in great diversity. In the interior, there are mines of metals, and the population is without number.[11]

Because of the vividness of Columbus's writing and, perhaps more important, because we live in a culture in which the ability to objectify natural environments as landscapes is commonplace, we tend to read descriptions like this as landscapes. But neither here nor anywhere else in his writings does Columbus represent a particular environment as a pictorial scene. Indeed, although this is the most fully developed environmental description in the letter and one of the most fully developed in all of Columbus's writings, it is a description not of a distinct valley or view but of what the island as a whole is essentially like.

The organization of Columbus's description is not psychological, logical, or pictorial. Although Columbus writes in the first person, he does not describe his changing response to or understanding of the place. And he does not arrange the things he describes by kind, size, or economic importance. Neither does he arrange them into a pictorial scene with a unified perspective and defined fore-, middle-, and backgrounds. Each of these kinds of description privileges difference, but Col-

umbus apprehended Hispaniola as a clear expression of the divinely ordered diversity of the world, and he therefore organized his account so as to emphasize this essential characteristic. The organization of Columbus's description is thus like that of contemporary cosmographies and of the multiperspectival style of landscape painting developed by the Flemish painter Joachim Patinir in the first two decades of the sixteenth century. As in a cosmography or one of Patinir's "world landscapes," the organization of Columbus's description is iconographic or conceptual in that it is designed to remind the reader of the ordered diversity which Columbus saw and which both Columbus and his original readers took to be an essential characteristic of the order of things.[12]

As Samuel Eliot Morison, Howard Mumford Jones, Charles L. Sanford, Robert Lawson-Peebles, and a host of other writers have pointed out, Columbus's emphasis on the fertile diversity of his discoveries evoked conventional descriptions of a wide range of other times and places, including the Golden Age, Elysium, Arcadia, and the terrestrial paradise. Depending on their own epistemological assumptions, these authors have interpreted these evocations as evidence of either expressive incompetence or misprision.[13] More recently, however, Mary B. Campbell has urged us to interpret these evocations as evidence of a fundamentally different way of being in the world: "There is a world of difference between the conceit of Donne's apostrophe to his mistress, 'Oh my America, my new found land,' and Columbus's identification of Haiti in his letter to the pope of 1502: 'This island is Tarsis, is Cythia, is Ophir and Ophaz and Cipango, and we have named it Española.' For Columbus both terms of the metaphor belong to the same species of reality." In this last sentence, as in her argument as a whole, Campbell somewhat confusingly conflates apprehension ("reality") and representation ("metaphor"), but the thrust of her analysis is clear and convincing. Within an epistemological field founded on the recognition of likeness, to know a thing is to know what it is like, and the most efficient way to describe a thing is to use a proper name. Unlike Donne, whose apostrophe creates a metaphoric relation between two things which he apprehends as being essentially different, Columbus announces the identity of six places which he apprehends as being essentially alike. His identifications do not deny the existence of differences; they suggest that differences are unimportant.[14]

In her discussion of Columbus's description of Hispaniola, Campbell identifies it as a representation of a *locus amoenus*, or pleasant place. The topos of the locus amoenus was first recognized by Ernst Curtius, who defined it as a description of "a beautiful, shaded natural site" consisting of "a tree (or several trees), a meadow, and a spring or brook" and often including singing birds and blooming flowers. Noting that many of these motifs could be traced back to the Arcadian pastorals of Theocritus and descriptions of gardens, grottoes, and Elysium in still earlier Greek poems, Curtius showed that it was Virgil's representations of pleasant places in the *Georgics* and the *Aeneid* which combined all these motifs to create a "clearly defined topos of landscape description." According to Curtius, *amoenus*

is Virgil's constant epithet for "beautiful" nature (e.g., *Aeneid*, V, 734 and VII, 30). The commentator Servius connected the word with "amor" (the same relationship, that is,

as between "love" and "lovely"). "Lovely places" are such as only give pleasure, that is, are not cultivated for useful purposes. . . . As a *terminus technicus* the *locus amoenus* appears in Book XIV of Isidore's encyclopedia. This book treats of geography in accordance with the schema: earth, orb, Asia, Europe, Libya (the only part of Africa then known . . .). Then follow islands, promontories, mountains, and other "names for places" ("locorum vocabula"), such as gorges, groves, deserts. Next in the list come "loca amoena," interpreted as Servius interprets the term. For Isidore, then, the *locus amoenus* is a geomorphological concept.

From the sixth century to the sixteenth, the locus amoenus was both a rhetorical and a geomorphological category. It was both "the principal motif of all nature description" and a technical term used to define the essential characteristic of a specific kind of physical environment.[15]

Columbus's way of being in the world was founded on the apprehension of likeness. Because he recognized Hispaniola as a locus amoenus, he described it as one. Although his descriptions have struck modern readers as being overgeneralized, disorganized, and hackneyed, Columbus's contemporaries would have read them as a kind of label naming the uncultivated pleasantness of the described place. Although we want to know what makes a place unique, they wanted to know what it was essentially like. What kind of place is Hispaniola? It is a locus amoenus. For most of his original readers, that is probably all they needed or wanted to know.

Interests and Disinterestedness

The invention and dissemination of the analytical and referential vocabularies and mental skills necessary to the objectification of natural goods as commodities was the most important precondition for the subsequent development of the more specialized vocabularies and mental skills with which people learned to apprehend natural goods as scientific and aesthetic objects. When individuals objectify things in their world, they imaginatively remove themselves from an immediate participation in that world. The resituation of the individual vis-à-vis his or her world is a single mental act, but it creates a new relation between the individual and the world and therefore needs to be defined in terms both of the apprehending subject and of the object of apprehension.

Economic objectification reconstitutes things in the world as commodities possessing value. At the same time, it reconstitutes the subject as an owner, consumer, or seller of commodities. In early modern Europe and Britain, natural philosophers such as Thomas Hobbes, La Rochefoucauld, and Adam Smith developed the concept of *interest* in order to describe the relation between this reconstituted subject and objects of apprehension. In the words of the mid-eighteenth-century French philosopher Claude-Adrien Helvétius, "as the physical world is ruled by the laws of movement so is the moral universe ruled by laws of interest." The philosophical development of the idea of interest reflected the social reality that as individuals learned to objectify natural things as commodities possessed of value, they discovered that they had an interest in the ownership, purchase, and sale of those values.[16]

The expansion of the market economy entailed the commodification not only

of things, but of knowledge as well. As the market became increasingly complex, competitive, and impersonal, individuals discovered an increasingly importunate need for reliable information concerning the material and social organization of their world. Because economic expansion encouraged increasing numbers of individuals to become increasingly aware of themselves as interested centers of consciousness whose understanding of the world was in part determined by their place in it, the increasing economic value of information quickly led to the development both of a desire for and the concept of an a-perspectival knowledge. The increasing economic necessity and desirability of possessing reliable knowledge concerning the actual organization of the material and social world led to the invention of the idea of *disinterested knowledge*.[17]

The concept of disinterestedness was developed over the course of the seventeenth and eighteenth centuries. In Britain as in Europe as a whole, the invention of modern scientific practice and of landscape were two of the most important manifestations of this development. The origins of both modern science and landscape date from the seventeenth century, and the invention of each was fueled by the new desire for an impersonal apprehension of things in the world. Just as the object of the New Science was a disinterested knowledge of material things, the object of landscape was a disinterested appreciation of natural beauty. In both cases, the disinterestedness of the experience was defined in terms of both the subject and the object of apprehension.

The Supersession of the Pleasant

The earliest books on the New World published in English date from the 1550s.[18] Until the publication of the first edition of Richard Hakluyt's *Principall Navigations, Voiages and Discoveries of the English Nation* in 1589, most of these were translations from continental publications. From these beginnings until the early decades of the seventeenth century, *pleasant* and related words such as *fruitful* and *commodious* were used geomorphologically to identify places as *loca amoena*. A few examples will suggest the prevalence of this usage. Jean Ribaut began his *Whole and true Discouerye of Terra Florida (englished the Flourishing lande)* (1563) by defining Florida as a "pleasant and fruitefull" country "lacking nothing at all that may seeme necessarie for mans food." He then offered a long description of its natural fecundity to prove his central claim that it was "the fairest, fruitfullest, & pleasantest [country] of al the world" and concluded by reiterating his belief that it was "the pleasantest & most commodious dwelling of al the world."[19] John Brereton used the adjective as a geomorphological concept in the title of his *Briefe and true Relation of the Discouerie of the North part of Virginia; being a most pleasant, fruitfull and commodious soile* (1602).[20] And in his *Map of Virginia* (1612), Captain John Smith suggested that Cape Charles "may have the prerogative over the most pleasant places of Europe, Asia, Africa, or America, for large and pleasant navigable rivers, heaven and earth never agreed better to frame a place for mans habitation being of our constitutions, were it fully manured and inhabited by industrious people. here are mountaines, hils, plaines, valleyes, rivers and brookes, all running most pleasantly into a faire Bay compassed but for the mouth with fruitfull

and delightsome land."[21] In these sixteenth- and early seventeenth-century narratives, words related to the concept of the pleasant are much more common than words related to any other descriptive concept, including that of beauty, and are used geomorphologically to name the essential characteristic of the environments being described.

The new concern for an impersonal knowledge of the unique characteristics of things is evidenced both by the supersession of the pleasant and by the invention of increasingly complex pictorial styles of environmental representation. In the literature of British North America, the supersession of the pleasant took place in two stages. The first was the abandonment of the locus amoenus as a style of environmental apprehension and representation. Although seventeenth-century narratives in English contain extended descriptions of natural environments as pleasant places, most of them appear in midcentury translations of earlier continental narratives. Like Columbus, the authors of these descriptions subordinate differences by presenting them as accidental variations masking the essential likeness of all naturally fertile places.[22] The handful of original examples I have found includes several descriptions in Ribaut's *Account of Florida* and the description of "this part of" St. George's River (Maine), in James Rosier's *True Relation of the most prosperous voyage* (1605).[23] Unlike Columbus, these authors attempt to use the conventions of the locus amoenus to represent the unique characteristics of specific places. Their descriptions thus evidence the emergence of a new interest in difference. But precisely because they rely on the conventions of the locus amoenus, these descriptions make environments which the authors want to represent as unique and different seem generic. What did Rosier see on the St. George? He saw another locus amoenus.

Until the second or third decade of the seventeenth century, English authors who used the locus amoenus did so out of necessity. It was the most fully articulated system for the representation of natural environments available. But the rarity of these descriptions suggests that most authors abandoned the conventions of the locus amoenus because they could not adapt them to the representation of difference. Later authors who did use them seem to have been aware of the fact that they were using a distinct, classical style of environmental representation. In the literature of British North America, the best-known instance of this is Thomas Morton's description of New England as "Nature's Masterpeece" in *New English Canaan* (1637). Unlike Columbus, who represented Hispaniola as a pleasant place because he experienced it as one, Morton adopted the conventions of the locus amoenus as a way of evidencing his sophistication. Like his earlier decision to vex the Plymouth and Massachusetts Bay colonists by constructing New England's first Maypole, Morton's ornately rhetorical description of the local environment simultaneously identified him as a learned man familiar with the culture of the Stuart elites and distinguished his point of view and values from those of his pious neighbors.[24]

The geomorphological use of the word *pleasant* survived longer, but as writers and readers became more concerned with the apprehension and representation of difference they gradually emptied the concept of its original meaning and began to

use *pleasant* as an adjective with which to characterize the distinctive qualities of particular environments. For example, in his promotional tract *New England's Prospect* (1634), William Wood introduced his discussion of New England animals by noting that "having related unto you the pleasant situation of the country, the healthfulness of the climate, the nature of the soil, with his vegetatives and other commodities, it will not be amiss to inform you of such irrational creatures as are daily bred and continually nourished in this country."[25] Although *pleasant* was occasionally used as a geomorphological term until after the turn of the eighteenth century, by the middle of the seventeenth century this usage was becoming archaic.[26] The supersession of the older usage is evident in the title of Edward Bland's *Discovery of New Brittaine . . . From Fort Henry, at the head of Appamattuck River in Virginia, to the Fals of Blandina, . . . (a pleasant Country,) of temperate Ayre, and fertile Soyle* (1651; fig. 3.1). In Bland's title, the parentheses simultaneously draw attention to the fact that "a pleasant Country" is being used as a technical geomorphological term and suggest that this usage had become unusual enough that readers needed to be reminded of it.[27]

3.1. Title page from Edward Bland, *The Discovery of New Brittaine* (London, 1651). The Beinecke Rare Book and Manuscript Library, Yale University.

Although the conventions of the locus amoenus had adequately met the needs of writers and readers primarily interested in the recognition of likeness, they could not satisfy the needs of later individuals who had developed a heightened awareness of themselves as centers of apprehension and whose way of being in the world was founded on the discovery of the differences which make things unique. The unsuccessful efforts by Ribaut and Rosier to use the conventions of the locus amoenus to describe the distinctive appearance of places are best understood as local effects of an epistemic crisis of representation which precipitated the development of a wide range of new analytical and referential discourses concerned with the uniqueness of things and places. The development of innovative strategies for the pictorial objectification of natural environments as views or scenes was a secondary effect of a systemic epistemological transformation.

The emergence of new pictorial techniques for the analysis and representation of natural environments is evidenced by changes in the kinds of titles given to English travel narratives dealing with North America. According to Edward Cox's standard bibliographical listing of these narratives, of the thirty-four titles published in the fifty years from 1563 to 1612 only John Smith's *Map of Virginia* (1612) presented itself as a verbal equivalent of a visual representation.[28] Of the seventy-two titles published between 1613 and 1662, five did so. They are William Alexander's *Mapp and Description of New-England* (1630), William Wood's *New England's Prospect* (1634), Robert Baylie's *Dissuasive From the Errours Of the Time: Wherein the Tenets of the principall Sects . . . are drawn together in one map* (1646), Ferdinando Gorges's *America Painted to the Life* (1658–59), and William Berkley's *Discourse and View of Virginia* (1661). This flurry of titles suggests that by the middle of the century a large percentage of the reading public had learned to objectify natural environments as pictures. But these titles and the contents of the narratives themselves make clear that in these texts the idea of a verbal picture did not connote a disinterested appreciation of the merely formal properties of the described object. Rather, the words *prospect, map, painting,* and *view* are treated as equivalent terms and used interchangeably to suggest verisimilitude. Although pictorial discourse was subsequently aestheticized, in these titles and narratives it is used to assert the accuracy of the author's information.[29]

Innovation and Incorporation

New discourses are created by individuals working within and frustrated by the limitations of existing structures of knowledge. Because they are necessarily constructed out of the cultural resources available, new discourses always incorporate elements of contemporary or older conceptual formations. For example, although William Wood almost certainly did not realize the historical implications of what he was doing, by helping to drain the pleasant of its historical connotations he was simultaneously assisting in the creation of a new style of more fully naturalistic environmental apprehension and description. Once the connection between pleasantness and the locus amoenus had been forgotten and pleasantness had

become an apparently natural category, it could be used to characterize the distinctive characteristics of particular environments.[30]

To this point in my argument, I have offered only indirect evidence for the role of individuals in the development and popularization of innovative conceptual technologies. George Alsop's *Character of the Province of Maryland* (1666) offers more direct evidence of the often obscure process by which historically determined individuals adapt inherited ways of knowing and describing in order to create new structures of apprehension and description.

Alsop's book is in two parts. The first and longer section seems to have been written after his return to England and describes Maryland, its inhabitants, its most important commodities, and opportunities for economic advancement. The second section consists of twelve letters to family and friends written during his five years residence in Maryland. Both parts contain environmental descriptions, but the descriptions in the letters work within the conventions of the locus amoenus while those in the promotional tract combine the latter with the emergent discourse of pictorial objectification.

The most extended environmental description in the second section is in a letter Alsop wrote to his father a few weeks after arriving in Maryland. After emphasizing that he had not yet seen much of the colony, Alsop continued:

> Thus much I can say, and that not from any imaginary conjectures, but from an occular observation, That this Country of *Mary-Land* abounds in a flourishing variety of delightful Woods, pleasant Groves, lovely Springs, together with spacious Navigable Rivers and Creeks, it being a most healthful and pleasant situation, so far as my knowledge has yet had any view in it.[31]

Alsop begins by seeming to promise a detailed report based on "occular observation." But despite this opening appeal to what he elsewhere describes as "*occular and experimental*" knowledge, the brief account he actually offers is no more than a catalogue of already archaic conventions (19). Like William Wood, Alsop tries to adapt these conventions to the representation of uniqueness by turning key concepts into adjectives ("pleasant groves"), but the limitations of this strategy seem to have been apparent even to him, and he therefore gives over the effort to describe the distinctiveness of Maryland and closes his brief account by simply defining it as a locus amoenus ("a most healthy and pleasant situation.")

In the promotional tract, Alsop solves the conceptual problem of how to describe the uniqueness of an environment by representing it as a pictorial object. One sign of the success of his solution is that his opening description of the physical character of Maryland runs to four pages. It begins,

> Mary-Land is a Province situated upon the large extending bowels of *America*, under the Government of the Lord *Baltemore*, adjacent Northwardly upon the Confines of *New-England*, and neighbouring Southwardly upon *Virginia*, dwelling pleasantly upon the Bay of *Chaesapike*, between the Degrees of 36 and 38, in the Zone temperate, and by Mathematical computation is eleven hundred and odd Leagues in Longitude from *England*, being within her own imbraces extraordinary pleasant and fertile. Pleasant, in respect of the multitude of Navigable Rivers and Creeks that conveniently and most profitably

lodge within the armes of her green, spreading, and delightful Woods; whose natural womb (by her plenty) maintains and preserves the several diversities of Animals that rangingly inhabit her Woods; as she doth otherwise generously fructifie this piece of Earth with almost all sort of Vegetables, as well Flowers with their varieties of colours and smells, as Herbes and Roots with their several effects and operative virtues, that offer their benefits daily to supply the want of the Inhabitant whene're their necessities shall *Sub-poena* them to wait on their commands. So that he, who out of curiosity desires to see the Landskip of the Creation drawn to the life, or to read Natures universal Herbal without book, may with the Opticks of a discreet discerning, view *Mary-Land* drest in her green and fragrant Mantle of the Spring. Neither do I think there is any place under the Heavenly altitude, or that has footing or room upon the circular Globe of this world, that can parallel this fertile and pleasant piece of ground in its multiplicity or rather Natures extravagancy of a superabounding plenty. [31–33]

Needless to say, much of the content of this account draws on the techniques of the locus amoenus, and Alsop's Maryland is easily recognized as a familiar kind of place. By "the Landskip of the Creation" Alsop means the Garden of Eden, and he actually names this likeness in the next paragraph when he defines Maryland as a "Terrestrial Paradise" (33). But Alsop recontextualizes these familiar characterizations and evaluations by first defining Maryland as a geographically distinct space and by then asking the reader to view that space "with the Opticks of a discreet discerning."

As the related map titled "A Land-skip of the Province of Mary Land" makes visually clear, the conception structuring Alsop's representation is cartographic (fig. 3.2). The method both of the map and of the verbal description expresses his ability to step back imaginatively from the described environment in order to objectify it as a pictorial space. Once he has created this mental space, he uses it as a canvas and fills it with information. As in a world landscape by Patinir or Brueghel, the information within the frame is not organized into clearly defined visual fields, but its very lack of visual order is used to illustrate the "rich variety and diversities" of nature. This method is especially clear in the map where the symbols, or "Hieroglyphicks," are keyed to Alsop's account of the native inhabitants, terrain, and fauna and visually represent the fecund diversity he describes. The same concept organizes the verbal description, which moves from the terrain to flora to wild fauna to domesticated fauna to fish to domesticated grains but always represents specific things as expressions of the ordered diversity which Alsop offers as the essential characteristic of the Maryland environment.

As has been shown by numerous historians of English landscape literature and painting, the modern English noun *landscape* dates from the late sixteenth century and derives from the Dutch *landschap*. Until the seventeenth century, *landschap*, the French word *pays*, and the English word *countryside* all denoted a rural agricultural community. In England, *landscape* or its equivalent *landskip* was originally used not as a synonym for countryside but to denote a Dutch painting or drawing of a country-side. *Countryside* denoted a place, *landscape* a representation of a place. The borrowed word was soon applied to physical environments as well as to Dutch paintings of the countryside. But throughout the seventeenth and early eighteenth centuries, this new usage carried the sense of a self-conscious objectification. To experience a

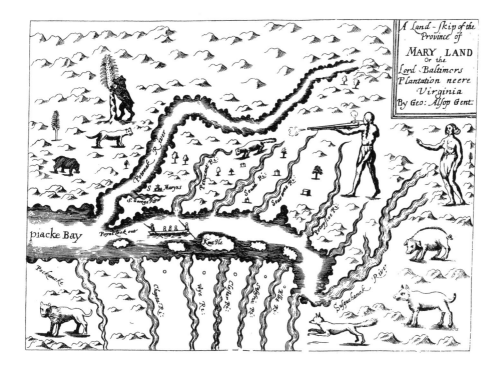

3.2. "A Land-skip of the Province of Mary Land," from George Alsop, *A Character of the Province of Maryland* (London, 1666). Courtesy of the John Carter Brown Library at Brown University.

physical environment as a landscape was to objectify it *as if* it was a painted or drawn representation of a physical environment. Although *landscape* can still be used to denote a self-conscious objectification and still carries connotations of such an objectification, during the nineteenth and twentieth centuries this usage became rarer, and the noun began to be more commonly used as a synonym for *environment, terrain,* or *land*.[32]

So far as I know, Alsop's verbal description and map are the two earliest uses of the noun *landskip* or any of its related forms in a text dealing with North America. But although Alsop's landskips exhibit his ability to step back imaginatively from the environment in order to objectify Maryland as a picture, they also make clear that he appreciates the view not for its inherent, formal beauty but as an expression of the ordered variety of the world. For Alsop as for the authors of the previously cited narratives with pictorial titles, pictorial objectification functioned not as a mode of aesthetic appreciation but as a style of factual apprehension and representation. Unlike Columbus, who did not objectify differences in this way and therefore did not worry about the subjectivity of his knowledge, these seventeenth-century authors were modern enough to be concerned with objective truth and therefore represented their descriptions as both subjectively impartial and factually accurate. But although Alsop and his more innovative contemporaries used pictorial objec-

tification as a practical technique for the description of environmental matter of fact, they still apprehended the contents of their pictures as exemplary of unchanging cosmological realities.

The Picturesque

The neologism *aesthetic* was coined by the eighteenth-century German philosopher Alexander Baumgarten. Rejecting classical and medieval theories of beauty which described the excellence of a work of art in terms of its truthfulness as a representation and its ability to move an audience, Baumgarten argued that the excellence of a work of art was a function solely of its formal "interconnection" or "coordination" with itself. For Baumgarten, an aesthetic judgment was doubly disinterested in that it was both subjectively impartial and unconcerned with either the meaning or the usefulness of the object of appreciation.[33]

Beginning in the 1730s, a few well-to-do, cosmopolitan members of the agricultural and mercantile elites learned to use pictorial conventions deriving from Dutch-Italianate landscape art to organize the visual elements of natural environments into formally integrated aesthetic wholes. Once individuals had learned to apprehend and represent natural environments as aesthetic wholes, they could both represent the uniqueness of particular places and abandon conceptual strategies of description deriving from the locus amoenus. The supersession of the conceptual and the emergence of the picturesque as a self-consciously aesthetic mode of disinterested apprehension and representation are two aspects of one historical development.

William Byrd's description of Great Creek in his *History of the Dividing Line betwixt Virginia and North Carolina* (c. 1738) is both one of the earliest representations of a North American environment as a visually integrated aesthetic whole and characteristic of the picturesque landscapes which became relatively common in later accounts:

> We pitched our tent on an eminence which overlooked a wide piece of low grounds, covered with reeds and watered by a crystal stream gliding through the middle of it. On the other side of this delightful valley, which was about half a mile wide, rose a hill that terminated the view and in the figure of a semicircle closed in upon the opposite side of the valley. This had a most agreeable effect upon the eye and wanted nothing but cattle grazing in the meadow and sheep and goats feeding on the hill to make it a complete rural landscape.[34]

From the vantage point of the late twentieth century, the conventionality of this landscape is obvious. Adopting the moderately high foreground, the clearly marked middle ground, the central regress to a closed background, the right and left lateral closure, and the rural figures characteristic of seventeenth-century Italianate landscape painting, Byrd represents the view on Great Creek as the very model of a modern "rural landscape."[35]

But to emphasize the conventionality of this description is to ignore its historical innovativeness. Like his British contemporaries who were busy naturalizing the

conventions of Italianate landscape painting into the simplified forms of what was later named the picturesque, Byrd ignores the classical concepts of diversity and order that had informed the spatial conventions of seventeenth-century Roman landscapes and simply adopts those conventions as a visual vocabulary with which to represent what he has learned to apprehend as the distinctive spatial form of a specific valley.[36] Byrd is delighted by this valley not because he recognizes it as a locus amoenus or as expressing the variety and diversity of the world but because he is able to objectify it as a spatially unified picture and appreciates the interconnectedness and coordination of the visual elements that are comprised in that whole. He appreciates the view neither for its economic potential nor for the other environments it reminds him of nor for what its fecundity reveals about the meaning of the world, but for what, in itself, it aesthetically is.

The Naturalization of Landscape Experience

In arguing that the distinguishing characteristic of the picturesque was its disinterest in meaning, I do not mean to suggest that picturesque landscapes were in fact empty of interpretive or ideological content. I assume that all representations carry cultural meanings and interests. In the case of the picturesque, Raymond Williams, John Barrell, and Carole Fabricant have each shown how representations of rural or wild environments as naturally beautiful were used by the eighteenth-century British elites both to validate their sense of superiority to their social inferiors who worked but did not appreciate environments as landscapes and to justify both the increasing commercialization of the rural economy and the attendant expropriation of traditional peasant rights to the use of common lands and of tenancy.[37] Rather, my point is that the distinguishing characteristic of the picturesque as opposed to earlier varieties of pictorial objectification is that it was organized as a distinctively aesthetic objectification and, therefore, that it was—and is—likely to be (mis)taken as nonideological. The apprehension of particular kinds of natural environments as picturesque landscapes differed from earlier forms of pictorial objectification not because it was altogether disinterested, but because it claimed to be and passed as such.

As a putatively disinterested mode of pictorial objectification and aesthetic appreciation, the picturesque was never as popular in British North America as it was in Britain. Until the very end of the eighteenth century, the vast majority of verbal as well as visual landscapes produced in British North America or dealing with North American subjects were primarily concerned with the accurate depiction of specific environments and continued to draw on concepts deriving from the locus amoenus. During this period, the ability to objectify natural environments as purely aesthetic objects was limited to the best educated and most cosmopolitan members of the colonial elites. But even late cosmopolitan narratives like Thomas Jefferson's *Notes on the State of Virginia* (1787) and William Bartram's *Travels* (1791) contain relatively few purely aesthetic picturesque landscapes.

The popularization of picturesque landscape dates from the end of the century, when the importation of more highly moralized landscape ideas from Britain and

Germany together with the increased wealth and leisure of the northeastern elites led to the development of a didactic picturesque in which natural environments were first objectified as visually integrated aesthetic wholes and then interpreted as evidencing unchanging moral truths. My point here is not that the didactic picturesque replaced what we might call the cosmopolitan or enlightened picturesque, but that the growth of the commercial elites and later the urban middle class led to the development of a new kind of picturesque as an alternative and, ultimately, a more common style of landscape experience and representation.[38] To cite but a single example, one early nineteenth-century visitor to Kaaterskill Falls showed off his skills as a moralizer of picturesque views by commenting that "it makes a man feel like a poor worm, or elevates him to a sublimity in keeping with his own, as his humility or his pride is uppermost. I felt both; for my temperament is chameleon."[39]

The moralization of the picturesque served at least three cultural needs. First, as with the cosmopolitan picturesque, the ability to objectify natural environments as moralized landscapes did not require either a classical education or scientific training, and landscape appreciation could therefore be used by men and women of both the elites and the emerging middle class to distinguish themselves from the laboring classes, who had not yet learned to value natural environments as views. Second, as economic development created the possibility of increased leisure for privileged members of American society, the constitution of landscape as a morally significant activity helped justify the expense both of leisure in general and of the various verbal, visual, and physical forms of landscape appreciation in particular. And finally, third, the constitution of landscape as a self-consciously moral activity meant that individual consumers could use it either to confirm or, much more rarely, to question the tenets of their Protestant piety or of their national pride.

By 1820, many well-to-do Americans had learned how to objectify natural environments as picturesque landscapes and to interpret them as illustrative of moral truths, but the cultural significance of the meanings they read into natural scenery was limited by the self-consciousness with which they approached the act of interpretation. So long as individuals were self-consciously aware of the role of the self in the construction of landscape experiences and the imposition of meanings, the contents of those meanings could be cited to confirm or question beliefs but could not be invoked as a higher kind of evidence as to the nature of the world or of God's purposes in it. In order for meanings to be revalued in this way, consumers of landscape had to become unconscious of the fact that the expectations and needs they carried with them in large part determined the meanings they discovered. The increased cultural importance and even wider popularization of mid nineteenth-century landscape depended on the ability of large numbers of increasingly secularized individuals to forget the labor of admiring and thus to (mis)take the meanings they imposed for the fruits of putatively impersonal insight.[40]

The labor of admiring can be forgotten only when the mental skills necessary to the objectification of natural environments as landscapes become so commonplace and habitual among a social group that individuals acquire them without being aware of the fact that they are learned. As Ann Bermingham showed in her study

Landscape and Ideology: The English Rustic Tradition, 1740–1860, this began to happen in England in the last quarter of the eighteenth century. Although we do not yet have an adequate study of the transmission of this new style of landscape to the United States, some suggestive evidence can be found in William Charvat's classic study of 1936 *The Origins of American Critical Thought, 1810–1835*. For example, Charvat's analysis of early nineteenth-century periodical and critical literature shows that American reviewers did not praise Wordsworth until after the War of 1812 and that his poetry did not begin to become popular until the mid 1830s. Although Charvat was not concerned with the history of landscape appreciation, his evidence concerning the critical reception of Wordsworth supports the periodization suggested by my own research into the history of the Catskill Mountains. Both suggest that the naturalization of landscape experience in the United States dates from the 1820s and was an effect of the importation of contemporary landscape art and literature from abroad and of the development of domestic sources of landscape art and literature which represented landscape appreciation as a natural or intuitive ability.[41]

I will conclude with an example illustrating something of the process by which early nineteenth-century Americans learned both to value landscape and to forget the mental labor involved in the work of environmental objectification and appreciation.

Most visual representations of the Catskills from the 1820s and 1830s treated them as a tourist resort and used figures of well-dressed tourists to suggest that landscape appreciation was a learned ability and that the possession of this ability was characteristic of the well-bred. For example, in his large colored aquatint of 1830 *Catskill Mountain-House* (fig. 3.3), John Rubens Smith's decision not to show what the tourists are looking at fixes our attention on the practice of landscape appreciation itself. Smith uses both the central vertical of the road and the slanting beams of the morning light to link visually the foreground tourists with the carriage in the middle ground that is carrying a second group of tourists to the hotel in the background; he employs this visual connection to suggest that mountain tourism is a kind of spiritual pilgrimage in which traveler-pilgrims seek ever-more-expansive, ever-higher views.[42] Unlike Smith's aquatint or the engraving after Thomas Doughty's view *Catskill Falls* (c. 1827; fig. 3.4) or Gherlando Marsiglia's lithograph of the same falls (c. 1828), Thomas Cole's paintings and engravings of the Catskills from the late 1820s almost never show tourists or tourist accommodations.[43] Rather, Cole used Native Americans, as in his *The Clove, Catskills* (1827; New Britain Museum of American Art), frontiersmen, as in his *Autumn in the Catskills* (1827; Arnot Art Museum), wild animals, as in his *View from the Top of Kaaterskill Falls* (1826; The Detroit Institute of Art); or he avoided figures altogether as in his *Sunny Morning on the Hudson River* (1827; fig. 3.5). In every case, the effect is to obscure the cultural construction of landscape experience and to validate the contents of such experiences as the fruit of a more valuable because putatively unlearned insight.

Whereas the visual landscapes by Smith, Doughty, and Marsiglia as well as the engraving after Cole's own *View of the Cattskill Mountain House, N.Y.* (1831; fig. 3.6) advertised the existence of the Catskills and taught consumers both the techniques of and the cultural value attached to landscape appreciation, the bulk of Cole's work

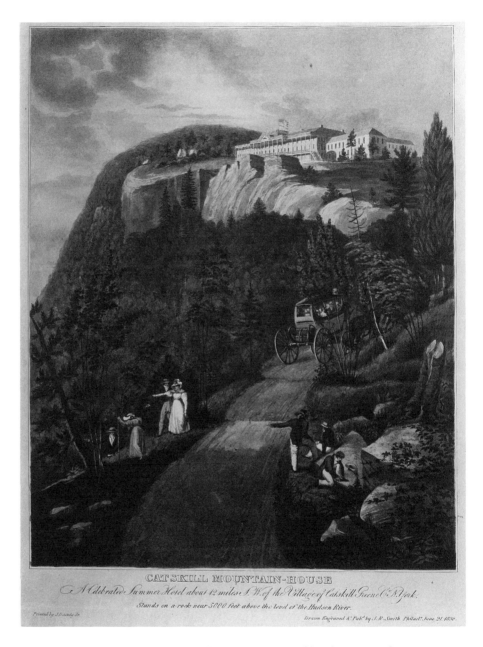

CATSKILL MOUNTAIN-HOUSE

A Celebrated Summer Hotel about 12 miles S.W. of the Village of Catskill Greene C° N. York.

Stands on a rock near 3000 feet above the level of the Hudson River.

Printed by J.Dainty Jr.

Drawn Engraved & Pub.d by J.R.Smith Philad.a June 21. 1830.

3.3. John Rubens Smith, *Catskill Mountain-House. A Celebrated Summer Hotel*, 1830. Print Collection. Miriam and Ira D. Wallach Division of Arts, Prints, and Photographs. The New York Public Library. Astor, Lenox and Tilden Foundations.

Drawn by T. Doughty Engraved by Geo. B. Ellis

3.4. Thomas Doughty, *Catskill Falls*. Engraved by George B. Ellis, 1828. From *The Atlantic Souvenir: A Christmas Book and New Year's Offering* (Philadelphia: Carey, Lea, & Co., 1828). Abernethy Library, Middlebury College.

further suggested that this ability was available to all men and women and that something was wrong with anyone who did not possess it. Like Wordsworth's poetry and Cooper's portrait of Natty, Cole's paintings taught Americans how to read landscape at the same time that they obscured the constructive role of the self in the process of interpretation. The effect both of this education and of this unconsciousness was to enable large numbers of well-to-do and middle-class Americans to (mis)take their interpretations of landscape for original revelations of impersonal meaning. As increasing numbers of Americans learned to forget the mental labor involved in the work of landscape appreciation, the national landscape became increasingly important as a repository of cosmological, moral, and

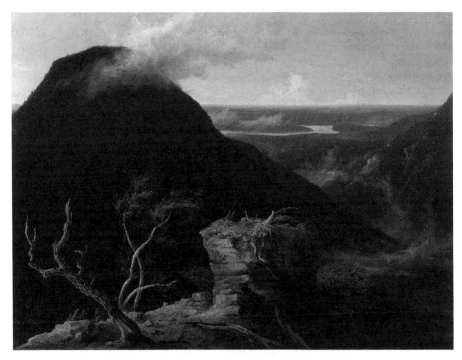

3.5. Thomas Cole, *Sunny Morning on the Hudson River*, 1827. Gift of Mrs. Maxim Karolik for the Karolik Collection of American Painting, 1815–1865. Courtesy Museum of Fine Arts, Boston.

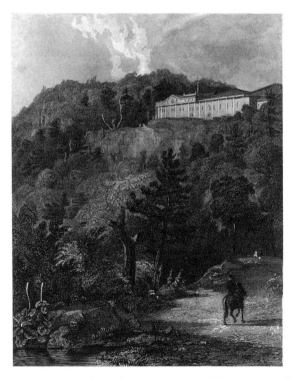

3.6. Thomas Cole, *View of the Cattskill Mountain House*, N.Y. Engraved by Fenner, Sears, & Company, 1831. From J. H. Hinton, *The History and Topography of the United States*, vol. 2 (London: Simkin & Marshall; Philadelphia: Thomas Wardle, 1832). Yale University Library.

social truths. Because arguments from the landscape could claim to be disinterested, they carried ideological heft. Because such arguments were rhetorically powerful and culturally effective, they were regularly contested. By midcentury, the national landscape had become one of the major cultural battlegrounds on which Americans contested the meaning of their lives and of their nation.

4

ALAN WALLACH

• • •

Making a Picture
of the View from
Mount Holyoke

Frequently reproduced in American painting and re- it were leitmotif of the Me- publicized and highly suc- can Paradise," Thomas Cole's now probably the most re- School landscape paintings. in part be traced to the posi- textbooks and histories of cently the emblem or as tropolitan Museum's widely cessful blockbuster "Ameri- Oxbow of 1836 (fig. 4.4) is nowned of all Hudson River Its current preeminence can tion accorded it by histori- ans of American art. Beginning with Wolfgang Born in 1948, *The Oxbow* has been considered a prototypical or paradigmatic work, anticipating the landscapes of such Hudson River School artists as Frederic E. Church, Albert Bierstadt, and Thomas Moran and thus cementing Cole's art-historical position as the school's founder.[1] And yet, despite *The Oxbow*'s centrality to recent accounts of the school, surprisingly little has been written about its paradigmatic qualities or its defining role. Born noted that *The Oxbow* along with the artist's *Course of Empire* series marked the beginning of what he termed "the panoramic style."[2] Subsequent discussions have simply reiterated Born's important insight or employed a somewhat different language to describe the advent of a new type of landscape painting.

This chapter concerns two drawings in the collection of the Detroit Institute of Arts (figs. 4.1, 4.3) which are already fairly well known through their association with *The Oxbow*.[3] I am interested in these drawings as evidence of the historical processes that contributed to the formation of the panoramic or, as I shall later call it, panoptic mode. Instead of seeing these drawings as aesthetically self-sufficient or, conversely,

as merely anticipating Cole's now-famous painting, I consider them in terms of the dynamics of a complex set of interrelated, and mutually reinforcing, cultural practices. Landscape painting and landscape drawing went hand in hand with landscape tourism, landscape literature, and landscape aesthetics. Or to change the emphasis somewhat, we can say that landscape tourism was and is still inseparable from its literary and visual representations. During the 1820s landscape tourism began to take shape in the United States as an important form of middle-class leisure, with Mount Holyoke as one of its major sites. Other major sites included Niagara Falls, the Catskill Mountains in the vicinity of the Catskill Mountain House (opened in 1825), and the White Mountain routes leading to Mount Washington.[4] Not surprisingly the 1820s were also crucial for landscape literature and landscape imagery. Literature and imagery provided the necessary context for tourism, lending significance to such activities as visiting Kaaterskill Falls, viewing the sunrise from the porch of the Catskill Mountain House, or ascending Mount Holyoke. These activities can be understood as part of the tourist's quest for authenticity and identity—a point to which I shall return later on.[5]

What attracted tourists to Mount Holyoke? In what terms can tourist experience be understood? Before considering Cole's drawings, I shall need at least provisional answers to these questions.

Although Mount Holyoke had drawn occasional travelers in the eighteenth and early nineteenth centuries, it began to function as a tourist attraction only in 1821, when a group of Northampton businessmen arranged for the building of a carriage road up the mountain and a log shelter at the summit. Mount Holyoke was in this rudimentary fashion marked out as a tourist site, and by the late 1820s several hundred sightseers were yearly making the ascent.[6] Two factors determined tourist experience: the *physical setting*, by which I mean both the apparatus of tourism (the road, the log shelter) and the landscape that tourism constituted as its object (the Oxbow and the Connecticut Valley); and what can be called the *ideological context*: the ensemble of texts and images having to do with Mount Holyoke and with landscape generally. The physical setting provided a space for symbolic or ritual activity; the ideological context supplied the materials out of which meanings were produced. What can be directly gleaned about these meanings derives primarily from guidebooks and travelers' accounts.[7] This literature tends to be repetitious, a rehashing of landscape motifs, and one example will often do pretty much as well as another. Moreover, because it is a tourist literature, it is best read instrumentally, that is, as a set of instructions to the tourist: how to perform the visit to Mount Holyoke; how to experience the landscape; how to look. With its touristic function in mind, consider this description by a British travel writer, Edward Thomas Coke, written in 1833:

> On the opposite side of the river, which is crossed at South Hadley by a horse ferry, two miles distant, is Mount Holyoke, 1070 feet above the level of the river, and a favourite resort of travellers and parties of pleasure. Seven carriages, filled principally with ladies, arrived at the foot of the mount at the same time as myself. The road winds along the

side of it through a dense forest of trees, until within 400 feet of the summit, where it is necessary to dismount and clamber over loose stones and logs of wood for the remaining distance. But the scene which bursts upon the spectator's view, as he steps upon the loose black rock on the summit—a scene of sublime beauty, of which but an inadequate description could be conveyed—amply repays him for his trouble and fatigue. A more charming day could not have been devised: it was one of those clear American atmospheres which are unknown in our hazy clime, with just sufficient light floating down to throw a momentary shadow over parts of the rich vale, which lay spread out beneath in all the various hues of a quickly ripening harvest. Innumerable white houses, and spires of churches, were seen scattered amongst the trees and along the banks of the smooth but rapid Connecticut (up which a solitary steamer was slowly creeping,) which river in its fantastic and capricious windings returned within a few yards of the same spot, after watering two or three miles of the vale—or, after being concealed at intervals by the hills and woods, would again reappear with its silvery surface glistening amidst dark foliage at the distance of many miles. These objects, and above all the high and rocky mountains, contrasted with the smiling valleys, altogether formed one of the most magnificent panoramas in the world. Places 160 miles apart from each other were distinctly visible. I soon recognized the bluff rocks near New-Haven at eighty miles distance, though only 400 feet in height, and could easily trace their rugged and bold outline upon the clear horizon.[8]

Coke describes a particular event, particularity being certified by such ancillary details as the "seven carriages, filled principally with ladies" and "a solitary steamer." Yet the visual formula Coke employs—his recipe for seeing—can hardly be said to be unique. In contemporary travel literature and in the writings of Cooper, Irving, Hawthorne, and a host of lesser-known contemporaries, there appear, repeatedly, passages in which the writer-tourist or fictional protagonist (Natty Bumppo in *The Pioneers*, the sculptor Kenyon in *The Marble Faun*) climbs to the top of a mountain, hill, or tower, confronts a "panoramic" landscape, is at first overawed by feelings of sublimity ("a scene of sublime beauty, of which but an inadequate description could be conveyed"); and then, as the initial excitement wears off, alternates between modes of vision: between remarking upon the myriad details that fall within his or her gaze ("innumerable white houses, and spires of churches") and observing the scene's extraordinary breadth ("places 160 miles apart . . . were distinctly visible"). This narrative convention is called panoramic because quite clearly it takes the circular panorama as its controlling metaphor. Coke, it will be remembered, pronounced judgment on the view from Mount Holyoke in terms that make no distinction between a painted and a natural or outdoors panorama.

The significance of this juxtaposition, this grafting of panoramic convention onto landscape, may be grasped through a discussion, if only a schematic one, of the panorama as a historical phenomenon. The panorama was an invention of the late eighteenth century.[9] Robert Barker created the first large-scale panorama in London in 1788; the word *panorama*, meaning, literally, all-seeing (from the Greek *pan* + *horama*), was coined a few years later. Typically, panorama paintings were exhibited in specially designed rotundas. To view a painting spectators climbed a tower, located at the center of the rotunda, to a viewing platform. The viewing platform was positioned in such a way that the painting's horizon-line roughly coincided

with the spectators's eye-level, which meant that spectators experienced a sensation of looking down at the scene. This was only one of several carefully calculated visual effects. The painting was illuminated by hidden skylights while the rotunda and its contents (the tower, the viewing platform) remained shrouded in darkness. The resulting contrast between light and dark, between the painting and the ghostly or insubstantial realm inhabited by the spectators—who thereby became anonymous and invisible witnesses to the scene—produced a powerful trompe-l'oeil effect, making the painting the only visible reality. All this was done to maximize visual drama since spectators did not casually come upon the painting but emerged from the shadowy space of the tower onto the viewing platform, where the painting suddenly burst upon them. This was a dramatic and no doubt sublime moment that early panorama visitors often found overwhelming. (A visit to a panorama could result in dizziness and *Sehkrankheit*, or see-sickness.)[10] The panorama might thus be thought of as a machine or engine of sight in which the visible world was reproduced in a way that hid or disguised the fact that vision required an apparatus of production, and that what was being produced was not only a spectacle but a spectator with a particular relation to reality.

Stephan Oettermann has argued for the historical specificity of panoramic vision: that the invention of the panorama belongs to a period in which new forms of middle-class hegemony arose and that the panorama itself encoded these forms. Consequently, Oettermann along with Michel Foucault has linked the panorama to Jeremy Bentham's almost contemporaneous invention of the panopticon (the word also translates as all-seeing), a circular prison with a tower at its center designed to allow for the constant surveillance of inmates.[11] In the panopticon, inmates were subject to an anonymous authority, "the eye of power" or "sovereign gaze," as Foucault has called it, that emanated from the tower. The sovereign gaze represented a new equation between vision and power—power that now aspired to total domination. The panorama, I would argue, embodied a similar aspiration. In the panorama, the world is presented as a form of totality; nothing seems hidden; the spectator, looking down upon a vast scene from its center, appears to preside over all visibility.[12] The totalizing vision I have been describing might be called panoramic; however, I prefer the term *panoptic* for two reasons. First, it underscores the connections between vision and power: the ascent of a panorama tower provided the visitor with an opportunity to identify, at least momentarily, with a dominant view—Foucault's "eye of power." The second reason has to do with the mode of vision itself. That mode was both extensive and intensive; it therefore needs to be distinguished somewhat from the usual meanings associated with the word *panorama*. It was extensive or panoramic in the everyday sense of that term because it covered the entire lateral circuit of visibility; but it was also intensive or telescopic because it aspired to control every element within the visual field. Which was precisely the point of Bentham's panopticon.

This analysis leads me to what I call the panoptic sublime. Having reached the topmost point in an optical hierarchy, the tourist experienced a sudden access of power, a dizzying sense of having suddenly come into possession of a terrain stretching as far as the eye could see. The ascent of Mount Holyoke was in this

respect a stunning metaphor for social aspiration and social dominance. The multiple displacements involved—the way in which social meanings were projected onto landscape; were absorbed into the forms of landscape; were quite literally naturalized—should obscure neither the historic roots nor the historical specificity of the process. To the tourist the panoptic sublime was primarily a matter of vision; however, as I have argued, it was something else as well. The panoptic sublime drew its explosive energy from prevailing ideologies in which the exercise of power and the maintenance of social order required vision and supervision, foresight, and, especially, oversight—a word equally applicable to panoramic views and to the operation of the reformed social institutions of the period: the prison, the hospital, the school, and the factory.

Could a picture be made of the view from Mount Holyoke? It seemed unlikely. Coke confessed to his readers: "I had carried my pencils and sketch-book up with me; but did not even presume to take them from my pocket."[13] The writer Theodore Dwight made a similar disclosure in a guidebook written a few years earlier: "It would be an almost hopeless task for an artist, to attempt the representation of all the beauties which are here presented in one view to the eye."[14] Coke and Dwight focused on presumed inadequacies of artistic technique. Technique, however, was not the primary issue. For artists of the 1820s, the view from Mount Holyoke or from the porch of the Catskill Mountain House was unrepresentable; or at least could not be represented in a form that would according to current standards result in a coherent picture. There were essentially two reasons for this. In the absence of a pictorial tradition, artists lacked the artistic means for making such a picture. In addition, they faced a formidable conceptual barrier. As Blake Nevius has observed, "Writers on the picturesque were unanimous in condemning the prospect view on canvas because of its extent and its lack of variety, detail, and foreground interest."[15] William Gilpin, an influential theorist, wrote of "the absurdity of carrying a painter to the top of a high hill to take a view. He cannot do it. Extension alone, though amusing in nature, will never make a picture."[16] Uvedale Price, another widely read theorist, argued that a long view could never be a fit subject for landscape painting because "any view that is unbroken, unvaried, undivided by any objects in the nearer parts, whether it be from a mountain or from a plain, is, generally speaking, ill suited to the painter."[17] Cole absorbed these prohibitions. Climbing Mount Chocura in New Hampshire in October 1828, he saw "on every side prospects mighty and sublime [that] opened upon the vision: lakes, mountains, streams, woodlands, dwellings and farms wove themselves into a vast and varied landscape." But for "all its beauty the scene was one too extended and map-like for the canvass."[18]

And yet, as might be expected, Cole was fully conversant with panoramic conventions of seeing and with the aesthetics of the panoptic sublime. In a letter to his patron Daniel Wadsworth written in August 1827 describing his ascent of Red Mountain in New Hampshire, the panoramic convention operates like a reflex. "I climbed," Cole wrote, "without looking on either side [in other words, as if he were climbing the tower of a panorama]: I denied myself that pleasure so that the full effect of the scene might be experienced—Standing on the topmost rock I looked

abroad!—With what an ocean of beauty, and magnificence, was I surrounded."[19] Thus when it came to representing panoptic vision, Cole found himself in something of a double bind. On the one hand, he subscribed to the theoretical prohibitions against representations of long views. On the other, he was as an increasingly successful landscape painter highly sensitive to cultural pressures. The extent to which these pressures were overt or Cole's responses were conscious or a matter of deliberate calculation is unknowable. But we can surmise from the evidence given so far that a problem lurked in Cole's mind and that the problem went something like this: How could a panoramic view be represented on a two-dimensional surface (as opposed to the cylindrical or three-dimensional surface of an actual panorama)? How could an artist *picture* the panoptic sublime?

These questions bring us to the first of the two drawings under discussion (fig. 4.1). It is a direct copy, a tracing on yellow architect's tracing paper of a view from the summit of Mount Holyoke (fig. 4.2) published in Capt. Basil Hall's *Forty Etchings, From Sketches Made with the Camera Lucida, in North America in 1827 and 1828*, which accompanied Hall's book of travels.[20] Hall was by no means a trained or professional artist, and his lack of aesthetic culture along with his reliance upon a mechanical aid resulted in the production of a landscape view that a more seasoned draughtsman probably would not have attempted. His use of a camera lucida, a device that like the camera obscura anticipated the invention of the photographic camera, is in itself symptomatic of the situation I am concerned with. The camera lucida imposed its own mode of representation or characteristic representational language upon a view for which there was no direct pictorial precedent; Hall then superimposed on this mode his own rudimentary drawing technique. (To the influence of the camera lucida we may attribute a certain monotony or uninflected quality in Hall's etching, a quality that carries over into Cole's tracing.) It is, I believe, highly

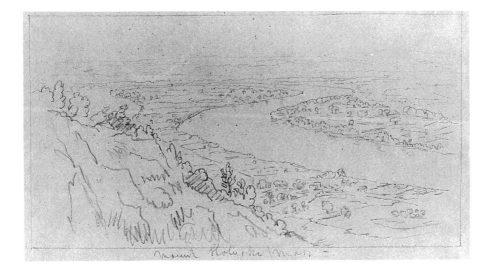

4.1. Thomas Cole, *Mount Holyoke Mass.*, ca. 1829. Founders Society Purchase, William H. Murphy Fund (39.70).

A PICTURE FROM MOUNT HOLYOKE

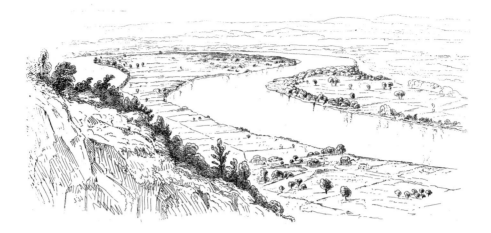

4.2. Basil Hall, *View from Mount Holyoke in Massachusetts*. From *Forty Etchings . . . Made with the Camera Lucida, in North America . . .* (London, 1829), pl. xi. Williamsburg, The College of William and Mary, Swem Library.

significant that Cole, who was not in the habit of making exact or detailed copies even of works he admired, went to the trouble of *tracing* Hall's amateur effort. If nothing else, Hall's etching demonstrated the possibility of representing what had hitherto seemed unrepresentable. By tracing rather than approximating the etching with a copy, Cole demonstrated a need for as well as the difficulty of acquiring a new representational technique. It is as if he had to reproduce the movements of Hall's hand in order to comprehend how it would be possible to picture the view from Mount Holyoke.

Because chronology is central to my argument I will at this point consider two proposals that have been made for the dating of Cole's tracing. Oswaldo Rodriguez Roque has argued that Cole executed the tracing while he was in London in 1829–31.[21] Ellwood C. Parry III has suggested that Cole may have made it "in 1836 to check the accuracy of his own rendering of the famous Oxbow meander on the Connecticut River."[22] Of the two proposals Parry's is the less convincing; however, it helps to pinpoint what is for us an important question: does the tracing predate or postdate Cole's 1833 sketch of the view from Mount Holyoke's summit (fig. 4.3)? Parry's suggestion fails on three counts. First, Hall's version of the view from Mount Holyoke differs substantially from Cole's sketchbook rendition, and it is the latter which appears closer to the painting Cole executed in 1836 (fig. 4.4).[23] Second, checking the accuracy of a view was not to my knowledge ever Cole's practice. And in any case, what would have been the upshot of a comparison between drawings that widely differed when it came to viewpoint and composition? Third, to raise the question in terms of accuracy or norms of photographic precision is to impose an

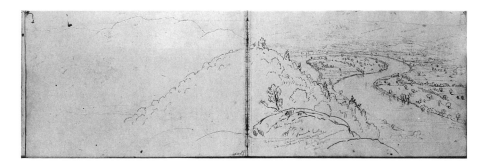

4.3. Thomas Cole, Sketch for *The Oxbow*, c. 1833. Founders Society Purchase, William H. Murphy Fund (39.566.66 and 39.566.67).

anachronistic standard on Cole's practice as a landscapist. Indeed, *The Oxbow*, like so many other views Cole painted, contains obvious and very probably conscious departures from what could be seen from a single vantage point.

Although it depends on circumstantial evidence, Rodriguez Roque's argument appears far more plausible. He assumes that Cole's awareness of Hall's camera lucida view coincided with the uproar generated on both sides of the Atlantic by the publication in 1829 of Hall's book. Because of the book's notoriety, he argues, "it is almost a certainty" that Cole became aware of the *Travels* and the companion volume

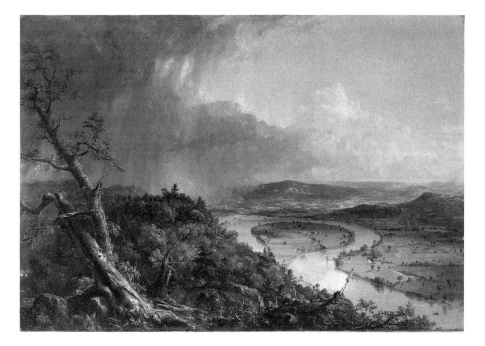

4.4. Thomas Cole, *View from Mount Holyoke, Northampton, Massachusetts, after a Thunderstorm (The Oxbow)*, 1836. New York, Metropolitan Museum of Art. Gift of Mrs. Rusell Sage, 1908 (08.228).

A P I C T U R E F R O M M O U N T H O L Y O K E

4.5. Thomas Cole, *Panoramic View of the Bay of Naples*, 1832. Founders Society Purchase, William H. Murphy Fund (39.566.6 and 39.566.7).

of etchings during the years he was in London.[24] To the evidence Rodriguez Roque adduces I would add the evidence of the drawings themselves. For it is at least logical that Cole would proceed from a tracing of Hall's etching to attempting his own sketch at the site, and subsequently turn the sketch into a painting.

If the tracing reveals a first step toward a representation of the panoptic sublime, the drawing executed in 1833 (fig. 4.3) marks a second. The drawing extends across two pages of Cole's sketchbook. The right-hand page, which—misleadingly—has on more than one occasion been published by itself, embodies a composition that might be compared to Hall's etching. By extending the drawing across the left-hand page, however, Cole doubled the angle of vision. This makes the sketch panoramic in the sense that it emphasizes the horizontal or lateral direction of sight. Cole began the sketchbook with a panoramic drawing of the Bay of Naples (fig. 4.5), probably executed in May 1832, at a time when he was, according to his early biographer, Louis L. Noble, considering the possibility of "painting a large panorama of the bay and city" and had made "a series of sketches for the purpose."[25] Such considerations, however, played no role in the later drawings in the sketchbook where the same format was employed: for example, in the case of a sketch called *Near Catskill* (fig. 4.6), probably done in the spring or summer of 1833. Indeed, in one instance the artist divided a page into four narrow strips (fig. 4.7), three of which he filled in with views of (1) "Cape de Gait [probably the Cabo de Gata] on the coast of Spain, bearing NNW—distant 15 miles"; (2) "Coast of Africa"; (3) "L[ake] George." Cole executed the first two drawings while on board the ship that took him from Leghorn to New York in October 1832; the last was probably drawn months later. Thus by the time Cole arrived at Mount Holyoke the elongated rectangle had become an all-purpose format, a signifier for panoramic vision.

For the painting, Cole stuck to a more traditional—and more saleable—format. The canvas's height-to-width ratio is approximately 7 : 10³/₁₀ as opposed to 7 : 11 for a single sheet in the sketchbook and 7 : 22 for the two-page spread. Nonetheless *The Oxbow* enlarges the angle of vision (which is not, in any case, dependent upon the height-to-width ratio of a particular surface).[26] Consequently, instead of producing

4.6. Thomas Cole, *Near Catskill*, ca. 1833. Founders Society Purchase, William H. Murphy Fund (39.566.44).

a view involving a normal angle of vision of about 55 degrees, Cole manipulated *The Oxbow*'s composition in such a way that it appears to take in approximately 85 or 90 degrees (as opposed to the 110 degrees of the sketch of 1833). This effect is achieved by a tight juxtaposition of what are almost two separate views, the sunlit vista to the right and the stormy prospect to the left. This split composition, with its abrupt transitions from left to right and from foreground to background, leads to a division or bifurcation of seeing. Cole represents the equivalent of a section of a panorama without the panorama's consistent and apparently seamless transition from point to point within the visual field. Instead, two related vistas are compressed or jammed

4.7. Thomas Cole, *Sketchbook Page with Three Panoramic Drawings*, 1832–33. Founders Society Purchase, William H. Murphy Fund (39.566.97).

A P I C T U R E F R O M M O U N T H O L Y O K E

against each other, so that a viewer scanning the landscape experiences both a feeling of panoramic breadth and a sense of imminent split or breakdown. There is, in other words, a spatial conflict in *The Oxbow* in which contradictory perspectives and modes of seeing, along with other sets of visual and symbolic oppositions— storm and sunshine, wilderness and pastoral landscape (the proverbial "Garden")— produce a type of optical excitement, a cacophony of vision that can be taken as a pictorial equivalent to the exhilaration of the panoptic sublime.

Cole was probably aware that with his experiments in extended formats and representations of hitherto unrepresentable views he was breaking with convention. In a letter of March 2, 1836, to his patron Luman Reed describing his intention of painting a picture to show at the National Academy of Design's annual exhibition he wrote, "I have already commenced a view from Mt. Holyoke—it is about the finest scene I have in my sketchbook & is well known—it will be novel and I think effective."[27] "Well known" but also "novel"? This puts the matter in a nutshell. By the early 1830s Mount Holyoke was a necessary stop on any North American tour. And yet because the view from the summit had never before been pictured in an oil painting—had scarcely been pictured at all—its effect would indeed have been novel.[28] But this novelty required the adoption of a new representational mode. Compared to the sketch of 1833, the painting for the most part emphasizes precisely those qualities I have called panoptic. The viewpoint is higher, the visible expanse of landscape greater. The viewer looks down upon the scene as if from a great height, an effect that is intensified by the deliberate upward tilt of the ground plane as it recedes toward the distant horizon. And because Cole introduced seemingly endless details—a flight of birds, boats on the river, figures in the boats, a horse and rider, figures working in the fields, rows of haystacks, herds of cattle, dozens of houses, each with its own chimney and plume of smoke—the viewer confronts further evidence of the visual dialectic or doubling of vision I have been describing: confronts, that is, a scene that is both panoramic and telescopic, vast and yet minutely rendered. Considering the way in which Cole played off contradictory aspects of vision, it is not difficult to imagine the painting producing a vertiginous sense of disproportion, a *Sehkrankheit* in viewers unschooled in its representational modes.

Although *The Oxbow*'s appearance at the National Academy of Design exhibition of 1836 did not engender much in the way of written comment, neither the painting's novelty nor the problems of comprehension it posed went entirely unremarked. A reviewer writing in the *Knickerbocker Magazine* responded to *The Oxbow* as to something unfamiliar: "This is really a fine landscape, although at first it does not appear so. It wants to be studied."[29] The statement suggests an inadequacy of seeing—the painting's initial failure to "appear" a certain way—and an ensuing process of accommodation. It also points to a difference between Cole's period and our own. After the National Academy of Design exhibition *The Oxbow* passed quietly into a private collection to be seen in public only infrequently for the remainder of the century.[30] Today it is the artist's most celebrated work, immediately recognizable as a powerful representation of what I have here called the panoptic sublime.

Although Cole experimented with panoramic formats in other drawings and paintings, the panoptic sublime did not become a persistent feature of his practice as a landscapist. Indeed, no other painting in his oeuvre directly compares with *The Oxbow*. Yet there was a certain historical inevitability about the panoptic sublime for American landscape painting. Its centrality to landscape tourism and, by the 1850s, to the very concept of American land as landscape seems beyond doubt.[31] Its implications for the Hudson River School cannot, however, be further explored here. It only remains to observe that the two drawings I have examined provide an insight into a cultural and, more generally, an ideological process. They reveal a moment of imaginative transformation: a moment in which the panoptic sublime achieved a new form of symbolic expression.

5

BRIGITTE BAILEY

· · ·

The Protected Witness: Cole, Cooper, and the Tourist's View of the Italian Landscape

The large-scale influx of American tourists into Italy in the 1820s and 1830s[1] coincided with the peak of what C. P. Brand calls the "Italianate fashion" in England. As travel became possible again after the Napoleonic Wars, this English vogue resulted in a wave of visual and literary representations of Italy and things Italian.[2] The widely diffused nature of the fashion, which spread through both elite and popular culture, suggests that the English encounter with Italy became for a time a vehicle for the ongoing construction of a national subjectivity. The image of Italy served as a focal point for aspects of experience defined in opposition to "English traits";[3] it therefore helped to define the traits themselves. For middle- and upper-class Americans, at work on building a national identity partially on the English model,[4] tourism became a way of furthering a similar cultural project. American tourists entered into English assumptions about the Italian journey and replicated the English sense of the tourist as a privileged observer, a spectator who could comprehend non-English traits without being influenced by them. In the journal of his Italian tour of 1833, Emerson defined "the singular position of the American traveller in Italy" in terms of this model of privileged spectatorship: "It is like that of a being of another planet who invisibly visits the earth. He is a protected witness."[5] In establishing their "singular position" with respect to Italy, Americans were conscious of engaging preexisting English habits of perception and of their own mixed feelings about identifying with these habits. While they resisted a full identification with England in other respects,

American travelers easily adopted British uses of Italy and set up a similar opposition between Italy and the United States.

Anglo-American tourists approached Italy through an ideology of gender; they constructed a feminine Italy as a counterpoint to the normative and masculine world identified with England and America. Their depictions of the encounter drew on an analogous cultural opposition of the period: that between word and image. Associating the visual with the feminine, many American travelers, including Cole and Cooper, concentrated their search for the meanings of Italy on an intensive aesthetic scrutiny of its landscape. This scrutiny also enabled male tourists to displace debates about the formation of an elite American self onto their interaction with the Italian scene. A trip to Italy offered the chance to reconsider and visualize power relations between an elite self and the cluster of attributes assigned to the landscape of the feminine other. Tourists enacted the debate over national identity through their aesthetic responses and by examining aesthetic categories; by reworking the concept of the sublime to include feminine traits, Cole and Cooper formulated a concept of power that was hegemonic rather than obviously coercive. Through their responses to Italy, Americans valorized a model of cultural authority based on the ability to create social harmony by enlisting the energies of those traits associated with the feminine and visible in Italy.

As critics have emphasized, Cooper and Cole were conspicuously active in defining an American identity.[6] Although best known for their depictions of the American landscape, both spent crucial years in Europe. Cooper lived in Italy for eighteen months of his seven-year European sojourn (1826–33), while Cole's three-year stay (1829–32) culminated with a sixteen-month Italian visit whose lessons were confirmed by a subsequent trip in 1841–42.[7] Cole's frequent Italian paintings, produced steadily for much of the rest of his life, and Cooper's treatment of Italy in both a novel and a travel book are good starting points for analyzing the implications of American representations of Italy. The significance of their responses emerges clearly in their similar depictions of Florence; my analysis will focus on Cole's *View of Florence from San Miniato* (1837) and Cooper's Florentine sketches in *Gleanings in Europe: Italy* (1838). I will explore here the English patterns of reading, depicting, and consuming Italy that most affected American perceptions, study the works of predominantly male American writers and painters of the 1820s and 1830s, and conclude with Cole's and Cooper's participation in the gendered aesthetics of the Italian journey.

In 1853 George Hillard, a tourist from Boston, commented on the qualities which different foreign landscapes brought out in their visitors. In *Six Months in Italy*, he defines the Alps as

> stern, sublime, and appalling. . . . The traveller's satisfactions are associated with toil and endurance. He must earn all he gets: he must pant up the sides of the mountain, . . . brave the cold of icy summits and sleep in lonely chalets. But a day's journey [into Italy] throws him at once upon the lap of the warm south, where he becomes a mere passive recipient of agreeable sensations. . . . Stretched listlessly upon the

grass . . . an enchanting picture is ever before him. Such scenes, such influences, are not nurses of the manly virtues.[8]

Despite warning against enervating influences, Hillard is comfortable in putting his manly virtues at risk during an extended visit. In characterizing Italy as a feminized landscape with feminizing effects on its inhabitants and visitors, Hillard evoked what, by 1853, had become a cultural cliché. Sandra Gilbert argues that by midcentury the "trope of Italy" as a woman in Anglo-American culture went far beyond the convention of representing nationhood in terms of female figures (such as Columbia) and took on a more "palpable" and "intensely felt" life.[9] This trope became firmly established during the surge of renewed English tourism in the 1820s.

Implicitly defining the Italian landscape as other—apolitical, female, noncommercial, even paradoxically ahistorical—the British perceived the ritual of the Italian journey as an exposure to displaced or repressed categories of experience. This exposure sometimes appears as a risky enterprise in romantic literature and its antecedents, as in the works of Goethe and Ann Radcliffe.[10] But writers and painters generally cooperated with tourists in controlling their contact with the Italian scene through the aesthetics of the ideal. The early nineteenth-century construct of Italy was easier to confront than gender and class differences at home, oppositions that the tour at once escaped and embodied. The recourse to aesthetics was a complex way of encountering difference; by idealizing the other, by labeling the Italian experience transcendent, the tourist was able both to contemplate the antithetical and to keep it separate from the mundane.

The dichotomy of England and Italy mirrors the opposing sets of gendered definitions associated with literature and the visual arts in the eighteenth and early nineteenth centuries. To adapt W. J. T. Mitchell's recent formulation of these definitions, England was the masculine sphere of language, history, intellect, and artifice, while Italy was conventionalized as the locus of the feminine and silent properties of space, painting, nature, and the body—a place outside of history where temporal motion had ceased.[11] Tourist culture in the early nineteenth century was governed by a pair of equations between the landscapes of these two nations and opposing aspects of a bifurcated subjectivity: on the one hand, between the rational (and rationalized) self and England; on the other, between an aesthetic self (the repository of marginalized values) and the Italian landscape. Accordingly England was associated with language, understood as an ordering, determining, controlling force, Italy with visual experience, whose implications could be suggested but not contained by language. These sets of oppositions are present in the works of both male and female travelers, who may, however, position themselves differently in relation to this tradition. Gilbert has described ways in which English and American women experienced the trip to Italy as a recovery of lost aspects of the self, while my focus is on the ways in which touring Italy became touring the other in texts and paintings by men.

The dialectic between these poles is evident in two of the texts which most influenced tourist perceptions of Italy: the fourth canto of Byron's *Childe Harold's Pilgrimage* (1818) and Germaine Necker de Staël's *Corinne ou l'Italie* (Corinne, or Italy,

1807). As critics have noted, these texts informed the consciousness of two generations of English and American travelers, including Cole and Cooper, and significantly shaped their patterns of response.[12] In both works the male protagonist's exile from England is the sign of an alienation from the normative self that leaves him open to an intimate contact with Italy. In some of the most frequently quoted apostrophes in the history of nineteenth-century tourism, Byron defines Italy in two complementary ways. Italy appears as a woman whose beauty has repeatedly invited military and political rape:

Italia! oh Italia! thou who hast
The fatal gift of beauty. . . .
Oh, God! that thou wert in thy nakedness
Less lovely or more powerful.

But he also sees Italy as a bereft "mother" of the arts and religion and of lost "nations":

Oh Rome! my country! city of the soul!
The orphans of the heart must turn to thee,
Lone mother of dead empires. . . .
The Niobe of nations! there she stands,
Childless and crownless, in her voiceless woe.[13]

The other that Italy represents is simultaneously object of desire and point of origin or "mother" of the speaker's "soul," those aspects of his identity that have no place at home. The transgressive behavior of Byron's persona in England, implied earlier in the poem, ejects him from the flow of history ("all was over on this side the tomb" [211]) and enables him to recognize his kinship with a posthistorical, mute, but visually expressive Italian landscape. Giving a voice to "her voiceless woe" offers the speaker a momentary release; he is able to define an alternate country or validating context for his non-English self. At the same time, he perpetuates the image of a passive and silent Italy lying open to the victor's conquest or the traveler's eye, whether hostile or friendly.

Italy gets a voice more directly in Staël's title character, the Italian improvisatrice Corinne, whose Platonic love affair with a Scottish nobleman, Lord Oswald Nelvil, unfolds through a prolonged debate between English and Italian values as the couple tours Rome. Their encounter opens with an explicit inversion of English norms as Oswald witnesses a ceremony honoring Corinne's artistic accomplishments. He is surprised by the adulation of the arts instead of the customary adulation of power and wealth and at the public elevation of a woman instead of the "statesmen" honored in his own country. Corinne's apotheosis occurs at the Capitol, where she displaces the spirit of politics and history that, along with the arts, is associated with the spot.[14] Oswald temporarily relinquishes English habits of perception: "In England he would have judged such a woman severely, but he did not apply any social conventions to Italy" (20).

Unlike Byron's Italia, Corinne does not begin the book as mute or victimized; as Gilbert points out (197–98), Staël was already attempting to reconceive the icon of a

feminine Italy as articulate, as incorporating masculine attributes of expression. But Corinne ends as the picture of "voiceless woe." When Oswald returns to England, he resumes English values, values that Staël presents as admirable: political freedom and order, a strong sense of moral duty, with its concomitant internal repressions, and "the life appropriate to men: action directed toward a goal." He assumes that "reverie is the portion of women." Oswald disassociates his Italian experience from his normal life: "The year spent in Italy had no connection to any other period in his life. It was like a dazzling apparition." And when he is "himself again" (the original is stronger: "Il se retrouvait lui-même"), Oswald obeys the wishes of his dead father and marries an Englishwoman.[15] Corinne proves vulnerable to abandonment, is silenced and dies. Kenneth Churchill notes that nineteenth-century literature conventionally dooms English attempts to establish "fruitful contact with the South" to failure.[16] By returning Oswald to what Avriel Goldberger calls "the unredeemably masculine world from which he comes" (xliv), Staël reluctantly confirms that the masculine sphere of action in the service of reason and history and the feminine sphere of reverie and the arts must remain separate.

In discussing the concept of the aesthetic at the turn of the nineteenth century, Terry Eagleton emphasizes its ambiguous ideological functions for the emerging bourgeois societies of northern Europe. As power moved from centralized institutions to the newly defined independent subject, this subject had to be reconstituted to internalize the law—to act spontaneously in the interests of the political order. To the extent that the aesthetic served to build consensus, it worked as an "effective mode of political hegemony." The aestheticizing of social relations, class and gender roles, for example, made them seem natural. And so, in its ability to produce social harmony through taste and feeling instead of through force, the aesthetic, like a woman, was a "co-partner" to reason, as long as she continued to "know her place." But in taking a "detour . . . through the feelings and senses," in "deconstructing the opposition between the proper and the pleasurable," the aesthetic also granted power to the aspects of experience that middle-class rationalism sought to colonize—the body, the passions, the imagination—and thus mounted an effective critique of authority.[17]

The Italian journey became in Staël's hands just such a detour through the senses staged by the aesthetic faculty for the sake of the rational faculty—by Corinne for Oswald. If aesthetic response in this period provided, as Eagleton argues, the connecting link between abstract reason and the world of the senses, it was either the means by which the gaze could structure this world or a conduit through which the external could invade and destabilize rational perception. Corinne teaches Oswald to see the Italian landscape, but this dazzling vision remains foreign to him, and, to save his identity, which is rooted in the patriarchal dictates of his conscience, he rejects the offer of aesthetic insight.

Together with Byron, Staël injected into the tourist's experience an ambivalent view of Italy. The Italian journey released and idealized marginalized categories of experience. Cole's *An Italian Autumn* (1844; fig. 5.1) represents this pleasurable reversal of English and Italian values. A goatherd turns his back on medieval ruins, emblems of past military and political power, as Bruce Chambers notes,[18] and

5.1. Thomas Cole, *An Italian Autumn*, 1844. Gift of Mrs. Maxim Karolik for the Karolik Collection of American Paintings, 1815–1865, and Bequest of Helen Wood Bauman, by exchange. Courtesy Museum of Fine Arts, Boston.

kneels in spontaneous homage to a painted shrine of the Madonna and Child. The sun's light supports his orientation by streaming through the ruins toward the idealized image of maternity. But seeing the goatherd's posture as a model for the tourist's aesthetic response was both attractive and problematic for American travelers, with their iconoclastic Protestant background. As Neil Harris demonstrated, one American response to Italian art in this period was simply to warn against the dangers of its appeals to the senses. But he also argued that many middle-class tourists, including Cooper, came to see the aesthetic faculty as a "means of engineering consent," of creating deference for hierarchy in the "unruly" crowds of American democracy. Like the theorists Eagleton discusses, these tourists learned "the uses of art as an instrument of social control" and, when they returned home, participated in a "campaign of conservative culture."[19] By embracing and idealizing the visual object, they both acknowledged its power and subordinated it to the transcendent idea it supposedly revealed.[20]

Nevertheless, the tourist's response is usually more complex than the simple closure implied by venturing from "England" to "Italy" and then incorporating the results of this detour back into the bourgeois ideology of "England." As Staël makes clear, the Italian sojourn offers a play of possibilities that cannot easily be integrated back into the premises that shape life at home. Turner's *Childe Harold's Pilgrimage—Italy* (1832; fig. 5.2), painted after his second trip to Italy and at the same time Cole was making his acquaintance in London,[21] indicates the romantic sense of excess in the visual impact of this landscape. Cecilia Powell explains that the painting is a "com-

5.2. J. M. W. Turner, *Childe Harold's Pilgrimage—Italy*, 1832. Tate Gallery, London.

posite depiction" of several Italian locations.[22] The figure of Childe Harold is absent. And the painting does not illustrate any specific episode; instead, the viewer stands in Harold's place and receives a visual summary of canto IV (188). Both contents and structure, derived from Claude Lorrain (168), are conventional for Italian scenes of the period. The painting shows a posthistorical scene in which past activity, represented by ruins, has given way to a timeless pastoral present. Contemporary but generalized peasant figures, mostly women, talk quietly or dance sedately at the center of a landscape shaped by ruins and natural formations. On the ground are musical instruments and containers of food, but no signs of labor. The Claudean structure of the painting reinforces these hints of Arcadian harmony: a pine tree and the gently rising ground on either side frame the view, and a calm body of water in the middle distance reflects a serene sky whose light casts a unifying golden tone over the scene.

The idealizing Claudean structure became the preferred vehicle for displaying and containing those analogous social and psychological categories assigned to Italy.[23] In his study of tourism, Dean MacCannell remarks on the double-edged character of the tourist's nostalgia for the past, for nature, and for societies that seem "outside of historical time." The modern world feels vulnerable to this nostalgia—to its own apparently regressive desires. But instead of promoting capitulation, this yearning exercises "control over tradition and over nature" by recreating them as museums and attractions.[24] The Claudean view—with its distancing internal frame and unifying, tension-resolving light—functioned as the structure of nostalgia. This pervasive mode of composition and perception made the contents of Italy available to English and American spectators even as it asserted the gap between the viewer and the viewed. The convention permits a safe, temporary reversal of the direction of influence; the aggressively rationalizing northerner relaxes into the dreamer

passively receptive to a feminine, nonutilitarian, and instinctual landscape. Tourists insisted on this "willingness to be acted upon, and not to act"[25] as essential to a true experience of Italy. But they also insisted on a more cheerful version of Oswald's inability to absorb permanently the lessons of this "dazzling apparition"; their own posture of nostalgia assured them that this territory, with its antithetical but attractive values, was unreachable—in other words, that it did not demand to be integrated into their familiar world.

Strategies of evoking and containing the pleasurable estrangement of travel in the Italian dreamscape pervaded both popular and elite culture. Giftbooks published engravings of drawings and paintings by well-known and lesser-known artists, including Allston and Turner,[26] and made possible a broadly shared middle-class set of assumptions about Italy. Samuel Rogers, an English writer whose influence was almost as wide in American tourist culture as Byron's and Staël's, effectively presented literary and visual depictions of Italy in the same publication as parallel and complementary products of tourist nostalgia. His edition of *Italy* of 1830, an account of his travels written largely in blank verse, derived much of its popularity from the illustrations he commissioned. Thomas Stothard contributed vignettes of figures (often women and children) based loosely on the sentimental stories Rogers included, while Turner provided a number of Claudean landscapes which Rogers juxtaposed with his own landscape descriptions and with trains of association prompted by historically significant sites. His marketing strategies targeted both elite and popular audiences with a range of expensive and inexpensive editions.[27] Reissued for decades, *Italy* solidified the conventional response to the south. Cole and Cooper, both of whom Rogers befriended in London, probably owned copies.[28]

In this polished sketchbook, the visual and the literary mediate each other's impact; the tourist's textually derived historical memory moderates the power of Italy-as-picture, and the illustrations, along with Rogers's descriptions, emphasize the quiet figures and pastoral scenery that permit the traveler's innocent "surrender" to violent historical associations or to tales of love and revenge. The end of his book brings even the visual aspects of the tour into the orbit of memory. Rogers says that his experiences will be transformed into memories that function as nostalgic works of art. He will "recall to mind . . . scenes" and "Many a note / Of wildest melody" to fend off the anxious northern weather and provide a refuge "While the wind blusters and the drenching rain / Clatters without."[29] In doing so he suggests that *Italy* will function for the reader as the memory of Italy functions for the author—as a contained and private vision, an enabling antithesis to England whose sight allows the observer to bear up under the pressures of life as one of the pillars of a rationalized, masculine, history-making culture.

In the half-articulated iconographical economy of the American tourist, these opposites, once defined, continued to depend on each other for their meaning. England and Italy became mutually reinforcing concepts, perhaps even more distinctly reified by their distance from home. As Nathalia Wright says of a later tourist, "England and Italy composed for Hawthorne twin centers of the civilized world."[30] Cooper

and Cole arrived in Europe as part of a generation of Americans engaged in constructing an elite subjectivity in terms of this polarized vision of cultural identity. Their concern with the relation between viewer and viewed manifested itself in a concern with genre. In conveying the significance of Italy, both media relied on forms that emphasized spectatorship rather than narrative, landscape instead of history, and calm landscapes rather than active ones. These formal habits derived from the different kinds of authority tourists granted verbal and visual experience—England and Italy.

The American England functioned as a sort of cultural superego: the locus of regulative power and authority, at once admirable and oppressive.[31] Cole's often-cited description of his "melancholy" in England, where his contact with the English art world and its institutions proved intimidating and isolating, is one reaction to this perceived atmosphere of judgmental authority.[32] Catharine Maria Sedgwick comments on the impressive "Order" of English society, an order without overt repression but depending nonetheless on an unhealthy caste system.[33] Cooper and Emerson consistently emphasize England's imperial machinery,[34] its "artificial construction" that has utterly transformed the landscape, so that even the geography is "factitious."[35] Emerson connects this imperial control explicitly with the abstraction of language, which, together with military power, extends English definition into other territories: the London Times "by its immense correspondence and reporting seems to have machinized the rest of the world" (21). For Margaret Fuller, writing in revolutionary Rome, English interpretations of events, epitomized in the Times, are not only antithetical but hostile to Italy, both culturally and politically.[36]

As Americans moved from England, the logocentric seat of authority, to Italy, they went from "the head of civilization . . .—a country that all respect, but few love," as Cooper put it (England, 308), to an often mute but visually powerful territory associated with the heart or the unconscious. After his return to Paris, Cooper writes to the sculptor Horatio Greenough, in Florence, of another American traveling in Italy:

> What has become of the [sic] Willis? Is the Eternal City blushing at the honor of his presence[?] Well, let him wander among her ruins, I am a man of too liberal a temper to envy him, though Italy, Master Horace[,] haunts my dreams and clings to my ribs like another wife. The fact is, I do often wish myself on your side, not of the Alps, for that would not satisfy me, but of the Appenines, the naked, downlike, shadowy Appenines—[37]

Both in his joking reference to N. P. Willis's rival travels and in his own expression of romantic desire for the Italian landscape, Cooper indulges in the discourse of tourism in which the landscape figures as a female body. The experience of this body has a lingering impact on the tourist's emotional or unconscious self—it "haunts [his] dreams."

In the 1820s and 1830s the male traveler feels called upon to identify, however anxiously, with England and to understand an Italian tour as a visit to a desirable and complementary counter image. His relationship with Italy is at once intimate—a wife—and distanced, as the necessarily fictional concept of another wife suggests.

Lifted out of his social, political, and economic environment, he is set down in what Louis L. Noble, Cole's friend and biographer, called "a painter's paradise . . . remote from the spirit of politics and money-making."[38] "Remote" from the primary demands of his own culture, from what Cooper calls the "terrible *energies* of trade,"[39] the tourist shifts from one language to another, from that of aggressive analysis to that of aesthetic reception. Looking at Italy is like looking through one-way glass; the "protected witness" does not enter the landscape or participate in its temporal life but passively receives revelations of its eternal significance through the medium of artistic insight.

The implications of Italy raise questions of genre in both media. When Cole leaves England for Italy he is leaving behind the judgmental hierarchy of the Royal Academy for the informal but more productive company of American artists in Florence.[40] But he is also showing his uneasiness with the English generic hierarchy that separates historical painting, whose source and authority is textual, from landscape painting and ranks it higher. Working in Italy reinforces Cole's predilection for landscape; he argues for the equality of these two genres and of their practitioners: "Claude, to me, is the greatest of all landscape painters: and, indeed, I should rank him with Raphael and Michael Angelo. . . . Will you allow me here to say a word or two on landscape? It is usual to rank it as a lower branch of the art, below the historical. Why so? Is there a better reason than that the vanity of man makes him delight most in his own image?"[41] In this formulation, art derived from the silence of nature, from the other's image, assumes an authority usually associated with art derived from written sources, an art which for Cole is potentially narcissistic. His protest at the lower ranking of landscape indicates that Cole experiences the academic discourse on genre as an ideological one, in which power accrues to one form of painting at the expense of another. As Mitchell points out, "The relation of genres [is] . . . like a social relationship—thus political and psychological, or (to conflate the terms) ideological. Genres are . . . acts of exclusion and appropriation which tend to reify some 'significant other'" (112). The dichotomy of England and Italy draws on and reinforces the separation and mutual reification of literary and visual arts. It also highlights the divisions and relations between the genres within each medium: between history and landscape painting or between critical and descriptive writing.

This reification also prompts attempts on the part of writers to bridge the gap, to escape the English uses of language and to approximate and appropriate the visual. A. William Salomone comments on the "pristine ahistorical response" of nineteenth-century Americans to modern Italy; in a period in which Americans produced a wide range of historical writings on other cultures, he notes that "not a single original and influential work was produced in the United States dealing with contemporary Italy." Instead, Americans constructed "an Italy . . . beyond historical time."[42] Daniel Huntington embodied the pictorial version of this construct in his painting *Italia* (1843; fig. 5.3), as a dark-haired woman in Renaissance dress who is gazing off to our left and is in the act of sketching what she sees. In the landscape behind her, as Otto Wittmann notes, are "classic ruins and a Tuscan bell tower,"[43] twin symbols of the pastness of history and the presence of art. Italia is both an

5.3. Daniel Huntington, *Italia*, 1843. National Museum of American Art, Smithsonian Institution.

object of the spectator's aesthetic gaze and a model for the tourist's behavior, which, in its openness to visual impressions and its eschewing of the linguistic aggression of historical analysis, should imitate Italia's.

This ahistorical and apolitical approach to reading Italy shaped the tourist's favorite genre: the sketchbook. Like Rogers's *Italy*, such texts as Longfellow's *Outre-Mer* (1833–34), Henry Tuckerman's *Italian Sketch Book* (1835), and Willis's *Pencillings by the Way* (1835) interweave landscape descriptions with sentimental tales and with generalized historical associations that transform the particularities of historical periods into moral or emotional universals.[44] In Longfellow's sketch of the Coliseum, the present silence of the structure makes him think of its noise and violence in its days as the "imperial slaughter-house"; he launches into an ubi sunt train of reflections, punctuated by Byron's famous line on the statue then known as the Dying Gladiator ("butchered to make a Roman holiday") and ending in a universalizing meditation on mortality: "Where were the senators of Rome? . . . Where were the Christian martyrs? . . . The dust below me answered, 'They are mine!'" (253). This practice of turning history into reverie reinforces the use of visual response to erase historical sequence.

In his avoidance of such sight-dimming associations, Cooper's travel books are deliberately different from those of many of his contemporaries; as his editors say, "He never allows his recollections to obscure his response to ruins as visible objects in a landscape."[45] But his five-volume series *Gleanings in Europe* (1836–38) also shows a segregation of aesthetic and political approaches. Cooper became involved in political and economic debates in Paris, his major place of residence during his European

stay; Robert E. Spiller documents Cooper's close association with Lafayette during the early days of the July monarchy and his resulting writings in defense of republican values.[46] And these concerns are reflected in Cooper's books on France and England. As John P. McWilliams points out, they are critiques of "political structure[s]," while his *Italy* "is a work of personal nostalgia."[47] *England* anticipates Emerson's *English Traits* (1856) in its focus on social and political institutions and in its analytic language; Cooper turns the English tools of analysis on England itself. But in *Italy* he frankly puts these questions to one side. For example, he supports Italian unification but confines some of his most considered political comments to the last few pages, after he has already recounted his own physical departure from the Italian landscape (295–99).

Cooper also separated aesthetic and political functions within his literary uses of Italy. The travel book conveys his visual experience of the landscape in a series of pictorial descriptions that value the eye as the vehicle of truth; indeed, he presses the experiment of relying on the aesthetically educated eye further than most English or American writers of the period do. On the other hand, his historical novel *The Bravo* (1831), set in eighteenth-century Venice, has little to do with his visual experience of Italy but is, as Donald Ringe notes, a political parable for the benefit of his American readers—a parable that warns, among other things, against British forms of aristocracy.[48] Unlike *Italy*, the novel is characterized by abrupt discrepancies between appearance and reality, between what the eye sees and what the mind comes to know, and thus seems to echo Cooper's exasperation with the mystification of such English institutions as Parliament.[49] Cooper assumes that while Italian sites and historical moments may be useful as a stage for the investigation of American and English political issues, the proper genre with which to confront the essential, timeless Italy is not the historical novel but the sketchbook. If northern Europe and America are now the province of time, of history-in-the-making, then southern Europe is the province of space.

This dichotomy, expressed in thematic and generic terms, informs the painterly gaze as well, which conceived of Italy as a world of delightfully inverted values. After a visit to Italy, Robert Weir composed two representative paintings of American and Italian subjects in 1828 and 1829. His famous portrait of the Seneca chief Red Jacket is at once a heroic image of a marginalized figure and an example of the American appropriation of native figures into its own ideology of energetic individualism. The background of sublime natural forces (Niagara Falls and a lightning bolt), as Elizabeth McKinsey explains, corroborates the viewer's knowledge of Red Jacket as a political leader and orator whose resistance to white expansion made him an active agent in the shaping of history.[50] In his *Fountain of Cicero* (fig. 5.4), on the other hand, Weir depicted a feminized landscape; two women talk quietly as they linger at an inscribed fountain that marks the place of Cicero's assassination.[51] They and the area immediately around the fountain, with its regular flagstones, a dozing dog, and the women's polished water vessels, suggest a domesticized space within the surrounding ruins of classical architecture. The masculine activity of statesmen, empire, and oratory is past, and, as in Turner's *Childe Harold's Pilgrimage—Italy*, the women's anonymity replaces the heightened individual identity (for example, of

5.4. Robert Walter Weir, *The Fountain of Cicero*, 1829. Courtesy Berry-Hill Galleries, New York.

Red Jacket or Cicero) Americans associated with historically active cultures. Instead of confronting them head-on, as with Red Jacket, the spectator overhears them. They are oblivious both to the classical past and to the contemporary tourist and seem to exist "out of time."[52]

Taken together, Cole's and Cooper's work represents perhaps the most thorough visual exploration of the Italian landscape in the American tourist culture of the 1820s and 1830s. Central to their efforts is the belief that this landscape is intrinsically ideal, that its composition and atmosphere combine to reveal a transfigured reality. Cooper's comment on a view of Naples serves as an epigraph to his and Cole's approach to Italy: "That bewitching and almost indescribable softness of which I have so often spoken, a blending of all the parts in one harmonious whole, a mellowing of every tint and trait, . . . threw around the picture a seductive ideal, that blended with the known reality in a way I have never before witnessed, nor ever expect to witness again" (111–12). Italy is the site on which natural (real) formations validate cultural (ideal) constructions. Here the contents of Italy undergo their most complete transformation and appear, to the educated tourist's gaze, in a form that invites intimate contact even as it assures him of his ultimate control over the nature of this contact.

Cooper and Cole pay attention to a spectrum of Italian scenes. They depict views which, like Weir's *Fountain of Cicero*, contrast the present, feminized Italy with ruins— the emblems of a past, masculine history. In an extended encounter with the landscape around the Bay of Naples, Cooper presents a series of "pictures" (126)

that mingle the "ravishing" beauty of nature and the present peaceful "movement of life" with relics of past military might ("old castles," 131–32).[53] Cole's landscapes with ruins also focus on the combined triumph of nature and the feminine. He paints a number of views which, as Matthew Baigell notes, juxtapose the crumbling ruins of empire with the immutable forms of distant mountains; they include *A View Near Tivoli (Morning)* (1832), *The Roman Campagna* (1843), and *Mount Aetna from Taormina* (1844).[54] These views often augment the commentary provided by the background mountains with foreground figures engaged in pastoral activity. But both artists also compose scenes which focus on Italia itself, without the pointed contrast of ruins.

Their imaginative engagement with this essential Italy emerges most clearly in their views of Florence. Cole's painting *View of Florence from San Miniato* (fig. 5.5) is both a representation of the romantic Italy and a study of the tourist's posture toward the Italian landscape and toward the silence of visual insight. This panoramic view is a picture of resolved tensions. It represents the possibility of a reconciliation of nature and humanity; as Noble explained, Italy, unlike the virgin American landscape, offered Cole a vision of nature "after long centuries of marriage with man" (110–12). The sunset throws a golden tone across the entire landscape, natural and artificial, "blending . . . all the parts in one harmonious whole." The river leads our eyes back toward the setting sun, as though its harmonizing function were the subject of the painting.

The way in which Cole adapts Claude's structure of nostalgia indicates his faith in the exceptionalism of the Italian landscape, in which "the known reality" does not oppose but rather reveals the "seductive ideal." In composing the painting, Cole

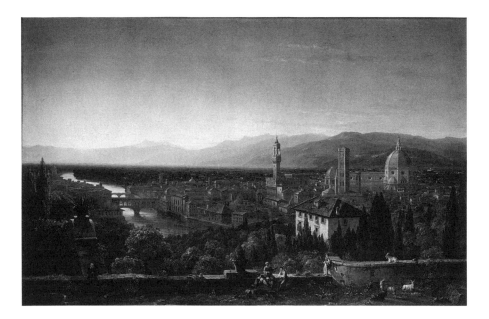

5.5. Thomas Cole, *View of Florence from San Miniato*, 1837. The Cleveland Museum of Art, Mr. and Mrs. William H. Marlatt Fund, 61.39.

COLE AND THE ITALIAN LANDSCAPE

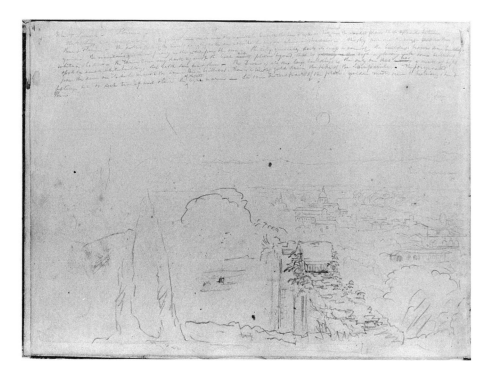

5.6. Thomas Cole, *Florence (left panel)*, 1831–32. The Detroit Institute of Arts, Founders Society Purchase, William H. Murphy Fund.

stays close to the detailed sketch he made on the spot (fig. 5.6). As Elizabeth Ourusoff points out, he does not resort to the convention of the *coulisses*, "the traditional framing devices . . . such as large trees which . . . gave a distinct focus to the ideal landscape." Instead he uses another "cliché"[55]—the wall that runs across the entire foreground. Cole indicates the presence of a wall on the sheet of the sketch but does not yet consider it important enough to draw. In the final painting, the wall emerges as the visible sign of the invisible barrier protecting and privileging the American witness. It emphasizes that the landscape exists for the spectator's visionary benefit, but it also underscores the inaccessibility of this transfigured landscape.

The figures on the wall are clearly symbolic in their function; there is an abrupt disjunction between them and the real people inhabiting Florence, who are merely tiny specks of color in the city's streets. As Ourusoff says, they serve as "an explanatory caption" (18) and mediate between the observer and the transfigured landscape. The figures—a monk, a musician playing to two young women and a young man, and a boy herding goats—suggest that the way into this dreamlike encounter lies through a meditation shaped by religious belief, art, and pastoral values. Together with the wall, they help to define the relationship between the protected witness and the contents of Italy. This aesthetic approach offers the landscape to the tourist but also asks that he temporarily submit to its requirements and permit it to define his subject position. This "detour . . . through the feelings and senses," in

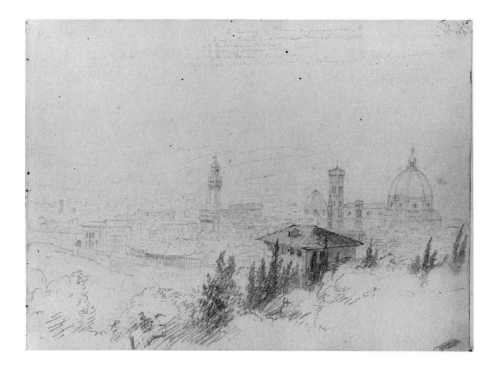

Cole, *Florence* (*right panel*)

Eagleton's words, places on him demands similar to those of Huntington's *Italia*. In order to see Italia, he has to be for a moment like Italia; the male figures on Cole's wall represent feminized pursuits and define the frame of mind through which the observer must pass in order to see Florence. The frames or distancing devices of such landscape representations suggest the gap between the male spectator (or the female spectator in a masculine culture)[56] and the attributes assigned to the feminine other. They also define the threshold between rationalism and aesthetic habits of perception.

If this painting represents Cole's memory of a "painter's paradise," then Cooper's reverie on Florence in "Letter IX" of *Italy* (67–71) is his memory of the aesthetic approach to Italy. He sets his chapter in early summer, when the heat has cleared most foreigners and members of the upper classes (those who live in historical time) out of the landscape. Their absence permits the timeless Italy to compose itself for the lingering tourist. The Coopers' suburban villa places them in a privileged spectator position: "It has two covered belvederes, where one can sit in the breeze and overlook . . . all the crowded objects of an Italian landscape." Cooper gives the reader a "panorama" of Florence and its environs from a nearby elevation. His "view" includes many of the same elements as Cole's in a similar "admixture" of nature and artifice, a harmony made possible by the "sleepy haziness of the atmosphere": "Indeed, everything . . . appears to invite to contemplation and repose. . . . There is an admixture of the savage and the refined in the ragged ravines of the hills, the villas, the polished town, the cultivated plain, the distant . . . peaks,

the costumes, the songs of the peasants, the Oriental olive, the monasteries and churches, that keeps the mind constantly attuned to poetry." The rest of this brief chapter explores the contents of this landscape from the perspective of a "mind . . . attuned to poetry." Other chapters are more characteristic of the sharper Cooper, who checks his submission to this conventionally exotic scene by occasional invidious comparisons between Italy and the United States. But after one such remark ("The town is as hot as Philadelphia"), "Letter IX" unfolds by the logic of association, through strings of sensual responses to sights, sounds, even tastes. For once the language of reverie applies to Cooper as easily as it does to Irving or Allston. As Gaston Bachelard puts it, "The dreamer's being is a diffuse being. . . . The world no longer poses any opposition to him. The I no longer opposes itself to the world. In reveries there is no more non-I."[57] Recourse to the feminine, open-ended pattern of reverie blurs the boundaries between subject and object.

Like Cole, Cooper is preoccupied with walls, with structures that mimic these sorts of conceptual boundaries or thresholds. He recreates the frame of mind appropriate to Italy by recalling a series of glimpses across walls. His villa's balconies provide a view into a walled lane that communicates with a church; this vantage point offers "rare touches of the picturesque. . . . The *contadini* assemble in their costumes beneath my belvedere, and I have an excellent opportunity of overlooking, and overhearing them too." He foregrounds the same kinds of figures that Cole seats on his barrier: figures that represent religious faith, music, and the conventionally pleasant labor of a pastoral landscape. He mentions encounters with "the lower classes," with a priest and a monk, and with a woman, all of whom exist, as MacCannell puts it, "outside of historical time" (77) and in a landscape magically drained of narrative content.

Cooper's acts of "overlooking" and "overhearing" across boundaries play with the dialectic between the privileged and dominant eye, which presides over the open Italian landscape, and the posture of "ravishment" (Rogers, 34), or the fantasy of surrender to this landscape. In an episode which exemplifies the first stance, he hears someone singing in a vineyard: "Getting on a stone that overlooked the wall, I found it came from a beautiful young *contadina*, who was singing of love as she trimmed her vines: disturbed by my motions, she turned, blushed, laughed, hid her face, and ran among the leaves." In this moment of cultural voyeurism, the tourist's gaze signifies power; the singer does not return his look but covers her eyes and runs. On the other hand, he recounts the experience of watching a nocturnal funeral procession as though its beauty and music invade and overwhelm him. The Coopers observe the procession from their balcony and in a receptive posture which seems to allow a provisional reversal of power between subject and object: "Lounging in the clerical belvedere . . . we saw torches gleaming in a distant lane. Presently the sounds of the funeral song reached us; and these gradually deepened, until we had the imposing and solemn chant for the dead, echoing between our own walls, as if in the nave of a church." In this version of the tourist's relationship with Italy, the aesthetic experience is momentarily transforming; the music surrounds the spectators and recreates the Coopers' rooms—their vantage point—as a church.

In their concern for according the sort of aesthetic experience they receive in Italy the highest status, both Cole and Cooper reexamine their period's aesthetic categories, especially that of the sublime. They give the Burkean sublime, whose energy and violence appear in the American landscapes of *The Last of the Mohicans* (1826) and in Cole's *Falls of the Kaaterskill* (1826), a secondary importance and elevate a definition closer to Allston's sense of the sublime as a glimpse into the "supernal source" of all "Harmony."[58] In a late journal entry, Cole makes the case for the "highest sublime": "Not in action, but in deep *repose*, is the loftiest element of the sublime. With action waste and ultimate exhaustion are associated. In the pure blue sky is the highest sublime. . . . We look . . . into the eternal, the infinite—toward the throne of the Almighty."[59] Unlike the divided skies of many of his American paintings, where moving clouds suggest a passing storm, Cole's Italian skies are usually clear. In his *View of Florence*, the serene sky remains above the reach of trees and buildings and performs a benediction on the landscape. While Weir's *Red Jacket* links the "action" of human history with that of natural history in its iconography, the "repose" of Cole's and Cooper's views of Italy transcends both of these forces and points to another concept of power.

Cooper measures his shift in allegiance from one definition of the sublime to the other by contrasting the Swiss and Italian landscapes. He concludes that his advance in taste beyond a preference for the Alps is due to "a long residence in Italy, a country in which the sublime is so exquisitely blended with the soft, as to create a taste which tells us they ought to be inseparable."[60] Rather than equate Italy exclusively with Burke's category of the beautiful,[61] Cooper takes pains to define the Italian landscape as an adult version of the sublime. He attempts to establish "the vast superiority of the Italian landscapes over all others" by distinguishing "the commoner feelings of wonder that are excited by vastness" from the "ideas awakened" in the elite traveler by the Italian scene, which he compares to a "landscape by Claude":

> I can only liken the perfection of the scene we gazed upon this evening to a feeling almost allied to transport; to the manner in which we dwell upon the serene expression of a beloved and lovely countenance. . . . In sublimity of a certain sort . . . Switzerland probably has no equal on earth . . . but these Italian scenes rise to a sublimity of a different kind, which, though it does not awe, leaves behind it a tender sensation allied to that of love. I can conceive of even an ardent admirer of Nature wearying in time of the grandeur of the Alps, but I can scarce imagine one who could ever tire of the witchery of Italy. [132]

A sublimity which inspires love rather than awe is one that departs from the Burkean tradition; nevertheless, by insisting on the word, *sublimity*, Cooper asserts not only the beauty but also the power of Italy, an image which "pour[s] a flood of sensations on the mind" (132) and, like the Burkean sublime, reconstructs the relation between the gazing subject and its overwhelming object. The range of gendered "expression[s]" Cooper finds in the "beloved . . . countenance" reveals his sense of the fluidity of this relation: the bay on a stormy day is "a beauty covered with frowns" (139), while the "*refinement* of Italian nature" is similar to that of "the man of senti-

ment and intellect" (132). Cooper continues to define the "soul" (132) of the Italian other through the erotics of tourism. But in the open-ended play of the tourist's frame of mind Italy sometimes turns from erotic spectacle into a mirror of the self; it has the characteristics not only of a Venus (143) but of a wife and of the cultivated man. In observing these fusions of self and other within the landscape, he seems on the verge of reimagining his relation to the categories of experience Italy signifies.

Emerson defines the contrast between Italy and England in terms borrowed from an eighteenth-century Italian poet: "Alfieri thought Italy and England the only countries worth living in; the former because there Nature vindicates her rights and triumphs over the evils inflicted by the governments; the latter because art conquers nature and transforms a rude, ungenial land into a paradise of comfort and plenty."[62] These extremes present two models for male American attitudes toward nature and such related categories as the feminine: the English promise of paradise through conquest and the Italian promise of paradise in spite of conquest and through submission to a nature that is not rude but civilizing. The dichotomy also implies two models for an elite American self: an energetic individualism that exercises power through the direct action represented by the natural or historical sublime and a refined cultivation whose power is hegemonic, that is, based on an openness to and an ability to use aesthetic or emotional experience. Cooper's anxious ambivalence toward this question in his American fiction and in such characters as Judge Temple in The Pioneers (1823) relaxes into an embrace of the Italian model abroad. Nevertheless, Italy provides the freedom to dream of submission to this scene by affording the assurance that the dreamer retains final control. His remark on leaving the country underscores both his love of this vision and his compartmentalization of it: "I felt that reluctance to separate, that one is apt to experience on quitting his own house" (295). In leaving Italy, he is quitting a domesticized vision of the triumph of nature and the feminine and returning to the public sphere of history and language.

Like Cooper, Cole sees Italy as the idealized alternative to Anglo-American traits. His sense of the ultimate inaccessibility of this alternative may have prompted him to separate pastoral emblems from ruins and to reinsert them, as The Pastoral State and Desolation, into historical time in his series The Course of Empire (1833–36). As William Vance says, it seems unnatural for an Arcadian scene to be "forced into a narrative" (94). In her remarks on "visual pleasure" and film, Laura Mulvey addresses a similar tension between spectacle and narrative; she argues that the presence of the feminine other as spectacle tends "to freeze the flow of action in moments of erotic contemplation," but that "this alien presence then has to be integrated into cohesion with the narrative."[63] In the 1820s and 1830s Italy is the place where the male tourist may suspend his impulse to integrate spectacle into narrative, where he may succumb to "erotic contemplation." But the conventions of tourism also provide ways of managing this contemplation without a coercive recourse to narrative. Drawing on the idealizing modes of nostalgia, tourists compose the cluster of attributes associated with Italy into a canonized museum piece which transcends historical contingency. These conventions of spectatorship educate the viewing subject in responding to the viewed object; aestheticized experience becomes pri-

vatized experience. Contact with this foreign ground, however rich and imaginatively varied, is naturalized as private experience, outside the scope of public life. Once canonized, icons of the feminine other can in turn become tools by which "the man of sentiment and intellect" is able to manage the "flow of action" at home, to reinforce distinctions in class threatened by "the anarchic forces of democracy and materialism."[64] Touring the Italian scene offers a pedagogy of identity in which middle- and upper-class tourists learn to use vision both to encounter and to control difference and, therefore, to reconfirm their function as bearers and shapers of the American social vision.

6

ANGELA MILLER

. . .

The Mechanisms of the Market and the Invention of Western Regionalism: The Example of George Caleb Bingham

Water is a pioneer which the settler follows, taking advantage of its improvements.
Thoreau, *The Maine Woods*

*Thus . . . do these highways of God's own making run, as it were, past every
man's door, and connect each man with the world he lives in.*
Atlantic Monthly (October 1858)

By the second quarter of the nineteenth century the myth of the frontier westerner offered a vigorous alternative to the Yankee New Englander as the quintessential American.[1] Herman Melville voiced a belief widespread among his contemporaries: "The Western spirit is, or will yet be (for no other is, or can be), the true American one."[2] In the eyes of easterners, the westerner was more than simply an avatar of the Yankee: he was a fundamentally new man. This western original called forth new forms of vernacular expression. The impulse toward original expression, however, was countered by a cultural need for containment. The frontier West focused communal anxieties about the dangers of social regression in partially settled areas. Nonetheless easterners wagered upon the probability that western communities would pattern themselves after the East, an investment of faith that helped them to accept the anomalous, potentially disturbing aspects of western society.

Accordingly, the polyglot culture of the early West assumed its place as one phase

in the progressive civilizing of the region, worthy of being documented before disappearing in the coming waves of settlement. From an eastern perspective, the West's assimilation into the body of the nation involved the imposition of a normative and unitary frame of reference within which defiantly local elements could be situated. Easterners authored an image of the West that suited their needs. This eastern strategy carried all the more authority when it was realized by a westerner, as was the case with George Caleb Bingham (1811–79).

Bingham's art and his political involvements were related expressions of a single ambition around which he focused his career: the cultural and economic integration of the West within the nation. Bingham constructed his artistic and political identity out of western materials, but he did so only by first organizing these materials according to a broad social taxonomy. Thus typed, regional peculiarities were subject to a universal natural law that regulated social fluidities.[3] Bingham's western gallery included the Indian, the fur trader, the raftsman, the bargeman, the squatter, the pioneer, the country politician, the patriarch of civilization in the wilderness, and the white woman as bearer of domesticity and as captive of savagery.[4] By means of his social typology, Bingham gave to the West an illusory stability, reconciling social variety with permanence. Within the natural world, types were stable, the individual retaining his or her allotted position within the greater scheme. The imperative to type countered a vernacular vitality in which characters thrived according to their ability to assume, chameleonlike, the colors of their environment. As Johnson J. Hooper's character Simon Suggs put it, "It is good to be shifty in a new country."[5] In place of polymorphous social and sexual identities—confidence-men kaleidoscopically changing roles and appearances, women behaving like men, and hunters and hunted exchanging identities—Bingham offered a social landscape at once exuberantly diverse and reassuringly fixed.

What helped anchor this exuberance was the chosen style in which Bingham worked. In the following analysis I will argue that Bingham's classicizing style served as a semantic code through which to negotiate the competing claims of local and universal truth. Furthermore, what was at stake in this negotiation was the relation of the West as a developing region to the economy and culture of the nation as a whole. The assimilation of the West was carried out on two fronts simultaneously: through trade and an emergent national market and through cultural mechanisms, in this case the forms of high art, that normalized and situated the exotic, the marginal, and the unfamiliar as the adolescent or primitive phase of national identity. Bingham, actively encouraging his region's assimilation through the political promotion of trade and commerce, had also internalized a nationalist perspective as it was shaped and produced in such eastern centers as New York. This perspective, though rooted in regional types (Yankees and pioneers, for instance), was meant to appeal across regional lines. Yet the national as it was being defined in the 1840s and 1850s was ultimately more than the sum of its regional parts. In the instance of genre painting it was defined as a process associated with the market. In Bingham's art economic and artistic forces mirrored one another. Like the civilizing power of commerce, the strategies of style that Bingham adopted promoted the domestication of western character types. Through a form of artistic marketing, the

raw materials of western culture were transformed into finished products for national consumption.

The West in the Emerging National Market: Fur Traders Descending the Missouri

Bingham's Fur Traders Descending the Missouri of 1845 (fig. 6.1) is a peculiarly poignant image of the antebellum West, suffused with longing for a maternal and encompassing wilderness purged of the human violence that so often accompanied settlement. The vision of stasis within motion, wherein nature and men are not adversaries but harmonious partners, is perpetually appealing. Bingham's dreamlike, self-contained world taps a twentieth-century fantasy of a West exempt from the pressures visibly transforming the East throughout the nineteenth century.[6]

Aspects of the painting encourage this view. Fur Traders appears to suppress any references to a world beyond the muffled stillness of the river landscape. Bingham's voyagers seem anchored only by their glassy image on the surface of the river. The horizontal shape of their boat is echoed by the outline of trees along the banks of the river and by the threadlike breaks in its smooth surface. The clothing of the two

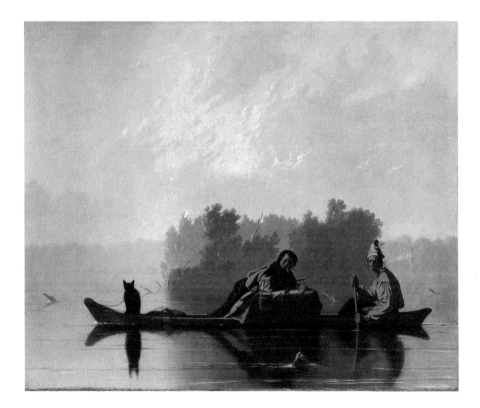

6.1. George Caleb Bingham, Fur Traders Descending the Missouri, 1845. The Metropolitan Museum of Art, New York City, Morris K. Jesup Fund, 1933 (33.61).

figures—the turquoise blue and garnet-red of the boy's shirt and trousers, the salmon shirt of the man—furnishes the only local color in an otherwise tonally unified landscape. The boy's leaning figure and its reflection form a diamond-shape in the center of the composition, accenting the stable grid of horizontals and verticals. The stability of the composition, the accented but gradual tonal modulations, the unruffled calm interrupted only by the smoke from the pipe of the man and the delicate white wake of the river as it is sliced by canoe and log all contribute to an image of the West as pure space, drained of activating motion or energy. Having escaped the tyranny of clock and calendar, this West is shaped by entirely natural agencies. The toil and labor of the passage up the Missouri is forgotten, the trace of labor erased.

Closer study, however, exposes the mythical elements within our own selective reading of Bingham's image. A number of observations about the painting allow us to reassess how Bingham's contemporaries might have read the work in the context of their attitudes and knowledge about the region. The presence of the world beyond his image is exposed in the small fissures that interrupt the airtight, luminous space of the canvas. Fine trails of pigment reveal the workmanship of the artist, calling attention not only to the materiality of the painted surface, but also to the current of the river pulling subject and viewer inexorably beyond the arcadia of the West and back into time and history. The two central figures are themselves agents of economic forces that had by the 1840s actively transformed the West from a wilderness into a source of raw materials for eastern manufactures and international markets. The river's current draws the boat toward its destination in St. Louis and into a larger world of trade that is defined by distant markets, patterns of taste, and abstract conditions of credit, currency, and supply and demand that frame the realities of the western experience.[7]

From the evidence of their cargo, the traders have completed their extractive efforts in the western wilderness and are returning with their goods to civilization, where these raw materials will be transformed into commodities for sale in a national market. *Fur Traders* thus implies its own geographical map, tracing a movement regulated not by nature but by the mechanisms of an emergent market economy. From the Missouri the traders will enter the Mississippi, the nation's spinal column connecting "the regions of almost perpetual snow" with "the region of sugar cane and olive" near the Gulf of Mexico.[8] The still, pristine image of the fur traders is actually part of a much larger continental panorama in which the geography and the economic ambitions of an expanding nation conspire in the movement of goods between East and West, North and South. The wilderness imagery of *Fur Traders* suggests neither aesthetic nor cultural opposition to civilization, but rather a transitory passage through a charmed landscape that is one link in a chain of production.

Fur Traders uses its spatial extensions to quite different ends from the radically planar landscapes of contemporary eastern painters such as Sanford Gifford and J. F. Kensett. Rather than suggesting a finely textured, self-enclosed microcosm of nature in which action and change are stilled, the world of the *Fur Traders* is as keenly exposed by what lies beyond the borders of the frame as by what the image itself

contains. Beneath its surface vision of undefiled wilderness, Bingham's painting reveals its western origins in the central place accorded to humans and to a primitive form of economic activity. His wilderness remains a backdrop.

The artistic autonomy of the image is as much a modern fiction as the autonomy of its subjects. Its horizontality and the absence of framing elements on either side contribute to the impression that the view can be extended laterally beyond the frame. In this respect, Bingham's image mirrors the horizontal, striplike format of the contemporaneous moving panoramas of the Missouri and Mississippi rivers, a popular art form which, like Bingham's art, originated in the West. In 1846, a year after Bingham finished *Fur Traders*, John Banvard completed his "Three mile long moving panorama," which took audiences on a painted voyage down the Missouri and Mississippi rivers to New Orleans and the Gulf of Mexico (fig. 6.2). Bingham may have observed Banvard's panorama in the making and incorporated its innovations into his own pictorial conception.[9] The panoramas, however, far from eschewing overt narrative, structured their voyage around the various phases in the passage from wilderness to civilization. But while their pictorial strategies differed, both Bingham and the panoramists appropriated local materials for nationalist purposes.[10]

Henry Adams has recently proposed that *Fur Traders* had a pendant, entitled *The Concealed Enemy* (fig. 6.3), also painted in 1845, and the same size as the now-better-known painting with which it was exhibited at the American Art-Union that year.[11] Indeed when *The Concealed Enemy* is hung to the left of *Fur Traders*, the two paintings suggest a series of thematic and aesthetic polarities contained within a panoramic continuum of space. The pendant depicts a figure hidden in the bluffs above the river preparing to ambush the unsuspecting traders with their cargo of animal skins.

6.2. Woodcut illustrating the machinery for Banvard's moving panorama, *Scientific American* (December 16, 1848).

6.3. George Caleb Bingham, *The Concealed Enemy*, 1845. Stark Museum of Art, Orange, Texas.

Their dreamy solitude is about to be violently interrupted. Seen from the perspective of its pendant, the wilderness of Bingham's Fur Traders becomes contested ground, the site, in nineteenth-century terms, of a conflict between savagery and civilization, one scene in an unfolding panorama of western settlement. Bingham's nineteenth-century audiences understood *wilderness* as a relative term, a fluid condition within a historical process, rather than an absolute entity. In this redefined context, *Fur Traders* reminds us that it is a mistake to see Bingham's image as a celebration of wilderness. The fact that Bingham chose to represent traders and not trappers further underlines their position within a market nexus.

On another level, *Fur Traders* is a self-representation, portraying a region just growing conscious of its own peculiarities at a time when they were most threatened. Bingham's own artistic identity turned upon this paradox of a regionalism that was itself the product of processes ultimately antagonistic to it. The classic serenity and order of *Fur Traders* would have been an unlikely achievement a decade earlier, for its visual control implies as well a cultural mastery over new lands which Americans had not yet won in the 1830s. Bingham realized a sense of regional character only imperfectly attained previously, at the very moment that regional autonomy was undermined by the emergence of a national market that placed the West in an economically and culturally subordinate position. The sense, in *Fur Traders*, of being

delicately poised between the direct response to frontier experience and the retrospective myth-making of a more self-conscious age, accounts in part for its special quality. If in *The Fur Traders* we witness Bingham actively inventing an image of the West, this image is instantaneously located within an eastern perspective whose creation it is.

Producing Culture in the West

By moderating the polyglot garishness of his subjects, Bingham served the promotional purposes of a regional art attempting to demonstrate its normative qualities and to extend its sympathetic reach beyond a local audience. If his western characters were still a refreshingly far cry from Daniel Huntington's *Sybil* (fig. 6.4), defended by one reviewer as a more appropriate topic for the annual American Art-Union subscription print, they achieved their local flavor and variety of expression within limits drawn by an older aesthetic of decorum and appropriateness.[12] Bingham was an artistic middleman, producing cultural value by transforming western

6.4. After Daniel Huntington, *A Sybil*, 1847. Engraving by John William Casilear. Pennsylvania Academy of the Fine Arts, Philadelphia. Bequest of the John S. Phillips Collection.

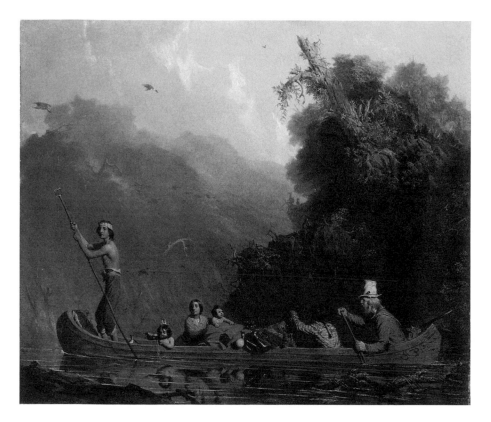

6.5. Charles Deas, *The Voyageurs*, 1845. Rokeby Collection, on loan to the
Metropolitan Museum of Art, New York.

characters into components of national character. This transformation occurred in
the eastern capitals, the centers of cultural production, providing artistic recogni-
tion, critical legitimation, and national patronage.

The degree to which Bingham had by 1845 already exchanged his regional dialect
for an authoritative national language is made evident by a comparison of *Fur Traders*
with a treatment of the same subject by Charles Deas. Like Bingham a westerner,
Deas also enjoyed the patronage of the American Art-Union, although he never
achieved Bingham's fame. The same year as *Fur Traders*, Deas painted *The Voyageurs* (fig.
6.5), which presented a rich spectrum of western types, from the half-breed boy at
the prow of the canoe to his full-blooded Indian mother and his grizzled French
father.[13] In completing the social portrait that Bingham preferred to leave to the
imagination—one based on miscegenation—Deas approached his western mate-
rials in a different spirit from Bingham. The river down which Deas's family of
voyageurs works its way is full of snags and practically unnavigable. The canoe is
wedged between a treacherous foreground of tangled branches and a background
wilderness too rough to inhabit comfortably. In contrast to Bingham's wilderness,
which is reduced to its most essential attributes, the space of Deas's painting sug-
gests not freedom but confinement within a hostile and resistant nature. Deas's

Voyageurs, in brief, offered a different version of the West, one that was discontinuous with the East, hostile, and inaccessible. By contrast, Bingham located the western fragment as part of a national whole, translating exotic tongues into a familiar formal and expressive language.

The National Significance of Rivers and the Geopolitics of Trade

The panoramic format of *Fur Traders* allowed Bingham to explore the relation between the wilderness of the Far West and the commercial economy of the East. The Mississippi and its urban nerve centers, St. Louis and New Orleans, were crucial links in a chain of rivers and harbors by which the bounty of the West was distributed throughout the Republic. Bingham's image is located at the beginning of the process through which a newly forming national economy came to dominate local realities, bringing the peculiarities of western forms of life and work into sharp relief.[14] During these years both the popular arts and easel painting expressed the new relations that were transforming how Americans experienced space. Contemporaneous bird's-eye views of river and harbor, foldout pocket size and full-scale panoramas of New York graphically illustrated the relation between "the great metropolis of this great Republic" and the productive but undeveloped hinterlands of the West.[15] The same impulse that gave rise to these developments also produced the horizontal reach of Bingham's *Fur Traders*. The landscape of *Fur Traders* is completed by piecing together other segments of the trade cycle. This tendency to think and perceive geopolitically was an ingrained part of how Americans, eastern and western both, thought about space.

The painting itself embodies the same process by which western experience was transformed into cultural products suitable for eastern consumption. Bingham had originally called it *French Trader and Half-Breed Son* in place of the more generalized title given the work when it was exhibited at the American Art-Union.[16] Dropping the overt allusion to miscegenation, a fact of western life, the new title assisted in the mythologizing process by which the social specifics of the western experience appeared as picturesque elements of variety—as heteroglossia—modifying a language organized according to universal rules of exposition.[17] *Fur Traders* subtly draws attention to the regional characteristics of the trappers—the Indian features of the son, the colorfully exotic costumes, the bear cub they carry—while muting any elements of aesthetic dissonance. This aesthetic containment becomes a strategy for subjecting the alien features of the West to a formal order that ultimately serves a social vision.

The geopolitical analogue to Bingham's formal order was the continental system of rivers which served Whig apologists for the West as the natural framework for channeling the productive energies of the region into the perpetuation of a national economy and social order. Bingham's effort to assimilate vernacular materials into high art forms and his insistence upon the *representative* quality of his subject matter paralleled the efforts of western Whigs to draw their region into the national fold through the mechanisms of the market. This confluence of economic and cultural assimilation was virtually assumed among western Whigs. Central to their national-

ist discourse was a geopolitics that found in the rivers and basins of the West a necessary guarantee of national unity. This geopolitics also informed Bingham's own most characteristic riverine subject matter.

In a country lacking the technological infrastructure that was so important a component of modern nationalism, the physical and economic integration of an expanding nation depended on natural features, and western rivers furnished the most compelling blueprint for expansion.[18] Market goods would flow along natural channels, creating economic interdependencies that would draw the West out of its regional isolation and tie it to eastern institutions. From the opening of the Mississippi Valley in the 1820s, regional apologetics had therefore emphasized those features of western geography most promising for economic development: its rivers and other natural links as well as its productive potential. John Filson noted in 1784 that the Ohio and Mississippi rivers were "the great passage made by the Hand of Nature . . . principally to promote the happiness and benefit of mankind; amongst which, the conveyance of the produce of that immense and fertile country lying westward of the United States is not the least."[19] The geopolitical faith was premised upon a productive and mutual alliance between nature and culture. The planners of the Republic themselves could not have provided a better guarantee of lasting union.

Given this geopolitical framework, the West, from its first large-scale colonization, evolved within a context defined by eastern economic and social requirements. The East, culturally prior to the West, enframed it from the start. There, American nationalism was actively invented and produced. Western regionalism was itself the ironic product of a successful nationalism that appropriated frontier materials for eastern highbrow culture. Not everything, of course, fell into its embrace, and it was the threatening possibility of a genuine cultural otherness that gave to nationalizing efforts an added intensity.[20]

The success of any nationalist program of expansion critically depended on Americans' ability to understand the relation between part and whole, region and nation, and to visualize abstract economic forces in concrete, experiential terms. It meant firmly grasping how one's peculiar local landscape and daily rhythms fitted within a national economy and culture that was more than the mere sum of its parts. But inevitably such a perspective implied a colonial relationship to the East, both in an economic and in a cultural sense.[21] Herein lay the paradox of western regionalism: the assertion of the West's regional distinctiveness occurred in the context of its culturally secondary status vis-à-vis the East. Bingham remained an outsider with an imperfect mastery of high art codes. He won his fame, after all, as the "Missouri artist."[22]

Expansion complicated the already vexed relation between local and national culture, the problem of how to sustain a sense of shared identity across the enormous barriers of space that resulted from the westward extension of the frontier. One way around such obstacles to nationalism was to imbue the region with national significance. Regional features such as rivers had a continental reach which could be exploited for nationalist purposes. They linked the East, the economic and cultural hub of the nation, to the West, widely proclaimed as the future seat of

empire. Western apologists, anxious to demonstrate their region's economic contribution, as well as eastern nationalists who were concerned about a persistent localism each welcomed trade between the regions, symbolized by rivers. The appearance of a national market made the assimilation of the West both more urgent and easier to accomplish. In theory the market would father a new sense of nationalism, and it was in turn the favored child of this nationalism.

As arteries of trade, rivers were not only the physical instrument of the market, but also the associative link between the known and the unknown, materializing abstract market operations and relating the near to the distant. Such relational identity rested on the notion that the West was incomplete, merely one feature of a national entity that required all its parts in order to work. Relational identity was best expressed through a panoramic treatment that permitted eastern audiences to image the West as a clearly readable element in a larger national puzzle.

Commerce was the key to this new form of inclusive nationalism; it replaced the language of civic virtue that had held such a key place in eighteenth-century republicanism with a quasi-utopian rhetoric of universal market laws:

> Rivers are the progressive and public element in . . . geographical expression. They throw the continent open; they are doors and windows, through which the nations look forth upon the world, and leave and enter their own household. They are the hospitality of the continent—every river-mouth chanting out over the sea a perpetual "Walk in," to all the world. Or again, they are geographical senses,—eyes, ears, and speech; for of these supreme mediators in the body, voice, vision, and hearing, it is the office, as of rivers, to open communication between the interior and exterior world; they are rivers of access to the outlying universe of men and things, which enters them, and approaches the soul through the freighted suggestions of sight and sound. Rivers, lastly, are the geographical symbol of public spirit, the flowing and connecting element, suggesting common interests and large systems of action.[23]

The organic analogy with the human body here fulfills the dream of a fully corporate communal identity, but it also embodies its deepest nightmare—an identity so porous that it loses its discreteness and merges into the oceanic, like the waters of the Mississippi flowing into the Gulf of Mexico. Interiority and exteriority merge. The language of economic exploitation is sublimated within the language of spiritual exchange. Yet this spiritualized access to the interior literally turns the inside out, revealing a mercantile fantasy by which the unknown becomes known, the hidden visible, and the alien domesticated. If coastal and marine views denoted the immensity of the unknown, river views denoted a process by which that unknown could be imaginatively grasped and assimilated, ultimately for economic ends. Through this process of making the unknown known and turning the inside out regional self-consciousness emerged. It developed with reference to the mediating power of the eastern market.

Between the particularities of local experience and the vague generalities of a mystical nationalism lay a gap that the growth of a national market might bridge. In addition, the new rhetoric of commerce between regions exploited nationalist sentiments by promising economic self-sufficiency and independence from Eu-

rope.[24] Rivers were a kind of rhetorical signpost alerting listeners to the nationalistic intentions of the speaker, his efforts to link East and West, a contracted past and an expansive future. The market was the chief historical agent transforming the Missouri and the Mississippi rivers from picturesque regional landmarks into powerful agents of nationalism.

The central place of rivers in Bingham's work can be understood only in the context of this geopolitical discourse. Bingham's colonial status, like that of his region, is evident from the fact that the very regional features he celebrates have value only in relation to economic and cultural centers of production in the East. Bingham was dependent upon the New York–based American Art-Union for the distribution of his prints, so his regionalism was never a purely local product. Equally important, the stylistic codes through which he processed his original regional materials derived from European painting, the medium of exchange with which all frontier materials were assigned a larger cultural value.

Aesthetics and Politics: Bingham's Classicism and Missouri Whigs

During his years of greatest artistic productivity, Bingham was also an active and vocal member of the Whig party of Missouri. Whig political rhetoric disavowed special interests in the name of higher national principles. Bingham assumed this higher ground in his art as well as his politics. Though he represented regional anomalies, he did so believing that the region's future was embedded in that of the larger nation. Herein lay his implicit political program.[25]

In the years from 1845 to 1857, when he painted his finest views of the Mississippi and Missouri rivers, Bingham's involvement with Missouri Whigs revealed his commitment to the larger whole that would develop around a national system of trade and economic integration.[26] He supported the influential Whig statesman Henry Clay in the presidential campaign of 1844. Of his many activities on behalf of the West, Clay was most celebrated as the author of the so-called American System, which committed the federal government to making internal improvements and to adopting other measures that would forge stronger trade and manufacturing links between East and West.[27]

Drawn to classical composition, Bingham was temperamentally averse to rhetorical or painterly flourish. Such stylistic preferences reveal a great deal about Bingham's political vision, demonstrating that for the artist painting and politics were distinct expressions of a common endeavor.[28] This is borne out by the homology between Bingham's balanced compositions and his social and political attitudes. The self-conscious classicism of Bingham's art has been attributed to an autodidact's dependence upon drawing instructional manuals.[29] The planar arrangement of his compositions, the predominance of the pyramid as a means of organizing figures, and the clear perspective grid within which objects are carefully placed reveal his debt to schematic Renaissance prototypes.[30] Such properties of restraint, stability, balance, order, and hierarchy, however, parallel the ideals and social motives espoused by his beloved Whig party. His pyramids contained the variety of western

types within an overall order in a manner that is structurally analogous to the way in which the federal perspective of the East contained and organized the heterogeneity of western life.[31]

Kenneth Lynn has noted a similar relation between style and political preferences as a feature of the so-called Southwestern humorists: Augustus B. Longstreet, Thomas Bangs Thorpe, Richard Malcolm Johnston, Johnson Hooper, Joseph Baldwin, and others who came to national attention by publishing their stories in the New York magazine *Spirit of the Times*, edited by William T. Porter. Like Bingham, these writers were Whigs, yet their connection with Bingham has been overlooked by the existing scholarship. Their uses of vernacular materials and their national perspective, however, offer insights into the broader relation between stylistic strategies and political intent among those involved with western materials.

Lynn's collective profile of the Whig humorists fits Bingham as well: "The ideal Southwestern humorist was a professional man. . . . He was actively interested in politics . . . well educated, relatively speaking, and well traveled." As a type he combined a sense of humor with "a notoriously bad temper." Lynn's group tended to be what he termed southern patriots. They were skeptical of the democratic mob and associated with the Whig party nationally.[32] The description recalls Bingham's personality—he was politically ambitious, proud, and irascible—as well as his politics. His ideal of temperateness, balance, and harmony was evident in his admiration for Clay, "the great compromiser."[33] Like the Southwestern humorists, Bingham rose to national prominence as a western artist with a regional accent. The American Art-Union promoted him as the *Spirit of the Times* promoted the humorists. Both organizations were based in New York, enjoyed a national circulation, and recognized the possibilities of regional materials.

Essential to the appropriation of western subjects by eastern culture was the device of framing. Such framing, according to Lynn, was "the structural trademark of Southwestern humor." What functioned as the frame in the work of the Southwestern humorists was the literate, cultured voice of the Whig narrator, based upon the Addisonian style of such eighteenth-century publications as *The Spectator* and *The Tatler*. This frame acted, in Lynn's words, as a "cordon sanitaire" roping off the narrator (and by extension the audience) from the rough-and-tumble world of the vernacular, separating cultured speech from dialect.[34] This formula helped maintain aesthetic, stylistic, and social distance from the anarchic elements of the frontier and preserved the fiction that the framing narrative controlled the dispersive energies of its vernacular subjects.

In Bingham's case, stylistic conventions and the formal order through which he organized his frontier materials served an analogous framing function. Like the narrative voice of the literate "Self-controlled Gentleman," these devices signaled Bingham's participation in the elite culture of European high art and removed him from identification with his frontier material.[35] Thus removed, Bingham, like his literary counterparts the humorists, drew his inspiration from the West—the most authentically American region—without sacrificing a nationalist breadth of vision and disinterested pursuit of the larger good. The riverboatmen, squatters, and backwoods politicians that humorists and artist shared as subjects testified by their

very existence to the need for a larger governing authority, to be furnished, it was supposed, by Whig leadership.[36]

Bingham, however, was by no means a disinterested or neutral observer of western life, as at least one scholar has maintained.[37] While he was quick to exploit the identifying features of western life and landscape and its peculiar inhabitants, they measured for him the region's difference from the East and in turn its progress toward bridging that distance.[38] In one instance at least, when Bingham used a buffalo as a humorous allusion to the power and energy of the Whig party, these signs of difference became symbols of identity.[39]

Bingham obliged the critical effort to elevate his art to national status by filtering out strongly flavored western mannerisms, echoing Renaissance and classical figural types, and constructing a visually clear and readable formal armature for his figures.[40] Apparently, however, not everyone agreed on the nationalist virtues of his art. A notorious attack on Bingham in the *Bulletin* of his erstwhile patron the American Art-Union provoked him to threaten a lawsuit: "[William Sidney] Mount," this critic asserted, "is the only one of our figure painters who has thoroughly succeeded in delineating American life. . . . Bingham has made some good studies of western character, but so entirely undisciplined yet mannered, and often mean in subject, and showing such want of earnestness in repetitions of the same faces, that they are hardly entitled to rank."[41] Attacks on Bingham typically focused upon his vulgar subject matter, his lack of skill, and the artificial quality of his compositions. Patrons of American art in both East and West preferred their images of common life "divested of everything like vulgarity," as one St. Louis writer put it.[42] Yet if certain critics found Bingham's art stilted and mannered, others responded to his skill in rendering the essential qualities of western character. A St. Louis notice wrote of "BINGHAM,—well-known in the East as the Missouri Artist, and being 'par excellence' the American Artist" as the originator of a "now rapidly forming School of pure American Art. He has no occasion to copy the old masters, for their genius is original in himself. He himself is a Master—one of the New Masters."[43] Bingham's critical reputation in the 1850s evidently suffered from a certain confusion of codes resulting from his efforts to translate a dialect into the lexical and semantic conventions of the King's English. For some his approach was unsuited to the subject, while for others his classicizing was what made his subject matter palatable.

The praise Bingham received contains a paradox: only insofar as local characteristics could be subsumed into a larger composite national character type could they be exploited as distinct regional features. The fascination with regional peculiarities before the war was doubled-edged, for while they were markers of place, signifying a proud localism, they could easily be turned against the region by condescending easterners as damning signs of provincialism. Mount and Bingham—two artists as noteworthy for their differences as for their similarities—were lauded by critics for their American qualities precisely because they succeeded in transforming local elements into pictorial types that fitted the established taxonomy of national character.[44]

The defense of Bingham's art that best served the patronage interests of the American Art-Union turned upon the transformation of "characters" into "charac-

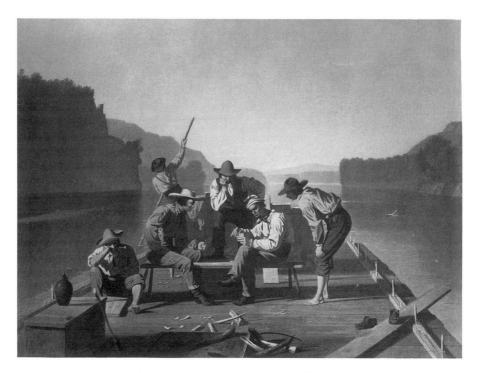

6.6. George Caleb Bingham, *Raftsmen Playing Cards*, 1847. St. Louis Art Museum, St. Louis, Missouri. Purchase: The Ezra H. Linley Fund.

ter." Discussing *Raftsmen Playing Cards* (fig. 6.6), *Jolly Flatboatmen* (fig. 6.7), and *Stump Orator*, a reviewer for the *Bulletin of the American Art-Union* praised them as "thoroughly American in their subjects," showing a "striking nationality of character, combined with considerable power in form and expression," qualities that "interested the Art-Union . . . notwithstanding the existence of obvious faults." The patronage of the art union had nurtured in Bingham's art "the higher qualities of *character* and *expression* and *general form* which first attracted the attention of the Committee."[45] Both western and eastern reviewers were drawn to the manner in which Bingham preserved with "ease and naturalness . . . [western] characteristics of dress and countenance, and of posture and attitude, yet did so in a manner that avoided the twin shoals of eastern condescension and western exaggeration, or 'carricature' [*sic*]."[46]

The original edition of Noah Webster's dictionary (1828) gave nine definitions of the word *character*, and these reveal a basic ambiguity about whether it was something inscribed by culture or transmitted by nature. The word's primary reference was to printing: the marks "made by cutting or engraving . . . with a pen or style, on paper, or other material used to contain writing" or to the letters or figures used "to form words, and communicate ideas." A second meaning, however, turns upon "the peculiar qualities, impressed by *nature* or habit on a person, which distinguish him from others," referring either to human nature or to the nature that cultural apologists began pointing to in the early nineteenth century as the source of the most distinctive features of national character. *Both* meanings informed the

nineteenth-century concept of national character. The notion of inscription is implied in the originating act of creating a republic through a written constitution. Yet the Constitution could not alone give rise to national character, which would evolve only as the product of an organic relation to place. As the concept of national character developed, it carried with it the lexical reference to both an inscriptive and a natural origin contained in Webster's definition.

This dual definition, which included both the artificial and the natural, projected two different attitudes toward the role of the American artist in the emergence of national identity. The first definition implies a more active role for art and literature in creating national character through artistic inscriptions, by means of a distillation and synthesis that would draw upon an older classical language of types.[47] The second invested the artist with the role of transcribing nature. This ideology of a natural or transparent language was the basis of Bingham's claim to originality. Yet it blurred the extent to which he relied on older formulas to articulate new materials, thus containing their fluid meanings.

Bingham, like so many of his eastern contemporaries, appealed to nature to legitimize his art. At the same time, however, his art referred, through its stylistic codes, to the legitimizing force of European tradition. His style combined the *appearance* of originality with a readability derived from familiar formulas. Herein lay

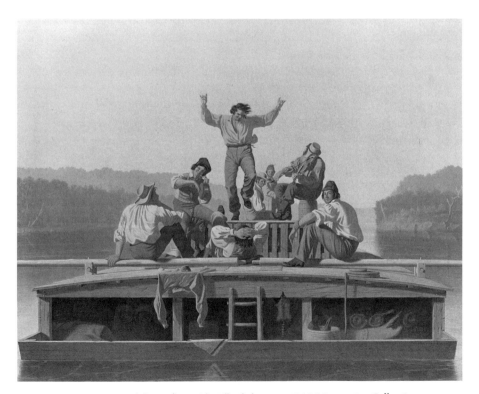

6.7. George Caleb Bingham, *The Jolly Flatboatmen*, 1846. Manoogian Collection. Photograph, Dirk Bakker.

one source of the contradictory assessments that contemporaries made of his art. The concept of character was served by certain stylistic codes derived from eighteenth-century academic theory.[48] Character implied decorum, a harmony of parts in which no discrete element was overly assertive. At the same time, character as the product of the American environment, a natural outgrowth of the soil, carried the added burden of originality or *difference* from European traditions. The use of authoritative codes of meaning and the resort to claims of originality confront one another in Bingham's art and help explain the contradictory criticism he received. In addition, they mirror the dual status of Bingham's subject matter. His characters evolved within a national repertoire of types that derived their authority from their local origins, their status as originals. Yet what defined them as types within academic theory also compromised their claims to originality. Bingham's self-conscious employment of European stylistic formulas, in tandem with the rhetoric of originality and of a natural art, for a while served the needs of eastern producers of culture by distancing them from charges of frontier barbarism at the same time that it permitted them to capitalize on the distinctive national (that is, non-European) features of their own emergent western culture.[49]

As Lillian B. Miller has pointed out, concern for national character was strongest in areas where national unity was central to economic development—as in the Northeast and the West.[50] The reasons for this emphasis upon the national status of regional features, however, had to do also with the perceived external and internal antagonists of American nationality. The American Art-Union's rhetorical insistence upon national qualities palliated persistent anxieties about the country's culturally colonial status vis-à-vis Europe.

The American Art-Union appreciated Bingham for another reason: his art preserved passages of a western social landscape that he and his patrons both knew was ephemeral. He offered visions of a West whose strangeness, no longer threatening, was now an animating and colorful addition to the cast of national character types. But in the process, he cleansed his subjects, heightened their impact, and dispelled through visually graphic qualities any indistinctness of feature that might prevent easterners from forming a fully developed mental image of westerners. Bingham's characteristic visual simplification, in short, assisted easterners' efforts to understand and locate the West.

The emphasis upon national over local also deflected regional, racial, and class differences by insisting upon an invented, composite identity that absorbed internal divisions. Beginning in the late 1840s and continuing into the 1850s, the deregionalization of the West and a corresponding emphasis upon the national, historical status of western subjects were characteristic strategies for counteracting a sense of regional difference. Bingham divested his western characters of those qualities that easterners, along with western Whigs, wished to downplay: the social marginality and lack of nobility resulting from the harsh poverty of western life. The riverboatmen that Bingham had encountered as a child in Franklin, Missouri, furnish an example. In his representations, their vaunted high spirits were unaccompanied by the brawling, eye-gouging, drunkenness, loose morality, and other behavior which terrorized respectable townspeople and which, to judge from contemporary ac-

counts of these men, constituted their most memorable qualities. Describing the river towns of the West prior to the introduction of the steamboat, James Hall painted a picture of "proverbially lawless and dissolute" boatmen who indulged "in every species of debauchery, outrage, and mischief." These "despots of the river," hostilely aligned against the peaceloving townspeople, were eventually doomed by the introduction of steam, which "at once effected a revolution." The captains of steamboats were "men of character" representing the new reign of commerce and property along the Mississippi that swept away barbarism and disorder.[51] By the later 1840s, the riverboatmen were picturesque relics, furnishing suitable subjects for a national audience and ready to receive the imprimatur of the art-union.

In offering such resolutely western subjects to a national audience, Bingham presented them within a stable matrix of forms. Through his balanced mise-en-scene and his carefully controlled disposition of figures, Bingham combined variety of type, which gave a savoring of authenticity, with a highly controlled formal order.[52] The words he used to describe the principles of the popular Düsseldorf school apply equally well to himself: "a freshness, vigor and truth, which captivates those of common understanding and is none the less agreeable to minds of the highest cultivation."[53] He was rewarded with critical acceptance and praise for his truthfulness:

> He has not sought out those incidents or occasions which might be supposed to give the best opportunity for display, and a flashy, highly colored picture; but he has taken the simplest, most frequent and common occurrences on our rivers—such as every boatman will encounter in a season—such as would seem, even to the casual and careless observer, of very ordinary moment, but which are precisely those in which the full and undisguised character of the boatman is displayed.[54]

Over the course of the nineteenth century, apologists for American art transformed the academic opposition between the particular and the universal into an opposition between the local and the national. Bingham himself fully recognized this distinction and put it to work on his own behalf. In ordering changes that he wished his engraver Sartain to make in his County Election, he specified, "The title of the newspaper in the extreme right hand corner of the picture, I wish you to change, so as to have in print 'The National Intelligencer' instead of 'Missouri Republican.' There will then be nothing left to mar the general character of the work, which I design to be as national as possible—applicable alike to every Section of the Union, and illustrative of the manners of a free people and free institutions."[55] Here, what qualified a subject as national rather than local was the delineation of democratic institutions common to the entire country rather than idiosyncratic local customs and habits.[56]

The solution to the problem of relating the local to the national, for Bingham and for nationalist critics, was not the elimination of regional differences, but their clear placement within a landscape that balanced variety and detail with formal and narrative unities. For Bingham, the challenge to artistic propriety was not in too little but in too much variety, which threatened a tyranny of the local. The loss of cohesion resulting from what Reynolds called "a partial view of nature" paralleled the

threatened loss of social cohesion resulting from the leveling force of the frontier.[57] The centrifugal pressure of expansion, bringing with it the development of local cultures remote from the East and the erosion of social and racial distinctions, threatened easterners' sense of order, an order implicitly asserted in the concept of a national art. Squatters, border ruffians, bushwhackers, and jayhawkers refused to stay put, transgressing not only the all-too-permeable borders between states in the aftermath of the Kansas-Nebraska Act, but moral, social, and racial borders as well.[58]

The mixed, hybrid character of the West proved consistently troubling for easterners, who saw in its social fluidity a projection of their own anxieties over the mysteries of social identity in the city. In *The Confidence-Man* of 1857, Herman Melville vividly captured the peculiar quality of the West as a place of promiscuous social and racial mixing. The social landscape on the decks of the steamboat ironically named *Fidèle* becomes for Melville a microcosm of the West:

> Natives of all sorts, and foreigners; men of business and men of pleasure; parlor men and backwoodsmen; farm-hunters and fame-hunters; heiress-hunters, gold-hunters, buffalo-hunters, bee-hunters, happiness-hunters, truth-hunters, and still keener hunters after all these hunters. Fine ladies in slippers, and moccasined squaws; Northern speculators and Eastern philosophers; English, Irish, German, Scotch, Danes; Santa Fe traders in striped blankets, and Broadway bucks in cravats of cloth of gold; fine-looking Kentucky boat-men, . . . Quakers in full drab, . . . slaves, black, mulatto, quadroon; modish young Spanish Creoles, Mormons and Papists; . . . hard-shell Baptists and clay-eaters; grinning negroes, and Sioux chiefs solemn as high-priests.

Melville assaulted eastern genteel desires for social containment with a vision of the West dizzying in its profligate variety. From an eastern perspective, Melville's West was a nightmare of the border condition.[59]

Bingham's revulsion at such frontier types as the squatter reveals his own deep discomfort with such social liminality—the western tendency, that is, toward shiftiness. Squatters, distinct from frontiersmen, were widely perceived as the undisciplined, socially volatile residue of the so-called barbaric stage of settlement, little better than the Indians they replaced.[60] The figure of the squatter also raised the broader issue of local versus national determination over the future of the West, an issue that flared into warfare with the passage of the Kansas-Nebraska Act of 1854, which placed the decision about slavery in the hands of the local "sovereigns."

The contrasting eastern response to two frontier figures—Davy Crockett and Daniel Boone—reveals what was at stake in the eastern assimilation of the western materials which filtered into eastern literary markets beginning in the late 1830s. Davy Crockett, the epitome of frontier humor, was a character who celebrated the unassimilated West, distinguished by grotesque exaggeration, hyperbole, bawdy irreverence, and a brash mockery of genteel sentimentalism. In 1833, the *Knickerbocker Magazine*, in a tone of good-humored tolerance, acknowledged him as an aspect of "the only indigenous literature we possess." The reviewer condescendingly located the Crockett myth for readers: "The Wits of every country have their butt; the English have their Irishman, with his 'bulls, blunders, botheration and blarney;' the French have the Gascon, with his contrasted points of magniloquence,

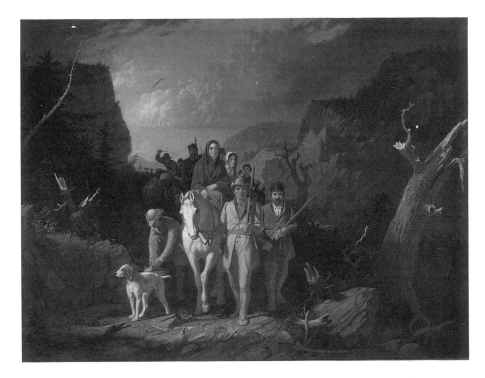

6.8. George Caleb Bingham, *Daniel Boone Escorting Settlers Through the Cumberland Gap*, 1851–52. Washington University Gallery of Art, St. Louis. Gift of Nathaniel Phillips, Boston, 1890.

and good-for-nothingness; and without multiplying examples, why should not we have the Backwoodsman, who can grin the bark off a tree, whip his weight in wildcats, and whisper a little louder than the thunder."[61]

By contrast, Daniel Boone, another quintessentially frontier figure, represented national interests.[62] His struggle with the wilderness and with barbarism was made in the name of civilized institutions.[63] He was "an instrument ordained to settle the wilderness."[64] In the years following his death in 1820, Boone of Kentucke became well established in western mythology; through his deeds the region earned the designation of "classic ground," precisely what it could never have become had it remained in the hands of such antiheroes as Crockett.[65] The representative status of such figures as Boone rested on their key place in the larger drama of nation building.

Bingham became Boone's self-appointed hagiographer. Although he painted only one oil directly inspired by the Boone legend, it remains a key statement of Boone's meaning for a national audience. In Bingham's *Daniel Boone Escorting Settlers Through the Cumberland Gap* (fig. 6.8), 1851–52, the patriarch of the West appears as an Old Testament figure leading his people into the wilderness.[66] An episode in the settlement of the American wilderness is associated with the biblical exile of Moses and his people, in which hardship and sacrifice are the prelude to the Promised

Land. Bingham's Boone acts out a drama whose real significance is revealed only from the vantage point of the present generation. Boone is an agent of the future, neither simply a colorful character in the local history of the region nor a quaint ancestral presence. The pyramidal group of figures he leads, supernaturally lit by a glow that sets them apart from the dark, howling wilderness that surrounds them, represents the progressive sequence of frontier types, from pioneers to pastoralists to farmers.[67] As a western hero, Boone answered Bingham's preference for subjects which both typified the West at a particular stage in its history and foreshadowed its key role in national development. The national status of the Boone myth in Bingham's mind is evident in his proposing the subject again for the nation's Capitol.[68]

In casting Boone as the harbinger of a new order, Bingham characteristically aligned himself with an eastern perspective, articulated by the archcustodian of culture, Henry Tuckerman, in an essay entitled "Over the Mountains, or the Western Pioneer." Tuckerman constantly reminded his audience of the framework of meaning that situated the "picturesque locality" of the West within a larger historical panorama. Boone, prototype of the pioneer who came "to clear a pathway, build a lodge, and found a State in the wilderness," linked past and future.[69] Tuckerman claimed Boone as the property of a national audience: "As related to the diverse forms of national character in the various sections of the country, as well as on account of its intrinsic attractiveness, the western pioneer is an object of peculiar interest." This claim is later followed by a plea for artists and writers to preserve the passing frontier, a plea that his contemporaries were sounding as well for the equally transitory wilderness and for the doomed native American. Tuckerman observed that "in the natives of each section in whom strong idiosyncrasies have kept intact the original bias of character, we find the most striking and suggestive diversity." Lest his readers mistake this statement for an affirmation of localism, Tuckerman explained the deeper significance of Kentucky as better suited "to represent the national type, than any other state." Boone, her most exemplary citizen, embodied many of the qualities that Tuckerman found represented in Kentucky as a whole, combining "the essential features of a genuine historical and thoroughly individual character."[70] Boone's western qualities, in short, were balanced by those characteristics that demonstrated his role in the national drama of implanting civilization in the wilderness.

Tuckerman's use of the term *historical* in this context reveals certain assumptions that shaped the significance of regional features in the West. Boone was a historical figure in at least two senses: he not only played a key role in opening the territory to settlement, but his place in history was assured. *Historical* here implies both retrospect and prospect: that which shapes history and determines its subsequent course. Those who wrote about the West, Timothy Flint, for example, saw their task not only as recording the local histories of the region but also, more important, as discovering the hidden order in the thicket of events that gave meaning to history. The design within Kentucky's history was the familiar pattern of the pioneer-emigrant laying the foundation for western community, often against great odds. Boone epitomized this figure. The myth that grew up around him gave him a central

role in reshaping the virgin territory of the West according to a preordained march of progress. Those whose performances did not fit neatly into this structure were not properly historical actors, but minor characters affording entertainment and local color. What made Boone a historical figure disqualified Davy Crockett (in his pre-Alamo days) from the honor. Crockett was himself too much a product of the frontier to be an emissary of the civilized order.

Tuckerman's use of the term *historical*, in short, was prescriptive, conforming to a narrative whose general outlines and final resolution were already established, in theory at least. The latent meaning in the discrete stages of western history was the prescribed place of the West in the larger destiny of the nation. The wayward, the circumstantial, the eccentric dropped away or were absorbed into local lore and custom—small eddies that failed to obstruct the broader flow of events.

Others turned to the West, ironically, as an antidote to the localism that still prevailed in the older states. In the western wilderness, bedrock traits of character, according to James Hall, would prevail over local eccentricities: "Take the Virginian from his plantation, or the Yankee from his boat and harpoon, or from his snug cottage, his stone fences, his 'neatly white-washed walls,' his blooming garden and his tasteful grounds, and place him in a wilderness, with an axe in his hand or a rifle on his shoulder, and he soon becomes a different man; his *national character* will burst the chains of local habit."[71] The implications of Hall's analysis are significant for understanding the role of the West in the developing sectional allegiances of the 1840s and 1850s. It served in theory as a tabula rasa on which the most deep-seated character traits of the American, uprooted from ancestral soil, would be figured uncompromised, an idea resembling the later so-called Turner thesis presented in 1893. In the West no region had priority. The superficial differences distinguishing "the Boston merchant" from "the Virginia planter" would fall away under the influence of the new environment.[72]

In practice the case was quite otherwise. Almost from the start the blank slate of the West was inscribed with the calculus of gain. The quasi-mystical emergence of the real American spirit, the slaking off of the inherited skin of habit and custom, took place primarily through mythical reenactments of western reality. What the eastern emigrant found at the end of his journey was that the communities on the frontier tended to confirm local prejudices. All the more reason, then, that emigrants would prefer to view the varieties of western culture through the legible types and forms of high art, a reminder of the world they had left behind.

In the increasingly dis–United States of the midcentury, the political, social, and economic rift between North and South was symbolically bridged by the West.[73] Increasingly the West served as a metonymy for the nation—a part standing for a larger whole—containing the promise of its future. The geopolitics of trade and the cultural custodianship of the East, encouraged by westerners anxious to assist in the assimilation process, seemed to be succeeding. Even frontier violence and liminality, the very measures of the West's cultural otherness, played a role in domesticating the West, familiarizing it with bourgeois tastes and standards.[74] Bingham addressed eastern anxieties about the new region by framing his subject matter in

the codes of high art and using formal homologies to signify the domesticating power of commerce and culture. His art embodies the ironies inherent in the formation of regional consciousness: awareness of place emerged in relation to market forces that both furnished the structures and language through which the region presented itself to the East and assured a process of economic and cultural assimilation that was ultimately antagonistic to localism.

7

DAVID LUBIN

· · ·

Lilly Martin Spencer's
Domestic Genre Painting
in *Antebellum America*

Among art historians, a new connoisseurship has replaced the old. *Connoisseur:* an expert; one who knows, who speaks with authority; who understands the techniques and principles of an art and is competent to act as a critical judge. The old connoisseurship was the practice of passing judgment on art or artist according to aesthetic criteria: a work was good or bad, original or derivative, refined or vulgar, graceful or awkward, and so forth depending upon how it measured up to a supposedly timeless and universal set of standards. Since the 1960s connoisseurship of this stripe has been discredited by Marxism, feminism, postmodernism, and even liberalism engaged in the legitimation of cultural pluralism: all of these parties, despite their varied, sometimes antithetical agendas, have agreed that a single standard of aesthetic value is insupportable.

What I am calling the new connoisseurship is a replacement of aesthetic judgment by moral or political judgment. Nowadays when a work is said to be good or bad, its social utility or ethical propriety is often what is being judged rather than its fidelity to universal aesthetic principles. Instead of discriminating between the refined and the vulgar, the new connoisseur must decide whether a work or an artist is to be condemned as hegemonic or praised as subversive, censured as surveillant and disciplinary or credited for being resistant and counterideological. The symbolic apparatus of the old-style connoisseur was the monocle and white gloves; the new connoisseur, symbolically speaking, wears X-ray glasses and writes with a raised fist.

The art of Lilly Martin Spencer, the most popular and widely reproduced female genre painter of mid nineteenth-century America, creates little problem for the old-style connoisseur but a great deal of it for the new. That is, from a modernist or formalist point of view, Spencer's work is simply and self-evidently bad, and that's all there is to it. For that reason, during the days that the old connoisseurship held sway, virtually no one took her art seriously enough to bother writing about it. On those rare occasions when Spencer was mentioned, as in this comment from a social historian of American art in 1950, the need to make aesthetic judgment remained irresistible: "*This Little Pig Went to Market* [fig. 7.1] shows a mother and baby being ostentatiously happy in the midst of an amount of detail which would quickly produce boredom except for the fact that the painter herself was fascinated with it and with her own knack of making it stand out with an extra degree of sharpness. The shiny brilliance of all textures, and in particular the sugary glossiness of what is supposed to be flesh, are amazing."[1]

Ever since the rediscovery of Spencer in the 1970s (initiated by her inclusion in the *Notable American Women* encyclopedia and by a retrospective of sixty-eight of her works at the National Collection of Fine Arts), the aesthetic deficiency of her art has

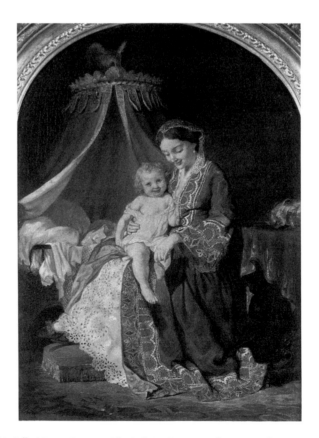

7.1. Lilly Martin Spencer, *This Little Pig Went to Market*, 1857. Ohio Historical Society.

generally, if only implicitly, been conceded, and discussion has focused instead upon her difficulties in earning a living as a professional female artist in a male-dominated art world.[2] Minimizing issues of quality concerning Spencer's oeuvre, such discussions emphasize that as a woman who gave birth to thirteen children, seven of whom survived to maturity, she heroically maintained a bustling household while also supporting it financially, her husband, Benjamin, taking the subordinate role of assisting his wife in daily chores around hearth and studio alike.[3]

But such discussions have tended to finesse the apparently conservative nature of Spencer's oeuvre. To contemporary eyes, her art appears reactionary, both in terms of its family values content, with idealized children, Madonna-like mothers, happy housewives, and lovably inept husbands, and its sentimental rhetoric apotheosizing motherly nurture, the beauty of domesticity, and the homey humor of family life. Regarded in this manner, Spencer's sentimental approach to the depiction of mothers, fathers, kitchen-workers, and children seems to have been complicit with furthering or "reproducing" systems of domination of mid nineteenth-century American women, those who were the main subjects of her work if not also its chief consumers.

My purpose here is to bring Spencer's artistic production back under scrutiny, but neither for purposes of proclaiming it admirable in light of the special struggles facing a female artist nor to castigate it for its alleged promulgation of bourgeois ideology. Instead of acting as a political connoisseur, passing judgment on the rightness or wrongness, social progressiveness or conservativeness of Spencer's work ("was she or wasn't she a progressive? only her revisionist knows for sure"), I want to examine the formal and iconographic devices of this work and consider the diverse and sometimes contradictory ways in which it took part in the class and gender conflicts of its era.[4] This is not an attempt to achieve a value-free analysis. But the effort to stave off blunt political or ideological categorizations of an artist's work is not the same as pretending to be value-free. It is, instead, an attempt to see with complexity and specificity, to understand modern culture's multitiered, multidirectional operations. It is an attempt to think dialectically about the intersection of elite and mass culture in mid nineteenth-century America as exemplified in the work of this particular artist and about the clash, during the same period, of religiously orthodox, bourgeois liberal, and socialist-feminist views of women and their place in the nuclear family.

The starting point, then, is the presupposition, as Michael Denning puts it, that "mass cultural artifacts are at one and the same time ideological and utopian, and that popular culture is neither simply a form of social control [by a dominant group] nor a form of class expression [by a subordinate group], but a contested terrain."[5] In what follows I seek to demonstrate that Spencer's work was both ideological (encouraging accommodation to norms associated with a rising middle class) and utopian (resistant to class or gender domination), at once an instrument of social control and an instrument of social subversion. If in the end the reader is left confused, uncertain as to which side of Spencer's art prevailed—the accommodational or the resistant; social control or social subversion—take this not as a dereliction of responsibility, a refusal to pass judgment (although it is a refusal to judge as a

connoisseur), but rather as an implicit acknowledgment that art and the social configurations that produce it are inevitably multivalent, heterogeneous, and self-contradictory. Our job is not to conclude whether Spencer's art was good or bad but to understand the diverse and self-opposing ways that it functioned in a diverse and self-opposing society.

Although Spencer's career stretched from the early 1840s to the end of the nineteenth century, she produced most of her best-known work during the decade between 1848, when she moved to New York from Cincinnati, and 1858, when she took up residence in New Jersey. This was a decade bounded at one end by the woman's rights convention in Seneca Falls, New York, and at the other by the financial collapse in the Northeast known as the panic of 1857. However different in kind these two events may have been, they were alike in that both symbolically challenged patriarchal male authority: Seneca Falls proclaimed equal rights for women; the panic, like earlier ones, demonstrated the fallibility of men and their vulnerability to social and economic forces beyond their control. An examination of a few representative works produced by Spencer during this decade—nursery scenes, kitchen scenes, and an anecdotal depiction of a husband—reveals an art that is neither an out-and-out affirmation of middle-class and patriarchal values nor an explicit rejection of such values, but rather an uncertain response: an embrace of them while also, increasingly (yet perhaps unconsciously), a teasing or mocking subversion of them.

In 1848, the year Spencer moved her family to New York in order to improve her opportunities as an artist, she painted *Domestic Happiness* (fig. 7.2), a work that achieved immediate acclaim. One reviewer reported that the attention it gathered at its initial exhibition "has exceeded that given to any other single production that has appeared on the walls of the Gallery since it was first opened."[6] Another commentator later recalled that the painting's "vigor and freshness were as remarkable as its rich and harmonious coloring."[7]

Glowing with joy, a young husband and wife peer tenderly at two sleeping babes wrapped in one another's arms. Lightly bearded and full of face, the father wears a patterned silk dressing gown that blends harmoniously in hue with his wife's flowing robes of rose and green. The mother, with a face from Raphael and golden softness from Titian, raises a hand as though to hold back her husband's enthusiasm for his children, whom he might inadvertently disturb—the work's original title was *Hush! Don't Wake Them.*

In terms of present debates over the nuclear family, *Domestic Happiness* may seem resoundingly conservative, but in the context of widespread debates during the 1840s over the function and structure of family, the position put forth by the painting was left of center—not radical, but not blandly middle-of-the-road either. Although the ideology of the home as a haven in a heartless world gained its ascendancy during the antebellum period, its route to acceptance was anything but uncontested. A wide range of sources provided what many Americans took to be compelling criticisms of or alternatives to the sentimental vision of the nuclear family. Orthodox Protestants clinging to Calvinist tradition decried the new liberal-

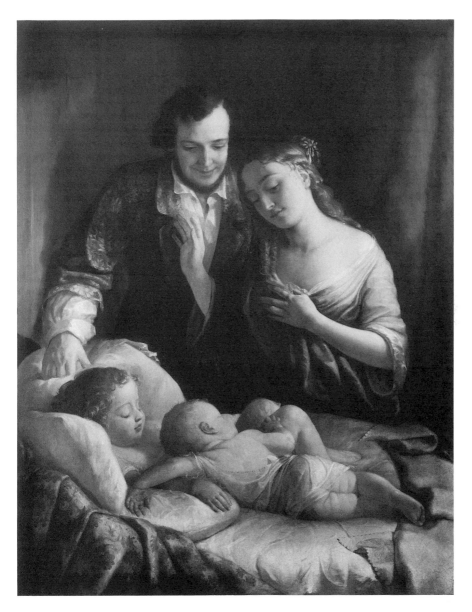

7.2. Lilly Martin Spencer, *Domestic Happiness*, 1848. Detroit Institute of Arts.

ization of the family, in which the status of mother and children was elevated at the expense of the patriarch. Feminists argued that the sentimental family was unduly binding of women. Socialists urged that household labor, including childcare and kitchen work, be reapportioned through public cooperatives. The followers of the utopian leader John Humphrey Noyes advocated free love, Mormons practiced polygamy, and many who believed that the millennial day of judgment was at hand forswore sexuality altogether. At the time Spencer painted *Domestic Happiness*, the recent war with Mexico and the hurried migration of thousands of American men

to California must have heightened the immediacy of the public debate, considering how many families were temporarily or permanently ruptured by these major events.

In this context, *Domestic Happiness* appears to be a vigorous assertion of the therapeutic value of the affectional nuclear family. Again, this may seem like a conservative position today, but it was not in the 1840s. At that time, conservatives were those who *lamented* the advent of the sentimental family, with its exaltation of harmony, mutuality, and equality. Conservatives maintained that the family should be structured according to a strictly observed hierarchy, with father reigning unopposed over mother and children.

This orthodox position, though losing ideological ground by the time Spencer painted, continued to hold sway for most of the antebellum years. Such nationally known authority figures as Heman Humphrey, the president of Amherst College, exhorted parents to safeguard the future of the Republic by instilling in their children patriarchal values at the earliest possible age. "Every father is the constituted head and ruler of his household. God has made him the supreme earthly legislator over his children," intoned Humphrey in 1840. "Children are brought into existence and placed in families, not to follow their own wayward inclinations, but to look up to their parents for guidance; not to teach, but to be taught; not to govern but to be governed."[8]

Domestic Happiness implicitly opposes this way of thinking. Whereas Humphrey claims that "children must be accustomed to cheerful subordination in the family," *Domestic Happiness* argues the opposite: that parents should cheerfully subordinate themselves to their children: "Hush, Don't Wake Them." Whereas Humphrey doubts "whether anything like a free constitutional government can ever be maintained over a people, who have not been taught the fifth commandment in their childhood," *Domestic Happiness* presents the sentimental family as a microcosm of social unity, with arms encircling arms as a metaphor for interconnectedness and cohesion.[9]

The painting, in other words, conveys the sensibility expressed by such liberal reformers as the popular novelist and essayist Lydia Maria Child, who insisted as early as 1831 that "all our thoughts and actions come from our affections; if we love what is good, we shall think and do what is good. Children are not so much influenced by what we say and do in particular reference to them, as by the general effect of our characters."[10] Heman Humphrey might have agreed with this last statement about how children are influenced by the character of their parents, but for him the proper goal of such parental influence was to instill absolute obedience to patriarchal authority. For sentimentalists the character to be instilled was not submissiveness but love—which, to be sure, was seen as involving humility and submission, but also democratic self-respect. Moreover, the influence of character was seen as traveling both ways: just as children would learn affection from their parents, so the parents would learn affection or be reawakened to it by their children. The compositional circularity of *Domestic Happiness* attests to the circularity, the reciprocity of familial love.

Richard Brodhead has astutely argued that the sentimental ethos of love, which

he terms "disciplinary intimacy," disguised and reinscribed rather than replaced authoritarian domination. According to Brodhead, "The primary assumptions of discipline through love—its assumptions of extreme physical and emotional closeness between parent and child, and of the parent's availability to make the child the center of his attention—codify, as if in the realm of objective moral truth, the new middle-class social fact of a parent disoccupied from other labors." Thus "child nurture, the devoted labor of the leisured mother, confirms her moral right and duty to be unemployed—and to put someone else to work as a domestic in the service of her domestic idyl."[11] One could certainly contend that, even though Spencer herself never achieved the financial wherewithal to become a "leisured mother" enjoying a "domestic idyl," works such as *Domestic Happiness* participated in this more insidious form of social control, seducing viewers into a new mode of affectional intersubjectivity (love) that, in helping to bring about the internalization of bourgeois norms, restricted behavior and political alternatives even more forcefully than the old authoritarianism had. The point at present, however, is not to judge the extent to which the liberal ideology embodied by *Domestic Happiness* was actually a form of social monitoring and control but to distinguish how this ideology positioned itself against the previously dominant form of control represented by patriarchal authority as sanctioned in conservative theology (see, for example, H. F. Darby, *Rev. John Atwood and His Family* [1845; fig. 7.3]).

In glorifying the sentimental family the painting amounts to a defense of sentimental thinking against political and religious conservatives who fumed over the breakdown of patriarchal authority, but at the same time it also defends the nuclear family from attack on the left. The socialist-communitarians of the era, for example,

7.3. H. F. Darby, *Rev. John Atwood and His Family,* 1845. Museum of Fine Arts, Boston.

the Owenites, Oneidaists, and particularly the Fourierists (the followers of the French philosopher Charles Fourier), argued that individuals faltered and failed morally or economically not because they came from inadequate families but instead from overly adequate ones. "The isolated household is a source of innumerable evils," wrote one Fourierist. It "is wasteful in economy, is untrue to the human heart, and is not the design of God, and therefore it must disappear."[12] *Domestic Happiness* opposes such a position. If on one level the painting served, as I believe it did, as a denial of Spencer's own anxieties about coping with a growing family during a period of financial scarcity, it was also, in the context of rising communitarianism and the woman's rights convention at Seneca Falls, an attempt to withstand an ever-mounting onslaught of feminist and socialist criticisms of the sentimental family.

In Spencer's case such criticisms originated from within her own family and were voiced by her mother, Angelique Martin. Martin, a schoolteacher who had emigrated to America from France, was an outspoken feminist and Fourierist. In the mid 1840s she and her husband helped form near Braceville, Ohio, a Fourierist "phalanx" (commune) that was dedicated to socialist principles, among them equality for women. Fourierists argued that isolated, single-family households and the wasteful duplication of domestic labor hampered the development of women and thus of society as a whole. They contended that the development of labor-saving devices and the removal of a variety of housekeeping responsibilities, including cooking and childcare, from the private into the public sphere would free women from the deadening drudgery that dulled their minds and political sensibilities.[13] "No fuming, no fretting over the cooking stove, as of old! No 'roasted lady' at the head of the dinner table!" predicted the Fourierist Jane Sophia Appleton in a utopian fantasy she conceived regarding a future in which women were the equal of men in all respects.[14]

Domestic Happiness as well as Spencer's numerous kitchen and nursery scenes of the 1850s eschews such a vision of collectivization, almost as though the artist were engaging in a private—probably unconscious—dialogue with her mother's radical ideology and was attempting to counter it with a centrist one of her own. When Angelique Martin urged her daughter to attend a woman's rights meeting, Spencer begged off, claiming that she was too busy. "My time . . . to enable me to succeed in my painting is so entirely engrossed by it, that I am not at all able to give my attention to any thing else."[15] Throughout the decade of the 1850s, feminism must have seemed to Spencer, who perpetually struggled to make ends meet, a luxury she simply could not afford, even though her mother might have argued that feminism was in fact not a luxury but a necessity, a way of clarifying the housewife's self-interest, which was obscured by the cult of domesticity.[16] How could the artist hope to compete with what she described to her mother as the "perfect swarm of painters" in New York when, as she bemoaned in a later letter, "the mending and patching of the babeys" was her never-ending responsibility?[17] Despite Spencer's acute recognition that childcare and housekeeping severely impeded her professional responsibilities, she turned away from the feminism and socialism held out to

her by her mother and embraced instead the sentimental ideal embodied in *Domestic Happiness.*

Posing her husband and infant sons as models for *Domestic Happiness,* Spencer produced it at a time when she was filled with anxiety about her ability to earn a living in the highly competitive art world of New York. "We have not yet been very successful in our efforts—I have not been well encouraged for a long time in my painting," she confides in a letter to her mother. But then, bucking herself up: "Still we hope on and struggle on and help each other harmoniously [and] though poor, we are very happy with each other."[18] This sudden reversal, this immediate denial of the anxiety that had just escaped her pen, is typical of Spencer's letters home and, moreover, of her work in general, which seems, in this regard, an art of denial.

And yet to characterize her habitual reversals as mere denial is to back into an oversimplifying binary opposition (expression/repression). It is to say that Spencer's work and sentimental culture in general were nothing more than a denial of social inadequacy, a repression of women's understanding of their political powerlessness. Another view of the matter suggests that denial is an implicit rejection of the current state of affairs rather than simply a refusal to acknowledge them. From this point of view, sentimental art such as Spencer's was an act of female instrumentality and agency, of antebellum women taking hold of the most effective weapon at their disposal, culture, and using it on their own behalf. Even if we could be certain, which we cannot, that the result of sentimental discourse was increased social control of the very women who were its chief producers and consumers, we would be historically remiss to regard such discourse as pathetically weak, passive, and insignificant, for at the very least it pictured a more equitable world, which is a necessary precondition for achieving such a world. Relevant here are the words of the first-person narrator of Margaret Atwood's *Lady Oracle* (1976), a closet romance writer who asks herself, "Why refuse them [her female readers] their castles, their persecutors and their princes, and come to think of it, who the hell was Arthur [her leftist husband who "took up Women's Liberation"] to talk about social relevance? Sometimes his goddamned theories and ideologies made me puke. The truth was that I dealt in hope, I offered a vision of a better world, however preposterous. Was that so terrible? I couldn't see that it was much different from the visions Arthur and his friends offered, and it was just as realistic."[19]

At a time when women possessed no legal protection for themselves or their children if abandoned by a husband, an image so lushly rendered as *Domestic Happiness* may even have served as a rhetorical device to persuade (in sentimental terms, inspire) male viewers to renew their commitment to their families. To look at it this way, the painting was a politically active endeavor designed to improve a grievous, real-world situation by means of a seductive representation of an ideal world (as sentimentally conceived). As such, it takes a stand against the "domestic misery" encapsulated in the following cautionary tale:

A young man meets a pretty face in the ballroom, falls in love with it, courts it, "marries it," goes to housekeeping with it—and boasts of having a home to go to and a wife. . . .

[But then] his pretty face soon gets to be an old story . . . [and he] gives up staying at home evenings; consoles himself with cigars, oysters, whiskey punch and politics; and looks upon his "home" as a very indifferent boarding house. A family of children grow up about him; but neither him nor his "face" knows anything about training them; so they come up helter-skelter . . . and not one quiet, happy, hearty, homely hour is known throughout the whole household.[20]

By means of its sinuous design, fluidly integrated hues, and sumptuous handling of paint (note for instance the father's white sleeve, tinted blue-green by the robe), *Domestic Happiness* tries to undo what by midcentury were becoming increasingly prevailing norms of household disharmony. Thus it battles on three fronts at once: against the reactionary hierarchism of religious conservatives, against the antisentimental values of socialist communitarians, and against the dissolution of the family.

One way of trying to grasp the enthusiasm of middle-class audiences for *Domestic Happiness* is to consider their enthusiasm for analogous texts such as Susan Warner's enormously successful evangelical novel of 1850, *The Wide, Wide World*.[21] The tear-stained tale of young Ellen Montgomery, who passes unwanted from one guardian to another until she finally accepts God's love, begins when Ellen's father, preoccupied with business, sends his ailing wife to France for a cure and dispatches Ellen to live with unkindly relatives she does not know. In the most often reprinted novel of the early Republic, Susannah Rowson's *Charlotte Temple* (1793), tragic circumstances were set in motion by a child's desertion of her parents, but now, in the sentimental culture that produced and so extravagantly admired *The Wide, Wide World*, the greater source of pathos was the parents', not the child's, abandonment of the home.

Domestic Happiness is the daydream to *Wide, Wide World*'s nightmare. Surely the popularity of both were forms of public response to the alarmingly accelerated unraveling of families in Jacksonian America: sons deserting farms to find work in the cities, daughters forsaking home to reside at the mills, fathers crossing the continent in search of California gold. Only mothers could be counted on to stay in place, unless, like Ellen's mother, they fell victim to sickness or death.[22] *The Wide, Wide World* addresses this unraveling by reconstituting it as a conversion narrative, a Victorian-American *Pilgrim's Progress*. Spencer's painting likewise responds to social disintegration. It does so, however, as a sentimental icon of family solidarity rather than as a pious saga of alienation followed by redemption through self-immolation.

Painted nearly a decade after *Domestic Happiness*, *This Little Pig Went to Market* (1857) treats the parent-child bond with more of a sense of humor, less total reverence than the earlier work. As noted in Virgil Barker's description of the painting quoted above, the surface texture of *This Little Pig* is hard and brilliant, the details everywhere sharply in focus: by contrast to the color-harmonized romanticism of *Domestic Happiness*, *This Little Pig* is brash and vulgar. Even their respective titles bespeak a contrast, the earlier one reverential and quasi-religious, the latter insistently secular and perhaps satiric. Its reference to the rollicking street rhythms of the Mother Goose nursery rhyme undercuts the religiosity of the composition, suggesting that this depiction of a latter-day Madonna enthroned beneath an imperial canopy is to be taken more as a

joke than as a pledge of allegiance to the middle-class sentimental creed—and maybe even as a criticism of such a creed, given the rhyme's attention to the disparity between rich and poor, haves and have-nots ("This little pig had roast beef, That little pig had none"). Perhaps what Barker calls "the sugary glossiness" of the flesh is an indication not of Spencer's inability to paint lifelike skin tones, for she did that ably well in *Domestic Happiness*, but rather of her inability to continue painting nursery scenes without her tongue finding its way into her cheek.

Once she moved to New York, Spencer consistently injected her domestic pictures with a touch of vulgar humor: a punning title, a grinning face, splashy, unmodulated colors, a comedic situation. Though the domestic and financial stresses of her life went unabated—indeed, they increased—she made a point of treating domesticity humorously, a point that won her many admirers. All the same, even with this newfound humor, her nursery paintings retained a flavor of syrup. It was not there but in her kitchen scenes that Spencer allowed herself more freedom to paint with vinegar.

She delighted her contemporaries with her anecdotal and in some regards implicitly utopian kitchen tableaux. Indeed, her career as an artist is said to have begun when, as a teenager in rural Ohio, she replied to her mother's request for help in baking bread by sketching onto the kitchen wall a depiction of herself kneading dough.[23] The story is hagiographic but nonetheless appropriate. The precocious Ohio farmgirl eventually became the nation's foremost portrayer of homey domestic scenes, especially those occurring in or beside the kitchen. One of the first of these was *The Jolly Washerwoman* (1851). Unfortunately, neither this work nor the chromolithograph made from it has been located. According to contemporary accounts, it depicted a serving maid with an amused expression on her face while she toiled in the kitchen by a washtub. At the American Art-Union auction the painting sold for $161, a relatively high price, and received much favorable comment, encouraging the artist to turn to similar subjects and treatment several more times in the next few years. One effort, *Shake Hands?* (1854; fig. 7.4), depicts a buxom, broadly grinning, doughy-handed cook pausing to reach out in greeting to a visitor, presumably the viewer of the painting. Another, *Kiss Me and You'll Kiss the 'Lasses* (1856; fig. 7.5), shows a slender, pert young woman standing before a fruit-laden sideboard while wielding a spoonful of molasses ("'lasses") with which she coyly threatens her visitor, probably a male suitor but also us, given the second-person address of the title as well as her direct gaze out of the painting's space into our own.

Other paintings by Spencer of kitchen scenes include *Peeling Onions* (c. 1852) and *The Young Wife: First Stew* (c. 1856; unlocated).[24] Admired by the public at large and often by critics as well, these images circulated widely in the form of inexpensive prints. *The Gossips* (1857; unlocated) was Spencer's most ambitious undertaking of the decade. One art journal deemed it a masterpiece, enthusiastically describing it as "a group of servant-girls out of doors, interchanging domestic news, surrounded with kitchen accessories—pans of clothes, meat, vegetables, babies, furnaces, and tubs of water, into which children have tumbled, laughing at each other's mishaps and at a lean dog running away with a beefsteak in the foreground."[25]

The Gossips was unusual for Spencer in that it represented a gathering of house-

7.4. Lilly Martin Spencer, *Shake Hands?* 1854. Ohio Historical Society.

hold workers instead of a single worker alone. In a sense, though, Spencer's kitchen workers are never alone, even if typically the paintings depicting them are single-figure compositions. The women always address someone just beyond the picture plane. They are never too preoccupied to welcome this implied visitor with a good-natured grin and friendly gag—a doughy hand, a spoonful of molasses.

For a point of comparison, place Spencer's kitchen workers beside Vermeer's scullery maids, who are similarly robust in appearance but so enwrapped in their duties or dreams as well as in a transfiguring light that there is no offstage to their world, no possible intrusion, no sudden visitor, welcome or otherwise (fig. 7.6).[26]

7.5. Lilly Martin Spencer, *Kiss Me and You'll Kiss the 'Lasses*, 1856. The Brooklyn Museum.

Vermeer's works were not known in the United States until after the Civil War, but even so the transcendent and aestheticized ideal of the silent domestic female that they put forth was already in place in antebellum America, as seen, for example, in Francis Edmonds's *Sparking* (1839) and *The Image Peddlar* (1844). Spencer's kitchen scenes violate the harmony and serenity of Vermeer and the idealization of domestic womanhood that he represents. Her scenes do to him what, a generation later, Mark Twain's Duke and Dauphin were to do to Shakespeare. With a Jacksonian contempt for classical unities and sophisticated European subtleties, these brashly

7.6. Jan Vermeer, *A Maidservant Pouring Milk*, c. 1655. Rijksmuseum, Amsterdam.

colored, overly detailed, vulgarly forthright kitchen scenes suggest their own version of Catharine Beecher's assertion in her *Treatise on Domestic Economy*, which was reprinted nearly every year from 1841 to 1856, that housework and democratic egalitarianism go hand in hand.[27]

Obviously, not all Jacksonians approved. A high-toned review of *The Young Wife* disdained the artist's "grinning housemaids" and wondered rhetorically, "Is there in her woman's soul no serene grave thought, no quiet happiness, no tearful aspiration, to the expression of which she may give her pencil?"[28] She offended good taste—in this case that of an older type of sentimentalism that looked back to the romantic neoclassicism of, say, Washington Allston's *Ideal*, Samuel Morse's *The Muse*, or Thomas Sully's *Mother and Child* (1840; fig. 7.7)—by her repeated transgression of the time-honored convention that women depicted in art be demure, that they not grin, giggle, or laugh, that they be still and allow themselves to be admired.[29] "Mrs. Spencer has no power over transitory expression," objects the reviewer, "and the slightest remove from immobility of features ends in grimace." A female artist who chose to be low and comical rather than grave and quiet; female figures within the paintings who grin or grimace rather than maintain radiant or mysterious sangfroid: Spencer and her paintings had become an affront to sexual, political, and aesthetic norms.

The Crayon, which carried the "grinning housemaids" review, was a journal devoted to the ideals of John Ruskin, who was as reactionary in his thoughts on "the woman question" as he was progressive on other social issues of the time.[30] Spencer fared better with the *Cosmopolitan Art Journal*, a periodical that courted female middle-

7.7. Thomas Sully, *Mother and Child*, 1840. Metropolitan Museum of Art.

class audiences and gave special attention to the production of women writers and artists, whose works it often promoted for sale. In reference to *Shake Hands?* it claimed that "no picture painted in this country is better fitted for popular appreciation. It reminds us constantly of the incomparable pictures by the Flemish [Netherlandish] artists."[31]

The comparison, not to Vermeer, would have been to seventeenth-century genre painters such as Gerard Dou, Pieter de Hooch, Gabriel Metsu, and Nicolaes Maes. A student of Rembrandt, Maes painted cheerfully anecdotal works such as *The Idle Servant* (1655) and *The Eavesdropper* (1657). In *The Idle Servant* (fig. 7.8), the lady of the house wryly smiles out of the composition into the viewer's space while pointing toward her kitchen maid, who dozes in a corner, oblivious of unwashed pots and pans and the cat about to make off with the dinner. In the other work, the mistress turns to us conspiratorially as she eavesdrops with amusement upon a scullery maid embracing her beau beneath the stairs. The differences between Maes and Spencer are significant. For example, his domestic women, wrapped in velvety, Rembrandt-like contrasts of light and shade, do not jump out at the viewer as do her women, who are pictured head-to-toe in disconcertingly high definition. Also, his housewives are never alone on canvas, unlike her kitchen workers, who are alone but for the implied, off-canvas visitor.

Still, despite the differences, Spencer is like Maes and other baroque artists who sought to incorporate the viewer within the work by means of direct address or, in theatrical terms, dialogue across the footlights. Like many of her antebellum contemporaries, Spencer was greatly taken with Shakespeare, himself a violator of classical unity.[32] In December of 1848, shortly after her move to New York, she drew Hamlet contemplating the skull of Yorick (fig. 7.9). This may seem the opposite of a

7.8. Nicolaes Maes, *The Idle Servant* (1655). National Gallery, London.

direct-address depiction—Hamlet's eyes gaze down at the skull in his hands—until one realizes that it is not Hamlet but the grinning skull itself that peers out at the viewer. "Where be your gibes now? Your gambols, your songs, your flashes of merriment that were wont to set the table on a roar?" Shakespeare's prince asks of the dead court jester.[33] It is a query that Spencer may have posed to herself in this time of financial, professional, and domestic hardship. Her comical domestic scenes of the 1850s, with their jocular direct address and reliance on puns, are perhaps her answer.

Let me further situate the challenge to neoclassical unity and decorum that direct address such as Spencer's conveys. In the early twentieth century, the Marxist playwright Bertold Brecht employed direct address as an "alienation effect" that compelled critical detachment by preventing emotional identification with the spectacle on stage, thus leaving "the spectator's intellect free and highly mobile."[34] Brecht's direct address assaulted theatrical conventions that maintained the ontological separation of characters upon the stage from the audience in front of it. Spencer, working nearly a century earlier, employed direct address to significantly different ends. Instead of undercutting the spectator's emotional involvement, her direct address, which was normal at the time in theater if not in painting, served to solidify it.[35]

The narrative theorist Robyn Warhol, discussing the "engaging narrator" of mid nineteenth-century female novelists such as George Eliot, Elizabeth Gaskell, and Harriet Beecher Stowe, argues that the purpose of narrative interventions of the "Dear Reader" sort was to rouse the reader from passivity and bolster her or his ability to proceed constructively from the world of fiction to that of social reality.

7.9. Lilly Martin Spencer, *Hamlet Contemplating the Skull of Yorick*, 1848. National
Museum of American Art.

"Writing to inspire belief in the situations their novels describe—and admittedly
hoping to move actual readers to sympathize with real-life slaves, workers, or ordi-
nary middle-class people—these novelists used engaging narrators to encourage
actual readers to identify with the 'you' in the text." Unlike the intruding narrators of
earlier novelists such as Fielding, Sterne, and Thackeray, these engaging narrators
interrupt the narrative not to remind the reader, in a playful or tongue-in-cheek
fashion, that this is only a story, but instead to provoke moral action. Their interven-
tions were attempts to rouse readers from complacency through intimacy rather
than alienation.[36]

In Fanny Fern's popular sentimental novel *Ruth Hall* (1854), the working mother
named in the title writes a newspaper column for women. One of her readers sends
a fan letter. "Every week your printed words come to me, in my sick chamber, like
the ministrations of some gentle friend, sometimes stirring to its very depths the
fountain of tears, sometimes, by odd and quaint conceits, provoking the mirthful
smile." She blesses Ruth for the "soul-strengthening words you have unconsciously
sent to my sick chamber, to wing the weary, waiting hours."[37] Perhaps Spencer's
kitchen scenes similarly offered "soul-strengthening words" and "mirthful smiles"

(Yorick's "flashes of merriment") for antebellum women. The gaze of her kitchen workers out of their own space into the viewer's must have collapsed social distance and thus helped eradicate the loneliness, the isolation of middle- or lower-middle-class housewives. With their reliance on direct-address grins, comical titles, and other "odd and quaint conceits" such as a dough-covered hand here, a spoonful of molasses there, these kitchen paintings may have seemed not merely anecdotal but antidotal.

Catharine Beecher, the antebellum period's greatest advocate for "domestic economy," acknowledged the stress that managing a household placed upon middle-class women. "There is nothing," she wrote, "which so much demands system and regularity, as the affairs of a housekeeper, made up, as they are, of ten thousand desultory and minute items; and yet, this perpetually fluctuating state of society seems forever to bar any such system and regularity." Beecher recognized this stress to be debilitating. "The anxieties, vexations, perplexities, and even hard labor, which come upon American women, from this state of domestic service, are endless; and many a woman has, in consequence, been disheartened, discouraged, and ruined in health."[38] Or as Elizabeth Cady Stanton, at the time a mother and housewife, was to declare, "A woman is a nobody. A wife is everything."[39]

To viewers who were in effect kept out of sight in what Stanton called "the isolated household," sequestered by the cult of true womanhood and the economic imperatives that underlay it, how pleasurable it must have been to be looked at, to be seen, to be called upon, even if only by hypothetical women inhabiting a painting or a print in a popular magazine.[40] While there is indeed power that derives from being the bearer of a gaze, there may also be power that results from being its recipient. In the words of Mae West, "It's better to be looked over than overlooked."

Antisentimentalists would argue that the power that comes from being looked at (or looked over) is at best only illusory. Being seen can make you *feel* important without actually making you important; hence the workings of hegemony, in which social subjects are seduced into accepting their domination by a class whose interests are ultimately antithetical to their own. Recently, for example, Nancy Armstrong's *Desire and Domestic Fiction* has contended that domestic sentimentalism, far from resisting the segmentations and gender separations of modern life, exacerbated them, teaching readers that women were radically unlike men, more exalted, more sensitive, more subjective. Such discourse privatized experience in a manner that colluded with the ongoing privatization of the economy and the state. "On the domestic front," according to Armstrong, "perhaps even more so than in the courts and the marketplace, the middle-class struggle for dominance was fought and won."[41]

Spencer's paintings may have placated housewives and encouraged them to accept their disfranchised lot, engaging them sentimentally rather than enraging them politically, and yet it seems condescending to write this off as merely bad faith, a manufactured, ersatz solidarity. Recent efforts in the feminist revision of nineteenth-century sentimental culture would urge us not to view sentimentalism as false consciousness imposed from above but instead to investigate how it looked from within. "I do not say that we can read sentimental fiction exactly as [its] audi-

ence did—that would be impossible—" writes Jane Tompkins, "but that we can and should set aside the modernist prejudices that consign this fiction to oblivion, in order to see how and why it worked for its readers, in its time, with such unexampled effect."[42]

Armstrong's view of domestic fiction derives from Michel Foucault, who argues that social discourses (medical, sexual, architectural, and so forth) produce the subjects that speak them. Sentimental fiction, by these lights, is yet another disciplinary discourse, forming its readers into sentimental and thus weak and submissive objects of social domination (this is the "disciplinary intimacy" described by Richard Brodhead). An opposing view derives from the work of Mikhail Bakhtin, who argues that discourse is "dialogic"—always inevitably a two-way, if not many-way, street. (Puns, which Spencer and her audiences found so congenial but which language police often find offensive, call attention to the dialogical nature of discourse.)[43] For Bakhtin, meaning is invariably plural. Because of this, those who read or hear a discourse produce from it the meanings that they require. The one theory maintains that readers (or viewers) *are shaped* by language in ways that subject them to social discipline, whereas the other argues that they *shape* the language in ways that enable them to resist such discipline.[44] In the present context, this means focusing not on the purposes of social control that sentimentalism may have served for statesmen, clergymen, editors, and other leaders of culture who disseminated its doctrines from on high, but rather the uses to which its primary recipients, women, were likely to have put it.

In other words, popular culture artifacts—for example, inexpensive engravings of grinning housewives—can be tools by which socially subordinate classes, such as housewives, try to pry themselves loose from domination by their social superiors. Popular discourse that may have been produced or distributed as a means of reinforcing hegemonic control nevertheless is read by its recipients in a way that is empowering to them. Let us take a late twentieth-century analogy. The popular culture theorist John Fiske argues that the reason adolescent girls were the first to make a star of the pop singer Madonna was that she modeled for them anti-authoritarian behavior and informed them of their own capacity for self-fashioning—as opposed to fashioning by parents, teachers, and boyfriends. "The provocation offered by Madonna to young girls to take control of the meanings of their femininity produces a sense of empowerment in one of the most disempowered of social groups that may well result in political progress in their everyday lives—in their relationships with their boyfriends or parents, in their refusal to give up the street to men as their territory."[45] For Fiske, "improved self-esteem in the subordinate [class member] is a political prerequisite of tactical or even strategic resistances."[46]

With Spencer, the crucial question is whether her kitchen scenes were vehicles of indoctrination into middle-class ideology, assisting women to accept their exclusion from political and economic power, or instead a means by which these women instinctively resisted privatization and its concomitant psychological isolation. My own initial response to Spencer led me to favor the former position, but now, after

studying the works, I incline toward the latter, though not without continuing reservations or sense of dialectic—a sense of her work as both/and rather than either/or.

Part of what I take to be her work's opposition to privatization is its eagerness to undercut romanticism and the solipsistic state of mind that goes with it. During the 1840s Spencer had been a romantic artist, turning often, in the words of a friendly critic, to "poetical and semi-allegorical" themes. Writing at the end of the 1850s, this critic was disappointed by Spencer's abandoning of such subjects and assumed that she had done so out of financial necessity, to cater to a popular art market that preferred cheap anecdotal humor to rarefied meditation on timeless concerns: "She found matter-of-fact pictures more salable than her cherished ideals."[47] *Reading the Legend* (1852; fig. 7.10) is the culminating work in Spencer's earlier, romantic style. An aristocratic, ornately gowned young woman rests her head on her hand while gazing pensively upon the ruins of a castle as a young man stationed at her feet reads from the pages of a book. The weathered but erect tower seems to rise from him with what today might be regarded as a hyperbole of phallic dominance. The woman appears passive and secondary, not the main actor. In most of the work that followed *Reading the Legend*, however, Spencer concentrated on the domestic here-and-now, a milieu in which women were central, active, fully engaged.

In *Shake Hands?* the sleeves of the grinning, apple-cheeked cook are rolled up, and her skirt is protectively gathered beneath her apron. Spencer's housemaid, a woman named Jane Thompson, modeled for the cook, but various features of the work encourage a reading of her as a housewife.[48] The arched shape of the canvas, for

7.10. Lilly Martin Spencer, *Reading the Legend*, 1852. Smith College Museum of Art.

example, suggests the sanctified terrain of a similarly arched work, Raphael's *The Marriage of the Virgin* (1504). But if this is a Madonna of the Kitchen, Spencer plays it for laughs, refusing to honor any ideology that would etherealize housewives and, in so doing, separate them from the real world of work and social relations. On the far right, over a fireplace screen, a depiction of an embracing couple peels away at the edge, as though to insist all the more on the thinness of romantic dreams in contrast to the fullness, the satisfactions, of domestic routine—or perhaps its dissatisfactions; if behind her are clichéd romantic dreams literally peeling off the wall, all that is before her is a plucked chicken. Maybe such dreams are what initially brings a young wife into the kitchen, but clearly they cannot take the heat so well as she can, with her earthy, outgoing sense of humor. She is like Fanny Fern's fictional Aunt Hetty, who says, "Now girls . . . do something sensible and stop building air-castles, and talking of lovers and honeymoons. It makes me sick; it is perfectly antimonial [sic]. Love is a farce. . . . The honey-moon is as short-lived as a lucifer-match; after that you may wear your wedding-dress at breakfast, and your night-cap to meeting, and you husband wouldn't know it."[49] One can only imagine what Aunt Hetty, with her disdain for "air-castles," would have thought of *Reading the Legend* (or of the passage in Atwood's *Lady Oracle* about not refusing female readers "their castles, their persecutors and their princes").

In other works from this period Spencer similarly eschews romantic sensibility. For example, in the ambiguously titled *The Young Wife: First Stew*, which is no longer extant but can be roughly known through studies or reproductions in other media, the housewife was in tears. Was this because she was chopping onions for a stew or rather because she was "in a stew" brought on by the difficulties of adjusting to marital life and responsibility?[50] Another work by Spencer that treats this subject shows a tear-streaked maiden in the kitchen wiping her eye. She holds a knife in the same hand, almost as though contemplating vengeance or self-destruction, Rembrandt's Lucretia in Jacksonian guise. Lest the viewer leap to the romantic assumption that this young woman weeps and wields a sharp blade because love has gone wrong, the reason for the tears and the knife is supplied with a certain taciturn irony by the painting's title: *Peeling Onions* (fig. 7.11).

The double-edged (if one might say) irony of such paintings complicates rather than reduces the conventional meaning of kitchen work and, by investing it with this greater, more complex meaning, discursively resists the marginalization of the kitchen worker even as that phenomenon was historically occurring.[51] At the same time, in juxtaposing the sentimental (i.e., tears) with the practical (onions), it enacts the sort of avowal/disavowal typical of Spencer's letters home, in which every expression of dire anxiety about her life is quickly renounced by a joke or a bromide ("let us hope for the best and it may come, is my motto").[52]

In other words, rather than imposing an either/or situation upon Spencer's sentimental kitchen comedies—either they are instruments of discursive discipline or they are carnivalesque subversions of dominant ideology—we do well to recognize them as instances of discipline *and* subversion occurring simultaneously and self-contradictorily. In this regard, the paintings are neither bad nor good, conserva-

7.11. Lilly Martin Spencer, *Peeling Onions*, c. 1852. Memorial Art Museum, Rochester.

tive nor progressive, hegemonic nor counterhegemonic, but entanglements of all these terms, messy, dialectical, and conflicted as to what they offered viewers and what, to diverse groups of viewers, they might have meant.

Although most of Spencer's genre scenes are about domestic women with or without children, some focus upon domestic men, that is, husbands. The husbands in Spencer's paintings are never refugees from the home, like Washington Irving's

henpecked Rip Van Winkle and so many subsequent males in nineteenth-century American art and literature who were all too eager to flee the clutches of domesticity and, in the words of Twain's Huck Finn, "light out for the territory."[53] Instead they are integrated and needed members of the home, taking on an importance much greater than that of mere breadwinner.

We surveyed this terrain earlier in terms of *Domestic Happiness*. In *The Young Husband: First Marketing* (1856; fig. 7.12), the companion piece to the now-lost *Young Wife: First Stew*, a bearded fellow laden with an unopened umbrella and an overflowing basket of groceries struggles to prevent the contents from tumbling onto the rain-slicked street. In *Fi! Fo! Fum!* (1858; fig. 7.13) the husband is an overgrown boy, appearing no less frightened by the spooky tale he recounts than are his children. In *The Picnic* (c. 1864), a work of the following decade, a portly father in the center of the composition comically collapses a rope-swing under his considerable weight. The humor is good-natured, to be sure, but what counts in all three instances is that Spencer designates husbands as figures as much to be laughed at as revered—even while maintaining that these men belong in the domestic world and are not estranged from it.

7.12. Lilly Martin Spencer, *The Young Husband: First Marketing*, 1856. Manoogian Collection.

7.13. Lilly Martin Spencer, *Fi! Fo! Fum!* 1858. Private collection.

These paintings rely upon what we nowadays term situation comedy, with its facile arrangement of family life's complexities into formulaic patterns of resolution. To the extent that situation comedy enforces regulated norms of response, it seems to restrict the permissible range of human behavior and subsume its viewers into a conservative cultural discourse. In other words, paintings such as *The Young Husband* and *Shake Hands?* could be seen as nonprogressive because in the one case husbands are treated as cute little darlings rather than as household tyrants who held virtually complete legal jurisdiction over their wives, and in the other case a

woman's confinement to her kitchen is normalized as healthy, happy, and empowering rather than as socially oppressive.

Yet such readings would be ahistorical. In 1950s America, in the absence of an organized woman's movement, the comic depiction on television and in Norman Rockwell-like magazine illustration of husbands rendered helpless by domestic chores amounted to an ideological obfuscation of actual power relations. Virtually the same depiction in the 1850s, however, would have participated, however mutely, in the challenge to masculine authority that was being mounted by feminists and sentimentalists alike in the aftermath of the convention at Seneca Falls. A similar argument applies to the kitchen comedies. The kitchen was or could be an empowering place for antebellum women, at least so Catharine Beecher and her sister Harriet Beecher Stowe maintained, but it was also, as suggested above, an isolated zone, cut off from the hallways of power and thoroughfares of the world.[54] Spencer's kitchen scenes, employing direct address as well as other anticlassical devices, may very well have constituted a form of popular female struggle against, rather than submission to, the privatizing and marginalizing of the domestic sphere.

As industrialization took hold in America, it drew men away from the home, centering their attention elsewhere (as decried in the editorial cited above about the typical husband who "looks upon his 'home' as a very indifferent boarding house"). But even when husbands were staying home, how could they possibly have maintained their traditional authority as paragons of wisdom and stability when sudden swings in the economy, as exemplified by the panic of 1857, swept thousands of middle-class households to the edge of destitution? A devastating financial collapse that ruined legions of speculators and sent the economy in the industrialized Northeast reeling, the panic inevitably undermined the cherished belief that home was a blessed place, a refuge from the storm, and that fathers, as God's representatives on earth, had the wisdom and power to keep it that way (this is the theme of a little-known work produced during a subsequent crash, Charles Knoll's *The Panic of 1869* [1869; fig. 7.14]).[55] Husbands, who had placed themselves in charge of an economy that they considered their wives incapable of understanding, had proven inept. They were no more in control of the economy than they were of the weather.[56]

In a financial climate such as this, *The Young Husband*, Spencer's painting of a man caught in the rain, takes on new meaning. The work was completed in 1854, well before the panic of 1857 but during a period of business stagnation and rising unemployment that led some observers to anticipate the crash yet to come.[57] Viewed in this light it testifies to anxieties about husbanding, being a man, maintaining control. Spencer's model for the husband who comically clutches a plucked chicken in one hand and a useless umbrella in the other was Benjamin Spencer, who in real life appears to have had no better grasp on full-time employment than he did on that slick chicken. A hurried pedestrian passing directly behind the young husband chuckles at his predicament. A woman across the street is similarly amused. The scene is funny, but it is also nightmarish, a vision of emasculation and public humiliation. A reviewer complained about "the enormous disproportion" of the husband's head.[58] It is indeed oversized in relation to the body, but given the

7.14. Charles Knoll, *The Panic of 1869*, 1869. Colby College Museum of Art.

skill with which Spencer had earlier depicted the male figure in *Domestic Happiness*, this disproportion is probably not, as the reviewer believed, indication of a deficiency of anatomical knowledge on the part of the artist. Instead it may have constituted a device to liken the husband to a child, if not, further, to emphasize his mental inquietude and convey through a stunted bodily form a stunted potency, devices that Edvard Munch was to use decades later in paintings such as *The Scream* (1893). The husband is coiled like a spring about to pop; his balance is precarious, his posture absurd. The furled umbrella, as black as his clothing, extends from his body like an arm chopped off at the wrist. His right leg, drawn upward in a desperate attempt to prevent his wife's eggs (!) from careening out of the grocery basket, also appears stunted or deformed. Both of these cropped appendages bespeak a sort of psychic amputation, in Freudian terms, a castration.

The chuckling pedestrian behind the young husband, similarly bearded and clothed in dark tones, seems to emerge from him. Is this the domestically unburdened bachelor that the husband once was or wishes he could be? This fellow virtually launches out of the composition, his shiny umbrella a black pirate sail or raven's wing already crossing into the infinite open space beyond the confines of the canvas. The husband, by contrast, is stuck in place: edged close to the picture plane, he cannot go forward. A wall hems him in from behind and the stairsteps that lead perhaps into his own home are steep and slippery, nothing to be negotiated with ease.

Fi! Fo! Fum!, Spencer's next painting about a husband, is also, by implication, about the dangers that inhere in the marketplace. The fairy-tale that the bug-eyed man recounts to his children, "Jack and the Beanstalk," is the story of a youth who on the

way to market trades the family cow for magic beans instead of money, causing his mother (a housewife) to curse his ineptitude. As with *This Little Pig*, painted a year earlier—the year of the panic—the homey setting and family circle motif are belied by the title's indirect allusion to the cruel outside world constituted by the market and its system of inequities, swindlings, imbalances (as rendered metaphorically by the Young Husband who spills the groceries), cutthroat competitions, and cannibalistic practices ("Fi! Fo! Fum! I smell the blood of an Englishman!"). In *Domestic Happiness*, from 1848, a husband was a benevolent figure whose enthusiasm needed to be held in check ("Hush, don't wake them"), but in the decade that followed, the middle-class husband typically portrayed by Spencer was a figure associated with ineptitude, childishness, and fear.

In general, then, Spencer's depiction of husbands is no more an innocent, untroubled idealization of fatherhood than her depiction of housewives and mothers is an unadulterated celebration of bourgeois femininity. When we read such works, as the new connoisseur is likely to read them, as expressions of naive faith in the worldview of the antebellum middle class, the naivete resides not in the works but in the reading. Lilly Martin Spencer confounds the connoisseur not because her work is so good or bad, progressive or reactionary, subversive of the ruling class or collusive with it but because forms of art history that rely, however implicitly, on such either/or formulations are in the end not supple enough to respond adequately to the contradictory, disunified nature of a cultural production such as hers.

Like most artists of the modern era, Spencer came from, belonged to, and was representative of differing and sometimes competing social groups. In her case, she was a westerner laboring in the eastern metropolis, a female engaged in what was conventionally a male profession, a working woman sometimes commissioned or "patronized" ("matronized"?) by female clients of the leisure class, a low-income, middle-class housewife who fulminated over the performance of her working-class housemaids, a bourgeois daughter of a socialist-feminist mother, and a devoted wife who supported her husband financially while sentimentalizing him but also belittling him in her correspondence and art. The work that she produced resulted from her never entirely stable placement within this variety of overlapping, sometimes antagonistic subject positions. In pondering Spencer's work—not only its iconography but its formal rhetoric, its ways of signifying—we can proceed beyond our current stereotypes (whether positive or negative) regarding middle-class domestic life in antebellum America to encounter work that is not so much a reflection of a particular society as a series of subpolitical interventions within various conflicted areas of that society.

Domesticity was an inescapable part of Spencer's life. How could she not have painted the nursery and kitchen, given how tethered to them she was? What would be surprising is if her depictions of the domestic scene were as one-dimensional and blithe as they might at first seem. Under inspection, these paintings appear to be deeply marked by pressures, financial and otherwise, inextricably related to the artist's uncertain embrace of domesticity and its implacable codes of maternal self-

sacrifice. It is easy to regard Spencer's paintings as instances of ideological masking, of middle-class hegemony. But to look at the paintings in terms of the material concerns of the artist and of the females in her audience, we see works that are hardly simpleminded propaganda for domesticity. They are instead ambivalent, dual-edged ways of thinking about it, representing it, and maneuvering within its contradictions.

ROBERT H. BYER

• • •

Words, Monuments, Beholders: The Visual Arts in Hawthorne's The Marble Faun

In its reception and imme- diate afterlife, Hawthorne's *The Marble Faun* was embraced by American readers as a sort of guidebook to the artistic monuments of Italy. From its opening chapters, set in the sculpture gallery of the Capitol in Rome, scenes of beholding and in- terpreting monuments (that is, canonical works of sculp- ture, painting, and architec- ture) pervade, even over- whelm, the novel's narrative, obstructing the movement of plot and confusing, even as they insistently suggest, the definition of character. From the date of its publication, this feature of the romance's organization has been the most conspicuous feature in its initial popularity and later, largely unfavorable critical assessment: one recent critical study views the romance as degenerating into picturesque "travelogue."[1]

Rather than signaling the failure of Hawthorne's literary artistry to digest and integrate his European experience of the visual arts, however, Hawthorne's ro- mance anticipates these divergent critical responses in the ambivalent perspective it develops toward the monuments and the activity of monumental beholding it so incessantly takes notice of. On the one hand, these visual monuments offer an extended parallel to and rationale for Hawthorne's efforts as a writer of romances which, in spite of their equivocations and apologetics for not being rooted in the real and in the historical, seek a monumental authority within their culture on just these grounds of reality and history. On the other hand, Hawthorne articulates an awareness of the profound differences between visual monuments and verbal arti-

facts, differences whose force and complexity arise from two sources. First, Hawthorne's text is keenly sensitive to the ways in which the differences between verbal and visual representation invest and are invested by the densely contrastive field of ideological perspectives that organizes the narrative: Protestant and Catholic, New World and Old, innocence and history, morality and art, masculine and feminine. Second, as Frank Kermode has argued, Hawthorne had a penetrating, subtle grasp of the ways in which the monuments of modern empire, unlike those of ancient empires, must of necessity be tentative and uncertain in their authority and relative in value to those who revere them, as only the "shifting and transitory" qualities of literary language made possible.[2]

I want to explore here the intimate if critical relation between the pedagogy of monumental beholding developed in the novel and two other contemporaneous modes, or scenes, of beholding monuments, both of which were authoritative in the 1850s in America: the monumental oration and the stereoscope. The larger interpretive issue of how Hawthorne conceives of the monumentality of *The Marble Faun* as a whole, of which its representation of monumental beholding forms only one part, however crucial, is beyond the scope of my discussion, though I will offer a few broad suggestions about how this romance constitutes a different sort of response to his culture's felt need for monuments. In its encounter with the monuments and monumentality of the Past, this last of Hawthorne's completed romances discovers even more paradoxically than do his earlier works that the route to cultural authority and permanence for a modern literary work aspiring to monumentality lay through the most complex possible, or bearable, articulation (I do not say resolution) of contingency and impermanence, through an insistent displacement and fragmentation of the monumental sublime.

As historians like John Higham, George Forgie, and Neil Harris have noted, the 1840s and 1850s in America saw a marked increase in interest in and efforts of monument building. The impulse to monument building was a response to what Higham has characterized as a widely felt "malaise," the "disturbing sense of remoteness from the heroic age of the Revolution." Monuments would, it was hoped, "rebuild continuity with the past," in particular with its heroisms of republican civic virtue that to many seemed to have given way to a pervasive, selfish materialism, and with the idea of a national community and the passion of a unifying patriotism that sectional conflict was making ever more remote.[3] As one American put it in 1846, monuments would "bring before us in our daily walks the idea of country in a visible shape." Lacking the traditional kinds of "external signs of this idea of country, . . . [we] need," he continued, "something tangible, to cling to . . . we need outward types."[4] Forgie's study of the political discourse of the 1840s and 1850s argues that the imagery of these "outward types" of the nation became increasingly domestic and sentimental. Monumental orations typically sought to reawaken and release domestic emotions (in a collective activity of "regression") that would establish a unifying bond of social affection more deeply rooted than the material interests and partisan loyalties of the nation's politics.[5]

The cultural work of the monument as symbol and ritual of national unity was

8.1. Bunker Hill Monument (completed 1843). Courtesy Library of Congress.

nowhere more fully revealed than in such popular monumental orations as Daniel Webster's effort at Bunker Hill in 1843 (fig. 8.1). For Webster, historical time and social change, the political and spiritual differences between his generation and the revolutionary one, provided an explicit context and disturbing subtext of his oration. In its didactic and sentimental theme of union, the oration sought to contain the anxiety that uncontrolled social change had opened up a fateful abyss between the present and the past. The oration also implicitly claimed the presence of the sublime spirit of the heroic past in the very scene itself of monumental veneration—that is, in the current generation's ritual activities of constructing, gathering at, and celebrating the monument for what it symbolized in both the past and present.[6] As the reporter for the New York Herald wrote, "It was a scene of singular sublimity. The tall pillar in all its impressive solemnity—the vast congregation—the serene sky—the majestic figure of the orator, as he stood silently regarding the colossal column—the hoary headed band of patriots who occupied the front seats of the platform—all made up a scene never to be forgotten."[7] As performed by the monumental oration, the sublimity of the monument was the product of a complex network of linkages established among three interdependent orders of verbal and visual signs, each designating for the audience a different register of the scene's visibility: the physical monument, with its silent, architecturally imposing visibility; the orator himself, a visible sign of the recurrence in the present of the heroic past, whose grandiloquent performance of both speech and gesture personified a kind of living equivalency both of the deeds commemorated by the monument and of the monument itself; the orator's discourse, whose sublime powers of "word painting" activated the monument's sublimity for the gathered community, making present to it and available for ritual veneration a sacred sign of its historic constitution, of its unifying values and heroic virtues.

The orator's ekphrastic enunciation of the monument, by invoking and attempting to make present the authority of a heroic past, played a key role in two ways in

this staging and figuration of the social sublime. First, it aimed to stabilize the auditor-beholder's understanding of history by presenting an authoritative, unifying picture of an idealized national past that limited the play of conflicting perspectives and interpretations. Not only did the monument symbolize this idealized past, but its visual presence stood security for the palpable reality, the self-evident monumentality, of the orator's verbal picturing of the heroisms and civic lessons of the Founders' deeds at Bunker Hill. This visual sign, which proclaimed and evoked an undoubted, universally accessible, transgenerational object of reverence—a sort of natural sign language of historical truth and national unity—was paradoxically valorized, in the rhetoric of the orator's performance, in contrast to words, whose written forms and malleable, unstable, merely rhetorical uses made them the medium of conflict and uncertainty between and within generations. The monument, declared Webster,

> is itself the orator of this occasion. It is not from my lips, it could not be from any human lips, that that strain of eloquence is this day to flow most competent to move and excite the vast multitudes around me. The powerful speaker stands motionless before us. It is a plain shaft. It bears no inscriptions, fronting to the rising sun, from which the future antiquary shall wipe the dust. Nor does the rising sun cause tones of music to issue from its summit. But at the rising of the sun, and at the setting of the sun; in the blaze of noonday, and beneath the milder effulgence of lunar light; it looks, it speaks, it acts, to the full comprehension of every American mind, and the awakening of glowing enthusiasm in every American heart.

Webster represents the oration's ritual occasion of communal memory and renewal in terms of an ideal of communication. Drawing a homology between the monument, himself, and his words ("There was the Monument, and here was Webster," remarked Emerson), Webster imagines a linguistic medium constituted by words that were "silent, but awful" in their "utterance"; that were motionless yet capable of sounding the depths of pathos and of an "elevation" which "raises us high above the ordinary feelings of life"; that needed no arts of inscription or "antiquary" deciphering but, "fronting to the rising sun" rather than arising from "the study of the closet," only the common mind and heart of "every American" to behold.[8] Like the monument and Webster himself, Webster's language was praised by contemporaries for its natural force and authority, for the "plain force of manhood" that lead "him contemptuously to reject all the meretricious aids and ornaments of mere rhetoric."[9]

Second, the historical drama as well as the symbolism of the monumental oration depended in a double sense on the trope of personification. All monuments and monumental discourse of the period, Forgie argues, sought to lay claim to the emotional effects and associations of transporting the beholder to "the tomb of Washington." As the nation's "one great sentiment," Washington was the supreme icon of filiopietistic reverence for the idealized authority and virtue of the past.[10] Webster's oration explicitly invokes the actual presence of Washington's spirit in the monument itself. The conclusion of Webster's Bunker Hill monument oration nicely illustrates this rhetorical strategy. After a lengthy, pictorially evocative account of the heroisms and historical lessons of the Founders' deeds at Bunker Hill, Web-

ster suddenly transports his auditors into a new version of the obelisk before which they have been gathered. "By its uprightness, its solidity, its durability," Webster intoned, "the structure now standing before us . . . is no unfit emblem of his [Washington's] character."[11]

The icon of Washington had complex and contradictory meanings, however, bearing associations both paternal and maternal. In "Aesthetics at Washington," Horatio Greenough speaks of the design for the proposed monument to Washington, an obelisk like that of Bunker Hill, in these terms: "If I understand its voice, it says, Here! It says no more." Peremptory, potent, and reassuring in an almost silent plenitude, the monument was for its beholder an idealized phallic presence, a sublime symbol reinvoking and identifying the viewer with an authoritative ideal of national identity and republican virtue, seeming thereby to overcome the deepening uncertainties of contemporary American society. The benevolent paternal authority of the monument, at least for the moment of its contemplation, brought to a halt the intensifying play of cultural difference and the sense of generational declension that haunted public life. At the same time, however, it was imagined that monuments would "impersonate" the nation "to us as a kind mother." In the same essay, Greenough offers Hiram Powers's statue *America* (fig. 8.2) as an example of "a statue of America which is not only a beautiful work of art but which 'breathes, smacks, and smells' of republicanism and Union." "If placed conspicuously . . . in one of the new wings of the Capitol," he wrote, this statue would become a monument to the Union, a shared object and inspiration to chastened, maternal love and reverence. This conflation of the idealized emotions associated with the origins of both home and state, of the cults of domesticity and of the Founding Fathers is powerfully epitomized by the inspirational, consoling presence of Washington's portrait hanging over the fireplace in Uncle Tom's cabin.[12]

Part of a nation's "educational system," as Albert Elsen has written, public sculpture in the nineteenth century "was thought to give the man on the street, preoccupied with petty affairs, the shock of great ideas, usually by showing the men and women who had thought of them. It not only provided models of ethical conduct, but good physical posture" as well.[13] You became what you beheld, as Blake put it. Such tropes of personification and the gender uncertainties of fluidities they enact are a key to the rhetorical strategy of monumental orations as well as to the illusive nature of the demands made by them on the beholder, who is invited by historical lesson and the "mystic chords" of sentiment to identify with the monument's sublimity.

Hawthorne's critique of conventional monumental practice and discourse is directed at its fictions of the visible and of personification. In contrast to the ritual symbolism of the oration, Hawthorne's romance presents the visual monument in the perspective of ruins, as the visible sign not of perpetuated historical memory but of time's inevitable passage and of the consequent decay or disfiguration of historical ideals and communal memory. In its tentative authority, rooted as Hawthorne puts it in the "shifting and transitory" medium of language, the romance performed a cultural work of embedding or inscribing the visual monument in a perspective of value and meaning different from the oration. As an object of a kind

8.2. Hiram Powers, *America* (or *Liberty*), 1848–50. National Museum of American Art, Smithsonian Institution, Museum Purchase in Memory of Ralph Cross Johnson.

of permanence, as itself a kind of monument, Hawthorne's romance undertakes to affiliate its readers in a work of recognition that acknowledges and mourns the loss or skeptical abandonment of their ideal objects of common value and belief, of community.

Hawthorne's own venture into the medium of his culture's sentimental discourse of monumental veneration, his campaign biography of Franklin Pierce (1852), sought to celebrate the Union as a kind of sublime sculptural monument, opposing the fanaticism of abolitionists who were bent upon "severing into distracted fragments that common country which Providence brought into one nation, through a continued miracle of almost two hundred years."[14] By the time he wrote *The Marble Faun*, however, Hawthorne had come to express privately his skepticism about the Union as outward type or inward conviction, now describing its dismemberment as both inevitable and desirable.[15] The novel is dominated by a mood of critical, often irreverent irony toward monuments as adequate visible embodiments of the politically and morally fractured "idea of country" and toward the idolatrous piety that revered their sublimity. In one scene, looking at the Bernini-inspired Fountain of Trevi (fig. 8.3), the American sculptor Kenyon and an English artist exchange satiric fantasies of designs for a monument to American national unity based on it. Kenyon imagines replacing its deities with thirty-one figures who would represent the "sister States, each pouring a silver stream from a separate can into one vast basin, which should represent the grand reservoir of national prosperity." More

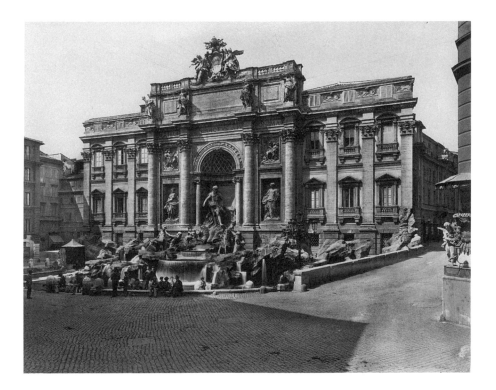

8.3. The Fountain of Trevi, Rome. Courtesy Art Resource.

VISUAL ARTS IN THE MARBLE FAUN

caustically, the Englishman proposes "to set those same one-and-thirty States to cleansing the national flag of any stains it may have incurred" (145–46).

After having spent some months in Florence in 1858, Hawthorne was led to reflect on the characteristic failure of America's monumental art: "I wish our great Republic had the spirit to do as much, according to its vast means, as Florence did for sculpture and architecture, when it was a Republic; but we have the meanest government, and the shabbiest—and, if truly represented by it, are the meanest and shabbiest people—known in history. And yet, the less we attempt to do for art the better. . . . There is something false and affected in our highest taste for art; and I suppose, furthermore, we are the only people who seek to decorate their public institutions, not by the highest taste among them, but by the average, at best." Hawthorne's remarks establish an analogy and suggest an even stronger causal connection between the nation's deepening crisis of political representation in the 1850s and the confusions and failures of America's monumental art as an art of representing the grandeur of the nation's legacy of political virtue. Like the current generation of political representatives, the monuments that sought to commemorate and revitalize the nation's republican ideals or to represent the heroic figures who embodied them seemed unable to personify, to make present again a convincingly unified vision of the nation. Hawthorne found Clark Mills's equestrian statue of Andrew Jackson, whom he considered to be "the greatest man we ever had," to be entirely unequal to its subject. Of Thomas Crawford's uncompleted, multi-figured Washington monument, he remarked, "It did not impress me as having grown out of any great and genuine idea in the artist's mind, but as being merely an ingenious contrivance," its architectural impressiveness and its useful historical lesson unable to conceal either the foolishness and illogical composition of the monument's iconography or its lack of "force[ful] . . . thought or depth of feeling." And though he admired it a great deal, Hawthorne found such disfiguration even in Powers's statue of Webster, Constitution grasped in hand, "symbolizing him as the preserver of the Union." Based on its representation of political virtue, he remarked, "posterity will look upon us as a far grander race than we find ourselves to be. Neither was Webster altogether the man he looked."[16] Whether shabby, merely decorative, or falsely idealizing, these notable instances of contemporary American monumental art decisively confirmed the view that "sculpture has no longer a right to claim any place among living arts," as Miriam puts it in The Marble Faun (124).

Though he rather liked Powers's statue America, which he saw in Florence, finding it imbued with more life than most of "the cold allegoric sisterhood" of such statues of "womanhood," Hawthorne voiced his skepticism about the underlying project of the monumental, exposing the wishful fictiveness of its ritual building, beholding, and oratorical celebration. Rather than stabilizing by a common sentiment the conflicting perceptions of the nation, the statue (originally titled Liberty by Powers) embodied, he remarked, "whatever [ideas] . . . we choose to consider as distinctive of our country's character and destiny." Furthermore, he wrote, "I somewhat question whether it is quite the thing . . . to make a genuine woman out of an allegory; we ask, who is to wed this lovely virgin? Who is to clasp and enjoy that beautiful form?" The monument's aim of establishing bonds of domestic affection came to

nought, in Hawthorne's view, in the face of the merely figurative possibility of the ritual performance: the chilliness of marble and of allegorical thought did not provide an adequate object to wed one's passions and loyalties to, nor did its "beautiful form" permit one "to clasp and enjoy" it, thereby raising and purifying those passions (*Notebooks*, 436).[17] Whatever the underlying idea or fantasy of such monumental beholding, it depends on the chilly fictions of sublime consummation. Such fictions established a kind of homology among the beholding, the making, and the (marble) medium of monuments, and Hawthorne's novel critically explores and imaginatively transforms each constitutive element of this scene and structure of monumental signification.

In contrast to the orator's supreme fiction of the presence and recurrence of the heroic past, the numerous scenes of beholding monuments in Hawthorne's romance offer a different pedagogy. Monuments might indeed be "sermons in stones," as Hilda declares and wishes them to be if they remained as legible in their iconography and inscriptions to later generations of beholders as they were to the first audiences that gathered to hear their dedicatory orations (151). Emerson said about one of Webster's orations that "the whole occasion was answered in his presence,"[18] and it is the absence of precisely this kind of authority about the "sermons in stones" that marks the novel's representation of beholding. As the scene with Kenyon at the Trevi fountain suggests, the young American artist-tourists in *The Marble Faun* are representative of a generational (and more broadly epochal as well as cultural) belatedness, their confrontations with the monuments of the Old World charged with a desire to recover their meaning and value, yet at the same time decontextualized, the seemingly accidental gatherings of rootless attention. Neither for his characters nor for his readers does Hawthorne's narrative attempt to restore to Rome's monuments (whether through didactic translation or "word painting")[19] the transparent, unproblematic authority that a sermon or an oration might have for its audience. And this belatedness and illegibility of monumental signs do not become, in the course of the novel, the occasion for sublime recuperation—that is, for discovering in the confrontation with the erosion of monumental signs a scenario of sublime reaffirmation of the mind—in particular, the American mind—confronting History. On the contrary, as many critics, beginning with Henry James, have remarked, the narrative seems to lapse into something like picturesque travelogue, with many of the characteristics of middle-class mass tourism: leisurely relaxation, conventional, middle-brow taste, pervasive imperceptiveness about the social and historical contexts of sights. I will return in a later section to this question of the sublime and the picturesque in Hawthorne's travel writing. Here I want only to emphasize how pervasively Hawthorne's writing concerns itself with this condition of belatedness and registers the awareness that the decay of monumental meaning is a function not only of the monuments themselves (as ruins), but of the situation of the beholder—of the beholder's interpretative capacities and desires—confronted as tourist (and as modern) with the absence of the orator and seeking in guidebooks, in copies, or in each other a substitute for the authority and sublimely legible presence of the orator's discourse.

The numerous scenes of beholding in Hawthorne's romance are structured, at least cumulatively, to acknowledge the elusive, uncertain play of distance and intimacy, of otherness and specularity between the monument and its beholder. From its opening scene in the Capitoline's sculpture gallery, in which "the perfect twin brotherhood" of Donatello and Praxiteles' Faun (fig. 8.4) is announced and affirmed by his companions, Hawthorne's novel invites the reader into and undoes, or at least radically qualifies, the frame of mind drawn to such fictions or fantasies of personification. This act of seeing resemblances between artworks and persons, this desire to see persons as personifications of monuments, turns out to be a literalization of how, in Emerson's words, "perception is not whimsical, but fatal."[20] What begins in this scene as a playful, affectionate motion of mind linking beholder, artwork, and model comes to shape the dramatic fate of each of the novel's characters in the wake of Donatello's murder of the model, the central event of the story. This act, which both seals and is a symbolic effort to sever these powerful emotional and psychological ties, produces in its wake a skeptical reassessment of the iconology of classical monuments and a web of troubled affiliations among the characters.

One revealing example will have to stand for many others. In an early chapter, Hilda and Miriam discuss their somewhat opposing interpretations of the "sin" and

8.4. The Faun of Praxiteles, Capitoline Museum, Rome. Courtesy Art Resource.

"sorrow" of Beatrice Cenci, both in Guido Reni's painting and in legend. Reacting to the judgmental coldness of Hilda's description of Beatrice, Miriam gives "passionate utterance" to her own sense of Beatrice's sin and of her kinship with it. At this moment, the narrator remarks that Hilda is struck by Miriam's resemblance to Beatrice (67). A few chapters later, however, while visiting Kenyon's studio and looking at his sculpture of Cleopatra, Miriam describes Hilda as Hilda had earlier described Beatrice: "Of sorrow, slender as she seems, Hilda might bear a great burden; of sin not a feather's weight." This characterization of Hilda occurs just moments after Miriam has perceived herself as having a deep affinity or likeness of expression to Kenyon's (in fact, William Wetmore Story's) statue *Cleopatra* (127–28). Who or what resembles who or whom? The algebra of recognitions and resemblances here is complex. Hawthorne's text configures a range of ambiguities involved not only with this network of (visual) resemblances remarked between artworks and characters, but also between verbal descriptions of artworks (and their expressiveness) and characters and between artworks themselves and descriptions of them.

At first, such moments of beheld recognition seem to establish the identities of and differences among the characters and to clarify their actions, both for the reader and in their own articulated conceptions of self. By the end of the novel, however, this network of resemblances has turned back upon itself, disclosing the contingent and projective, hence ambiguous and disfiguring, nature of these recognitions. In producing a sense of fluid, if partly unconscious, interchange of identity, the narrative calls into question the idea of individual autonomy at least insofar as this is conceived in terms of the metaphor of statuelike monumentality.

In the context of this drama of recognition, the numerous canonical works of art in the novel are insistently represented as operating on the characters not by the delineation and clarification of inherent and enduring values, with which they come to identify, but by a kind of circulation or contagion of their desires through the activity of beholding. This, in turn, creates among the characters a suffusing sense of moral complicity and ambiguity, and for the reader an intensifying, dramatically significant complication of the characters' outlines—an obscuring of the sharp delineation of their differences from one another and of the terms by which they aim to differentiate themselves from one another. The narrative thus calls into question, both through its representation of the effects of monumental artworks on the characters and through the action of its own discourse, the cultural role of such works as agencies of moral pedagogy and character formation.

In this unfolding representation of character, the novel reverses and revalues an aesthetic distinction central both to neoclassical conceptions of beauty and form and to the conventions of characterization in Gothic fiction. In the Gothic, according to Eve Kosofsky Sedgwick, "figures of play and change" are "firm[ly] subordinat[ed] to the figures of fixity, . . . to what inheres and endures," an opposition and a dramatic fate best represented in "a typically pictorial image: color as opposed to outline." Though conventionally signifying the presence of even "the fiercest motive of desire," "color stands for the temporally fugitive." "The last word," Sedgwick continues, "is almost always with the linear residue, with structure drained of

color. Sexually passionate characters come to the end of their histories not imbued or suffused or deep-dyed with passion but, often dismayingly, emptied of affective passion, retaining only those etiolating graphic traces . . . of 'true character.' "[21] This hierarchical opposition between line and color, this deathly draining of color and the violent subordination of passion before the "ultimate of structure," is seen most powerfully among Hawthorne's works in the figure of the dead Zenobia in *The Blithedale Romance*, emptied of her vital, colorful "warmth and mirthful life" and become a "marble image." Zenobia's casting off of her ubiquitous, brilliantly colored flower and her soon-to-follow "death-agony" of "terrible inflexibility" and "rigidity" are, more generally, figures for the frozen, devitalized life agony that is the shared fate of the romance's other characters.[22]

In revaluing the qualities of color and line, *The Marble Faun* inverts as well the typically tragic resolution or violent transumption in Gothic fiction of these conventionally opposed figures. The fateful dominance of outline and form, the authority of structure, is subverted as the sharp outlines and asserted differences between the characters and their moral ideals come to be viewed in a perspective disclosing them to be projections of desire. Sedgwick shows how for Freud and earlier for Ruskin this "ultimate of structure" in contrast to the play of desire is conceived in terms of the compulsion to repetition. Hawthorne's romance embodies this figure not simply in Hilda's being a copyist. More compellingly (and ironically), it appears in the very sympathy by which her sphere of spirituality, her rigid subordination of all other instincts of mind and imagination to the monumental authority of copying, draws these instincts to it, even while finally silencing their "perpetual difference, change, play" (in Ruskin's words).[23]

These reversals at the levels of both characterization and plot elaborate and sustain a fundamental imaginative premise of Hawthorne's romance in bringing Praxiteles' sculpture to life and subjecting it to the play and change of narrative perspective. The very choice of that sculpture is significant. In the first chapter, its outlines are described in feminine terms: not only is the Faun said to be "marvelously graceful," but it is described as having a "fuller and more rounded outline, more flesh" and as being more "rounded and somewhat voluptuously developed" in contrast to the "heroic . . . types" of classical "masculine beauty." "Unlike anything else that was ever wrought in that severe material of marble," Hawthorne writes, the Faun conveys ideas of the "amiable," the "sensual," the "mirthful"—"as if its substance were warm to the touch, and imbued with actual life" (8–9).

Hawthorne's account performs this valorization of color and passion at the expense of one of his culture's fundamental aesthetic canons, its association of the "severity" and idealism of line and form with the neoclassical meanings and uses of marble. Both inside and outside its explicit discourse of aesthetics, then, Hawthorne's narrative criticizes the monumental sign at a second level by continually directing our attention to figurations of artistic media, especially to the nature of the sculptor's marble medium and to the inhuman, unearthly qualities of representations of character and value in it. For Hawthorne's culture, marble was the privileged signifier of monumentality—of eminence, of purity, and of permanence: more generally, it was the medium of representation naturally identified, as it were, with

the embodiment in form of the ideal (120–21, 135–36). Though initially deploying this conventional sense of marble as a medium of innocence and idealization in defining the classical qualities of the original sculptural Faun that Donatello is said to resemble and in characterizing Hilda in terms of "the marble purity of her heart," the overall narrative and discursive movement of The Marble Faun is not to celebrate or conserve these common associations of marble, but to criticize them. In the course of the novel, marble is repeatedly said to imprison the form it takes. Kenyon's Cleopatra is remarked as being so imprisoned, for example (377–78). The marble salon of Monte Beni, the only room in the castle that does not experience a change of atmosphere when Donatello returns from Rome after committing his crime, is described as a "hall where the sun was magically imprisoned, and must always shine" (278–79). This prefigures Donatello's imprisonment at the novel's end, as much by the marble sunshine of Hilda's purity as by a Roman jail.

By contrast, the many images in the novel of clay and of "earth-stained," discolored marble are figures not only for its transfigured vitality, its infusion with blood and passion, but also for this narrative desire to transform marble from a substance of purity and smoothness to one that is "warm to the touch, and imbued with actual life." Kenyon's last bust of Donatello, unlike his earlier sculptures, somehow manages to make marble signify not a condition of purity impermeable and other to time and decay, but rather the textures of earthiness itself or, at least, the spirit's necessary growth "through the incrustation of the senses" (381). The most remarkable instance of this, perhaps, is the earth-stained, fragmented, mud-incrusted Venus excavated near the end of the novel, which inverts with a vengeance the marble images of feminine desire embodied by both Hilda and the dead Zenobia. As something embedded in earth, the buried statue is linked to Kenyon's earlier fantasy of Rome's bloody past in terms of "a mighty subterranean lake of gore, right beneath our feet" (161–63). This image of the earth as a blood-engorged body, separated only by a "thin crust" which provides "illusive" support to the structures of happiness and moral authority, is refigured by the earthy, excavated Venus in an image suggestive of birth, of menstrual flow, and of excrement: "a far truer image of immortal womanhood," declares Miriam (quoting Hawthorne's own remarks in his notebooks [516–17]), than that of the canonical Venus de Medici, with its ideal associations of female purity. Kenyon, thinking only of Hilda and unable to see this embodiment of beauty or shrinking from it, declares at this moment his imaginative deadness and is judged by the narrator to have failed as "a consummate artist." Itself one of the narrative's consummating moments, this scene—structured around the strongly gendered oppositions between blood, color, earthy fragments, on one side, and purity, smoothness, severity of line, on the other—is subversive of the gender lines in the novel as well as of the conventional gender associations of Hawthorne's culture (422–27).

At other moments, when Hawthorne's irony turns acid or gives way to anger, when mournfulness is replaced by iconoclastic aggression, the narrative's aim seems to be to disfigure or mutilate what is marblelike. "It is an awful thing," he writes, "this endless endurance, this almost indestructibility, of a marble bust!" The physical qualities of marble make it a grotesque medium in which to represent "the

little, little time during which our lineaments are likely to be of interest to any human being." "The concretions and petrifactions of a vain self-estimate," Kenyon's portrait busts of "illustrious" contemporaries are especially inappropriate in the context of American social life. "The brief duration of" American families, he writes, continuing a central theme of *The House of the Seven Gables*, means that great-grandchildren will almost certainly "not know" their sculpted ancestor, ensuring a kind of impious, even hostile relation to these forgotten stone "blockhead[s]," as he puts it. "It ought to make us shiver, the idea of leaving our features to be a dusty-white ghost among strangers of another generation, who will take our nose between their thumb and fingers," Hawthorne whimsically imagines, "and infallibly break it off if they can do so without detection!" This fantasy, I take it, records his own desire in relation to the "fossil countenance" of historical monuments and provides a significant figure for the kind of gesture, or logic, performed by the narrative as a whole. Hawthorne aligns the impiety of its aims with nature's activity of recuperative forgetfulness. Imagining a simple memorial of grass that "will sprout kindly and speedily" over a grave in contrast to marble that "make[s] the spot barren," Miriam declares that "it will be a fresher and better world, when it flings off this great burden of stony memories, which the ages have deemed it a piety to heap upon its back" (118–19).

A medium figured by gestures that stain, incrust, or disfigure marble with mud: the opening pages of Hawthorne's novel define the character of its own narration in terms of figures of "texture" in contrast to those of line. "Woven" out of "airy and insubstantial threads" and "twisted out of the commonest stuff of human existence," the narrator desires to create a work which will "seem not widely different from the texture of all our lives"(6). Through this imagery of texture—associating a feminine vocabulary of making with ideas of the ordinary and the overlooked, of "the near, the low, the common" in contrast to the monumental[24]—Hawthorne's narrative represents its own activity, its own way of making a story line or producing dramatic form. The narrative's texture, defined in part by its complex attention to the medium (or several media) of sculpture, as well as to the expressiveness of other art forms, is defined as well by its exploratory representation of scenes of artistic creativity.

Hawthorne's novel, then, disrupts the aesthetic of monumental signification at this third level as well. The idea or ideal of personifying resemblance postulated in the first scene's imagined twinning of Donatello and the Faun is displaced in the course of the novel, as a paradigm for the activity of representing or delineating character, by a more fluid, ambiguous notion of likeness. We can see this displacement especially in two scenes, set not long after Donatello's crime, in which Kenyon tries to model his bust.

Kenyon first undertakes to sculpt Donatello's bust at Monte Beni, a task which gives him unprecedented difficulty. Donatello's moral transformation lends to his features, ordinarily "the index of the mind within," an impermanence of expression that even his "ponderous depression" could not "compel . . . into the kind of repose which the plastic art requires." Abandoning "all preconceptions about the character of his subject"—that is, about preexistent, settled lines of character to be

modeled into plastic expression—Kenyon takes up a method of working "uncontrolled with the clay, somewhat as a spiritual medium . . . yields to an unseen guidance other than that of her own will." Allowing the restless, irritable play of his fingers to guide his modeling, Kenyon "compressed, elongated, widened, and otherwise altered the features of the bust in mere recklessness," hoping that "every change" might capture by spontaneity the "intangible attributes" of the soul of his model. "By some accidental handling of the clay," Kenyon does at one moment give the sculpture's "countenance a distorted and violent look" that Donatello recognizes as his own at the moment of the murder, hence as the outward sign of his guilt and of the agony of his developing moral consciousness. At the moment that Donatello's recognition halts Kenyon's modeling and before Kenyon's horror at the clay bust's "ugliness" leads him to erase its features, Kenyon reads its agitated dissymmetries as having formed an iconic resemblance to the mark of Cain. Donatello and, I take it, Hawthorne read the bust's disfiguration in another way: the compressed, elongated, widened, and lumpy features are seen as constituting a plastic language of formal inflection that somehow has the capacity to make fully and instantaneously manifest the very process of Donatello's inner moral transfiguration (270–74).

Hawthorne constructs this scene to suggest two ways of understanding the emerging aesthetic of Kenyon's sculpture. First, the serial activity of his clay modeling embodies a kind of likeness of Donatello's evolving inner state, of its phases and gestures, of its expressive inflections of agony and awareness: that is, if each moment had been preserved by casting. Second, and perhaps more important, the very restlessness, agony, and mutability of expression produced by Donatello's moral turmoil become contagious, affecting Kenyon's manner of working, imparting to his fingering of the clay the same kind of gesturalness that marks Donatello's growth. Independent of Kenyon's will to imitate the fixed lines of Donatello's character according to the canons of a neoclassical taste, the very process of his modeling mimics the turmoil of Donatello's inward evolution. Kenyon's activity of representation leaves on the clay a record of its own restless play of mood, of the very condition of its "accidental" transformation into a mode of "grotesque realism" as this is defined by Bakhtin: the reflection of "a phenomenon in transformation, an as yet unfinished metamorphosis," a representation "not separated" from either the activity or the scene of representation.[25]

This reading is confirmed by a later scene in which Kenyon discusses with Hilda another version, this one in marble, of his "not nearly finished" bust of Donatello (379–81). "Lacking sharpness," the features of the sculpture's countenance are said to be emerging from but still partly "incrusted all round with the white, shapeless substance of the block." As did others in the nineteenth century,[26] Hawthorne unlike Kenyon seems to be imagining a sculptural style in imitation of some of Michelangelo's work, the deliberately unfinished taken to be the paradigmatic manner by which the gesturing of the spirit's struggle to emerge or emancipate itself from an enveloping materiality could be expressed in final, finished form. Hawthorne writes that this version of Donatello's bust was not the one begun by Kenyon at Monte Beni, but rather "a reminiscence of the Count's face, wrought under the

influence of all the sculptor's knowledge of his history, and of his personal and hereditary character." The sculpture, then, abstracts into a momentary expression the full action of Donatello's moral history, capturing the spirit "kindling up . . . like a lambent flame."

Hilda at first hesitates to recognize the bust's subject. Recalling the perceived "perfect twin-brotherhood" between Donatello and the classical Faun of Praxiteles that initiates the novel, she remarks on what she takes to be the imprecision of the likeness of Kenyon's work, formed (or unfinished) according to an aesthetic no longer of neoclassical imitation. "Given that only one spectator out of a thousand," remarks the narrator, did not mistake it for an unsuccessful copy of Praxiteles' Faun and was able to recognize instead its remaking of the reposed, idealized features of the classical statue, one might see this imaginary work of Kenyon's as heralding a new sculptural aesthetic, one based on gesture, on the shifts and transitoriness of character. What Kenyon and Hilda consider the chance result of the bust, in "being just so shaped out in the marble, as the process of moral growth had advanced in the original," characterizes its organic expressiveness. Here, the monumental art of sculpture is reimagined by Hawthorne after the model of language's metamorphic flux or revisionary troping.

In both of these scenes, Hawthorne imagines the powerful sculptural expressiveness and penetration of character to be a consequence of the conditions of their making, the resulting products reflecting the peculiarities of the creative process. Three conditions in particular distinguish these works from the conventional processes of sculptural creation described in the earlier chapter, "A Sculptor's Studio" (114–15). First, the continuing hands-on engagement of Kenyon's modeling with the materials in these scenes (even with the later marble bust) preserves the satisfying, sketchlike immediacy ordinarily typical of only the clay stage. Second, the very continuousness of Kenyon's process of working contrasts to the usual division of the sculptor's labor into directly handcrafted model and indirectly executed transfer of the sculptor's own model into another material by hired assistants who copy, with the aid of machinery. Third, along with these other two conditions, Hilda's responses to Kenyon's labors constitute an implicit commentary on and critique of the adequacy of the neoclassical aesthetic dictum, attributed to Thorvaldsen, to account for their results: "the Clay-model, the Life; the Plaister-cast, the Death; and the sculptured Marble, the Resurrection" (380). These two scenes link, instead, the clay bust and the later roughly worked marble one with Donatello's "advancing towards a state of higher development," a notion (whether morally or psychologically construed) differing significantly from "Resurrection." In its more conventionally polished smoothness, finished by other hands, the marble transfer or copy seems hardly to have struck Hawthorne as the "Resurrection" of the form. And, while the narrative imagines the possibility of a faithful, nonmechanical (i.e., organic) copying in terms of Hilda (or, more exactly, her embodiment of purity), its depiction of Hilda in this context clearly suggests the exception (as well as a fantasy) of copying, not the rule (56–61).[27]

"Classic statues escape you with their slippery beauty, as if they were made of ice. Rough and ugly things can be clutched," Hawthorne wrote in his notebooks. "This is nonsense, but yet it means something" (Notebooks, 404). Up to a point, these scenes

with Kenyon parallel his own novelistic confrontation with Praxiteles' Faun. Like Kenyon's sculptures of Donatello, Hawthorne's romance proceeds, as I have been arguing, according to an aesthetic that fundamentally diverges from the imitation of the idealized repose, of the monumentality, of the original. The narrative's depiction of the beholding, the medium, and the creation of artworks in terms of a revision of figures of line and color central to the neoclassical canon of form and beauty mirrors its own aesthetic and performance. Hawthorne's "nonsense" suggests, furthermore, something like Ruskin's central idea of the grotesque as a "delight in" the "fantastic and ludicrous," as an imagination of form and ornament that worked a playful texture into the severities and laws of structure.[28]

Like Ruskin, who may have influenced him in this regard, Hawthorne shared in the nineteenth century's revaluation of the Gothic as a canon of grotesque forms more natural than the rational symmetries and orders of classicism. Only two weeks after leaving Italy, he wrote, "It did me good to enjoy the awfulness and sanctity of Gothic architecture again, after so long shivering in classic porticos." As his travel notebooks make abundantly clear, Gothic architecture seemed to Hawthorne "unspeakably more impressive than all the ruins of Rome," serving both as a standard of moral sublimity and as a metaphor for the disjunctive, dispersive activity of the imagination in time, the architectonics of his romance. "Classic forms," he wrote a few days earlier, "seem to have nothing to do with time, and so to lose the kind of impressiveness that arises from suggestions of decay and the Past" conveyed by Gothic forms (Notebooks, 549–50, 537). While still in Italy, Hawthorne had meditated on the peculiar "moral charm" of the Gothic, its way of "filling up its outline with a million of beauties that perhaps may never be studied out by a single spectator. It is the very process of Nature. . . . Classic architecture is nothing but an outline, and affords no little points, no interstices, where human feelings may cling and grow like ivy" (Notebooks, 405). The asymmetry of form, the digressiveness and playful explosion of its lines into fanciful detail specify a notion of design opposing the classical one, which "regarded the totality" of forms "as forming a single unified and immediately intelligible composition, of which the elements were subdivisions constituting smaller but still harmoniously related parts."[29]

Not proportioned to the repose and closure, the rational geometric clarities of form of this classical statue, Hawthorne's own narrative ekphrasis of Praxiteles' statue required an architectonics that translated it as much from one canon of aesthetic form into another as it does from one medium into another. To achieve through language a representation of this classical statue—reimagined as the form of an action, "the soul's growth, taking its first impulse amid remorse and pain, and struggling through the incrustations of the senses"—that satisfied Hawthorne's imagination required nothing less than an entire romance's brooding, playful meditation on it: not only a Pygmalion-like personification of it in narrative, but an optics of asymmetry that complicates the textual perspectives of innocence and experience in which to read it, so as to avoid the dangers of monumentalization that threaten the reader with muteness, with transformation into a mere viewer.

Not long after his return from Europe, Hawthorne paid a visit to the Emersons, primarily to call on his daughter Una's friend Ellen Emerson. As she had already

gone to bed, Hawthorne stayed a while talking to the other Emerson children. "To cover his shyness," relates Edward, "he took up a stereoscope on the center table and began to look at the pictures. After looking at them for a time he asked where these views were taken. We told him they were pictures of the Concord Court and Town-houses, the Common and Mill-dam, on hearing which he expressed some surprise and interest, but evidently was as unfamiliar with the center of the village where he had lived for years as a deer or a wood-thrush would be. He walked through it often on his way to the cars, but was too shy or too rapt to know where he was."[30] This anecdote can be interpreted in another manner than from the perspective of Edward's astonishment and child's smugness at Hawthorne's seemingly incomprehensible unworldliness, a view that via Henry James has retained immense authority. Hawthorne surely knew what it was he was looking at in the stereoscope, let me venture to suggest, but was struck by how the apparatus made unfamiliar what had been for many years his home. Having been oriented for so long in his imagination to creating defamiliarizing perspectives of the real in juxtaposition to its more self-evident appearances, Hawthorne may well have felt a bemused, perhaps wearied shock of recognition at the effects of the stereoscope on his immediate, intimate world: for the moment, anyway, this apparatus may have seemed to actualize his deepest, most private inward eye (and need). Or it may have struck him as an uncanny reenactment of his often tiring, abrasive, estranging experience as a European traveler. The affinity and analogy suggested by this anecdote between the effects of stereoscopic viewing and the kind of reader responsiveness produced by *The Marble Faun* are worth exploring further.

In Italy, Hawthorne remarked on the pervasive existence of copyists in museums, was fascinated by Hiram Powers's Yankee ingenuity in inventing new machinery to facilitate copying sculpture, and was surely struck by the family resemblance manifest in the prosperous stereoscopic business run by Powers's sons in Florence. This curiosity about the methods and magic of reproducing images continued what was a long-standing interest in his work. From such early works as "Drowne's Wooden Image" and "The Prophetic Pictures" to "Main Street" to *The House of the Seven Gables*, Hawthorne's writings show a recurrent interest in magical or prophetic images and in the desires, the arts, and the mechanical devices (diorama, panorama, daguerreotype) that produce and exhibit them. These tales, sketches, and notebook entries represent visual images which have for spectators a quality of animation, of dreamlike, hallucinatory presence. These moments of personal fascination and imaginative elaboration, in which the boundaries between spectator and spectacle, reality and representation are uncannily, if temporarily dissolved, can be thought of as preliminary articulations rehearsing the sort of enchantment that was to become central to Hawthorne's mature theory of the romance: the representation of "a neutral territory, somewhere between the real world and fairyland, where the Actual and the Imaginary may meet, and each imbue itself with the nature of the other."[31] In this uncanny realm, narration and optics become figures for and haunt one another. If *The House of the Seven Gables* figures the verbal powers of its mode of romance in terms of the experience of the daguerreotype, *The Marble Faun* refigures the experience of the visual in terms of the powers and possibilities of

reading invited by romance: letter and figure dissolve into one another as text and monument, reader and viewer are "imbued" with each other's materiality.

Whatever the actual extent of Hawthorne's knowledge and experience of the stereoscope, there are a number of striking ways in which the "magic" of the stereoscope based on "binocular vision" has affinities to his manner of prominently foregrounding works of visual art (i.e., foregrounding of the Italian background) in *The Marble Faun*. The obtrusive apparatus accompanying the dreamlike, even hallucinatory presence of the artwork, the confusions of scale between the homely and the monumental, a mode of vision depending on the resolution of divergent optical perspectives—these elements and effects of stereoscopic vision can also seem to characterize Hawthorne's narrative mode, especially in the last of his completed romances.[32] In his later book *Our Old Home*, he more explicitly relates his travel writing to stereoscopic voyaging: "Give the emotions that cluster about" the actual scene, he wrote of the evocative and referential powers of this kind of writing, "and, without being able to analyze the spell by which it is summoned up, you get something like a simulacre of the object in the midst of them."[33] The narrative mode of *The Marble Faun* possesses a version of the verbal magic figured here in terms of a photographic or stereoscopic "simulacrum" of them (a process that is a sort of inverse of Eliot's "objective correlative"). Through its complex and ambiguous positioning of visual artworks in highly variable, allusive relations to the novel's characters and actions, the narrative constitutes a dense medium or texture of orientation and significance in which these artworks are encountered. While much of its action takes place in art galleries and artists' studios, the novel produces, both for its characters and readers, a "stereoscopic" experience of the Roman setting as a whole as a "museum without walls."[34]

Though photography's novel powers of copying artworks made possible this new kind of museum without walls, the particular hold of the stereoscope in the 1850s and 1860s as the dominant mode of photography is to be understood more, perhaps, in terms of the history of the theater (as Sergei Eisenstein has suggested)[35] and of the phenomenology of modern mass tourism than of the history of photographic reproduction. The stereoscope's peculiar qualities (different from other sorts of photographs) of three-dimensional illusionism, its illusion of form and space, seemed more palpably than other photographic modes to involve the viewer's body, not just the eye, seemed, that is, bodily to transport the viewer into the space of the image.

In a series of remarkable essays written in the years around the publication of *The Marble Faun*, Oliver Wendell Holmes claimed that with the stereoscope "form is henceforth divorced from matter," transforming our experience of the world. In his "Sun-Painting and Sun-Sculpture; with a Stereoscopic Trip across the Atlantic" (1861), Holmes imagines a new kind of experience made possible by this stereoscopic travel to a world without boundaries in terms that have an extraordinarily suggestive relation to the special kind of reader responsiveness demanded and produced by Hawthorne's romances: "there is . . . some half-magnetic effect in the fixing of the eyes on the twin pictures,—something like . . . hypnotism. . . . The shutting out of surrounding objects, and the concentration of the whole attention,

which is a consequence of this" in stereoscopic viewing, "produces a dream-like exaltation of the faculties, a kind of clairvoyance, in which we seem to leave the body behind us and sail away into one strange scene after another, like disembodied spirits."[36]

The wonder of stereoscopic viewing is epitomized (even allegorized), above all, in Holmes's account through the viewer's encounters with the minor, accidental detail of an inscription, on or near the monument, which can be read. The minor, accidental detail becomes a sort of metaphor for the viewer's presence in or at the scene of the monument. Like the detail, the viewer stands in a metonymic relation to the monument itself, encountering it not through a one-to-one, sublime confrontation with a structure that he identifies with and that in some sense signifies and guarantees his identity, but rather through a kind of displacement. Here, the motions of curiosity about the scene and about the mode of sight enabled by the apparatus enact, in relation to the monument's sublimity, something like what Gaston Bachelard has described as the originating impulse of daydreaming: "We do not see it start, and yet it always starts the same way, that is, it flees the object nearby and right away it is far off, elsewhere, in the space of elsewhere."[37]

Stereoscopic wonder can, then, be linked to or, more strongly, can be understood as a version of picturesque travel: for example, of the kind of evasive, circumlocutionary peregrinations of Washington Irving's comic and sentimental traveling bachelor.[38] Though in no sense comic, Holmes's stereoscopic pleasures depend, like the comic, on a reduction, on a play of scale (of interest and attention) against that of the monument and its sublimity. "A painter shows us masses," he wrote. In the stereoscope, "every stick, straw, scratch" appears "as faithfully as the dome of St. Peter's, or the summit of Mt. Blanc, or the ever-moving stillness of Niagara. The sun is no respecter of persons or of things."[39] Viewed in the stereoscope, the monument is democratically leveled or encountered as a miniature. Or, one might say, it is naturalized by the apparatus, at a considerable, safely picturesque distance from the viewer, who confronts it as if in a "peep show." The effect of the apparatus's photographic reduction is to stimulate a *greater* attention to detail not ordinarily perceived or focused on in the willed activity of beholding, to call into play a sort of "unconscious optics," as Walter Benjamin termed it. Such miniaturizing reduction, such displacements of scale are, as Bachelard and Susan Stewart have argued, constitutive of the medium of reverie and longing, of the immensities of perspective and control opened up by fantasy.[40]

In the optics of the minor detail and chance discovery, in the wondrous yet unthreatening hallucinatory, three-dimensional presence of the object, stereoscopic viewing enacts a kind of defamiliarization of the real (we "sail away into one strange scene after another") comparable to that sought in Hawthorne's romances. Yet, whereas the stereoscope reaffirms in the face of its uncanny views and passivities the honorific perspective of the sublime—through the pleasurable instruction and possessiveness, the memories and desires contained by the middle-class parlor, with its conventional subjects and discourse of culture[41]—Hawthorne's romance performs a related but distinctive work of defamiliarization that is subversive of both the monumental sublime and its displacement into the domestic and the picturesque.

ROBERT H. BYER

A recent essay by Jonathan Crary suggests just how much was being contained by the domestic pedagogy of the stereopticon, just what depths and degrees of strangeness, of the uncanny were being entertained yet kept at a safe distance, in this willed enterprise of entering a world of "form divorced from matter." He argues that "photography . . . defeated the stereoscope as a mode of visual consumption" not only because of the latter's necessarily inconvenient and obtrusive "physical engagement with the apparatus" but, even more significantly, because of its unsettling address to "a fully embodied viewer," binocular and situated in the space of pasteboard cards. By contrast, the photograph, which "masqueraded as a transparent and incorporeal intermediary between observer and world, . . . depends on the denial of the body, its pulsings and phantasms, as the ground of vision."[42] "We seem to leave the body behind us," remarked Holmes, acknowledging the body's presence in stereoscopic viewing even as his genteel words sought to contain its flights and motions within the order of domesticity. Whitman's contemporaneous lines express his poetry's comparable project of bodily entering the world through vision: "Locations and times—what is it in me that meets them all, whenever and wherever, and makes me at home? / Forms, colors, densities, odors—what is it in me that corresponds with them?"[43] These lines constitute a brief epitome of the sorts of questions raised by stereoscopic "travel" but evaded in its popular, domestic pedagogy: questions about what and where a home is, about the bodily phenomenology of the self's constitution as part of the weave of the world, about the erotics of the beholder's absorption or "transport" into the picture.

Hawthorne too was aware that the magic of images was addressed to and grounded in the bodily existence of the beholder. In his earlier tales, a bemused skepticism tends to deflect or repress this awareness of the erotics, the black magic of images, an awareness and containment best seen, perhaps, in the sexualized "magnetism" of the Alice Pyncheon tale in *Seven Gables*. Holgrave's acknowledgment of domesticity curbs the seductive pleasures and powers of his storytelling's "magical" images. *The Marble Faun* situates its representation of the embodiedness of vision somewhere beyond Holgrave's moral scruples: the erotic energies of vision continually place the conventionally domestic in a perspective of instability, of skepticism about value; the safe distances containing "magical" images are time and again abrogated by the disjunctive shiftings of perceptual scale and focus; the thematics of the body's implication in vision is recurrently unearthed. "The fact is," Hawthorne wrote James Fields, "in writing a romance a man is always, or always ought to be, careering on the utmost verge of a precipitous absurdity, and the skill lies in coming as close as possible, without actually tumbling in."[44] In its placements and displacements of the monumental sublime, the romance draws its reader (like its writer) not into the private, domesticated spectacle of the stereoscopic beholder, but into an abyss of "extra-vagant" expression (as Thoreau put it) and skeptical doubt that requires continuous renegotiation and optical adjustment of the self's situation.

In several recent articles, James Young has sought to describe a critical attitude toward monuments that might "save icons of remembrance from hardening into idols of remembrance." Memorialization occurs, he writes, "not merely within these icons, but between the events and icons, and then again between the icons and

ourselves. By recalling this movement between events, icons, and ourselves, we accept more than a ritual responsibility for the images that lie enshrined in our monuments."[45] While I do not think that Hawthorne's novel aims precisely to "save" or "rescue us" from a "complicity" that turns icons into idols, as Young would have it, its narrative does enact a critical perspective toward monuments that invites a dialogic movement between monument, beholder, and the event or idea of nation, and that loosens thereby the investment of ritual responsibility and stabilizing identification called for in the popular practice of monumental beholding.

Hilda is the only character in the novel who does not engage in, who indeed continually fears, this mode of playful, skeptical dialogue with monuments. The irony of this can be characterized in two complementary ways. This "daughter of the Puritans" is the only character whose capacity to read is blocked or annulled. The originating iconoclastic impulse of Protestantism has come full circle in Rome, paralyzed by its own burden of repression and virtue. "The marble purity" of her heart, which mimics her activity as copyist, is rooted in an idealizing view of and idolatrous reverence for the artistic monuments of the Old Masters. Unable to revise, remake, or reinterpret these works whose paternal authority and virtue she trusts unquestioningly—notably, unable finally to accept Kenyon's sculptural reimagining of Donatello—she is prey to the abyss of numbed perception which, in her lonely isolation in art galleries, finds visual artworks to be only deceitful illusions, mere "crust[s] of paint over an emptiness" (341). Abandoning Europe and its monuments altogether at the end of the novel, Hilda's attitude can be interpreted as the obverse of the critical attitude cultivated by Hawthorne himself in Europe and which is the novel's pedagogy in the face of the Old World's monuments and the New World's need for them.

The mood expressed in the novel's opening passage, "the state of feeling which is experienced oftenest at Rome," is initiatory both to and of the romance, with its mingled moods of skepticism and enchantment. The contrast, felt in the gallery, between the "weight and density" of the past and a present whose sense of value and actuality is "pressed down or crowded out," between "ponderous remembrance" and weightless existence, epitomizes the entire narrative's mood and mode (6). The later chapter "The Emptiness of Picture Galleries" marks the apogee of the narrative's inversion of this initial scene. Here, a skeptical mood has overtaken the enchantment of visual artworks and galleries, robbing that world of its meaning and power. If still inside this special world of the museum, the romance has by this point established a perspective which is no longer of it. Between these polarities of idolatrous enchantment and iconoclastic skepticism, the narrative struggles to keep alive some sense of natural intimacy and conversation between visual monuments and human beholders, that is, of the museum world as a potential habitation for our everyday need of the world's durability.

Hawthorne's romance enacts a version of the "wise skepticism" encouraged by Emerson at the end of his essay on Montaigne: "Let a man learn to look for the permanent in the mutable and fleeting; let him learn to bear the disappearance of things he was wont to reverence without losing his reverence . . . though abyss open under abyss, and opinion displace opinion."[46] Hawthorne's verbal monu-

ment seeks to negotiate the twin dangers of idolatry and iconoclasm. Only by acknowledging the tempting heights of the moral and aesthetic sublime, the "exaltation" of monumental beholding, as Webster had put it, can one avoid the empty iconoclasm of universally denying the value or possibility of the monumental.

9

DAVID C. MILLER

• • •

The Iconology of Wrecked or Stranded Boats in Mid to Late Nineteenth-Century American Culture

The image of the wrecked or stranded boat that frequently appears in mid to late nineteenth-century American painting contrasts strikingly with the long-established iconography of shipwreck.[1] Consider, for example, the opposition between Claude Josef Vernet's *Storm on the Coast* (fig. 9.1) of 1777 and the American artist Francis Augusta Silva's *Seascape at Sunset* (fig. 9.2), executed approximately one hundred years later. The first is an image of human crisis, immersing the viewer in the suspenseful moment-to-moment action. The visual image, locked in space, explodes into the continuum of time. Our sense of ongoing action derives both from the human drama packed into the hyperbolic structure of the "pregnant moment" and from the canvas's tumultuous surface, intensified by the stark contrasts of light and dark.

The fate of the figures in the foreground hangs in the balance. We respond empathetically to these victims of nature's overwhelming wrath. The theatricality of the Burkean sublime—emphasizing the terror of nature—produces a spectacle that robs us of meditative distance. We are forced willy-nilly to confront the helplessness of humanity before uncontrollable natural forces. We hasten to a devastating realization: the precariousness of civilization in a world in which traditional meanings are jeopardized. For the ship cast adrift on the open seas or hurtled headlong toward a rocky coast characteristically represents the ship of state, the corporate human enterprise.

It is an age-old trope. We have only to think of the scene in Sophocles' *Antigone* in

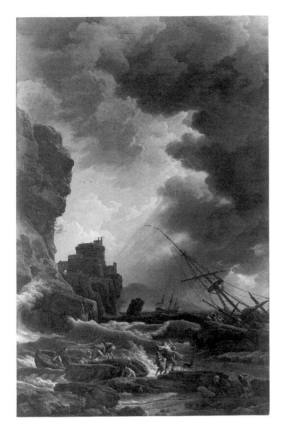

9.1. Claude Josef Vernet, *Storm on the Coast*, 1777. Musée Calvet, Avignon, France.

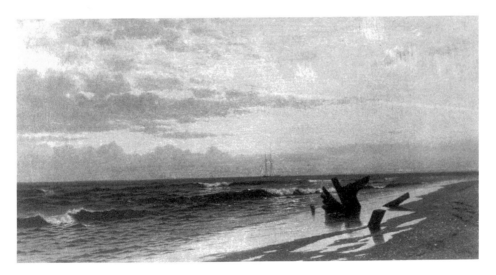

9.2. Francis Augusta Silva, *Seascape at Sunset*. Date and whereabouts unknown.

which Creon addresses the chorus in the wake of civil war: "Gentlemen: I have the honor to inform you that our Ship of State, which recent storms have threatened to destroy, has come safely to harbor at last, guided by the merciful wisdom of Heaven." Over two millennia later, John Winthrop, aboard the *Arbella*, referred to a hypothetical breach of the Puritan covenant with God in terms of shipwreck. As George Landow has demonstrated, shipwreck emerged in British and European iconography of the eighteenth century as an arresting image of civilization threatened by the collapse of traditional beliefs, impelled into a perilous world of intellectual, moral, and emotional uncertainty.[2] The ship of state was a staple metaphor of American political rhetoric in the mid–nineteenth century, most memorably in Daniel Webster's speech defending the Compromise of 1850, "The Constitution and the Union":

> It is not to be denied that we live in the midst of strong agitations, and are surrounded by very considerable dangers to our institutions and government. The imprisoned winds are let loose. The East, the North, and the stormy South combine to throw the whole sea into commotion, to toss its billows to the skies, and disclose its profoundest depths. . . . I have a part to act, not for my own security or safety, for I am looking out for no fragment upon which to float away from the wreck, if wreck there must be, but for the good of the whole, and the preservation of all.[3]

Not surprisingly, the fate of the America ship of state preoccupied Americans obsessively around the Civil War. The association of boats with the voyage of life topos is perhaps equally venerable and closely interrelated in meaning. But in America, it was essentially subsumed by the reference to the ship of state—just as the particular concerns of individuals tended to be seen in terms of corporate and cosmic ones.

Turning to Silva's painting, we encounter a very different image, yet one closely related to this iconography of shipwreck. We are engaged not with a sense of action or with the fate of human actors, but with a feeling of aftermath, underscored by the rutilant sunset and the endless breaking of waves upon the beach. Any suspense or thought of futurity dissolves. We anticipate nothing more than the advent of darkness and a slow, indiscernible process of decay.

What do we make of this difference? The clear formal and expressive distinctions between these two images correspond, I would argue, to contrasting temporal schemes which in turn underwrite divergent cultural attitudes. My assumption is that there is a structural parallel between the sense of active crisis depicted in the traditional image of shipwreck and older European notions of time which separated the providential from the cosmic, focusing on the former. By the same token, there is a no-less-striking homology between the mood of aftermath conveyed by American depictions of wrecked or stranded boats and a distinctly American conception of time that was undergoing transformation in the latter part of the nineteenth century under the impact of a new awareness of natural history.

This prophetic sense of time involved the Puritan perception of the eternal in the momentary, of cosmic dimensions of meaning in providential or human history. At the basis of the American national mission, as Sacvan Bercovitch and others have

argued, it found expression in a mode of hermeneutics and a federal eschatology which together constituted an American selfhood, at once individual and corporate.[4] Above all, Bercovitch showed, this sense of time informed a rhetorical mode—the jeremiad—which simultaneously expressed disappointment and hope, lament and celebration, in a ritual affirmation of the national mission that remained current through the first half of the nineteenth century.[5] Affirmation, moreover, was part of a middle-class ideology that originated with the Puritan experiment in the New World and that from the start had been virtually unopposed by the vestiges of an aristocratic social structure.[6] It coexisted with an aristocratic tendency to think of history pessimistically, in cyclical terms.

As Stow Persons established some time ago, the cyclical theory of history current in America at the end of the eighteenth century performed a mediating function between an older "frankly supernaturalist interpretation of history as the unfolding revelation of divine purpose" and the Enlightenment idea of progress which, ever since Carl Becker's work, has been understood "as a secularization of [this] millennialist interpretation of history."[7] The cyclical theory of history persisted into the romantic period in America and was closely intertwined with the ideology of republican virtue. It gave temporal shape to the threats posed by property and luxury to the national enterprise all the way back to the prerevolutionary period, and it is most often associated with Thomas Cole's famous series *The Course of Empire* (1831–35). But by Cole's day it appears (despite evidence of apocalyptic fears among contemporary writers like Poe, Cooper, and Hawthorne) to have been very much on the wane.[8] Bercovitch agreed that a linear model of history superseded the cyclical one: "The course of empire became for [Americans] the millennial schedule." But he emphasized the ongoing religious dimension of this postmillennialist conception of history, contending that from the revolutionary period onward, Americans substituted "redemptive for providential history," declaring that "America was the last act in the drama of salvation."[9]

Confronting a painting like Francis Augusta Silva's *The Schooner "Progress" Wrecked at Coney Island, July 4th, 1874* (fig. 9.3), we realize just how much of an issue the fate of the national enterprise could still be in the years following the Civil War and that it was tied to the motif of the wrecked or stranded boat. Not surprisingly, an editorial published on the same day in the New York *Herald* and commenting on President Grant's intention of running for a third term in office, employed the very figure of "the disorganized, demoralized condition of democracy, stranded and wrecked."[10] For if the jeremiad had always before sustained an ultimately optimistic faith in the national mission, the basis for such optimism now appears to have been seriously questioned and along with it the assumptions of middle-class ideology. This suggests a reemergence of the cyclical version of time in the years around the Civil War, but with a crucial difference.

While this new cyclical view of time bespoke a profound questioning of the millennialist model of history, it drew its character from an emerging conception of natural history that undermined or complicated the notion of human progress, opening up new directions which I will explore here by way of a passage from Thoreau's *Walden*. In contemplating a rotting boat, Thoreau evokes the very tension

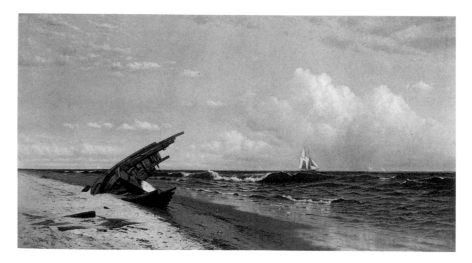

9.3. Francis Augusta Silva, *The Schooner "Progress" Wrecked at Coney Island,* July 4th, 1874. The Manoogian Collection.

between the cyclical character of natural history and the linear and teleological character of human history given visible form by some of the paintings I will consider.

Especially telling in all this is that the motif of the wrecked or stranded boat, when it appears in American paintings of the period, generally coincides with a particular set of formal tendencies that sustain a mood of emptiness and aftermath. If Silva's painting signals an end to millennial hopes and republican virtue, its message may also be the key to certain trends in later nineteenth-century American landscape representation that by themselves have proved difficult to decipher. My analysis is not meant to exclude other explanations for such trends but to identify one generally overlooked but important set of contributing factors in nineteenth-century American culture. These factors both shape and reflect the shift from representations dominated by temporal modes to those dominated by the spatial ones and they have a bearing on changing conceptions of agency and subjectivity which constitute the internal dynamic of cultural production.

In exploring the meaning of the wrecked or stranded boat in American culture against the background of the older and more dominant iconography of shipwreck, I will probe the interaction among artistic, literary, and cultural factors. The first of these is a group of formal and expressive features which historians of American art have categorized by the term luminism. It is no accident that wrecked or stranded boats generally appear in luminist paintings. The sense of aftermath associated with this motif, the transcendence of the moment, and the absence of the anthropomorphic all relate closely to the elusive mood of luminism.[11]

The high incidence of wrecked or stranded boats in luminist paintings started me wondering about its possible significance and prompted me to speculate more generally about the relation between iconography and the formal and expressive

aspects of vision. I was led in turn to consider the relation between these areas of concern and the question of iconology raised by the art historian Erwin Panofsky. Opposed to iconography—the explicit and conventional linking of motifs with themes or concepts with images—iconology is "apprehended by ascertaining those underlying principles which reveal the basic attitude of a nation, a period, a class, a religious or philosophical persuasion—qualified by one personality and condensed into one work."[12]

For Panofsky such principles illuminate not only "iconographical significance" but "compositional methods." Not simply pictorial elements like motifs, images, stories, and allegories but pure forms function as "symbolical" values (in the sense designated by Ernst Cassirer). Moreover, symbolical values, Panofsky noted, "are often unknown to the artist himself and may even emphatically differ from what he consciously intended to express."[13] It is because interests and values are implicit as well as explicit in pictures and texts, a matter of structure and mood as well as of subject matter, that I am interested in luminism, for the formal and expressive qualities designated by this term may indeed wind up illuminating something quite tangible if inarticulate in the cultural milieu in which they appear.

The concept of luminism has lately fallen out of favor in American art-historical circles, though for a long time one heard of little else. Its proponents were simply unable to pin it down to a consistent cultural context.[14] I seek to recuperate the concept only insofar as it is useful in talking about a group of formal and expressive features that can be effectively recontextualized. Luminism is perhaps best understood along the lines of film noir: as a quality of vision its practitioners unconsciously expressed which bore a profound affinity to the contemporary cultural climate. It was in no sense a movement, as certain art historians claimed.[15] Far from leaving behind a manifesto or program, luminist painters cannot even be categorized along purely formal lines. We are left to delineate a set of *tendencies* evolving from the overlapping area between compositional and expressive realms and the domain of characteristic subject matter. Moreover, these tendencies assert their direction only in relation to the complex of iconological and ideological factors which constitute their subversive and culturally prophetic function.

In other words, we must adopt a more dynamic conception of culture than the essentially reflective model utilized by those who sought to establish luminism as a significant American mode of vision. This means discarding any reified distinction between images and the sociocultural context in order to engage their instrumentality in mapping (to borrow a term from Clifford Geertz) emerging areas of social experience and of the collective mentality or subjectivity these areas open up.[16] The formal tendencies of luminist painting help us understand the cultural work of these images in representing and shaping novel states of consciousness and in guiding key ideological shifts. Moreover, by keeping in mind the complex interrelation between visual and verbal modes that exists in any particular period and place and is subject to continual alteration, we avoid the problems and limitations of formalist analysis that troubled so many proponents of luminism.

If it is unfair to call luminism a movement, it is equally unfair to designate it as uniquely American, as some have. It is possible to trace the roots of some of

luminism's formal qualities to certain basic dynamics of romantic and postromantic thought at the international level which brought about the transformation of agency from a divine or personal source to one that is immanent or atmospheric.[17] This shift is paralleled by a movement away from the theatrical mode of the Burkean sublime to the quietistic if often unsettling vision not only of the American luminists but of the German artist Caspar David Friedrich. Friedrich's celebrated painting *The Wreck of the Hope* (1822) shares not only formal affinities with luminism but much of its mood of aftermath—albeit in a far more portentous key. The fact that Friedrich's painting is so much earlier than the work of the luminists above all points to the time lag in the transmission of romantic culture to America.

An American culture resistant to European romanticism was, however, also capable of pushing its implications in unusual directions because of the strong, unique sense of national mission. The coincidence of the wrecked or stranded boat with luminist vision relates directly to cultural strains and anxieties as well as to ideal modes of thought peculiar to mid nineteenth-century America. In order to see this, we must first give up any doctrinaire understanding of the formal qualities in question. Again, I see them as tendencies which should not be abstracted from subject matter or broadly based literary and cultural concerns and which cannot be too closely specified or separated from affective qualities. In the iconology of wrecked or stranded boats, we confront a stylistic continuum that runs from the taut, highly conceptual visions of Martin Johnson Heade and Fitz Hugh Lane to the more naturalistic or closely observed works of artists like William Trost Richards, Francis Augusta Silva, and William Bradford. This continuum also embraces works by James Hamilton, Alfred Thompson Bricher, John F. Kensett, Norton Bush, Winslow Homer, and a host of lesser-known artists working in the second half of the century. Such artists represent one trajectory in late nineteenth-century American landscape art that remains staunchly nativist while eschewing the dramatic effects of a Bierstadt or Church, on the one hand, and the mysticism and stylistic experimentation of Inness on the other. What brings the stylistic diversity of these artists together has more to do with a striking departure from the earlier preoccupations of American landscape painters—as well as with characteristic subject matter—than with formal features alone.

Still, such features cannot be ignored, given the assurance that they quickly find their appropriate sociocultural coordinates. In luminist paintings like Heade's celebrated *The Stranded Boat* (fig. 9.4) and Fitz Hugh Lane's memorable *Brace's Rock, Brace's Cove* (fig. 9.5), both dating from the mid 1860s, we are struck with undeniable singularities of vision. As art historians have pointed out, there is not just a pervasive stillness, but a lack of personal gesture, of what was known in nineteenth-century Anglo-American art circles as expression or character. The impersonality of these works derives from the simplification and abstraction of forms, verging on a democratization of the picture plane. As Barbara Novak first argued, the artist's presence is expunged in the collapse of established visual hierarchies and in the airless atmosphere, the minute brushstroke, the glistening surfaces.[18] The world is rendered subtly alien, for the eye lacks the conventional signals to guide it over the canvas; instead, it confronts nearly uniform contours and emphases which create an optical

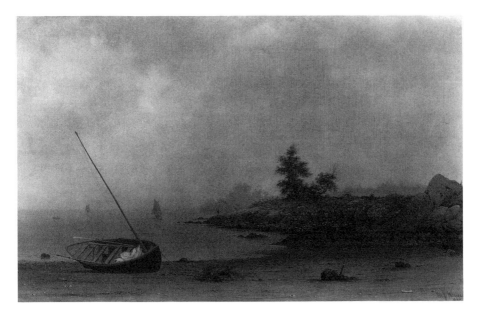

9.4. Martin Johnson Heade, *The Stranded Boat*, 1863. Museum of Fine Arts, Boston, Karolik Collection.

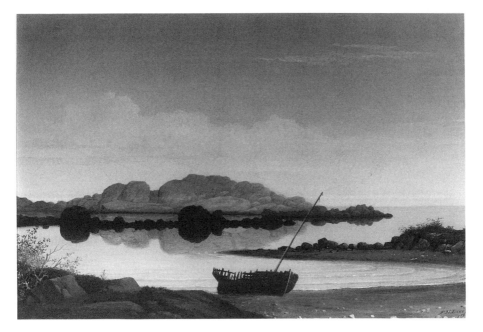

9.5. Fitz Hugh Lane, *Brace's Rock, Brace's Cove*, 1864(?). Museum of Fine Arts, Boston, Karolik Collection.

ambiguity, unsettling to the mind. This sometimes generates an intensity of vision which evokes a sense of the surreal.

If this is true for twentieth-century viewers, we can only imagine what those steeped in the picturesque mode must have felt before such paintings. In an act of defamiliarization, these images reverse all the dominant modes of American high romantic culture: not only the picturesque but the pastoral, the sentimental, the allegorical, the rhetorical, the theatrical, the monumental. There was, in fact, little way contemporary commentators could talk about them outside the rubric of "natural history" and the Ruskinian and scientific ideals of "truth to nature" and close observation.[19] They depart (no less than Impressionism and Tonalism) from the prevailing tradition of the Sister Arts in which the visual image is mediated by the literary and rhetorical. In their tense and understated, often ominous appearance, these images betoken nothing less than a restructuring of emotion. This shift in the center of gravity is reflected in the preoccupation of so many luminist painters with the liminal area of the shoreline, the meeting ground of land and sea. It is no accident that luminist artists fixed on this domain where values constantly turn into their opposites, where the moment confronts eternity, where flux and stasis endlessly trade places. This image of transvaluation deeply touched people confronting a world whose underlying assumptions were giving way to an unprecedented degree in the years around the Civil War.

Luminist paintings are above all characterized by the seemingly palpable presence of light diffused throughout the canvas, enveloping all in a uniform glow that may appear numinous or foreboding, as in William Bradford's *The Coast of Labrador* (fig. 9.6) of 1872. Luminosity replaced the earlier emphasis on dramatic contrasts of light and dark known as chiaroscuro. Here, light has become atmospheric. Commensurate with this pervasive light is a radical reduction of forms (as in John Kensett's later works) as well as a high proportion of sky to land, emphasized by horizontal format.

What is more, luminist paintings deemphasize the presence of human concerns and artifacts. Ships, hayricks, houses begin to lose reference to the documentary or utilitarian, becoming instead simply integral parts of the design or objects of aesthetic contemplation. The subject matter that engages luminist artists minimizes

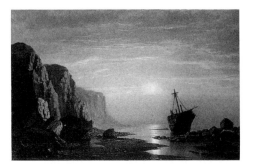

9.6. William Bradford, *The Coast of Labrador*, 1872. The Fine Arts Museum of San Francisco, Gift of Mr. and Mrs. Duane Garrett.

traditional moral reference. Instead of mountains connoting spiritual aspiration, waterfalls giving rise to thoughts of purity and resolution, or forest interiors offering sanctuary to the religious devotee, such landscapes incline toward the flat and unprepossessing; their minimalism fails to evoke the familiar inspiring associations; they are deserted, forlorn, at times even blank or eerily elusive. They belong under the traditional rubric of "desert" places.[20]

To invoke this all-but-forgotten category and to stress the significance of light is to open up a more general perspective in which to examine the particular formal and expressive features associated with luminism. For light, within the discursive sphere of nineteenth-century American art, stood not only for the emanation of spirit but—once no longer mediated by natural forms which explicitly recalled the Old Testament world of the law and of judgment, of communal aspiration and moral striving—it came to signify the merely subjective qualities of vision. As religious hierarchy gradually gave way to the pantheistic diffuseness of romantic thought, some Americans had difficulty keeping these subjective qualities of vision in proper relation to the dictates of the Law and of the Gospel. The highly conceptual images of Heade and Lane then appear as simply the most radical examples of the general momentum of American landscape representation toward distilling a secular world out of the emotional energies of traditional Protestant Christianity.

Nevertheless, and this points to the crux of my argument, the presence of the decaying boat in a number of these luminist paintings continues to refer to the traditional moral realm; first, because the decaying boat literally looks back to the heroic and morally tendentious moment of shipwreck; second, because, as it lapses into the timeless condition of nature, it necessarily calls attention to the passage of time. For both reasons, it bridges the gap between the older iconography of shipwreck and the iconology (putting stress on the subversive potential) of luminism. This transition between the temporal and the atemporal accounts for the visual tension we detect in the most extreme versions of luminist painting.

It is a tension that most immediately derives from the confrontation between dynamic and static aspects of experience as well as between perceptual and conceptual modes of representation. When we look at Lane's *Brace's Rock, Brace's Cove*, for instance, we encounter an image in which the representation of physical movement has been suppressed, only to reemerge in the visual rhythms the eye experiences through echoing forms and concerted contrasts of light and dark. The formal design of the painting translates time from the sphere of the actual (moment-to-moment temporality) to that of the mental, involving a sense of teleology or entelechy (the purposeful movement toward organic wholeness) that is deeply lodged in the culturally constructed structures of the mind and that is subtly at odds with the relatively static appearance of the landscape being represented. The manifest tranquility of the scene competes with the tightly bound energies emanating from the concerted patterning of vision. The painting's design heightens the demand on the viewer to respond to a spate of insistent visual stimuli that compete for attention rather than massing into expressive gestural features and expressive moods, as in the older aesthetic of the picturesque and sublime.

Elsewhere, I have argued that such tension is the visual counterpart of the anar-

chic potential inherent in democracy.[21] Paradoxically, as things equalize, the mind struggles to reimpose hierarchy. In doing so it is thrown back upon itself, becoming self-consciously aware of its ongoing effort to apprehend the unfamiliar, to judge and to categorize it and thereby to consign it to the realm of the habitual. The act of beholding is subtly transformed into a dialectical process in which it is revitalized by encountering resistance from what it beholds. What is more, the viewer confronts previously unremarked and possibly disturbing aspects of his or her own sensibility. The painting presents a "world out there" experienced in the very moment of becoming a "world in here." Yet, in remaining a surprisingly accurate rendition of the quality of landscape along the coasts of New England for anyone who has viewed these regions, it oscillates unnervingly between literal and metaphoric representation, conscious and unconscious awareness.

The decaying boat creates the most salient tension of all as it intrudes its narrative content into this scene of abstract design. The boat alone has a story to tell, and the pathos of its decay (conveyed by its skeletal condition) is underscored by the contrast it provokes with the semantically neutral and visually rhythmic forms that surround it. The concentrated patterning of the painting's background suggests the emergence of self-conscious form that would be the hallmark of modernism.[22] This native protomodernist sensibility is crystallized from the dialectic of democratic individualism in which individuality and equality compete in the wake of the dissolution of traditional hierarchies that had their visual counterpart in history painting and heroic landscape painting.

To take the largest perspective, in the image of the stranded or wrecked and decaying boat we witness a transition from a traditional view of the world that is God- and human-centered, historicist, and dramatically conceived to one that could be characterized as radically impersonal, primitivistic (in its abolition of linear time), and atmospherically conceived.[23] The latter is a world in which God no longer clearly presides. Given the reference of the boat, whether direct or oblique, to the ship of state stranded or wrecked upon an alien shore, it seems fair to relate this transition to a loss of conviction on the part of some Americans—certainly the painters themselves—in their nation's sacred mission, to a failure of what has since come to be known as postmillennialist faith. Commensurate with this loss of faith is nothing less than a transformation of the conception of time and even of representation. The visions in question are postapocalyptic; they thus imply an end to the nation's quest for transcendent status.

An arresting example of this symbolic dimension of the wrecked or stranded boat is afforded by Fitz Hugh Lane's *Dream Painting* (fig. 9.7) of 1862. Painted in the midst of the Civil War, this work evokes deep-seated anxiety about the outcome of the national enterprise. According to a letter Lane wrote and attached to the back of the canvas, the picture was suggested to the artist by a dream: "Sometime last fall while lying in bed asleep, a richly furnished room was presented to my imagination upon [sic] the wall, my attention was attracted to a picture which I have here endeavoured to reproduce. The dream was very vivid and on awakening I retained it in memory for a long time. The effect was so beautiful in the dream that I determined to attempt its reproduction, and this picture is the result."[24] Significantly, the picture

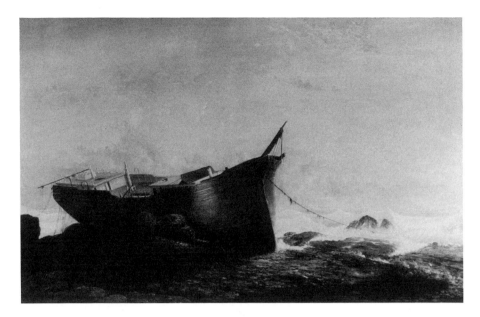

9.7. Fitz Hugh Lane, *Dream Painting*, 1862. Berry-Hill Galleries, New York.

of a stranded, abandoned, and dismasted boat recalls an earlier, more romantic and rhetorical style than the crisp, almost abstract delineation we customarily associate with Lane. An exception that tellingly proves the rule, this enigmatic image reso- nates suggestively against a work like *Brace's Rock, Eastern Point, Gloucester* (fig. 9.8), which the artist completed shortly afterward and whose stark and ominous character asserts the tension between moment-to-moment time and duration. By contrast, Lane's dream vision merges an image symbolic of the nation's failure (at a time when its very existence was in fact being challenged) with a faraway oneiric world. This vision is also, as Angela Miller has pointed out, "a haunting premonition of [Lane's] death three years later in 1865, the year of Appomattox."[25]

Similarly, in Lane's letter, the allegorical meaning of his dream is displaced onto the aesthetic concern with the dream image's startling colors and ideality. As the artist noted of the painting, "The drawing is very correct, but the effect falls far short of what I saw, and it would be impossible to convey to canvas such gorgeous and brilliant colouring as was presented to me. This picture, however, will give the beholder some faint idea of the ideal" [sic].[26] Lane's remarks imply a parallel between his own artistic failure to realize his dream ideal in executing the painting (a stock theme of nineteenth-century American art theory) and the fate of the national enterprise, a falling short of the corporate ideal suggested by the iconography itself.

We know that Lane, a staunch New Englander, dissented from the nationalistic fervor exemplified by his contemporary Frederic Church, preferring a localism in keeping with his deeply skeptical temperament. He could never feel comfortable with the dominant postmillennialist faith that drove the expanding democracy.[27] America's postmillennialism—the religious counterpart of the doctrine of Manifest Destiny—remains alive today in the conviction that the country carries the torch of

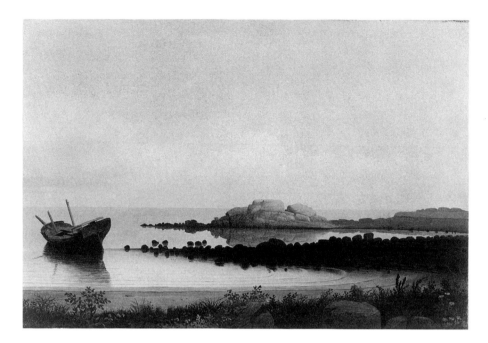

9.8. Fitz Hugh Lane, *Brace's Rock, Eastern Point, Gloucester*, n.d. Collection of Mr. and Mrs. Harold Bell.

freedom and democracy to the rest of the world. As James Moorhead has convincingly shown, this ideology was taken out of the closet and dusted off just before the Civil War in the rhetoric of the Yankee pulpit. Northern clergymen spurred aggression toward the South by casting the war as a crisis, an Armageddon, in America's mission to redeem the world for Christ.[28] Throughout the period of the Civil War, Americans adopted the Christian linear scheme of history, ending either in millennium or apocalypse, as a way of making sense of their own history. This scheme held together the various strands of American national identity, rewarding its proponents with the conviction that they were a chosen people. As Moorhead argued, "If America were not different, it was nothing. In baptizing the Civil War with the bloody urgency of the Apocalypse, Protestants were fighting for more than the political integrity of the Union; the issue was no less than the survival of corporate identity and purpose"[29]—a purpose closely connected to the myth of progress.

In this context, as I have already noted, shipwreck served as a reminder of threats to the national mission. As one American politician of the 1850s claimed, "We live in troublous times. Our lot is cast in a crisis of our country's destiny. The Ship of State is plunged headlong upon an angry sea, amid tempest tost waves and threatening clouds."[30] Examples of the perilous passage of the American ship of state from the political rhetoric of the day could be multiplied indefinitely. American faith in the country's sacred destiny struggled with this specter and was buoyed by the rhetoric of northern aggression against the South. According to Moorhead, "The vision of uniqueness was troubled by the apparent fragility of an American civilization that

had come apart at the seams. America clearly needed to discover within its life a unifying power that would correspond to the symbols, memories, and constraints of European nations."[31] It is all the more noteworthy then that images of wrecked and stranded boats often confront us with a cross (made up of mast and spar) thrown off kilter or even broken, in either conscious or unconscious reference to the crisis of Christianity which lay behind doubts about the nation's mission.[32]

While Lane's painting dissents from the dominant postmillennialist faith, as a dream image it suspends the all-important reference to actual time. Its romantic and rhetorical appeal thus contrasts with the protomodernist intensity of either of the *Brace's Rock* paintings. T. S. Eliot's *Four Quartets* offers a revealing literary counterpart of this intensity:

> We must be still and still moving
> Into another intensity
> For a further union, a deeper communion
> Through the dark cold and empty desolation,
> The wave cry, the wind cry, the vast waters
> Of the petrel and the porpoise.
> In my end is my beginning.[33]

This passage, with its play on the double meaning of "still" as both stasis and duration, captures the tension between time and eternity—as Eliot too experienced it on the coasts of New England—that lies at the heart of the formal and expressive features I have been discussing. Eliot instates what is missing in Lane's *Dream Painting*: the dimension of natural history which brings this tension into play.

Eliot's stark, troubling juxtaposition of present moment and eternity has been identified by John Lynen as a defining characteristic of American literature, from the Puritans to Eliot. Whereas British poets like Wordsworth saw time as primarily a continuum "in which the past evenly advances toward the present,"[34] American poets exploited the symbolistic powers of temporal contrast, reflecting the paradoxical relation between the limited capacities of immediate perception and the dawning if inevitably indirect sense of something unified beyond the scope of human ken. Yet this general pattern does not altogether account for the nuances and variations in the American sense of time and history. Lynen's view of American temporal experience must be filled out with a closer consideration of changing cultural concerns during the nineteenth century.

While the intensity of vision in the radical luminist paintings anticipates the concerns of Eliot, an even more illuminating interarts comparison occurs in a passage from *Walden* in which meditation on the image of the decaying boat reveals a conception of time even closer to the temporal subtext of these paintings. Though it predates the Civil War, Thoreau's text nevertheless lays bare some of the underlying assumptions and modes of thought expressed by luminist vision, for his writing participates in many of the same cultural dynamics as the work of painters who were his younger contemporaries.

Walking along the shore of Flint's Pond, Thoreau encountered an arresting hieroglyphic (to use his own word), the mouldering remains of a boat. He found it "as

impressive a wreck as one could imagine on the seashore," one that had as "good a moral." Product of human invention and use, wrought from the materials of nature, this artifact is now returning to its source. With its "sides gone and hardly more than the impression of its flat bottom left amid the rushes," still "its model was sharply defined, as if it were a large decayed [lily] pad, with its veins."[35]

Before considering this comparison of the boat to a "decayed pad, with its veins," we should glance at a painting that offers a close analogue to Thoreau's image: Worthington Whittredge's *The Old Hunting Grounds* (fig. 9.9) of 1864. This work could hardly be characterized as luminist, for, though the canvas is luminous, we miss the radical simplification of forms, the even diffusion of light, and the horizontal format generally associated with luminist style. Still, there are underlying thematic affinities with luminism in the concern, shared by Thoreau, with the wasting away of the human artifact, the relative loss of the anthropomorphic design in the dense natural growth, leading the artist away from the conventional formulas for representing landscape. The point underscores the subversive and transforming impact of the raw American environment upon older ways of seeing so integral to the cultural dynamic under discussion.

9.9. Worthington Whittredge, *The Old Hunting Grounds*, 1864. Reynolda House, Museum of American Art, Winston-Salem, N.C.

On his return from ten years' study abroad, Whittredge lamented the resistance of the American environment to expectations instilled in him by European landscape:

> It was impossible for me to shut out from my eyes the works of the great landscape painters which I had so recently seen in Europe, while I knew well enough that if I was to succeed I must produce something new and which might claim to be inspired by my home surroundings. . . . I hid myself for months in the recesses of the Catskills. But how different was the scene before me from anything I had been looking at for many years! The forest was a mass of decaying logs and tangled brush wood, no peasants to pick up every vestige of fallen sticks to burn in their miserable huts, no well-ordered forests, nothing but the primitive woods with their solemn silence reigning everywhere.[36]

In the painting, Whittredge has overcome his resistance to this wilderness and its lack of narrative and anecdotal content, to find intelligible form and significance in the intricate recesses of the woods—but with what a difference!

The painting's stencillike background and slightly skewed planar organization reflect nature's undermining of the established compositional schema. And this structural innovation seconds what is thematized: the decaying birchbark canoe stands for the return of human artifacts to the conditions of nature. This is a cyclical pattern at odds with any myth of civilization's linear progress through time. But what distinguishes it from the earlier neoclassical version of cyclical history—evident in the work of Thomas Cole—is its representation of the recurring processes of natural history through a much closer observation of natural detail. Even more critical, whereas Cole suggests cyclical time by conveying actual movement and change (moment-to-moment time) on the surface of the canvas (similar to Vernet's image of shipwreck) as well as through the autumnal foliage, Whittredge portrays a moment of stillness that only indirectly evokes recurrence.

Whittredge's image of natural history as both cyclical and eternally abiding—reflecting Emerson's title, *The Natural History of Intellect*—is shared by Thoreau. Writing more than a decade earlier, Thoreau presents us with an image which implies not only the recurrent nature of natural history but other dimensions of meaning as well—dimensions in tension with the cyclical implications of the return to nature. This tension finds its visual counterpart in the radical qualities of luminist vision. To establish this point will take some preliminary explanation.

Thoreau compares the decaying boat to the pattern of a lily pad or leaf. This analogy looks forward to the famous passage in "Spring" on the thawing sand and clay which flow down the cut on a railroad bank: "As it flows it takes the forms of sappy leaves or vines, making heaps of pulpy sprays a foot or more in depth, and resembling, as you look down on them, the laciniated, lobed, and imbricated thalluses of some lichens; or you are reminded of coral, of leopards' paws or birds' feet, of brains or lungs or bowels, and excrements of all kinds" (565). Thoreau then *exfoliates* upon the meaning of this leaf pattern, finding it in vegetable and animal life, in geography, in human organs and excrement, even in etymology and the oral production of words—so that it resonates with the underlying unity of nature

in process. As he whimsically concludes, "The Maker of this earth but patented a leaf" (568).

Through its association with the leaf, the decaying boat takes its place in the world order. As Thoreau asks, "What Champollion will decipher this hieroglyphic for us, that we may turn over a new leaf at last?" (568). Observing the flow of sand and clay down the railroad bank, he has an impression of nature's ever-recurring processes of creation and renewal and concludes that the earth "is not a mere fragment of dead history, stratum upon stratum like the leaves of a book, to be studied by geologists and antiquaries chiefly, but living poetry like the leaves of a tree . . . not a fossil earth but a living earth; compared with whose great central life all animal and vegetable life is merely parasitic" (568). Just as anthropomorphic design disappears in the welter of living things that are analogous to each other, so does any merely progressive or evolutionary scheme of natural history.

Thoreau's acknowledgment of a temporal scheme which is neither cyclical nor linear but both at once, his sense of the *simultaneity* of natural history in which the temporal is spatialized, leads to the heart of *Walden*'s structure, and takes a significant step beyond the implications of Whittredge's painting. This temporal scheme exemplifies the transformation of religious ideas into romantic ones in American cultural history, having to do with the shift from a symbolic mode that is predominantly temporal to one that is predominantly spatial; from one based on the Bible to one based on natural history. *Walden* owes much of its underlying structure to the Puritan vision of millennial history, in which persons, places, situations, and things in the Old Testament are types that foreshadow the advent of Christ, the antitype, in the New Testament.[37] The temporal scheme of typology established an ongoing basis for finding testimony in the present for the world's future state. Material manifestations anticipated divine ones.

Prophetic history was crucial in establishing America's mission as a redeemer nation. It reverberates in the motif of the wrecked or stranded boat and its association with the ship of state, an association which gained new vitality as a result of the reemergence of millennialist thinking on the eve of the Civil War.[38] But what is most germane here are the underlying dynamics of this prophetic conception of history. The schema of prophetic history transformed the linear course of profane existence by placing it within the ever-present or simultaneous dimension of cosmic salvation. It thereby gave individual entities—persons and places, situations and things—representative and spiritual meaning. Such a way of thinking is the matrix out of which the American romantic (and specifically Emersonian) concept of the symbol evolved. The symbol acts as a bridge between this world and the ideal world, but only after the temporal dimension of scripture has been transformed by the spatial conditions of the image in the romantic doctrine that nature is the new scripture.[39]

The genesis of the symbolic mode out of the typological is everywhere evident in *Walden*. It is the basis for Thoreau's claim to write a representative and prophetic text and for the symbolistic method that so often undermines as well as underwrites this presumption. Moreover, the decaying boat he writes about typologically foreshadows "Spring" for two reasons: first, because meaning in the earlier passage

remains largely undivulged, merely immanent and imminent—only fully to emerge in the latter passage; and second, because the veins of the decaying pad the boat is compared to suggest the memento mori. The skeletal appearance of pad and boat is superseded by the lively transformations detailed in "Spring" just as the "death-dealing" power of the law and the letter is superseded by the eternal life of the gospel. Given the "higher" reading Thoreau demands, the earlier passage on the decaying boat is to be read prophetically since, according to the apostle Paul, the law is fulfilled by the gospel, not abrogated by it. Thoreau's typological method implies a gradual process of revelation: we fully understand the passage on the decaying boat only in relation to the book as a whole. Contrary to Puritan typology, however, Thoreau shifts authority to the individual interpreter; the relatively rational frame-work of the temporal collapses into the relatively subjective spatial image.

In the subtle links between the two passages, Thoreau implies a dialectical inter-action rather than a unilateral distinction between life and death. The two are not ontological opposites but depend upon each other for their very possibility. This relational understanding of life and death situates the hieroglyphic of the decaying boat within the living "text" of the world; as in prophetic history, life is conceived as the fulfillment of death. Not surprisingly, Thoreau's rumination on the wreck he finds near Walden pond involves a projection of its future decay from a retrospec-tive point of view: "It is by this time mere vegetable mould and undistinguishable pond shore, through which rushes and flags have pushed up" (478). The grammati-cal construction and narrative stance here call attention to the spatialization of time inherent in typological method, realized when it is reconfigured imagistically. Tho-reau's point of view cannot be located temporally—within the text—but floats above it, beyond any particular moment. Appropriately, there is an indication not merely of decay but also of the transcendence of time, a shadowing forth of regeneration: the mould the boat turns into is procreative. Cyclical and linear time merge in the transcendental moment.

By the same token, the shape of the boat, both a utilitarian construct and a moral configuration, is in the process of merging with the margin of the pond ("undis-tinguishable pond shore," "rushes and flags"), representing the opacity of nature. Once again, for Thoreau, life depends on death. Decaying boat and the vegetable life its mouldering substance nurtures, skeleton and flesh, prefigure the human "leaf," which also combines the static and processual qualities at the source of the pre-scient associative chain along which Thoreau deciphers the hieroglyphic of the world.

In Thoreau's subtle account of the interaction between nature and human arti-fice, nature gradually gains the upper hand. Yet we are left to wonder whether the design of the boat is losing out to nature's chaos or seeping into the wholeness of the natural scene. This ambiguity projects Thoreau's acute awareness of the inex-tricability of cognitive and visual modalities, an awareness shared by Heade and Lane, the intensity of whose images also evolves from the pitting of human con-structs (organized by time) against external stimuli in a vision that is neither wholly inner nor outer but shimmers on the borderline between the two, a borderline that is itself subject to constant relocation. Such awareness constitutes the symbolistic

dimension of Thoreau's writing wherein a continual renewal of perception is nurtured by the very skepticism about language and its ability to articulate the world that tugs the interpreter back to death, signified by the endless, unprogressive cycles of nature.

Significantly, the symbol under Thoreau's scrutiny, whether leaf or decaying boat, alternatively suggests a fossil that has left its imprint on the shore of the lake. In this case, three-dimensional, animate reality flattens into a two-dimensional inscription, a kind of natural writing abstracted from the living image that makes that living image intelligible by paradoxically attesting to the grand temporal drama of perpetual transformation and evolution. Thoreau's extraordinary sensitivity to the determinations of his own writerly process as it subsumes nature recalls the problem of a higher reading demanded by both nature and his own words. Without interpretation, the letter does indeed lie inertly before us, its message one of spiritual death.

Such awareness of the role of dynamic natural processes in transforming vision would only gain in the post–Civil War period from systematic formulation in Darwinian science. Not surprisingly, the skeletal or fossillike appearance of wreckage on the shore is frequently evoked in late nineteenth-century American paintings (figs. 9.10, 9.11). In such cases, the drama of perpetual transformation and evolution is not moment-to-moment but preternaturally static; linear or narrative time condenses into a sentient memorial under the pressure of the seemingly unchanging conditions of nature. Such fossilization of time within the perspective of eternity had far-reaching implications for the changing structure of narrative as well as of authority, as suggested by the dilemmas Eliot explored in *Four Quartets*.[40]

The tense opposition between two orders of awareness structurally parallels the mood of aftermath that pervades the paintings,[41] epitomizing a fundamental cultural shift, the logical prelude to the exploration of formal tensions between static and dynamic elements through which luminism looks forward to modernism. In the romantic world which lies behind this type of thinking, divine antitype had given way to natural archetype. The "myth of the eternal return" (to use Mircea Eliade's suggestive phrase),[42] so long repressed, took its revenge on the usurper, the myth of millennial history. This is essentially what is at stake in most paintings of stranded or wrecked and decaying boats and in Whittredge's *The Old Hunting Grounds*. Yet for Thoreau, as for the most intense luminist vision, linear time is not so much

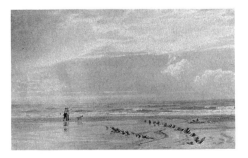

9.10. William Trost Richards, *Day at the Beach*, n.d. Courtesy Christie's, New York.

9.11. William Louis Sonntag, Jr., *Seashore Play*, n.d. Courtesy Christie's, New York.

deposed as made to stand in tension with the cyclical aspects of natural process. The conceptual framework of human history comes face to face with the open-ended yet deterministic perceptual possibilities of natural history. Accordingly, Thoreau synthesizes the spiral from the two versions of time it supersedes, linear and cyclical. His transcendental faith sustains his conviction that the millennial is still a possibility—but one imagined not under the terms imposed by the popular notion of a redeemer nation, with its tendency to literalize the millennium. Rather it is a possibility that incorporates the act of individual interpretation just as it involves a profound respect for the natural. Thoreau's evangelism could never be confused with the popular evangelism that comported with the doctrine of Manifest Destiny. For him, the Kingdom of God was most definitely *within*.

To realize that the natural cycle is at odds with any linear and therefore literal rendition of human civilization's progress through time undermines the most obvious meaning of the decaying boat—just as Thoreau's equation of the mouldering wreck to any wreck "one could imagine on the seashore" ironically places it in the context of the grand romantic tradition of shipwreck. The stock symbolic prop is undermined or reconfigured, as in the opening chapter of *Cape Cod*, where understatement and open-ended meaning also transform this topos. Indeed, Thoreau's decaying boat at Flint's Pond subverts the heroic imagery characteristic of high romantic painting by invoking its very language: "It was as *impressive* a wreck . . . and had as *good a moral*." Given the peculiar moral Thoreau derives from his hieroglyphic, this shorthand invocation of the traditional rhetoric of shipwreck only throws into relief a very different tone and significance.

As in luminist paintings, Thoreau deflates the theatrical, human-centered mood permeating the traditional iconography of shipwreck. Paintings that include a wrecked or stranded boat suggest a crisis not simply in the linear march of history but in the very notion of history itself. Time is radically reconceived. Human history, with its tacit assumptions, dogma, and teleology, is supplanted by natural history, with its endlessly repetitive cycles and rhythms. The anthropomorphic surrenders to the vegetable and mineral, the active to the passive, the dramatic to the atmospheric, the momentary to the eternal.

Yet the boat still alludes to the passage of time, thereby incorporating the histori-

cal process in a vision that is not simply timeless, mystical, but all the more intensely present, this-worldly. The drama of salvation is replaced by a solemn occasion for meditating on the possibility of human damnation unrelated to the question of human faith. The mood projected in these paintings of stranded or wrecked boats is akin to the desolation experienced by Byron as he overlooked the ruins of Rome or embodied in Thomas Cole's last painting in *The Course of Empire*[43] except that it tends to be devoid of romantic affect, of the melancholy and nostalgia that accompany a profound sense of loss. Meaning in these postromantic visions remains forever imminent and immanent, promoting a very different and much less tendentious emotional response. The world is caught in a perpetual state of pregnancy, of expectation or foreboding, that blends with the sense of aftermath in a vision that transcends the distinction between before and after. Commentary and determinate value find no foothold in this world. There is only the mute observation of relentless elemental processes that effectively foreclose on personal agency. This world is a naturalistic one and something else again.

It is possible to understand the deeper currents of meaning in luminist painting in light of the transition I have been discussing. The most radical luminist paintings tend to materialize what is still obscure in *Walden* but is highlighted in the disturbing accents of Thoreau's later and more somber book, *Cape Cod*. If there is an elegiac quality in these depictions of wrecks mouldering on the shore, any such traditional pattern of feeling struggles to express itself through their minimal forms and in spite of their momentum toward blankness—a "dumb blankness full of meaning," to invoke Ishmael's phrase in *Moby-Dick*. Should we remain puzzled about the implications of this sensibility for the millennial hopes of the national project, with all of its

9.12. Frederic Edwin Church, *The Icebergs*, 1861. Dallas Museum of Art, Foundation for the Arts Collection. Anonymous gift.

9.13. Charles Graham, U.S.M. *Mississippi Passenger Steamer*, 1888. *Harper's Weekly*.
Courtesy Library of Congress.

assurance of divine favor, Silva's title, *The Schooner "Progress" Wrecked at Coney Island, July 4th, 1874*, will put us back on track.[44]

While I have sought to pinpoint the cultural source for the suggestive tensions in the most radical of luminist visions, the larger category here goes well beyond the works designated luminist, pointing to a continuum of images and styles that includes tonalist and naturalistic examples as well as some still assertively romantic ones. It subsumes a range of images that share an iconography touching upon the fate of the ship of state. Frederic Church's stunning vision of *The Icebergs* (1861; fig. 9.12) is a preeminent example. Another intriguing instance is the illustration in *Harper's Weekly* of 1888 (drawn by Charles Graham) of the U.S.M. *Mississippi Passenger Steamer* stranded and rotting in the midst of a southern swamp (fig. 9.13)—"Clear as a widowed memory / Of the days before the war," as the accompanying poem by Will Wallace Harney concluded. Such images open up the phenomenon of luminism to broader cultural currents. The iconographic motif places its stylistic tendencies in the larger context of the romantic intuition that human experience is frag-

mented, opposed to the enlightenment faith in progress and the possibility of perfection. For with the loss of a sense of national innocence and purpose, at least as far as the artists were concerned, there was a more fundamental loss which reflected the end of a convincing linear narrative of history—a submergence of the conventional modes of human understanding in the mysterious voids of nature.

Still, the most radical features of luminist vision, when placed in this context, come back to haunt us. For if we can locate the source of the formal and affective tension of Heade's and Lane's works in the conflict between spatial and temporal modes, then we can begin to trace the direction of the internal dynamic of American romantic culture. It is a direction determined by the energies of the spatial image as it gradually freed itself from temporality only to be pulled back to the necessity of temporality—yet a temporality defined not by human civilization but by natural history.

The disjunction between spatial and temporal modes in turn informs our interpretation of other works which share qualities (if not formal then affective or iconographic) with the luminist ones. What wrecked or stranded boats spelled for the painters was an unraveling of the Sister Arts alliance that underlay their deepest assumptions about painting and that assumed a parallel rather than a conflict between the temporal and the spatial before these modes achieved their modernist redefinition. Such an unraveling amounted to a liberation from the heroically conceived visions that had dominated the American landscape tradition through the Civil War and were characterized by such typical antebellum modes as the panoramic, the oratorical, and the sentimental. American art was set in the direction of experimentation from within itself. If the decaying boat served as a memento mori then what it perhaps most clearly memorialized was the end of the American artist's own prophetic quest.

10

SARAH BURNS

• • •

The Price of Beauty:
Art, Commerce, and the
Late Nineteenth-Century
American Studio Interior

In the late nineteenth cen- tury, the opulently adorned studio came to symbolize a new breed of American painter: the cosmopolitan, sophisticated world traveler who crammed his (or, less frequently, her) rooms with artifacts commemorating ex- otic wanderings. William Merritt Chase's spectacularly cluttered studio (figs. 10.1, 10.2) was at once the cor- nerstone and pinnacle of this fashion, adopted by so many and so often high- lighted in the popular press that by the century's end such interior decoration, thick with so-called art atmosphere, had become virtually synonymous with the image of the successful painter in urban America.[1]

Both then and now, commentators have viewed such highly decorated studios as artfully contrived projections of the painter's taste and personality, as enclaves of an upper-crust Bohemia, and as shrines to a quasi-religious ideal of beauty and cultural elevation. In varying degrees, the studios aspired to be all these things, but they also performed another role, seldom noted. During the period when America's emer- gent consumer culture, with its attendant ethos of self-gratification, began to remodel and ultimately transform the Victorian moralities of work, thrift, and self- denial that lay at its foundations, the decorated studio became in essence a sales- room: an aesthetic boutique, where the carefully compounded art atmosphere functioned very specifically both to set off the painter's own wares and to create desire among potential clientele by seducing their senses through the romantic associations of the aesthetic commodities on show. In this respect, the painter's

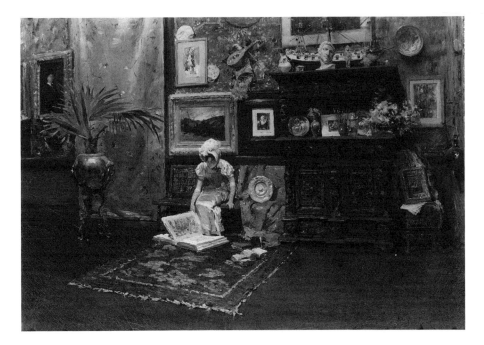

10.1. William Merritt Chase, *In the Studio*, c. 1880. The Brooklyn Museum, 13.50.
Gift of Mrs. Carl H. De Silver in memory of her husband.

studio was closely analogous to the contemporary department store, where merchants learned to concoct an atmosphere of rich, evocative displays to tempt the consumer.[2]

By exhibiting the parallels between the art atmosphere of the studio and the department stores' techniques and psychology of display, this chapter will suggest the extent to which art and culture itself came to be commodified in the marketplaces of fin de siècle America. The process of commodification, which involved both accommodation and resistance to new and compelling market conditions, promoted the collapse of culture into commerce and commerce into culture. But because aesthetic culture traditionally occupied and drew power from a privileged site ostensibly well removed from the sphere of economic relations, the fiction that the two realms remained distinct and even antithetical had to be maintained. Art had to pretend not to be implicated in commerce, and commerce, even while appropriating art to advance its own interests, found it advantageous to invoke the purifying rather than profit-generating agency of beauty. The fictions themselves often crumbled, however, to reveal a vast area of ambivalence and anxiety that adjoined the escalating conflict between older discourses shoring up art's elevating moral and ideological cultural functions and the new, market-driven circumstances that forced confrontation with the commercial dimensions of artworks produced as luxury consumer goods promising individual self-gratification, both sensual and spiritual. In these dialectical patterns, gender relations came forcefully into play, displaced in this instance onto the domains of business and art, at the century's end

SARAH BURNS

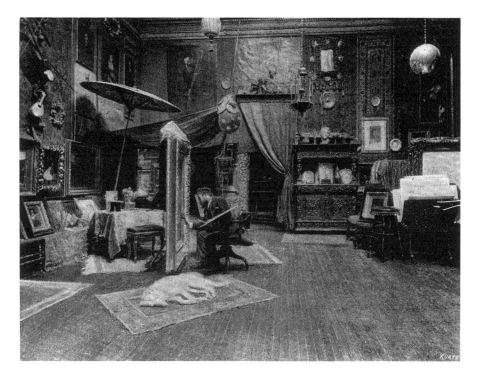

10.2. William Merritt Chase studio, photograph. Published in Elizabeth Bisland, "The Studios of New York," *Cosmopolitan* 7 (May 1889): 4.

more than ever dramatically polarized into masculine and feminine principles, which were themselves vulnerable to the pressures born of changing gender roles and expectations. Situated at the intersection of commerce and culture, the opulently decorated studio became a symbol of the unresolved, unstable play of social and economic power relations, figuring now as rarefied sanctuary, now as cultural department store, now as lair of a potentially threatening, exotic other. Whatever the figure, though, the studio, like the department store, was the domain of desire, speaking a vivid language of images and contributing thereby to the construction of a modern national subjectivity centering more on outward appearances than inner character.

Painters' studios in the last two decades of the century were both abundantly equipped and lavishly described: contemporary reports on the New York art world regularly undertook exhaustive inventories of the studios occupied by Chase and his peers, most of them French- or German-trained cosmopolitans who came of age in the 1870s and 1880s.[3] Chase's cavernous rooms in the well-known studio building at 51 West Tenth Street presented a dazzling array of beautiful, exotic, and curious things, decontextualized and massed for maximum visual effect. Confronted by the painter's stupendous accumulation, the journalist John Moran almost despaired of doing it justice; it would take days, he said, to explore, and even then, "one would only be entering on a knowledge of the variety, value, and interest of its contents." Rising to the challenge, he devoted an entire large-format page in

close-set type to a partial catalogue of the studio's effects, which included Japanese umbrellas, old church velvets, a carved Renaissance chest displaying "a Turkish coffee-pot of fine bronze, an Italian jar of exquisite green glaze . . . a white, pewter-mounted Renaissance jug of lovely shape and tone . . . a candlestick of delicate blue, an old Nuremberg pot, duelling-pistols," and a German silver lamp. Hard by was a collection of women's shoes, and over the entrance door the head of a polar bear grinned down on three stuffed cockatoos. There were a scarlet Spanish donkey-blanket, rococo brocades, a dried devil-fish, and an eclectic chorus line consisting of a Japanese ivory idol next to a carved wooden saint and a Greek bronze of Apollo. In addition, the studio was heaped with portfolios, crowded with paintings by Chase and other masters old and new and stacked with rare books that would "ravish the soul of a bibliomaniac." Ten years later, the journalist Elizabeth Bisland roved through the same "phenomenally lofty rooms" and marveled at the "old brasses, pearl-inland long-necked stringed instruments, and . . . the glittering ebon countenances of prognathous Peruvian mummies suspended by their long black hair." "Everything," she noted, "is on a large scale here, and gives the impression of superb profusion, a fortune having been spent in the gathering of these rich properties."[4]

In its lavish eclecticism, Chase's studio set the keynote for contemporaries. Typical of the fashion as it percolated through the art population of New York was R. D. Sawyer's studio in the Sherwood Building on Fifty-seventh Street (fig. 10.3). This studio, reported Bisland, was "hung with magnificent Gothic tapestries" and lined with paintings by old masters and the "modern French school." Furnished with "black, deep-carved oak," it harbored "antiques in bronze, marble, and pottery" jammed into "every spare niche and cranny." Other painters, such as Samuel Colman, developed thematic groupings of objects (fig. 10.4): Oriental ceramics of all sorts, including "large and gorgeous vases of old Imari" and "little Japanese tea-jars" so valuable that each was "carefully encased in a small silken bag."[5] As in Chase's domain, such studio displays furnished evidence of the painter's taste and authenticated his cosmopolitan status while signaling his activity as a prodigious yet refined consumer.

Like the studios but on an immensely expanded scale, department stores, urban marketing phenomena of the post–Civil War epoch, offered a vast array of temptations to bedazzle the consumer. Although the big stores initially limited their inventory to dry goods, such as fabrics, underwear, and notions, by the 1880s they had begun to multiply their departments to encompass a whole universe of commodities, beautiful and luxurious as well as useful.[6] In 1881, the *Philadelphia Press* asserted that Wanamaker's, displaying "the riches of the world brought together from all lands" and representing "all departments of art and industry, tastefully arranged to be shown with advantage," far outshone Philadelphia's Centennial Exposition of recent memory. By 1882 this gigantic emporium had seventy-five departments encompassing everything from hairpins to jewelry, fans, umbrellas, china, and furniture as well as an art gallery displaying "hundreds of the best modern paintings," which, while educating and entertaining the public, proved that art and business could be "happily mated." Wanamaker's, along with Macy's in New York among

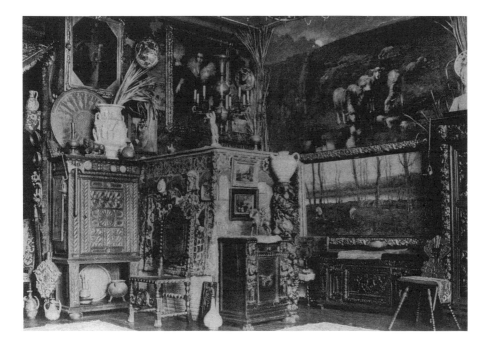

10.3. R. D. Sawyer studio, photograph. Published in Elizabeth Bisland, "The Studios of New York," *Cosmopolitan* (May 1889): 9.

10.4. *Studio of Mr. Samuel Colman*, wood engraving. Published in John Moran, "Studio-Life in New York," *Art Journal* 5 (December 1879): 355.

others, featured an Oriental rug department and sections devoted to antiques and bibelots, and its splendid, cosmopolitan art gallery was by no means unique.[7]

Terms used to describe the dazzle and abundance of the stores and their contents very much resembled those applied to artists' studios. Macy's pottery and glass department, for example, "truly vast and bewildering in its brilliancy," was, in one journalist's view, indisputably the best place in the country "to study the character, the gracefulness of outline, the delicacy of blending shades and quiet and brilliant colorings in pottery and glassware. . . . Bisque figures and ornaments of the most elegant designs and decorations, and plain, engraved, and richly cut glass, domestic, German, Bohemian, French, English, and Venetian. . . . Rich enameled Austrian, Bohemian, and shell goods. . . . Burmese shaded and tinted glass . . . pearl goods, and Charles' English fairy lamps, as well as a multitude of elaborate novelties impossible to mention in my limited space."[8] This aesthetic of overload clearly exhibits itself in a photograph from the late 1890s of an unidentified department store interior (fig. 10.5), a conglomeration of fragile filigree tables, ornamental lamps and vases, gilt-framed mirrors, and lace handkerchiefs and sashes, with dolls swinging above from crepe-paper arches. Although the commodities here do not have the luster of rarity emanating from Samuel Colman's choice Oriental pottery (fig. 10.4), both spaces are equipped and displayed as overflowing treasure troves.

In neither case did the arrangement result from happenstance or the mere exuberance of abundance. The creators of studio and department store displays alike

10.5. *Interior Decoration*, photograph. Published in L. Frank Baum, *The Art of Decorating Dry Goods Windows and Interiors* (Chicago: Show Window Publishing Company, 1990), 217.

S A R A H B U R N S

followed certain principles of organization which dictated the immersion of the individual commodity in an ensemble so rich and alluring and so skillfully harmonized that the splendor of the whole shed its radiance upon and enhanced the desirability of every component part. The critic Clarence Cook promoted the artist's studio as a worthy model of refinement in interior decoration because there "everything that is brought into it will be brought because it is felt to belong there; it is to take its place as part of the whole. It has not been bought because it is pretty or rare, but because it is to be in harmony with its surroundings." William Merritt Chase managed his countless "spoils and trophies" with an exemplary flair, provoking John Moran to wonder "how constituents so multifarious and seemingly incongruous can make up such a delightful *ensemble*." The answer lay in the production of a "restful sense of harmony in colour" and a "deep mellow tone" unifying the "apparently fortuitous arrangements of line, drapery, and group." An oft-repeated tale maintains that Chase allowed dust to gather on the side walls and on objects hanging from the ceiling in his studio in order to bring about a refined transition from richness and brilliance below to cool, gray atmosphere above.[9]

The aesthetic principles of department store window display and interior arrangement were virtually identical to those practiced by painters in harmonizing their elaborate studio collections. As early as the 1870s, Macy's had introduced its fabulously ornate Christmas window exhibit, but it was not until the 1890s that store display began to organize itself as a dynamic mode of communication and seduction in the new world of consumer culture.[10] In that decade, such trade publications as *Show Window* and *Dry Goods Economist* undertook to disseminate the latest in display theory and practice, and professional societies were established, the first, in 1898, being L. Frank Baum's National Association of Window Trimmers. For a brief interval Baum, now more renowned as the author of *The Wizard of Oz*, styled himself the grand master of the new art of display, and his writings spelled out its governing principles in exhaustive detail. After a peripatetic career in theater management and assorted ventures in retailing, Baum settled in Chicago in the early 1890s. Having launched the magazine *Show Window* in 1897, he subsequently synthesized his knowledge and craft in *The Art of Decorating Dry Goods Windows and Interiors*, published in 1900. The primary objective of good display, Baum stated here, was to arrest the potential consumer's attention: "In order to make a window stand out from its fellows something more than a plain arrangement of merchandise is needed. It must be unusual and distinctive." It was poor practice, however, merely to crowd a window with articles; "the simple artistic arrangement of a few attractive goods" served the purpose far more effectively.[11] Baum's book offered both aesthetic guidelines and elaborate instructions for building successful displays, both in and outside the store. Despite his vaunted advocacy of the simple, artistic arrangement, some of Baum's prize windows today seem obviously contrived and even comic, as instanced by the *Scene in Venice* (fig. 10.6), a reproduction of the Trocadero Palace, lit from within by colored electric lights and fronted by a procession of constantly passing gondolas, the whole fabricated of six thousand pocket handkerchiefs. Ludicrous or not, this Venetian fantasy illustrates the principle of complete subordination of individual commodity to general design. In the same manner the arrange-

10.6. *A Scene in Venice*, photograph. Published in L. Frank Baum, *The Art of Decorating Dry Goods Windows and Interiors* (Chicago: Show Window Publishing Company, 1900), 107.

ment of *Art Goods* (fig. 10.7) conveys an overall impression of sumptuousness, even though its components are merely pillows, doilies, and other textile products.

Baum and other writers on display and advertising never failed to emphasize the vital necessity of achieving harmony of both line and tint in all arrangements. *The Art of Decorating Dry Goods Windows* included an entire chapter on up-to-date color theory that explained color interaction in great detail. Another advisor, emphasizing the importance of arrangement "to make the shopper buy," pointed out that the artistic use of color and light as part of an overall program of sensory stimulus was crucial: "The large stores aim to dress their decorations in bright colors for a half-tone light and in subdued colors for broad daylight. . . . The most brilliant lights are provided for the china and glass department, while the furniture rooms call for subdued lights that emphasize general lines and effects rather than details." The display strategist Kendall Banning, likening the modern retailer to a theatrical producer because both were concerned with staging—one, a play, the other, a sale—stressed the suggestive

10.7. *Display of Art Goods*, photograph. Published in L. Frank Baum, *The Art of Decorating Dry Goods Windows and Interiors* (Chicago: Show Window Publishing Company, 1900), 276.

power of the well-planned environment in engineering desire. "Many a hat or gown or painting," he asserted, "that would have been comparatively inconspicuous amid ordinary surroundings assumes a new charm when viewed in the restful atmosphere of a well ordered, well lighted, and richly furnished gallery."[12]

Orchestrated into harmony, department store and studio displays were calculated to awaken desire by appealing through the senses to the imagination by means of skillfully crafted illusions. "The buying impulse," wrote a journalist in 1895, "is born of the noblest of human faculties; it is the child of imagination. The true genius in window-dressing is he who knows how to set the imaging faculty in action." To this end, department stores suppressed the facts of production beneath a veneer styled by one Wanamaker publicist as "the romance of Merchandise and Merchandising." In this romance, glamourous associations obscured the economic relations of the commodity and removed it to some timeless, imaginary realm. Thus, the exquisite beauty of Venetian lace conjured up "moonlit evenings on the Grand Canal," while quaint Swiss textiles recalled "the Alpine glow upon Mont Blanc." Rare Eastern silks, with their wondrous hues, evoked the "sandalwood scent of the treasure-laden Orient," and simply to touch an Oriental carpet was to summon a vision of "the fadeless beauty, that perfect flower of architecture, the Taj Mahal!" Far from purchasing mere rugs and commonplace tablecloths, the shopper could buy and possess exotic romance in material form.[13]

Like the buyers who roamed the world to find treasures for Wanamaker's and Macy's, painters imported beauty, glamour, and culture in the form of wares from other lands and other times. Luxuriously embellished, their studios, like department store displays, exerted irresistible inducements to dream of what was distant and past, while deemphasizing the material circumstances of production and enhancing the notion of sanctuary from the humdrum world outside. In Humphrey Moore's studio (fig. 10.8) with its profusion of Moroccan motifs, the suggestive John Moran sank deep into the mysteries of the harem: "Leaning back on a divan," he wrote, "and sending out rings of smoke around his head, one . . . seems to gaze

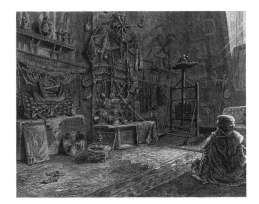

10.8. *Studio of Mr. Humphrey Moore*, wood engraving. Publishing in John Moran, "Studio-Life in New York," *Art Journal* 5 (December 1879): 353.

into some 'dim seraglio,' where languourous ladies, with henna-stained fingers and kohl-tinged eyes, recline, guarded by 'thick-lipped slaves with ebon skin,' sip their coffee or sherbert, and lazily smoke their nargiles." The carved Venetian Renaissance chest in William Merritt Chase's studio prompted reveries of swashbuckling romance: "Doubtless, could it speak, it could tell strange tales; it has heard many a page whisper soft speeches in the ears of pretty, black-eyed tire-women, men-at-arms telling of their doughty deeds, or assassins plotting some secret crime." The magic of these fantasies, of course, helped to surround the painter's own products with a glamorous aura.[14]

In studio and department store alike, the creation of a sumptuous environment and the concoction of aesthetic atmosphere were in essence a form of advertising the product and its desirability. L. Frank Baum made no bones about the ultimate goal of store decoration. In his introduction to *The Art of Decorating Dry Goods Windows*, he laid the greatest emphasis on the all-important master principle of display design: "There must be positive knowledge as to . . . what will arouse in the observer cupidity and the longing to possess the goods you offer for sale." Masquerading as entertainments or as spectacles of abundance and beauty, the windows were advertisements and inducements to buy. As one observer noted, "It was advertising when McCreary, to stimulate the house furnishing branch of his business, [made] a season's feature of an Indian room perfect in every detail from the grille copied from an ancient temple to the brass box upon a stand, or of a Marie Antoinette bedroom, pink and beautiful, or an old English hall, dark and rich." By such means, she concluded, the big stores created "appetites and caprices" in order that they might "wax great in satisfying" such desires. The power of advertising disguised as atmosphere asserted itself in the parable of a department manager who moved a large, unsold inventory of cedar chests by exhibiting several of them open-lidded, each opulently draped in "a handsome oriental rug." This display "immediately caught the eye of the women coming and going from the carpet department and suggested the many uses there are in a home for cedar chests. The entire lot was soon sold—sales that were induced by a proper arrangement." While the report emphasized the prosaic side of association, the association of the Oriental carpet with luxury and exoticism surely played no small role in stimulating the would-be purchasers' desire.[15]

The advertising mechanism of the decorated studio was somewhat more subtle, veiled as it was by layers of rhetoric that styled the place as a temple of art, crucible of inspiration, haunt of genius, and the like. Yet paradoxically these veils were projections of that very function they seemed designed to obscure; they were the attractive, seductive wrappings of the artistic "package" the painter had devised. Magazine and newspaper articles about the fabulous decorated studios provided free publicity and were instrumental in helping to construct the image of the well-traveled, highly cultivated artist in his "natural" habitat of exotic accoutrements. The formal studio reception, which became a distinctive feature of art life in the early 1880s, was also a form of advertising.[16] This ritual was meant expressly to promote contact between painters and their prospective clients, who were encouraged to shop around amid the variety of pictorial wares displayed in ornate, romantically

evocative settings. Popular for several years, the studio receptions met with mixed results, and most artists seem to have abandoned them when attendance dwindled along with their novelty. Public shows such as the annual exhibitions of the National Academy of Design and the Society of American Artists remained important vehicles by which painters reached their publics, as did, increasingly, some private galleries and other forms of brokerage, although artists and their supporters incessantly deplored the dealers' preference for fashionable (and attractively profitable) European paintings. Nonetheless, the sumptuous studio remained a vital image-making and advertising medium for many American painters in the late nineteenth century and beyond. It was precisely this function, in fact, that contributed to mounting anxieties about excessive materialism and commercialism in contemporary art practices and products.[17]

The vast increase of surplus capital, the proliferation of families with leisure and disposable incomes, and the rising status of art as a desirable luxury provoked a storm of anxious protest in late nineteenth-century America, where life, as one critic put it, was becoming ever more rapid, unreflective, crudely materialistic, and spiritually meager. Writing for an American audience, the English positivist Frederic Harrison argued vehemently that "art in all its forms is become a mere article of commerce. We buy works of imagination, like plate or jewelry, at so much the ounce or carat; and we expect the creator of such works to make his fortune like the 'creator' of ball costumes, or of a dinner service." As a result of such exchanges, art had become "as much a matter of professional dealing as a corner in pork, or a Bear operation in Erie bonds." Under those circumstances, "any high type of art" was flatly impossible to achieve: "In an age when fortunes are made, either by pleasing vast numbers of persons, and those for the most part half-taught and rude of habit, or else by pleasing those who have amassed fortunes and nothing else—the pursuit of fortune is the ruin of art." Nowhere was this more apparent than in the luxury hotel business in turn-of-the-century New York. As one journalist reported, certain New Yorkers were buying precious things like art collectors "gone mad," squandering huge sums on paintings, tapestries, old velvets, antique Chinese pottery, and rare rugs. Rivaling J. Pierpont Morgan, such spenders were not, however, connoisseurs but the proprietors of fashionable new hotels, acquiring treasures for their adornment as a "cold business proposition," which expressed the conviction that "art pays" by attracting an opulent clientele.[18]

Those who sought to defend high culture from the taint of the marketplace believed that the commercial degradation of art had leached out all of its inner value, leaving nothing save a gorgeous but spiritually cheap veneer. A president of the Chicago Woman's Club contrasted modern art disparagingly with that of the Renaissance, pointing out that whereas the Renaissance artist, actively engaged in civic and social as well as art life, produced great public works full of meaning, today art had become merely "the decoration and adornment of life, and a picture is painted to hang with hundreds of others on the wall of a gallery! . . . Science rules modern thought. . . . Art can never be the supreme thing in modern life; it is the adornment of a civilization rich in material things, and scientific in its thinking." The novelist Elizabeth Stuart Phelps deplored the materialism of the modern artist's

subjects: "Art, as we all know, kneels no longer before her angels, but . . . 'paints two dropped eggs on toast' and seems content to do so." William J. Stillman, apostle of the aesthetic moralist John Ruskin, castigated contemporary art for pandering to vulgar tastes able to comprehend only the superficial aspect of things. Artists no longer competed to express the loftiest ideas but only to outdo each other in the production of technically brilliant surfaces.[19]

The rise of the dealer-middleman, along with distinct preferences (assiduously cultivated by art merchants) for expensive European art, often sold through American branches of foreign galleries, helped to aggravate the perceived degeneration of art into commodity. Dealers, claimed one critic, accentuated the material nature of the art object by displaying it lavishly framed in gold, well understanding "the effect to be produced on the expectant purchaser by the twists and curves of the carving, the play of light and shade on the gilding, and the general effect of suggested costliness . . . even when that gold is but a cobweb surface on plaster." Worse, in order to raise his prices still higher, the dealer "oftentimes places a glass in front of an oil painting, to protect, as he tells his patron, this precious work from smoke and dust and dirt. He places around the outside of the frame . . . a 'shadow box,' usually of some costly and rich-colored wood, and lined with crimson plush or silk velvet. Here is a gorgeous dress. Surely a thing which is worthy of so much costly decking out . . . must have great value in itself." The satirist Williston Fish recounted a visit to such a gallery, where paintings were standing "in their shadow-boxes about the floor." When the dealer complained that Americans tended to look without buying, Fish advised him to "turn these pictures around and chalk the prices on the back, and our people will look at them more understandingly. That is the way to get the values."[20] While American artists occasionally objected to such practices, particularly as employed to enhance the attractions of foreign goods, they were hardly exempt from criticism on the same score. Life's cartoon (fig. 10.9) of an exhibition at the National Academy of Design in 1892 pokes fun at the use of frames so large and fancy that they overwhelm the paintings altogether.

How, then, could an artist create an aesthetic product destined for consumption in the marketplace without appearing to collude too deeply with the process of its commodification? Was the art produced in and by this process all surface and no depth, as critics alleged? Or did those gorgeous frames contain something more? Chase's In the Studio (fig. 10.1) provides key directions for discussion of these issues. Just as verbal descriptions of his sumptuous habitat stressed the harmony that prevailed among hundreds of disparate objects, so Chase's painting characteristically emphasizes the visual properties of things, arranged to create a ravishing display of color, pattern, and texture. The painting is about the pleasure of beholding beautiful artifacts, beautifully arranged. With this emphasis on the visual and physical charm of things, Chase's In the Studio falls neatly into place as paradigm of the aesthetic commodity: the luxuriously coated surface, the precious object celebrating the joys of seeing a material world full of delectably lovely things. Chase received both praise and blame for what seemed to be the uncomplicated materialism of his art. "His work is the healthy exercise of highly organized and highly trained faculties," wrote Kenyon Cox, "and is as natural as the free play of a child, and as pleasur-

10.9. *Reminiscences of the Academy, Where the Frames Are So Much Better Than the Pictures*, line engraving. Published in *Life* 20 (1892): 345.

able as the exercise of an athlete." Calling Chase a "wonderful human camera," Cox averred that the painter cared nothing for thought or story, only for "the iridescence of a fish's back" or "the red glow of a copper kettle." Mariana van Rensselaer saw him above all as "a *painter* pure and simple, and a true child of today." While Cox and Van Rensselaer accepted and enjoyed Chase's virtuosity, many others were uneasy about it, because behind "brilliant workmanship," as the journalist H. Monroe put it, there was, disappointingly, "a paucity of that high poetic quality which . . . is the soul of art."[21]

Yet for all his perceived materialism, Chase's obsessive cultivation of visual pleasure and his rejection of literary content align him squarely with the period's aesthetic movement, which sought to transcend whatever was crude, commonplace, and shoddy in modern life by creating an exclusive world of beauty and taste. This cult of beauty, with its quasi-religious overtones, became a new source of spirituality in a secular age.[22] In his single-minded endeavor to aestheticize visual experience of the physical world without suggesting higher poetic or spiritual dimensions, Chase occupied an extreme position among his contemporaries. However, even those such as Dwight William Tryon and Thomas Wilmer Dewing who strove to poeticize their subjects shared Chase's insistence on expressing content and mood by pictorial means, rather than creating literary works in which the pictorial signs referred to some external text; the ideal was to embed meaning in design and color themselves. This was the thrust, too, of art theory in the last decades of the century, when

devotees of aestheticism sought to educate the bourgeois public in the fine points of aesthetic experience. John C. Van Dyke, in his treatise *Art for Art's Sake*, declared firmly, "There is something radically wrong with those pictures . . . which require a titular explanation. For if they be pictorial in the full sense of the word, they will reveal themselves without comment or suggestion." He likened the "pictorial idea" to "a sympathetic sensation or an emotional feeling . . . about the only mental conception that painting is capable of conveying or revealing." Emotional vibrations, rather than intellectual substance, were the true province of visual art.[23] In keeping with this modern emphasis on pictorial expression, painters of Chase's generation, whether they were realists, classicists, tonalists, impressionists, or typically eclectic combinations thereof tended to specialize in subjects that lent themselves to decorative treatment suffused with personal taste and feeling: the impressionists' colorful, morally noncommittal city views, for example; Dewing's elegantly arranged, solipsistic women gazing into mirrors and rendered in the subtlest of nuanced tones; poetic landscapes almost without number that subjected nature to a rigorous process of selection, arrangement, and personalization.

Color in such works was the supreme medium of expression. Even in the case of picturesque, touristic subjects such as the Moroccan, Venetian, and Dutch views by Samuel Colman of the orientalizing studio, critics responded as much to their refined atmospheric effects and exquisite color as to their evocations of quaintness and romance. Praising one of Colman's Amsterdam canal scenes, exhibited at the first Society of American Artists' show in 1878, the *Art Journal* reviewer described the charm of the gabled houses with their irregular chimneys and "strange windows" overlooking the "dim waters" of the canal but stated that such interesting objects composed merely a "superficial view." The real subject was color: "The artist . . . delights in the *motif* which has introduced the shade of the big houses near at hand for the pleasure and purpose of combining with it such tremendous strength and vigour of deep-blue and red and greenish tones. . . . Like the bass notes of an orchestra, these low colors strike the key of the picture. The same colours are taken up and repeated in the bright light of the sunshine . . . again this beautiful melody of colour is taken up in a yet higher key . . . till at length it flies into the air, and red, blue, and rosy-white . . . bury themselves in the blushing form of a big round cloud." Color, color harmonies, and decorative color effects figured prominently in the new criticism, which often described them in a highly discriminating connoisseur's language. Attempting to characterize the color-sense of painters such as George Inness and John La Farge, one writer defined the artist's primary activity as the search for "a simile in pigment for rare and precious things, for the lavender of the orchid, the milky blue of the turquoise, . . . the creamy yellow of . . . Japanese ivories, . . . the deep blue of Hirado china." Source of pure visual delight, colors were also linked with all shades of emotional experience. Van Dyke devoted an entire chapter of *Art for Art's Sake* to the spectral and emotional properties of color. The landscape painter Birge Harrison noted that "the cool colors—blue, green mauve, violet, and all the delicate, intervening grays" were "restful colors in the emotional sense," while H. Monroe registered a response to the "note of joy" in the delicate lavenders and greens of a spring landscape by Dwight Tryon and felt the

"softer mood" of the darker tones in the same painter's *Rising Moon, Autumn* (1889; Freer Gallery).[24]

Spanning the contemporary art scene—from Chase's aestheticized realism to Colman's tasteful travel souvenirs and Tryon's ethereal, decorative landscapes—was the shift to surface values, the tendency to imbue these with meaning through expressive pictorial devices, and to awaken feeling by stimulating the visual sense. Pleasure, emotional and visual, was the intended result. Even if those pictorial values were invested with the promise of the spiritual, the fact remains that, like the windows of the department stores, they relied on the power of pure appearances to make their appeal. Just as the store displays with their rich color harmonies and luxurious textures induced pleasure while arousing desire, so did paintings by Chase and his contemporaries gratify sight while evoking feeling. The point is not that artists cynically entered into compliance with the values of consumer culture. Yet by producing and marketing paintings whose beautiful surfaces constituted the primary means of access, they participated actively in constructing a modern world increasingly driven by desire and dominated by images and appearances.

The strategy of aestheticism provided only a partial and flawed solution to the problem of art's place in modern society. It allowed artists to negotiate a buffer zone between themselves and the marketplace, but this zone was an illusory one that did little to assuage the fears of those who anticipated art's ultimate collapse into commerce. Some painters, though, did manage to achieve a frictionless union of the two. The career of F. Hopkinson Smith (fig. 10.10) offered an eminently practical paradigm of success without compromise to high ideals, since the ideals themselves were modest to begin with. Trained as a civil engineer, Smith was a highly successful producer of travel prose and touristic landscape views. Although he professed to love the beautiful and the picturesque for their own sake, he did not permit such sentiments to dilute the profit motive. Far from being critical of Smith's practicality, some commentators admired him as a remarkable and exemplary combination of clearheaded business sense and artistic sensibility. He produced pictures for the "average man": one who, living in rooms with "paper on the walls," wanted a picture that would "harmonize with his surroundings," be in "good taste, and no more aggressive than an open window." An interviewer conversing with Smith in the latter's "treasure laden studio" quoted the practical artist's explanation of his system. "I apply business principles to whatever I do," Smith stated. "The very minute my picture goes into the frame, it is then to me simply an article of merchandise, for which I insist on receiving the largest market value; just as a farmer, who can afford it, asks the maximum market price for his sheep."[25]

That Smith escaped the censure often leveled against flagrant artistic money-grubbing bears witness to the confusion of values surrounding the modern artist in America. On one hand, the successful businessman, wealthy and powerful, was the very incarnation of American Enterprise. Some, like the publisher S. S. McClure praising John Wanamaker, would maintain even that the great businessman was, indeed must be, a great artist. Relative to this model, F. Hopkinson Smith, adjusting his abilities to the commercial character of late nineteenth-century culture, acted with realistic business instincts to ensure himself a lucrative place in the art market

10.10. John W. MacKecknie, *Hopkinson Smith, the Artist*, photograph. Published in
Gilson Willets, "F. Hopkinson Smith," *Munsey's Magazine* 11 (May 1894): 142.

and deserved credit for winning against the competition. On the other hand, any
such hardheaded capitulation to business values and ethics seemed to threaten
everything that cloaked art discursively with the mystery, purity, and transcendence
of religion and empowered the rhetoric that still had a vested interest—particularly
in a time of rapid, destabilizing social change—in holding art aloft as a powerful
instrument of cultural elevation and social control. Smith may have achieved a
delicate balance, but it offered no assurance that the scales would not tip finally in
the direction of the marketplace.[26]

Culture critics, evangelizing to reverse that fatal tip of the scales, exhorted artists
to rise as leaders out of the materialism and luxury of the age. Frederic Harrison, like
many another aesthetic moralist, sounded an urgent warning. Young artists should
shudder to become tradesmen; rather, as devoted priests serving their religion, they
must hold fast to high ideals, swearing by all that was pure, beautiful, and broadly
human. Deploring the increase of money-making opportunities in illustration and
design, other writers joined Harrison in admonishing young artists to reject the
temptations of material success and consecrate their talents to something nobler.
The mural painter Will H. Low sternly criticized art students who defected for gain:
"You have seen some of the most advanced of your fellows disappear from the
school at a critical period of their career . . . to make a short apparition a few weeks

later, with a high hat and a large cigar, to announce their engagement, at a good salary, as the artist of the 'Daily Screecher.'" Such moves, warned Low, could only depress the standards and blight the future of art.[27]

In the course of this campaign to reinscribe art into the discourse of ideological, cultural, and moral elevation that had largely directed public artistic ideals in the earlier decades of the century, the decorated studio—temple of Mammon, not of beauty—came to be configured as a sign for everything that had corrupted art and brought it tumbling from its heights of idealism. Many a cautionary tale now figured the opulent studio as a hollow sham that in turn revealed the artist as fraud and poseur. The artist as opportunist plays a prominent role in William Dean Howells's novel *A Hazard of New Fortunes* (1890). In Howells's examination of the dialectics of culture and commerce, the painter Angus Beaton appears as an overrefined cosmopolitan with poetic looks who dabbles in several media, spends time hobnobbing with socialites in New York salons and flirting with a vulgar heiress from the gas fields of Indiana while he alienates the affections of the worthy and genuinely talented artist Alma Leighton. Begging money from his father, an honest stonecutter in Syracuse, Beaton spends extravagant sums to outfit his studio with rugs, stuffs, and Japanese bric-a-brac. "When he saw these things in the shops," wrote Howells, "he had felt that he must have them; that they were necessary to him; and he was partly in debt for them, still without having sent any of his earnings to pay his father." Among these expensive items is "an aesthetic couch covered with a tigerskin, on which Beaton had once thought of painting a Cleopatra, but he could never get the right model." Egotistical, capricious, and insincere, Beaton is a man of poses who knows how to make his eyes dreamy and seductive but can neither love deeply nor find the will to discipline his genius. Appropriately, his superficiality is mirrored in the aesthetic stage set of a studio more show than substance.[28]

When Theodore Dreiser published *The "Genius"* twenty-five years later, he set up a similar correspondence between moral failure and the elaborately aestheticized studio setting. In this case, realist painter Eugene Witla, the novel's hero and Dreiser's alter ego, is highly gifted, ambitious, and virile. The narrative follows him through early struggles, painfully achieved recognition, nervous collapse, subsequent rise in the fiercely competitive magazine publishing industry, and various passionate love affairs. When Witla finally does attain fabulous material success in New York, he realizes a long-cherished dream to imbue his studio with the murkiest of art atmosphere, including a "great wooden cross of brown stained oak, ornamented with a figure of the bleeding Christ . . . set in a dark shaded corner behind two immense wax candles set in tall heavy bronze candlesticks, the size of small bedposts." In addition to the dramatic crucifix "there were . . . a black marble pedestal bearing a yellow stained marble bust of Nero, with his lascivious, degenerate face, . . . and two gold plated candelabra of eleven branches each." Despite the presence of Witla's "best picture" displayed on a "carved easel," this studio is strictly for show, backdrop for the teas and receptions where Witla, now an art director rather than a productive painter, sells himself. Having exchanged his artistic soul for riches and luxury, he now creates merely a self-image compounded of the right clothes, the right address, the right friends, and the right investments; his fancy

studio is an egregious sham. Only when he fails catastrophically in business and society does he rediscover himself as a true artist.[29]

Witla, according to his narrator, had authentic talent; his showplace studio symbolized his deflection from the path of truth. Other writers associated the opulently equipped studio with the outright fraud and the shallow profiteer who erected a facade of aesthetic splendor as a substitute for talent. "The modern artist," wrote the New York Times in 1882, "wants everything, and everything is dear. . . . Taught at the smart schools of London, Paris, Antwerp, he commands a price for a picture that has taken him a week to paint, which keeps him well lodged, well fed, well clothed for two months. He has to resort to buying bric-à-brac and getting an expensive studio, but these are really his 'properties,' and aid in bringing him customers and raising his prices. He travels in Europe, gets lazy, fastidious, luxurious." Ultimately, moralized the Times, his appetites would be his ruin; he would become a "society artist" famous and rich but sadly diminished in talent and spiritually bankrupt.[30]

In his novel of art life The Fortunes of Oliver Horn F. Hopkinson Smith, wearing his author's hat, outlined the same cynical formula for success in the career of "The Honorable Parker Ridgway, R. A., P. Q.," whose studio with its veneer of culture and luxury was a vital component in the artist's carefully planned packaging and sale of himself and his work. A painter who "can't draw, never could," Ridgway prepared himself for success by joining the right New York clubs and having his wardrobe made by the right tailor. Then "he hunted up a pretty young married woman occupying the dead-centre of the sanctified social circle, went into spasms over her beauty . . . grew confidential with the husband at the club, and begged permission to make just a sketch . . . for his head of Sappho, Berlin Exhibition. Next he rented a suite of rooms, crowded in a lot of borrowed tapestries, brass, Venetian chests, lamps and hangings; gave a tea—servants this time in livery—exhibited his Sappho; refused a big price for it from the husband, got orders instead for two half-lengths, $1,500 each, finished them in two weeks." One of the idealistic artists listening to this tale mutters, "Just like a fakir peddling cheap jewelry." Another, already disillusioned, reasons, "Merchants, engineers, manufacturers, and even scientists, when they have anything to sell, go where there is somebody to buy; why shouldn't the artist?" The supreme incarnation of the society artist as poseur is Claud Walsingham Popple in Edith Wharton's The Custom of the Country. His success established by a wealthy patron's declaration that Popple is the only man who can "'do pearls',," he specializes in the art of flashy, shallow image-making. All that his sitters (exclusively female) ask of a portrait is that "the costume should be sufficiently 'life-like' and the face not too much so." He stages elaborate teas in his "expensively screened and tapestried studio" and always keeps it at "low-neck" temperature for the comfort of the empty-headed social climbers who frequent the place and drink up his oily compliments along with their tea.[31]

However profitable such activities, their cost ran high. As a luxury acquired by the newly moneyed classes, art had formed an alliance with fashion and celebrity that threatened to extinguish the last sparks of its spiritual life. The journalist Aline Gorren took alarm at an increasing tendency of artists to mingle with the "wealthy and unoccupied class" amidst "luxurious surroundings." The society woman used

the artist to enhance her own status and garner "the prestige which he confers upon a drawing-room." But in time the artist would be undone: "The result of it all for him is a relaxing of the mental fibre, and a fatigue, flat, stale, and unprofitable." The greatest danger lay in wait for artists who became celebrities themselves, objects of hysterical adulation. These outbursts of "so-called artistic enthusiasms" would not only sicken but "eventually emasculate" and enervate the recipients.[32]

Gorren's association of luxury and high society with loss of virility pinpoints one of the most critical areas of concern about the role of art in modern life. Fatally compromised by its connections with the marketplace on one hand and stylish salons on the other, art in this pattern of anxiety had become trivial and marginal, mere embellishment for a powerful commercial, industrial class. Its practitioners were frauds and charlatans, pets and parasites of the wealthy. Morally disempowered, something to be consumed, confined increasingly to the littleness of the private, domestic realm, art had become feminized, and as Jackson Lears has noted, to some this signaled a disturbing "decline of vital energy in art and life." In a civilization in which, in Lears's construction, conflict and ambivalence blurred the boundaries between the world of men, which valorized conscious control and autonomous achievement, and that of women, who were confined to dependent passivity, the problematics of the perceived feminizing of art were worrisome indeed. For male artists, at least, feminization meant loss of control, the erosion of the ability to act meaningfully in the world, and consequent loss of authority. The artist's dilemma mirrored destabilization of gender roles in the wider culture, too: the end of the century saw ever-greater numbers of women forsaking domesticity, agitating for political rights, and seeking their own autonomy through higher education and entry into the professions.[33]

In such a climate of unease, many demonized whatever was associated with the feminine and campaigned for a concerted return to what Theodore Roosevelt, chief agitator for the cult of the strenuous life, called the "rougher, manlier virtues." Roosevelt and his converts pinned the blame for the decline of virility on the refinements of peaceful civilization, which had resulted, deplorably, in "effeminate tendencies in young men." The "multitudinous appliances" of school, home, social circles, and church had softened, polished, and refined away the "grosser features of masculinity," which were further threatened by insidious temptations in the form of "abundant luxuries of artificial taste."[34] Within this frame of apprehension about the loss of masculine potency, the critique of art's commodification took a gendered turn, manufacturing a constellation of associations between women (or more generally, the feminine principle) and studios. Constructed as feminized and feminizing space, the studio became the domain of seduction, consumption, and self-indulgence.

As William Leach has observed, by midcentury shopping had already become a woman's job in conjunction with the process of accentuated gender differentiation arising from the separation of workplace and home. By the turn of the century it had developed into an "almost full-time secular and public business," with a new emphasis, smoothly engineered by the department stores, on self-indulgence. It was for women primarily that the stores developed what Leach called a seductive "festi-

val environment" of luxury, spectacle, and cultural offerings. The illustration *A Street Scene in the Shopping District* (fig. 10.11) accentuates the fact that magazine pieces on new consumption habits almost invariably referred to shoppers in the feminine gender.[35] Accounts of artists' studio receptions also recorded the presence of women in overwhelming numbers. In 1881 the *New York Times* covered a reception at the Sherwood Building and noted that the artists "stood their ground in the usual manner, welcoming the inevitable floods of appreciative women that inundated the corridors." Another *Times* account, of a reception at Tenth Street, reported that "ladies constituted the majority of the visitors, and went into raptures over the curios in many of the studios." Chase's rooms (fig. 10.12) proved to be especially popular with women, yet, as the *Times* observed, "the easels, with half-finished canvases, were but a small part of the attractions of the place, and the ladies spent hours in talking with the artist's birds and petting his spaniel, which lay stretched out upon a couch of brilliant upholstery. The artist, with a little polo cap on his head, was kept busy entertaining his many friends. Two colored valets in gorgeous costumes directed the curious observers hither and thither . . . with quaint courtesy."[36] Such tactics created the studio equivalent of William Leach's "festival environment" and entertained much the same clientele. In paintings, women were often featured as natural occupants of luxurious studios, as in Chase's Tenth Street interior illustrated here and in the Boston painter Edmund Tarbell's *Breakfast in the Studio* (fig. 10.13), where choice aesthetic treasures provide a sumptuous habitat for a beautiful young woman.

Women in decorative studio or domestic interiors in late nineteenth-century

10.11. *A Street Scene in the Shopping District* (detail), half-tone engraving. Published in Lillie Hamilton French, "Shopping in New York," *Century Magazine* 61 (March 1901): 652.

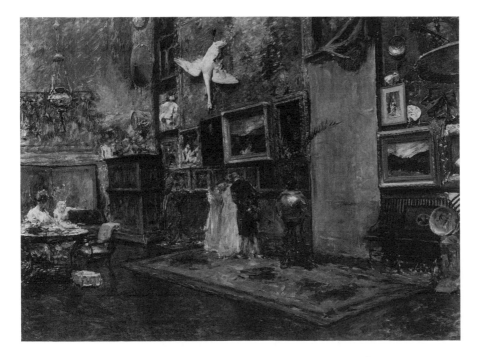

10.12. William Merritt Chase, *The Tenth Street Studio*, c. 1889–1905. The Carnegie Museum of Art, Pittsburgh; Purchase 17.22.

American painting have been the subject of considerable discussion. Their presence in those opulent, insulated settings has been criticized as the projection of sexist attitudes (women reduced and confined to the status of luxury objects) and, in a contiguous discourse, viewed as pictorial corroborations of Thorstein Veblen's theories of conspicuous consumption by the leisure class, in which women, elaborately outfitted and immersed in opulent surroundings, become signs for their husbands' wealth. They have also been construed as artist surrogates, signs for the feminizing construction of artistic activity and refined culture in general during the period, as symbols of genteel, elitist insulation from the rough-and-tumble world of commerce and industry, or for some form of aesthetic and philosophical introspection. Without attempting to sort through these sometimes conflicting interpretations, I want to suggest that these figures may also be read as cultural "shoppers." Rather than remaining passive, aesthetic objects among aesthetic objects, as the Veblen model would have it, they are more intensely engaged as players in a drama of cultural consumption. This is not to say that they are ever represented or even implied to be in the midst of a purchase. Instead, they inhale, absorb, and savor the aesthetic atmosphere, thereby metaphorically consuming it.[37]

In many cases, indeed, the culturally shopping women were not the nominal purchasers of art or at least of major artworks. The preponderance of names (with notable exceptions like Isabella Stewart Gardner) among late nineteenth-century American collectors is masculine: Thomas B. Clarke, William T. Evans, George Seney, Charles Lang Freer, William H. Vanderbilt, J. Pierpont Morgan, the depart-

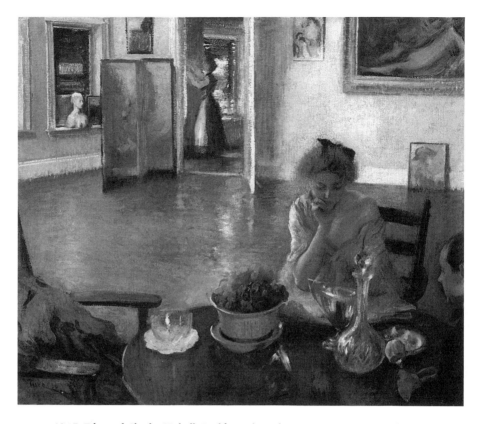

10.13. Edmund Charles Tarbell, *Breakfast in the Studio*, 1896. Courtesy Pennsylvania Academy of the Fine Arts, Philadelphia. Gift of Clement Newbold, 1973.

ment store magnates Alexander Turney Stewart and John Wanamaker. The studio women are stand-ins: mediators between raw money from the arenas of commerce and capital and the pure, transcendent spheres of art. At a time when commercial values seemed more and more to tarnish art's shining sanctity, the figure of its metaphorical consumption by elegant women sanitized or sublimated the circumstances of its consumption in the secular marketplace.[38] At the same time, however, the almost exclusive identification of women with studio interiors reinforced the construction of the art world as feminine, passive, and dependent for its very existence on industrial and commercial sources of wealth, unseen and unmentioned, yet all-powerful. A short story published in the popular *Cosmopolitan Magazine* suggests the extent to which these assumptions governed gender roles in the consumption of art. The subject of the tale is a handsome Italian barber who somewhat improbably succeeds after long trials in becoming a successful painter, producing hazy, "poetic" landscape paintings which are "much admired, especially by women, and [have] begun to sell well." Chatting with an acquaintance at an exclusive men's club, Stoddington, a manufacturer, sums up his relation with the artist: "Found him rather a bore myself. Talking art's not in my line. . . . Bought a couple of his pictures to please Mrs. S. They're said to be very fine, but I can't see it myself. It's all right,

though. Dare say they're as good as pictures I've paid a devilish sight more for. Mrs. S. is after me to buy another, and of course I'll do it." Here, although the woman is the ultimate consumer of the painting, Mr. S.—whose club, not his mansion, seems to be his natural habitat—pays the bills.[39]

The gendering of consumption in the late nineteenth century wove itself into subtly or heavily eroticized suggestions embedded in the commercial displays and environments organized with the aim of weakening resistance while intensifying desire. Peter Gay has analyzed the erotic, seductive dynamics of consumption in Emile Zola's *Au Bonheur des dames* (1883), a novel which figures the department store of the title as a "steamy sanctuary of appetites," where shopping is a voluptuous experience of sexual excitement and ultimate surrender. Neil Harris has proposed a similar interpretation of the role of the department store in Theodore Dreiser's *Sister Carrie* (1900), in which the traveling salesman Drouet takes advantage of the "rich mercantile atmosphere" of a Chicago emporium to create a "garden of desire" for his seduction of the ingenuous Carrie Meeber. And when realistic mannequins appeared on the scene in the second decade of the twentieth century, they invoked, in William Leach's words, "individual indulgence in luxury as often as they did traditional domestic behavior."[40]

In the studios, women figured both as objects and subjects of seductive acts, in either case reinforcing associations (usually covert) of erotic experience with the studio. As cultural shoppers inhaling the perfume of art atmosphere, women surrendered themselves to the sensuous inducements of their surroundings. These inducements are abundantly present, for example, in the studio of Edith Wharton's "society artist," Popple. With its low necklines, high temperatures, and cushioned corners, Popple's studio is a hothouse of desire: even the sandwiches and pastries on his tea table are seductive. Here the artist plays the seducer's role, however metaphorical, and his art atmosphere is infused with a faint but unmistakable hint of venery. On other occasions, woman herself became the provocative sign of everything to be desired and feared in the sensuous ambience of the artist's domain. Descriptions of the dancer Carmencita's performance in 1890 in the eclectic gorgeousness of Chase's studio make it plain that the actions of the tempestuous Spaniard pungently eroticized the painter's already exotic terrain. The author Brander Matthews paid tribute to the event in a sort of prose poem, in which the studio's decor functions as supremely appropriate setting for (and extension of) the dancer, a "daringly handsome woman . . . of intense vitality" possessing some "intangible, invisible, indisputable potency of sex" that lends fascination to her dark, irregular features and fires her primitive gyrations, which are somehow "voluptuous and yet decent." Charles Dudley Warner's thinly fictionalized account casts the dancer's sexuality in even less evasive terms. Here, the select audience of artists, wealthy clubmen, and society beauties, finding themselves "in Bohemia" at an hour far past decent bedtimes, are in a "flutter of expectation of seeing something on the border-line of propriety," something so daring, mysterious, and morally hazardous that certain among the spectators have left their genteel wives at home. When Carmencita appears, she begins a languorous dance that mounts to a Maenad's frenzy; Warner's description pictures the "snakelike movement of the limbs," the

"quickening pulse," the heaving bosom, the palpitating body, mounting intensity of movement until "the whole woman" is "agitated, bounding, pulsing with physical excitement." In the figure of the dancer, the erotic suggestiveness of the studio, always insinuating itself at some subliminal level, rose dramatically and overtly to the surface.[41]

Orientalizing decor harbored an especially potent erotic charge, as suggested by John Moran's ready linkage of the exotic atmosphere permeating Humphrey Moore's studio with fantasies of languid, sensuous beauties in an eastern harem. But the Oriental studio, with its insinuations of the forbidden, licentious, and mysterious East, was not merely a place for voluptuous dreams. Conjuring up an atmosphere of seduction as persuasive as that of the department stores, eastern exoticism could be turned to good account as a practical business asset. Painters like the fashionable portrait producer Eliot Gregory (fig. 10.14)—a real-life society artist— were not slow to see its utility. Gregory enjoyed a considerable vogue in the 1890s, painting wealthy female socialites on both sides of the Atlantic. His home base was the Madison Square Building in New York, where his studio (fig. 10.15), with its "soft Eastern rugs and heavy draperies," worked hard to generate a seductive art atmosphere to attract and fascinate his potential clientele. The area illustrated here was "consecrated to the Eastern collection made by Mr. Gregory during several journeys

10.14. Mr. *Eliot Gregory*, photograph. Published in W. A. Cooper, "Artists in Their Studios, X.—Eliot Gregory," *Godey's Magazine* 132 (January–June 1896): 190. Photograph, Library of Congress.

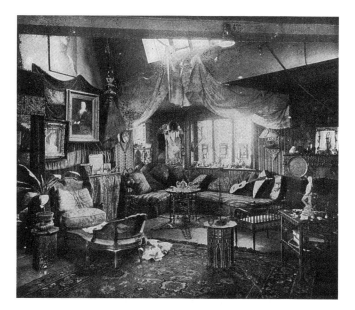

10.15. Mr. *Gregory's Studio*, photograph. Published in W. A. Cooper, "Artists in Their Studios, X.—Eliot Gregory," *Godey's Magazine* 132 (January–June, 1896): 192. Photograph, Library of Congress.

to the Orient" and featured "a hareem window of wooden lattice" lighting "a divan running around the two sides of a room," the whole much embellished with "arms and stuffs, lamps and inlaid furniture."[42]

Invested with erotic allure, Oriental motifs also appeared frequently in store windows and domestic interiors around the turn of the century. It is most likely, indeed, that the stores deliberately coopted the studio pattern, well knowing that artists' habitats signaled a seemingly Bohemian freedom from buttoned-up middle-class conventionality. Tracing the origins and diffusion of the Oriental "cosy corner," a journalist in the midnineties reported that the first one had consisted of nothing more than bits of draperies covering a packing box in some Bohemian's room; next it acquired a cushion or two and became a corner. Then, "wanderers in that desert country of Bohemia, who had been taught that here ideas blossomed and were to be culled, . . . started a fashion which . . . took on the headlong rush of a fad." Now, "Indian stores, Chinese shops, and Japanese importers, have filled their windows with every variety of it" (fig. 10.16). The basic "curtain, rug, lamp, lance, and cushion arrangements" could be personalized by individual owners: the smoker's cosy corner might be Turkish and softly shaded, while the hunter's exhibited guns and skins. Appropriated to domestic or commercial ends, the material symbols of Bohemian life were tamed and made respectable. Like the "voluptuous but decent" movements of Carmencita, the Oriental displays suggested licentious, hedonistic possibilities yet checked their play well short of the limits of conventionality. This is apparent, for example, in the New York Wanamaker's Oriental show window (fig. 10.17) in which Juana Romani's *Salome* (1898; location unknown) unambiguously

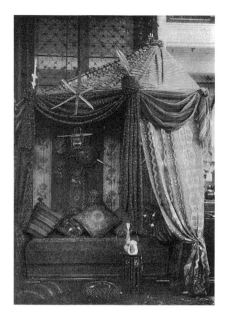

10.16. *Cosy Corner*, photograph. Published in L. Frank Baum, *The Art of Decorating Dry Goods Windows and Interiors* (Chicago: Show Window Publishing Company, 1900), 220.

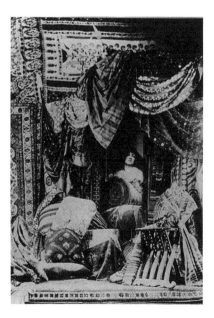

10.17. *Mr. Rubens' Oriental Display*, photograph. Published in L. Frank Baum, *The Art of Decorating Dry Goods Windows and Interiors* (Chicago: Show Window Publishing Company, 1900), 234.

refers to a particularly fatal brand of eastern eroticism, which is simultaneously neutralized by its context.[43]

In the stores, Oriental eroticism made its seductive appeal, awakening desire and promising fulfillment, but in a controlled, public space that sublimated passion into purchasing. In the studios, it signaled freedom and seduction, but this was more often than not only a figure in a stylized ritual of persuasion. Contained and subordinated to the commercial imperative, the untrammeled sexuality of the exotic was a mere fiction after all. Artists might equip their studios as harems, but the sheer inauthenticity of this ploy made mockery of their potency. On the other hand, if the studio was the domain of female sexual power, as Carmencita's voluptuous dance so dramatically suggested, then this too posed a threat to the artist's virility. In the realm of the exotic other, would he not risk being seduced himself and disempowered, if only metaphorically?

This unsettling question underlay the construction of the studio as a feminizing space which took two forms: one in which the society artist has quite literally metamorphosed into a woman; the other the moral tale in which the male finds himself encaged and creatively disabled in a claustrophobic, overdecorated trap of some woman's making. A number of successful or striving women artists maintained their own urban studios at the end of the century, and while writers usually characterized these places in more domestic terms than they did the studios of male artists, they seldom construed them in a negative light.[44] In fiction, however, the woman with a studio exuding art atmosphere was likely to be cast as a fraud or lightweight. For example, the wealthy, effusive Charmian Maybough in William Dean Howells's *The Coast of Bohemia* lives in her family's luxurious and very proper New York mansion but pursues a would-be Bohemian existence, attending classes at the Synthesis for Art Studies (the Art Students' League in disguise) and furnishing her studio to express her pose as unconventional, liberated genius. "I must have a suit of Japanese armor for that corner, over there," she tells her friend Cornelia, "and then two or three of those queer-looking, old, long, faded trunks, you know, with eastern stuffs gaping out of them, to set along the wall." While Charmian babbles on, Cornelia eyes her sketches, all of them a characteristic mixture of "bad drawing and fantastic thinking." One reviewer of the novel complained that Howells had failed to deal with the real life of real art students but instead set his scene either in society or in "the sham studio of a sham Bohemian who poses as an artist for her own amusement." Here, artistic imposture or failure is unambiguously linked with gender and the overdecorated studio, which speaks not of genius but of feminine taste and purchasing power.[45]

The oppressively feminized environment plays a key role in the popular story "Maloney's Masterpiece," which points the moral that a woman's touch in the studio is antithetical to the production of serious, manly art. Maloney, an impoverished painter of gigantic battle scenes, marries a rich widow so that he can stop making potboiler portraits and concentrate instead on his supreme battle epic. After the marriage, Maloney's artist friend Rayburn, a dedicated Bohemian, pays a visit to the studio that Mrs. Hotchkiss has recently made "habitable" for her new husband. "There were muslin curtains up at the windows, and affected bits of velvet thrown

around over easels to catch the light. . . . The floor had rugs on it, . . . and some badly carved things, for which there seemed to be no particular use, cluttered up the apartment. . . . Rayburn seated himself disdainfully in a wicker chair which was run through with old-rose ribbons. 'Just the thing for a battle-painter, I should think,' said he." So compromised that redemption seems hopeless, Maloney in the end destroys his great painting (slated, courtesy of Mrs. Hotchkiss, for some vulgar, nouveau riche salon) and disappears, much to the joy of Rayburn, who sees this desperate act as testament that Maloney, after all, had kept faith with himself. What was true of the studio also pertained to middle-class interiors, in one writer's opinion: any home in which a wife enjoyed unrestricted freedom in the decoration of the masculine den was invariably the abode of a submissive, overdomesticated husband, condemned to comfortless repose in a Turkish boudoir, "while all the time his soul yearns for four bare walls, . . . a plain easy chair, a blazing light, and an emancipation from the Orient." Here, too, what purports to be a masculine den is really a cage wrought by female cunning, from which the prisoner is powerless to fly, except in dreams.[46]

Coopted by commerce and annexed by the feminine, the opulently decorated studio threatened to become more liability than asset. Represented as a suffocatingly feminized trap, realm of surfaces without substance, backdrop for the poseur and the society artist, the decorated studio was no sanctuary of art but merely the calculated showplace of social and aesthetic commodities, different in kind but not in degree from the show window of a department store. Emasculated, spurious, morally disempowered, the artist represented (and seduced) by such surroundings had sold out. It became clear to many artists that to regain lost ground they must maneuver to create an appearance of greater distance between themselves, the feminine, and the marketplace. The production of grand-scale civic art was one such maneuver; the turn-of-the-century simplification of the studio interior was another. Stripping the studio constituted a sign that the artist rejected materialism, and this was concomitant with a movement away from cosmopolitanism toward an emphatically nativist masculinization campaign in the world of art.[47]

The figure of the artist starving in a garret was a well-worn stereotype by the late nineteenth century. Nonetheless, the association between artistic integrity and asceticism enjoyed continuing currency. In one cliché-fissured tale of the Latin Quarter, Frances Hodgson Burnett narrated the tragic career of a poor, sensitive, American art student in Paris who executes one great work before his untimely death from some wasting disease. The painting portrays a demimondaine whose beautiful soul only he can see and realize on canvas. The painter's room has a low, slanted ceiling and is poor and bare, containing nothing but a narrow iron bed, a wooden table, and an easel. Even the hard-boiled model is affected by this monkish chamber. She thinks, "He is one of the good. He cares only for his art. How simple, kind, and pure! The little room is like a saint's cell." Nothing could be more remote from the opulence of the fashionable cosmopolitan, and this austerity, as the story makes clear, is matched by the occupant's spiritual nobility.[48]

When William Merritt Chase closed his famous Tenth Street studio in 1896, a

critic took advantage of the occasion to praise "better-inspired painters and sculptors" who were returning to "simpler and somewhat more austere forms of expression in their works and in their working-places." Dismissing Chase's heady art atmosphere as bewildering and distracting, this commentator noted that "the most approved model nowadays" was the "bare workshop of Puvis de Chavannes in the Place Pigalle," rather than the studio "heaped with the plunder of Asian, African, and European shores." One key to this new preference was Puvis himself, who was an idol to many young Americans and the epitome of high-mindedness in art. As Kenyon Cox wrote, Puvis's grand, classicizing murals signaled that the day of mere fact and mere research was soon to end, with the resurrection of the old true notion that art's highest aim was to make something useful beautiful. Puvis led the way with his lofty aim "to beautify the walls of the temples and palaces of the people." By following his example, the American artist could convincingly package himself as a disinterested subscriber to art's traditional, transcendent cultural program. The popular novelist Richard Harding Davis claimed acquaintance with just such a new idealist, an American art student in Paris, whose studio was "so bare as to appear untenanted." When questioned about this, the young man answered loftily, "I am afraid that you are one of those people who like studios filled with tapestries and armor and palms and huge hideous chests of carved wood. . . . *We* believe in lines and subdued colors and broad bare surfaces." Taste for materialistic splendor had now become the badge of "an American Philistine."[49]

The stripped studio, index of sincerity and asceticism in art, also accompanied a rejection of urban luxury, of the suffocating accumulation of things associated with cosmopolitanism, consumerism, and the feminization of culture. This took place both in urban venues, as proponents of a rugged realism (for example, John Sloan and George Bellows) sought to establish hegemony or at least parity in the aesthetic establishment, and in rural retreats, where artists such as the landscape painter Edward W. Redfield embraced a set of values embodying the wish to return not just to nature but to the producer ethos of some idealized, simpler, older America. If the cosmopolitan artist and his studio signified the cultivation of the facade, the perfection of the pose and package, the glossy surfaces of a culture in which display and consumption had become spectacular public rituals, Redfield seemed to be the very opposite: a worker, a craftsman, a man of the soil, an artist as sincere and honest as the urban cosmopolitan was superficial and deceptive. "A fine type of sturdy American manhood," as described by B. O. Flower, Redfield approached painting as a test of strength in a battle with the elements: "He paints in the winter when it is down to zero and the wind is blowing forty miles an hour." He raised "all the vegetables and chickens" his family could eat, and he also assumed the role of general handyman and carpenter on his land in the pastoral Delaware valley. Far from overflowing with exotic, expensive plunder, Redfield's studio (fig. 10.18) was a rude, bare, barnlike enclosure furnished with tables, benches, and stools he himself had manufactured "out of the driftwood he caught that was floating down the river to the sea."[50]

Like his cosmopolitan predecessors, Redfield depended on the marketplace. Like them, he exhibited at institutional shows as well as commercial galleries and for success depended on attracting a clientele to consume his wares. By constructing a

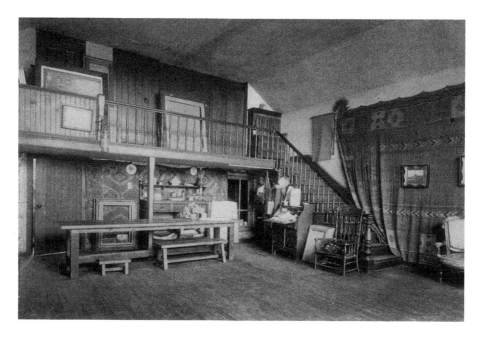

10.18. *Interior of Mr. Redfield's Studio*, photograph. Published in B. O. Flower,
"Edward W. Redfield: An Artist of Winter-Locked Nature,"
Arena 36 (July 1906): 21.

self-image that gave prominence to masculinity coupled with a kind of Emersonian self-reliance, however, Redfield effectively managed the appearance of detachment from commercial spheres. With its marks of primitivism and rusticity, this image seemed unconstructed and naturally opposed to the obvious showmanship of the decorated studio and its creator. After the turn of the twentieth century the construction of an image and the problem of the marketplace remained central to negotiations about artistic identity, but as the Redfield example suggests, the terms refocused themselves, blurring the commodity character of the artwork and sharpening the emphasis on whatever made the artist appear natural, genuine, and substantial. For this construction of the artist, the commodity display of the opulent studio would sound an egregiously false note.[51] No maneuvers, however, could reverse the process by which art, style, taste, culture, and even personality had become commodities in the American marketplace. Younger artists in the early years of the new century may have shifted their ground to evade the onus of materialism. But they were powerless to escape the modern marketplace and its consequence: the cult of endlessly flowing, self-renewing images ever promising the satisfaction of ever-present desire.

11

HARRIET SCOTT CHESSMAN

. . .

Mary Cassatt and
the Maternal Body

In 1881, both Mary Cassatt and Berthe Morisot won enthusiastic praise for their entries in the Sixth Impressionist Exhibition.[1] Both women, one American, the other French, showed paintings on the theme of mothers and children. For Morisot (1841–95), this subject was familiar: she had painted pictures of a mother with a child in the early 1870s, using her sisters Edma and Yves and their children as her models, and in 1878 she had given birth to her first and only child, Julie, who would become one of the central subjects of Morisot's art from then on. For Cassatt (1844–1926), a painter who was to remain single and without children, the subject was new and marked a fascinating turning point in her art.[2] Although Cassatt continued to paint a range of figures and settings, this subject became meshed with her public identity as an artist even during her lifetime, to such an extent that Achille Segard titled his biography of 1913 *Un Peintre des enfants et des mères, Mary Cassatt*.

Cassatt's rich oeuvre, centering increasingly in the 1890s and the early twentieth century around figures of mothers and children, may seem to us to have an air of the natural. Europeans and Americans, in particular, have absorbed such images into their cultural vocabulary about motherhood, so that even in the late twentieth century these images still hold the power to represent a cherished—or contested—ideal attached to the inherited ideology of the sentimental. The privacy of the middle-class interiors, the intense focus on the mother–child dyad, the quiet absorption of the mother in her child, the appearance of effortlessness and tranquillity in the mother's occupations, the Madonna and child motif—all may suggest an idealization so familiar to us as to be almost invisible.

Cassatt's art, of course, helped in one sense to promote and shape this cultural ideal. Her relation to the sentimental was intricate, however. Early on, in the 1880s especially, the space occupied by the mother and child became for Cassatt a valuable space in which to investigate and refigure the relation between the creator and the subject (or object) being represented. How to move the female object of art into a protected position of genuine subjecthood became a crucial part of Cassatt's enterprise. Her use of a traditional sentimental vocabulary for such an essentially feminist shift suggests just how complicated her art can be.

In the 1890s and into the first few years of the twentieth century, Cassatt continued to create prints and paintings on this earlier model of the sentimental mother, but her most unusual work appears to chafe at the restrictions imposed by the sentimental, in an artistic as well as a cultural sense. She produced during these years immensely thoughtful and questioning images of the maternal, especially by bringing into view the problematic relation between the sentimental mother and a larger cultural matrix within which this mother is revealed to have little power or agency and in which she may be constructed precisely in such a way as to reproduce her own powerlessness, to pass it on to her children and especially to her daughters.

Cassatt's entrance into the representation of mothers and children was an entrance into a highly fraught and self-conscious field. The Cult of True Womanhood forms only one part of the social puzzle, although a dominant part. The True Woman of America, as Carroll Smith-Rosenberg has recently described her, was, like her middle-class European counterparts, thought to be a woman who happily assumed the one "socially respectable, nondeviant role for women—that of loving wife and mother. . . . Thus women . . . had to find adjustment in one prescribed social role, one that demanded continual self-abnegation and a desire to please others. Literature on child rearing, genteel women's magazines, children's books, all required of women an altruistic denial of their own ambition and a displacement of their wishes and abilities onto the men in their lives."[3] Or, one might add, onto the children, for, as Smith-Rosenberg goes on to describe in her essay "The Abortion Movement and the AMA, 1850–1880," "the True Woman was domestic, docile, and reproductive," accepting of her "biological destiny" and "glor[ying] in her reproductive sexuality."[4] Reproductive sexuality came to be seen as the only possible and certainly the only acceptable sexuality for women. Whereas in the 1820s and 1830s medical writers had understood women to be "naturally lusty and capable of multiple orgasms," "by the 1860s and 1870s . . . their professional counterparts counselled husbands that frigidity was rooted in women's very nature."[5]

The loving and selfless angel at the heart of the house, pouring herself into the spiritual education and sustenance of her family, came into full being in America in the popular sentimental novels written by women in the mid to late nineteenth century, the period spanning Mary Cassatt's childhood and maturity.[6] Motherhood so conceived came increasingly to represent a sign of social stability. According to the dominant cultural idea, men could accomplish the public business of the world because women, especially mothers, held their place in the private and sanctified sphere of home and family. The images and common public vocabulary of two separate spheres held well into the early years of the twentieth century, despite

actual changes marking a breakdown of such a division. The situation was similar in France. As Tamar Garb has suggested in her catalogue *Women Impressionists*, "The painting of mothers and children, with the mother's gaze often directed at the child, was one of the most popular subjects during the Third Republic. Motherhood was almost universally promoted as the only legitimate option for women, and paintings of mothers and children proliferated at the Salons of this time."[7]

The social realities, however, contradicted such a picture, then as now. By the 1880s and 1890s, more and more women were moving into the public sphere; as families became smaller and middle-class women became more active as consumers and gradually as educated and professional people too, the insistence on the True Woman began to become clearly contradictory to much social practice. It is no accident, as Smith-Rosenberg has shown, that it was precisely during the height of this change in social structures that the subject of abortion assumed such sudden and frenzied magnitude.[8] The aborting woman became, in popular rhetoric, the corrupt sign of myriad forms of social fragility and dissolution.

The ideology of woman's separate sphere emerged even in the language of feminism. Wanda Corn has suggested that the majority of feminists, called by historians domestic or social feminists, often held strongly to the idea of separate spheres. The causes they supported were understood to be compatible with all that was womanly: in particular, higher education and the arts.[9] The True Woman could enter such fields and remain recognizable as a figure primarily concerned with the nurturance and support of others.

Mary Cassatt is a fruitful figure to study in this context, for although the vocabulary of the True Woman would have been in the air around her as she grew up, first in Pittsburgh and then in Philadelphia, and to some extent took shape in her own family, she heard other vocabularies as well. As Nancy Mathews has suggested, Cassatt "launched her career at a time when women were receiving more and more encouragement to become successful artists and never thereafter tolerated any hint that women were less capable than men of artistic genius."[10] Changing attitudes toward women, running counter to the dominant sentimental ideology, found form in the greater possibilities opening up for women who wanted to enter the field of art. The Pennsylvania Academy of the Fine Arts, unlike the prestigious but more rigid Ecole des Beaux Arts in Paris, which opened its doors to women only in 1897, accepted women as students; and women could participate in all classes except, predictably, drawing from the nude. Cassatt spent four years there (1861–65), the Civil War years, and graduated with a degree in fine arts, before graduating from America to Europe, where she spent the following nine years largely in and around Paris and Parma, Italy, with only a brief return to Philadelphia in 1870–72, during the war in Europe.

What is striking about Cassatt's European journeying in these years before she settled down in Paris in 1874 is her independence. Although she lived with friends most of the time, when she studied in Parma and possibly when she studied in Rome and Madrid as well she apparently managed to live alone, a rare situation for a young American woman in Europe.[11] Cassatt's social independence finds a corollary in her ambition, clear to her friends and family from the time she was in her

early twenties. As Eliza Haldemann, one of Mary's close friends and artistic traveling companions, wrote to her mother from the little French village of Ecouen in 1867, when Mary was twenty-three, "Mary wishes to be remembered to you, she laughed when I told her your message and said she wanted to paint *better* than the old masters. Her Mother wants her to become a portrait painter as she has a talent for likenesses and thinks she is very ambitious to want to paint pictures."[12]

Although both of Cassatt's parents had doubts about her choice of painting as a profession (her father apparently remarked, in response to her announcement of this choice, "I would almost rather see you dead"),[13] they gradually came to support her ambition, especially once it became clear that she had a chance to succeed both in terms of money and fame. She was expected to be a good daughter, one who was attentive to their needs, and once they moved to Paris in 1877 with Mary's sister Lydia, they made heavy demands on her time and energy. They differed, however, from most middle-class parents of the time in their acceptance of her bold professional life and of her association with an unconventional crowd of artists as well as in their abstention from pressuring her to marry and have children.

As dozens of American expatriate writers would soon begin to discover, France offered a comparatively freer and more open environment to Americans interested in the avant-garde. Cassatt's reception in America was never as warm as her reception in France. Yet even in France women artists faced much difficulty, of subtle and not-so-subtle forms. Griselda Pollock writes, "To be a producer of art in bourgeois society in late-nineteenth-century Paris was in some sense a transgression of the definition of the feminine, itself a class-loaded term. Women were meant to be mothers and domestic angels who did not work and certainly did not earn money."[14] This contradiction between the definitions of artist and middle-class woman found poignant expression in the lives of many French women painters. Berthe Morisot's sister Edma, who had studied painting seriously for many years with Berthe and whose paintings had been highly praised by many artists, including Corot, gave up her art once she began to have children. Marie Braquemond too gave up her painting largely owing to her husband's disapproval and his wish that she devote herself solely to her family.[15] Even Berthe Morisot, who was highly unusual in her capacity to create art and to engage with energy and happiness in the life of her family, struggled often with self-doubt; as a disturbing end-marker of such a full life, her death certificate records that she had "no profession."[16]

It is intriguing to speculate on Cassatt's attitudes toward her own unconventional course, her creation of an identity so little influenced, at least on the surface, by the image of the True Woman. She has often been quoted as saying, in later life, "After all, a woman's vocation in life is to bear children," although it is difficult to know the context and even the tone of this assertion.[17] She also made a corollary statement: "A woman artist must be . . . capable of making the primary sacrifices."[18] Yet there is little indication in any of Cassatt's extant letters that she regretted the shape her life took. Louisine Havemeyer, one of Cassatt's close friends and a patron of the arts, writes in her memoirs that Cassatt told her how it was possible to "get on" with a man as difficult as Degas: "'Oh,' she answered, 'I am independent! I can live alone and I love to work.'"[19]

In this context, it is important to note that Cassatt quite consciously engaged in the construction of the maternal. Berthe Morisot tended to make use of family members as her models, so that her mother and child pairs are of actual mothers with their own children, who come to us with an air of being "found," in the artist's own intimate daily life. In contrast, Cassatt, although she often made use of family members as models—especially her sister Lydia until she died in 1882, her nieces and nephews, and her mother—tended to use servants and other working-class women as models for her mother and child compositions, and often the children in these pictures are not the women models' actual children.[20] While her pictures of mothers and children have an air of naturalness, the two figures often were brought together by Cassatt. All painters, of course, are immersed in the intricate process of constructing their images, in arranging the setting and the posture, the clothing and the light; and the images available to even the most original artist come at some level out of the culture itself. Yet the fact that Cassatt went out of her family circle to find women and children who pleased her as models and who could be put into compositions together heightens the idea that her paintings represent not what motherhood was, but what she constructed it to be, given her position as a subject in culture, immersed in profound ways in the vocabulary about women and families in the world around her.

It is this aspect of construction, that is, the artist's own construction as a subject within her culture, and her attempts in turn to shape further constructions, that had eluded most viewers of Cassatt's art until Griselda Pollock's powerful interpretations of the social and pictorial spaces of these paintings.[21] From early on, Cassatt was thought of not simply as an artist, but as a woman artist, whose art somehow accorded with (or, as Wanda Corn has suggested in the case of the Chicago exposition, refused to accord with) assumptions about femininity. In response to Cassatt's contributions to the Impressionist Exhibition in 1881 the novelist J.-K. Huysmans praised Cassatt as "an artist who owes nothing any longer to anyone, an artist wholly impressive and personal." He asserted that she had found a way "to escape from sentimentality" in her portrayal of children, interiors, and gardens, subjects which, in the hands of the English, had become overly sentimentalized. Huysmans goes on to explain, however, how Cassatt has managed to paint "the likenesses of ravishing children. . . . There is a special feeling that a man cannot achieve. . . . Only a woman can pose a child, dress it, adjust pins without pricking themselves. . . . This is family life painted with distinction and with love."[22] Huysmans subtly implies here that Cassatt's art is somehow on a continuum with her natural womanly capacity to dress children and "adjust pins." Her art, in this sense, comes to seem a natural, not a cultural, production.

In the following interpretations of Cassatt's paintings, I wish to take up Griselda Pollock's challenge to such assumptions. Pollock makes an important connection between the social space, or context, within which a painter like Mary Cassatt worked and the pictorial space created within her paintings. Pollock defines this relation as one of a kind of circling intricacy: "The producer is herself shaped within a spatially orchestrated social structure which is lived at both psychic and social levels. The space of the look at the point of production will to some extent deter-

mine the viewing position of the spectator at the point of consumption. This point of view is neither abstract nor exclusively personal, but ideologically and historically construed."[23] Pollock interprets Cassatt as making a significant refiguration of femininity: Cassatt "rearticulat[es] . . . traditional space so that it ceases to function primarily as the space of sight for a mastering gaze, but becomes the locus of relationships."[24] The one imagined to be looking at Cassatt's subjects, according to Pollock, is always "equal and like,"[25] as suggested by the "shallow pictorial space which the painted figure dominates." The figures represented tend to avert their heads or show absorption in their own activities in such a way that the viewer cannot assert dominance or familiarity.[26]

Pollock defines here a major preoccupation in Cassatt's paintings: the safety or vulnerability of the figures represented, especially in relation to a dominating and intrusive gaze. I wish to investigate this preoccupation further, to ask, first, how Cassatt represents female sexuality, and second, whether the ideal Pollock describes holds true for all of Cassatt's art. I argue both that the sentimental gave Cassatt a rich language within which to encode women's sexuality indirectly, through the child's body,[27] and that the ideal "space of the look" as a locus of relationships often becomes suggested through its disruption or absence rather than through its fully realized presence. Cassatt confronts with unusual clarity the issue of the artist's—even the woman artist's—implication in a structure of dominance that cannot so easily be reimagined or avoided.

In the first of her paintings to focus on a mother and child, *Mother About to Wash Her Sleepy Child* (1880; fig. 11.1), Cassatt transforms the genre of the conventional bathing scene, in which a female, nude or half-nude, becomes in her isolation and positioning an object for our gaze. She creates instead a small, intimate space filled by a mother and a sleepy child, one of whom holds the other and one of whom is happily held. The traditional basin for washing is present, but the figure to be washed has changed, just as the idea of the washing has shifted. Whereas in conventional bathing pictures the women could be said often to be presented as bathers in order to be seen in the nude, here, at least at first glance, the reason for washing seems more immediate and held safely within a domestic, familial realm.

This image makes it difficult for our gaze to become intrusive, although, as I will suggest, our gaze becomes engaged in complicated ways. Our presence is, by implication, unnecessary to this pair. Neither the woman nor the child looks out at the viewer, who occupies a position close to the figures and in front of them. Their serene unawareness of any other figure suggests either that they are alone (a fiction, of course, since during the space of the painting's production Mary Cassatt herself was present) or that the implied third figure is someone trustworthy, familiar, and unobtrusive. The structure of the images does not allow our gaze to dwell too long on any one place in the painting, but asks our vision to be in constant movement, in a circle from the woman's head to the child's and through the child's left arm and leg up again to the woman's hand, arm, and head. Further, because of the mother figure's averted face, her own gaze toward the child, and the child's greater accessibility as an object of sight, our gaze lingers more on the child's body than on the

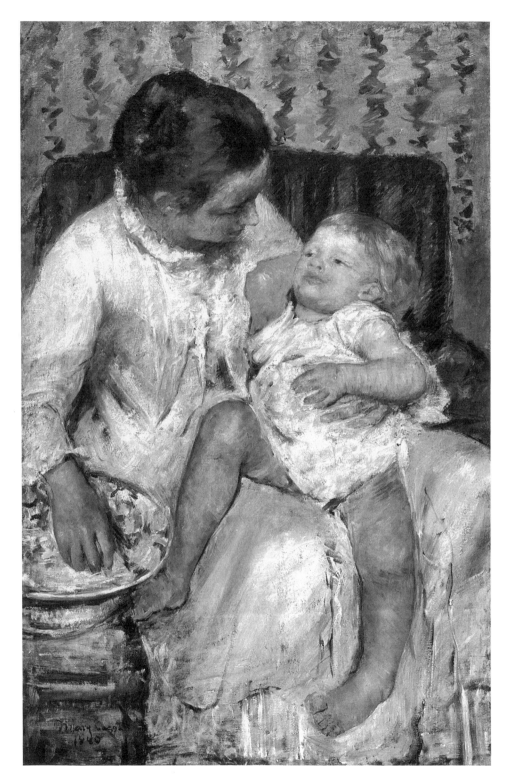

11.1. Mary Cassatt, *Mother About to Wash Her Sleepy Child*, 1880. Los Angeles County Museum of Art, Mrs. Fred Hathaway Bixby Bequest.

mother's. She eludes us. Her body, in contrast to the child's, is fully clothed, so that only her hands and part of her face and neck can be seen. The paint of her dress and of the child's smaller and more revealing garment has been impressionistically built up—white, blue, pink, and yellow—to suggest a kind of shimmering veil.[28]

In one sense, the mutual gaze here held between mother and child forms a crucial part of a sentimental vocabulary. The love between mother and child, suggested by such an intimate gaze, fills the canvas just as, by implication, it fills the world for both mother and child. The varied whites, the angelic, puttilike aspect of the child, and the Madonna motif all suggest a world of innocence and goodness, a domestic sanctuary far from the strife of industry and public business. The mother, in the stillness of this prolonged moment, appears wholly occupied with her child. She is like the Mater Amabilis, the loving mother, described by Anna Jameson in her volume of art history *Legends of the Madonna as Represented in the Fine Arts* (1852), a book devoted to the figure of Mary in all of her aspects: "She is occupied only by her divine Son. She caresses him, or she gazes on him fondly. She presents him to the worshipper. She holds him forth with a pensive joy as the predestined offering. . . . The baby innocence in [each model's] arms consecrated her into that 'holiest thing alive,' a mother."[29]

The sense of the mother as holy attaches to the further sense in which she is inaccessible to all but the child. The mutual gaze between the mother and the child in Cassatt's painting is also, for the observer, a lost gaze. The baby looks through sleepy eyes into the mother's eyes, but we cannot share its look. We remain outside the circle. This loss of a loved maternal presence acted as the primary loss and goad to the plot of the sentimental novel. The girl who has lost her mother, as in Susan Warner's extremely popular novel *The Wide, Wide World* (1850), has lost the spiritual ground of her existence. She must search for substitutes, and ultimately she must herself grow into her mother's place: the place of the selfless, spiritually perfect, and utterly loving woman.

Cassatt brings such a vocabulary into this painting, and yet I wish to suggest that she makes use of the sentimental in order to bring other, less socially legitimate elements into her painting. Her painting opens up possibilities kept outside the language of domestic love and purity: specifically, female sexuality and identity, where identity can be defined in terms other than selflessness. Although the female body in this painting as in most of Cassatt's art could be said to remain absent, just as Cassatt could be said to choose the asexual and idealized image of women over and against the sexual, I would suggest that this absence and asexuality form only part of the picture.

As with any cultural patterning, it is difficult to think simply in terms of Cassatt's "choice." To keep her models largely clothed would have been necessary in terms of Cassatt's own position as a middle-class woman artist, since the use of nude models was restricted for women painters not just in the academies but in the art world generally until the 1890s, a fact reinforced by the Victorian concern for women's purity.[30] Further, to present the maternal body (and the child's body, for we can know that a body is maternal only through the presence of the child) is to enter into a well-established tradition in painting, grounded in medieval and Renaissance

images of the Madonna. It is rare in the history of Western art, especially in the latter half of the nineteenth century, to find a painting of a mother and child in which the mother is nude or clearly sexual in a way suggestive of her own rightful and legitimate pleasure. Maternal sexuality tends to become represented either as transgressive (like Venus herself, that most irresponsible mother) or as revealed only in a moment of violation (as in David's *Rape of the Sabine Women*).[31]

Cassatt uses the vocabulary of the asexual mother, yet she makes a critical difference. Although at one level a painting like *Mother About to Wash Her Sleepy Child* presents a modern Madonna, it also invites us to see through or around the veil to a sexuality intimated, if largely hidden. In this sense, she asks us as well to look again at the classical models—the Correggios and Parmigianinos, for instance—and to think more deeply about the indirect encoding of maternal sexuality there. In Cassatt's paintings, as in those of her Italian precursors, one of the major keys to the representation of the mother's sexuality lies in the erotic presence of the child. While the mother often may seem hardly to have a body, the child can represent the mother's sexuality indirectly, through a visual metonymy. The child's body, in this sense, can become the site of maternal sexuality.

In *Mother About to Wash Her Sleepy Child*, the child's sensuality becomes evident in the languorous position the child assumes: toes flexed and legs lazily open, one arm with elbow bent to cushion the head, as the child's heavy-lidded eyes gaze in an absorption that is at once inward and gently directed toward the face tilted down. The child, as a small odalisque, enters in one sense into the position of vulnerability often assigned to female nudes, yet, clothed in the same white material—the same brushstrokes—as the mother, the genitals hidden from view, the child appears to occupy a position of safety. The child can allow her (his?) legs to dangle and fall open because she (he?) feels safe, held close to the mother and absorbed in their mutual gaze. The gaze itself exists within a context of safe, caressive touch.[32]

The question of the child's gender becomes important to this issue of mutuality. Although the shortness of the child's hair may suggest a boy, the child is young enough that this sign remains ambiguous. The two brown lines near the child's genital region seem to mark the child as sexual, yet to resist specificity: it is difficult to read these lines. This ambiguity is part of what allows for the mutuality between the figures. In holding afloat the possibility both for a sexual identification and for a difference between these two figures, Cassatt creates a situation theorized by recent feminists, especially Irigaray, who imagines a field of play between two figures at once the same and different, in contrast to what she identifies as the more conventional field, in which the masculine position is always one and the same, the feminine always other.[33] In Cassatt's painting the adult masculine is absent, leaving the space open for a largely female world, in which sexual difference can be conceived as unhierarchical and unthreatening. In this way, too, Cassatt adheres to the kind of space opened up in sentimental novels, in which men hover outside the primary social and emotional relationships, which are among women and between women and children.

This painting's suggestiveness about a woman's sexuality counters the discourse of the sentimental. Yet Cassatt makes more direct use of the sentimental to establish

a further idea: that the creation of art does not have to be grounded in a separation between artist and object but can rise out of a mutual relation between the one seeing and the one seen. The mother in this painting can be interpreted as a form of artist too. She acts as a figure for Cassatt herself, who wishes to suggest a mutuality in which the artist is not a dominant and mastering figure.

About to wash her sleepy child, the woman poses with her right hand in the basin of water. The focus on this hand as the most visible part of the mother's body and as the site of activity in the painting suggests an association between this hand about to wash and the hand engaged in painting. The bowl, composed of the same whites and blues and greens used in the rest of the painting, suggests a palette, and (to follow out this line of thought) the baby suggests the work of art about to be touched up.

My own language here hints at the danger the painting both reveals and dismantles. Although the mother's left hand holds the child closely and even seems to melt into the child's garment, her right hand appears oddly cut off from the surrounding fabric and the child, just as her right arm and a third of the bowl are cut off by the cropped frame—a cutting off that in this instance bears a hint of the arbitrary and reminds us of the painter's possibly whimsical and controlling presence.[34] In the positioning of one hand touching the child and the other hand touching the basin, the child and the basin become subtly parallel and even similar: insofar as the bowl is an object being represented, we are reminded that the child too might not escape from the position of object. The painting hints that the child, like the mother, is less safe than we would like to think.

Cassatt allows this danger to be kept quietly in our eye, even as she shows us how we might begin to imagine a solution. For the artist figure here, of course, is also a mother. The act of representation, about to be defined within the painting's narrative just as the child is about to be washed, may become redefined as nurturing touch, just as the model and the work of art could be seen to become fused in such a way that no painful gap opens up between the painting's subject and the painting's representation. Further, the child may be touched up, but she or he already exists in full fleshly glory. To wash, in fact, implies the opposite of an addition of paint; rather, it marks a return to the subject's own perfectly good surface, without any foreign matter. In this sense, Cassatt's artist figure does not create the subject, although according to the painting's fiction of a mother and child this bodily creation has taken place earlier; she contemplates it, embraces it, and helps it to be, quite simply, itself.

This artist figure's relation to the child suggests, then, Cassatt's implicit proposal for her own newly defined relation both to her model and in a more abstract sense to the subject of her painting. Cassatt creates a situation in which her subjects' sexuality can become intimated within a protective framework. The mother resists the gaze through her veiling and her absorption in her own activity as well as through her assumption of the role of artist, which is in turn redefined so that the child as subject may be protected as well. The child offers a safe figure for the mother's more hidden erotic life.

HARRIET SCOTT CHESSMAN

Once one begins to think about the child as a figure for the mother's sexuality, however, this neat tie-up may not seem quite adequate. What does it mean to represent a child as vulnerable and open sexually, even if this vulnerability is held within a context of loving touch and protection? I suggest that this problem emerges in myriad forms in many of Cassatt's paintings, perhaps nowhere so explicitly as in a haunting painting of two years earlier titled *Little Girl in a Blue Armchair* (1878; fig. 11.2) (also called *Le Salon Bleu*). I suggest further that *Mother About to Wash Her Sleepy Child* is a response to this earlier image, for the mutuality figured in the embrace of mother and child—and the concomitant presencing of a protected sexuality—is precisely what is missing in *Little Girl*.[35]

The open legs and supine position of the little girl in this earlier painting may remind us of the child about to be washed. A crucial difference is noticeable, however: she has no mother with whom to engage in mutual gazing and touch. She is alone, her isolation emphasized by the room's cavernous appearance, its dark interior space illuminated only slightly by the French windows, which have been cropped dramatically by the frame. The room seems populated insistently by furniture rather than by other human figures, the large chairs and settee placed in awkward relation to each other, as if this room were not for intimate conversation or a family grouping. The vertical lines of the windows, together with the compression of the space and the absence of height or air, create an effect of claustrophobia and imprisonment. The only being who appears comfortable here is the little dog,

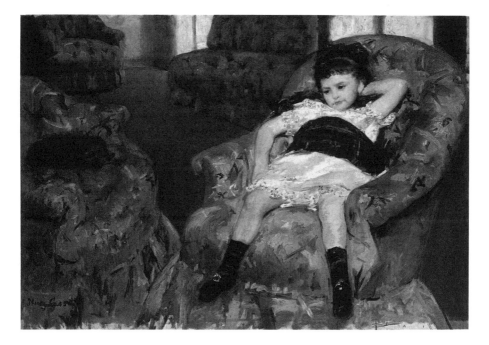

11.2. Mary Cassatt, *Little Girl in a Blue Armchair*, 1878. National Gallery of Art, Washington, Collection of Mr. and Mrs. Paul Mellon.

whose presence offers some degree of companionship to the girl; this is Cassatt's own Brussels griffon, one of a series of griffons she lived with all her life and presented in surprising places in many of her paintings. In adding her dog right above her signature (a kind of dog that in a sense became her signature), Cassatt seems to be reminding us of her presence as the painter here, although this indirect presence is difficult to read. Cassatt's relation to the girl is an intricate one.

The girl's expression is pensive and inward, hard to interpret, although one can speculate about her sense of boredom and dissatisfaction. Such feelings seem connected to or even to spring from her inactivity, which in turn seems associated with the fact that she is dressed up in a ruffled blouse and a skirt with matching socks and buckled shoes, her hair carefully combed and beribboned. At first glance, Cassatt seems to mark her entrance into the realist school here, especially the world of Manet and Degas. The air of spontaneity, the refusal to arrange objects in conventional and familiar ways, the asymmetry and the blunt cropping of the frame all suggest an allegiance to Degas's principles of realism. The little girl, although dressed for her portrait, sits for it in only the most disinterested way. She slouches in the chair, her skirt unceremoniously wadded above her waist, her thoughts miles away from her appearance.

Cassatt's participation in this form of realism comes freighted, however, with an element that may have seemed to Cassatt inherent in the new art itself: a subtly brutal presentation of the female subject as open to the gaze of the viewer. The girl's frontal position, apparently unself-conscious, implies a particular kind of viewer. The pose of an odalisque, in the absence of a maternal embrace, positions this child in a tradition of representations of female (and not maternal) sexuality. The image prefigures the child's mature sexuality, compelling us to wonder what form this sexuality will take, even as the picture disturbs us by its intimation that the child is to be perceived as if she were already mature. To be mature, this posture suggests, is to be constructed as a fleshly object of desire: an object participating in and representative of the leisure world of late nineteenth-century bourgeois culture, in which the woman contributes not her labor or productivity, but herself as consumable product.

The child's seductiveness becomes a problem posed by this painting, which anticipates Freud's early speculations on women hysterics' accounts of childhood incest.[36] The painting asks the same questions Freud would soon be asking: Is the child seductive? Or can we recognize our own implication in a form of abuse by believing her to be seductive and so in some sense an object of erotic arousal? The construction of the painting's space supports this second possibility, for the only way in to the curved, empty space in the middle of the room is literally through the child's body, whose shape in turn offers an odd inverted image of the empty space. Her open legs, dangling over the edge of the overstuffed chair, seem disturbingly inviting to the eye, which follows a V again and again to the white material covering her genitals, just as the V of the room's brown space asks us to enter.

The troubling aspect of this painting becomes even more intricate when placed within the context of Cassatt's friendship with Edgar Degas, who was ten years older than Cassatt and well established in his own art when she met him in 1877. The child

model, in fact, was the daughter of friends of Degas. As Cassatt wrote to Ambroise Vollard, the well-known art dealer, in 1903,

> I had done the child in the armchair, and [Degas] found that to be good and advised me on the background, *he even worked on the background*—I sent it to the American section of the Gd. exposition 79 but it was refused [this was the Exposition Universelle in Paris, actually in 1878]. Since M. Degas had thought it good I was furious especially because he had worked on it—at that time it seemed new, and the jury consisted of three people, of which one was a pharmacist![37]

Cassatt writes with pride here of Degas's advice and additions to this painting. For an artist to paint on another artist's canvas, however, is never a simple matter. Berthe Morisot felt immense distress when Edouard Manet got carried away with his sudden additions to her large portrait of her mother and her sister Edma (1869–70), just before she sent this picture to the Salon jury.[38] Cassatt's pride in Degas's additions may represent only the more conscious or acknowledged part of her relation to Degas.

Between their first meeting in 1877 and the early 1880s Cassatt and Degas worked together with intensity; they remained close friends throughout their lives, despite difficulties. It was Degas who first urged Cassatt to come over to the Independents. In agreeing to act as a regular (clothed) model for him, both in his millinery series and in his print and pastel series of Cassatt (and sometimes her sister Lydia) at the Louvre, she followed the traditional path of a woman artist in apprenticeship to an older and more well known male artist. In *Portrait of Mary Cassatt* (c. 1884), he depicts an independent, straightforward, jaunty woman and fellow artist: a pictorial vocabulary directly opposed to the sentimental one she was about to adopt. And both artists worked together in 1879 on a series of prints to be published in a proposed periodic review entitled *Le Jour et la nuit*, a project never completed but important for its experimental plunge into printmaking.

One of Cassatt's most revealing discussions of Degas comes in a conversation with Louisine Havemeyer, recorded in Louisine's memoirs:

> "Oh, my dear, he is dreadful! He dissolves your will power," she said. "Even the painter Moreau said to Degas after years of friendship that he could no longer stand his attacks. . . . Sometimes it made him furious that he could not find a chink in my armor, and there would be months when we just could not see each other, and then something I painted would bring us together again and he . . . would go to Durand-Ruel's and say something nice about me or come to see me himself."[39]

The quote suggests that Cassatt found Degas's presence both enriching and potentially overwhelming. It does not seem accidental that three years after meeting Degas she moved into a realm of subject matter utterly different from his. Apparently Degas suggested the mother-child theme to Cassatt, as being filled with potential for her artistry; he remained in the world outside the domestic spaces she embraced, to begin his series on the ballet.[40] It was in 1880 and 1881 that Morisot became more of an influence for Cassatt, and this turn from a male to a female mentor and colleague suggests Cassatt's larger turn from a more conventional gaze to an attempt to refigure the gaze as mutual and undestructive. It is striking that in most of Cassatt's

work after this point almost no male figures are present. Cassatt may have created a utopian, idealized world of women and children in response to her sense of deep implication in the male gaze, both as a young woman model and as an artist, painting her female subjects as an artist like Degas might see them.

Cassatt's early formulation, in paintings like *Mother About to Wash Her Sleepy Child*, of a maternal and artistic intimacy wherein a female erotics may be suggested remains a possibility throughout Cassatt's work, yet its strongest and most successful realizations come in the 1880s and early 1890s. One can see variations of such intimate structures, for instance, in other bathing pictures such as *The Bath* (1892) and *Baby's First Caress* (a pastel, 1891) and in an aquatint like *Maternal Caress* (1891). Cassatt retained this preoccupation with intimacy throughout her life; her later work often became simplified and bland popularizations of these early intense images. By the mid-1890s and into the early years of the twentieth century, however, Cassatt began to counter her utopian images of the artist as a (largely) protective and pleasurably erotic mother with more disturbing images of mothers. Such paintings show a quiet irony, exposing the workings of an intrusive gaze at the same time as they appear to critique it; yet the haunting nature of these later images, like that of *Little Girl in a Blue Armchair*, suggests the fragility of the ironic stance, the threat of its dissolution into complicity with the very structures it attempts to undermine.

A pivotal painting in this sense is *Breakfast in Bed* (1897; fig. 11.3), which at first shows striking similarities to a painting like *Mother About to Wash Her Sleepy Child*: the intense focus on a mother and child in physical closeness; the tranquillity and privacy of an ordinary domestic scene; the near-merging of the two figures through the placement of their heads, the variations on whites and blues and yellows which compose the bed linens, the child's shift, and the mother's gown, and through the graceful, irregular curves of arms and legs; the flattening of the surface so that the figures fill the canvas and can be seen at close range. The child figures the mother's sexuality even more vividly than in the earlier painting, for this child seems compact of libidinal energy. With toes flexed, hip and buttock nonchalantly exposed, fist filled with something to eat, and flesh rosy and plump, this child shows an eagerness suggestive of a general state of excitement linked to the mother's quiet but nonetheless palpable eroticism.[41] The child, again ambiguous sexually, almost seems to spring out of the mother and to represent the sexuality that in her remains present but in repose, just as her hands rest folded on her lap. The mother, by her calm circling of the child's energetic, half-naked body, appears to contain the child's movement.

The contrast between the two figures suggests a tension about eroticism that is absent in the earlier painting. Significantly, the mother here, partly by her placement in a bed, shows a more direct sexuality than the earlier mother figure. Although her sexuality is less hidden, however, the angle of her face, turned away from the viewer, and the gesture of her arms, containing the child, suggest a desire to cover her arousal or at least to deflect our perception of it. Her more direct sexuality, in fact, links to the fact that both figures, as I shall suggest, are more vulnerable to a gaze than are the subjects in the earlier picture.

The unself-consciousness of the two figures in the earlier painting gives way here

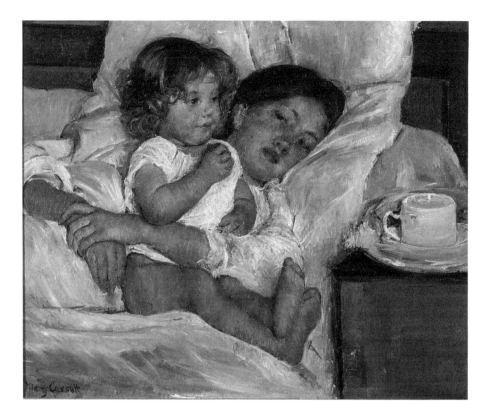

11.3. Mary Cassatt, *Breakfast in Bed*, 1897. Huntington Library and Art Gallery, Virginia Steele Scott Collection.

to the heightened possibility of the mother figure's self-consciousness in being seen. The cup and saucer, sitting on the plate to the side of the bed and composed of the same whites and blues as the bedclothes, become a subtle sign of a third figure's presence, for this figure is in one sense the artist working from a particular palette and engaged in still life (the cup and saucer and plate) and figure painting. The presence of such objects to the side of the bed echoes the palettelike presence of the bowl in the earlier painting. The relation between the objects and the painting's subjects, however, is in this painting a form of equivalency: rather than making use of the bowl to do her work, this mother, the underlying grammar of the painting suggests, is like a cup and a saucer and a plate; her circling arms suggest the comparison, just as the conventional symbol of the vessel suggests the circles of her womb and genitals. The cup's openness implies her own openness, an implication self-consciously contradicted by her closed and unsmiling mouth. Cassatt seems to go as far as she can here toward representing the sexuality of a woman who is a mother; and the painting seems to be poised right on the fragile edge between a protected sexuality and a sexuality exposed to our habitual intrusive acts of seeing.

The question of whether an artist—especially a woman artist aware of the vulnerability of the subject—can establish a position, an angle and proximity at once intimate and protective appears in different form in a slightly earlier painting, *The*

CASSATT AND THE MATERNAL BODY

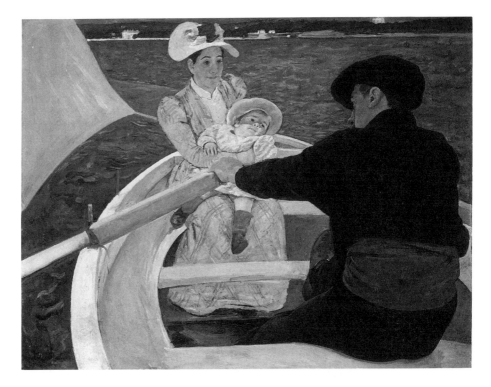

11.4. Mary Cassatt, *The Boating Party*, 1893–94. National Gallery of Art, Washington, Chester Dale Collection.

Boating Party (1893–94; fig. 11.4). Although the ostensible subject of this painting is the pleasure excursion of a mother and child in a sailing rowboat, rowed by a boatman on a sunny day, the structure of the image evokes the question of protection with heightened urgency.[42] The sensed but absent third figure of a painting like *Breakfast in Bed* here becomes realized in the imposing and rather mysterious figure of the rower, whose broad back, clothed in deep blue, links through his hand with the oar to form a barrier between ourselves and the woman and child. During Cassatt's mature period, the inclusion of a male figure (apart from her father, brother, or nephews) in a finished composition was rare; here it appears to be quite deliberate and thoughtful. Although the sunniness of the scene and the ordinariness of the situation suggest that nothing is amiss, this barrier appears sinister, allied as it is with only the smallest glimpse of the man's profile. What is he saying? we begin to wonder. Or how is he looking at the woman? That he is looking is a crucial aspect of the image, calling up the question of what looking means.[43]

The figure of the woman gives us little direct help in answering these questions, for her gaze too is difficult to interpret. She may not even be looking back at the man; like the child, she may be looking outside the boat, possibly at the other shore. It is as if we see two paintings in one, two worlds coming into quiet collision: at one end of the boat, a familiar Cassatt image of a mother and child; and, as our eye moves backward to take in more of the scene, a second image, that of an evocative

triangle, mother, child, and man. The first image, the painting within the painting, becomes newly placed in a larger context in which its safety and integrity come into question.

Our eye becomes engaged in the tension between these two images. We follow the curve from the man's eye through his arm and to his hand, which, as it forms the apex of a triangle made of arm and oar, gives the impression of thrusting into the picture space directly to the woman's own V as well as to the child's barely covered genitals, at the precise center of the painting. Cassatt here brings to life the implied third presence, the gazer beyond the picture frame, of a painting like *Breakfast in Bed*. Suddenly the gaze assumes a powerfully real and aggressive presence in the boatman, who seems to control the space, the woman and child, and the boat too. The dangling, open legs of the children in other Cassatt paintings here enter into a context in which the danger of openness—even the danger of being female and so able to be opened—becomes palpable.

As if in response to the aggressive sexuality implicit in this central thrust, the woman is completely clothed and covered by the child. The mother's sexuality has become covered as well. The cross-hatching of the dress's pattern together with the high collar and hat suggests an imprisoning effect similar to that of the barrier of arm and oar. An incipient libidinal energy remains only in the child, who wiggles out of her mother's arms with a restlessness interpretable as a desire to get out of the boat and out of the position of pinioned object as well.

This painting approaches the modern family with a cold eye. The sentimental vocabulary still exists, in small, in the Madonna structure of mother and child, but this modern woman and her child have been catapulted out of the domestic, sanctified space of the private interior. Sentimental ideology claimed that it was women who held the only aspect of power that was genuinely important: spiritual and moral power. The addition of the boatman here brings into question this claim. At a metaphoric level, Cassatt's painting seems to ask: what about other forms of power—economic, professional, and political? Who really rows the boat? And who is ready to rock such a boat, especially when it offers a (small) space above the waves?

The year before Cassatt painted *The Boating Party*, she was at work on her huge mural for the Women's Building at the Chicago exposition, a mural that quite self-consciously included only women and children. Discussions about woman's place and about issues of women's health, education, and identity had begun to be heard in America as in Europe. Feminist writers like Charlotte Perkins Gilman in *The Yellow Wallpaper* (1892) had begun to address such issues head-on and to suggest that the cultural boat had already sprung dangerous leaks. This painting offers no exit, but it evokes with electric intensity the problems of gender and power nudging their way into the public consciousness in fin de siècle culture.

Cassatt pursues the question of the female and particularly the maternal subject's vulnerability within a painting's frame in an even more chilling direction in one of her most powerful and disturbing paintings, *Mother and Child* (1905; fig. 11.5). This late work can be seen to engage in a dialogue with the much earlier *Mother About to Wash*

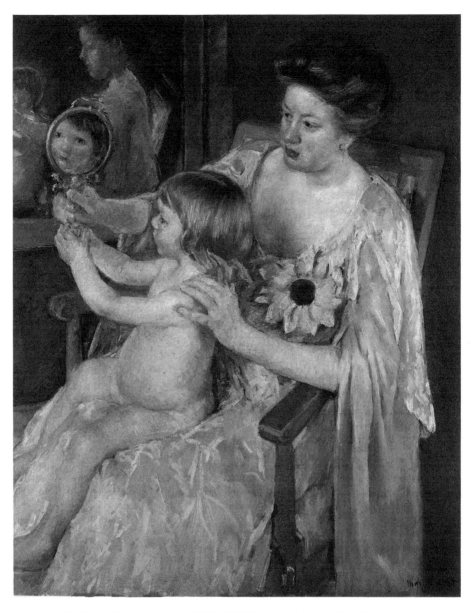

11.5. Mary Cassatt, *Mother and Child*, 1905. National Gallery of Art, Washington, Chester Dale Collection.

Her Sleepy Child: in both paintings a child is on a mother's lap, either about to be bathed or in a state of nakedness suggesting a recent bathing. The later painting, however, raises difficult questions about the mother's implication in a culture that clothes women and makes them figures to be seen but invests them with so little power of their own—a subject explored with equal depth and brilliance in a novel published the same year, Wharton's *The House of Mirth*.

Although in this painting the mother again touches the child with one hand

while with her other hand she touches an object, the relationship between the two figures has undergone a marked shift. The girl sits up instead of sensually reclining, her body creating a shadow that falls on the mother. Rather than gazing at each other, both figures stare at a third term, the small mirror held up by the mother, whose hand finds an echo in the girl's hands, held together in a gesture almost of prayer. This mirror cuts the girl off from her own image in a subtly violent way. She literally is cut in two: the image is severed from the actual girl, just as her face seems to float apart from her body. The face in the mirror looks out at us blankly, with an expression as difficult to interpret as the mother's and even more difficult to see, for the features remain curiously unfocused and marked by daubs of paint.

The definiteness of the child's sexual identity, in contrast to the indefiniteness of her face, prepares us for the dark vision of this painting. Within Cassatt's implicit developmental scheme, to become readable as a girl is to move beyond the utopian possibility of mutuality, predicated on sexual ambiguity, suggested by an earlier painting like *Mother About to Wash Her Sleepy Child*. The vagueness of the girl's features acts as an unsettling predicate to the definition implicitly framed in this narrative of mother and daughter: "A little girl is _____." This painting fills in the blank with the child's own blank face: a little girl, as the painting implies, is a face in a small gold-rimmed mirror held at the correct angle by her mother, who is in turn reflected in a larger mirror.

The question of who a woman or a mother is or might be, or of what a female body might be like, cannot be answered in the terms posed by the painting, for the female cannot be understood as an entity separate from the culture's mirroring constructions of her. The mother's participation in this mirroring constitutes a full-blown betrayal, reminiscent of Irigaray's "culture-mother," ice-mirror, who imprisons her daughter in old forms, and the painting does not suggest the possibility of an alternative.[44]

The mother, then, in presenting the mirror to her daughter, engages in an ongoing discourse of substitution, through which an actual body of an actual girl becomes subsumed in a series of representations. The mother's investment in this discourse is figured in her vestments. Her gown can be understood, in fact, as a garment of substitution. Its large sunflower, creating a triad with the mirror and the girl's head, marks a metaphorical relationship: the girl is a flower. This metaphor goes straight to the heart of the cultural frame, marking an accepted femininity on the one hand and a more disturbing female sexuality, Medusa-like, on the other, to be hidden out of anxiety just as the child's body seems about to become clothed and invested.

Cassatt, as the painter of this representation, occupies an ambivalent position with respect to such mirrorings. She participates in this split between body and image insofar as she represents bodies in paint; as a painter still allied to referentiality and realism, she holds up a mirror too. In a further sense, she participates in the long tradition of painting women with mirrors, a tradition dependent on notions of women's vanity and women's acquiescence in their status as beautiful objects of others' and their own gaze.

Cassatt allows us, however, to think of her own painterly mirror as itself open to

question. She builds mistakes in perspective into her painting, in such a way that we cannot imagine her to be an objective recorder of these female figures. I would speculate that the inaccuracy of her own mirroring invites us to see and understand the inaccuracy of the cultural mirrorings charted with such soberness in this image. And in a further sense our position as viewers comes into direct challenge through this distortion of perspective. For how do we find a place from which all the angles of the painting make sense? If we really stand above the two figures, as the angle of the closest chair arm indicates, then it is doubtful that we would see the mother's face as above our own in the way that we do. And if the angle of the chair's back is accurate, the image of the chair's back in the mirror must be off, since too much of the front and not enough of the back of the chair becomes reflected.

In a final eerie twist, Cassatt turns the mirrors back onto us, compelling us to participate in the painting in a way that implicates us both as objects and as subjects of vision. She shows us the girl's face in the mirror, as if this were the face that the girl herself sees; yet we realize that, if we can see an image of the girl's face, the image she can see must, uncannily, be our own.[45]

The sentimental vocabulary of a sacred domestic space, impermeable by the world outside, becomes deeply shaken in this painting. The small mirror, with its artificially disconnected and floating child's face, is held up to our gaze with startling directness, as if to acknowledge that a world does exist outside this space, one that impinges on the world of mother and child and determines how the child will be dressed, how her meanings will become figured. In the same way, the relation between painter and painted, intimated in the relation between mother and child, has made any claims to innocence problematic. It is part of the richness and integrity of this painting to show with such carefulness the vulnerability of women and girls in culture as in art. Cassatt seems in such sober images to ask, What is possible for women, once a sentimental vocabulary has become inaccessible? In this sense, she opens the way for further inquiries into this subject in the twentieth century, not only in art but in literature and psychology as well.

12

EMILY FOURMY CUTRER

. . .

A Pragmatic Mode of Seeing:
James, Howells, and
the Politics of Vision

"You've done it this time and no mistake!" a jovial William James congratulated William Dean Howells in 1890 after reading his friend's latest novel. "I've . . . just read, first your 'Shadow of a Dream,' and next your 'Hazard of New Fortunes,'" he reported, "and can hardly recollect a novel that has taken hold of me like the latter." The psychologist-philosopher then went on to praise the novel in very Jamesian terms, claiming that "never a weak note, the number of characters, each intensely individual, the observation of detail, the everlasting wit and humor, and beneath all the bass accompaniment of the human problem, the entire Americanness of it, all make it a very great book."[1] Such praise, while almost unconscionably impressionistic to present-day readers, was particularly pertinent coming from James and coming at that moment. For at the same time James was enjoying his friend's novel, he was correcting the fourteen hundred pages of proof that would be released within a few weeks as *The Principles of Psychology,* a work that often in the last century has been similarly praised. Indeed, a year later, Howells himself commended *The Principles of Psychology* from his "Editor's Study" at *Harper's* in remarkably familiar terms, noting James's "humorous touch" and his "human" performance and adding comments on the work's "aesthetic and ethical interest," qualities that later commentators believe Howells strove for in *A Hazard.*[2]

The similarities are more wide-ranging, however, and while the ever-perceptive James did note the publication date of the two works, prophesying that they along with his brother Henry's *Tragic Muse* would make the year 1890 "a memorable one in American Literature,"[3] he left for later commentators the task of exploring the larger meaning of their coincidence and the responsive chord that each work struck in the

other's author. Indeed, despite its rather false ring to the twentieth-century ear, the praise Howells and James bestowed upon each other was more than Victorian good form, the expected congratulations one might give or receive from a friend. Their comments indicate, instead, a genuine interest in what the other had to say that stems, at least in part, from a common concern with the relation between knowledge and representation.

A comment from Howells's major character in *A Hazard of New Fortunes*, Basil March, is indicative of their mutual interests. At the end of the novel, March answers a question from his wife about an acquaintance they have just encountered on a busy New York street. His reply, "We must trust that look of hers," seems a throwaway line; yet it is an important statement, not only to *A Hazard*, but also to American culture at the end of the nineteenth century.[4] While March's line summarizes both formal and thematic issues raised in the novel, it also points to one of the era's major cultural and artistic issues—that is, the significance of vision as a means of understanding and representing experience. I use Howells's novel and James's treatise as points of departure or, perhaps more appropriately, as lenses through which to examine the common issues they explored. *A Hazard of New Fortunes* and *The Principles of Psychology* provide a means of exploring visual discourse, the historical construction of seeing, at a moment when that discourse was markedly self-conscious and ideologically charged.

Critics and historians, of course, have long recognized the significance to modern Western culture of vision—as physical operation, social and historical construct, and determinant of meaning.[5] With the beginning of the Renaissance, the commencement of the scientific revolution, and the invention of such devices as the telescope, the microscope, and the printing press, scholars typically argue that sight came to dominate the other senses as a source and metaphor of knowledge. As Martin Jay has acknowledged in his essay "Scopic Regimes of Modernity," however, just what "constitutes the visual culture of this [modern] era is not so readily apparent."[6] While Cartesian perspective, with its regular, mathematical order and distanced, dispassionate observer, has dominated Western culture, other "scopic regimes" have competed with it. The art historian Svetlana Alpers has identified one competitor in what she calls an "art of describing" associated with Baconian science, an emphasis on empirical visual knowledge and an identification between picture and eye. She attributes this art of describing to seventeenth-century Dutch painting, which is characterized by its frequent inability to situate a viewer, the lack of a clearly defined frame, and an insistent sense of the canvas as surface rather than window. In short, Alpers argues that Dutch art, as opposed to Italian art, is visual rather than textual and thus deals with the world as seen rather than with significant human actions that must be read.[7]

If the model that Alpers proposes, in which there is a virtually complete identification among sight, representation, and an outer reality, is at one end of a continuum of vision, the model articulated by the historian Jonathan Crary is at the other. Crary argues that beginning in Europe in the early 1800s, social, intellectual, and scientific forces produced ideas about the physical operation of sight that differed radically from those of previous centuries. Early nineteenth-century psychology

and physiology questioned the seemingly objective truth of visual experience as embodied in the seventeenth and eighteenth centuries' favorite optical device, the camera obscura, and proposed a model of vision that was abstract, subjective, and unstable. Physiologists' experiments reinforced philosophers' speculations that such optical phenomena as afterimages were not mere illusions but were corporeally produced. Thus they confirmed that individuals could be active, autonomous producers of their own visual experience and allowed for a modern conception of sensory perception as not necessarily linked with an external referent.[8]

Late nineteenth-century Americans participated in this continuing discourse about vision and its meaning. Often drawing upon the experiments of their European predecessors and contemporaries, American scientists, philosophers, and psychologists further explored the physical basis of sight and grappled with its epistemological implications. Articles in both scientific and literary journals documented new discoveries in the physiology of vision and their applications, practical and otherwise. At the same time, reports on such seemingly disparate topics as the visual memory of chess players and the relation between sight and the perception of space filled the pages of both the technical and popular press. The work of the English scientist Francis Galton, for example, had a wide following in the United States. He published the results of his research on mental imagery in such prominent journals of philosophy and psychology as *Mind*, but his exercises in composite photography, in which he combined photographs of individuals in order to reveal "a true type," could be seen in such mass circulation magazines as *McClure's*. As the historian Miles Orvell has pointed out, Galton's idea of the composite image as a kind of visual truth bears a striking resemblance to Charles Sanders Peirce's "more or less contemporary notion of 'the real' as a kind of infinite consensus" of what is true.[9]

This correspondence is also more broadly suggestive, for, as I shall argue, at least a few Americans at the turn of the last century did not adopt a static model of vision, such as the Cartesian or those described by Alpers and Crary. Rather, they explored and adapted characteristics of these scopic regimes, transforming them into what I call a pragmatic mode of seeing. This mode was pragmatic because it acknowledged, even embraced, the "slipperiness" of vision, the possibility that sight was subjective and unstable, at the same time that it affirmed the significance of the visual sense in perceiving an external reality. This pragmatic mode was, therefore, operational and contingent, finding its truth in action, consequences, and practice.

Although William James never focused on the study of vision for its own sake, his early writings provide a convenient way of approaching what I mean by a pragmatic mode of seeing. Anyone who has read *The Principles of Psychology* or the numerous essays leading up to it must be struck by the psychologist's frequent reference to vision. Well versed in eighteenth- and nineteenth-century theories of visual perception, James often cited and argued with the work of such predecessors in the field as George Berkeley, John Locke, Arthur Schopenhauer, and Hermann von Helmholtz, picking and choosing aspects of their theories in order to generate notions of his own. In *Principles*, however, he never pulled these notions together into a single, coherent general theory. Instead, embedding his theories of the visual within his

treatment of such other topics as the stream of thought, association, sensations, and the perception of space and reality, James discussed vision as both an internal operation and a sense by which one knows the external world.

Although he disclaimed his abilities as a "visualizer," James, like many of his contemporaries, was fascinated by the internal aspect of vision, in other words, by the notion of visual mental images.[10] Although aware of the research on afterimages by such scientists as Helmholtz and Gustav Fechner—sources, Crary argues, of the modern subjective observer—James spent fewer pages discussing such phenomena, of which, he claimed, "common men never become aware" (1:285), than he did on the visual images that he termed "optical memory-pictures."[11] James's two major points about such images were, first, that like all other mental images they could be vague, and second, that they differed from individual to individual. Indeed, in insisting in his chapter on imagination that images did not have to be the distinct, discrete representations that Hume and Berkeley had taken them to be, he was reiterating one of his most widely celebrated points in "The Stream of Consciousness," in which he claimed to have reinstated "the vague to its proper place in our mental life" (1:254). James had come to value the notion of vagueness not only because, on introspection, it seemed a more apt description of one's thought processes, but also because of its potential. As James had pointed out, vague images could be harbingers of great things; "great thinkers have vast premonitory glimpses of schemes of relations between terms" and hardly think in discrete elements verbal or otherwise, "so rapid is the whole process" (1:255). Moreover, in allowing vague images, James also could subscribe to the notion that one's visualizing ability differed in frequency and vividness, a notion borne out by much contemporary research. Indeed, in his chapter on imagination, James quoted liberally from Galton's *Inquiries into Human Faculty and Its Development* of 1883, a work that dealt extensively with research on mental imagery and Galton's conclusions, based on a wide sampling, that the ability to see with the "mind's eye" varied from person to person.[12] So interested was James in Galton's inquiry that "for many years [he] collected from each and all of [his] psychology-students descriptions of their own visual imagination; and found . . . corroboration of all the variations which Mr. Galton reports" (2:56).

James's ideas about one's inner eye also had consequences for his view of the operation of sight. "No sense gives such fluctuating impressions of the same object," James wrote, "as sight does" (2:101), and it did so because of the relation between one's inner, mental image and optical sensations. As a subject, one incessantly reduces "optical objects to more real forms"; the optical memory one carries around, in other words, conditions what one perceives so that "the only things which we commonly see are those which we preperceive" (1:444). The danger such "incessant reduction" entailed, of course, was that "most of us grow more and more enslaved to the stock conceptions with which we have once become familiar. . . . Old-fogyism" becomes "the inevitable terminus to which life sweeps us on" (2:110).

For James, it seems, reliance on the visual would condemn the subject to an increasingly narrow view of the world, but never to a truly solipsistic one. Except in the rare cases of "true hallucinations," James's vision always referred to an outside

world. Indeed, he borrowed the traditional Lockean definition for mental images as copies or representations of sensations "after the original outward stimulus is gone" (2:44), and he continually reaffirmed his belief that sensations have an objective character.[13] The problem with vision was that while it was based in sensation, it, perhaps more than any other sense, was subject to perception, and as James concluded, a general law of perception was that "*whilst part of what we perceive comes through our senses from the object before us, another part* (and it may be the larger part) *always comes . . . out of our own head*" (2:103). Thus, it is not surprising that at one point in his treatise James affirms his allegiance to words, citing them as "the handiest mental elements we have." Unlike visual images or tactile, motile, or audile images, words are "revivable as actual sensations more easily than any other items of our experience" (1:266); they are less subject to the perceptual negotiations that transform sensations and circumscribe thought. Little wonder, as well, that late in his treatise James claimed he was a "poor visualizer" when, in the first volume, he claimed that "the older men are and the more effective as thinkers, the more, as a rule, they have lost their visualizing power and depend on words" (1:266). Visualizing, seeing with one's mind's eye, belonged, as James's lengthy quotation from Galton asserted, to women and children, not to "scientific men" or "men who think hard" (2:55). James's theory of the visual thus participated in the long-standing rivalry between picture and word and in that rivalry's implication in a gender politics that, as W. J. T. Mitchell has shown, traditionally associated the verbal with the masculine and the pictorial with the feminine, to the detriment of the latter.[14]

Yet consistency was hardly one of James's hobgoblins, and despite his alignment at points in *Principles* with the word rather than the visual image and his identification with the tough-minded men of science, he was attracted to the pictorial of the more tender-minded. The trick—and this was an issue that James would develop years later in his *Essays in Radical Empiricism*—was to free the visual as much as possible from the coding function of perception, to strip it as near as one might to its status as a sensation.[15] "Genius, in truth," he wrote, "means little more than the faculty of perceiving in an unhabitual way" (2:110). Thus, he suggested that his reader try looking at the landscape with his head upside down or turning over a painting to view it. "We lose much of its meaning, but to compensate for the loss, we feel more freshly the value of the mere tints and shadings, and become aware of any lack of purely sensible harmony or balance which they may show" (2:81). Indeed, the painter became, at least implicitly, James's genius, and the training of an artist the model of how one might learn to renew one's acquaintance with sensation. As James noted, "The whole education of the artist consists in his learning to see the presented signs as well as the represented things" (2:243). In more concrete terms, he thus wrote, "The grass out of the window now looks to me of the same green in the sun as in the shade, and yet a painter would have to paint one part of it dark brown, another part bright yellow, to give its real sensational effect" (1:231).

Furthermore, when James wished to explain an important point, he depended upon pictorial language. Indeed, his use of visual metaphors in *Principles* and other writings is, if anything, even more striking than his frequent reference to vision. Some of these images, such as his description of a chapter in *Principles* as a "painter's

first charcoal sketch upon his canvas," seem mere window dressing. In others, the visual metaphor is more apparently integral to his argument, as when he explains his concept of the vagueness of images in the stream of thought: "The traditional psychology talks like one who should say a river consists of nothing but pailsful, spoonsful, quartpotsful, barrelsful, and other molded forms of water. Even were the pails and the pots all actually standing in the stream, still between them the free water would continue to flow" (1:255).

In either case, however, James's use of pictorial language is critical. As he remarked on more than one occasion, "Philosophies are only pictures of the world which have grown up in the minds of different individuals."[16] As Gerald Myers has suggested, this statement should be taken seriously; it summarizes what James's insistent use of pictorial writing indicates: for the philosopher "the metaphor of the picture is more than casual or offhand." Indeed his "imagery represents more than the pleasant or decorative use of poetic and vibrant language; rather," Myers concludes, "it marks the mind's movement from a tentative grasp of an idea to a confident possession of it."[17] To know something is to be able to see it; and as James, the beloved teacher, recognized, to convince someone else of a point is to enable them to see it as well, but in striking and fresh ways.

If as a man of science, then, James found words conducive to abstract thought, as a pragmatic philosopher he was insistently drawn to pictures. Vision might well be an unreliable, unstable, feminine mode, but it was also useful. As James pointed out in his discussion of spatial knowledge, human beings almost invariably favor what seems a visual truth over alternative forms of knowing, and this in itself was a commonsense reason to privilege it. Nevertheless, it would be oversimplifying to assume that what I have termed a pragmatic mode of seeing was anything other than contested. While James adopted an uncomfortable, often contradictory attitude toward the visual, Howells, whose mode of vision was perhaps equally pragmatic, was even more profoundly ambivalent. Not only did the politics of gender affect his negotiation of the relation between the visual and the verbal, as it did James's, but also, as *A Hazard of New Fortunes* reveals, issues surrounding the emergence of increasingly visual mass media influenced it as well. Thus whereas James's *Principles of Psychology* provides a launching point for an exploration of pragmatic vision, Howells's novel charts that mode's progress across the ideological terrain of late nineteenth-century American culture.

As numerous scholars have recognized, the visual, the process of picturing, and the metaphor of picture as knowledge were crucial elements in Howells's theory of realism. As Howells commented in 1894 to Stephen Crane, the realist novel was "made for the benefit of people who have lost the true use of their eyes"; its purpose was to help readers truly see and understand the life around them. It thus should "picture daily life in the most exact terms possible, with an absolute and clear sense of proportion."[18] His insistence that true fiction "preserves the balances" and "adjusts the proportions" echoed his earlier pronouncement that realism "becomes false to itself, when it heaps up facts merely, and maps life instead of picturing it."[19] To such scholars as Alan Trachtenberg and Amy Kaplan this metaphor of "picturing" indicates Howells's essential conservatism. To Trachtenberg, for example, it implies

"perspective, balanced and proportioned seeing," "the making of form" and plot which "preserve the moral assurances of his realism." Kaplan notes the way in which Howells's picturing frames the chaos of his late nineteenth-century environment, and she argues specifically that his main character in *A Hazard of New Fortunes*, Basil March, uses his ability to picture to "aggressively compose the fragments of urban life into a spectacle for observation."[20] Thus they implicitly identify Howells's theories and art with a Cartesian scopic regime and its distanced and dispassionate perspective; in doing so, however, they miss part of the picture.

One of Howells's great misfortunes was that he wrote more appealing "sound-bites" than novels, and as a result, he is frequently remembered for pithy phrases and statements ("the smiling aspects of life") that belie the complexity of his work. Such has certainly been the case with his statements about the relation between writing and picturing. Although his critical statements about realism seem to indicate that he was less than a discerning observer himself, his fiction, particularly *A Hazard of New Fortunes*, more subtly explores and articulates the meaning of the visual at the end of the nineteenth century than previous commentators have allowed.

As is well known, Howells's novel of 1890 was his attempt to come to grips with the social and political unrest of the 1880s and with the conditions, as he wrote Henry James, that had profoundly shaken his confidence in American society's "ability to come out all right in the end."[21] Written in New York City at the close of the decade, it was, most specifically, his response to the Chicago Haymarket Riot, which had ended with the execution of four anarchists in 1888. Howells, virtually alone among the American literary establishment, had called for the release of the condemned men and decried their deaths as "civic murder." More generally, however, as Howells came to spend time in New York during the eighties, his impulse to "do justice" to "those irreparably wronged men" was quickened by his exposure to how "the other half" lived.

Thomas Bender relates how Howells, upon moving to New York, "came to know the city by walking its streets and neighborhoods."[22] His life thus imitating a familiar motif from art, the author as flaneur learned about the conditions of modern life by literally seeing them. When it came to translating his experiences into fiction, Howells has Basil March navigate the hazards of the city in much the same way. Miles Orvell correctly points out that *A Hazard of New Fortunes* examines "the whole process of learning to see that was at the ethical and aesthetic core of the new realism,"[23] and it does so through the character and experiences of March. However, in contrast to Orvell, who believes that March's "comfortable perceptions . . . remain, for the most part, unchallenged," I would argue that, in fact, March does learn a lesson. At first a detached spectator, by the end of the novel March has become a pragmatic seer, and this transformation raises significant questions about the nature of representation.

When the reader meets March in the novel's opening chapters, his world is close and circumscribed. Whereas earlier in his adulthood, March and his wife, Isabel, had traveled and "formed tastes which they had not always been able to indulge," as they grew older they had retreated to their Boston home. Isabel "remained shut up in its refinement," while Basil went to his office everyday only to hurry back "to

forget it, and dream his dream of intellectual achievement in the flattering atmo-sphere" of Isabel's "sympathy" (26). March had always considered himself a literary type and had hoped eventually to land in a literary position, although he never seems to have sought one. Indeed, March never seems to have sought anything. Both Basil and Isabel believed their sympathies to be broad and liberal; "if it had ever come into their way to sacrifice themselves for others," Howells writes, "they thought they would have done so, but they never asked why it had not come in their way." Passive, generally self-satisfied, and detached, the Marches both literally and metaphorically were "satisfied to read" (27).

Their move to New York, however, forced them out of the enclosed space of their home and away from the mediated experience of reading. Out on the street, searching for an apartment, Basil and Isabel encounter the sensual assault of the urban environment, and like so many others this experience was primarily visual. In one of his sketches of New York written for *Harper's* in the late 1870s, Howells's now-unknown contemporary William Rideing characterized the procession of "Life on Broadway," for example, as "the surface glow of the picture—the superficial epi-sodes, the exhilarations of the traffic—the light and shade and the dramatic spirit of the thing." While acknowledging that each member of the crowd had "his own pet scheme of life, his own secrets, his own theories," Rideing was most interested in the crowd as a crowd, in its appearance as a mass, in the picturesque nature of the scene before him. For him, "individuality is subverted" to such a scene in a formula-tion that mirrors Georg Simmel's famous generalizations from some thirty years later.[24]

Whereas Rideing's perspective was that of the outsider looking into the crowd, Simmel sought, in "The Metropolis and Mental Life," to understand the psyche of the individual looking out. "The psychological basis of the metropolitan type of individuality," he wrote, "consists in the intensification of nervous stimulation," of stimuli that were most often visual: "The rapid crowding of changing images, the sharp discontinuity in the grasp of a single glance, and the unexpectedness of onrushing impressions."[25] The result, Simmel concluded, was a new type of per-sonality, one that sought protection "from the overwhelming power of metro-politan life" in the privileging of intellect over heart and the development of a "blasé attitude."

Both Rideing and Simmel might have been describing March as he first encoun-tered New York. Like Rideing, who wrote of watching the crowd from a position under a hotel portico, March experienced the city as a spectacle. Although disap-pointed on one of his first mornings in the city that Broadway no longer had the look "of five, of ten, of twenty years ago, swelling and roaring with a tide of gayly painted omnibuses and of picturesque traffic," he quickly brought his perspective into line by entering Grace Church in order "to gratify an aesthetic sense" and by walking through Washington Square, where he and Isabel "met the familiar pictur-esque raggedness of southern Europe with the old kindly illusion that somehow it existed for their appreciation" (54–55). Bombarded with the kind of sensory im-pressions that Simmel described or, as Basil put it, "obliged . . . to the acquisition of useless information in a degree unequalled in their experience" (58), the Marches

compose and organize what they see into a picture, a process for which the term *picturesque* is a recurrent cue.

The term is important, of course, because of what it implies about framing and distancing. By characterizing their experience as picturesque, Basil and Isabel are able to turn the environment in which they find themselves into a scene they can step out of in order to better see it. This is precisely Kaplan's point about the Marches as, in their search for a New York apartment, they "came to excel in the sad knowledge of the line at which respectability distinguishes itself from shabbiness" (58). As Kaplan notes, "The 'line,' rather than the city" is the object of the couple's knowledge, and this "knowledge of the line" fulfills a double role: "it frames a coherent picture of the city and relegates unassimilable fragments to the peripheral category of 'useless information.'"[26] In much the same way, both the theater and the elevated railway allow the Marches to objectify their experience. The theater provided them with an escape, permitting them to forget what they see during the day, and, similarly, the L, which March deemed "perfectly atrocious" but "incomparably picturesque" (62), enabled them on their first few rides to view human drama at a safe distance. Isabel was enthralled by "the fleeting intimacy you formed with people in second and third floor interiors" as she sped along at night, and Basil found that he liked it even "better than the theater, of which it reminded him, to see those people through their windows" (76). The vignettes that he witnessed—"a family party of work-folk at a late tea, some of the men in their shirt sleeves; a woman sewing by a lamp; a mother laying her child in its cradle"—led him to exclaim, "What suggestion! what drama! what infinite interest!" (76).

Of course, March expressed delight in these scenes because just as Grace Church and Washington Square conformed to his aesthetic and social ideals, so the glimpsed tableaux fit his preconceived notions of domesticity, an ideal for which he and Isabel had been vainly searching in a New York apartment. Thus, March's ability to find the picturesque in the environment around him not only framed and distanced his experience, but also, as the term's dictionary definition would suggest, evoked mental images or "memory pictures" and thus prevented him from truly experiencing life in an "unhabitual" way. In line with James's notion of perception, in other words, March saw only what he had been conditioned to see.

The fact that March was unable to perceive the world around him should not necessarily indict the novel's author, a point that a number of scholars seem not to have grasped. Howells, of course, did note the resemblance between March and himself: a midwesterner by birth, Bostonian by adoption, journalist in his youth, and poet by desire, "I had been all that March was," Howells wrote, "except an insurance man."[27] Yet the resemblance is hardly transparent; the correspondence not one-to-one. March is no more Howells than the painter to the left of the canvas in *Las Meninas* is Velázquez. As in the case of the painter depicting himself painting a picture, Howells's invention of March is self-reflexive and ironic, a fact that has significant implications for reading the novel.

In *A Grammar of Motives*, Kenneth Burke discusses irony in a manner that is suggestive for understanding Howells's treatment of March. He cites Allen Tate's characterization of irony both as a partner of humility and as "that arrangement of experi-

ence . . . which permits to the spectator an insight superior to that of the actor." Burke then points out the illogic of Tate's comments by asking "how one could possibly exemplify an attitude of 'humility' by feeling 'superior.'" His answer, of course, is that one cannot. While admitting a type of irony that he terms romantic, an irony that arose "as an aesthetic opposition to cultural philistinism, and in which the artist considered himself outside of and superior to the role he was rejecting," Burke believes that true irony does not allow the spectator a superior insight. "True irony, humble irony, is based upon a sense of fundamental kinship with the enemy, as one *needs* him, is *indebted* to him, is not merely outside him as an observer but *contains* him within, being *consubstantial* with him."[28] The genius of Howells's novel is that it plays with both of these ironic types.

At the beginning of *A Hazard*, March assumes the stance of romantic irony. His acquired tastes, for example, enable him "to look down upon those" (26) who are without such sophistication, just as his social station allows him to characterize the man who shines his boots as "a little Neapolitan" (55). In contrast, Howells's ironic position is humble. In looking at March looking down upon others, he seems to be saying (as Tate and Burke would have it), "There but for the grace of God go I."[29] But, of course, March is precisely where Howells has been, and the point of humble irony at which Howells has arrived is where he must bring March. He does so by teaching him to see, in James's terms, "the presented signs as well as the represented things."

Rather than a sudden conversion, March's education is a gradual process built of a number of incidents that undermine his habitual perceptions. One such scene occurs early in the novel as Basil and Isabel are concluding a day of apartment hunting and considering an evening at the theater to "get this whole house business out of our minds." As they walk along, Isabel catches sight of an old man and exclaims to her husband,

> "Why, did you *see* that man?" and she signed with her head toward a decently dressed person who walked beside them, next the gutter.
> "No. What?"
> "Why, I saw him pick up a dirty bit of cracker from the pavement and cram it into his mouth and eat it down as if he were famished. And look! he's actually hunting for more in those garbage heaps!"
> This was what the decent-looking man with the hard hands and broken nails of a workman was doing—like a hungry dog. They kept up with him, in the fascination of the sight, to the next corner, where he turned down the side street, still searching the gutter." [70]

The significant fact for Isabel, of course, was that what she saw—a man "pick[ing] up a dirty bit of cracker from the pavement and cram[ming] it into his mouth"—contradicted her expectations of a person whose primary visible sign, his dress, represented decency. His behavior, March agreed, was that of a "hungry dog" rather than that of a "decent-looking man," and "the fascination of the sight," of the gap between sign and signified, prompted the couple to follow the man down the street.

Yet the scene does not end when the man disappears from sight. After Basil and

Isabel walk just a few steps away, March turns back, insisting that he "must go after him." While the ostensible reason is March's desire to help the man, his action is also directed at resolving the contradiction between his expectation and what he has seen. Collapsing that distance, however, has ramifications for which March is not yet prepared. When March, much like a priest pressing a wafer into the hand of a communicant, puts a coin in the man's hand, the relationship between the two changes. The supplicant "caught the hand of the alms-giver in both of his, and clung to it," thus shattering the spectacle, collapsing the difference between spectator and sight, and making them, as Burke would say, consubstantial. Not surprisingly, however, just as vision gave way to touch, March "pulled himself away, shocked and ashamed, as one is by such a chance," and returned to the safe vantage ground of distance at the side of his wife.

March's attempt to relegate the incident to chance and his related comment that one "might live here for years and not see another case like that" ring false and are belied by his subsequent remarks. Reacting to his wife's suggestion that New York had been a good deal happier and cleaner when they visited it as a young couple, March replies that, in fact, it might well have been worse. In their youth, however, they were programmed not to recognize misery. "You don't starve in parlor cars and first-class hotels"; March pointed out to her, "but if you step out of them you run your chance of seeing those who do" (72). Despite his rather offhand way of dismissing what has just occurred and despite his professed desire to "go to the theatre and forget" the miserable conditions rather than change them, the fact of his complicity in what he sees is beginning to dawn upon him and to change his mode of seeing.

At the conclusion of this scene, the man whom the Marches encountered "lapsed back into the mystery of misery out of which he had emerged" (71), yet other ciphers and signs of that mystery present themselves.[30] On a trip along the Third Avenue elevated, for example, March encounters conflicting signs that disorient his vision and, paradoxically, allow him to see more clearly. In a passage that gains momentum like the train in which he rides, March's vision changes from a distancing, objectifying gaze that classifies the various ethnic groups he encounters in his car to almost cinematically disjointed glimpses of the architectural elements that pass by his window. "The colossal effigies of the fat women and the tuft-headed Circassian girls of cheap museums; the vistas of shabby cross streets; the survival of an old hip-roofed house here and there at their angles; the Swiss-chalet, histrionic decorativeness of the stations in prospect or retrospect; the vagaries of the lines that narrowed together or stretched apart" became emblematic in their confusion of "the life that dwelt, and bought and sold, and rejoiced or sorrowed, and clattered or crawled, around, below, above" (183–84). They "were features of the frantic panorama that perpetually touched his sense of humor and moved his sympathy." As the passage reaches its climax, they also led him to recognize, if only momentarily, the "accident and then exigency" as well as "the fierce struggle for survival" at play in the urban environment. The disruption of his perspective or, as March saw it, "the absence of intelligent, comprehensive purpose in the huge disorder" disoriented his vision and at the same time "penetrated with its dumb appeal the consciousness

of a man who had always been too self-enwrapt to perceive the chaos to which the individual selfishness must always lead" (184).[31]

In a curious and revealing reversal, then, March no longer possesses the male gaze but becomes himself the "penetrated" object of desire. He sees how the other half lives, and it touches him. This situation does not last long, however, for Howells abruptly changes tone and in deadpan prose reveals that March still only half-recognized "such facts." Upon reaching his destination, March descended the stairs at Chatham Square conscious only of "a sense of the neglected opportunities of painters in that locality." He has reverted, in other words, to the picturesque, a fact underscored by his immediate attraction to a "shabby-genteel ballad-seller," whose picture he determines will be an illustration for one of his own city sketches (184).

Precisely when March loses his "vague discomfort," this "half recognition" of the "facts" of modern life, is difficult to pin down. By the middle of the novel, however, Howells's ironic tone begins to disappear, and March witnesses another incident in which he recognizes the disjunction between his expectations and what he quite literally sees.

In this very brief scene, Basil and Isabel have just left an upper-class gathering, and in her musing upon the beauty and innocence of their hostess, Miss Vance, Isabel questions if the loveliness of such women does not come at the expense of the rest of the human race. March's unthinking but conventional reply that one "couldn't pay too much" for a "creature" like Miss Vance is immediately brought up short. "A wild laughing cry suddenly broke upon the air," and the two watch as the shadowy image of "a woman's figure rushed stumbling across the way and into the shadow of the houses, pursued by a burly policeman" (250), thus confirming Isabel's concern and undercutting March's flippancy. In sharp contrast to their earlier responses to such incidents, neither of the Marches sought a means of framing or aestheticizing what they have just seen. Instead they "went along fallen from the gay spirit of their talk," and Howells simply ends the chapter with March's comment, "Can that poor wretch and the radiant girl we left yonder really belong to the same system of things? How impossible each makes the other seem!" (251).

While one might read March's response as passive acceptance, I suggest that the rhetorical question and answer indicate a different attitude. Whether March likes it or not, he has come to accept the conflicting signs that his vision constantly presents to him. This acceptance, however, is not passive. Rather, it is humble and stems from March's recognition that he, too, is implicated in what he sees. As Howells admits in a later passage, March's explorations of New York changed his mode of perception. While he continued to believe the city was "huge, noisy, ugly, kindly," he no longer "regarded it as a spectacle" but "saw it now more as a life." He "could not release himself from a sense of complicity with it, no matter what whimsical, or alien, or critical attitude he took." Paradoxically, as March became more aware of his own viewpoint, more conscious of the distance between himself and others, the more he empathized with the objects of his vision. "A sense of the striving and the suffering deeply possessed him," Howells writes, "and this grew the more intense as he gained some knowledge of the forces at work" (306).

March gained this knowledge, moreover, by relying upon his senses, by exposing

himself to the "nervous stimulation" of the metropolis rather than retreating from it. As a result, his initial attitude—passive, intellectualizing, blasé—gave way, and, to reverse Simmel's formulation, he began to privilege the heart over the head. Like Lindau, the German socialist who serves as March's moral touchstone, March has come to understand that to truly know "the forces at work," to understand urban poverty, one "must zee it all the dtime—zee it, hear it, smell it, dtaste it—or you forget it" (190). The lesson is one Howells himself had learned and would repeat a few years later in his sketches of New York. As he wrote in "Tribulations of a Cheerful Giver," "As soon as you cease to have it ['the whole spectacle of poverty'] before your eyes,—even when you have it before your eyes,—you can hardly believe it, and that is perhaps why so many people deny that it exists." The spectacle is so contrary to what many people expect that even when they see it, they deny it or see it only as a kind of distanced mental image. "When I get back into my own comfortable room," Howells continued, "among my papers and books, I remember it as I remember something at the theatre."[32]

In contrast to this statement, the last line of *A Hazard of New Fortunes* becomes especially important. By remarking to Isabel when they see an acquaintance on the street that they must "trust that look of hers," March is articulating a process of seeing that differs radically from that which Howells practices in his study. Unlike Howells's mental image, which is one-sided, distanced by his study walls, and mediated by the metaphor of the theater, March's vision is an immediate, reciprocal kind of looking rather than a simple seeing. "That look of hers" is not only *how* she looks but also the look that *she gives* in return. It thus inscribes the spectator in the scene and makes that person implicit within, rather than detached from, what is seen. Significantly, one also "trusts" such a look rather than believes it, for whereas *belief* implies a one-sided relation in which the subject believes in an objective truth, *trust* connotes a reciprocal or mutual relation between two subjects. In addition, *trust* indicates more contingency than *belief* does and thus more closely characterizes the relation between vision and knowledge in the modern metropolis. The "changing images" and "onrushing impressions" of which Simmel wrote undermine any stable point of view and make old notions of visual truth, such as the picturesque, untenable.

The changing images and onrushing impressions also call into question the nature of representation. Thus, for a literary artist who wished to communicate what he saw, Howells's New York experience and his education in vision made the links among knowledge, sight, and representation problematic. As a result, Howells not only examines "the whole process of learning to see" in *A Hazard of New Fortunes*, but also questions the means of representing that sight. He does so by using the establishment of a new journal as a narrative frame. Not merely a convenient autobiographical detail, *Every Other Week* and the cast of characters who are associated with it provided Howells with a means of yoking his social concerns with his interest in representation. The journal also reveals his fundamental ambivalence toward the visual, which much of the novel seems otherwise so intent upon privileging.

In his introduction to the 1909 edition of *A Hazard*, Howells explained that he had

used his "own transition to the commercial metropolis in *framing* the experience" of Basil March and claimed that the "scene" into which he placed March and Isabel filled "the largest *canvas* he had yet allowed"[33] himself. By thus conflating painter and novelist, Howells foreshadowed the novel's questioning of the relation between the visual and the verbal, a concern, as he indicates, at least partially triggered by his own experience. Howells's biographer, Edwin Cady, claims that, after his years in literary Boston, one of the most intriguing things about New York for the editor was its status as a center for painting, illustration, and sculpture. Certainly his letters from the period contain numerous references to members of New York's artistic elite, men such as William Merritt Chase, Augustus Saint-Gaudens, and George deForest Brush, who moved in his social and professional world. These associations, along with his younger daughter's experience as an art student during this period, may partially account for his use during the late 1880s and early 1890s of various kinds of visual artists as both major and minor characters in his fiction. William Merritt Chase, for example, appears in both *A Hazard* and *The Coast of Bohemia* as Wetmore, the art instructor to whom aspiring young artists flock. And Howells created no fewer than a half dozen characters who were women artists, thus fictionalizing the press accounts of their numbers that appeared with increasing regularity toward the end of the nineteenth century.

His purpose, however, was not merely to be topical or to create romans à clef. As personally intriguing as he found this contact with the visual arts, Howells undoubtedly also recognized a professional challenge. In New York he encountered, to a much greater extent than he had in Boston, the realities of the publishing industry's love affair with illustration. From *A Hazard*'s opening chapter, Howells indicates that Basil March's education, like his own, would be visual in more ways than one. When March talks about taking over the editorship of a new journal with Fulkerson, the syndicate man and "pure advertising essence" who has packaged the product, and asks him whether the journal will be illustrated, Fulkerson replies with an incredulous, "Do I look like the sort of lunatic who would start a thing in the twilight of the nineteenth century *without* illustrations? *Come off!*" (14).

Indeed, illustrations distinguished the first issue of *Every Other Week*. From the cover, which March noted was "at once attractive and refined," through the "graphic comment" upon each of the seven literary pieces, the "art of the number acquired homogeneity, and there was nothing casual in its appearance." Though March was "not ashamed" of the literature, "he foresaw that the number would be sold and praised primarily for its pictures" (195–96). Yet if Howells's characterization of the journal's art editor is any indication, this development was not positive: no more unlikable and immoral personality than Angus Beaton populates the novel.[34] Affected and weak, Beaton takes money from his poverty-stricken father for foolish things and flirts with the vulnerable daughter of *Every Other Week*'s backer even when he believes that he cares for someone else. As a visual artist, Beaton is even more prone to aestheticizing than March is. In his own case, however, Beaton is the center of the picture. At one point, in fact, Beaton imagines himself getting married at Grace Church because he "had once seen a marriage there, and had intended to paint a picture of it some time" (136). Indeed, if March begins the novel as a

detached observer, Beaton never gets around to observing anything. Living in a solipsistic world of mental images, the visual artist sees little but himself.

In his unpublished preface to the novel, Howells exonerated "the whole delightful artistic acquaintance which I made during my early New York days" from the charge of being models for "the artist bearing the role of anti-hero in the story" (508). A clue to his respect for his artistic contemporaries and his contempt for Beaton may be found in his first description of Beaton's studio. Although it "looked at first glance like many other painters' studios," with casts, prints, and props scattered about, it also contained a number of objects not normally associated with a painter, among them "a bookcase with an unusual number of books" and "an open colonial writing desk" with "some pages of manuscript" covering it (118). These mixed attributes were signs of the artist's multiple gifts; with his interests in painting, writing, as well as sculpting, Beaton found that "one art trod upon another's heels" (119). Such broad talents, however, were more a curse than a blessing. As Howells explained, "When Beaton was writing . . . up to a certain point" he believed that literature was his true calling, and "when he was painting, up to a certain point he would have maintained against the world that he was a colorist and supremely a colorist" (118–19). When he reached that certain point in either art, however, "he was apt to break away in a frenzy of disgust, and wreak himself upon some other" (119). Sounding like a latter-day G. E. Lessing, Howells seems to be saying that unless one maintains clear boundaries between visual and verbal art forms, one can achieve little in either.[35] As he later wrote when March was considering illustrations for his sketches, "The two arts can never approach the same material from the same point" (184).

The relation of genres, however, has rarely, if ever, been a matter of theory alone but has been embedded in historicosocial relations, that is, ideology.[36] Such is certainly the case in *A Hazard of New Fortunes*, in which the narrative frame of a modern journal pulls together the two genres of illustration and writing. In doing so, it touches upon one of the more ideologically sensitive issues of the late nineteenth century: the transition from the "gentle reading" of Gilded Age journals to the "paragraph skimming" of the mass-circulation magazines that rose to prominence after 1885.[37]

As Christopher Wilson has shown, at the turn of the last century at least a handful of commentators detected a transformation in the Victorian mode of refined reading and bemoaned what they saw as the "impending demise of the traditionally conceived 'gentle reader.'" Concerned that the polite literary conventions of dedications, narrative intrusions, and contemplative spaces were giving way to a new realism that actually destroyed the intimacy between reader and author, these critics called for a return to "the ideal of companionate readership."[38] Similarly, other commentators decried the increasing use of illustrations, a development also associated with the changing mode of magazine production. Although a writer for *Lippincott's* (which discontinued illustration in the 1880s) probably exaggerated when claiming that "the purely pictorial element was the controlling end and be-all" of an "enterprising publisher" whom he knew, he was certainly not alone in feeling that "The Tyranny of the Pictorial" reigned in American periodicals.[39] As Arthur Reed

Kimball, in a survey of the nation's magazines, concluded at the end of the century, "Nowadays it is often the text which is illustrative, rather than the pictures."[40] Complaints about the adverse effects of illustrations began appearing in the press in the 1880s with the advent of the halftone printing process and became common by the end of the century.[41] Often the arguments sounded like the grumblings of unsuccessful writers, jealous of their contemporaries' achievements in the graphic arts. "It is far easier for an artist of ability . . . to get profitable work," the author of "The Tyranny of the Pictorial" groused, for example, "than it is for the equally good writer."[42]

In most cases, however, such laments stemmed from more complex ideological roots. Indeed, the critics seem to have intuitively recognized what Wilson so perceptively unmasks: the cheap magazines, while seemingly more democratic than their literary predecessors, in fact were instruments of an emerging managerial elite who both played upon and helped develop America's consumer culture. Obsessed with "news, information, and objectivity," these editors encouraged a direct, lucid, and nonliterary voice that, in its seeming impartiality, naturalized the new social environment, and in so doing transformed readers into passive spectators rather than active citizens. "Instead of promoting participation, the magazines elevated 'seeing,'" Wilson has shown; "instead of encouraging readers' criticism, the editors interpreted for them."[43] The new journals, in other words, promoted the kind of seeing that March—and Howells—had come to reject.

Thus, although Howells, as Kaplan argues, was a transitional figure with a home in both old and new publishing worlds, his theoretical writing and, even more particularly, his fiction participated in what she terms "an uneasy debate with the development of the mass media."[44] In *A Hazard of New Fortunes*, the ground of that debate was vision, both as sensation and as a means of representation. If for March, seeing was a means of knowing, it was so only when it was direct, unmediated by perception, and, paradoxically, self-conscious. Conversely, when seeing was a means of aestheticizing, framing, or naturalizing experience, when it transformed life into the picturesque, it encouraged spectatorship rather than knowledge. In *A Hazard of New Fortunes*, the literary editor, March, rather than the artist, Beaton, successfully differentiates between the two. Perhaps Howells, in casting the wordsmith as his hero, was indicating that words are better able to denaturalize that which is seen. Just as irony operates dialectically, the word may also call attention to the gap between what is expected and what is observed. Certainly, Howells acknowledged as much by adopting an ironic stance toward his persona March.

At the same time, his preference for the verbal may have had other ideological implications. As the critics of illustration asserted, "The written word is the first and the highest expression of thought, and it ever will be."[45] Pictures, they either implied or explicitly stated, should be subservient to the text if they accompanied it at all. Given their statements' striking resemblance to criticism of the so-called New Woman, whose development was also frequently lamented in the established media, it is understandable that these commentators associated pictures with women and children. Indeed, the author of an article entitled "Over-Illustration" conflated many of these categories and issues by beginning his essay with a quotation from

Macbeth: "'Tis the eye of childhood that fears a painted devil,' cried Lady Macbeth to her unnerved husband," and as the critic pointed out, this "scornful remonstrance is suggestive in more ways than one."[46]

Certainly, it suggests another avenue for exploring Howells's ambivalence toward visual representation. For although little explicitly links the image with the feminine in a negative way, there are clear ties between the world of women and illustration in *A Hazard of New Fortunes*. Fulkerson, for example, not only insists that *Every Other Week* should be targeted at women—and thus illustrated—but he also envisions a corps of "God-gifted girls" (141) to provide the graphics; Alma Leighton, Beaton's most serious love interest and an aspiring book illustrator, becomes one of his original group. The seeming innocence of these connections, however, masks a more invidious aspect of the relation between commercial illustration and gender. Just as Beaton is torn between his artistic talents, Howells hints that he and Alma Leighton in varying degrees are confused about their own sexual identification.[47] While Alma, all business and common sense, is at least neuter, "wedded," as she states, "to my Art," Beaton, with all his posturing, indecisiveness, and daydreaming, might be a feminine character in a popular romance. "He's fascinating, but he's false and he's fickle," (211) Alma concluded.

Simply change the gender of the pronoun in Alma's statement, and one could find no more apt description of James's and Howells's ambivalent attitude toward vision. Like many of their contemporaries, the psychologist/philosopher and the novelist were captivated by the physical sensation of sight and explored its epistemological possibilities. In James's case, the active use of pure vision might allow one to break through perception and to see the world afresh. Similarly, for Howells, vision could tear down the walls between individuals and social groups and lead to the construction of new personal and social relations. Indeed, James wrote that "sight is only a sort of anticipatory touch" (2:180), while Howells, in *A Hazard of New Fortunes*, showed how pragmatic seeing could be a prelude to touching and ultimately changing the lives of others. At the same time, neither was able to take his attitude too far. As men with at least one foot still in the nineteenth century, they shied away from sight's more radical implications. Vision, or its representation as image, often proved itself to be both "false" and "fickle," and, thus, to both men, it was also frighteningly feminine.

DAVID C. MILLER

. . .

Afterword

Any theory of iconology that seeks to inform as well as to benefit from current conceptions of ideology should begin with an account of the relation between the visual and the verbal. In the Introduction to this book, I suggested that such a theory would seek a middle ground between formalist approaches to either art or literature that minimize or ignore visual–verbal interaction and postmodernist approaches that tend to collapse any distinction between text and image by relating both to an underlying linguistic or semiotic system. Moreover, just as there is a need to relinquish the formalist territoriality that would ignore the endlessly fertile exchange between the visual and the verbal, there is also a need to go beyond the traditional approach to the Sister Arts that focuses on matters of content, viewing painting or literature as illustrative of the cultural background while eschewing questions of medium and form.

Postmodernism has provided a variety of conceptual maps with which to navigate the arid divide between form and content that has kept scholars stymied for years. Yet postmodernist approaches far too often simply reconstitute this divide along new lines. If images, whether visual or verbal, physical or mental, are no more than systems of signs that can be read like texts, then the visual loses its distinctive character, and art history winds up a colony of literary studies. The familiar face-off between formalists and cultural historians too often today reappears as a stalemate between those who defend a cultural poetics focused on the body and those who mount a cultural critique centered on ideology. The theory of iconology promises a way around this stalemate through an integration of both positions into a workable synthesis.

What I am arguing for involves a reassessment and partial reformulation of traditional modes of critical impressionism, formalism, and connoisseurship within the context of a theory of iconology that asserts a distinction between the verbal and the

visual which is continually changing; one that is both subject to prevailing ide-
ologies and an instrumental factor in shaping and transforming them. My underlying
assumption is that the visual is more closely tied to the body and that it is therefore
relatively more stable—less subject to continuous historical reconstruction—than
the verbal.[1] Images provide access to less articulate, more unconscious levels of
awareness in the cultural past than we can reach through merely verbal means.
While at one level the visual works to naturalize power relations and the distribution
of wealth and expertise within a given sociocultural context, at other levels it may
embody sensibility or insight that eludes or contradicts ideological constraints.

Contemporary critical discourse often loses sight of this distinction between the
visual and the verbal in its tendency to reduce everything to a matter of ideological
determination. As Edward Snow points out, "Crucial as the unmasking of patri-
archal/ideological/pornographic motives may be, the demystifying project runs the
risk of occluding whatever in the gaze *resists* being understood in these terms. The
fugitive elements within vision that elude or strain against the ideological can all too
easily get ground up in the machinery that seeks to expose the ideological, so that
the critical apparatus winds up functioning as a simulacrum and supplement of the
ideological apparatus itself."[2] Similarly, the anthropologist James Clifford advocates
that "rather than grasping objects only as cultural signs and artistic icons, we can
return to them . . . their lost status as fetishes—not specimens of a deviant or exotic
'fetishism' but *our own* fetishes." In his view, "This tactic, necessarily personal, would
accord to things in collections the power to fixate rather than simply the capacity to
edify or inform."[3] To do this, according to Clifford, is not only to acknowledge the
unique embodiment of particular objects but to give them back some of their
capacity to resist our efforts to possess and appropriate them as extensions of the
modern bourgeois self, consumed by a mania for classification and rational under-
standing. This approach would necessarily involve a rehabilitation of the body's
ways of knowing, for fetishistic responses are deeply imprinted in the human
organism.

The danger here is of falling into primitivism, all the more suspect for its self-
consciousness. Obviously, there is no formula for avoiding this pitfall. But any
responsible approach would nonetheless begin with a critique of the rationalism
that has so often blinkered the examination of art's relation to the verbal. Indeed,
the interarts issue can best be viewed in relation to persistent underlying tensions
between rationalism and irrationalism, which should not be considered as reified
categories but as ways of responding to the world that, throughout history, are
constructed and continually reconstructed in relation to each other.

What relevance this perspective holds for the study of nineteenth-century Amer-
ican art and literature remains to a large extent an open question. I will indicate its
bearing on the concerns of the chapters in this collection through an examination
of the salient differences and underlying affinities between the art of Thomas Cole
and that of William Harnett, here chosen as paradigmatic of the shift in attitudes
from the early part of the century to the latter. Such a juxtaposition reflects the
transition from a culture still dominated by religious values rooted in premodern
modes of consciousness to a modernist culture in which commercial values pre-

dominate. The striking contrasts and underlying connections between the work of these two artists illuminate complexities of interpretation that undermine the conceptual polarities—not only the verbal versus the visual but the commercial versus the religious, the rational versus the irrational, and the semiotic versus the symbolic—by which we attempt to trace the fabrication of representation, subjectivity, and agency in nineteenth-century America. As the example of these two artists shows, such polarities, far from being absolute, continually reconfigure each other in a dialectical process that extends into contemporary discourse itself.

A theory of iconology should seek both to connect the visual and the verbal and to distinguish between them. At the most basic level, it must overcome the age-old devaluation of the visual in Western culture, an attitude still carried on by postmodernism in its adaptation of the linguistic model. Rudolf Arnheim has long taken pains to undermine this attitude, contending that there is much evidence to show "that truly productive thinking, in whatever area of cognition, takes place in the realm of imagery."[4] Rather than reiterating the traditional distinction between perceiving and thinking, we should stress that neither activity can go on without the close cooperation of the other. Images, Arnheim demonstrated, have an exceptional capacity to achieve abstraction: "Only because perception gathers types of things, that is concepts, can perceptual material be used for thought; and inversely, . . . unless the stuff of the senses remains present the mind has nothing to think with" (1). Furthermore, the incompleteness of most mental images "is not simply a matter of fragmentation or insufficient apprehension but a positive quality, which distinguishes the mental grasp of an object from the physical nature of that object itself" (107).

As Arnheim asserted, the notion of an objective world not accessible to perception was just what established the fundamental distinction, so productive for Western civilization, between body and mind, the material and the spiritual. It was the basis for psychology as well as for the concept of the ideal. If study of the mind led to suspicion of what was apparent to the eye, belief in a spiritual dimension ratified this suspicion by embodying it as a metaphysical principle. Hence the ongoing diatribe in the Hebraic and Christian traditions against idolatry, the mistaking of the present and physical for the absent and divine. This diatribe was intensified in Protestantism, and it continued to hold an important ideological resource in the ongoing prestige of Platonic philosophy and idealist aesthetics. Fear of idolatry posed a continuing challenge to the visual artist in Protestant cultures, and it profoundly conditioned expectations about art in the Anglo-American context throughout the nineteenth century. It lay behind the persistence of the Sister Arts idea in American culture, based as it was on commonsense assumptions that posited an objective world and a mimetic theory of representation.

The complex, often elusive interplay between image and text, the visual and the verbal, in nineteenth-century American culture has yet to be fully appreciated. From the picturesque mode that characterized art and literature during the earlier part of the century to the analogy between novel and picture at the core of Henry James's theory of "the art of fiction," American artists and writers worked under the legacy

of the age-old doctrine of the Sister Arts.[5] The close but contradictory relation between visual and verbal culture in this country takes us to the heart of what is distinctively American about both. While the American cultural establishment continued to distrust the image unmediated by moral, religious, social, and literary frames of reference—attesting to the long shadow cast by Puritan fears of idolatry—the challenge of the relatively untrammeled American environment gave rise to the activity of "making it new." This tension between iconoclasm and the power of the image fundamentally affected the character of American art before the Civil War. Even after the war, when American artists and writers rejected the traditional alliance between literature and art, their rebellion was influenced by habits of thought about the two that preserved their interconnection at deeper levels. It is thus hardly surprising that American modernists like Gertrude Stein, Ezra Pound, and William Carlos Williams led the way during the years around the First World War in renewing the Sister Arts idea in a new key as they fashioned a literary aesthetic based on the analogy with the visual arts. They turned the tables on the older Sister Arts doctrine, with its suspicion of the visual and its mimetic theory of representation, by imbuing their language with the plastic and expressive qualities of the nonverbal arts. Still, the transition from the one position to the other remains a murky if intriguing issue in the study of American culture.

To the extent that contemporary scholarship recapitulates the assumptions of the older Sister Arts tradition, it fails to perceive the many ways in which the rich visual culture of nineteenth-century America actually served to undermine and transform the established hierarchy of the verbal over the visual. Only when we posit a dialectical relation between perception and thinking, images and words, can we sensitize ourselves to the fullest ideological implications of the changing nature of these terms. No longer prejudiced by a heritage of invidious distinctions, we realize that the status, indeed the very conception, of the one can be established only in relation to the other. Yet in order to sustain a dialectic between the two, we have to talk about a difference between them. And any such difference must be posited in the face of philosophical and psychological theories that see both as matters of convention.

Most arguments about the relation between the visual and the verbal wrestle with the legacy of the "picture view of language" that descended from the Aristotelian notion of mimesis, was reasserted by British empiricism and most recently manifested in logical positivism. This view held that images are natural while words are conventional yet aspire to the status of the natural through intercourse with the visual. Ever since the pioneering work of E. H. Gombrich in the 1950s, however, images have been treated as conventional too. This position received its most sophisticated philosophical defense in Nelson Goodman's *Languages of Art* (1968).

Nevertheless, Goodman did acknowledge that imagery still differs from language in its "density," or the lack of "differentiation" so essential to the functioning of words. If there is no absolute distinction between words and images, there is at least a significant difference of degree. Relative to words in a logical sequence, where gaps are inevitable, images are continuous.[6] W. J. T. Mitchell has elaborated suggestively on this point:

The image is syntactically and semantically dense in that no mark may be isolated as a unique, distinctive character (like a letter of an alphabet), nor can it be assigned a unique reference or "compliant." Its meaning depends rather on its relations with all the other marks in a dense, continuous field. A particular spot of paint might be read as the highlight on Mona Lisa's nose, but that spot achieves its significance in the specific system of pictorial relations to which it belongs, not as a uniquely differentiated character that might be transferred to some other canvas.[7]

Goodman used the opposed terms *analog* and *digital* to identify this distinction between dense and discrete sign systems (though he disregarded the conventional meaning of these terms). For anyone interested in establishing the special power of visual images within cultural history, his terminology is quite suggestive. Highlighted by Mitchell's gloss, it points to the uniquely sensuous quality of the visual image that may not only provoke but also shape awareness in the viewer which is not fully translatable into words.

Goodman's formulation is not unproblematic, as Mitchell has shown.[8] Above all, his thinking about the languages of art ignored the ideological dimension. And his failure to account for ideology led him, in turn, to overlook the difference between the verbal text and the act of reader-response at stake in the final product of any literary work. As Mieke Bal reminds us, "In order to 'tell' a narrative syntagm of the form subject-action-object, a text needs more words than just the three that fill the slots in the syntagm. As a sequence of mere words, language may be discrete; as a readable form of representation, it is not."[9] Conversely, according to this semiotic view, the indeterminate aspects of visual images—frame, background, color—may be rendered into discrete signs, thereby bringing them into closer parity with the discontinuous nature of the verbal.[10]

While this sort of congruence may be possible, it is not necessarily preferable. Semiotic approaches, by bringing into play the response of readers and viewers, do take us beyond the formalist implications of Goodman's distinction between visual and verbal by subjecting them to reader-response and reception theory as well as to ideological analysis. Yet to the extent that they discount the difference in medium, they exact a certain fee. As Donald Kuspit characterized the objection of art historians to such approaches, "Sexual curiosity about the libidinal surface of the work of art is repressed by reading it as a costume party of signs."[11] We may take this as referring to a repression not simply of sexual curiosity but of the body, the physical work of art, that is its object. Any translation of visual experience into verbal terms or vice versa must respect what is lost in translation. Although neither painting nor literature is inherently temporal, the codes they utilize for creating a sense of the passing of time are inevitably different. As Kuspit implies, this is so not only because the structural aspects of the two media never coincide but because we must also keep in mind the differences entailed in the unique physical embodiment of a work of art—its facture, the texture of its surface, its color, tonality, and forms, its various expressive features—which elicit our own instinctive response and bodily awareness and elude the exact reiteration so much a factor in the linguistic code, especially in the age of print culture and mechanical reproduction.[12]

That the verbal itself is merely a matter of semiotic codes is called into question

by the ability of literary imagery to evoke experience that lies beyond the bounds of the properly linguistic. Christopher Collins places the distinction between verbal and visual in the more precise terms of cognition. Pinpointing the difference between the productive and reproductive imaginations, he begins by distinguishing between semantic memory and episodic memory. Semantic memory "classifies, labels, and stores the general schematic aspects of our world so that when individual events occur we recognize their components and can anticipate their behavior. Its imagery, one of abstract types rather than concrete and particularized tokens, is possessed collectively by all individuals within a given cultural community."[13] Episodic memory, on the other hand, "stores information that is unique to every individual. . . . Since visual input is normally our most discriminative set of signals, most of this episode-grounded information is stored as detailed, particularized, visual imagery" (13). Along with the structuralists, Collins formulates reading as a "precisely constrained act." Such a formulation

> implies a culturally determined repertoire of readerly responses, but it also obeys procedural constraints that we might well regard as hard-wired and common to the social discourse of all natural languages. The transfer of information from one mind to another, which Saussure called le circuit de la parole, involves, in cognitive terms, a transfer of data from the episodic or semantic memory system of a speaker to the semantic, and only the semantic, system of an addressee. Reading literary texts is therefore best understood as a specialized form of one-to-one communication. [18]

Yet Collins goes on to "confront directly the paradoxical aspect of this imaginative act" of reading: "Individually considered, the noun-cued images which the reader generates are drawn from the semantic memory system; yet, once generated, they appear to comport themselves like the components of episodic memory. Mere schemata though they are, these images interact like fully detailed beings" (26).

In applying the visual experience of episodic memory to the theory of the literary image, Collins points to a "visionary" (rather than a merely visual) potential in reader-response that exploits the subjective, experiential aspects of mental imagery. Literary images, when considered from the standpoint of the reader, hence do share the dense, continuous quality of the visual—"so rich in circumstantial detail that figures appear surrounded by a peripheral ground of recognizable objects that, if we choose, can become in turn fully revealed as figural images" (27). This way of thinking about the literary image has the advantage over Bal's more strictly semiotic approach of reinstating the specifically visual aspects of experience in the equation, thus sustaining the difference of degree between visual and verbal media that a theory of iconology depends upon.

Collins's distinction between episodic and semantic memory relates to another touchstone for differentiating verbal from visual that switches our focus back to the other pole: the "ostensive" quality of the visual image. As Michael Baxandall pointed out, language is a generalizing tool, ill-equipped to capture the continuous and intensely relational nature of the pictorial image: "The repertory of concepts it offers for describing a plane surface bearing an array of subtly differentiated and ordered shapes and colours is rather crude and remote."[14] Accordingly, "what a

description will tend to represent best is thought after seeing a picture" (4). Similarly, Lorenz Eitner insisted that, with a painting or a piece of sculpture, "part of the meaning remains locked in the material form. The delicate complexity of the expressive structure instantly registers and magnifies every interference." This is especially relevant to the problem with reproductions—photographs and copies as well as verbal descriptions and memory images: "Since the total organization of a work of art embodies an intention, any disturbance of this organization must in some way affect its meaning."[15] The old saw "A picture is worth a thousand words" continues to ring true in a certain respect. One need not share Henry James's conviction that showing is superior to telling to grant the point that, while this distinction is far from absolute, it nonetheless remains a useful one.

Following Baxandall's lead, David Summers has called attention to the value for art history of a language which, far from being general and analytic, is "particularizing, sensate and 'poetic.'"[16] He concludes that "art history in such a view is an ongoing discussion about works of art by people who continually indicate and try to explain to others what they see either in works of art or series of them and what is significant about what they see. Such description, seriation, and explanation are by nature consensual and open to the works themselves" (395). This goes as well for criticism which attempts to infer agency or intention from a work of art. Such criticism, for Summers, "points partly in the direction of the sort of proximity to the work of art familiar in connoisseurship and conservation. The same characterization of material, facture, and quality of facture used to establish the historical relations of the work might also be used to attribute it to Donatello" (396).

Such cogent distinctions between visual and verbal media should alert scholars to the care that must be taken in comparing the two. While any rigid separation is clearly misplaced, it is just as important to resist the conflation of image and text, the pictorial and the literary. Moreover, far from calling for resolution, the long-standing debate over the relative primacy of visual or verbal modes may in fact point in a potentially more fruitful direction. Mitchell has set forth the challenging thesis that since there is no absolute, metaphysical divide separating words and pictures, there may still be a revealing distinction that takes into account the history of the various ways in which imagery, as opposed to textuality, has been employed and responded to in the practical sphere. He asks, "What are we to make of this contest between the interests of verbal and pictorial representation?" and proposes that "we historicize it, and treat it not as a matter for peaceful settlement under the terms of some all-embracing theory of signs, but as a struggle that carries the fundamental contradictions of our culture into the heart of theoretical discourse itself. The point, then, is not to heal the split between words and images, but to see what interests and powers it serves."[17]

To assess this purely relational condition (partly the lesson of structuralism, semiotics, and deconstruction) is to grasp a revealing index of the cultural and ideological viewpoint at any particular time and place. For instance, as Mitchell has argued, G. E. Lessing's fear of the visual reflects a rigid gender differentiation (identifying the visual image as female) which is fiercely Protestant and patriarchal.[18] Em-

bracing the image to any greater degree, in this view, would betoken a softening of patriarchal attitudes. As we move toward greater intimacy with the image, the active, time-oriented nature of the Word might be expected to give way to less logical, more projective experience, in which historical time is deposed in the abiding presence of space. This is the assumption at least of those who, like Frank Kermode, have linked Joseph Frank's concept of "spatialization" in modernist writing to Fascist politics—since it negates the historical dimension of time necessary for a belief in social progress.[19]

But the shift is actually much more complicated than this conclusion implies, as we realize when we think beyond the rigid distinction between mental and physical realms which the Western tradition inculcates. As Theodor Adorno pointed out, "By denying the implicitly conceptual nature of art, the norm of visuality reifies visuality into an opaque, impenetrable quality—a replica of the petrified world outside, wary of everything that might interfere with the pretence of the harmony the work puts forth."[20] Such a condition lies behind the inability of much contemporary theory adequately to conceptualize motivation, to establish a dynamic realm of subjectivity and directed agency within the ideological system through what Marx called "sensuous human activity . . . practice."[21] The changing ratio of visual to verbal is actually mediated by a wide variety of factors stemming from the motivational matrix that underlies both thinking and representing. Catchwords like *iconoclasm* and the *power* of images are themselves equivocal, referring either to conservative or radical possibilities. Iconoclasm may serve very different political agendas. In certain situations, the image may simply underwrite hegemonic values, as much postmodernist criticism has stressed. In others, however, it may act in a highly creative, exploratory manner, opening up a revolutionary political perspective, charging the soul with messianic fervor, or transmitting new energy to a partially petrified discourse.[22] There may be some combination of both possibilities. The fact that current critical inquiry strongly favors the first of these possibilities reflects its tendency to collapse the distinction between visual and verbal. Yet the very nature of the distinction itself depends upon the particular cultural dynamics at work in any given situation. A constellation of factors determines just how space and time or word and image are conceived as well as how eye and ear interact. From this standpoint, to merge word and image could mean much the same thing in the long run as radically to differentiate them. Either tendency results in formalism.

What keeps word and image in productive tension within discourses, as Mitchell suggests, depends upon contextual matters having as much to do with the ideological makeup of the historian's own perspective as it does with that of the culture of the artist or writer under scrutiny. This is to say that contemporary theory is an instrumental force within the matrix of economic, social, and cultural production just as it is a product of that matrix. In examining the past through our own ideological lenses, we run the risk of simply remaking it in our own image. Can we study the past in order to throw our own ideologically conditioned presuppositions into a critical light?

Whether such a critical dialectic is possible ultimately depends upon whether or not ideology is conceived of as a hermetically sealed system. While much poststruc-

turalist theory, in its appeal to the linguistic model first proposed by Ferdinand de Saussure, succumbs to this kind of determinism, the challenge facing Marxist, feminist, and psychoanalytically informed historians who want to change the world is to establish a basis for some kind of intention or directed agency, some latitude of thought or freedom of action, within a world that is otherwise ideologically bound. The subject must achieve a certain autonomy within the structure or, more accurately, the *process* of language and culture. While subjectivity was taken to extremes in the older, idealistic theories of culture, any materialistic approach must reverse its own tendency to do away with such internal causality altogether. For to do so is to be left with an elaborate rationale for political passivity.

Mitchell's proposal that we historicize the distinction between visual and verbal and carry it into the sphere of contemporary theoretical discourse promises to reconcile the cultural critique based on ideology—which structuralists, semioticians, and deconstructionists have developed—with a cultural poetics focused on the body. The latter brings into play the insights and methods of formalism and connoisseurship, phenomenology and hermeneutics, feminism and psychoanalysis in a synthesis that avoids the postmodernist extremes of either simply denying subjectivity or of diffusing it so thoroughly throughout the linguistic and cultural system that it becomes impossible to locate meaningfully. This reconciliation is first of all possible because of the distinction between the visual and the verbal itself. As I have been arguing, the difference of degree between visual and verbal experience provides the very grounds upon which a theory of subjectivity and internal causality may be posited. Second, this reconciliation depends on Mitchell's point that our very experience of the visual or verbal, far from being fixed for all time, is subject to continual reformulation and redefinition right up to the present day.

It may well be that much contemporary scholarship has uncritically adopted a conception of the visual and its relation to the verbal that is the product of relatively recent historical conditions and therefore not fully applicable to earlier periods. A recent book by Jonathan Crary has done much to throw this possibility into relief. Crary offers an illuminating history of the "'points of emergence' of a modern heterogeneous regime of vision" in the nineteenth century that closely comports with Foucauldian accounts of the "technologies of power."[23] His concern with the "relentless abstraction of the visual" converges with my concerns about the role of the body in visual awareness, especially when he asks, "How is the body, including the observing body, becoming a component of new machines, economies, apparatuses, whether social, libidinal, or technological?" And he is fully aware of the nexus between evolving bodily awareness or the lack of it and the changing structure of subjectivity. "In what ways," he asks, "is subjectivity becoming a precarious condition of interface between rationalized systems of exchange and networks of information?" (2).

Such questions imply the dematerialization and rationalization of the visual that may hold close affinities with the "bodiless" semiosis of poststructuralist analysis as well as of contemporary media like film, television, video, and the computer. For Crary, contemporary visualism owes its conception and mode of functioning to a

modernizing process "by which capitalism uproots and makes mobile that which is grounded, clears away or obliterates that which impedes circulation, and makes exchangeable what is singular" (10). In tracing the "rebuilding of the observer fitted for the tasks of 'spectacular' consumption" which began to take place in the early nineteenth century, Crary focuses on the dissociation of the visual from the tactile: "The loss of touch as a conceptual component of vision meant the unloosening of the eye from the network of referentiality incarnated in tactility and its subjective relation to perceived space." As I will show, this dissociation is relevant to the difference between Thomas Cole's sense of the visual as still deeply semantic and symbolic—fundamentally mediated by temporal modalities and the traditionalist theme of mortality—and William Harnett's much more semiotic version of the visual. In any case, such new objects of vision as commodities and photographs assumed "a mystified and abstract identity, sundered from any relation to the observer's position within a cognitively unified field" (19). This "liberation of sensation from signification," issuing in a "pure perception," involved the separation not only of optic and haptic responses but the very suppression of language, historical memory, and sexuality (96).

Clearly, the difficulty faced by contemporary theory in developing a viable concept of subjectivity that would give power and mobility to human actors within a world mediated by a language "always already" constructed has something to do with this displacement of the body from perceived space, this deracination of the visual from anything referential. Such pure perception is really only the other side of the coin from a purely linguistic awareness. Any creative tension between the visual and the verbal, based on a difference of degree, has collapsed. The world of signifiers whose signifieds are endlessly deferred is a world in which the sensuous surface of the body finds no continuity with anything beyond itself but remains a discrete counter. Once again to invoke the terminology of Nelson Goodman, it is a world of the *digital* as opposed to the *analog*. We might speculate further about such a world, suggesting that it is one in which power relations seem to have displaced those of love and beauty. In any case, it is one in which subjectivity has been so diffused that not only the concept of origins but the basis for intentionality and commitment has become deeply problematic.

It seems imperative to see such a world as simply one version of reality among a plurality of possibilities. My purpose here is certainly not to dismiss it, for it remains not only useful, a primary way of understanding our contemporary world and how it came about, but inevitable. Nonetheless, if the past is to mean anything to the present, it is important to take stock of the limitations of prevailing conceptions of visuality and subjectivity, and of the "disembodied" body to which they are linked, and to try to gain access to alternative conceptions that place them in historical perspective. Crary's account of the changing techniques of the observer and Mitchell's theory of iconology take us decisively in this direction.

What about images which resist the modern regime of vision either because they are grounded in premodern modes of consciousness or manage in some way to avoid cooptation by the capitalist system? We may restore to them some of their

original power by imaginative acts of historical recreation that reconstitute aspects of the context in which that power took shape. This means developing a notion of subjectivity grounded in the materiality of the body and in the impulses and desires, pleasures as well as pains, that constitute its internal politics. It means treating the image not simply as a sign but as a body that projects metaphorically and that, because it derives from aspects of consciousness that are less rational or articulate and that reside at a greater time-depth than language, may not be fully accessible to textual analysis.[24] It also means balancing ideological analysis with a respect for the various levels of agency, including the level of conscious intention. Because perception and bodily awareness accrue over centuries, the image is like a palimpsest that contains myriad traces of meaning. Sensory awareness mobilizes psychological and affective responses that derive from even the remotest cultural past, and it can be used in turn, through the medium of imagery, to evoke them "poetically" in critical discourse.

Lessing reminded his contemporaries that, unlike words, visual images must adhere to a criterion of beauty or pleasing form that would forever limit their realm of expressiveness. More recently, the psychologist Anton Ehrenzweig employed the notion of the "good Gestalt" to define both the criterion of harmony and the need for a unitary effect which have dominated idealist aesthetics for centuries.[25] While we may now feel skeptical about such efforts to capture the defining character of the visual, it is still useful to reconsider them anew within a historical perspective. Indeed, as long as they are seen from such a perspective, they may prove invaluable to any effort to reconstitute the role of critical subjectivity within the field of cultural history. For, to the extent that they remain an essential part of our own acculturated equipment for experiencing the world, such concepts represent our most tangible link to the past. Even while we view them critically, they afford us a way of reimagining the past which takes into account the fact that we as historians are inevitably products of the very past we investigate, creatures whose innermost responses—far from interfering with the supposedly neutral findings of social science—may save us from overzealous, even misguided reliance on "objective" or "rational" criteria on the one hand or from theoretical nominalism on the other.

This view finds its theoretical premises in a number of different directions. It is perhaps closest to the theory of hermeneutic experience developed by Hans-Georg Gadamer. Gadamer's methodology, as it relates to the question of history, emerges from a particular conception of what is at stake in the effort of a person to understand a text: "A hermeneutically trained consciousness must be, from the start, sensitive to the text's alterity. But this kind of sensitivity involves neither 'neutrality' with respect to content nor the extinction of one's self, but the foregrounding and appropriation of one's own foremeanings and prejudices. The important thing is to be aware of one's own bias, so that the text can present itself in all its otherness and thus assert its own truth against one's own foremeanings."[26]

Gadamer goes on to argue for recognition of the element of tradition in historical research. As he puts it,

> Time is no longer primarily a gulf to be bridged because it separates; it is actually the supportive ground of the course of events in which the present is rooted. Hence

temporal distance is not something that must be overcome. This was, rather, the naive assumption of historicism, namely that we must transpose ourselves into the spirit of the age, think with its ideas and its thoughts, not with our own, and thus advance toward historical objectivity. In fact the important thing is to recognize temporal distance as a positive and productive condition enabling understanding. It is not a yawning abyss but is filled with the continuity of custom and tradition, in the light of which everything handed down presents itself to us. Here it is not too much to speak of the genuine productivity of the course of events. [297]

Behind this statement stands Gadamer's effort to retrace the course of West European thinking about objectivity and the standards of truth in the natural sciences as they apply to the human sciences. His theory seeks to rehabilitate the traditional notion of *sensus communis*, common sense, which sufficed for truth and aesthetic perception up to the end of the eighteenth century. Such a project does not especially invite consideration of the factors of class, gender, and race in defining what makes sense, though it surely does not exclude it. At any rate, Gadamer's notion of common sense helps reveal the limitations of any theoretical model which seeks to discount or erase the effects of historically engendered prejudice or bias, resulting in iconoclastic repudiation of the past and its institutions. In short, it shares the goal of poststructuralism to see reality as a matter of social construction but without succumbing to its rationalistic or at least antisensuous methods.

The hermeneutic awareness of history Gadamer expounds attributes creative, metaphoric thinking to individual actors (whether on the productive or receptive side of the process) whose source of insight is their participation in a collective consciousness that is continuous with the social process and also the basis for a special, very personal colloquy between present and past. Kindred perspectives have recently appeared in a variety of quarters. Patrocinio Schweickart has persuasively argued for gynocentric interpretive strategies "consonant with the concerns, experiences, and formal devices" that characterize gynocentric texts. Schweickart comments on Adrienne Rich's essay "Vesuvius at Home: The Power of Emily Dickinson," in which Rich states, "For years, I have been not so much envisioning Emily Dickinson as trying to visit, to enter her mind through her poems and letters, and through my own intimations of what it could have meant to be one of two mid-nineteenth century American geniuses, and a woman, living in Amherst, Massachusetts."[27] As Schweickart points out, Rich's essay develops several metaphors: "the feminist reader speaks as a witness in defense of the woman writer"; "the literary work cannot be understood apart from the social, historical, and cultural context within which it was written"; the text is seen "not as an object, but as the manifestation of the subjectivity of the absent author—the 'voice' of another woman" (130).

Casting reading as an intersubjective encounter between reader and author, Schweickart replaces the dualistic approach to the text common to formalism and deconstruction with one that is dialogic and dialectical. While she accepts Stanley Fish's notion of interpretive communities and interpretive strategies, she does not give up the text or its author's alterity: "On the one hand, reading is necessarily subjective. On the other hand, it must not be wholly so. One must respect the

autonomy of the text. The reader is a visitor and, as such, must observe the necessary courtesies" (131). Moreover, this approach brings into play not only the text itself but the "'heart and mind' of another woman" (134). The aim is "contact," not mastery or getting it right. Schweickart balances the more radical implications of reader-response theory—pushing toward the relativistic pole—with the phenomenological approach of Georges Poulet. While one might wonder to what extent her formulation of gynocentric criticism is more widely applicable, her concern with changing the world (shared with other feminist theorists) and her implicit desire to balance the female body as a cultural construct with some acknowledgment of it as a natural given go hand in hand.

Feminist perspectives which emphasize thinking through the body have made more explicit the role of nonverbal modes of experience in critiquing the rationalistic bias of social science as applied to the humanities. Similarly, in arguing for "the power of images," David Freedberg echoes Nelson Goodman's attack on "the domineering dichotomy between the cognitive and the emotive."[28] Freedberg's use of the concept of animism offers a controversial example of the way in which older modes of being persist, despite the transformations wrought by modernity, providing a bridge to a fuller understanding of images originating in the very distant past: "We refuse—or have refused for many decades—to acknowledge the traces of animism in our own perception of and response to images: not necessarily 'animism' in the nineteenth-century ethnographic sense of the transference of spirits to inanimate objects, but rather in the sense of the degree of life or liveliness believed to inhere in an image" (32).

Not surprisingly, Freedberg aligns his methodology with Gadamer's: "In order to arrive at a viewpoint that might cover both art and history, Hans-Georg Gadamer took a stand against traditional aesthetics and stressed the importance of examining the 'mode of being [of] a picture.' For him, as for us, the picture is an ontological event; hence it cannot be properly understood as the object of aesthetic consciousness" (76). Both approaches involve reassessing the dynamic contribution of sense and sensibility to any consideration of the ideological matrix. This brings us back to the middle ground staked out by a theory of iconology which I referred to at the outset of this Afterword. The age-old fissure between form and content, reconstituted in aesthetic consciousness, may continue to keep scholars at loggerheads with each other. But there do seem to be ways in which to bridge the divide by acknowledging the role of nonverbal experience in transforming culture and ideology and by exploiting the body's ways of knowing in order to evoke a sense of this process.

I will end by suggesting how an understanding of the dynamics of representation in nineteenth-century America which balances ideological analysis with a concern for the poetics of form and medium underscores the insights of the various essays in this volume. In assessing formal and stylistic shifts in American art from the earlier part of the century to the latter, it is useful to keep in mind certain key factors examined by these essays—above all religion and commerce—which govern and are in turn themselves mediated by the dynamic relation between visual and verbal

modes. Such an approach takes into account not only the determinations of material practices and social relations but the conscious as well as unconscious intentions of individual artists in relation to the physical embodiment of images.

In comparing Thomas Cole's "wilder images" and the trompe l'oeil still life paintings of William Harnett, I will consider both continuities and discontinuities, constituting a dialectical exchange between the verbal and the visual, temporal and spatial modalities, symbolic (or semantic) modes and semiotic ones. The point is not so much to argue for the prevalence of one constituent of these dichotomies over the other in the work of either artist. Rather, it is to suggest how the shifting ratio of their relation to each other is not only symptomatic of fundamental changes in values, attitudes, and ideals but instrumental to them. It is critical to attend to altering conceptions of the visual and verbal (as expressed in such matters as style and facture) as well as to the complex interplay between cultural norms and the social and economic processes of capitalism, for the former factor offers perhaps the most acute index available for evaluating the role of subjectivity in determining the direction of cultural and ideological change. In discounting it, we run the risk of flattening historical development. At one level, the shift from the symbolic to the semiotic, from Cole to Harnett, is a matter of historical progression. At another level, this progression is complicated by the web of contradictory motives and levels of intention that postmodernist theory has sensitized us to. My point is partly that we must not forget one level in focusing on the other. Both are critical to a full historical understanding.

Any sense of continuity between the work of Cole and that of Harnett must be put forward in the face of striking formal and iconographic differences. On the one hand we encounter a work like *Falls of the Kaaterskill* of 1826 (fig. A.1), an image of virgin nature that embodies the sublime in all of its quasi-religious overtones. The painting is organized around a single hyperbolic gesture which collects the energies immanent in nature and stage-manages them for maximum effect, not hesitating to make significant material changes in the actual scene in order to proffer an image of concentrated authority. On the other hand we confront *Old Models* of 1892 (fig. A.2), one of the shelf paintings of Harnett, a painter of images comprised almost exclusively of human artifacts which seem to embody some occult or uncanny relation to each other emanating from their seemingly random placement within a space that emphasizes the tension between the illusory and the actual.

Unlike nature in Cole's picture, which disguises the artist's act of reconfiguration by posing as the vehicle of a divine energy, the various artifacts in Harnett's still lifes call attention to the ingenuity of the artist, who defamiliarizes them by removing them from their original contexts—where use-value reigns—and placing them in a new, pictorial context in which certain merely formal exchanges take place. If Cole's world attests to God's creativity, Harnett's world luxuriates in sheer contrivance. Whereas Cole eschews what he would have thought of as a servile *imitation* of God's handiwork in order to transfigure nature in the alembic of the painter-poet's imagination (a direct if shadowy reflection of God's), Harnett's minute and glossy surfaces reflect all the presumptuousness implied by the mode of trompe l'oeil.

The trompe l'oeil effect of presenting an illusion of a real world that is inevitably

A.1. Thomas Cole, *Falls of the Kaaterskill*, 1826. The Warner Collection of the Gulf
States Paper Corporation, Tuscaloosa, Alabama.

revealed as illusion points to Freud's concept of the uncanny.[29] At the source of the
uncanny is a return of the repressed. Accordingly, Harnett's painting designates its
own artifice in the context of an otherness that is clearly not nature (in some
bedrock sense) but something that takes shape only in dialectical relation to artifice.
Harnett's still lifes thus ultimately remind us of the pictorial conditions for illusion
after inviting us to forget them, self-consciously dispelling any intrinsic connection
between a representation and what it *re-presents*.

If it is fair to suggest that the world Harnett evokes in his trompe l'oeil still lifes is

A.2. William Harnett, *Old Models*, 1892. Courtesy Museum of Fine Arts, Boston, Hayden Collection.

an uncanny one, it might also be worth considering this world as animistic. Animism here points not only to the unusual liveliness of the visual image but, from the nineteenth-century standpoint, to the immanence of spirit in matter to a degree to which any distinction between the two blurs. This represents a pantheistic fusion of opposites which the traditionally religious mind found deeply threatening. For Thomas Cole, as for anyone in the mainstream of American romantic painting who was committed to the dynamics of transcendence epitomized by the sublime, such a collapse of metaphysical hierarchy would have seemed simply idolatrous.

To call the world of Harnett animistic is indeed to point to the often strange vitality generated by material surfaces whose relation to each other has ceased to be merely conventional, utilitarian, or "natural." Moreover, there is no longer any explicit narrative connection or thematic affinity among the various objects in the painting, as in Dutch still life, in which the allegory may allude (through the leftovers of a meal, for instance) to the story of decay and death. While Harnett was certainly capable of this kind of allegory, the tendency in his later work is to offer semantically arbitrary collections of objects which at most provide only hints to some hidden story.

The painter himself subsumed his effort "to make the composition tell a story" under his preoccupation with formal concerns: "The chief difficulty I have found has not been the grouping of my models, but their choice. To find a subject that paints well is not an easy task."[30] In the animistic world of Harnett's trompe l'oeil pictures, spirit seems to emanate from material things if only because they have entered a new formal relation to each other, a relation of manifest contrivance betokening the artist's deeply subjective choice. The interaction of visual values, the echoing of shapes, the interplay of textures and colors, the ironies of juxtaposition, the ambiguities of pictorial space, the tensions between the visual and the verbal—all of which have replaced the more traditional emphasis on content or the utility of objects—attest to the last refuge of spirit in the exercise of formal ingenuity by the painter. That these objects only *seem* to overcome the reality of the painted surface underlines the refreshing ironies that emanate from their exquisitely managed formal disposition.

All of this has something to do with the question of time, especially as seen in a religious context, and it is here we can most distinctly trace the interaction of visual with verbal modes. The overtly religious tone of Cole's landscapes depends fundamentally on their avoidance of "mere imitation," and this avoidance took place in the dimension of time during the process of conceiving the picture just as it takes shape in the picture's allegorical allusions to time. Everyone knows how Cole liked to paint from memory, using only a sketch to remind himself of the scene. As he wrote, "I never succeed in painting scenes, however beautiful, immediately on returning from them. I must wait for time to draw a veil over the common details, the unessential parts, which shall leave the great features, whether the beautiful or the sublime, dominant in the mind."[31] Time is what transfigures the world's body, presumably imparting divine sanction to Cole's paintings. It is precisely what makes his art into a mode of prophecy, not of idolatry—and we should keep in mind here the Renaissance commonplace that time is of the soul just as space is of the body.

This correspondence underlay the Sister Arts doctrine inherited by Cole and his generation of American painters and writers.

The visible presence of time in the landscape painting is conveyed—and here I arrive at the crux of my argument—as much by Cole's brushstroke as it is by the reconfiguration of the actual scene effected by memory that is the key to his compositions. For the artist's handiwork calls attention not only to his inspired creativity but, paradoxically, to the very materiality of his medium of representation. In short, Cole's application of paint is at once loose and suggestive and very palpable. If his overt message has to do with the natural cycle of decay and regeneration (conveyed by the autumn foliage, for instance), reminding his viewers that they should attend not only to immortal aspirations but to mortal limitations, the implicit message of his technique will not allow us to forget this paradox either. Artistic contrivance for Cole is thus indistinguishable from artistic transfiguration; both interact in order to keep alive the biblical distinction between mortal and immortal while expressing the biblical paradox of bodily weakness and spiritual striving. Like Adam, we are made in God's image but also fatefully fashioned of clay. Cole belonged to the Christian tradition of memento mori. All the poignancy of this awareness is transmitted not only by the overt allegory of his painting but by its very mode of handling, its sensuous surface.

The paradox entailed in Cole's vision of the human condition has collapsed in the world of Harnett. Here, artistic inspiration has given way to bravura imitation; the illusory has triumphed in the simulacrum.[32] By this token, values have lost ontological status and succumbed to a pictorial "economy" of fluid exchange. The symbolic dimension of the image has given way to the semiotic, the highly motivated and controlled metaphor to the unmotivated sign. We might say that the conditions of the market economy, determined and limited only by desire and imaginary investments, have fully transformed the pictorial world. In this situation, anything is capable of turning into anything else. Without stable content, all relations become matters of formal affinity and antithesis, the underlying structural relation that is integral to the constitution of the sign.

Objects in the world now fail to point beyond themselves except by pointing back to the formal features of their own objecthood. To speak from Cole's standpoint, the immaculate rendering of minute detail looms as an audacious usurpation of God's creativity. The miracle of life has given way to a display of the artist's technique and to the trick of "dead nature"—a glimpse of the uncanny ambiguities emanating from the collapse of metaphysical distinctions. Here we touch upon the underlying affinities—despite obvious formalistic differences—between Harnett's technique and that of William Merritt Chase, which Alfred Frankenstein long ago discerned.[33] Beneath the tight application of paint and the polished surfaces of Harnett's trompe l'oeil still lifes resides the same attitude toward artistic technique as in the virtuoso display of talent that impresses the viewer in Chase's impressionistic style. Both Harnett and Chase worked very fast. In any case, the spiritualizing impress of time no longer characterizes the painterly technique of either of these late nineteenth-century artists. Just as the imaginary desires for more commodities which fuel capitalism depend on forgetting mortality, Harnett's trompe l'oeil tech-

nique erases the artist's personalizing presence in a demonstration, whether unwitting or not, of time transcended. The tension between visual and verbal modes which depends upon a distinction between them has relaxed. With this relaxation has gone a dimension of artistic intentionality that leaves in its wake a profoundly altered basis for subjectivity, a startlingly new set of relations among artist, work of art, the beholder, and the cultural context.

Chase's displays of painterly facility—reflecting a very different self-consciousness from Harnett's—along with his preoccupation with surface, likewise belie the sense of time, beginning with the time invested in training and execution. Indeed, his impressionism points almost programmatically to the ephemeral moment. His paintings too are about juxtapositions that stress formal qualities over use value, narrative meaning, and cultural context. Such is the studio display which acts as a catalyst for ever-renewed desire and ever-deferred satisfaction that Sarah Burns discusses in this volume. The "art atmosphere" she refers to radiates not only from the arrangement of refined colors, shapes, and textures but from the painterly effects themselves. Atmosphere itself represents a merging of spiritual and material elements, a pantheistic fusion issuing in an impersonal agency. Unlike Chase's New England contemporaries whose heritage still motivated their efforts to see the spiritual through the material veil (George Fuller, George Inness, and Thomas Dewing come readily to mind), Chase's painterly technique provides no veil at all. His different approach resounds, ironically, in his own protestation against such a charge: "Do not imagine that I would disregard that thing that lies beneath the mask. . . . but be sure that when the outside is rightly seen the thing that lies under the surface will be found upon your canvas."[34] Chase placed far more stress upon the power of appearances than his more visionary New England counterparts, impatient as they were in their Emersonian (or Swedenborgian) efforts to get from the thing to the thought.

Despite these clear discontinuities between Cole's wilderness and Harnett's and Chase's indoor world, some very significant continuities do exist. And, predictably, they have to do with the ongoing influence of the expanding market economy, its proliferation of a consumer mentality, and art's complicity with this process. As David Lubin has argued, while Harnett's paintings clearly function as commodities, as another aspect of the extraordinary visual stimulation of the late nineteenth-century American environment, they are also fundamentally about nostalgia.[35] By the same token, the Persian carpets and imported porcelains of Chase's studio interiors are about exoticism. Nostalgia and exoticism are parallel strategies of fantasy and evasion. The objects of Harnett's paintings exist within a perfectly static and impersonal world in which the material—just as in mass production—has overcome the very conditions which define it as material. This allows it to be fetishized. No paradox between spiritual and material, mortal and immortal, or between image and word, visual and verbal, for that matter, can exist where no distinction between the two survives. Far from being a mode of prophecy, art has become one of manipulation. Like a return of the repressed, eighteenth-century fancy (the faculty which assembles inert parts) has come back to haunt the organic process of imagination. The latter had lost its battle to overcome the reification of subject and object imposed by capitalist development.

Harnett's art might thus be seen, as Lubin has suggested, as fully complicitous with that system. Yet we should not forget that the subject matter of these paintings is all about the past, the discarded, the dilapidated, the timeworn. And it is all about the culture of artistic expression and knowledge—books, musical instruments, objects of recreation—that is being lost in an increasingly commodified world. How do we resolve this apparent paradox?

That Harnett's world is one of nostalgia winds up being exactly the point. For nostalgia (as we can even more clearly see today in its unabashed exploitation by the advertising world) is complicitous with the very forces which destroy the objects of nostalgia. It proffers an antidote to the discontents of civilization without fundamentally altering them. It is here that we touch upon the most direct link between the effects of consumerism and commodification in Thomas Cole's day and those far more evident half a century later in Harnett's and Chase's day. Cole's message of memento mori, a relic of precapitalistic thinking, already exists in uneasy relation to the more facile mode of subsuming the temporal under the spatial which we generally associate with the culture of sentimentalism: nostalgia.

The rise of sentimentalism has been convincingly linked to the consumer revolution and its sources in the Protestant ethic by Colin Campbell in his richly suggestive book *The Romantic Ethic and the Spirit of Modern Consumerism* (1987).[36] Campbell is concerned with the fabrication of what he terms "modern autonomous imaginative hedonism." Without going into his complex account of how such a pervasive habit of mind actually came about, I suggest that such hedonism relates closely to sentimentalist aspiration—usually backward in time—as the creation of a symbolic world that cushions the depredations of time while generating the longing, the unconsummated desire, behind the unending acquisition of commodities. Fantasy is instrumental here, and it manifests itself in everything from the novel to romantic love to a constant and restless quest for pleasure. The point is that such regression ironically serves a future that in turn deprives the past of its power by gradually reducing it to merely imaginary status. Just as capitalism tends to collapse the traditional dialectic between material and spiritual, mortality and immortality, it minimizes any distinction between past and future, space and time. Historical understanding is thus usurped by myth.

Yet it is precisely here that the fetishistic dimension of Harnett's art may, surprisingly, transcend complicity with the capitalist system by giving rise to meanings that bring the self into relation to primary, even primordial aspects of its being once again mobilized by historical change; meanings that, far from operating merely ideologically, may unfold new directions in thought and experience. To see it this way is to remind ourselves that the dialectic between word and image takes place at a variety of levels and that it is dangerous to impose a model of progress or any single paradigm upon an example of historical change.

Conversely, to the extent that Cole's sublime visions weaken the dialectic between material and spiritual in picturing a pristine world of nature (either pastoral or sublime)—in "forgetting," as Kenneth Myers puts it, their own artifice—they anticipate their own undoing. They undermine the *imaginative* by resorting to the merely *imaginary*. It is not, therefore, a hopeless leap from Cole to Harnett or Chase.

In denying the depredations of time in a landscape like *Falls of the Kaaterskill*, in eschewing the theme of civilization's decline (or romantic disillusionment) as he turned away from explicit allegory, Cole unconsciously acted at the behest of a system whose very existence depended fundamentally on the denial of mortality. Here we detect his own covert role in the commodification of art so much more clearly operative in the careers of Harnett and Chase.

Complicity or resistance? Constraint or freedom? It is only by holding on to a sense of the various interlocking and often contradictory levels of motivation at stake in the subject's relation to language and materialism, as well as to the systematic processes of economics and society, that we avoid neutralizing the dynamic, paradoxical, as well as temporal aspects of the emergence of the culture of capitalism and preserve the possibility of resistance to it. If this approach involves carefully keeping in view our own subjectivity and bodily awareness in the project of writing history, it also depends on our developing sensitivity to the complex and instrumental role of visual-verbal interaction in the unfolding of culture.

<center>· · ·</center>

Notes

Introduction

1. Erwin Panofsky, *Meaning in the Visual Arts* (Garden City, N.Y.: Doubleday Anchor, 1955), 28.

2. W. J. T. Mitchell, *Iconology: Image, Text, Ideology* (Chicago: University of Chicago Press, 1986), 1.

3. Wanda Corn, "Coming of Age: Historical Scholarship in American Art," *Art Bulletin* (June 1988): 203.

4. Bryan Jay Wolf, "All the World's a Code: Art and Ideology in Nineteenth-Century American Painting," *Art Journal* 44 (Winter 1984): 336.

5. See in particular John Barrell, *The Dark Side of the Landscape* (Cambridge: Cambridge University Press, 1980); idem, *The Political Theory of Painting from Reynolds to Hazlitt: 'The Body of the Public'* (New Haven: Yale University Press, 1986); Ann Bermingham, *Landscape and Ideology: The English Rustic Tradition, 1740–1860* (Berkeley: University of California, 1986); David H. Solkin, *Richard Wilson: The Landscape of Reaction* (London: Tate Gallery, 1982); James Turner, *The Politics of Landscape: Rural Scenery and Society in English Poetry, 1630–1660* (Cambridge: Harvard University Press, 1979). For two studies with a feminist emphasis, see Carole Fabricant, "The Aesthetics and Politics of Landscape in the Eighteenth Century," in *Studies in Eighteenth-Century British Art and Aesthetics*, ed. Ralph Cohen (Berkeley: University of California Press, 1985), 49–81; and idem, "Binding and Dressing Nature's Loose Tresses: The Ideology of Augustan Landscape Design," in *Studies in Eighteenth-Century Culture*, ed. Roseanne Runte (Madison: University of Wisconsin Press, 1979), 109–35. A work of fundamental influence here is Raymond Williams, *The Country and the City* (New York: Oxford University Press, 1973).

6. Raymond Williams, *Problems in Materialism and Culture* (London: NLB, 1980), 34.

7. In an excellent discussion of the concept of cultural hegemony, T. J. Jackson Lears qualifies this position, preserving the distinction between the Gramscian model of hegemony and traditional notions of social control from the top down by arguing that "new forms of cultural hegemony can bubble up from below, as historical blocs fashion a world view with wide appeal." He goes on to write, "Dominant groups can revitalize a hegemonic culture by incorporating what they imagine to be the instinctual vitality of the lower orders—as, for example, during the late nineteenth century when neurasthenic Americans were urged

to adopt a more relaxed pace of life by emu-
lating 'Oriental people, the inhabitants of
the tropics, and the colored peoples gener-
ally.' No top-down model of domination
can explain the complex growth, dissolu-
tion, or transformation of hegemonic cul-
tures" (587). See "The Concept of Cultural
Hegemony: Problems and Possibilities,"
American Historical Review 90 (June 1985): 567–
93.

Peale's Mammoth

1. Charles Willson Peale to Rubens Peale,
September 10, 1806: "I have begun a view
of the pit emtied, and which will in a more
particular manner shew the immen[s]e la-
bour I had."
2. Rembrandt Peale, *An Historical Disquisition on
the Mammoth, or great American incognitum, an
extinct, immense, carnivorous animal, whose fossil
remains have been found in North America* (Lon-
don: July 18, 1803). *The Selected Papers of
Charles Willson Peale and His Family*, ed. Lillian
B. Miller (New Haven and London: Yale
University Press, 1988), vol. 2, part 1, 571.
The story of the excavation and recon-
struction of the mastodon is recounted in
Charles Willson Peale's Autobiography,
typewritten transcript by Horace W.
Sellers, *The Collected Papers of Charles Willson
Peale and His Family*, ed. Lillian B. Miller (Mill-
wood, N.Y.: Kraus Microform, 1980), se-
ries II-C, microcards 1-21; *The Selected Papers
of Charles Willson Peale and His Family*, esp. vol.
2, part 1, 308–592; Charles Coleman
Sellers, *Mr. Peale's Museum, Charles Willson
Peale and the First Popular Museum of Natural Sci-
ence and Art* (New York: Norton, 1980); and
idem., *Charles Willson Peale*, 2 vols., *Later Life*,
vol. 2 (Philadelphia: American Philosophi-
cal Society, 1947).
3. Rembrandt Peale, "An Account of the
Mammoth" (London: October 1, 1802), 5.
4. Thomas Jefferson to Charles Willson
Peale, May 5, 1809, *The Pennsylvania Magazine
of History and Biography*, no. 110 (July): 318.
5. Thomas Jefferson, "Manufactures," in *Notes
on the State of Virginia*, ed. William Peden
(New York: Norton, 1954), 164–65. Peale
had read Jefferson's *Notes*, as demonstrated
by a debate he had with an Englishman,
recorded in his diary: "John Bull replied,
ah we shall see by and by–Roberspere,
once was thought highly of and we shall
see whether the President will have reso-
lution to keep to the Sentiments of his [in-
augural] Speech. I replied that he had be-

fore shewed himself to be a man of firm
nerves by his writings. He replied that
some of his works had been brought for-
ward to his censure. Yes, but by a party that
stoped at nothing to obtain their end,
making improper implications and mis-
representations[,] and more honor than
want of just sentiments [is] manifest to ev-
ery on who will read the whole of his
notes on Virginia." Diary 18. Part 1: Phila-
delphia to New York, June 5–July 2, 1801,
Selected Papers, 314; also quoted in *Mr. Peale's
Museum*, 125.
6. Eric Foner, *Tom Paine and Revolutionary America*
(New York: Oxford University Press,
1976), 101–06.
7. Quoted in Jeffrey A. Smith, *Franklin and
Bache: Envisioning the Enlightened Republic* (New
York: Oxford University Press, 1990), 102.
Louis Hartz distinguishes the Federalists
from the European reaction in *The Liberal
Tradition* (1955; reprint New York: Harcourt
Brace Jovanovich, 1983), 80: "There is a feu-
dal bleakness about man which sees him
fit only for external domination, and there
is a liberal bleakness about man which
sees him working autonomously on the
basis of his own self-interest; Maistre be-
lieved in the one, Adams believed in the
other. . . . Everything goes to show that
the difference between Federalism and
the European reaction is the difference be-
tween liberal Wiggery and the European
'ancien regime.'"
8. Drew McCoy, *The Elusive Republic: Political
Economy in Jeffersonian America* (Chapel Hill:
University of North Carolina Press, 1980),
121–84, 211-59; John Nelson, *Liberty and
Property: Political Economy and Policymaking in the
New Nation, 1789–1812* (Baltimore and
London: Johns Hopkins University Press,
1987), 22–36.
9. For a description of this transformation in
the Delaware Valley, see Cynthia Shelton,
The Mills of Manayunk: Industrialization and So-

cial Conflict in the Philadelphia Region, 1787–1837 (Baltimore and London: Johns Hopkins University Press, 1986), 7–25, 27–35, 37–46.

10. As Sean Wilentz summarizes, "The Progressives' insistence that political parties, in New York and elsewhere, directly embodied class interests–that the Whigs were the party of business, the Democrats the party of farmers and labor, or simply 'the people'—led them in turn to ignore the plain truth that in New York and in the rest of the country, both major parties were led by established and emerging elites and their progressive allies, usually lawyers." "However," he continues, "in refuting the Progressives . . . American historians from the late 1940s through the early 1970s retained some of their elders' assumptions, above all their fixation on party politics and their willingness to understand class as an abstract institution. . . . the counter-Progressives discovered a past in which political conflict turned on deep ethnic, religious, and 'status' divisions but in which class and class consciousness were either nonexistent or submerged by an American entrepreneurial consensus." Sean Wilentz, *Chants Democratic: New York City and the Rise of the American Working Class, 1788–1850* (New York and Oxford: Oxford University Press, 1984), 8.

11. Jefferson's interest in natural history was long-standing and well known: like Peale, he believed that "the very sinews of government are made strong by a diffused knowledge of this science." Charles Willson Peale, "Introduction to a Course of Lectures on Natural History delivered at the University of Pennsylvania, Nov. 16, 1799," *Selected Papers*, vol. 2, part 1, 267. While president of the United States Jefferson was also president of the American Philosophical Society (of which Peale was curator), and in 1799 he published a paper on the Giant Sloth, or Megalonyx, of Virginia. In May 1797, soon after his election as president of the American Philosophical Society, Jefferson presided over a meeting in which the society considered "A plan for the collecting of information respecting the Antiquities of

North America." The editors of the Peale Papers recount that "a year later a committee was appointed with Jefferson and Charles Willson Peale as members, that drafted a public letter appealing for information concerning the whereabouts of natural and archaeological artifacts. An entire skeleton of the 'mammoth' was singled out as something important to acquire." *Selected Papers*, vol. 2, part 1, 349n.

12. Quoted in a letter from Thomas Jefferson to Dr. Caspar Wistar, Washington, February 3, 1801, Henry Fairfield Osborn, "Thomas Jefferson as a Paleontologist," *Science*, n.s. 82 (December 6, 1935): 535. Jefferson comments, "From this extract, and the circumstance that the bones belong to the town, you will be sensible of the difficulty of obtaining any considerable portion of them. . . . It is not unlikely they would with common consent yield a particular bone or bones, provided they may keep the mass for their own town."

13. Thomas Jefferson to Dr. Caspar Wistar, Washington, March 20, 1808, "Thomas Jefferson as a Paleontologist," 536.

14. Linda K. Kerber, *Federalists in Dissent: Imagery and Ideology in Jeffersonian America* (Ithaca: Cornell University Press, 1970), 1–23, 67–95.

15. William Cullen Bryant, "The Embargo" (Boston: Printed for the Purchasers, 1808), facsimile edition with introduction by Thomas O. Mabbott (Gainesville, Fla.: Scholars' Facsimiles and Reprints, 1955), 22.

16. J. H. Powell, "The Mammoth Cheese," in *General Washington and the Jack Ass and Other American Characters in Portrait* (New York and London: Thomas Yoseloff, 1969), 261.

17. Ibid., 252–66.

18. See, for example, Samuel Ewing's Federalist "Satire on the Mammoth," The Philadelphia *Port Folio*, February 20, 1802, published in response to a description in the *Aurora*, February 18, 1802, of a Republican "Mammoth Feast" held at the Peale Museum prior to Rembrandt and Rubens Peale's journey to Britain with the duplicate skeleton. Both are reprinted in Samuel Ewing Esquire, "The Mammoth Feast," in *The Philadelphia Souvenir: A Collection of Fugitive Pieces from the Philadelphia Press* (Philadelphia: The Port Folio Office, Wm.

Brown, Printer, 1826), and in *Selected Papers*, vol. 2, part 1, 401–07, 408n.

19. John Wilmerding and Lillian Miller argue that *Exhuming the Mastodon* is generically hybrid, a creative (or disastrous) blend of history, genre, and portrait painting. Lillian B. Miller, "Charles Willson Peale as History Painter: "The Exhumation of the Mastodon," *American Art Journal* 13, no. 1 (Winter 1981): 30–51; John Wilmerding, "Peale, Quidor, Eakins: Self-Portraiture as Genre Painting," in *Art Studies for an Editor: 25 Essays in Memory of Milton S. Fox* (New York: Harry Abrams, 1975): 290–305. Miller determines that *Exhuming the Mastodon* is a history painting and traces its ancestry through Peale's earlier work. However, due to Peale's failure "to generalize" adequately, it is not so much "a history painting" as "an assemblage of portraits." Conversely, John Wilmerding praises as typically American Peale's eccentric and creative blending of portraiture, history, and genre painting in *Exhuming the Mastodon*. Abraham Davidson interprets the painting in light of eighteenth-century theories of catastrophism: "Charles Willson Peale's 'Exhuming the First American Mastodon: An Interpretation," in *Art Studies for an Editor: 25 Essays in Memory of Milton S. Fox* (New York: Harry Abrams, 1975), 61–71. Also published in *American Quarterly* 21 (1969): 620–29.

20. Charles Willson Peale, *Guide to the Philadelphia Museum* (Museum Press: first printing 1804), *Selected Papers*, vol. 2, part 2, 764. Likewise, in his Autobiography of 1822, Peale also claimed that the idea of founding a museum had come to him at the end of the American Revolution with a small pile of mammoth bones, uncovered during the war. Charles Willson Peale, Autobiography, *Collected Papers*, series II-C, microcards 1-21, 107–08.

21. *An Historical Disquisition on the Mammoth*, *Selected Papers*, vol. 2, part 1, 554.

22. Peale was appointed a commissioner of forfeited estates on May 6, 1778. Charles Coleman Sellers, *Charles Willson Peale*, 2 vols., *Early Life* (Philadelphia: The American Philosophical Society, 1947), 1:185.

23. Ibid., 1:12, 151–214.

24. Ibid., 215–17.

25. Ibid., 220–22.

26. "Discourse Introductory to a Course of Lectures on the Science of Nature; with original music, composed for and sung on the occasion," November 8, 1800, Delivered in the Hall of the University of Pennsylvania (Philadelphia: printed by Zachariah Poulson, Jr.), 41.

27. Charles Willson Peale, January 12, 1802, *Selected Papers*, vol. 2, part 1, 386.

28. Charles Willson Peale, "Address to the Public," *Aurora*, January 27, 1800, *Selected Papers*, vol. 2, part 1, 274.

29. Peale, "Introduction to a Course of Lectures," 19.

30. Charles Willson Peale, "A Walk through the Philadelphia Museum," first page of unpublished manuscript (1805), in *The Collected Papers of Charles Willson Peale and His Family*. Never completed, this description of the museum was written in imitation of "A Walk" through the Paris museum by J. B. Pujoulx: *Promenades au Jardin des Plantes, à la Menagerie et dans les galeries du Musée d'Histoire Naturelle* (Paris, 1803).

31. *Mr. Peale's Museum*, 218.

32. "Introduction to a Course of Lectures," 268.

33. *Guide to the Museum*, 761.

34. Ibid., 759–66.

35. Philadelphians were proverbial for punning. Washington Irving in his mock travel account of a trip to Philadelphia in *Salmagundi* writes, "The amusements of the philadelphians are dancing, punning, tea-parties and theatrical exhibitions." Upon arriving in the city, Jeremy Cockloft, the narrator, is immediately confined to his bed "with a violent fit of the pun mania— strangers always experience an attack of the kind on their first arrival." "The Stranger in Pennsylvania, By Jeremy Cockloft the Younger," in *Salmagundi: or the Whimwhams and Opinions of Launcelot Langstaff, Esqu. and Others*, ed. Bruce I. Granger and Martha Hartzog, *The Complete Works of Washington Irving*, ed. Henry A. Pochmann et al. (Boston: Twayne Publishers, 1977), 185, 188.

36. *Guide to the Museum*, 764.

37. Charles Willson Peale, Autobiography, quoted in Charles Coleman Sellers, "A Supplement to 'Portraits and Miniatures by Charles Willson Peale'," *Transactions of the*

American Philosophical Society, n.s. 59:3 (1969): 36.

38. Charles Willson Peale to Thomas Jefferson, January 10, 1803, *Selected Papers*, vol. 2, part 1, 480. See also, Charles Willson Peale to Rubens Peale, September 10, 1806: "I have begun a view of the pit emtied . . . the figures in this piece will be large enough for me to introduce some portraits, I have prepared the Canvis of it 22 Inches wider than that which Rembrandt began." *Selected Papers*, vol. 2, part 2, 982.

39. Charles Willson Peale to Elizabeth DePeyster Peale, June 28, 1801, *Selected Papers*, vol. 2, part 1, 336; *Historical Disquisition*, 552.

40. These supplies included pumps and military tents (such as the one pictured in the background of *Exhuming the Mastodon*), provided by Jefferson through the war office of the secretary of the navy. Thomas Jefferson to Charles Willson Peale, July 29, 1801, *The PA Magazine of History and Biography* 28, no. 109 (April):137.

41. "For several weeks no exertions were spared, and the most unremitting were required to insure success: bank after bank fell in; the increase of water was a constant impediment, the extreme coldness of which benumbed the workmen. Each day required some new expedient, and the carpenter was always making additions to the machinery: every day bones and pieces of bones were found between six and seven feet deep. . . . Twenty-five hands at high wages were almost constantly employed at work." *Historical Disquisition*, 553–54.

42. C. W. Peale to Angelica Peale Robinson, September 13, 1806, *Collected Papers* (Millwood, N.Y.: Kraus Microform, 1980), microcard 39, series II-A.

43. *Historical Disquisition*, 553.

44. *Historical Disquisition*, 543–44, 550.

45. Charles Willson Peale, Diary 19, *Selected Papers*, vol. 2, part 1, 361n.

46. *Historical Disquisition*, 551–52.

47. Ibid., 552.

48. Ibid., 553.

49. Ibid., 543–44, 550.

50. Ibid., 552.

51. Ibid.

52. "Intent upon manuring his lands to increase its production (always laudable) he felt no interest in the fossil shells contained in his morass." Ibid.

53. Bryan J. Wolf, *Romantic Revision* (Chicago: University of Chicago Press, 1982), 123–26.

54. In his Autobiography Peale identifies the family members and friends represented in *Exhuming the Mastodon*. The information is reproduced in Sellers, *Later Life*, 205; Charles Coleman Sellers, "Portraits and Miniatures by Charles Willson Peale," *Transactions of the American Philosophical Society*, n.s. 42 (1952): 75; and Edgar P. Richardson, Brooke Hindle, and Lillian B. Miller, *Charles Wilson Peale and His World* (New York: Harry Abrams, 1982), 85.

55. This is not as farfetched as it may seem; in the foreground of an earlier family portrait, *The Peale Family of 1773*, a half-peeled apple and apple peel punningly represent "the Peales."

56. Autobiography, series II-C, 331–34.

57. Titian Ramsay Peale I was Rachel Brewer's son. He died of yellow fever in 1798 at the age of eighteen. When Elizabeth Peale gave birth to a son a year later Peale named him Titian Ramsay Peale II. The "second birth" of Titian Peale formed a tenuous link between the two halves of Peale's family, which were otherwise quite divided by age, jealousies, and temperament. By 1806, when Peale was painting *Exhuming the Mastodon*, all of his children had lost their mothers; the presence of Elizabeth DePeyster in the painting suggests that Peale made the fact of shared loss a source of family unity.

58. This is a wedding portrait of Sophonisba and Coleman Sellers. Coleman Sellers was a member of the Sellers family of Philadelphia, engineers and manfucturers. Sellers, *Later Life*, 205; idem, "Portraits and Miniatures," 75.

59. Charles Willson Peale to Angelica Peale Robinson, September 13, 1806, *Collected Papers*, series II-A, card 39.

60. Michel Foucault, *Discipline and Punish*, trans. Alan Sheridan (New York: Vintage Books, 1979), 187.

61. *Mr. Peale's Museum*, 171–87.

62. Thomas Jefferson, First Inaugural Address, March 4, 1801, *The Writings of Thomas*

62. *Jefferson*, ed. Paul Leicester Ford (London and New York: G. P. Putnam's, 1897), 8:3.

63. See 54n passim.

64. Wilson, Philadelphia, July 6, 1813, *The Life and Letters of Alexander Wilson*, ed. Clark Hunter (Philadelphia: American Philosophical Society, 1983), 406.

65. "Since many of my audience may not know under what difficulties I have formed a Museum permit me here to give a concise account of its rise and progress." "Introduction to a Course of Lectures," 21–22.

66. Ibid.

67. Luce Irigaray, *The Speculum of the Other Woman*, trans. Gillian C. Gill (Ithaca: Cornell University Press, 1985), 21.

68. Charles Willson Peale, "A Walk through the Philadelphia Museum," unpublished manuscript of 1805, quoted in *Mr. Peale's Museum*, 199.

69. Roger B. Stein, "Charles Willson Peale's Expressive Design: The Artist in His Museum," *Prospects* 6 (1981), ed. Jack Salzman (New York: Burt Franklin, 1981), 157.

70. "An Epistle to a Friend on the Means of Preserving Health, Promoting Happiness, and Prolonging the Life of Man to its Natural Period" (Philadelphia: from the press of the late R. Aiken, by Jane Aitken, 1803), *Selected Papers*, vol. 2, part 1, 504–05.

71. "Discourse Introductory to a Course of Lectures," 14. The same passage reappears in Peale's "Epistle to a Friend," 505.

Resistance to Allston's Elijah

I am indebted to David C. Miller, whose criticism has served to stimulate my thinking on Washington Allston. I also am grateful that he allowed me to read his manuscript "Washington Allston and the Sister Arts Idea in America."

1. Elizabeth Garrity Ellis, "The 'Intellectual and Moral made Visible': The 1839 Washington Allston Exhibition and Unitarian Taste in Boston," *Prospects: An Annual of American Cultural Studies* 10 (1985): 39–75.

2. William H. Gerdts, "The Paintings of Washington Allston," in *'A Man of Genius': The Art of Washington Allston* (1779–1843), William H. Gerdts and Theodore E. Stebbins, Jr. (Boston: Museum of Fine Arts, 1979), 105.

3. On Coleridge's concept of Reason in *The Statesman's Manual* (1816), see Steven Knapp, *Personification and the Sublime: Milton to Coleridge* (Cambridge: Harvard University Press, 1985), 22.

4. *The Collected Works of Samuel Taylor Coleridge*, ed. Kathleen Coburn and Burt Winer, vol. 6, *The Lay Sermons*, ed. R. H. White (Princeton: Princeton University Press, 1972), 77.

5. Charles R. Leslie quoted in Jared B. Flagg, *The Life and Letters of Washington Allston* (1892; reprint, New York: Benjamin Blom, 1969), 131. W. J. T. Mitchell and Roy Park argue that romantic poets like Coleridge and Wordsworth employed Edmund Burke's antipictorial theory of poetry as a weapon against Lockean epistemology and the commonsense notion that all knowledge is based upon clear ideas derived from visual images. W. J. T. Mitchell, "Blake's Wond'rous Art of Writing," in *Romanticism and Contemporary Criticism*, ed. Morris Eaves and Michael Fischer (Ithaca: Cornell University Press, 1986), 49–54; Roy Park, "'Ut Pictura Poesis': The Nineteenth Century Aftermath," *The Journal of Aesthetics and Art Criticism* 28 (Winter 1969): 155–64. See also Mitchell, *Iconology: Image, Text, Ideology* (Chicago: University of Chicago Press, 1986), 137–40.

6. Ellis, "The Intellectual and Moral made Visible," 45 and Gerdts, "The Paintings of Washington Allston," 162.

7. Elizabeth Johns, "Washington Allston's Later Career: Art about the Making of Art," *Arts Magazine* 54 (December 1979): 122.

8. *Evening Transcript*, May 2, 1839, quoted in Ellis, "The Intellectual and Moral made Visible," 49.

9. Donald Preziosi discusses the notion of the Eucharist as the "perfect signifier" in the terms formulated by Port-Royal grammarians in the seventeenth century. *Rethinking Art History: Meditations on a Coy Science* (New Haven: Yale University Press, 1989), 102–10. On Allston's "concealment of pigments," see Asher B. Durand, quoted in Gerdts, "The Paintings of Washington Allston," 168. On Allston's insistence that the glazing technique "takes away the appear-

ance of paint," see Henry Greenough's recollection of Allston's words in Flagg, *Life of Allston*, 195.

10. "Notes on Aesthetics; Lecture Notes from James Marsh, Transcribed by W. H. A. Bissell," in *Three Christian Transcendentalists: James Marsh, Caleb Sprague Henry, Frederic Henry Hedge*, ed. Ronald Vale Wells (1943; reprint, New York: Octagon Books, 1972), 186.

11. "Self-Culture," in *The Works of William Ellery Channing*, vol. 2, 10th ed. (Boston: George G. Channing, 1849), 366-67.

12. David C. Miller writes that Allston's *Elijah* "both succumbs to and exploits the ambiguity of the act of faith it seeks to represent: for faith, as a turning inward, always eventually runs the risk of solipsism or spiritual death." "Allston and the Sister Arts Idea."

13. On the aesthetics of cohesion, see Robert A. Ferguson, *Law and Letters in American Culture* (Cambridge: Harvard University Press, 1984), 80–82. See also Terry Eagleton, *The Ideology of the Aesthetic* (London: Basil Blackwell, 1990), 97–98.

14. Tamara Plakins Thornton, *Cultivating Gentlemen: The Meaning of Country Life among the Boston Elite, 1785–1860* (New Haven: Yale University Press, 1989), 142.

15. Channing, "Self-Culture," 390.

16. Joy S. Kasson has demonstrated how Horatio Greenough, Allston's disciple, warned against a "close" vision of the art object, for such "vision represented the gaze of daily life . . . and was not poetic enough." *Marble Queens and Captives: Women in Nineteenth-Century American Sculpture* (New Haven: Yale University Press, 1990), 36. Carter Ratcliff has observed that Allston's paintings "are often scruffy when seen from close up" but that from a distance, "theme and scale are induced to turn the glow of layered glaze into a symbol of radiant consciousness." "Allston and the Historical Landscape," *Art in America* 68 (October 1980): 102.

17. See Daniel Walker Howe on Unitarians' insistence upon a moral taste to guide art. *The Unitarian Conscience: Harvard Moral Philosophy, 1805–1861* (Cambridge: Harvard University Press, 1970), 109, 189–90.

18. For a postmodernist interpretation of Allston's paintings, see Bryan Jay Wolf, *Romantic Re-Vision: Culture and Consciousness in Nineteenth-Century American Painting and Literature* (Chicago: University of Chicago Press, 1982), 24–77.

19. *Discourses on Art*, ed. Robert R. Wark (San Marino, Cal.: Huntington Library, 1959), 63.

20. Thornton, *Cultivating Gentlemen*, 56.

21. Charles L. Sanford, *The Quest for Paradise: Europe and the American Moral Imagination* (Urbana: University of Illinois Press, 1961), 142–43.

22. On Allston's tendency to stress "the incommensurability of earthly and spiritual phenomena," which put him at odds with Unitarianism and Scottish Common Sense philosophy, see David Bjelajac, *Millennial Desire and the Apocalyptic Vision of Washington Allston* (Washington, D.C.: Smithsonian Institution Press, 1988), 177–78.

23. Allston belonged to the Episcopal church partly because he found comfort in the mediating power of church ritual and art. Ibid., 93.

24. Steven Knapp discusses how abstract personification acts as a distancing agent in the romantic sublime. *Personification and the Sublime*, 82–83.

25. Elizabeth Johns, "Washington Allston's Theory of the Imagination" (Ph.D. diss., Emory University, 1974), 72.

26. John Dixon Hunt, *The Figure in the Landscape: Poetry, Painting, and Gardening during the Eighteenth Century* (Baltimore: Johns Hopkins University Press, 1976).

27. Richard W. Wallace, *Salvator Rosa in America* (Wellesley, Mass.: Wellesley College Museum, 1979), 105–06.

28. Katherine Emma Manthorne, *Tropical Renaissance: North American Artists Exploring Latin America, 1839–1879* (Washington, D.C.: Smithsonian Institution Press, 1989), 13–19.

29. *The Imitation of Christ*, trans. Leo Sherley-Price (Harmondsworth: Penguin Books, 1987), 72.

30. Stephen Prickett, *Words and The Word: Language, Poetics and Biblical Interpretation* (Cambridge: Cambridge University Press, 1986), 11.

31. Washington Allston, *Lectures on Art and Poems*, ed. Richard Henry Dana, Jr. (1850; reprint, Gainesville, Fla.: Scholars' Facsimiles and Reprints, 1967), 68.

32. James B. Twitchell, *Romantic Horizons: Aspects of the Sublime in English Poetry and Painting, 1770–1850* (Columbia: University of Missouri Press, 1983), 21.

33. J. Robert Barth, S.J., "Coleridge's Scriptural Imagination," in *Coleridge, Keats, and the Imagination: Romanticism and Adam's Dream*, eds. J. Robert Barth, S.J. and John L. Mahoney (Columbia: University of Missouri Press, 1990), 137–38.

34. James Engell, "Imagining into Nature: 'This Lime-Tree Bower My Prison,'" in *Coleridge, Keats, and the Imagination: Romanticism and Adam's Dream*, 88.

35. Allston, *Lectures on Art and Poems*, 251–52.

36. Ibid., 68.

37. Richard Shiff has associated Charles Peirce's concept of the indexical sign to painting conceived as an authentic record of artistic performance or character. "Performing an Appearance: On the Surface of Abstract Expressionism," in *Abstract Expressionism: The Critical Developments*, ed. Michael Auping (New York: Harry N. Abrams, 1987), 100.

38. Quoted in Edgar Preston Richardson, *Washington Allston: A Study of the Romantic Artist in America* (Chicago: University of Chicago Press, 1948), 60.

39. David Brett, "The Aesthetical Science: George Field and the 'Science of Beauty,'" *Art History* 9 (September 1986): 341.

40. Allston, *Lectures on Art and Poems*, 95.

41. Johns, "Washington Allston's Theory of the Imagination," 68–70.

42. Virgil Barker, *American Painting: History and Interpretation* (New York: Macmillan, 1950), 344. David C. Miller has observed that the "expressive, painterly surface" threatens "to overwhelm subject matter" and that it is in this surface where "the painting's symbolic dimension" resides. "Allston and the Sister Arts Idea."

43. Quoted in Flagg, *Life of Allston*, 131.

44. Ibid., 196.

45. James A. W. Heffernan, "The English Romantic Perception of Color," in *Images of Romanticism: Verbal and Visual Affinities*, ed. Karl Kroeber and William Walling (New Haven: Yale University Press, 1978), 136–37.

46. Rebecca Harding Davis has one of her fictional characters say, "I was raised on the milk of the Word" in her short story of 1861, "Life in the Iron Mills," in *Four Stories by American Women*, ed. Cynthia Griffin Wolff (New York: Penguin Books, 1990), 19.

47. Quoted in Johns, "Washington Allston's Theory of the Imagination," 45–46.

48. Allston also recommended the English interior decorator David Ramsay Hay and his book *The Laws of Harmonious Colouring* (1828). Flagg, *Life of Allston*, 192. See also Brett, "The Aesthetical Science," 336, 346.

49. George Field, *Chromatics, or an Essay on the Analogy and Harmony of Colours* (London: A. J. Valpy, 1817), 56–57.

50. For a thorough discussion of Morse's painting technique, see Paul J. Staiti, *Samuel F. B. Morse* (Cambridge: Cambridge University Press, 1989), 25–59.

51. Samuel F. B. Morse, *Lectures on the Affinity of Painting with the other Fine Arts*, ed. Nicolai Cikovsky, Jr. (Columbia: University of Missouri Press, 1983), 89.

52. David S. Reynolds demonstrates that nineteenth-century American Protestants were increasingly evading theological disputes for the harmony of aesthetics. *Faith in Fiction: The Emergence of Religious Literature in America* (Cambridge: Harvard University Press, 1981), 1–6.

53. David Bjelajac, "Washington Allston's Prophetic Voice in Worshipful Song with Antebellum America," *American Art* 5 (Summer 1991): 78–79, 83–84.

54. Richardson, *Washington Allston*, 119–20.

55. Jules David Prown, *American Painting from its Beginnings to the Armory Show* (New York: Rizzoli, 1980), 63. David C. Miller also makes this point.

56. Twitchell, *Romantic Horizons*, 9.

57. See Jan Cohn and Thomas H. Miles, "The Sublime: In Alchemy, Aesthetics and Psychoanalysis," *Modern Philology* 74 (February 1977): 289–304.

58. Robert C. Alberts, *Benjamin West: A Biography* (Boston: Houghton Mifflin, 1978), 225–39.

59. Sir Joshua Reynolds, "Notes on the Art of Painting," in *The Art of Painting of Charles Alphonse du Fresnoy*, trans. William Mason (1783; reprint, New York: Arno Press, 1969), 94.

60. Ibid. Dolce quoted in Moshe Barasch, *Light and Color in the Italian Renaissance Theory of Art*

(New York: New York University Press, 1978), 106.

61. Quoted in Flagg, *Life of Allston*, 187–88, 195.

62. Ibid., 187, 194–95.

63. Ibid., 184. Charles Alphonse du Fresnoy praised Venetian harmonic color as being "congenial," "neighb'ring," and "mutual." *The Art of Painting*, trans. Mason, 37.

64. Field, *Chromatics*, 28–29.

65. Quoted in Robert A. Ferguson, *Law and Letters in American Culture* (Cambridge: Harvard University Press, 1984), 26.

66. Bjelajac, "Washington Allston's Prophetic Voice," 8–20 and Gerdts, "The Paintings of Washington Allston," 148.

67. William Ware, *Lectures on the Works and Genius of Washington Allston* (Boston: Phillips, Sampson, 1852), 80–82.

68. Ibid., 82–83.

69. Ibid.

70. Ibid., 87–89.

71. Ibid., 87.

72. Ibid., 86–87. David C. Miller has characterized the desert in Allston's *Elijah* as a symbol of "that anarchic realm which lies beneath the world of cultural values." "Allston and the Sister Arts Idea."

73. Ibid., 89.

74. Ibid., 96.

75. Linda Kerber, *Federalists in Dissent: Imagery and Ideology in Jeffersonian America* (Ithaca: Cornell University Press, 1980), 75–94.

76. Quoted in ibid., 88–89.

77. For an analysis of nineteenth-century Protestantism and its dependence upon moralism and empirical evidence, see James Turner, *Without God, Without Creed: The Origins of Unbelief in America* (Baltimore: Johns Hopkins University Press, 1985).

78. William Gilmore Simms, "The Writings of Washington Allston," *Southern Quarterly Review* 4 (October 1843): 374.

79. Bjelajac, *Millennial Desire*, 5–8, 103–04.

80. Holmes criticized Martin's "scene-painting," "in the midst of which the actors were reduced to puppets, and the uncounted multitudes dwarfed away into bundles of pinheads." "Exhibition of Pictures Painted by W. Allston at Harding's Gallery, School Street," *North American Review* 50 (April 1840): 372. See also Bjelajac, *Millennial Desire*, 6–7.

81. Edward J. Nygren, "From View to Vision," in *Views and Visions: American Landscape before 1830*, Edward J. Nygren et al. (Washington, D.C.: Corcoran Gallery of Art, 1986), 18–76.

82. Thornton, *Cultivating Gentlemen*, 21–145.

83. Hannah Josephson, *The Golden Threads: New England's Mill Girls and Magnates* (New York: Duell, Sloan and Pearce, 1949), and Philip S. Foner, ed., *The Factory Girls* (Urbana: University of Illinois Press), xiv–xxi.

84. Quoted in Thornton, *Cultivating Gentlemen*, 132.

85. On the notion of semiverbal messages in images, see David Lubin, *Act of Portrayal: Eakins, Sargent, James* (New Haven: Yale University Press, 1985), 160, n. 50.

86. Nathan O. Hatch has challenged the traditional view that the Second Great Awakening was a socially integrative, stabilizing movement. *The Democratization of American Christianity* (New Haven: Yale University Press, 1989), 63.

87. *Jonathan Edwards: Basic Writings*, ed. Ola Elizabeth Winslow (New York: New American Library, 1978), 88.

88. Catherine L. Albanese, *Sons of the Fathers: The Civil Religion of the American Revolution* (Philadelphia: Temple University Press, 1976), 39.

89. Channing quoted in Elizabeth Palmer Peabody, *Reminiscences of Rev. Wm. Ellery Channing* (Boston: Roberts Brothers, 1880), 284–87.

90. David Robinson, *Apostle of Culture: Emerson as Preacher and Lecturer* (Philadelphia: University of Pennsylvania Press, 1982), 12–21. Reynolds, *Faith in Fiction*, 33–37.

91. Robert A. Ferguson writes of Brown's ventriloquist, Carwin, that he is "the first clear image of the romantic artist in American literature. His power of assuming any other voice, and hence any other identity, suggests the imagination transcending its own situation." *Law and Letters in American Culture*, 142.

92. Samuel Lorenzo Knapp, *Sketches of Public Characters Drawn from the Living and the Dead* (New York: E. Bliss, 1830), 196.

93. Ibid., 195.

94. Ibid., 195–96.

95. Quoted in Flagg, *Life of Allston*, 196.

96. Eagleton, *Ideology of the Aesthetic*, 8–9.

97. Flagg, *Life of Allston*, 195.

98. Reynolds, *Faith in Fiction*, 13–68; Nancy F.

Cott, *The Bonds of Womanhood: 'Woman's Sphere' in New England, 1780–1835* (New Haven: Yale University Press, 1977), 63–100.

99. Henry David Thoreau, *Walden and Other Writings of Henry David Thoreau*, ed. Brooks Atkinson (New York: Modern Library, 1950), 7. Thornton, *Cultivating Gentleman*, 141–72.

Culture and Landscape Experience

This essay was written during an academic leave funded by a grant from the Middlebury College Faculty Professional Development Fund and a J. Paul Getty Postdoctoral Fellowship in the History of Art and the Humanities. I would like to thank both institutions for their support. I would also like to thank Timothy Spears and David C. Miller for their close readings of earlier drafts of the essay.

1. James Fenimore Cooper, *The Pioneers, or The Sources of the Susquehanna; A Descriptive Tale* (1823; reprint, Albany: State University of New York Press, 1980), 294. On the popularity of *The Pioneers*, see Frank Luther Mott, *Golden Multitudes: The Story of Best Sellers in the United States* (New York: Macmillan, 1947), 305; James Franklin Beard, "Historical Introduction," in Cooper, *The Pioneers*, xxxviii-l; and James D. Wallace, *Early Cooper and His Audience* (New York: Columbia University Press, 1986), 163–69.

2. Basil Hall, *Travels in North America in the Years 1827 and 1828* (Edinburgh: Cadell, 1829), 1:96.

3. On the picturesque, see esp. Christopher Hussey, *The Picturesque: Studies in a Point of View* (London: F. Cass, 1927); Martin Price, "The Picturesque Moment," in *From Sensibility to Romanticism: Essays Presented to Frederick A. Pottle*, ed. Frederick W. Hilles and Harold Bloom (New York: Oxford University Press, 1965), 259–92; Malcolm Andrews, *The Search for the Picturesque: Landscape Aesthetics and Tourism in Britain, 1760–1800* (Stanford: Stanford University Press, 1989); and Sidney K. Robinson, *Inquiry into the Picturesque* (Chicago: University of Chicago Press, 1991).

4. See esp. Raymond Williams, "Base and Superstructure in Marxist Cultural Theory," *New Left Review* 82 (November–December 1973), repr. in Raymond Williams, *Problems in Materialism and Culture* (London and New York: Verso, 1980), 31–49; and idem, *Marx-ism and Literature* (Oxford and New York: Oxford University Press, 1977), 121–27.

5. Christopher Columbus, *The Four Voyages of Columbus*, ed. Cecil Jane, 2 vols. in 1 (1930 and 1933; reprint, New York: Dover Publications, 1988), 2:36; *Poems of Michael Drayton*, ed. John Buxton (Cambridge: Harvard University Press, 1953), 1:123; John Smith, *Captain John Smith: A Select Edition of His Writings*, ed. Karen Ordahl Kupperman (Chapel Hill: University of North Carolina Press, 1988), 235; Thomas Morton, *New English Canaan*, ed. Charles Francis Adams, Jr. (1637; reprint, Boston: Prince Society, 1883), 180; George Alsop, *A Character of the Province of Maryland* (1902; reprint, Freeport, N.Y.: Books for Libraries Press, 1972), 33.

6. Howard Mumford Jones, *O Strange New World: American Culture: The Formative Years* (New York: Viking, 1964), 13, 353. For other examples, see Charles L. Sanford, *The Quest for Paradise: Europe and the American Moral Imagination* (Urbana: University of Illinois Press, 1961), 9–18, 83–84; and Hugh Honour, *The New Golden Land: European Images of America from the Discoveries to the Present Time* (New York: Pantheon Books, 1975), 5–6.

7. Wayne Franklin, *Discoverers, Explorers, Settlers: The Diligent Writers of Early America* (Chicago: University of Chicago Press, 1979); Edward J. Nygren, *Views and Visions: American Landscape before 1830* (Washington, D.C.: Corcoran Gallery of Art, 1986); and Robert Lawson-Peebles, *Landscape and Written Expression in Revolutionary America* (Cambridge: Cambridge University Press, 1988).

8. The quoted phrases are from Lawson-Peebles, *Landscape and Written Expression*, 28, 57; and Franklin, *Discoverers, Explorers, Settlers*, 105, 107, 165, 155.

9. Michel Foucault, *The Order of Things: An Archaeology of the Human Sciences* (New York: Vintage Books, 1973), 30. Additional references to *The Order of Things* will be cited par-

enthetically by page. My argument in this section also builds on material in Marjorie Grene, *The Knower and the Known* (London: Faber & Faber, 1966); Richard Rorty, *Philosophy and the Mirror of Nature* (Princeton: Princeton University Press, 1979); and Timothy J. Reiss, *The Discourse of Modernism* (Ithaca: Cornell University Press, 1982).

10. Foucault, *Order of Things*, 29. I have modified the original translation.

11. Christopher Columbus, *The Journal of Christopher Colombus*, trans. Cecil Jane (New York: Bonanza Books, 1989), 192–94.

12. On Patinir, see Walter S. Gibson, "Mirror of the Earth": *The World Landscape in Sixteenth-Century Flemish Painting* (Princeton: Princeton University Press, 1989), 3–16. On the relation among the world landscape, contemporary cosmographies, and maps, see ibid., 48–59.

13. For examples, see Samuel Eliot Morison, *Admiral of the Ocean Sea: A Life of Christopher Columbus* (Boston: Little, Brown, 1942), 380; Jones, *O Strange New World*, 13, 353; Sanford, *Quest for Paradise*, 9–18, 83–84; Honour, *New Golden Land*, 5–6; Franklin, *Discoverers, Explorers, Settlers*, 1–6; and Lawson-Peebles, *Landscape and Written Expression*, 8–15.

14. Mary B. Campbell, *The Witness and the Other World: Exotic European Travel Writing, 400–1600* (Ithaca: Cornell University Press, 1988), 178–79. Although she sometimes falls back on the language of misprision and exaggerates the distinctiveness of the Columbian I, the central thrust of Campbell's argument is similar to mine. In addition to Campbell's study, my reading of Columbus has been most heavily influenced by the analysis of his epistemological assumptions in Tzvetan Todorov, *The Conquest of America: The Question of the Other*, trans. Richard Howard (New York: Harper & Row, 1984), 3–50.

15. Ernst Robert Curtius, *European Literature and the Latin Middle Ages*, trans. Willard R. Trask (New York: Pantheon, 1953), 195, 198, 192. More recent discussions of the *locus amoenus* include A. Bartlett Giamatti, *The Earthly Paradise and the Renaissance Epic* (New York: Norton, 1966), 34–47; and A. C. Spearing, *Medieval Dream-Poetry* (London:

Cambridge University Press, 1976), 17–18. See also Harry Levin, *The Myth of the Golden Age in the Renaissance* (Bloomington: Indiana University Press, 1969), 33–34, 59–60, 183–86.

16. The quotation from Helvétius is taken from Albert O. Hirschman, *The Passions and the Interests: Political Arguments for Capitalism before Its Triumph* (Princeton: Princeton University Press, 1977), 43. On the history of the idea of interest, see ibid.; C. B. MacPherson, *The Political Theory of Possessive Individualism* (Oxford: Oxford University Press, 1962); Joyce Appleby, *Economic Thought and Ideology in Seventeenth-Century England* (Princeton: Princeton University Press, 1978); and Milton L. Myers, *The Soul of Modern Economic Man: Ideas of Self-Interest, Thomas Hobbes to Adam Smith* (Chicago: University of Chicago Press, 1983). More generally, see Foucault, *Order of Things*.

17. On the emergence of the concept of objective, scientific knowledge, see Steven Shapin and Simon Schaffer, *Leviathan and the Air-Pump: Hobbes, Boyle, and the Experimental Life* (Princeton: Princeton University Press, 1985), 22–79; and Rorty, *Philosophy and the Mirror of Nature*, esp. 129ff. See also the discussion of probability, *opinio*, and knowledge in Ian Hacking, *The Emergence of Probability: A Philosophical Study of Early Ideas about Probability, Induction, and Statistical Inference* (Cambridge: Cambridge University Press, 1984), 18–48, 85–91, 166–75. On the concept of disinterestedness, see M. H. Abrams, "From Addison to Kant: Modern Aesthetics and Exemplary Art," in *Studies in Eighteenth-Century British Art and Aesthetics*, ed. Ralph Cohen (Berkeley: University of California Press, 1985); and Jerome Stolnitz, "On the Origins of 'Aesthetic Disinterestedness,'" *Journal of Aesthetics and Art Criticism* 20 (1961–62): 131–43; and idem, "On the Significance of Lord Shaftesbury in Modern Aesthetic Theory," *Philosophical Quarterly* 11 (April 1961): 97–113.

18. Bibliographical information in this and following paragraphs derives from Edward Godfrey Cox, *A Reference Guide to the Literature of Travel*, 2 vols. (1938; reprint, Seattle: Univ. of Washington Press, 1950).

19. Jean Ribaut, *Whole and true Discouerye of Terra*

Florida (London, 1563). I am quoting from the reprint, titled *The True and last discouerie of Florida*, in Richard Hakluyt, *Divers Voyages Touching the Discoverie of America* (1582; reprint, Ann Arbor: University Microfilms, 1966), E4r, F2r–F2v, G3r.

20. John Brereton, *Discoverie of the North Part of Virginia* (1602; reprint, Ann Arbor: University Microfilms, 1966), 1.

21. Smith, *Captain John Smith*, 211–12.

22. Examples include the translation of Peter Martyr's account of Columbus's first voyage in Richard Eden, *The Decades of the Newe Worlde* (1555; reprint, Ann Arbor: University Microfilms, 1966), 2–5; and the translation of Giovanni da Verrassano's letter describing his 1524 voyage in Hakluyt, *Divers Voyages*, C2r–G3v.

23. Ribaut, *True and last discouerie*, in Hakluyt, *Divers Voyages*, F2r–F2v; and James Rosier, *A True Relation of the most prosperous voyage* (1605), reprinted in *Sailors Narratives of Voyages along the New England Coast, 1524–1624*, ed. George Parker Winship (1905; reprint, New York: Burt Franklin, [1968]), 140.

24. Morton, *New English Canaan*, 180.

25. William Wood, *New England's Prospect* (1634; reprint, Amherst: University of Massachusetts Press, 1977), 41.

26. I am borrowing the distinction between residual and archaic from Raymond Williams, *Marxism and Literature*, 122. According to Williams, every "culture includes available elements of its past, but their place in the contemporary cultural process is profoundly variable. I would call the 'archaic' that which is wholly recognized as an element of the past, to be observed, to be examined, or even on occasion to be consciously 'revived,' in a deliberately specializing way. . . . The residual, by definition, has been effectively formed in the past, but it is still active in the cultural process, not only and often not at all as an element of the past, but as an effective element of the present."

27. Edward Bland, *The Discovery of New Brittaine* (1651; reprint, Ann Arbor: Readex Microprint, 1966). Although the sample is admittedly small, the supersession of the older usage is also evidenced by changing patterns in the titles of English travel narratives. According to Edward Cox's biblio-

graphical listing of narratives pertaining to North America, in the fifty years from the first listing in 1563 until 1612, 3 of 34 titles contained some form of *pleasant* in its title. In the fifty years between 1613 and 1662, only 2 of 72 did. Of the 106 titles listed for the period 1663–1712, the only one to adopt this usage was John Archdale's *New Description of that Fertile and Pleasant Province of Carolina* (1707).

28. On the importation of continental landscape art and ideas into sixteenth- and seventeenth-century England, see John Hayes, "British Patrons and Landscape Painting," *Apollo* 82 (July 1965): 38–45; Henry V. S. Ogden and Margaret S. Ogden, *English Taste in Landscape in the Seventeenth Century* (Ann Arbor: University of Michigan Press, 1955); and James Turner, *The Politics of Landscape: Rural Scenery and Society in English Poetry, 1630–1660* (Cambridge: Harvard University Press, 1979).

29. Robert Burton's *English Empire in America: Or a Prospect of his Majestes Dominions* (1685) was the only title to identify itself as a verbal image in the next fifty-year period (1663–1712). I suggest that this kind of title became less common not because pictorial discourse became less important—which is clearly not the historical case—but because it became increasingly specialized. As pictorial objectification came to be associated with the aesthetic appreciation of natural environments as landscapes, the connotations of verisimilitude and accuracy which had led to the first, broader usage were gradually obscured.

30. On incorporation, see Williams, *Marxism and Literature*, 122–27.

31. Alsop, *Character of the Province of Maryland*, 98. Additional references will be cited parenthetically.

32. On the history of the words *landskip* and *landscape*, see John Brinckerhoff Jackson, "The Meanings of 'Landscape,'" *Kulturgeographi* 88 (1965): 47–50; John Barrell, *The Idea of Landscape and the Sense of Place, 1730–1840: An Approach to the Poetry of John Clare* (Cambridge: Cambridge University Press, 1972), 1–3; James Turner, "Landscape and the 'Art Prospective' in England, 1584–1660," *Journal of the Warburg and Courtauld Institutes* 42 (1979): 290–93; Michael

Rosenthal, *British Landscape Painting* (Ithaca: Cornell University Press, 1982), 12–14; and Gibson, "Mirror of the Earth," 53–54.

33. Abrams, "From Addison to Kant," 33. See also Terry Eagleton, *The Ideology of the Aesthetic* (Oxford: Basil Blackwell, 1990), 13–30.

34. *The Prose Works of William Byrd of Westover*, ed. Louis Wright (Cambridge: Harvard University Press, 1966), 306.

35. On the reception of Dutch-Italianate and other styles of landscape in eighteenth-century England, see John Hayes, "British Patrons and Landscape Painting," *Apollo* 83 (March 1966): 188–97; 83 (June 1966): 444–51; and 85 (April 1967): 254–59.

36. On the picturesque as a naturalization of more complex Italianate models, see Deborah Howard, "Some Eighteenth-Century English Followers of Claude," *Burlington Magazine* 111 (December 1969): 726–33. Howard shows that over the course of the eighteenth century British collectors began to pay less attention to the human figures and associative content in their Italian landscapes and began to appreciate them as masterworks of naturalistic representation. Howard's point is not that British connoisseurs came to value Claude and the Roman landscapists less as they came to value Ruisdael and the more naturalist Dutch or, increasingly, British landscapists more, but that they stopped apprehending neoclassical landscapes as complex objects to be interpreted and began to apprehend them as picturesque landscapes to be appreciated.

37. Raymond Williams, *The Country and the City* (New York: Oxford University Press, 1973); Carole Fabricant, "Binding and Dressing Nature's Loose Tresses: The Ideology of Augustan Landscape Design," *Studies in Eighteenth-Century Culture* 8 (1979): 109–35; idem, "The Aesthetics and Politics of Landscape in the Eighteenth Century," in *Studies in Eighteenth-Century British Art and Aesthetics*, ed. Ralph Cohen (Berkeley: University of California Press, 1985); and John Barrell, *The Dark Side of the Landscape: The Rural Poor in English Painting, 1730–1840* (Cambridge: Cambridge University Press, 1980).

38. A particularly useful introduction to recent scholarship on the emergence of the middle class is Stuart Blumin, "The Hypothesis of Middle-Class Formation in Nineteenth-Century America: A Critique and Some Proposals," *American Historical Review* 90 (1985): 299–338. Of this scholarship, I have been most influenced by Mary Ryan, *Cradle of the Middle Class: The Family in Oneida County, New York, 1790–1865* (Cambridge: Cambridge University Press, 1981); and Stuart Blumin, *The Emergence of the Middle Class: Social Experience in the American City, 1760–1900* (Cambridge: Cambridge University Press, 1989).

39. "Catskill Mountain," *New-York Mirror* 4 (21 October 1826): 101. The moralization of the picturesque was an aspect of a larger cultural shift which Henry May described as the decline of the "moderate enlightenment" and the emergence of the "didactic enlightenment." More recent historians, including Gordon S. Wood and Ruth Bloch, have described this shift in terms of republican ideology. In this analysis, the dominant culture of the mid eighteenth-century colonies was commercial but not egalitarian. In these colonial societies, local political and social authority could be monopolized by the agricultural and mercantile elites because both the rulers and the ruled accepted the legitimacy of a social hierarchy founded on the disinterested civic virtue of the elites and the deference of the ruled. The rapid expansion of the market economy fostered by the exigencies of the Revolution led to the establishment of a more competitive and democratic society in which increasing numbers of individuals refused to defer and insisted that no one acted out of disinterested motives. The supersession of the cosmopolitan picturesque is best understood as an aspect of emergence of a more liberal society and of new classes of consumers who believed that all human actions were motivated by private interest. See esp. Henry F. May, *The Enlightenment in America* (New York: Oxford University Press, 1976); Gordon S. Wood, "Interests and Disinterestedness in the Making of the Constitution," in *Beyond Confederation: Origins of the Constitution and American National Identity*, ed. Richard Beeman et al. (Chapel Hill: University of North Carolina Press,

1987), 69–109; and Ruth Bloch, "The Gendered Meanings of Virtue in Revolutionary America," *Signs* 13 (1987): 37–58.

40. On the concept of naturalization, see Roland Barthes, *Mythologies*, trans. Annette Lavers (New York: Hill & Wang, 1972), 109–59.

41. Ann Bermingham, *Landscape and Ideology: The English Rustic Tradition, 1740–1860* (Berkeley: University of California Press, 1986); William Charvat, *The Origins of American Critical Thought, 1810–1835* (Philadelphia: University of Pennsylvania Press, 1936); Kenneth Myers, *The Catskills: Painters, Writers, and Tourists in the Mountains, 1820–1895* (Yonkers: Hudson River Museum of Westchester, 1987).

42. For a fuller reading of the imagery of pilgrimage in verbal and visual representations of the Catskills, see Myers, *The Catskills*, 51–55.

43. Marsiglia's engraving is reproduced in ibid., 47.

Making a Picture of the View from Mount Holyoke

This article is a slightly revised version of an essay that appeared in the *Bulletin of the Detroit Institute of Arts* 66, no. 1 (1990): 35–46. My thanks to Judith A. Ruskin, the Bulletin's editor, for suggesting I write an article on an aspect of Cole's drawings; and to Ellen Sharp, curator of graphic arts at the Detroit Institute, and Kathy Erwin, assistant curator, for their assistance and expertise. I also wish to express my thanks to Patricia Hills, Elizabeth Johns, David Lubin, Paul Mattick, Jr., Rodney Olsen, Phyllis Rosenzweig, Roger Stein, and the members of the Research Group in American Culture at the College of William and Mary for their critical reading of the manuscript and for many useful suggestions. This article is dedicated to the memory of Oswaldo Rodriguez Roque, who was the first to attempt a close study of Cole's *View from Mount Holyoke*.

1. Wolfgang Born, *American Landscape Painting, An Interpretation* (New Haven: Yale University Press, 1948), 80–86. See also Barbara Novak, *American Painting of the Nineteenth Century* (New York: Praeger, 1969): 75–77, 80; Matthew Baigell and Allen Kaufman, "Thomas Cole's 'Oxbow': A Critique of American Civilization," *Arts Magazine* 55, no. 5 (January 1981): 136–39; Oswaldo Rodriguez Roque, "The Oxbow by Thomas Cole: Iconography of an American Landscape Painting," *Metropolitan Museum Journal* 17 (1982): 63; and idem., "View from Mount Holyoke, Northampton, Massachusetts, after a Thunderstorm (The Oxbow)," in Metropolitan Museum of Art, *American Paradise, The World of the Hudson River School* (New York, 1987), 127.

2. Born used this phrase for the title of his chapter on the Hudson River School.

3. Oswaldo Rodriguez Roque published both drawings in conjunction with *The Oxbow*. See his "The Oxbow," 63–74; and "View from Mount Holyoke," 125–27. To my knowledge, Ellwood C. Parry III was the first to publish Cole's sketchbook drawing (fig. 4.3) with *The Oxbow*. See his "Landscape Theatre in America," *Art in America* 59, no. 6 (November 1971): 52–61.

4. For histories of tourism at these sites, see George Walter Vincent Smith Art Museum, *Arcadian Vales: Views of the Connecticut River Valley* (Springfield: Springfield Library and Museums Association, 1981); David Graci, *Mt. Holyoke, An Enduring Prospect: History of New England's Most Historic Mountain* (Holyoke: Calem, 1985); Jeremy Elwell Adamson, *Niagara: Two Centuries of Changing Attitudes* (Washington, D.C.: Corcoran Gallery of Art, 1985); Roland Van Zandt, *The Catskill Mountain House* (New Brunswick: Rutgers University Press, 1966); Kenneth Myers, *The Catskills: Painters, Writers, and Tourists in the Mountains* (Yonkers: Hudson River Museum of Westchester, 1987); Donald D. Keyes et al., *The White Mountains: Place and Perceptions* (Durham: University Art Galleries, University of New Hampshire, 1980). See also John F. Sears, *Sacred Places: American Tourist Attractions in the Nineteenth Century* (New York: Oxford University Press, 1989), esp. chaps. 1, 3, 4.

5. The theory of landscape tourism is a ne-

glected subject. For tourism in general, see Dean MacCannell, *The Tourist: A New Theory of the Leisure Class* (New York: Schocken Books, 1976). MacCannell considers tourism a central feature of modernization, arguing that it replicates, symbolically and ritualistically, "the empirical and ideological expansion of modern society." See also George Van den Abbeele, "Sightseers: The Tourist as Theorist," *Diacritics* 10, no. 4 (Winter 1980): 2–14, which reworks some of MacCannell's formulations.

6. For the early history of tourism on Mount Holyoke, see Graci, *Mt. Holyoke*, 1–18; Jill A. Hodnicki, "The Connecticut Valley in Literature," in *Arcadian Vales*, 11–26.

7. Main texts from the period we are concerned with are Theodore Dwight, *Sketches of Scenery and Manners in the United States* (New York: A. T. Goodrich, 1829), 9–24; Basil Hall, *Travels in North America in the Years 1827 and 1828*, 3 vols. (Edinburgh: Cadell; London: Simpkin and Marshall, 1829), 2:94–99; E. T. Coke, *A Subaltern's Furlough: Descriptive Scenes in Various Parts of the United States*, . . . *during the Summer of 1832*, 2 vols. (New York: J. & J. Harper, 1833), 1:191–92; Augustus E. Silliman, *A Gallop among American Scenery: Or, Sketches of American Scenes and Military Adventure* (New York: D. Appleton, 1843), 157–58.

8. Coke, *A Subaltern's Furlourgh*, 1:191–92.

9. The most comprehensive history of the panorama is Stephan Oettermann, *Das Panorama, Die Geschichte eines Massenmediums* (Frankfurt am Main: Syndicat, 1980). See also Ralph Hyde, *Panoramania!* (London: Trefoil, 1988); and [G. R. Corner,] "The Panorama: With Memoirs of its Inventor, and His Son, The Late Henry Aston Barker," *The Art-Journal*, new ser. 3 (February 1857): 46–47.

10. Oettermann, *Das Panorama*, 12–13.

11. See ibid., 7–41; Michel Foucault, *Discipline and Punish*, trans. Alan Sheridan (New York: Vintage Books, 1979): 195–228, 317 n. 4; and idem, "The Eye of Power," *Power/Knowledge, Selected Interviews and Other Writings 1972–1977*, ed. Colin Gordon, trans. Colin Gordon, Leo Marshall, John Mepham, Kate Soper (New York: Pantheon Books, 1980), 146–65. Foucault speculates that Bentham may have been inspired by Barker's panorama, but Bentham's own account seems to preclude this. See "Panopticon, or The Inspection-House," in *The Works of Jeremy Bentham*, ed. John Bowring (Edinburgh: William Tait, 1843), 4:37–172. For a recent analysis, see Robin Evans, "Bentham's Panopticon, An Incident in the Social History of Architecture," *Architectural Association Quarterly* 3, no. 2 (April–July 1971): 21–37.

12. It is impossible in a relatively short article to develop the historical bases for equating vision and power in landscape painting, although I would observe that the equation was never as abstract as it appears to be in Foucault's writings. It should also be said that in landscape painting the equation evolves from an identity between sight or vision and land ownership to metaphorical forms in which landscape comes to signify "a well-constructed survey of the nation's prospects" as seen through the eyes of an aristocratic elite. See James Turner, *The Politics of Landscape* (Oxford: Basil Blackwell, 1979); and idem, "Landscape and the 'Art Prospective' in England, 1584–1660," in *Journal of the Warburg and Courtauld Institutes* 42 (1979): 290–93; and Carole Fabricant, "The Aesthetics and Politics of Landscape in the Eighteenth Century," in *Studies in Eighteenth-Century British Art and Aesthetics*, ed. Ralph Cohen (Berkeley: University of California Press, 1985), 49–81.

13. Coke, *A Subaltern's Furlough*, 192.

14. Dwight, *Sketches of Scenery*, 16–17. Interestingly enough, Dwight undertook this "hopeless task," supplementing his written account with a very crude drawing of his own showing a view of the Connecticut Valley and a corner of a cliff, which in all probability he inserted in order to give some indication of the height from which the view was taken (plate facing p. 17).

15. Blake Nevius, *Cooper's Landscapes: An Essay on the Picturesque Vision* (Berkeley: University of California Press, 1976), 27.

16. William Gilpin, *Observations on the River Wye, and Several Parts of South Wales, &c. relative chiefly to Picturesque Beauty: Made in the Year 1770*, 5th ed. (London: T. Cadell Junior and W. Davies, 1800), 128f.

17. Cited in Nevius, *Cooper's Landscapes*, 28.

18. In Louis LeGrand Noble, *The Life and Works of Thomas Cole*, ed. Elliot S. Vesell (Cambridge: Harvard University Press, Belknap Press, 1964), 65; Nevius, *Cooper's Landscapes*, 28, also takes note of this passage.

19. Thomas Cole to Daniel Wadsworth, August 4, 1827, in Bard McNulty, ed., *The Correspondence of Thomas Cole and Daniel Wadsworth* (Hartford: Connecticut Historical Society, 1983), 10–11.

20. See Basil Hall, *Forty Etchings, From Sketches Made with the Camera Lucida, in North America in 1827 and 1828* (Edinburgh: Cadell; London: Simpkin, Marshall, and Man, Boys & Graves, 1829), pl. 11; and idem, *Travels in North America*. Rodriguez Roque, "The Oxbow," 68, and "View from Mount Holyoke," 126, argued that Cole's familiarity with Hall's etching implied a familiarity with his travel volumes and that *The Oxbow* represented the artist's nationalistic response to Hall's generally unflattering account of American society and landscape. The latter part of Rodriguez Roque's argument, it appears to me, lacks plausibility since Hall had nothing but praise for the view from Mount Holyoke, which he found "really splendid, and . . . otherwise most satisfactory for travellers" (*Travels* 2:94). Martha Hoppin, "Arcadian Vales: The Connecticut Valley in Art," in *Arcadian Vales*, 35, first observed the relation between Cole's drawing and Basil Hall's etching. Parry, "Landscape Theater," 58–59, earlier published Hall's etching along with Cole's sketchbook drawing of the view from Mount Holyoke (fig. 4.3) but left unnoticed Cole's tracing.

21. Rodriguez Roque, "The Oxbow," 68, and "View from Mount Holyoke," 126.

22. Ellwood C. Parry III, *The Art of Thomas Cole* (Newark: University of Delaware Press, 1988), 172.

23. There can be no doubt that *The Oxbow* is based upon the drawing under discussion (fig. 4.3). Supplementing the visual evidence is a letter the artist wrote his patron Luman Reed (March 2, 1836, Cole Papers, New York State Library, box 1, folder 2): "I have already commenced a view from Mt. Holyoke—it is about the finest scene I have in my sketchbook & is well known."

24. Rodriguez Roque, "The Oxbow," 68.

25. Noble, *Life of Thomas Cole*, 119. Parry has twice published this drawing ("Landscape Theater," 57, and *The Art of Thomas Cole*, 125) and has argued for Cole's familiarity with Vanderlyn's panorama and the London panoramas of Robert Barker's son, Henry Aston Barker.

26. It is in theory possible to represent an entire panorama on a single rectangular or square sketchbook leaf, although the details of landscape or cityscape would have to be drawn in miniature. Actual panorama proportions varied, but some idea of the typical height-to-width ratio can be gathered from the fact that Robert Barker's London panorama had a height-to-width ratio of approximately seven to fifty-four.

27. Letter cited in n. 23 above.

28. As far as I can tell only three attempts to represent the view from Mount Holyoke precede Cole's painting: the print that appeared in Theodore Dwight's *Sketches*; Hall's etching; and a lithograph after Orra White Hitchcock showing "West View from Holyoke," which appeared in Hitchcock's *Report on the Geology, Mineralogy, Botany, and Zoology of Massachusetts* (Amherst, 1833), Atlas of Plates, no. V; reproduced in Parry, *The Art of Thomas Cole*, 174. None of these works would have been particularly well known.

29. "National Academy of Design: Eleventh Annual Exhibition," *Knickerbocker Magazine* 8, no. 1 (July 1836): 115.

30. See Albert Ten Eyck Gardner and Stuart P. Feld, *American Paintings: A Catalogue of the Collection of the Metropolitan Museum* (New York: Metropolitan Museum of Art, 1965), 1:229, for *The Oxbow*'s exhibition history.

31. See Henry M. Sayre, "Surveying the Vast Profound: The Panoramic Landscape in American Consciousness," *Massachusetts Review* 24 (Winter 1983): 723–42, for a broad outline history of "the panoramic landscape in American consciousness." Sayre's analysis focuses on literary representations, but it has, I believe, important implications for the line of argument pursued here.

1. Paul R. Baker, *The Fortunate Pilgrims: Americans in Italy, 1800–1860* (Cambridge: Harvard University Press, 1964), 20–21. Regina Soria points out that after Washington Allston's Italian visit (the first decade of the century) American artists did not really return to Italy until 1825: *Dictionary of Nineteenth-Century American Artists in Italy, 1760–1914* (London: Associated University Presses, 1982), 31.

2. C. P. Brand, *Italy and the English Romantics: The Italianate Fashion in Early Nineteenth-Century England* (Cambridge: Cambridge University Press, 1957), 3, 228. Brand mentions that the publication of travel books and articles on Italy was at its greatest volume during the decade from 1819 to 1828 (23) and that "a crowd of . . . English painters" copied old masters and sketched landscapes in this period (141, 168).

3. This is Emerson's title for one of his own exercises in implied national self-definition: *English Traits*, ed. Howard Mumford Jones (Cambridge: Harvard University Press, 1966).

4. A recent study of the vexed American process of developing a literary voice both in terms of and in opposition to the British voice is Robert Weisbuch, *Atlantic Double-Cross: American Literature and British Influence in the Age of Emerson* (Chicago: University of Chicago Press, 1986).

5. Emerson, *Journals*, ed. Alfred R. Ferguson (Cambridge: Harvard University Press, 1964), 4:78.

6. Joy S. Kasson carries this critical assumption, present in most of the works on Cole and Cooper that I will cite below, into her study of the European phases of their careers. See the chapters on Cole and Cooper in her *Artistic Voyagers: Europe and the American Imagination in the Works of Irving, Allston, Cole, Cooper, and Hawthorne* (Westport, Conn.: Greenwood Press, 1982). James T. Callow explains the context of their association in New York in *Kindred Spirits: Knickerbocker Writers and American Artists, 1807–1855* (Chapel Hill: University of North Carolina Press, 1967).

7. For helpful chronologies, see Ellwood C. Parry III, *The Art of Thomas Cole: Ambition and Imagination* (Newark: University of Delaware Press, 1988), 375–78, and Cooper, *Gleanings in Europe: Italy*, ed. John Conron and Constance Ayers Denne (Albany: State University of New York Press, 1981), xviii.

8. George Hillard, *Six Months in Italy* (Boston: Ticknor, Reed, and Fields, 1853), 11–12.

9. Sandra Gilbert, "From *Patria* to *Matria*: Elizabeth Barrett Browning's Risorgimento," *PMLA* 99, no. 2 (March 1984): 196.

10. Goethe's conclusion that Rome is not a "supplement" to the tourist's identity but instead a catalyst for its transformation influences such later travelers as Margaret Fuller: *Italian Journey*, trans. W. H. Auden and Elizabeth Mayer (1962; reprint, San Francisco: North Point Press, 1982), 412; *Italienische Reise*, ed. Herbert von Einem and with commentary by Peter Sprengel (Munich: Goldmann, 1986), 400. Another way of suggesting the risk that Italian travel poses to identity appears of course in the tradition of Gothic fiction, which produces Ann Radcliffe's *The Mysteries of Udolpho* (1794). English perceptions of north/south polarities reflect northern attitudes generally. For similar French and German approaches, see Stendhal's 1826 edition of *Rome, Naples et Florence* and the third and fourth volumes (1830–31) of Heinrich Heine's *Reisebilder*.

11. W. J. T. Mitchell, *Iconology: Image, Text, Ideology* (Chicago: University of Chicago Press, 1986), 110.

12. Baker, *Fortunate Pilgrims*, 27–28, 200; Brand, *Italy and the English Romantics*, 3; Van Wyck Brooks, *The Dream of Arcadia: American Writers and Artists in Italy 1760–1915* (New York: Dutton, 1958), 15, 31; Nathalia Wright, *American Novelists in Italy. The Discoverers: Allston to James* (Philadelphia: University of Pennsylvania Press, 1965), 31. Cole's paintings, according to Alan Wallach, show an extensive engagement with Byron: "Cole, Byron, and *The Course of Empire*," *Art Bulletin* 50, no. 4 (December 1968): 375–79. Cooper's remarks on both writers reveal an ambivalent reaction to this predominance. For his irritation with French discussions of *Cori-*

nne, see his *Gleanings in Europe: France*, ed. Thomas Philbrick and Constance Ayers Denne (Albany: State University of New York Press, 1983), 184. Of Byron, whose works he seems to know quite well, Cooper says he disliked his character, although "he was certainly a man of great genius": *Letters and Journals*, 1:405.

13. Byron, *Poetical Works*, ed. Frederick Page and John Jump (Oxford: Oxford University Press, 1970), 233, 237.

14. Germaine de Staël, *Corinne, or Italy*, trans. and ed. Avriel H. Goldberger (New Brunswick: Rutgers University Press, 1987), 19–22. See William L. Vance, *America's Rome*, 2 vols. (New Haven: Yale University Press, 1989), 1:4–5, 184–88, for examples of the ways in which the Capitol building, designed by Michelangelo, and the Capitoline hill in general, with its views and sculpture galleries, prompted both historical and aesthetic associations in American visitors.

15. Staël, *Corinne, or Italy*, 315; Madame de Staël, *Corinne ou l'Italie*, ed. Simone Balayé (Paris: Gallimard, 1985), 447.

16. Kenneth Churchill, *Italy and English Literature 1764–1930* (London: Macmillan, 1980), 3, 23.

17. Terry Eagleton, *The Ideology of the Aesthetic* (Oxford: Basil Blackwell, 1990), 27–28, 116, 40–41, 28, 118.

18. Bruce Chambers provides an illuminating reading of Cole's Italian compositions in "Thomas Cole and the Ruined Tower," *Currier Gallery of Art Bulletin* (Fall 1983):11–12.

19. Neil Harris, *The Artist in American Society: The Formative Years, 1790–1860* (New York: George Braziller, 1966), 146, 159, 168.

20. Longfellow grapples with this problem in his sketchbook of 1833–34, *Outre-Mer*, in which he concludes that the sensual beauties of southern European religious art and verse are best managed by the educated Protestant spectator, who knows how to subordinate their sensual impact to "the comtemplation of . . . the Eternal Mind": *Outre-Mer and Drift-Wood*, Introduction by Horace E. Scudder (Boston: Houghton, Mifflin, 1886), 187; see also 190–94.

21. Wallach, "Cole, Byron, and *The Course of Empire*," 377.

22. Cecilia Powell, *Turner in the South: Rome, Naples, Florence* (New Haven: Yale University Press, 1987), 166, 170.

23. Barbara Novak mentions this prevalence of "Claudian conventions" in depictions of the Italian landscape in *Nature and Culture: American Landscape and Painting 1825–1875* (New York: Oxford University Press, 1980), 214.

24. Dean MacCannell, *The Tourist: A New Theory of the Leisure Class* (New York: Schocken Books, 1976), 77, 82–84.

25. Hillard, *Six Months in Italy*, quoted in Novak, *Nature and Culture*, 209.

26. See, for example, the engraving of Allston's *Moonlit Landscape* by George B. Ellis in *The Atlantic Souvenir* of 1828 (Philadelphia: Carey, Lea, & Carey), and Turner's view of Florence, which Parry thinks Cole may have seen (192), in *The Amulet*, ed. S. C. Hall (London: Westley & Davis, 1831).

27. For information on *Italy* and its publication history, see J. R. Hale, Introduction, *The Italian Journal of Samuel Rogers* (London: Faber & Faber, 1956). For information on his collaboration with Turner, see Powell, *Turner in the South*, 131–36, and Adele M. Holcomb, "A Neglected Classical Phase of Turner's Art: His Vignettes to Rogers's *Italy*," *Journal of the Warburg and Courtauld Institutes* 32 (1969): 405–10. In some of the cheaper editions, Turner's landscapes disappeared and only Stothard's figures remained.

28. Cooper, *Letters and Journals*, 1:263–64, and 2:178; Parry, *The Art of Thomas Cole*, 100, 103, 211.

29. Samuel Rogers, *Italy* (London: Edward Moxon, 1859), 257, 178, 243.

30. Wright, *American Novelists in Italy*, 142.

31. I am borrowing Gilbert's language here: "Female Italy neither contains nor condones the super-egoistic repressions that characterize patriarchal England" (196).

32. Cole adds, "I found myself a nameless, noteless individual, in the midst of an immense selfish multitude." Most recently quoted in Parry, *The Art of Thomas Cole*, 102.

33. Catharine Maria Sedgwick, *Letters from Abroad to Kindred at Home* (New York: Harper & Bros., 1841), 1:111–12.

34. Cooper, *Gleanings in Europe: England*, ed. Donald A. Ringe, Kenneth W. Staggs, James P. Elliott, Robert D. Madison (Albany: State

University of New York Press, 1982), 259.

35. Emerson, *English Traits*, 60. See Christopher Mulvey's discussion of Emerson's view of the mechanization of British life in *Transatlantic Manners: Social Patterns in Nineteenth-Century Anglo-American Travel Literature* (Cambridge: Cambridge University Press, 1990), 187–88.

36. Fuller, *At Home and Abroad*, ed. Arthur B. Fuller (1856; reprint, Port Washington, N.Y.: Kennikat Press, 1971), 400.

37. Cooper, *Letters and Journals*, 2:371.

38. Louis L. Noble, *The Life and Works of Thomas Cole*, ed. Elliot S. Vesell (Cambridge: Harvard University Press, 1964), 103.

39. Cooper, *Italy*, 21.

40. Kasson, *Artistic Voyagers*, 98, 101–04.

41. Cole, letter to William Dunlap, quoted in Noble, *Life of Thomas Cole*, 125.

42. A. William Salomone, "The Nineteenth-Century Discovery of Italy: An Essay in American Cultural History. Prolegomena to a Historiographical Problem," *American Historical Review* 73, no. 5 (June 1968): 1364, 1360, 1369. Brand notices a similar lapse of "serious" historical writings on either past or present Italy in England between the efforts of Gibbon and Roscoe in the late eighteenth century and the resumption of "conscientious" research in the 1840s (187, 195).

43. Otto Wittmann, "The Attraction of Italy for American Painters," *Antiques*, May 1964, 553.

44. I have discussed Washington Irving's treatment of Italy in *Tales of a Traveller* (1824) elsewhere: "Irving's Italian Landscapes: Skepticism and the Picturesque Aesthetic," *ESQ: A Journal of the American Renaissance* 32, no. 1 (1986): 1–22.

45. Conron and Denne, Historical Introduction, in Cooper, *Italy*, xxxix. Another approach to Cooper's visual habits is Donald A. Ringe, *The Pictorial Mode: Space and Time in the Art of Bryant, Irving and Cooper* (Lexington: University Press of Kentucky, 1971).

46. Robert E. Spiller, *Fenimore Cooper: Critic of His Times* (New York: Minton, Balch, 1931), chap. 12.

47. John P. McWilliams, *Political Justice in a Republic: James Fenimore Cooper's America* (Berkeley: University of California Press, 1972), 183.

See also his discussion of *The Bravo*, 154–66.

48. Donald Ringe, Introduction to *The Bravo*, ed. D. Ringe (New Haven: College and University Press, 1963): Ringe summarizes several critical readings of the political debate in which the novel is involved on pp. 8–9. A recent analysis of *The Bravo* that establishes its American political and social context in greater detail is chap. 2 in Robert S. Levine, *Conspiracy and Romance: Studies in Brockden Brown, Cooper, Hawthorne, and Melville* (Cambridge: Cambridge University Press, 1989).

49. Cooper, *England*, 103, 107.

50. Elizabeth McKinsey, *Niagara Falls: Icon of the American Sublime* (Cambridge: Cambridge University Press, 1985), 111. Like many Italian landscapes, Weir's portrait of Red Jacket also entered popular culture via the medium of the gift annual; an engraving of it, together with an anonymous poem inspired by it, appeared in *The Talisman* of 1829 (New York: Elam Bliss).

51. References: reproduced in *Antiques* 101 (June 1972): 981. See also *The Arcadian Landscape: Nineteenth-Century American Painters in Italy*, exh. cat., text by Charles C. Eldredge and Barbara Novak (Lawrence: University of Kansas Museum of Art, 1972), item no. 43.

52. Eldredge uses this phrase to describe American impressions of Italy in general: *The Arcadian Landscape*, vi.

53. Blake Nevius gives a very helpful reading of these scenes in *Cooper's Landscapes: An Essay on the Picturesque Vision* (Berkeley: University of California Press, 1976), 49–55.

54. Matthew Baigell, *Thomas Cole* (New York: Watson-Guptill, 1981), 46. In thinking about Cole's Italian work, I have also consulted *The Italian Presence in American Art 1760–1860*, ed. Irma B. Jaffe (New York: Fordham University Press, 1989); and *Fair Scenes and Glorious Works: Thomas Cole in Italy, Switzerland, and England*, exh. cat., text by Kathleen Erwin (Detroit: Detroit Institute of Arts, 1991).

55. Elizabeth Ourusoff, "*View of Florence from San Miniato*," *Bulletin of the Cleveland Museum of Art* 49 (1962): 17, 18. Her article is the best I have read on the painting.

56. Women tourists sometimes shift between

an identification with Italy and an identification with the male voice. See Anna Jameson's popular *Diary of an Ennuyée* (1826) for an English example of a largely successful negotiation between these two positions, although sometimes she stretches a bit in borrowing the masculine terms of tourist desire; as she describes a landscape near Perugia, she says, the "mist sank gradually to the earth, like a veil dropped from the form of a beautiful woman, and nature stood disclosed in all her loveliness" (Boston: Ticknor & Fields, 1857), 121.

57. Gaston Bachelard, *The Poetics of Reverie*, trans. Daniel Russell (Boston: Grossman, 1969), 167.

58. Washington Allston, *Lectures on Art and Poems*, ed. Richard Henry Dana, Jr. (New York: Baker & Scribner, 1850), 70, 60, 74.

59. Cole's entry of Sept. 1847 appears in Noble, *Life of Thomas Cole*, 281–82.

60. Cooper, *Gleanings in Europe: The Rhine*, ed. Ernst Redekop, Maurice Geracht, Thomas

Philbrick (Albany: State University of New York, 1986), 157–58.

61. A brief example of recent discussions of the ideological implications of Burke's gendered aesthetics appears in Mitchell, *Iconology*, 129–30.

62. Emerson, *English Traits*, 21.

63. Laura Mulvey, *Visual and Other Pleasures* (Bloomington and Indianapolis: Indiana University Press, 1989), 19.

64. I am relying on David Bjelajac's description of the New England clerisy's attempt to control social change through art and other institutions: *Millennial Desire and the Apocalyptic Vision of Washington Allston* (Washington, D.C.: Smithsonian Institution Press, 1988), 148. See also the publication of Cole's and Cooper's thoughts on and images of landscapes in *The Home Book of the Picturesque* (New York: George P. Putnam, 1852), together with contributions by other writers, painters, and clergymen.

Bingham and the Market

1. M. J. Heale, "The Role of the Frontier in Jacksonian Politics—Davy Crockett and the Myth of the Self-Made Man," *Western Historical Quarterly* 4 (1973): 405–23.

2. Quoted in George E. Probst, ed., *The Happy Republic: A Reader in Tocqueville's America* (Gloucester, Mass.: Peter Smith, 1968), 138.

3. Peter C. Marzio, "The Not-So-Simple Observation of Daily Life in America," in Peter C. Marzio and Edward J. Nygren, *Of Time and Place: American Figurative Art from the Corcoran Gallery* (Washington, D.C.: Corcoran Gallery of Art, 1981), 179, notes the combining of fine arts conventions with everyday subject matter as a steady feature of genre in America. See also Edward J. Nygren, "American Art: Its Changing Form and Content," in *Of Time and Place*, 10–11.

4. Bingham's trip to the East in 1838 brought with it self-consciousness about his own contribution to the gallery of national types just emerging in eastern genre painting. The work of William Sidney Mount offered a formula Bingham would soon adopt: regional character types involved in definably American activities.

5. Kenneth S. Lynn, ed., *The Comic Tradition in*

America (New York: Doubleday Anchor Books, 1958), 106.

6. This mythical reading of the *Fur Traders* is summarized by Nancy Rash, *The Painting and Politics of George Caleb Bingham* (New Haven: Yale University Press, 1991), 4–5.

7. For a related interpretation, see Dawn Glanz, *How the West was Drawn: American Art and the Settling of the Frontier* (Ann Arbor: UMI Research Press, 1982), 43. The awareness of the market as an element in Bingham's vision of the West is still recent in the scholarship on Bingham, to wit, in Rash, *George Caleb Bingham*, esp. 45–54.

8. Robert Baird, quoted in *North American Review* 16 (1832): 60.

9. E. Maurice Bloch, *The Paintings of George Caleb Bingham: A Catalogue Raisonné* (Columbia: University of Missouri Press, 1986), 18, states the influence even more definitively. See also Rash, *George Caleb Bingham*, 44. Nowhere else did Bingham repeat this rigorously panoramic composition. The majority of his river paintings locate the figural subject in the center of the river or along its banks, so that the observer looks back into deep space rather than being

drawn along by the horizontal movement of the boat.

10. See Curtis Dahl, "Mark Twain and the Moving Panoramas," *American Quarterly* 13, no. 1 (Spring 1961): 31.

11. Henry Adams, "A New Interpretation of Bingham's 'Fur Traders Descending the Missouri,'" *Art Bulletin* 65 (1983): 675–80.

12. See *Literary World* 1 (April 3, 1847): 209; *Literary World* 2 (October 23, 1847): 277. On American audiences' preference for "ideal" or elevated subject matter, see Elizabeth Johns, "The Missouri Artist as Artist," in *George Caleb Bingham*, ed. Michael Edward Shapiro et al. (St. Louis: St. Louis Art Museum and Harry N. Abrams, 1990), 95.

13. See Charles D. Collins, "A Source for Bingham's 'Fur Traders Descending the Missouri,'" *Art Bulletin* 66, no. 4 (December 1984): 678–81. Deas never exhibited *The Voyageurs* at the American Art-Union.

14. See Theodore Stebbins, ed., *A New World: Masterpieces of American Painting, 1760–1910* (Boston: Museum of Fine Arts, 1983), 261.

15. This colonial relation between the Empire State and the frontier West was baldly stated in "The Spirit of the Age," *Knickerbocker Magazine*, August 1836, 194–95, in which the author asserted that New York State would unlock "the treasures of the great West" and by securing access to eastern markets also secure western tribute "and the advantage of controlling its rapidly growing trade for ever." Hans Bergmann, "Panoramas of New York, 1845–1860," *Prospects* 10 (1985): 119–37, discusses the ideological function of panoramic prints and written narratives in rendering the city into "a single, comprehensible whole" that furnished evidence of the rationalizing power of the mercantile economy (119–20). Bird's-eye views proliferated throughout the nineteenth century.

16. Glanz, *How the West Was Drawn*, 42. Glanz, however, reads *Fur Traders* as an instance of the Enlightenment ideal of a benign fusion of native and European stock. The fact that Bingham changed the painting's title when he exhibited it in New York indicates to me an acknowledgment of eastern anxieties about racial mixing.

17. See Mikhail Bakhtin, *The Dialogic Imagination: Four Essays by M. M. Bakhtin*, ed. Michael Hol-

quist (Austin: University of Texas Press, 1981). Holquist defines the term (428) as "that which insures the primacy of context over text." I use the concept in reference to the relation in Bingham's work of a high art aesthetic to the varied meanings that surround his subject matter and decenter his efforts at formal and stylistic control.

18. A good example of the geopolitical faith is Daniel Drake's conclusion to an 1834 peroration: "Rest the political and social upon the physical—and they will be preserved from all serious revolutions, but those which change the surface of the earth itself." Drake, "Discourse on the History, Character, and Prospects of the West" (1834; reprint, Gainesville, Fla.: Scholars' Facsimiles and Reprints, 1955), 51.

19. John Filson, *The Discovery, Settlement, and Present State of Kentucke* (1784; reprint, Ann Arbor: University Microfilms, 1966), 38–39.

20. An excellent example of a surviving western vernacular is the marvelously bizarre woodcuts that appeared in the so-called Davy Crockett almanacs; they defied all the conventions of high art, including consistent scale, perspective, and narrative credibility.

21. See, for instance, "Improvement of Western Rivers," *Western Journal and Civilian* 6, no. 1 (April 1851): 3, in which the writer alludes to the western states' "colonial dependence on the East."

22. See Johns, "The Missouri Artist," 93, on this designation. Rash, *George Caleb Bingham*, 8, 42, takes the title as a sign of the virtual identity between Bingham's regional status and his nationalism. I find this identity to be far more problematic, both from the standpoint of western autonomy vis-à-vis the East and from an eastern perspective that was never entirely comfortable with regional subject matter unless it was heroicized, sanitized, or made condescendingly humorous.

23. "The New World and the New Man," *Atlantic Monthly* 2, no. 12 (October 1858): 518–19.

24. See "Present Population and Future Prospects of the Western Country," *Western Monthly Review* 1 (October 1827): 331.

25. This Whig pose of disinterestedness may have influenced Bingham's uncaricatured

treatment of the squatter class of settlers in his painting of 1850 entitled *The Squatters*. This pose later gave way to undisguised revulsion. See below.

26. These years are generally conceded to be the period of his finest production. See Paul C. Nagel, "The Man and His Times," in *George Caleb Bingham*, ed. Shapiro, 28.

27. Bingham's Whig belief in the importance of encouraging manufacturing and trade in the West was programatically stated in a series of political banners he painted for the successive Whig presidential campaigns of William Henry Harrison and Clay in 1840 and 1844. See John McDermott, *George Caleb Bingham, River Portraitist* (Norman: University of Oklahoma Press, 1959), 35–36, 46–47; Rash, *George Caleb Bingham*, 14–32.

28. The case has been argued by Rash, *George Caleb Bingham*, esp. 1–6.

29. Bingham briefly studied at the Pennsylvania Academy of Fine Arts from March to June 1838 during a trip east for that purpose. On the influence of drawing manuals, see Peter C. Marzio, *The Art Crusade* (Washington, D.C.: Smithsonian Institution Press, 1976).

30. Bingham's debt to Renaissance sources was first pointed out in 1935 by Arthur Pope, quoted in McDermott, *River Portraitist*, 185–87. More recently, Robert Rosenblum and H. W. Janson have made the connection in *Nineteenth-Century Art* (New York: Harry N. Abrams, 1984), 184.

31. Critics attacked Bingham's reliance on geometric forms to contain the often boisterous actions he portrayed: "In composition, Mr. B. should be aware that the regularity of the pyramid is only suitable to scenes of the utmost beauty and repose; that when motion and action are to be represented, where expression and picturesqueness are objects sought for, proportionate departures must be made from this formal symmetry." "The Fine Arts. The Art-Union Pictures," *Literary World* 2 (October 23, 1847): 277.

32. Kenneth S. Lynn, *Mark Twain and Southwestern Humor* (Boston: Little, Brown, 1959), 52.

33. Like the Southwestern humorists, he allied himself politically and personally with powerful individuals in Missouri,

most notably his lifetime friend and supporter James Rollins.

34. Ibid., 64.

35. The phrase is Lynn's, ibid., 66.

36. An important aspect of this was Bingham's Unionism, demonstrated by his enlistment in the Army of the Union. More generally Bingham remained committed to federal authority. See McDermott, *River Portraitist*, 131, 135.

37. Ibid., 188. His view was repeated by John Demos, "George Caleb Bingham as Social Historian," *American Quarterly* 17 (1965): 218–28. Rash, *George Caleb Bingham*, counters this view.

38. Bingham's proposed political banner for Boone County Whigs in the presidential campaign of Henry Clay in 1844 depicted "old Daniel Boone himself engaged in one of his death struggles with an Indian. . . . It might be emblimatical (sic) also of the early state of the west, while on the other side I might paint a landscape with 'peaceful fields and lowing herds' indicative of his present advancement in civilization." Quoted in C. B. Rollins, ed., "Letters of George Caleb Bingham to James S. Rollins," *Missouri Historical Review* 32 (October 1937–July 1938): 13–14.

39. See McDermott, *River Portraitist*, 46.

40. See Marzio, "The Not-So-Simple Observation of Daily Life," 183, on the influence of classical principles of design in American genre. Bingham formalized his ideas about art in an address—"Art, the Ideal of Art, and the Utility of Art"—written toward the end of his life. It is reproduced in McDermott, *River Portraitist*, 394–401.

41. "Development of Nationality in American Art," by W, *Bulletin of the American Art-Union* 4 (December 1851): 139. Bloch, *Paintings of George Caleb Bingham*, 14, identifies the author of the article as Thomas W. Whitley, who at the time was waging a campaign against the American Art-Union.

42. *St. Louis Weekly Reveille*, August 24, 1846, 977, as quoted in Ron Tyler, "George Caleb Bingham, the Native Talent," in *American Frontier Life: Early Western Painting and Prints* (Fort Worth: Amon Carter Museum and Abbeville Press, N.Y., 1987), 30.

43. "Fine Arts," *Western Journal and Civilian* 7, no. 2 (November 1851): 145. The subject of

this encomium was Bingham's *Election Scene*, exhibited in his St. Louis studio.

44. *New Orleans Daily Picayune*, March 18, 1853, supplement, 1, proclaimed Bingham's *County Election* "AN AMERICAN WORK OF ART," and in the same article wrote that Bingham was "to the Western what Mount is to the Eastern States, as a delineator of national customs and manners. Both are original and both occupy very honorable places in the ranks of American artists." Quoted in McDermott, *River Portraitist*, 97.

45. Emphasis added. "The Gallery.—No. 4," *Bulletin of the American Art-Union* 2, no. 5 (August 1849): 10. A related review appeared in the *Bulletin* (December 1850).

46. *Missouri Republican*, November 30, 1847. Quoted in McDermott, *River Portraitist*, 65.

47. See Marzio, 'The Not-So-Simple Observation of Daily Life,' 183, on the concept of types in Joshua Reynolds's *Discourses* and "basic to nineteenth-century aesthetics."

48. Samuel F. B. Morse, "Lectures on the Affinity of Painting with the Other Fine Arts," ed. Nicolai Cikovsky, Jr. (Columbia: University of Missouri Press, 1983). Hugh Blair, Henry Home, Lord Kames, and Reynolds all influenced Bingham. See Cikovsky, ibid., 23.

49. Rash, *George Caleb Bingham*, 3.

50. Lillian B. Miller, "Paintings, Sculpture, and the National Character, 1815–1860," *Journal of American History* 53, no. 4 (March 1967): 700. In the South, according to Miller, nationalism was "rejected for sectionalism."

51. James Hall, *Letters from the West* (Gainesville, Fla.: Scholars' Facsimiles and Reprints, 1967), 229–31. Bingham's own attitude toward the role of these boatmen in the coming order of western society is revealed in their absence from his Election series, as noted by Gail Husch, "George Caleb Bingham's 'The County Election': Whig Tribute to the Will of the People," *American Art Journal* 19, no. 4 (1987): 36. Rash, *George Caleb Bingham*, 67–68, contends that riverboatmen in flatboats and keelboats remained an active presence on the river through the 1840s, distinguishing them from the fur traders who plied the river during the earlier phases of western river life. However, their days were numbered. "Progress of the Great West," *De Bow's Commercial Review* 4, no. 1 (September 1847): 50, concluded that "the first steamboat that ascended the Ohio sounded their death-knell."

52. Bingham wrote to Rollins about *The Verdict of the People*, "The subject will doubtless strike you as one well calculated to furnish that contrast and variety of expression which confers the chief value upon pictures of this class." "Letters," April 16, 1854, *Missouri Historical Review* 32: 180.

53. "Letters," *Missouri Historical Review* 32: 347.

54. From the *Missouri Republican*, quoted in McDermott, *River Portraitist*, 62.

55. Letter from Bingham to John Sartain, October 4, 1852, cited in George R. Brooks, "George Caleb Bingham and 'The County Election,'" *Missouri Historical Society Bulletin* 21 (1964): 39.

56. Bingham's distinction between a disinterested national community of taste and the self-interested and prejudiced local behavior parallels Reynolds's distinction between universal public values and personal preference. See John Barrell, *The Political Theory of Painting from Reynolds to Hazlitt* (New Haven and London: Yale University Press, 1986).

57. Reynolds, Discourse IV, 73. See Barrell, *The Political Theory of Painting*, 90, on the relation between aesthetic form and political stability; and 99–112 on the dangers of artistic ambiguity.

58. On Bingham's outrage over the activities of Colonel Jennison, who was hired as a Union officer during the Civil War, see his letter to the "Representatives of Missouri," dated February 12, 1862, in "Letters," *Missouri Historical Review* 32: 50–58.

59. Bingham explored the implications of this disturbing frontier liminality in his *Captured by Indians*, or *The Captive* (1848; no. 182 in Bloch, *Paintings of George Caleb Bingham*), which deals with the well-worn theme of white captivity and the attendant dangers of miscegenation.

60. For an expression of this attitude, see "The Kansas Usurpation," *Atlantic Monthly* 1 (February 1858): 494. However, opinion on the role of the squatters in the settlement of the West varied along a wide political spectrum; one man's squatter was another man's empire builder. See, for instance,

Glanz, *How the West was Drawn*, 60. Bingham viewed the squatter as a mobile and disreputable political agent misusing democratic privileges on the frontier, as is evident from a proposed but never executed series on the Squatter figure. See "Letters," August 10, 1856, *Missouri Historical Review* 32: 201.

61. *Knickerbocker Magazine* 2 (December 1833): 483, "Literary Notices," Review of *Sketches and Eccentricities of Col. David Crockett.*

62. See Marshall W. Fishwick, "Daniel Boone and the Pattern of the Western Hero," *Filson Club History Quarterly* 27, no. 2 (April 1953): 119–38; Johns, "The Missouri Artist," 133–39.

63. Glanz, *How the West was Drawn*, 1–25. Also relevant are Richard Slotkin, *Regeneration through Violence: The Mythology of the American Frontier, 1600–1860* (Middletown, Conn.: Wesleyan University Press, 1974); Henry Nash Smith, *Virgin Land: The American West as Symbol and Myth* (Cambridge: Harvard University Press, 1950), 51–58.

64. Filson, *The Discovery, Settlement, and Present State of Kentucke*, 81.

65. Hall, *Letters from the West*, 12.

66. On the painting, its sources, and meanings, see Glanz, *How the West was Drawn*, 164–65; Bloch, *Paintings of George Caleb Bingham*, 19–20, n. 68; Rash, *George Caleb Bingham*, 61–64.

67. Glanz, *How the West was Drawn*, 21. Bingham repainted the landscape of Boone in 1852 to enhance the sense of a hostile wilderness.

68. Bingham eventually lost the Capitol commission to Emanuel Leutze. The artist also proposed the Boone subject to Rollins as a possible decoration for the state capitol of Missouri and later called upon Congress to commission a work "properly illustrative of the history of the West." "Letters," January 12, 1855, July 18, 1858, in *Missouri Historical Review* 32: 187, 365.

69. *The Home Book of the Picturesque* (1852; reprint, Gainesville, Fla.: Scholars' Facsimiles and Reprints, 1967), 117. Elsewhere Boone appears as a romantic hunter fleeing civilization. On the dual identity of the Boone figure, see Smith, *Virgin Land*, 51–58.

70. *Home Book of the Picturesque*, 118, 127, 135.

71. Hall, *Letters from the West*, 234, 245.

72. Ibid., 237.

73. Robert Russel, *Critical Studies in Antebellum Sectionalism: Essays in American Political and Economic History* (Westport, Conn.: Greenwood Press, 1972), analyzes the economic and cultural factors drawing West and East together in the 1850s.

74. Carroll Smith-Rosenberg, in "Davy Crockett as Trickster: Pornography, Liminality, and Symbolic Inversion in Victorian America," *Disorderly Conduct: Visions of Gender in Victorian America* (New York: Knopf, 1985), 101, argues that Crockett was the "uncultured civilizer." He too, as she argues, played a role in the bourgeois appropriation of the West, though he did so through means antithetical to bourgeois values. Slotkin, *Regeneration through Violence*, demonstrates the central place of violence in the domestication of the West through myth.

Lilly Martin Spencer's Domestic Genre Painting

1. Virgil Barker, *American Painting: History and Interpretation* (New York: Macmillan, 1950), 513.

2. Ann Byrd Schumer, "Lilly Martin Spencer," *Notable American Women, 1607–1950*, vol. 3 (Cambridge: Harvard University Press, Belknap Press, 1971); Robin Bolton-Smith and William H. Truettner, *Lilly Martin Spencer (1822–1902): The Joys of Sentiment* (Washington, D.C.: National Collection of Fine Arts, 1973).

3. See, for example, Whitney Chadwick, *Women, Art, and Society* (New York: Thames & Hudson, 1990); Wendy Slatkin, *Women Artists in History: From Antiquity to the 20th Century* (Englewood Cliffs: Prentice-Hall, 1990); and Eleanor Tufts, ed., *American Women Artists, 1830–1930* (Washington, D.C.: National Museum of Women, 1987).

4. Two recent responses to Spencer that similarly seek to understand the diverse ways her art functioned during a period of fledgling woman's rights activism and the sentimental cult of true womanhood are Elizabeth Johns, *American Genre Painting: The Politics of Everyday Life* (New Haven: Yale Uni-

versity Press, 1991), 160–75, and Helen S. Langa, "Lilly Martin Spencer: Genre, Aesthetics, and Gender in the Work of a Mid-Nineteenth Century Woman Artist," *Athanor* 9:37–41.

5. Michael Denning, "The End of Mass Culture," *International Labor and Working-Class History* 37 (Spring 1990): 4.

6. Henriette A. Hadry, "Mrs. Lilly M. Spencer," *Sartain's Union Magazine* 9, no. 2 (August 1851): 152–53. Quoted in Bolton-Smith and Truettner, *Lilly Martin Spencer*, 133.

7. Elizabeth Ellet, *Women Artists: In All Ages and Countries* (New York: Harper & Brothers, 1859), 324.

8. Heman Humphrey, *Domestic Education* (Amherst, Mass.: J. S. and C. Adams, 1840), 16. Reprinted in David Brion Davis, ed., *Antebellum American Culture: An Interpretive Anthology* (Lexington, Mass.: D. C. Heath, 1979), 10. See Philip Greven, *The Protestant Temperament: Patterns of Child-Rearing, Religious Experience, and the Self in Early America* (New York: Knopf, 1977), on the historically evolving religious controversy over child-rearing.

9. Humphrey, *Domestic Education*, 21; Davis, *Antebellum American Culture*, 11.

10. Lydia Maria Child, *The Mother's Book* (Boston: Carter & Hendee, 1831), 22; Davis, *Antebellum American Culture*, 23.

11. Richard Brodhead, "Spare the Rod: Discipline and Fiction in Antebellum America," *Representations* 21 (Winter 1988): 74.

12. *The Phalanx* 1, no. 21 (February 8, 1844): 317–19, in Nancy Cott, ed., *Root of Bitterness* (New York: E. P. Dutton, 1972), 246–47.

13. See Charles Fourier, *Design for Utopia: Selected Writings of Charles Fourier*, trans. Julia Franklin (New York: Schocken Books, 1971). See also Dolores Hayden, *Seven American Utopias: The Architecture of Communitarian Socialism, 1790–1975* (Cambridge: MIT Press, 1976). For an antebellum-era discussion of Fourier principles, see Parke Godwin, *A Popular View of the Doctrines of Charles Fourier* (1844; reprint, New York: AMS Press, 1974).

14. [Jane Sophia Appleton], "Sequel to the 'Vision of Bangor in the Twentieth Century,'" in *Voices from the Kenduskeag* (Bangor, Maine, 1848), 256–57; reprinted in Arthur O. Lewis, Jr., ed., *American Utopias: Selected Short Fiction* (New York: Arno Press & The New York Times, 1971).

15. Lilly Martin Spencer to Angelique Martin, October 11, 1850, Archives of American Art, microfilm roll 131. See Elsie Freivogel, "Lilly Martin Spencer: Feminist without Politics," *Archives of American Art Journal* 12, no. 4 (1972): 9–14.

16. "Fourier's phalansterie community life and co-operative households had a new significance for me," recalls Spencer's activist contemporary Elizabeth Cady Stanton, of the late 1840s. "The general discontent I felt with woman's portion as wife, mother, housekeeper, physician, and spiritual guide, the chaotic conditions into which everything fell without her constant supervision, and the wearied, anxious look of the majority of women impressed me with a strong feeling that some active measures should be taken to remedy the wrongs of society in general and of women in particular." Elizabeth Cady Stanton, *Eighty Years and More: Reminiscences, 1815–1897* (1898), intro. Gail Parker (New York: Schocken Books, 1971), 147–48.

17. December 29, 1859.

18. July 9, 1848.

19. Margaret Atwood, *Lady Oracle* (New York: Ballantine Books, 1976), 35 [and 20].

20. "Home Sweet Home," *The Lily*, vol. 1, no. 2 (Seneca Falls, N.Y., February 1, 1849), 10, reprinted in Davis, *Antebellum American Culture*, 94. For a recent collection containing this and similar journalistic pieces from the period, see Ann Russo and Cheris Kramarae, eds., *The Radical Women's Press of the 1850s* (New York: Routledge, 1991).

21. Susan Warner, *The Wide, Wide World*, afterword by Jane Tompkins (New York: Feminist Press, 1987).

22. A concise summary of these developments is contained in Carroll Smith-Rosenberg, *Disorderly Conduct: Visions of Gender in Victorian America* (New York: Knopf, 1985), 79–89.

23. From *Marietta Intelligence*, September 12, 1839, quoted in Ann Byrd Schumer, "Lilly Martin Spencer: American Painter of the Nineteenth Century" (M.A. thesis, Ohio State University, 1959), 12.

24. For details on all Spencer's work, extant and otherwise, see Bolton-Smith and Truettner, *Lilly Martin Spencer*.

25. *The Crayon* 5, no. 6 (June 1858): 177.

26. In the words of Sir Lawrence Gowing, "It is simple, immaculate: the perfection of Vermeer no longer needs expounding. His pictures contain themselves, utterly self-sufficient. . . . The scene is a familiar room, nearly always the same, its unseen door is closed to the restless movement of the household, the window opens to the light. Here a domestic world is refined to purity. . . . [Its female inhabitant] has no thought in particular, no remarkable occupation. Her mooning is caught in a mathematic net, made definite at last, part of a timeless order." Lawrence Gowing, *Vermeer* (New York: Harper & Row, 1970), 17–18.

27. Catharine Beecher, *A Treatise on Domestic Economy* (1841), intro. Kathryn Kish Sklar (New York: Schocken Books, 1977).

28. *The Crayon* 3, no. 5 (May 1856), 146.

29. In effect, Spencer's kitchen paintings eschew the code of modernism that Michael Fried has described as the triumph of "absorption" over "theatricality," or in other words, of the art object's internal self-sufficiency over evidence of concern with a world, and an audience, beyond itself. In this regard, Spencer is strictly premodern. Or is she instead what many today would describe as postmodern? The way her jaunty females insist upon eyeballing us is a brazen transgression of one of Western art's most adhered to codes, that of the invisibility of the viewer. With portraits one expects the direct gaze and thinks nothing of it, but these are genre scenes, not portraits. They aggressively disrupt the "separate spheres" convention that neatly divides the world of the narrative from the world outside it. See Fried, *Absorption and Theatricality: Painting and Beholder in the Age of Diderot* (Berkeley: University of California Press, 1980).

30. The most explicit account of Ruskin's ideal of true womanhood is contained in his lecture "Lilies—Of Queens' Gardens," which he published in *Sesame and Lilies* (1865).

31. *Cosmopolitan Art Journal* 1, no. 5 (September 1857): 165.

32. Bolton-Smith and Truettner, *Lilly Martin Spencer*, 30. On Shakespeare in nineteenth-century America, see Lawrence W. Levine, *Highbrow/Lowbrow: The Emergence of Cultural Hierarchy in America* (Cambridge: Harvard University Press, 1988), 13–81.

33. See Hamlet V. i. 185–97.

34. Bertold Brecht, "A Short Organum for the Theatre," in *Brecht on Theatre: The Development of an Aesthetic*, ed. and trans. John Willett (New York: Hill & Wang, 1964), 191.

35. For elaboration upon the political effects of Brecht's alienation device, see Ernst Bloch, "Entfremdung, Verfremdung: Alienation, Estrangement," trans. Anne Halley and Darko Suvin, in *Brecht*, ed. Erika Munk (New York: Bantam, 1972), 3–11, and Colin MacCabe, "Realism and the Cinema: Notes on Some Brechtian Theses," in *Screen* 15, no. 2 (Summer 1974). Levine, *Highbrow/Lowbrow*, discusses the interaction of actors and audiences in nineteenth-century American theater.

36. Robyn R. Warhol, "Toward a Theory of the Engaging Narrator: Earnest Interventions in Gaskell, Stowe, and Eliot," *PMLA* 101, no. 5 (October 1986): 811–18.

37. Fanny Fern [Sara Willis Parton], *Ruth Hall* (New York: Mason Brothers, 1855), 260–61.

38. Beecher, *Treatise on Domestic Economy*, 18. For a full account of Beecher's views, see Kathryn Kish Sklar, *Catharine Beecher: A Study in American Domesticity* (New Haven: Yale University Press, 1973).

39. Quoted in Howard Zinn, *A People's History of the United States* (New York: Harper Perennial, 1990), 121.

40. Stanton, *Eighty Years and More*, 147. Noting the historical origins of the relationship between housewife isolation and capitalist production, Eli Zaretsky observes that "in contrast to the proletarian who worked in large socialized units and received a wage, the housewife worked alone and was unpaid. . . . Housework and child-rearing came to be seen as natural or personal functions performed in some private space outside society." Zaretsky, *Capitalism, the Family, and Personal Life* (New York: Harper Colophon, 1976), 81.

41. Nancy Armstrong, *Desire and Domestic Fiction: A Political History of the Novel* (New York: Oxford University Press, 1987), 24.

42. Jane Tompkins, *Sensational Designs: The Cultural Work of American Fiction, 1790–1860* (New York: Oxford University Press,

1985), 127. In addition to *Sensational Designs*, some of the key texts to have argued for treating women's sentimental or romantic literary production with respect rather than disdain are Nina Baym, "Melodramas of Beset Manhood: How Theories of American Fiction Exclude Women Authors," *American Quarterly* 33, no. 2 (Summer 1981): 123–39; Nancy Cott, *The Bonds of Womanhood: "Woman's Sphere" in New England, 1780–1835* (New Haven: Yale University Press, 1977); Mary Kelley, "The Sentimentalists: Promise and Betrayal in the Home," *Signs* 4, no. 3 (1979): 434–46; Tania Modleski, *Loving with a Vengeance: Mass-Produced Fantasies for Women* (New York: Methuen, 1984); and Janice Radway, *Reading the Romance: Women, Patriarchy, and Popular Literature* (Chapel Hill: University of North Carolina Press, 1984). Two recent books making analogous claims for the critical recuperation of working-class texts are Michael Denning, *Mechanic Accents: Dime Novels and Working-Class Culture in America* (London: Verso, 1987), and George Lipsitz, *Time Passages: Collective Memory and Popular Culture* (Minneapolis: University of Minnesota Press, 1990). Influential arguments that sentimental fiction contributed to the cultural domination of American women and of Americans in general include Ann Douglas, *The Feminization of American Culture* (New York: Knopf, 1977); George Forgie, *Patricide in the House Divided: A Psychological Interpretation of Lincoln and His Age* (New York: Norton, 1979, 159–99); and Barbara Welter, "The Cult of True Womanhood, 1820–1860" *American Quarterly* 18 (Summer 1966): 151–74. See also Armstrong, *Desire and Domestic Fiction*, and Brodhead, "Spare the Rod." In "Everybody's Protest Novel" (1949), reprinted in *Notes of a Native Son* (Boston: Beacon Press, 1955), 13–23, James Baldwin found racism to be a feature of sentimentalism in general and of *Uncle Tom's Cabin* in particular.

43. See John Fiske, *Understanding Popular Culture* (Boston: Unwin Hyman, 1989), 106–14, on punning as a form of class struggle.

44. See, for example, Michel Foucault, *History of Sexuality*, vol. 1, *An Introduction*, trans. Robert Hurley (New York: Pantheon, 1978), and Mikhail Bakhtin, *The Dialogic Imagina-* tion: *Four Essays*, trans. Michael Holquist (Austin: University of Texas Press, 1981).

45. John Fiske, *Reading the Popular* (Boston: Unwin Hyman, 1989), 10–11. See chapter 5-a on Madonna as a vehicle for popular resistance to patriarchy. For a collection of essays focusing on Madonna as the site of cultural and feminist debate, see Cathy Schwichtenberg, ed., *The Madonna Connection: Representational Politics, Subcultural Identities, and Cultural Theory* (Boulder: Westview Press, 1993).

46. Fiske, *Understanding Popular Culture*, 68. Tania Modleski argues against Fiske, Janice Radway, and other ethnographers of popular culture, calling into question their empirical methods of gaining—or assuming they have gained—reliable knowledge of their informants' various responses to popular-culture texts (Madonna, romance novels, soap operas, etc.). See Modleski, *Feminism Without Women: Culture and Criticism in a "Postfeminist Age"* (New York: Routledge, 1991), 35–58.

47. Ellet, *Women Artists*, 323. "This [low, comic] manner the artist has been obliged to adhere to on account of the ready sale of such pictures, while the subjects that better pleased her own taste have been neglected" (324).

48. For valuable information and insights regarding this and other works by Spencer, I am indebted to Elizabeth O'Leary. See her chapter 3, "Lilly Martin Spencer: Women's Work and Working Women, 1840–1870," in "At Beck and Call: The Representation of Domestic Servants in Nineteenth-Century America" (Ph.D. diss., University of Virginia, 1993).

49. Fanny Fern, *Fern Leaves from Fanny's Port-Folio* (Auburn and Buffalo, N.Y.: Derby and Miller, 1853), 377.

50. One contemporary reviewer, not convinced of the youth of the "young" wife, complains that she "looks like an old maid who might have been in a great many stews before." *Knickerbocker Magazine* 47 (May 1856): 547.

51. Gillian Brown shows that even among middle-class domestic women, the political nature of housework was contested. Catharine Beecher, for example, proclaimed its integral alliance with democ-

racy while her sister, Harriet Beecher Stowe, worried that it needed to be purged of its complicity with slavery and capitalism alike. Contrary to our present-day stereotypes, sentimental culture had no single, monolithic understanding of what it meant for a woman to work in her kitchen. See Brown, "Getting in the Kitchen with Dinah: Domestic Politics in *Uncle Tom's Cabin*," *American Quarterly* 36, no. 4 (Fall 1984): 503–23. For a historical view of the cult of domesticity in America, see Glenna Matthews, *"Just a Housewife": The Rise and Fall of Domesticity in America* (New York: Oxford University Press, 1987).

52. September 10, 1856.

53. In Leslie Fiedler's infamous words, "The figure of Rip Van Winkle presides over the birth of the American imagination, and it is fitting that our first successful home-grown legend memorialize, however playfully, the flight of the dreamer from the shrew." *Love and Death in the American Novel* (New York: Criterion, 1960), xx–xxi.

54. Harriet Beecher Stowe believed that the American kitchen had once been and still could be a crossroads and political gathering place rather than a cloistered retreat

from the problems facing society. See chapter 6, "Fire-Light Talks in my Grand-mother's Kitchen," in *Oldtown Folks* (1869), intro. Dorothy Berkson (New Brunswick: Rutgers University Press, 1987).

55. The Panic of 1869 looks like a wild blend of William Holman Hunt's *The Awakening Conscience* and the German expressionist silent film *The Cabinet of Dr. Caligari*. For a more stolid rendering of mid nineteenth-century middle-class men faced with financial ruin, see the detailed street scene painted by James H. Cafferty and Charles G. Rosenberg, *Wall Street, Half Past Two, October 13, 1857* (1858, Museum of the City of New York).

56. Ann Fabian, "Speculation on Distress: The Popular Discourse of the Panics of 1837 and 1857," *Yale Journal of Criticism* 3, no. 1 (1989): 127–42. See James L. Huston, *The Panic of 1857 and the Coming of the Civil War* (Baton Rouge: Louisiana State University Press, 1987), 1–34.

57. Samuel Rezneck, *Business Depressions and Financial Panics: Essays in American Business and Economic History* (New York: Greenwood, 1968), 103.

58. *The Crayon* 3, no. 5 (May 1856): 146.

Visual Arts in The Marble Faun

1. Particularly illuminating is the "Publisher's Advertisement" to the 1890 edition of the novel, "Illustrated with Photogravures," published by Houghton, Mifflin. On the reception of the novel, see Bettina Faust, *Hawthorne's Contemporaneous Reputation: A Study of Literary Opinion in America and England, 1828–1864* (1939; reprint, New York: Octagon, 1968), 118–42, and J. Donald Crowley, ed., *Nathaniel Hawthorne: The Critical Heritage* (New York: Barnes & Noble, 1970). Still powerful, and decisive for later criticism, is Henry James's discussion of the novel in *Hawthorne* (Ithaca: Cornell University Press, 1956), 126–34. The negative assessment of the novel as "travelogue" is Kenneth Dauber's in *Rediscovering Hawthorne* (Princeton: Princeton University Press, 1977), 219. A recent and richly suggestive reading of the novel that argues for Hawthorne's successful use of the visual arts is Wendy Steiner, *Pictures of Romance: Form against Context in Paint-*

ing and Literature (Chicago: University of Chicago Press, 1988), 91–120. See also Jonathan Auerbach, "Executing the Model: Painting, Sculpture, and Romance-Writing in Hawthorne's *The Marble Faun*," *ELH* 47 (1980): 103–20.

2. For a rather differently conceived assessment of the novel's bid for cultural authority, see Richard Brodhead, *The School of Hawthorne* (New York: Oxford University Press, 1986), 67–80, and his Introduction to the 1990 Viking-Penguin edition. My understanding of the interplay between verbal and visual representation in the novel is deeply indebted to the work of W. J. T. Mitchell, in particular, *Iconology: Image, Text, Ideology* (Chicago: University of Chicago Press, 1986). See also Murray Krieger, "The Ekphrastic Principle and the Still Moment of Poetry; or *Laokoön* Revisited," in *The Play and the Place of Criticism* (Baltimore: Johns Hopkins University Press, 1967),

105–28. Frank Kermode's discussion of Hawthorne is in *The Classic: Literary Images of Permanence and Change* (Cambridge: Harvard University Press, 1983), 83–114. The characterization of literary language as "shifting and transitory" is from Nathaniel Hawthorne, *The Marble Faun*, vol. 4 of *The Centenary Edition of the Works of Nathaniel Hawthorne* (Columbus: Ohio State University Press, 1968), 135. All subsequent references to the novel will be cited parenthetically in the text.

3. John Higham, *From Boundlessness to Consolidation: The Transformation of American Culture, 1848–1860* (Ann Arbor: William L. Clements Library, 1969), 18.

4. Neil Harris, *The Artist in American Society: The Formative Years, 1790–1860* (New York: George Braziller, 1966), 188–98; the quotation is from p. 194.

5. George B. Forgie, *Patricide in the House Divided: A Psychological Interpretation of Lincoln and His Age* (New York: Norton, 1979), esp. 159–99.

6. "The Completion of the Bunker Hill Mounument," *The Works of Daniel Webster*, 6th ed. (Boston: Little, Brown, 1853), 1:83–107. My discussion of Webster's oration is heavily indebted to an unpublished essay by David C. Miller, "Daniel Webster's Bunker Hill Mounument: Assimilating the Verbal to the Visual in Conservative Whig Political Culture," which was delivered at the American Studies Association Convention, New Orleans, November 1, 1990. Prof. Miller generously provided me with a typescript of the essay.

7. Quoted in Miller, "Webster's Bunker Hill Monument," 1.

8. Webster, *Works*, 86–87.

9. The contemporary comments on Webster's oration, including Emerson's from "The Fugitive Slave Law" (1854), are quoted in Miller, "Webster's Bunker Hill Monument," 4, 9.

10. Forgie, *Patricide in the House Divided*, 198; see also 164, 172, 186.

11. Webster, *Works*, 105.

12. Forgie, *Patricide in the House Divided*, 187–90; Horatio Greenough, *Form and Function: Remarks on Art, Design, and Architecture* (Berkeley: University of California Press, 1966), 26, 5 n. 1; Harris, *Artist in American Society*,

194. The presence of Washington's portrait in Uncle Tom's cabin is remarked by Forgie, 185.

13. Albert Elsen, *Origins of Modern Sculpture: Pioneers and Premises* (New York: George Braziller, 1974), 4.

14. Nathaniel Hawthorne, *The Life of Franklin Pierce* in *Tales, Sketches, and Other Papers*, with a Biographical Sketch by George Parsons Lathrop (Boston: Houghton, Mifflin, 1891), 415.

15. See James R. Mellow, *Nathaniel Hawthorne in His Times* (Boston: Houghton, Mifflin, 1980), 533–36, 541.

16. *The French and Italian Notebooks*, ed. Thomas Woodson, vol. 14 of *The Centenary Edition of the Works of Nathaniel Hawthorne* (Columbus: Ohio State University Press, 1980), 130–31, 367, 431–34. All subsequent references will be cited parenthentically in the text. Michael North has an interesting discussion of Hawthorne's attitudes about the monumental in *The Final Sculpture: Public Monuments and Modern Poets* (Ithaca: Cornell University Press, 1985), 197–203, though his conclusions about Hawthorne differ from mine. See also William H. Gerdts, *American Neo-Classic Sculpture: The Marble Resurrection* (New York: Viking, 1973).

17. An informative discussion of Powers's statue can be found in Sylvia E. Crane, *White Silence: Greenough, Powers, and Crawford, American Sculptors in Nineteenth-Century Italy* (Coral Gables: University of Miami Press, 1972), 223–27.

18. Quoted in Miller, "Webster's Bunker Hill Monument," 4.

19. The provenance of this commonplace Victorian term is somewhat obscure, though see the valuable discussion in Hugh Witemeyer, *George Eliot and the Visual Arts* (New Haven: Yale University Press, 1979), 1–8. Hawthorne uses the term, considerably earlier than the English figures discussed by Witemeyer, in the sketch "The Old Apple Dealer" (1843), relating it to what he terms the "moral picturesque."

20. Ralph Waldo Emerson, "Self-Reliance," *Selected Essays*, ed. Larzer Ziff (Harmondsworth: Penguin, 1982), 188.

21. Eve Kosofsky Sedgwick, "The Character in the Veil: Imagery of the Surface in the Gothic Novel," *PMLA* 96 (1981): 264–65.

22. Nathaniel Hawthorne, *The Blithedale Romance*, vol. 3 of *The Centenary Edition of the Works of Nathaniel Hawthorne* (Columbus: Ohio State University Press, 1964), 234–35.

23. Sedgwick, "The Character in the Veil," 264. The Ruskin quotation is from *The Elements of Drawing* (1857).

24. Emerson, "The American Scholar," *Selected Essays*, 101.

25. Mikhail Bakhtin, *Rabelais and His World*, trans. Helene Iswolsky (Cambridge: MIT Press, 1968), 24.

26. See, for instance, Walter Pater, *The Renaissance: Studies in Art and Poetry*, ed. Donald L. Hill (Berkeley: University of California Press, 1980), 52–54, 59–60, and Rudolf Wittkower, *Sculpture: Processes and Principles* (1977; reprint, New York: Viking-Penguin, 1991), 244–45.

27. Thorvaldsen's remarks are also quoted with a degree of skepticism in the *Notebooks*, 133. Some brief but highly suggestive remarks about this chapter in the novel are made in Michael Fried, "Antiquity Now: Reading Winckelmann on Imitation," *October* 37 (1986): 97n. 9.

28. See John Ruskin, "The Nature of the Gothic," in *Stones of Venice*, ed. J. G. Links (New York: Hill & Wang, 1960), 173. For a brief but valuable discussion of Ruskin's idea of the grotesque, see Elizabeth K. Helsinger, *Ruskin and the Art of the Beholder* (Cambridge: Harvard University Press, 1982), 123–35. Ruskin's influence in America is explored in Roger B. Stein, *John Ruskin and Aesthetic Thought in America, 1840–1900* (Cambridge: Harvard University Press, 1967). See also Dennis Berthold, "Hawthorne, Ruskin, and the Gothic Revival: Transcendent Gothic in *The Marble Faun*," *ESQ* 20 (1974): 15–32.

29. Peter Collins, *Changing Ideals in Modern Architecture, 1750–1950* (Montreal: McGill University Press, 1967), 53.

30. Quoted in Mellow, *Nathaniel Hawthorne*, 540.

31. "The Custom House," *The Scarlet Letter*, vol. 1 of *The Centenary Edition of the Works of Nathaniel Hawthorne* (Columbus: Ohio State University Press, 1962), 36. Suggestive in this regard is Roy R. Male, "Hawthorne's Literal Figures," in *Ruined Eden of the Present: Hawthorne, Melville, and Poe, Critical Essays in Honor of Darrel Abel*, ed. G. R. Thompson and Virgil L. Lokke (West Lafayette: Purdue University Press, 1981), 71–92.

32. My discussion of stereoscopic vision draws upon Sir David Brewster, *The Stereoscope: Its History, Theory, and Construction* (1855; reprint, Hastings-on-Hudson: Morgan & Morgan, 1971).

33. Nathaniel Hawthorne, *Our Old Home and English Notebooks*, (Boston: Houghton, Mifflin, 1883), vol. 1, p. 306. This is vol. 7 of the Riverside Edition of *The Complete Works of Nathaniel Hawthorne*.

34. The idea of a "museum without walls" is developed in the first part of André Malraux, *The Voices of Silence*, trans. Stuart Gilbert (Garden City: Doubleday, 1953), 13–127.

35. Sergei Eisenstein, *Notes of a Film Director* (New York: Dover, 1970), 134.

36. Holmes's essays—"The Stereoscope and the Stereograph," "Sun-Painting and Sun-Sculpture; with a Stereoscopic Trip across the Atlantic," and "Doings of the Sunbeam"—appeared in the June 1859, July 1861, and July 1863 issues of the *Atlantic Monthly*, respectively. They are collected in *Soundings from the Atlantic* (Boston: Ticknor & Fields, 1864). References are to this collection: the quotations here are from pp. 161, 171–72.

37. Ibid., 171; Gaston Bachelard, *The Poetics of Space*, trans. Maria Jolas (Boston: Beacon Press, 1964), 183–84.

38. On Irving's comic reduction of the sublime, see Bryan Jay Wolf, *Romantic Re-Vision: Culture and Consciousness in Nineteenth-Century American Painting and Literature* (Chicago: University of Chicago Press, 1982), 107–40.

39. Holmes, *Soundings*, 148.

40. Walter Benjamin, "The Work of Art in the Age of Mechanical Reproduction," *Illuminations* (New York: Schocken Books, 1969), 236–37; Bachelard, *The Poetics of Space*, 172–73, and idem, *The Poetics of Reverie*, trans. Daniel Russell (New York: Orion Press, 1969), 162; and Susan Stewart, *On Longing: Narratives of the Miniature, the Gigantic, the Souvenir, the Collection* (Baltimore: Johns Hopkins University Press, 1984).

41. On the social uses of the stereoscope, see Alan Trachtenberg, "Photography: The Emergence of a Key Word," in *Photography in Nineteenth-Century America*, ed. Martha A. Sandeweiss (Fort Worth: Amon Carter

Museum; New York: Abrams, 1991), 37–43, and idem, "Albums of War: On Reading Civil War Photographs," *Representations 9* (1985): 5–6. See also Edward W. Earle, ed., *Points of View: The Stereograph in America—A Cultural History* (Rochester: Visual Studies Workshop Press, 1979).

42. Jonathan Crary, "Techniques of the Observer," *October 45* (1988): 3–35; the quotations are from p. 35.

43. Walt Whitman, "Locations and Times," *Leaves of Grass*, ed. Sculley Bradley and Harold W. Blodgett (1965; reprint, New York: Norton, 1973), 277–78.

44. Nathaniel Hawthorne to James T. Fields, 3 November 1850, letter 453 of *The Letters, 1843–1853*, ed. Thomas Woodson, L. Neal Smith, Norman Holmes Pearson, vol. 15

of *The Centenary Edition of the Works of Nathaniel Hawthorne* (Columbus: Ohio State University Press, 1985), 371.

45. James E. Young, "The Texture of Memory: Holocaust Memorials and Meaning," in *Writing and Rewriting the Holocaust: Narrative and the Consequences of Interpretation* (Bloomington: Indiana University Press, 1988), 172–89, and idem, "The Biography of a Memorial Icon: Nathan Rapoport's Warsaw Ghetto Monument," *Representations 26* (1989): 69–106. The quotations are from "The Biography of a Memorial Icon," 102n. 5, and "The Texture of Memory," 189.

46. Emerson, "Montaigne; Or, the Skeptic," *Selected Essays*, 336.

The Iconology of Wrecked or Stranded Boats

1. In examining this contrast, we should not forget that two distinct sets of images are under consideration. What the *wrecked* boat of Silva's painting is to the iconography of shipwreck, the many views of *stranded* boats in late nineteenth-century American painting are to the more traditional image of the derelict ship on the open ocean. While these different images possess similar connotations, they should not simply be conflated. It is only in the more general contexts of cultural history that they can meaningfully be coupled.

2. George Landow, *Images of Crisis: Literary Iconology, 1750 to the Present* (Boston: Routledge & Kegan Paul, 1982); see esp. 35–130. See also Lorenz Eitner, "The Open Window and the Storm-Tossed Boat: An Essay in the Iconography of Romanticism," *Art Bulletin 37* (December 1955): 281–90. Eitner focuses upon a more general meaning in explicating the metaphor of the storm-tossed boat: "Used to dramatize man's struggle against fate or against nature, or to point up the need for salvation, it occurs in poetry and painting with the frequency of a popular figure of speech" (287).

3. "The Constitution and the Union," in *The Writings and Speeches of Daniel Webster*, 18 vols. (Boston: Little, Brown, 1903), 10:57.

4. Sacvan Bercovitch, *The Puritan Origins of the*

American Self (New Haven: Yale University Press, 1975), esp. 136–63.

5. Sacvan Bercovitch, *The American Jeremiad* (Madison: University of Wisconsin Press, 1978), esp. 11.

6. As Bercovitch puts it, "In all fundamental ideological aspects, New England was from the start an outpost of the modern world. It evolved from its own origins, as it were, into a middle-class culture—a commercially oriented economy buttressed by the decline of European feudalism, unhampered by lingering traditions of aristocracy and crown, and sustained by the prospect (if not always the fact) of personal advancement—a relatively homogeneous society whose enterprise was consecrated, according to its civic and clerical leadership, by a divine plan of progress" (see *The American Jeremiad*, 20).

7. Stow Persons, "The Cyclical Theory of History in Eighteenth Century America," *American Quarterly 6* (Summer 1954): 148–49. Of this cyclical theory, Persons writes, "The new view of history which came into vogue among conservative thinkers in the years following the revival found the source of historical dynamics in the operation of the universal moral law, the effect of which upon history was an endless cyclical movement analogous to the life cy-

cle of the individual organism. Societies and nations rise and fall in endless sequence according as they observe or disregard those universal moral laws ordained of God and graven upon men's consciences for their governance and happiness. . . . It was subsequently to become a familiar theme in romantic thought" (152).

8. For an account of the shift from the cyclical and apocalyptic view of Cole's series to an emphasis on progress and millennial promise in American painting, see Angela Miller, *The Empire of the Eye: The Cultural Politics of Landscape Representation, 1825–1875* (Ithaca, New York: Cornell University Press, 1993).

9. Bercovitch, *The Puritan Origins*, 146.

10. *New York Herald*, June 15, 1874.

11. The concept of luminism was pioneered by John I. H. Baur in "American Luminism," *Perspectives USA*, no. 9 (Autumn 1954): 90–98. It was further developed by Barbara Novak in *American Painting of the Nineteenth Century: Realism, Idealism, and the American Experience* (New York: Praeger, 1969), 92–137. Novak attributed to luminist painting such characteristics as horizontal framing, lack of drama, homogeneous emphasis (lack of subordination of parts), high ratio of sky to ground, anonymity of the artist, and the effect of light that, rather than creating a sense of action, "produces a mirror-like plane that both disappears and assumes a glass-like tangibility" (122). Novak's effort to tie luminism to Emersonian transcendentalism is insightful and provocative but also deeply problematic. For two important efforts to revise the concept of luminism by putting it in a more specific and carefully realized literary and cultural context, see two articles by Barton L. St. Armand which, while clearly different in emphasis, also anticipate and parallel concerns I raise here: "Luminism in the Work of Henry David Thoreau: The Dark and the Light," *Canadian Review of American Studies* 11 (Spring 1980): 13–30; and "Fine Fitnesses: Dickinson, Higginson, and Literary Luminism," *Prospects: An Annual of American Cultural Studies* 14 (1989): 141–73. See also my article, "'Kindred Spirits': Martin Johnson Heade, Painter; Frederick Goddard Tuckerman,

Poet; and the Identification with 'Desert' Places," *American Quarterly* 32 (Summer 1980): 167–85.

12. Erwin Panofsky, *Meaning in the Visual Arts* (Garden City, N.J.: Doubleday, 1955), 30.

13. Ibid., 31.

14. Invoking the evidence of contemporary criticism of works usually designated luminist by twentieth-century art historians, J. Gray Sweeney has asserted, "This documentation compels us to inquire if the meanings of such works are richer and more complex than may have been previously suspected by modern scholars, most of whom approached these 'rediscovered' pictures from a formalist perspective, anxious to explain their relevance to modernist movements such as Surrealism. If this is the case, is it not appropriate first to attempt to read them within a context of artistic, cultural, and religious values of their day before resorting to the attribution of unspecified surrealistic elements or the even more nebulous attributes of Luminism, formalist terms that are strictly creations of the present century?" (See "A 'very peculiar' picture: Martin J. Heade's *Thunderstorm Over Narragansett Bay*," *Archives of American Art Journal* 28, no. 4 (1988): 12). While I second Sweeney's skepticism about formalist approaches, it seems to me valuable to keep formal concerns in the forefront of any effort to locate works of art and literature within a particular cultural milieu. Moreover, Sweeney's objections to luminism appear naively to assume that artistic intention remains objectifiable, that it can be separated from the interpretation of later critics and historians.

15. See, for instance, John Wilmerding, et al., *American Light: The Luminist Movement: 1850–1875* (Washington, D.C.: National Gallery of Art, 1980).

16. Clifford Geertz, *The Interpretation of Cultures* (New York: Basic Books, 1973), 220.

17. See Thedore E. Stebbins, Jr., "Luminism in Context: A New View" in Wilmerding, *American Light*, 211–34. Stebbins fails to explain the many images by European artists which share affinities with American luminist works. For my own attempt to connect luminist images to underlying dy-

namics in romantic culture, see "Infection and Imagination: Atmospheric Agency and the Problem of Romanticism in America," *Prospects: An Annual of American Cultural Studies* 13 (1988): 37–60.

18. I owe this point about luminism and a number of others to Barbara Novak's discussion in *American Painting of the Nineteenth Century*, 92–137.

19. In his brief review of Heade in *The Book of the Artists* (1867), Henry T. Tuckerman praised the artist's landscapes as "clever and novel." "None of our painters has," he added, "a more refined sense of beauty, or a more delicate feeling for color." But then he characterized Heade above all as "an accurate and graceful illustrator of natural history" (*The Book of the Artists* [New York: J. F. Carr, 1966], 542–43). In discussing Heade's *Thunderstorm Over Narragansett Bay*, J. Gray Sweeney quotes from a review of the painting which appeared in the *Brooklyn Eagle* on March 21, 1868: "The only point on which everybody agrees as to Mr. Heade's picture is that it is 'very peculiar.'" See "A 'very peculiar' picture," 2–14.

20. See my article "'Kindred Spirits,'" 167–85.

21. See my book *Dark Eden: The Swamp in Nineteenth-Century American Culture* (New York: Cambridge University Press, 1990), 163–64.

22. The protomodernist implications of luminist painting were explored by John Wilmerding in "Fire and Ice in American Art: Polarities from Luminism to Abstract Expressionism," in *The Natural Paradise: Painting in America, 1800–1950*, ed. Kynaston McShine (New York: Museum of Modern Art, 1976).

23. My thinking here has been deeply influenced by Kenneth Burke, *A Grammar of Motives* (Berkeley: University of California Press, 1969); see esp. 76.

24. Quoted in John Wilmerding, *Fitz Hugh Lane: American Marine Painter, 1804–1865* (Gloucester, Mass.: Peter Smith, 1969), 31.

25. Angela Miller, from an unpublished manuscript.

26. Quoted in Wilmerding, *Fitz Hugh Lane*, 31.

27. Once again, I am indebted to discussions with Angela Miller and to her forthcoming manuscript, *The Empire of the Eye*.

28. James Moorhead, *American Apocalypse: Yankee Protestants and the Civil War, 1860–1869* (New Haven: Yale University Press, 1978); see esp. chap. 2, "The Armageddon of the Republic," 42–81.

29. Ibid., 164.

30. Beverly R. Wellford, Jr., "Address Delivered before the Ladies of the Mt. Vernon Association, July 4, 1855," *Southern Literary Messenger* 21 (September 1855): 565.

31. Moorhead, *American Apocalypse*, 165.

32. I owe this observation to Barton L. St. Armand of the English Department, Brown University.

33. T. S. Eliot, *The Complete Poems and Plays, 1909–1950* (New York: Harcourt, Brace & World, 1971), 129.

34. John Lynen, *The Design of the Present: Essays on Time and Form in American Literature* (New Haven: Yale University Press, 1969), 329.

35. Henry David Thoreau, *Walden* (New York: Library of America, 1985), 478. Subsequent page numbers in text.

36. Quoted in John McCoubrey, ed., *American Art: Sources and Documents, 1700–1960* (Englewood Cliffs: Prentice-Hall, 1965), 119–20.

37. As Sacvan Bercovitch argued, certain American Puritan divines projected Puritan history back into the Old Testament, investing it with prophetic meaning that was in turn extended to the future millennium. For instance, if Moses, the deliverer of the chosen people from Egypt, typified Christ, deliverer of humankind from sin, Cotton Mather could associate John Winthrop with Moses because he too delivered his people from England, the figurative Egypt. The Puritans, in short, saw themselves in direct descent from the Israelites. Moreover, just as the exodus of the Israelites foreshadowed Christ's redemption, the experience of the Puritans could be seen to typify the millennium (see *The Puritan Origins of the American Self*).

38. As Bercovitch pointed out, this trope had been well established in Puritan eschatological thinking: "Foxe's perishable ship of England has as its counterpart in Puritan New England writing the world-redeeming ark of Christ. The world's tempest might buffet this ship and the helmsmen felt it their duty to threaten disaster if the crew flagged or veered off course. But,

unlike Foxe, they understood those warnings teleologically, as the temporal means towards an absolute goal that precluded shipwreck. Christ was simply 'not willing that our Nation should perish'" (see ibid., 90–91).

39. For the relation between type and symbol in American literature, see Karl Keller, "Alephs, Zahirs, and the Triumph of Ambiguity: Typology in Nineteenth Century American Literature," in *Literary Uses of Typology: From the Late Middle Ages to the Present*, ed. Earl Miner (Princeton: Princeton University Press, 1977), 274–314.

40. It seems hardly coincidental that Eliot's meditations on the need for Incarnation (a return to the ways of the body and the realization that "Only through time time is conquered" [120]), along with his effort to juxtapose human and absolute time in "The Dry Salvages," should take shape in the same locale traversed by Heade and Lane—the northeast coast of Cape Ann, Massachusetts:

> And under the oppression of the silent
> fog
> The tolling bell
> Measures time not our time, rung by the
> unhurried
> Ground swell, a time
> Older than the time of chronometers,
> older
> Than time counted by anxious worried
> women
> Lying awake, calculating the future,
> Between midnight and dawn, when the
> past is all deception,
> The future futureless, before the
> morning watch
> When time stops and time is never
> ending;
> And the ground swell, that is and was
> from the beginning,
> Clangs
> The bell.

For Eliot, the sea "hints of earlier and other creation: / The starfish, the hermit crab, the whale's backbone . . . / It tosses up our losses, the torn seine, / The shattered lobsterpot, the broken oar / And the gear of foreign dead men." It is here that "emotion takes to itself the emotion-

less / Years of living among the breakage / Of what was believed in as the most reliable— / And therefore the fittest for renunciation" (*Complete Poems and Plays*, 131).

41. Thoreau adumbrated the telling implications of his visionary sense of time in *A Week on the Concord and Merrimack Rivers* when he wrote, "We should read history as little critically as we consider the landscape, and be more interested in the atmospheric tinges and various lights and shades which the intervening spaces create, than by its groundwork and composition. . . . In reality, history fluctuates as the face of a landscape from morning to evening. What is of moment is its hue and color. Time hides no treasures; we want not its then but its now" ([New York: Library of America, 1985], 124).

42. Mircea Eliade, *The Myth of the Eternal Return: Cosmos and History*, trans. Willard R. Trask (Princeton: Princeton University Press, 1974).

43. For a similar sentiment, see Keats's *Endymion*, book II:

> Hence, pageant history! hence, gilded
> cheat!
> Swart planet in the universe of deeds!
> Wide sea, that one continuous murmur
> breeds
> Along the pebbled shore of memory!
> Many old rotten-timber'd boats there be
> Upon thy vaporous bosom, mangified
> To goodly vessels; many a sail of pride,
> And golden keel'd, is left unlaunch'd
> and dry. . . .
> Are things to brood on with more
> ardency
> Than the death-day of empire. [lines 14–
> 34]

I am indebted to Barton L. St. Armand for this reference.

44. Sarah D. Cash, assistant curator of the Amon Carter Museum, informs me that Silva's first sketch for the painting, dated July 11, 1874, "clearly states that the wreck occurred on July 4" (see her n. 5 in *American Paintings from the Manoogian Collection* [National Gallery of Art, Washington, D.C. / Detroit Institute of Arts, 1989], 48). This suggests a "remarkable providence" on the

order of the incredible coincidence, on the same date in 1826, of the deaths of both Adams and Jefferson. The implication here, however, while pointing beyond the realm of ordinary providence to the cosmic dimension of history, is apocalyptic.

Art, Commerce, and the Studio

1. On the late nineteenth-century American studio, see Celia Betsky, "In the Artist's Studio," *Portfolio* 4 (January/February 1982): 32–39; Richard N. Gregg, *The Artist's Studio in American Painting 1840–1983*, exh. cat. (Allentown Art Museum, 1983). American studios followed a pattern established by such prominent Europeans as Karl Theodor von Piloty, Chase's teacher in Munich. Since so many Americans studied in Paris, studios of prominent painters there, such as Jean-Léon Gérôme's, were important models as well; see John Milner's informative *The Studios of Paris* (New Haven: Yale University Press, 1988). A general, well-illustrated overview of the artist's studio is Michael Peppiatt and Alice Bellony-Rewald, *Imagination's Chamber: Artists and Their Studios* (Boston: New York Graphic Society, 1982). On the related subject of the aestheticized domestic environment, see Roger B. Stein's stimulating essay "Artifact as Ideology: The Aesthetic Movement in Its American Cultural Context," in *In Pursuit of Beauty: Americans and the Aesthetic Movement*, exh. cat. (New York: Metropolitan Museum of Art, 1986), 23–51.

2. There were, of course, certain obvious differences between studio and store. Whereas the artist offered a unique product made by hand, the store normally purveyed mass-produced or standardized items, however exotic or precious they might appear. The painter's wares reached a small number of consumers, most of them at least prosperous, if not wealthy; the store depended on high-volume sales to middle- and even lower-class income groups. But both recognized the importance of concocting an ambience that worked to enhance their prospects of success. Ronald G. Pisano, *A Leading Spirit in American Art: William Merritt Chase 1849–1916* (Seattle: Henry Art Gallery, 1983), 45, mentions the salesroom function of the studio but does not develop this theme. The best (though very condensed) analysis of the showroom function of the studio is Linda Henefield Skalet, "The Market for American Painting in New York: 1870–1915" (Ph.D. diss., Johns Hopkins University, 1980), 11–22. In profiling cultural transition to consumer values during this period, I follow T. J. Jackson Lears's model as presented in his "From Salvation to Self-Realization: Advertising and the Therapeutic Roots of Consumer Culture, 1880–1930," in *The Culture of Consumption: Critical Essays in American History 1880–1980*, ed. Richard W. Fox and T. J. Jackson Lears (New York: Pantheon Books, 1983), 3–38. Discussions of consumer culture include Daniel Boorstin, *The Americans: The Democratic Experience* (New York: Vintage Books, 1974), 89–164; Neil Harris, "The Drama of Consumer Desire," in *Yankee Enterprise: The Rise of the American System of Manufactures*, ed. Otto Mayr and Robert C. Post (Washington, D.C.: Smithsonian Institution Press, 1981), 189–216; Daniel Horowitz, *The Morality of Spending: Attitudes toward the Consumer Society in America, 1875–1940* (Baltimore: Johns Hopkins University Press, 1985); Grant McCracken, *Culture and Consumption: New Approaches to the Symbolic Character of Consumer Goods and Activities* (Bloomington: Indiana University Press, 1988). An important collection of essays on the material culture of consumption is Simon J. Bronner, ed., *Consuming Visions: Accumulation and Display of Goods in America, 1880–1920* (New York: Norton, 1989).

3. Nicolai Cikovsky, Jr., "William Merritt Chase's Tenth Street Studio," *Archives of American Art Journal* 16, no. 2 (1976): 2–14, is an excellent, detailed account, with valuable notes on contemporary sources; also useful is Keith L. Bryant, Jr., *William Merritt Chase: A Genteel Bohemian* (Columbia: University of Missouri Press, 1991), 65–74; Pisano, *A Leading Spirit in American Art*, 42–45,

summarizes the history of Chase's activities in Tenth Street; on Tenth Street in general, see Annette Blaugrund, "The Tenth Street Studio Building: A Roster, 1857–1895," *American Art Journal* 14 (Spring 1982): 64–71; Mary Sayre Haverstock, "The Tenth Street Studio," *Art in America* 54 (September 1966): 48–57; and Garnett McCoy, "Visits, Parties, and Cats in the Hall: The Tenth Street Studio Building and Its Inmates in the Nineteenth Century," *Archives of American Art Journal* 6 (January 1966): 1–8.

4. John Moran, "Studio-Life in New York," *Art Journal* 5 (1879): 344–45; Elizabeth Bisland, "The Studios of New York," *Cosmopolitan* 7 (May 1889): 5–6.

5. Bisland, "The Studios of New York," 12; Moran, "Studio-Life in New York," 354.

6. On the department store, see H. Pasdermadjan, *The Department Store: Its Origins, Evolution, and Economics* (London: Newman, 1954); Harry E. Ressequie, "Alexander Turney Stewart's Marble Palace: The Cradle of the Department Store," *New-York Historical Society Quarterly* 48 (April 1964): 131–62; Susan Porter Benson, "Palace of Consumption and Machine for Selling: The American Department Store, 1880–1940," *Radical History Review* 21 (Fall 1979): 199–221; idem, *Counter Culture: Saleswomen, Managers, and Customers in American Department Stores* (Urbana: University of Illinois Press, 1986); Rémy G. Saisselin, *The Bourgeois and the Bibelot* (New Brunswick: Rutgers University Press, 1984), 31–49; and for illustrations, Robert Hendrickson, *The Grand Emporiums: Illustrated History of America's Department Stores* (New York: Stein & Day, 1979). On the institution of the department store in France, see Michael B. Miller, *The Bon Marché: Bourgeois Culture and the Department Store* (Princeton: Princeton University Press, 1981). William Leach's studies of the early history and culture of store display have been immensely useful and suggestive: "Transformation in a Culture of Consumption: Women and Department Stores," *Journal of American History* 71 (September 1984): 319–42, and "Strategists of Display and the Production of Desire," in Bronner, ed., *Consuming Visions,* 99–132. On display history, see also Leonard Marcus, *The American Store Window* (New York: Watson-Guptill, 1978).

7. John Wanamaker Firm, *Golden Book of the Wanamaker Stores: Jubilee Year 1861–1911* (Philadelphia: John Wanamaker, 1911), 70–71, 73, 75. See Neil Harris, "Museums, Merchandising, and Popular Taste: The Struggle for Influence," in *Material Culture and the Study of American Life,* ed. Ian M. G. Quimby (New York: Norton, 1975), 140–74, for a discussion of conflicts and negotiations over cultural territories among the department stores, world's fairs, and museums in the Gilded Age and later; Russell Lewis develops the relation between department stores and world's fairs in "Everything under One Roof: World's Fairs and Department Stores in Paris and Chicago," *Chicago History* 13 (Fall 1983), 28–47.

8. Richard Spenlow, "Decorating and Furnishing," *New York Times,* October 9, 1887.

9. Clarence Cook, "Studio Suggestions for Decoration," *Monthly Illustrator* 4 (1895): 237; Moran, "Studio-Life in New York," 344; Gifford Beal, "Chase—The Teacher," *Scribner's Magazine* 61 (February 1917): 258.

10. Leach, "Strategists of Display," 106–07, dates the first step toward a modern display aesthetic to 1889, when the trade magazine *Dry Goods Economist* shifted its format "from the mechanics to the theatrics of exchange."

11. Leach, "Strategists of Display," 107–10, gives a concise sketch of Baum's background; see also Frank Joslyn Baum and Russell P. McFall, *To Please a Child: A Biography of L. Frank Baum, Royal Historian of Oz* (Chicago: Reilly and Lee, 1951). L. Frank Baum, *The Art of Decorating Dry Goods Windows and Interiors* (Chicago: Show Window Publishing Co., 1900), 147, 14.

12. C. E. Cake, "Arranging Goods to Make the Shopper Buy," *System* 18 (December 1910): 591; Kendall Banning, "Staging a Sale," *System* 16 (1909): 280.

13. Tudor Jenks, "Before Shop Windows," *Outlook* 51 (April 27, 1895): 689; Wanamaker, *Golden Book,* 203–04.

14. Moran, "Studio-Life in New York," 354, 345.

15. Baum, *The Art of Decorating Dry Goods Windows,* 8; Anne O'Hagan, "Behind the Scenes in the Big Stores," *Munsey's Magazine* 22 (January 1900): 537; Cake, "Arranging Goods to Make Shoppers Buy," 592.

16. Reception days at the Tenth Street Studio building had been held as early as 1858, but in the 1880s artists deliberately and vigorously attempted to make their receptions fashionable, glamorous, noteworthy social events.

17. Elaborate rooms were not, certainly, always part of an individual's packaging. Painters such as George Inness spared little concern for their backgrounds; Winslow Homer, whose star was rising in the 1880s, removed himself entirely from the New York scene during the same decade. The *Cosmopolitan* reported in 1889 that Frederic Stuart Church, popular creator of fairy and animal whimsies, worked in a bare, ugly room on Thirteenth Street and sold his pictures "before they [were] off the easel." (Bisland, "The Studios of New York," 21).

18. "Our National Genius and Our National Art," *Harper's Weekly Magazine* 47 (February 28, 1903): 349; Frederic Harrison, "Art and Shoddy—A Reply to Criticisms," *Forum* 15 (August 1893): 721–25; J. M. Bowles, "Business Buildings Made Beautiful," *World's Work* 9 (November 1904): 5499–5500.

19. Elizabeth Stuart Phelps, "The Décolleté in Modern Life," *Forum* 9 (August 1890): 680; Marie C. Remick, "The Relation of Art to Morality," *Arena* 19 (April 1898): 491; William James Stillman, "The Decay of Art," *The Old Rome and the New* (Boston: Houghton, Mifflin, 1898), 195–97.

20. William Lewis Fraser, "Exhibition of Artists' Scraps and Sketches," *Century Magazine* 42 (May 1891): 96; Williston Fish, "Art Criticism," *Life* 22 (August 10, 1893): 91.

21. Kenyon Cox, "William Merritt Chase, Painter," *Harper's Monthly Magazine* 78 (March 1889): 551, 549; Mariana Schuyler Van Rensselaer, "William Merritt Chase," in *American Art and American Art Collections: Essays on Artistic Subjects*, ed. Walter Montgomery (Boston: S. Walker, 1889), 1:229; H. Monroe, "Paintings in Chicago," *Art Amateur* 21 (1889): 90.

22. For a wide-ranging and stimulating look at this cultural impulse, see *In Pursuit of Beauty*; also valuable, especially on the philosophical underpinnings of the aesthetic movement, is David C. Huntington, "The Quest for Unity: American Art between Worlds' Fairs 1876–1893," in the exhibition cata-logue bearing the same title (Detroit Institute of Arts, 1983), 11–46.

23. John Charles Van Dyke, *Art for Art's Sake* (New York: Charles Scribner's Sons, 1893), 13, 34.

24. S. N. Carter, "First Exhibition of the American Art Association," *Art Journal* (New York) 4 (1878): 125; "American Studio Talk," *International Studio* 11 (September 1900): xiv; Birge Harrison, *Landscape Painting*, 5th ed. (1909; reprint, New York: Charles Scribner's Sons, 1911), 24; Monroe, "Paintings in Chicago," 90; on Colman, see Wayne Craven, "Samuel Colman (1832–1920): Rediscovered Painter of Faraway Places," *American Art Journal* 8, no. 1 (1976): 16–37.

25. "Art and Business Ability," *Munsey's Magazine* 18 (March 1898): 810; Gilson Willets, "F. Hopkinson Smith," *Munsey's Magazine* 11 (May 1894): 144. On Smith, see Nick Madorno, "Francis Hopkinson Smith (1838–1915): His Drawings of the White Mountains and Venice," *American Art Journal* 17, no. 1 (Winter 1985): 68–81.

26. Wanamaker, *Golden Book*, 107. See Alan Trachtenberg, *The Incorporation of America: Culture and Society in the Gilded Age* (New York: Hill & Wang, 1982), 140–61, for a discussion of the pervasiveness and political implications of ideas about cultural hierarchy and cultural elevation during the late nineteenth century, when the mass culture associated with working-class and immigrant populations seemed to pose a monstrous threat to the existing social and cultural orders and especially to menace the educated elites' self-appointed status as cultural guardians. An excellent full-length study of the transition from shared public culture to rigidly separated high and popular cultural territories is Lawrence W. Levine, *Highbrow/Lowbrow: The Emergence of Cultural Hierarchy in America* (Cambridge: Harvard University Press, 1988).

27. Will H. Low, "The Field of Art," *Scribner's Magazine* 34 (October 1903), 511.

28. William Dean Howells, *A Hazard of New Fortunes* (1890; reprint, New York: New American Library, 1980), 339, 403.

29. Theodore Dreiser, *The "Genius"* (1915; reprint, New York: New American Library, 1981), 459.

30. "Rewards of Painters," *New York Times*, October 1, 1882.

31. F. Hopkinson Smith, *The Fortunes of Oliver Horn* (1902; reprint, New York: Scribner's, 1915), 437–38. Edith Wharton, *The Custom of the Country* (1913; reprint, New York: Berkeley Books, 1981), 121–28.

32. Aline Gorren, "American Society and the Artist," *Scribner's Magazine* 26 (November 1899): 629, 632–33.

33. Jackson Lears, *No Place of Grace: Antimodernism and the Transformation of American Culture 1880–1920* (New York: Pantheon Books, 1981), 104, 218.

34. Theodore Roosevelt, "The Manly Virtues and Practical Politics," *Forum* 17 (July 1894): 555; Maurice Thompson, "Vigorous Men, A Vigorous Nation," *The Independent* 50 (September 1, 1898): 610–11. Among the studies that examine gender roles and gender politics in this period are Michael S. Kimmel, "Men's Responses to Feminism at the Turn of the Century," *Gender & Society* 1 (September 1987): 261–83; E. Anthony Rotundo, "Body and Soul: Changing Ideals of American Middle-Class Manhood, 1770–1920," *Journal of Social History* 16 (Summer 1983): 23–38; Joe L. Dubbert, *A Man's Place: Masculinity in Transition* (Englewood Cliffs: Prentice-Hall, 1979); Peter Gabriel Filene, *Him/Her/Self: Sex Roles in Modern America* (New York: Harcourt, Brace, Jovanovich, 1974); John Higham, "The Reorientation of American Culture in the 1890s," *Writing American History: Essays on Modern Scholarship* (Bloomington: Indiana University Press, 1970). Lears, *No Place of Grace*, chap. 3, "The Destructive Element: Modern Commercial Society and the Martial Ideal," 98–139, examines the antimodern cult of militarism as a class-revitalizing, masculinizing antidote to overcivilization as well as a literal defense against the instabilities incurred by social, demographic, and economic change. A different view is presented by Margaret Marsh, "Suburban Men and Masculine Domesticity, 1870–1915," *American Quarterly* 40 (June 1988): 165–86, which argues for the importance of recognizing and studying the model of masculine domesticity as an available contemporary alternative to that of undomesticated virility.

35. Leach, "Transformations in a Culture of Consumption," 333, 321.

36. "An Artist Reception," *New York Times*, February 25, 1881; "Artists Receiving," *New York Times*, March 5, 1882.

37. For examples of differing interpretations of women in interiors, see Patricia Hills, *Turn-of-the-Century America: Paintings, Graphics, Photographs 1890–1910* (New York: Whitney Museum of American Art, 1977), 74; Bernice Leader, "Anti-Feminism in the Paintings of the Boston School," *Arts Magazine* 56 (January 1982): 112–19; Betsky, "In the Artist's Studio," 37; Martha Banta, *Imaging American Women: Idea and Ideals in Cultural History* (New York: Columbia University Press, 1987), 339–74; Bailey Van Hook, "Decorative Images of American Women: The Aristocratic Aesthetic of the Late Nineteenth Century," *Smithsonian Studies in American Art* 4 (Winter 1990): 45–70. Jean-Christophe Agnew discusses the figuring of women in the late nineteenth-century "commodity aesthetic," as seen in Boston Schools works by Tarbell and William McGregor Paxton and in the novels of Henry James and Edith Wharton, in "A House of Fiction: Domestic Interiors and the Commodity Aesthetic," in Bronner, ed., *Consuming Visions*, 133–55. Harris, "The Drama of Consumer Desire," 198, uses the term "buying drama" with reference to the thrills and rituals of consumption around the turn of the century, especially as those rituals were staged in such realist works as those by William Dean Howells and Theodore Dreiser. On women and the dialectics of their relations with commodities in the late nineteenth century, see Rachel Bowlby, *Just Looking: Consumer Culture in Dreiser, Gissing and Zola* (New York: Methuen, 1985), 18–34.

38. See Montgomery, ed., *American Art and American Art Collections* for a contemporary account of representative collections; also see Albert Boime, "America's Purchasing Power and the Evolution of European Art in the Late Nineteenth Century," in *Salons, Galleries, Museums and Their Influence in the Development of 19th and 20th Century Art* (Bologna: Cooperativa Libraria Universitaria, 1979), 123–39. I pursue in this paragraph a suggestion by Saisselin, *The Bourgeois and the*

Bibelot, 103, which figures art collecting as "a sublime, pleasurable, novel form of capital formation," the "aesthetic because disinterested form of capital." Discussions of the feminine gender assigned to culture in the later nineteenth century and the anxieties this provoked include Lears, No Place of Grace, esp. 220–25, though the themes of cultural gendering, ambivalence, and the related critique of overcivilization are woven into the entire fabric of this study; and Trachtenberg, The Incorporation of America, 140–47.

39. Arthur McEwen, "The Reversion of Pietro," Cosmopolitan Magazine 47 (November 1909): 725–26.

40. Peter Gay, The Bourgeois Experience: Victoria to Freud, vol. 2: The Tender Passion, (New York: Oxford University Press, 1986), 312–19; Harris, "Dramas of Consumer Desire," 196; Leach, "Strategists of Display and the Production of Desire," 113. An alternative reading of the mannequin is Stuart Culver, "What Manikins Want: The Wonderful Wizard of Oz and The Art of Decorating Dry Goods Windows," Representations 21 (Winter 1988): 111–14, 116, which figures the mannequin as "a broken body organized around a lack," conducive not to dreams of possible wholeness (i.e., completion through satisfaction of desire) but rather to the sustained experience of desire in its purest form.

41. Wharton, The Custom of the Country, 121–28; Brander Matthews, "A Cameo and a Pastel," Harper's New Monthly Magazine 86 (December 1892): 132–35; Charles Dudley Warner, "The Golden House," Harper's New Monthly Magazine 89 (July 1894): 166. Bowlby, Just Looking, 32, argues that in the rituals of late nineteenth-century consumption, an endless round of reciprocity bound woman to commodity: "Seducer and seduced, possessor and possessed of one another, woman and commodities flaunt their images at one another in an amorous regard."

42. W. A. Cooper, "Artists in Their Studios, X—Eliot Gregory," Godey's Magazine 132 (1896): 187, 190.

43. "The Cosy Corner," Munsey's Magazine 15 (May 1896): 245. Jackson Lears, "Beyond Veblen: Rethinking Consumer Culture in America," in Bronner, ed., Consuming Visions, 77, notes that as early as the 1830s, many consumer goods were associated with "an aura of sensuous mystery" emanating from the "mysterious East." Lears goes on to examine the ways in which cultural elites addressed the potential loss of control and balance implicit in undisciplined exoticism by finding new ways of mediating the meanings attached to goods, including the "sanitizing" of exoticism. (86)

44. See, for example, Dora M. Morrell, "Workers at Work. I. Miss Rimmer in Her Studio," Arena 21 (January 1899): 73. The Boston studio of Caroline Flint Rimmer, a sculptor and daughter of William Rimmer, impressed the reporter as a distinctively feminine studio because, in contrast to the masculine, it contained more "pretty things" and suggested "hominess."

45. Howells, The Coast of Bohemia (1893; reprint, New York: Harper & Brothers, 1899), 129–32; "More Fiction," The Nation 57 (November 23, 1893): 395.

46. Elia W. Peattie, "Maloney's Masterpiece," Harper's Weekly Magazine 35 (August 8, 1891): 593–95; Christine Terhune Herrick, "Man, the Victim," Munsey's Magazine 27 (September 1902): 890.

47. Cikovsky, "William Merritt Chase's Tenth Street Studio," 12–13, briefly discusses the simplification trend without pursuing its implications. The campaign for masculinization in art relates to issues discussed earlier; see n. 34.

48. Frances Hodgson Burnett, "A Story of the Latin Quarter," Scribner's Monthly Magazine 18 (May 1879): 25.

49. "The Field of Art," Scribner's Magazine 19 (January–June, 1896): 522–23; Kenyon Cox, "Puvis de Chavannes," Century Magazine 51 (February 1896): 569; Richard Harding Davis, "Americans in Paris," Harper's New Monthly Magazine 91 (July 1895): 280.

50. O. B. Flower, "Edward W. Redfield: An Artist of Winter-Locked Nature," Arena 36 (July 1906): 21–23. The illustrator and painter Maxfield Parrish's studio in Cornish, New Hampshire, offered a somewhat different alternative, no less a rejection of cosmopolitan opulence: it was equipped like a woodshop, with lathes,

circular saws, and other implements for building the scale models and figures the artist used to create his pictures. For a contemporary illustration of and comment on the Parish studio, see Homer St. Gaudens, "Maxfield Parrish," *The Critic* 46 (June 1905): 516, 518. Both artists' studios express strong connections with reformist and reactionary tendencies, notably the Arts and Crafts movement with its antiindustrial, anticosmopolitan stance.

51. See Miles Orvell, *The Real Thing: Imitation and Authenticity in American Culture, 1880–1940* (Chapel Hill: University of North Carolina Press, 1989), for an extended and provocative consideration of the shift from a nineteenth-century culture "in which the arts of imitation and illusion were valorized to a culture in which the notion of authenticity became of primary value" and which involved, among other things, the construction of a functionalist ethos that "sought to elevate the vernacular into the realm of high culture" (xv–xvi).

Mary Cassatt and the Maternal Body

1. In fact, most of the critics saw Cassatt and Morisot in 1881 as the leaders of the Impressionist—or, more accurately, the Independent—movement. For descriptions of this exhibition, see Nancy Hale, *Mary Cassatt* (New York: Doubleday, 1975), 103–04; Anne Higonnet, *Berthe Morisot* (New York: Harper & Row, 1990), 158–60; and Charles F. Stuckey and William P. Scott, *Berthe Morisot: Impressionist* (New York: Hudson Hills Press, 1987), 88, 90.

2. Anne Higonnet sees 1881 as a "turning-point" in the art of both Cassatt and Morisot, as they move to this "new subject matter." She discusses Morisot's numerous visits to Cassatt and her family during the summer of 1880, when the American family was living at a villa in Marly-le-Roi, close by Morisot. Higonnet also notes an important difference in the treatment of this theme of maternity: while Cassatt tends to paint mother figures with children, Morisot tends to paint Julie as an independent figure; the mother is the artist, at an important and literal level. Higonnet, *Morisot*, 158–60.

3. Carroll Smith-Rosenberg, *Disorderly Conduct: Visions of Gender in Victorian America* (New York: Knopf, 1985), 213.

4. Ibid., 225, 239.

5. Ibid., 23.

6. For the by now classic discussion of such novels, see Jane Tompkins, *Sensational Designs: The Cultural Work of American Fiction, 1750–1860* (New York: Oxford University Press, 1985), especially chap. 5, "Sentimental Power: *Uncle Tom's Cabin* and the Politics of Literary History" and chap. 6, "The Other American Renaissance." See also Nancy Schnogg, "Inside the Sentimental: The Psychological Work of *The Wide, Wide World*," *Genders* 4 (Spring 1989): 11–25, for an excellent discussion of the sentimental in terms of object relations theory, in which female "sentiment" becomes an "emotional landscape," marked by a series of "deep attachments and traumatic separations" (13).

7. Tamar Garb, *Women Impressionists* (New York: Rizzoli, 1986), 72.

8. Smith-Rosenberg writes, "Between the 1870s and the 1890s, abortion became illegal, birth-control information was banned from the U.S. mails, brothels were closed or prostitutes made to register and submit to gynecological examinations" as part of a large movement on the part of male physicians and government to control women's sexuality (*Disorderly Conduct*, 24). In the political vocabulary of the time, "married women's selfish practice of birth control and their perverted use of abortion threatened the very survival of Protestant America" (ibid., 23).

9. Wanda Corn, paper given at College Art Association, 1985, titled "Style as Politics: Mary Cassatt's Mural at the 1893 Fair."

10. Nancy Mowll Mathews, *Mary Cassatt and Edgar Degas*, exh. cat., San Jose Museum of Art, 1981 (unpaginated).

11. Hale, *Cassatt*, 51.

12. Nancy Mowll Mathews, ed. *Cassatt and Her Circle: Selected Letters* (New York: Abbeville Press, 1984), 46. Wanda Corn argues persuasively that "what makes Cassatt so singular is that she took her professional self so seriously." This seriousness allowed

Cassatt to embrace a style of painting judged, at least by Americans, to be unfeminine in its "piercing colors and earthy forms." Her mural for the Women's Building of the 1893 Exposition in Chicago met with disapproval from many quarters, Corn argues, precisely because of this independence from an expected "feminine" style.

13. Hale, *Cassatt*, 31.

14. Griselda Pollock, *Vision and Difference: Femininity, Feminism and Histories of Art* (New York: Routledge, 1988), 10.

15. Garb, *Women Impressionists*, 11–12.

16. See Higonnet, *Morisot*, passim.

17. E. John Bullard, *Mary Cassatt: Oils and Pastels* (New York: Watson-Guptill, 1972), 11. Nancy Hale translates this sentence differently, saying that in response to A. F. Jaccaci, the publisher and writer on collecting, who asked her, "If you could start your life again, would you marry?" she said, "There's only one thing in life for a woman; it's to be a mother."

18. Hale, *Cassatt*, 150.

19. Ibid., 110–11.

20. Mathews, *Mary Cassatt*, 75. See Mathews's discussion of this theme of mothers and children, 72–76.

21. See Pollock, *Vision and Difference*, chap. 3, "Modernity and the Spaces of Femininity," and Pollock's earlier book *Mary Cassatt* (London: Jupiter Books, 1980).

22. Hale, *Cassatt*, 103–04.

23. Pollock, *Vision and Difference*, 66.

24. Ibid., 87.

25. Ibid.

26. Ibid., 63.

27. Pollock says in a note that she "may have overstated the case that bourgeois women's sexuality could not be articulated within these spaces. In the light of recent feminist study of the psychosexual psychology of motherhood, it would be possible to read mother-child paintings by women in a far more complex way as a site for the articulation of female sexualities" (*Vision and Difference*, 79).

28. It would be interesting to compare this covering of the child's genitals with other Cassatt paintings in which the child is naked and clearly a boy. I would speculate that a different relation emerges here, one in which the boy-child's overt sexuality does not represent the mother's, but, in a more traditional Freudian scheme, represents what she does not have. The paintings in which the sex of the child is more deliberately ambiguous appear in this sense more imaginative about the possibilities of maternal sexuality.

29. Anna Jameson, *Legends of the Madonna as Represented in the Fine Arts* (New York: Longmans, Green, 1902), 115.

30. The contrast in moral standards held up to women and men painters is evident; Degas, Renoir, Manet, and others found no obstacle to painting women in the nude. Both Cassatt and Morisot, in the 1890s, sometimes painted partially nude figures, although their models for these were servants or other working-class figures.

31. See Margaret R. Miles, "The Virgin's One Bare Breast: Female Nudity and Religious Meaning in Tuscan Early Renaissance Culture," in *The Female Body in Western Culture: Contemporary Perspectives*, ed. Susan Rubin Suleiman (Cambridge: Harvard University Press, 1985), 193–208, for a discussion of the cultural meanings accruing to the image of the Virgin's bare breast as she nurses the Christ child. This body is clearly understood within its historical context not as a sexual one, but as a nourishing one.

32. Jane Silverman Van Buren discusses this mutuality between mother and child as a figuration of the "holding environment" described by object relations theory. I agree with this interpretation to a large extent; however, Van Buren views this complete protection of the child by the mother as a relationship somehow outside any ideology. Van Buren asserts that Cassatt's "couples seem safe from history, tradition, and biased mythology" (*The Modernist Madonna: Semiotics of the Maternal Metaphor* [Bloomington and Indianapolis: Indiana University Press, 1989], 134). As in object relations theory, Van Buren focuses on the child as the active and growing identity; the mother becomes important solely as a reliable and continuing presence. I am attempting to think about Cassatt's indirect representation of the mother not simply as a loving environ-

ment for the child, but as a desiring and sexual self in her own right.

33. Luce Irigaray, "When Our Lips Speak Together," trans. Carolyn Burke, *Signs* 6, no. 1 (Autumn 1980): 69–79. It is important to note, however, that for Irigaray this situation can be accomplished only with two biological females. I disagree with this absolute linking of biology to such a possibility of relationship.

34. Helen Tartar has suggested to me that such cropping in Impressionist paintings often suggests the opposite of such control: that is, the painting seems to suggest itself as a spontaneous and sudden glimpse of a real moment. The frame's cropping signifies in this sense a giving over of control, and an allowance that the world actually extends outside the frame. This interpretation makes sense, yet there is something about the stark separateness of the woman's right hand that suggests to me a subtle but nonetheless disturbing isolation that I find mirrored in the other cuts.

35. Pollock discusses the social space of Cassatt's paintings as being often limiting or constricting in some way. But her reading of this painting suggests nothing of the disturbing overtones I discover in it. See her *Mary Cassatt*, 15–16, and *Vision and Difference*, 65–66. John Bullard's description of this painting as amusing resembles that of most interpreters, although he does notice that "the slightly languid and provocative pose of the little girl is disconcertingly similar to the young nymphetes in Balthus' post–World War II pictures." Bullard, *Cassatt: Oils and Pastels*, 24.

36. Josef Breuer's work with Freud on hysteria, to be published as *Studies on Hysteria* (1893–95), had its origins in Breuer's treatment of Anna O., which occurred between 1880 and 1882. Once Freud began to practice in Vienna in 1886, he gained numerous hysterical women patients. See Josef Breuer and Sigmund Freud, *Studies on Hysteria*, in *The Standard Edition of the Complete Psychological Works of Sigmund Freud*, trans. James Strachey, in collaboration with Anna Freud (London: Hogarth Press and the Institute of Psycho-Analysis, 1955), x–xi. It is interesting too to compare Henry James's intricate account of the "tomb of Maisie's

childhood" in *What Maisie Knew* (1897) to Cassatt's portrayal of the little girl. Maisie is a new kind of child, one who has been made to know all that adults know and perhaps more.

37. Mathews, *Cassatt and Her Circle*, 281–82.

38. See Stuckey and Scott, *Berthe Morisot*, 34–36. Berthe wrote to Edma, "He found it very good, except for the lower part of the dress. He took the brushes and put in a few accents that looked very well; mother was in ecstasies. That is where my misfortunes began. Once started, nothing could stop him; from the skirt he went to the bust, from the bust to the head, from the head to the background. He cracked a thousand jokes, laughed like a madman, handed me the palette, took it back; finally by five o'clock in the afternoon we had made the prettiest caricature that was ever seen. . . . And now I am left confounded. My only hope is that I shall be rejected. My mother thinks this episode funny, but I find it agonizing" (36).

39. Hale, *Cassatt*, 110–11.

40. Many critics have mentioned Degas's suggestion to Cassatt. See, for instance, ibid., 93. Nancy Mathews suggests that Cassatt's "adoption of [the theme of mother and child] signals a shift in her relationship to Degas and Impressionism. The intimate interaction that can be seen in the works of 1879 gradually gave way to the more sporadic contact typical of two friends who are pursuing their own directions. Cassatt's dedication to the theme of the mother and child parallels Degas' love of the ballet" (*Mary Cassatt and Edgar Degas*, 4, 6).

41. It would be valuable to think about the idea of repose in relation to the representation of women's sexuality at the end of the nineteenth century. There is often something passive and somnolent about such images, qualities that lead to thoughts about how middle-class women could be seen as sexual only if their sexuality was not conscious or deliberately acted on.

42. As Bullard suggests (*Cassatt: Oils and Pastels*, 56), Cassatt may have had Manet's painting titled *Boating* (1874) in mind here, although Cassatt reverses the positions of man and woman and adds a child. The figures in Cassatt's painting appear much more in-

tensely tied up with each other than those in Manet's open, free-spirited image.

43. Nancy Mathews links *The Boating Party* persuasively to "the new, expansive style of the post-mural period [referring to Cassatt's mural designed for the Womans' Building at the 1893 Chicago exposition], with its various experiments in composition and subject matter. The large size of the painting and its carefully designed composition indicate that it was meant as a kind of showpiece, perhaps to answer critics of the mural who complained of the absence of men in her interpretation of the 'Modern Woman'" (*Mary Cassatt*, 107).

44. Luce Irigaray, "And the One Doesn't Stir Without the Other," trans. Hélène Vivienne Wenzel, *Signs* 7, no. 1 (Autumn 1981): 60–67. Van Buren offers an ex-

tremely different interpretation of this painting, as a positive image of the mother's helpful and nurturing invitation to the daughter to move beyond the sphere of infantile undifferentiation. She interprets the sunflower to signify the mother's "capacity to feed, nurture, and foster the child's growth and development." She also suggests that the daughter has more freedom to "enjoy her sensuality" than did women of her mother's generation. Van Buren, *Modernist Madonna*, 149–50. I think that Van Buren does not confront the more disturbing aspects of this painting, including the mediations of the mirrors.

45. I am grateful to Richard Goodkin for this observation, made at the International Conference on Narrative in Madison, Wisconsin, April 1989.

James and the Politics of Vision

1. William James to William Dean Howells, August 20, 1890, *The Letters of William James*, ed. Henry James (Boston: Atlantic Monthly Press, 1920), 1:298–99.

2. William Dean Howells, "Editor's Study," *Harper's Monthly* 83 (July 1891): 314.

3. James to Howells, August 20, 1890, *Letters*, 299.

4. William Dean Howells, *A Hazard of New Fortunes; A Selected Edition of W. D. Howells*, (Bloomington: Indiana University Press, 1976), 16:496. Subsequent references are to this text.

5. In this essay, I use the term *vision* to denote both the physical and discursive dimensions of sight. In his preface to *Vision and Visuality* (Seattle: Dia Art Foundation, 1988), Hal Foster uses the two terms in the title to differentiate between the two functions, but I think this differentiation actually oversimplifies the issues, as his text seems to acknowledge, and needlessly complicates reading the text.

6. Martin Jay, "Scopic Regimes of Modernity," in *Vision and Visuality*, ed. Foster, 3.

7. For fuller explanation of Alpers's thesis, see her *The Art of Describing: Dutch Art in the Seventeenth Century* (Chicago: University of Chicago Press, 1983), esp. chap. 2. Jonathan Crary, in *Techniques of the Observer: On Vision*

and *Modernity in the Nineteenth Century* (Cambridge: MIT Press, 1990), 34–36, like many others, questions several of Alpers's controversial theses, particularly that the visual culture she describes belongs only to a north European tradition; nevertheless, her book as well as her notion of an "art of describing" are pertinent to turn-of-the-century American culture.

8. See Crary, *Techniques of the Observer*, 16–24, for a general outline of this argument.

9. Miles Orvell, *The Real Thing: Imitation and Authenticity in American Culture, 1880–1940* (Chapel Hill: University of North Carolina Press, 1989), 92–94. Articles by Galton appeared with some regularity in *Mind* and *Popular Science Monthly* (*PSM*); see particularly, "Mental Imagery," *PSM* 18:64–76, "Statistics of Mental Imagery," *Mind* (July 1880): 301; "Measurements of Men," *PSM* 21:53. Significantly, Galton was one of the leading promoters of eugenics in the nineteenth century, and his experiments with composite photographs as well as on visualizing capacities (discussed briefly later in this essay) were important elements in his ideas about eugenics. An examination of the connection, beyond the scope of this essay, would shed further light on the discourse of vision in the late nineteenth cen-

tury. On Galton, see Derek Forrest, *Francis Galton: The Life and Work of a Victorian Genius* (New York: Taplinger, 1974).

10. Ulric Neisser, "A Paradigm Shift in Psychology," *Science* 176 (May 1972): 628–30, compares nineteenth-century research on mental imagery with work done in the twentieth century. For James's classifications of images, see chap. 18 in James, *The Principles of Psychology* (New York: Henry Holt, 1890), 2:44–75. Subsequent citations are to this edition.

11. In fact, although James discussed afterimages in his chapter "Imagination," he did not classify them as mental images but as direct sensations.

12. In his chapter on imagination, James reproduced more than half of Galton's discussion of mental imagery in *Inquiries into Human Faculty and Its Development* (London: J. M. Dent, 1907). *Inquiries* was published in numerous editions between its first publication date and World War I.

13. James discussed the relation between sensation and an outward reality at many points in *Principles*. For an overview of his thoughts, see the chapter entitled "Sensation" in vol. 2, esp. 31ff.

14. W. J. T. Mitchell, *Iconology: Image, Text, Ideology* (Chicago: University of Chicago Press, 1986). See esp. chaps. 4, 5, in which Mitchell examines the influential work of Lessing and Burke and their ideologies of the visual and verbal.

15. See Henry Adams, "William James, Henry James, John La Farge and the Foundations of Radical Empiricism," *American Art Journal* 17 (Winter 1985): 60–67.

16. Cited in Gerald Myers, *William James: His Life and Thought* (New Haven: Yale University Press, 1986), 317. Myers's book is the most comprehensive study of James's thought.

17. Ibid.

18. Cited in Alan Trachtenberg, *The Incorporation of America: Culture and Society in the Gilded Age* (New York: Hill & Wang, American Century Series, 1982), 185–86.

19. Howells, "Editor's Study," 973.

20. Amy Kaplan, *The Social Construction of American Realism* (Chicago: University of Chicago Press, 1988), 49–50. Kaplan's reading of *A Hazard of New Fortunes* is extremely persuasive and sensitive, and while it does deal

with Howells's metaphor of sight, it says little, if anything, about that metaphor's relation to visual media. In addition, her arguments assume a transparent relationship between Howells and March.

21. Cited in Thomas Bender, *New York Intellect: A History of Intellectual Life in New York City, from 1750 to the Beginnings of Our Own Time* (Baltimore: Johns Hopkins University Press, 1987), 193.

22. Ibid., 192.

23. Orvell, *The Real Thing*, 110.

24. William H. Rideing, "Life on Broadway," *Harper's Monthly Magazine* 56 (1877–78): 229–39.

25. Georg Simmel, "The Metropolis and Mental Life," in *Classic Essays on the Culture of Cities*, ed. Richard Sennett (New York: Appleton-Century-Crofts, 1969), 48.

26. Kaplan, *Social Construction of American Realism*, 48.

27. Howells, "(The Author to the Reader) Autobiographical," *A Hazard*, 503–05. The quotes are from a provisional manuscript of the "Bibliographical" preface to the 1909 edition of *A Hazard* that is reproduced in its entirety in the appendix of the Indiana University Press edition of the novel.

28. Kenneth Burke, *A Grammar of Motives* (Berkeley: University of California Press, 1969), 513–14.

29. Ibid., 514–15.

30. Trachtenberg discusses the metaphor of city as mystery in *The Incorporation of America* (see esp. chap. 4) as well as in his essay "Experiments in Another Country: Stephen Crane's City Sketches," in *American Realism: New Essays*, ed. Eric Sundquist (Baltimore: Johns Hopkins University Press, 1982), 138–54. Although Trachtenberg contrasts Crane's work with Howells's in this essay, what he discovers in Crane's city sketches is, in fact, quite similar to what I discern in at least those moments of vision in *A Hazard*.

31. Compare this passage to Carolyn Porter's discussion of Emerson's detached observer and Werner Heisenberg's dilemma in the preface to *Seeing and Being: The Plight of the Participant Observer in Emerson, James, Adams, and Faulkner* (Middletown, Conn.: Wesleyan University Press, 1981), xii. As Porter points out, "In moments of crisis, . . . the

detached contemplative observer may be forced to recognize his own participation in the reality he presumes to observe," and this was precisely the crisis that forced Heisenberg to articulate his indeterminacy theory.

32. Howells, "Tribulations of a Cheerful Giver," *Impressions and Experiences* (New York: Harper and Brothers, 1896), 163.

33. Howells, "Bibliographical," 3. Quotes are from the published 1909 preface as reprinted in the Indiana University Press Howells Edition (italics added).

34. Kaplan argues that the concept of character carried for Howells "connotations of personal integrity and that, at least implicitly, he associated character with productive work, an activity that Beaton performed only sporadically." See *Social Construction of American Realism*, 24.

35. For a discussion of Lessing's *Laocoon: An Essay upon the Limits of Poetry and Painting* (1766) and its ideological implications, see Mitchell, *Iconology*, 95–115.

36. Mitchell, *Iconology*, 112.

37. See Christopher P. Wilson, "The Rhetoric of Consumption: Mass Market Magazines and the Demise of the Gentle Reader, 1880–1920," in *The Culture of Consumption: Critical Essays in American History, 1880–1980* ed. Richard W. Fox and T. J. Jackson Lears (New York: Pantheon Books, 1983), 39–64.

38. Wilson, "Rhetoric of Consumption," 41.

39. Sidney Fairfield, "The Tyranny of the Pictorial," *Lippincott's* 56 (1895): 861.

40. Arthur Reed Kimball, *Journal of Social Science* 37 (1899): 37, cited in Frank Luther Mott, *A History of American Magazines, 1885–1905* (Cambridge: Harvard University Press, 1957), 4:150.

41. Neil Harris develops this idea in "Iconography and Intellectual History: The Half-Tone Effect," in *New Directions in American Intellectual History*, ed. Higham and Conkin (Baltimore: Johns Hopkins University Press, 1979), 196–211.

42. Fairfield, "Tyranny," 861.

43. Wilson, "Rhetoric of Consumption," 61.

44. See Kaplan, *Social Construction of American Realism*, 15–25; Christopher Wilson, in *The Labor of Words: Literary Professionalism in the Progressive Era* (Athens: University of Georgia Press, 1985), more closely identifies Howells with the genteel tradition; see esp. 10–11. In fact, although Howells remained most closely tied to the genteel literary magazines such as *Atlantic* and *Harper's*, he also took a turn at editing *Cosmopolitan* in 1892. Further, at the same time that he composed polite conversations with his readers in his "Editor's Study," he recognized the implications of business for a "man of letters" and used the modern techniques of marketing to his own advantage. For Howells's treatment of the relation between literature and business, see "The Man of Letters as a Man of Business," *Scribner's Magazine* 14 (October 1893): 430.

45. Fairfield, "Tyranny," 864.

46. "Over-Illustration," *Harper's Weekly*, July 29, 1911: 6.

47. Compare with Walter Bagehot's opinion that women artists and scientists were "simply an anomaly, an exceptional being, holding a position more or less intermediate between the two sexes." Such women, in other words, were "monstrosities." "Biology and Woman's Rights," *PSM*, 14:201–13.

Afterword

1. In making this assertion (however qualified by the word *relatively*) I am aware that I am courting dismissal by those who would accuse me of essentializing both the visual and the body to which it is tied. Without getting tangled up in this thorny issue, I would suggest that the challenge here is to develop an approach to the problem that asserts the priority of the visual over the verbal in certain critical areas of culture without implying essentialism. Of course, the question of priority remains a hotly debated one and takes us to the heart of the postmodern polemic. Even in the case of cognitive science, there is no resolution between those whose experimentation leads them to conclude that mental imagery is indistinguishable from language and those who assert a difference and give the former some sort of

primacy. As Ned Block characterized the lines of disagreement, "One side, the picto-rialist side, takes the naive response to the experimental and introspective evidence to lead us in the right direction. The picto-rialists agree that we don't literally have pictures in our brains, but they insist nev-ertheless that our mental images represent in roughly the way that pictures represent. The other side, the descriptionalist side, re-gards the introspective and experimental evidence mentioned as misleading. On their view we should think of mental images as representing in the manner of some non-imagistic representation—namely, in the manner of language rather than pictures" (see Block, ed., Imagery [Cambridge: MIT Press, 1981], 4–5). My ar-gument in this Afterword is that just as there is no ontological divide between vis-ual and verbal there can be no single defi-nition of either term, and we must there-fore rely on a careful delineation of the relation between context and point of view in any particular situation in order to avoid making essentialist claims.

2. Edward Snow, "Theorizing the Male Gaze: Some Problems," Representations 25 (Winter 1989): 31.

3. James Clifford, "On Collecting Art and Cul-ture" in Out There: Marginalization and Contem-porary Cultures, ed. Russell Ferguson et al. (Cambridge: MIT Press, 1990): 151.

4. Rudolf Arnheim, Visual Thinking (Berke-ley: University of California Press, 1969), 1.

5. On the Sister Arts idea, see Jean H. Hag-strum, The Sister Arts: The Tradition of Literary Pictorialism and English Poetry from Dryden to Gray (Chicago: University of Chicago Press, 1958); Mario Praz, Mnemosyne: The Parallel be-tween Literature and the Visual Arts (Princeton: Princeton University Press, 1970); and Rensselaer Lee, Ut Pictura Poesis: The Humanis-tic Theory of Painting (New York: Norton, 1967). For the relevance of this tradition to American painting and literature in the first half of the nineteenth century, see esp. James T. Callow, Kindred Spirits: Knicker-bocker Writers and American Artists, 1807–1855 (Chapel Hill: University of North Carolina Press, 1967); Donald Ridge, "James Fen-imore Cooper and Thomas Cole: An Anal-ogous Technique," American Literature 30

(March 1958): 26–36; idem, "Kindred Spirits: Bryant and Cole," American Quarterly 6 (Fall 1954): 232–44; idem, The Pictorial Mode: Space and Time in the Art of Bryant, Irving, and Cooper (Lexington: University of Ken-tucky Press, 1971); and H. Daniel Peck, A World By Itself: The Pastoral Moment in Cooper's Fiction (New Haven: Yale University Press, 1977). For the epistemological back-ground of the Sister Arts idea in America, see esp. H. Daniel Peck, A World by Itself and William Charvat, The Origins of American Criti-cal Thought, 1810–1835 (New York: Barnes, 1961).

6. Nelson Goodman, Languages of Art: An Ap-proach to a Theory of Symbols (Indianapolis: Bobbs-Merrill, 1968). Goodman writes, "Nonlinguistic systems differ from lan-guages, depiction from description, the representational from the verbal, paint-ings from poems, primarily through lack of differentiation—indeed through den-sity (and consequent total absence of articulation)—in the symbol scheme. Nothing is intrinsically a representation; status as representation is relative to sym-bol system" (226).

7. W. J. T. Mitchell, Iconology: Image, Text, Ideol-ogy (Chicago: University of Chicago Press, 1986), 67.

8. See ibid., 69–74.

9. Mieke Bal, "De-disciplining the Eye," Criti-cal Inquiry 19 (Spring 1990): 508.

10. For an example of this sort of analysis, see Meyer Shapiro, "On some Problems in the Semiotics of Visual Art: Field and Vehicle in Image-Signs," Semiotica 1, no. 3 (1969): 223–42. Cited by Bal, "De-disciplining the Eye."

11. Donald Kuspit, "Traditional Art History's Complaint against the Linguistic Analysis of Visual Art," Journal of Aesthetics and Art Criti-cism 45 (Summer 1987): 345–49.

12. Such exact reiteration has been focused upon by deconstructive analysis, which effaces the distinction between metaphor and metonymy, between rhetoric (or il-locutionary speech acts) and grammar and syntax, and between "inside" and "out-side." It thus reduces everything to a face-off between an overdetermined realm of intentionality—emerging from a myste-rious interior as well as from a boundless

sociocultural context—and a code conceived of as purely material, external. In this formulation the code is the only thing accessible to analysis; the subject disappears. Referring to a passage by Proust, Paul de Man points to the implications of this analysis for the subject: "By passing from a paradigmatic structure based on substitution, such as metaphor, to a syntagmatic structure based on contingent association such as metonymy, the mechanical, repetitive aspect of grammatical forms is shown to be operative in a passage that seemed at first sight to celebrate the self-willed and autonomous inventiveness of a subject" (see "Semiology and Rhetoric," in *Contemporary Literary Criticism: Literary and Cultural Studies*, 2d ed., ed. Robert Con Davis and Ronald Schliefer [New York: Longman, 1989]: 129–30).

13. Christopher Collins, "Groundless Figures: Reader Response to Verbal Imagery," *CEA Critic* 51 (Fall 1988): 11–29.

14. Michael Baxandall, *Patterns of Intention: On the Historical Explanation of Pictures* (New Haven: Yale University Press, 1985), 3. Baxandall also notes the commonly cited difference between the "simultaneously available field" of the picture and a "medium as temporally linear" (3) as language. He goes on to qualify the distinction in an especially precise and interesting way: "But if a picture is simultaneously available in its entirety, *looking* at a picture is as temporally linear as language. Does or might a description of a picture reproduce the act of looking at a picture? The lack of fit here is formally obvious in an incompatibility between the gait of scanning a picture and the gait of ordered words and concepts. (It may help to be clear about how our optical act is paced. When addressing a picture we get a first general sense of a whole very quickly, but this is imprecise; and, since vision is clearest and sharpest on the foveal axis of vision, we move the eye over the picture, scanning it with a succession of rapid fixations. The gait of the eye, in fact, changes in the course of inspecting an object. At first, while we are getting our bearings, it moves not only more quickly but more widely; presently it settles down to movements at a rate of something like four or five a second and shifts of something like three to five degrees—this offering the overlap of effective vision that enables coherence of registration)" (3–4).

15. Lorenz Eitner, "Art History and the Sense of Quality," *Art International* 19 (May 15, 1975): 75.

16. David Summers, "'Form,' Nineteenth-Century Metaphysics, and the Problem of Art Historical Description," *Critical Inquiry* 15 (Winter 1989): 394.

17. Mitchell, *Iconology*, 44.

18. Ibid., 109–15.

19. On this controversy, see Josephy Frank, *The Widening Gyre: Crisis and Mastery in Modern Literature* (Bloomington: Indiana University Press, 1963); Frank Kermode, *The Romantic Image* (New York: Random House, 1957); Joseph Frank, "Spatial Form: An Answer to Critics," *Critical Inquiry* 4 (Winter 1977): 231–52; and "Spatial Form: Some Further Reflections," *Critical Inquiry* 5 (Winter 1978): 275–90; William Holtz, "Spatial Form in Modern Literature: A Reconsideration," *Critical Inquiry* 4 (Winter 1977): 271–83; and W. J. T. Mitchell, "Spatial Form in Literature: Toward a General Theory," *Critical Inquiry* 6 (Spring 1980): 539–67.

20. Theodor Adorno, *Aesthetic Theory*, trans. C. Lenhardt (London, 1984), 139–40.

21. Karl Marx, "Theses on Feuerbach," in *The Portable Marx*, ed. Eugene Kamenka (New York: Viking Penguin, 1983), 155.

22. This is specifically where, it seems to me, the theory of iconology has something crucial to offer to the concept of hegemony, which, as T. J. Jackson Lears has pointed out, has been limited by rationalistic psychology. Lears points to the importance of "half-conscious psychic needs that seem far removed from the public realm of class relations but may serve to revitalize or transform a hegemonic culture" along with an "emphasis on the unintended consequences of purposive social action" (588). Focus on such issues differentiates the theory of hegemony from "the dead end of social control" (588) while reinstating the role of individual subjectivity in a cultural process otherwise dominated by group psychology and rational self-interest. See "The Concept of

Cultural Hegemony: Problems and Possibilities," *American Historical Review* 90 (June 1985): 567–93.

23. Jonathan Crary, *Techniques of the Observer: On Vision and Modernity in the Nineteenth Century* (Cambridge: MIT Press, 1990).

24. A moment's thought will illuminate the implications of this distinction between image and sign, metaphor and metonymy. The meaning of signs, as Saussure first insisted, is arbitrary, simply a matter of convention. Hence, whereas the image traditionally conceived is a "body" which evokes *presence* as well as immediacy, providing direct access not only to itself but beyond itself, the sign, paradoxically, is both subsumed by its referent and calls attention to the *absence* of that referent. It appears only within a dialectic of presence and absence, as Derrida showed. Similarly, if metaphor (to offer only a preliminary definition) substitutes something known or tangible for something unknown or intangible, metonymy collapses this verticality or "depth" into the horizontality of signs which are contiguous to each other, as in the linearity of a sentence. What is more, the semiotic is distinguished not only from the imagistic but from the semantic, for it transforms images into "chains of signifiers" which connect not with a signified but with other signs in an all-inclusive system. Designating *how* words mean rather than *what* they mean, the semiotic collapses any difference between the linguistic sign and what it stands for as well as between the image and the linguistic system that articulates it.

25. Anton Ehrenzweig, *The Hidden Order of Art: A Study in the Psychology of Artistic Expression* (Berkeley and Los Angeles: University of California Press, 1967).

26. Hans-Georg Gadamer, *Truth and Method*, 2d rev. ed., trans. Joel Weinsheimer and Donald G. Marshall (New York: Crossroad, 1990), 269.

27. Quoted in Patrocinio Schweickart, "Reading Ourselves: Toward a Feminist Theory of Reading," reprinted in *Contemporary Literary Criticism*, ed. Davis and Schleifer, 129–30.

28. David Freedberg, *The Power of Images: Studies in the History and Theory of Response* (Chicago: University of Chicago Press, 1989), 25.

29. In Freud's suggestive formulation, "An uncanny experience occurs when infantile complexes which have been repressed are once more revived by some impression, or when primitive beliefs which have been surmounted seem once more to be confirmed." See Freud, *The Complete Works*, Standard Edition (London: Hogarth Press, 1953–74), 17:249. As Freud pointed out and as the German *das Unheimliche* (the opposite of "homely") suggests, the uncanny "is in reality nothing new nor alien, but something which is familiar and old-established in the mind and which has become alienated from it only through the process of repression" (241).

30. Quoted in Alfred Frankenstein, *After the Hunt: William Harnett and Other American Still Life Painters, 1870–1900* (Berkeley and Los Angeles: University of California Press, 1953), 55.

31. Quoted in Louis Legrand Noble, *The Life and Works of Thomas Cole* (Cambridge: Harvard University Press, 1964), 185.

32. I am much indebted in my analysis of Harnett to a stimulating essay by Jean Baudrillard, "The Trompe-l'Oeil," reprinted in *Calligram: Essays in New Art History from France*, ed. Norman Bryson (Cambridge: Cambridge University Press, 1988), 53–62.

33. Frankenstein, *After the Hunt*, 48.

34. Quoted in Ronald G. Pisano, *William Merritt Chase* (New York: Watson-Guptill, 1979), 28.

35. See David Lubin, "Permanent Objects in a Fast-Changing World: Harnett's Still-Lifes as a Hold on the Past," in *Materials for a Leisure Hour: The Still-Life Paintings of William Michael Harnett*, ed. Doreen Bolger and John Wilmerding, 49–59 (New York: Metropolitan Museum of Art, 1992).

36. Colin Campbell, *The Romantic Ethic and the Spirit of Modern Consumerism* (Oxford: Basil Blackwell, 1987).